THE ILLUMINATING MIND

In American Photography

THE ILLUMINATING MIND
in
American Photography:

Stieglitz, Strand, Weston, Adams

David P. Peeler

 University of Rochester Press

First published 2001
by the University of Rochester Press

The University of Rochester Press is an imprint of Boydell & Brewer, Inc.
668 Mount Hope Avenue, Rochester, NY 14620, USA
and of Boydell & Brewer, Ltd.
P.O. Box 9, Woodbridge, Suffolk 1P12 3DF, UK

Library of Congress Cataloging-in-Publication Data

Peeler, David P.
 The illuminating mind in American photography : Stieglitz, Strand,
Weston, Adams / by David P. Peeler
 p. cm.
 Includes bibliographical references and index.
 ISBN 1-58046-059-3 (alk. paper)
 1. Photographers–United States–Biography. 2. Stieglitz, Alfred,
1864-1946. 3. Strand, Paul, 1890-1976. 4. Weston, Edward, 1886-1958.
5. Adams, Ansel, 1902- . I. Title.
 TR139 .P44 2001
 770'.92'273–dc21 20010117108

British Library Cataloguing-in-Publication Data
A catalogue record for this item is available from the British Library

Acknowledgment is made for permission to quote from *The Selected Poetry of Robinson Jeffers* by Robinson Jeffers, Copyright © 1935 & renewed 1963 by Donnan Jeffers and Garth Jeffers. Reprinted by permission of Random House, Inc.

Designed and typeset by George Joseph Madden
Printed in the United States of America.
This publication is printed on acid-free paper.

Contents

ILLUSTRATIONS

Alfred Stieglitz (1864–1946)

Paul Strand (1890–1976)

Edward Weston (1886–1958)

Ansel Adams (1902–1984)

ACKNOWLEDGMENTS

I am grateful for the material support that several institutions have extended to this project. Both the Beinecke Rare Book and Manuscript Library at Yale and the Huntington Library provided visiting fellowships. The Center for Creative Photography at the University of Arizona extended an Ansel Adams Research Fellowship. The National Endowment for the Humanities provided travel support, a Summer Institute in "Theory and Interpretation in the Visual Arts," and also a Fellowship for College Teachers. I am thankful, too, for summer, sabbatical, and production support from the United States Naval Academy.

This project would not have been possible without assistance from archivists, librarians, and curators. My greatest debt is to Amy Rule, Archivist at the Center for Creative Photography, whose help and support has continued steadfastly over the years. My gratitude extends to Leslie Calmes, also of the Center's Archives, as well as to others at the Center: Nancy Lutz, Dianne Nilsen, Terence Pitts, Marcia Tiede, and Tim Troy. Patricia C. Willis helped guide me through Yale's Beinecke Rare Book and Manuscript Library. There was similar guidance from Katherine C. Ware and Weston Naef at the Department of Photographs of the J. Paul Getty Museum. Alice Lefton helped me locate materials in the Archives of the Philadelphia Museum of Art, and I am likewise indebted to Sarah Greenough, Carlotta Owens, and Charlie Ritchie of the National Gallery of Art. At the George Eastman House, this project has received the support of Curator of Photography Therese Mulligan, Assistant Archivist Joseph Strubble, and Curatorial Assistant Sean Corcoran. For day-to-day assistance I have relied upon Barbara Manvel, Alice Creighton, Mary Rose Catalfamo, and Florine Todd, all of the Naval Academy's Nimitz Library.

My thanks goes to the scholars who have read and commented on portions of this project: Fraser Cocks, James Curtis, James Gilbert, Mary Warner Marien, Victor LaViola, George Lipsitz, Melinda Parsons, Miles Orvell, George Roeder, Sally Stein, and William A. Turnage. Other readings have come from the members of the Washington Seminar in American History and Culture, and from my colleagues in the Works in Progress Seminar of the Naval Academy's History Department: Richard Abels, David Appleby, Tom Brennan, the late Ted Bogacz, and Nancy Ellenberger.

I am deeply indebted to Molly Cort of the University of Rochester Press. Her fine taste, solid judgment, and unflagging support have been essential in the making of this book.

Paula Marie Woodward nurtured the project. Gary, Kasey, Yankee, and Dixie lived it.

Annapolis, Maryland
February, 2001

ABBREVIATIONS

AA	Ansel Adams
AAA/CCP	Ansel Adams Archive, Center for Creative Photography, University of Arizona, Tucson, AZ
AS	Alfred Stieglitz
ASA/YCAL	Alfred Stieglitz Archive, Yale Collection of American Literature, Beinecke Rare Book and Manuscript Library, New Haven, CT
BN	Beaumont Newhall
DBI	Edward Weston, *The Daybooks of Edward Weston, Volume I: Mexico*. Nancy Newhall, ed. (Rochester, NY: George Eastman House, 1961; Millerton, NY: Aperture, 1973)
DBII	Edward Weston, *The Daybooks of Edward Weston, Volume II: California*. Nancy Newhall, ed. (Rochester, NY: George Eastman House, 1961; Millerton, NY: Aperture, 1973)
EW	Edward Weston
EWA/CCP	Edward Weston Archive, Center for Creative Photography
GEH/IMP	George Eastman House, International Museum of Photography, Rochester, NY
Getty Collection	Department of Photographs, J. Paul Getty Museum, Malibu, CA
GOK	Georgia O'Keeffe
HL	Huntington Library, San Marino, CA
NGA	National Gallery of Art, Washington, DC
NN	Nancy Newhall
PS	Paul Strand
PSC/CCP	Paul Strand Collection, Center for Creative Photography
RSS	Rebecca Salsbury Strand
VSC/CCP	Virginia Stevens Collection, Center for Creative Photography

1. INTRODUCTION: *FOUR LIVES AND THE ILLUMINATING MIND*

This book focuses upon four major twentieth-century American photographers: Alfred Stieglitz (1864-1946), Paul Strand (1890-1976), Edward Weston (1886-1958), and Ansel Adams (1902-1984). These men worked within the motifs of straight, modernist photography. They often created good art, and at their best they made superb photographs which became some of the century's best-known images. Weston and the others were innovative workers, forging into new areas and setting examples that influenced generations of photographers throughout the world. Largely because of their efforts, Americans came to accept photography as a fine art; when Stieglitz began working in the 1880s, photography had a tenuous art status, but by the time Adams died a century later, museums, galleries, and the public agreed that the best photography has the seriousness, creativity, and market value of other visual arts.

In many ways these photographers are familiar figures. Elements of their lives have become part of the popular consciousness (Stieglitz is recognized as the spouse of his famous second wife, Georgia O'Keeffe), and some of their images have become so commonplace as to be almost banal (Adams's mountain photographs inhabit a wide variety of calendars, posters, and note cards). This familiarity has bred contempt in some quarters, where these photographers seem like yet another set of dead white male artists too well and too long ensconced in the modernist canon as well as the popular mind. More significantly, this apparent familiarity has bred a good deal of ignorance, obscuring lives and work that were more varied and complex than is usually recognized. Also, broad swathes of these photographers' images have been neglected, so that the scholarship is mute about themes that occupied these artists for years or even decades. One such theme engaged Strand during the 1950s when he undertook a project rather like Emerson's *Representative Men*—portraits of prominent Europeans whom he respected for having kept their left wing faith in spite of Cold War repression. Similarly, in the 1930s and 1940s Weston left behind a reverential treatment of natural forms and commenced a decidedly sardonic exploration of American oddities.

Many of these photographers' words, as well their images, have been overlooked. Digging into their archival manuscripts and unrenowned publications reveals unrecognized psychological intricacies as these men progressed through their careers. Adams, for instance, fell into a deep depression during the 1930s, and as he worked his way through his despair he rather studiously began to photograph sunrises and clearing storms, images in which nature not only reified his own emergence from darkness but also provided the reassuring suggestion that light and clarity come with time's passing. Strand likewise experienced considerable intellectual turmoil in those same years as he abandoned his earlier political assumptions and fascination with Nietzsche, and took on a new world view based upon his discovery of Marx; the transition was exciting as well as painful, a metamorphosis that Strand eloquently documented in letters that have only recently become available.

Accordingly, the time has come to look more closely at these four photographers. Much of my structure in this project is biographical, for the intimate linkage of art and life was an essential quality about these men; their careers were a persistent conjoining of creative impulse and biographical episode. Certainly there were sometimes unique events surrounding the making of any one particular photograph, but my larger purpose is to explore the circumstances and ideas that more broadly influenced the photographers' work. Thus it was that the vicissitudes of World War I and the draft transformed Strand into an Army hospital orderly at the Mayo Clinic, where his operating room experiences dramatically, if improbably, redirected his photographic vision. In a similar manner, Stieglitz launched upon his famous cloud photographs at a time when the women in his life achieved an independence from his influence and denied him the nude motif that had theretofore been one of his preoccupations. In Adams's case, World War II led him to an odd nature nationalism, and he made photographs that he hoped would enhance Americans' patriotism by showing them the beauty of their native landscape. There is, then, considerable obliqueness in the relationship between these men's lives and their art, so that the origins of important projects often rested in seemingly unrelated events. There was also a similar kind of curious association between the photographers' ideas and the intellectual influences upon which they drew. Stieglitz's talk of a fourth dimension resonated with the vocabulary of a largely forgotten physicist, Weston imbibed the nascent theosophy of fellow California bohemians, and Adams's outlook owed a good deal to his trail-side reading of an obscure British poet.

My aim in bringing together these four photographers is to achieve a kind of comparative biography. I hope to show the interrelationships of these lives as well as their shared themes and experiences. But it would be a stretch to call Adams, Weston, Strand, and Stieglitz a "school." Each was a terrific egoist, and the men had their distinctive styles, subjects and venues, as well as personalities and politics. Yet for all of their differences, these photographers were connected by mutual influence and shared interests. They knew each other, often quite well, and the younger men of the group were influenced by Stieglitz: Strand was his protégé, and Adams and Weston nervously sought Stieglitz's recognition. All four men exchanged ideas and studied each others' images, and on occasion they actually photographed together. They belonged to some of the same organizations, at times displayed their works together, occasionally shared living quarters, and sometimes pursued the same women.

Even more strongly, these men were linked by the intensity with which they produced their art. Each came to photography remarkably early and enthusiastically. As youths they acquired the fundamentals of making photographs, and from that moment none of them doubted that photography would be a commanding interest for the rest of their days; the only questions were about the type of photography to practice and how the art might relate to the other portions of their lives. For each man photography was a compelling art and not to be denied—even when one's family complained that this was not a very remunerative career, or that photography lacked the worth and status of a "true" art like music. That commitment propelled these artists through long, productive careers which had a certain com-

monality in their later phases. Over the years their visions became more expansive, for Strand and Weston turned from still life to landscape, Adams's attention moved from a Western to a national landscape, and Stieglitz's city images rose beyond the sidewalks to encompass large parts of the New York skyline.

Much of this enduring intensity arose from a certain shared orientation among the photographers. As a biographical perspective helps to show, these men were concerned not just with making art but also how one should live as an artist. In some ways they were rather like Thoreau with his *Walden*, for they hoped not merely to create the work, but to live it. That impulse arose most obviously in the case of Strand; once he became a Marxist he not only adopted a proletarian—even propagandistic—form of expression, but he also dutifully served the cause by arranging political displays, donating images for fund-raisers, and even drafting the arts platform of a national political party. For Stieglitz, much of life was connected with the gallery known as 291, where he spent most of his waking hours and where he devoted himself to discussing art and photography with all comers; for a time self and place and project became so closely intertwined that Stieglitz signed his letters with "291." Identity was also an issue for Weston, who adopted a series of literary aliases before finally identifying himself with the character of a wandering musician whose work alleviates moral malaise and brings beauty and expressive freedom to the people. Finally there was Adams, who chose a similar peripatetic identity, describing himself as a persistent hiker through the California back country.

These then were lives of high purpose—at least in the photographers' imaginations and sometimes in the actual living. Although Strand and the others sometimes took odd camera jobs to boil the pot, they seldom identified themselves as journalists or journeymen. Nor did they often work in the mode of documentary photography. Instead they had largely aesthetic goals for photography, and with their desires for status and standing they hankered to have their images displayed in the most prestigious locales. They rejected the older motifs of pictorial photography with its softly-diffused outlines and its dreamily allegorical orientation, and instead they embraced the sharply focused outlines and great physical depth of what came to be known as straight photography. They were also thoughtful individuals, if not quite minds of the first order. Stieglitz, Strand, Weston, and Adams had little advanced education or formal training, but they read with some breadth, and reflected with considerable seriousness about some of the underlying questions of their craft in particular, and of art in general.

In particular, these four men were fascinated with issues of representation. For decades Stieglitz and the others worked to describe the association between the photographic image and the real world subject, to define the relationship between the photographer's mind and the physical object before his camera. As Stieglitz and the others made their photographs and wrote their pieces, they concluded that the photograph is no mere copy of the outer world, and, although they granted that there was some linkage between what the photographer knew and that outside world, they believed that there is no point-by-point correspondence between the two. Bias, viewpoint, technical limitations, and of course creativity—all these (and more) meant that what the photographer has to say about a subject, and how the

photographer represents that subject, are distinct, sometimes joyously distinct, from the observed subject.

These conclusions aligned Strand and the others with larger intellectual currents of their time. During the late nineteenth and early twentieth centuries, American intellectuals and their counterparts throughout the West asked how it is that we humans come to know the world, and just what it is that we mean by "knowledge." In what might be called an epistemological revolution, thinkers concluded that even the most honestly gathered knowledge is incomplete and approximate, and that knowledge necessarily bears the imprint not only of the real world but also of the investigator. This revolution was not characterized by a single creed, but instead by a bundle of interrelated assumptions. Common among them was the belief that change and flux—not permanence—characterize nature, implying that there is no permanent "out there" which we know or represent. Time and space were no longer regarded as a fixed grid upon which the drama of reality plays out, and as time and space came to be thought of as flexible, folding, or collapsing, thinkers accepted the legitimacy, even the necessity, of multiple perspectives that might render contradictory depictions of the same subjects.

In such an atmosphere, truth was not seen as some wholly external quality that we uncover. Instead, what we know about the world was understood to be deeply affected by what we bring to it, so that knowledge might better be thought of as more of a construction rather than a discovery. There was lots of talk about how the mind worked in all this, and plenty of new metaphors were coined. It no longer seemed adequate to characterize the mind as mirroring reality, and William James began to describe knowledge and truth as things which the mind sculpts from the stone of reality. Accordingly, transcendental issues became moot or irrelevant, for even if transcendent arenas did exist, it now seemed that they were impossible for humans to grasp.

This epistemological revolution left scarcely any field untouched, and its implications continued to reverberate throughout the twentieth century. In physics, Americans grappled with a series of innovations that challenged older notions of scientific certainty not only in Albert Einstein's general theory but also in Niels Bohr's doctrine of complementarity and Werner Heisenberg's uncertainty principle. In areas such as economics, education and jurisprudence, there was, in what Morton White once called "the revolt against formalism," a growing sense that laws were not so much eternal verities but rather guides that could be shifted to accommodate needs of the moment. Similarly, historians like Charles Beard and Carl Becker abandoned a dream that had motivated their profession for years, and concluded that it was impossible to achieve an absolutely objective, just-the-facts reconstruction of the past. As it came to seem that reality was characterized as much by contradiction as consistency, novelists displayed predilections for devices like paradox and ambivalence, and began to explore themes of contradiction and absurdity. Pragmatic philosophers like William James and John Dewey became skeptical about the possibility of objectivity, and when their intellectual heir Richard Rorty later said that truth is something "made rather than found," Rorty was only voicing what had become a commonplace among those who accepted the new epistemology.[1]

These issues were raised dramatically in the visual arts. Modernists explored with relish the domains of flux and irony, accepted the variousness of time and space, composed from a multiplicity of perspectives, and abandoned conventional continuities. There was a characteristic self-awareness, too, as American painters like Charles Demuth and John Marin created works that frequently commented more upon the medium employed than upon the subject depicted, more upon the signifier than upon the signified. The arts also illustrated just how closely the era's epistemological concerns were associated with questions of representation. Earlier art orientations had often assumed a mirroring correspondence between image and reality, but as the objective report came to seem chimerical in other fields, many visual artists abandoned the mimetic project.

No field of the visual arts is more fraught with issues of representation than is photography. Common, drugstore-variety photography appears to be an easy transcriptive or mimetic process, a virtually automatic method for getting a machine-produced, interpretation-free image or report. This is what Carl Chiarenza has called the "transparency fallacy," an all-too-easy inclination to regard the photograph as a clear window upon reality.[2] But like other means for describing the world, photography is also affected by point-of-view, accident, and imagination. Thus akin to writing, or painting, or other representational systems, photography likewise involves issues of how we come to know the world—and how well we know it. Looking at the world and knowing it, pointing a camera at the world and photographing it—both seem so intuitive and appear to produce simple reports: facts and photographs. Yet despite their deceptively glossy straightforwardness, the truth and the photograph are both complex tangles, problematically related to the world beyond ourselves.

A number of critics and scholars have explored these complexities. Much of the critical tradition can be traced to Walter Benjamin, a contemporary of Strand, Weston, and Adams, who wrote key essays in the 1930s. After Benjamin, this discussion has tended, as Allan Sekula has said, to oscillate between "faith in the objective powers of the machine and a belief in the subjective, imaginative capabilities of the artist."[3] Among those disposed toward objectivity, Rosalind Krauss has been inclined to emphasize photography's mimetic qualities, saying that the "connective tissue" providing coherence within a photograph comes from the world itself, and Roland Barthes has written that the photograph "is never anything but an antiphon of 'Look,' 'See,'" a kind of mechanical pointing to the outside world.[4] Others like Norman Bryson and W. J. T. Mitchell contend that it is impossible for art to execute an "essential copy" or reduplication of the outer world, for cultural conventions and the mind's necessary touches are invariably bound into any art, including photography.[5]

These representational and epistemological issues were not just the purview of scholars and critics. They were central concerns for Stieglitz, Strand, Weston, and Adams as they made their photographs and thought about their art. Like so many others, there could be a dichotomous quality to their descriptions, and at times they characterized the art photographer, in David Hollinger's terminology, as either a knower or an artificer, saying that a given photograph was either more imbued with recognition or with fabrication. Historian Joel Eisinger has described this as an

on-going debate over "trace and transformation," with some photographers and critics inclined to think of the photograph as more a copy of the world, and others inclined to think of it as more a reconfiguration of that world.[6] But most of the time Stieglitz and the others were disinclined to choose one side or the other in this debate, and although these four photographers were not always consistent in their stances, their basic inclination was to regard themselves as playing both roles—as being both knowers and artificers.

Sometimes they evinced a deep respect for what they called the thing itself, and they complained that language and metaphor harmed that real-world subject by burdening it with unnecessary associations or analyses.[7] They gravitated toward straight photography's sharp renditions as a means for conveying the subject supposedly without manipulation, and sometimes their work reflected individual photographer's pursuit of intimate connection with certain beloved subjects: Weston was an enthusiastic vegetarian who made luscious photographs of bell peppers, and Adams's landscapes were often created as he hiked deep into his adored Western mountains.

Yet for all this respect for the things in their images, these photographers also eagerly employed the artist's power to control and manipulate those things. They readily made use of words to exercise artistic dominion over their subjects, employing narrative and captions so as to tweak certain meanings from their images. If the subject before them failed to meet their aesthetic needs, they readily manipulated it to achieve their desired ends: Weston and Stieglitz were particularly facile at disguising the ugly appendectomy scars of nude models, and Adams was adept at obscuring graffiti scars on his California mountains. Likewise, the longing intimacy of some photographs was countered by the more mocking and distanced renditions in other images, as when Weston secretly photographed a urinating Mexican man, or when Stieglitz arranged his images so as to advertise a lover's dependency.

This varying allegiance, sometimes to the mind and sometimes to its subjects, also surfaced in the four photographers' ambivalence toward modernism. At times they accepted the world as a place of flux, picturing writhing organic forms and celebrating the spontaneity of political revolution. Yet at other times they desperately sought patterns in that flux, patterns they variously identified as Marxist historical forces or the currents of Bergsonian vitalism. Similarly, they would echo modernism's concerns for authenticity by embracing the concrete actualities of their surroundings, and then fly off in quite unmodernistic directions as they sought a transcendence beyond those actualities. No one better illustrates this than Adams, who on one chilly Sierra morning first celebrated the "magic actuality" of "the cold burning of the morning star" and "the crystalline chaotic murmur of the stream"—only to have those qualities slip away from him as "this actuality became but the shadow of an infinitely greater world...a transcendental experience."[8] The other photographers similarly brought considerable amounts of romanticism into their modernism, and like Emerson famously nodding to the trees, they often hoped that a familiarity with worldly actualities might lead them to transcendental universals. This was what Weston hoped to do when he photographed a subject such as a bedpan, examining the universal and beautiful shapes to be found in such commonplace things. Yet for all this, Weston and the

others stopped short of the American romantic tradition which has, in Hilton Kramer's words, "made of individual consciousness a sovereign of all it surveyed."[9] Though they thought the mind was mighty, they still granted considerable autonomy to the subjects that it surveys.

In this manner, Strand, Weston, Stieglitz, and Adams assumed their own particular stance in the representational debates of their era. They rejected the prevailing inclination to see the photograph as either a trace or a transformation; in metaphorical terms, they did not think of photography so much as a process of *either* mirroring *or* sculpting reality. Instead, their more autonomous position was that the good photograph was a product of the illuminating mind. Stieglitz and the others thought of the world as being quite dim until the mind had been brought to bear upon it, and in this way they agreed with many of their contemporaries. For these photographers, knowledge was not a passive acquisition, not something that simply comes to one; instead it is a product of active, searching engagement. But they also differed from their contemporaries in that they believed that if the photographer had done his job well, then he had lit up a portion of the world and shown it as it *really* exists. With this emphasis on searching and discovering, it is no surprise that Adams described himself as a camera-toting Diogenes, one who actively goes a-looking for honesty and truth.[10] These four photographers acknowledged a strong human agency or component in what we consider truth, or truthful reports, or photographs—for them there was no knowledge without the illuminating mind. But they also believed that there is a kind of truth out there, that it is possible to know some things about a photographic subject which exists independent of humans and photographers. Thus, unlike Richard Rorty, they felt that truth is both made and found. They were also distinct from the pragmatist James, who believed, in Daniel Singal's words, that humans are "doomed forever to epistemological uncertainty."[11] Stieglitz and the others believed that they must bring the illumination of photography to bear upon the world if they were to know its reality, and they also believed that their images could assuredly depict some portions of that reality and convey it to the viewers of those photographs.

This project is archivally based, and I have relied heavily upon the photographers' unpublished manuscripts and letters. In many ways, working with these materials has been an introduction to these men's personalities. Edward Weston's warmth and his penury become manifest when one encounters the now long-dried flowers that he enclosed with his letters, touching gifts that were about all he could afford to send his correspondents. In contrast, there is an off-putting quality to Stieglitz's page-filling scrawl and his magisterial disregard for the courtesies of punctuation. Similarly, Adams's drunken ramblings reveal a personality often on the verge of spinning out of control, and Strand's crabbed hand hints at a sometimes painful introversion.

Work in the archives also leads one to confront the canonical aspirations of Stieglitz and the others. They intensely wanted to be known as *the* American art photographers, the truly legitimate lineage that subsequent artists should acknowledge and accept. There were several ways that they sought to achieve such standing, but one of the more striking was to leave behind records. Mounds of

records. There is a kind of reverse Orwellian quality to all these visual and literary documents, for if Orwell's Ministry of Truth sought to insure certain interpretations by destroying documents, Adams and the others sought to insure their own historical standing by first creating and then preserving piles of materials.

That compulsion to be remembered, and remembered just so, also gives these archives something of an eerie quality. There is an intimacy to the materials, a sense that these were lives lived and documented with the historian in mind, so that some letters seem almost doubly directed, addressed not only to the original recipient but also to the subsequent historian. And even if such impressions are only illusionary, it is undeniable that Stieglitz and the others cozied up to the historical craft during their lifetimes, encouraging chroniclers like Herbert Seligmann and Dorothy Norman, and closely cultivating the very first American historians of photography, Beaumont and Nancy Newhall.

There is still another association with history. Like Alan Trachtenberg, I have come to see connections between the scholarly enterprise of history and the art of making photographs.[12] But where Trachtenberg has been concerned about the necessarily incomplete fragments with which both historians and photographers must deal, I have focused more upon questions of knowledge. Obviously there are differences between photography and history, the one being analytical scholarship bounded by rules of evidence, and the other a more creative and less restrained activity. But still both are representational enterprises, concerned with describing the world and conveying renditions of it. As I have watched Stieglitz, Strand, Weston, and Adams wrestle with their epistemological issues, I have repeatedly found their questions pertinent to my own craft: To what degree do we truly know the subjects before us? And when we describe those subjects, how much of what we report is a product of our minds rather than the subjects upon which those minds focus? In the end, I rather suspect that these photographers have given all of us working in representational fields some dramatic, even beautiful, reminders that our histories and our other reports, like their photographs, have the dual nature of being both constructions and discoveries.

1. Morton White, *Social Thought in America: The Revolt Against Formalism* (New York: Viking, 1949). Peter Novick, *That Noble Dream: The "Objectivity Question" and the American Historical Profession* (New York: Cambridge University Press, 1988). Daniel Joseph Singal, "Towards a Definition of American Modernism," *American Quarterly* 39 (Spring 1987), 7-26. Richard Rorty, *Contingency, Irony and Solidarity* (New York: Cambridge University Press 1989), 3.
2. Carl Chiarenza, "Notes Toward an Integrated History of Picture Making," *Afterimage* (Summer 1979); in Thomas F. Barrow, et al., (eds.), *Reading into Photography: Selected Essays, 1959-1980.* (Albuquerque: University of New Mexico Press, 1982), 220.
3. Walter Benjamin, "A Short History of Photography," (1931) in *Artforum* 15, 1977, 49-54. Walter Benjamin, "The Work of Art in the Age of Mechanical Reproduction" (1936), in Benjamin *Illuminations* (New York: Schocken, 1978, 1955). Allan Sekula, "The Traffic in Photographs," in Allan Sekula, *Photography Against the Grain: Essays and Photo Works 1973-1983* (Halifax: The Press of the Nova Scotia College of Art and Design, 1984), 78.

4. Rosalind E. Krauss , *The Originality of the Avante-Garde and Other Modernist Myths* (Cambridge, Mass: MIT Press, 1985), 212. Roland Barthes, *Camera Lucida: Reflections on Photography* (New York: Hill and Wang, 1981, 1980), 5.

5. Norman Bryson, *Vision and Painting: The Logic of the Gaze* (New Haven: Yale University Press, 1983). W. J. T. Mitchell, *Iconology: Image, Text, Ideology* (Chicago: The University of Chicago Press, 1986). Other important explorations of these issues include Allan Sekula, "The Invention of Photographic Meaning," *Artforum* (January 1975), 36-45; Joel Snyder and Neil Walsh Allen, "Photography, Vision and Representation," *Afterimage* 3 (January 1976), 8-13; and John Tagg, *The Burden of Representation: Essays on Photographies and Histories* (Amherst: The University of Massachusetts Press, 1988).

6. David A. Hollinger, "The Knower and the Artificer," *American Quarterly* 39 (Spring 1987), 37-55. Joel Eisinger, *Trace and Transformation: American Criticism of Photography in the Modernist Period* (Albuquerque: University of New Mexico Press, 1995).

7. This craving for authenticity and distrust of language emerged elsewhere in American modernism; see Bram Dijkstra, *The Hieroglyphics of a New Speech: Cubism, Stieglitz, and the Early Poetry of William Carlos Williams* (Princeton, NJ: Prinecton University Press, 1969), 120.

8. Adams's moment was in the summer of 1923, in the high country at Thousand Island Lake. Nancy Newhall, *Ansel Adams: Volume I, The Eloquent Light* (San Francisco: The Sierra Club, 1963), 36. For more on the photographers' fascination with the transcendental, see Alan Trachtenberg, "Introduction," in Maren Stange, ed., *Paul Strand: Essays on His Life and Work* (NY: Aperture, 1990), 2, and Ralph Bogardus, "The Twilight of Transcendentalism: Ralph Waldo Emerson, Edward Weston and the End of Nineteenth-Century Literary Nature," *Prospects* 12 (1987), 347-64.

9. Hilton Kramer, "Abstraction in America: The First Generation," *The New Criterion* 18 (October 1999), 11.

10. Nancy Newhall, *Ansel Adams: Volume I, The Eloquent Light* (San Francisco: The Sierra Club, 1963) 83-85.

11. Singal, "Towards a Definition of American Modernism," 16-17.

12. Alan Trachtenberg, *Reading American Photographs: Images as History, Mathew Brady to Walker Evans* (New York: Hill and Wang, 1989), xiv.

Part One

Alfred Stieglitz

2. Photography Calling

When Alfred Stieglitz was a young boy, his father routinely hosted Sunday-afternoon soirees. After sharing a substantial lunch with as many as thirty of his male friends, Edward Stieglitz escorted them into an inner room of his New York City brownstone, closed the shutters, turned on the gas lights, and proclaimed a recess from the world's worries. The guests were often businessmen like Edward, but there were also painters, writers, and teachers. They shared Edward's interest in culture, and though they might turn to cards or billiards along with their brandy and cigars, their chief preoccupation was an ongoing discussion of the arts. Quietly listening to these conversations was Edward's eldest son, Alfred, whose job was to bring new bottles from the cellar.

In may ways Alfred Stieglitz remained, as a friend once called him, that "boy in the dark room," and those Sunday afternoons eerily presaged much of Stieglitz's own adult life.[1] He became a photographer, working with light-proof boxes or in darkened rooms. Like the men on those Sunday afternoons, Stieglitz often privileged the inner world of imagination over the outer physical one. Never one for the life of solitary creativity, Stieglitz surrounded himself with people resembling Edward's companions, individuals as concerned with discussing art as with making it. Finally, during much of his career Stieglitz was preoccupied with what might be called aesthetic status; just as the young boy learned to negotiate his way in a room full of adults, the adult Stieglitz labored to secure photography's place in an art world populated by older, more established media.

Born in 1864, Alfred Stieglitz had an exceptionally comfortable childhood. His parents Edward and Hedwig were German Jewish immigrants who prospered in mid-nineteenth century America and raised their children in a thoroughly secular environment. A New York businessman, Edward provided Alfred and his siblings with a fashionable home and many of the bourgeois perquisites of the day, including servants, private schooling, and ample allowances. There was a certain cultural ambiance, too, for Edward encouraged the children's creative interests and pursued his own Sunday painting.[2]

As a boy Stieglitz complained of ill-health, especially weak eyes, and although similar complaints continued throughout his life, he also had an athletic side that began with childhood foot races and continued with hiking, swimming and rowing well into old age. His boyhood reading included standard fare such as Horatio Alger's tales of incredible luck, as well as selections from Dickens, Shakespeare, and Byron. But by the time Stieglitz was thirteen, one book took precedence over all others: Goethe's *Faust*. For the rest of his life Stieglitz routinely revisited Goethe's epic tale, and he often described himself as a long-suffering Faustian magus.[3]

If Goethe introduced Stieglitz to German idealism, family fortunes allowed him to explore it firsthand. By the end of Alfred's second year of engineering studies at City College, Edward had concluded that German education was superior, and that

at age forty-eight his own fortune was sufficient for retirement. So, in the summer of 1881 the entire Stieglitz family moved to Germany where Edward devoted himself to painting and travel, the children were variously lodged in schools, and for the next nine years Alfred had a handsome allowance and considerable independence.

The first year was given over to preparatory work in a *realgymnasium* at Karlsruhe, and then in the fall of 1882 Stieglitz entered the mechanical engineering program at the Berlin Polytecknikum. Within weeks of beginning his Berlin studies, Stieglitz realized he was no engineer. The mechanical courses bored him, he had no aptitude for drafting, and he soon abandoned his technical training in order to pursue a heady, if erratic cultural self-education. Allowing plenty of time for billiards, chess, and cards, Stieglitz also immersed himself in an intoxicating brew of nineteenth-century romanticism. He haunted the opera, claiming to have seen Wagner's *Tristan* more than a hundred times, and at the theater he devoted himself to productions of Goethe.[4] There was a similar romantic core to his reading, and his journal from the period is peppered with lines from Wordsworth and Shelley. Germans received even more attention, and Stieglitz saw fit to record selections from Lessing, Schiller, Schopenhauer, and Schleiermacher; but the pole star of Stieglitz's Germanic constellation remained Goethe, whom he quoted more times than any other author save Shakespeare.[5]

Vexed with mechanical engineering, Stieglitz drifted away from the Polytechnikum and toward the more diverse and theoretical offerings of the University. But if work at the Polytechnikum had been dull, the University lectures bewildered him. His physics professor was the brilliant Hermann von Helmholtz, and even Helmholtz's most rudimentary presentations baffled Stieglitz; in the face of this and other academic challenges, Stieglitz stopped attending lectures, and by the end of his first semester in Berlin, he was quite adrift.[6]

At that crucial moment Stieglitz came to photography. In January 1883 Stieglitz purchased a camera and other rudimentary equipment, and began his first tentative explorations. His enthusiasm grew with each new image, and what had started as a struggling student's self-indulgence soon grew into the passion of a lifetime.[7] He discovered that the Polytechnikum offered a course in photochemistry and esthetics, and promptly enrolled in the class offered by Hermann Wilhelm Vogel. Once again Stieglitz was lost in the classroom, but he relished the opportunities for practical laboratory work, and managed to get himself appointed Vogel's laboratory assistant. Thus granted twenty-four-hour access to facilities, Stieglitz conducted hit-and-miss experiments, and as he later said, did "nothing according to rote, nothing as suggested by professors or anyone else." Consuming huge amounts of material and time in haphazard fiddling with lenses, light, and chemicals, Stieglitz was a self-described Faustian figure, groping away, he said, "from an inner urge, without theory" as he thrashed about "to fathom the secrets" of photography. Slowly Stieglitz pushed the limits of his equipment and materials, and eventually achieved a formidable, if largely intuitive, understanding of his medium's capabilities. He gave up mechanical engineering, abandoned any plans for a degree, and in 1884 devoted himself to photography.[8]

Stieglitz later described his early days in photography as a time of almost child-like purity, when he worked completely free of any iconographic influences.[9]

But Stieglitz had enjoyed the benefits of haute-bourgeois childhood, with introductions to art that included conversations with his father's painter friends, his mother's coaching on the contents of the Louvre, and his own explorations of the likes of Tintoretto and Rubens.

Thus despite what he later said, the young Alfred Stieglitz was no esthetic foundling in 1884. He had a broad though unsystematic introduction to painterly conventions and German romanticism, and as his interest in photography grew, he acquainted himself with contemporary photographic practice. The lessons he learned from Vogel were largely technical ones, and Stieglitz apparently ignored the professor's esthetics; instead, Stieglitz turned to actual photographers for his models. English practitioners were some of the more advanced of the day, and in British photographic journals Stieglitz followed the work of two giants, Henry Peach Robinson and Peter Henry Emerson. Robinson stressed the photographer's control over his subjects, and, in pursuit of images conveying moral lessons, would paint or draw upon his images, or assemble composite pictures out of several separate photos. In contrast, Emerson rejected much about these painterly techniques and synthetic assemblages, and preached a respect for the actual scene before the camera. Though Stieglitz's subsequent photography was a blend of Robinson's outlook and Emerson's style, it was Emerson who was more directly a part of Stieglitz's early career. As judge in an 1887 competition, Emerson awarded first prize to one of Stieglitz's images, and he later selected Stieglitz to prepare a German translation of his book, *Naturalistic Photography* (1889).[10]

Stieglitz remained in Berlin when the rest of the family returned to New York, and by 1885 he had settled into a photographic routine. First came long hiking trips through Germany, Austria, Switzerland, or Italy, expeditions in which he photographed typical tourist attractions: mountain vistas, rustic villages, and major cities. Back in Berlin he entered his images in a host of competitions, and eventually won more than 150 honors, prizes and medals. These awards were gratifying ratifications of his art and ability, and Stieglitz pursued the affirmation with such intensity that he became, in his own words, a veritable "medal fiend."[11]

Many of Stieglitz's images were quiet renditions of the tree-lined brooks, country lanes, and mountains he had seen across Europe. Such landscapes were studiously composed, but elsewhere among the early images there is bolder testimony to the active and creative hand that Stieglitz brought to his craft. He often transformed people into symbols, as in one 1886 portrait where he rendered Herman Vogel as a hybrid of mad scientist and inspired artist, with eyes a-blaze and hair dramatically swept back.[12] Almost from the very beginning Stieglitz transmuted women of all kinds into creatures of mystery, and in a photo that he captioned "One of My Earliest Attempts at Picture Making" (1886), he depicted a peasant woman not so much as a perspiring field hand but as an enigmatic contemplator of the far horizon. Children were likewise transformed, and in *Venetian Gamin* (1887) a ragged street urchin with a scarred face and sinister gleam became the youthful embodiment of a wildness that civilization might never tame.

Stieglitz additionally brought a narrative dimension to these early photographs. He often tried to tell quaint little stories by using captions to supplement his images, so that a child with a school bag became *The Truant* (1886), while *The*

Unwilling Bath (1887) depicted an ox being washed by its handler. One of the more blatant examples was entitled *The Wanderer's Return* (1887), a carefully posed picture in which Stieglitz retold the prodigal's tale—this time with a female figure: a weary, remorseful-looking woman pauses with her hand upon the knocker of a closed door.[13] These are hackneyed compositions, trifles conveying unimaginative mawkish tales. But they also won him prizes and say a good deal about Stieglitz's emerging photographic praxis. With their strong narrative components, these images were less "about" the people before his camera than they were "about" the stories that were on the photographer's mind.

In many ways Stieglitz was one of his own most favorite subjects, and a number of his early images were not just pictures of the stories he created, but pictures of the photographer and his creative process. In the winter of 1886, for instance, Stieglitz gave his father an album of eight photos made over the preceding summer. The first seven images were depictions of his playful companions on a hiking trip; but the eighth is a solemn portrait of Alfred in his bowler, a somber artist alone with his camera, beyond the hijinks of his pals.[14] At another time Stieglitz preferred the persona of the carefree vagabond, and portrayed himself in loose tie and misshapen hat, impossibly asleep on a set of stone steps.[15]

The most phenomenal of these early self-referential images is *Paula, Berlin* (1889; fig. 2.1). At first this photograph might seem a straight-forward representation of a young woman working at her table, a picture-report in which the subject dominates the setting: "Here's Paula, in *her* room, tending to *her* writing." But Paula is not nearly so dominant in this image as she might at first seem, for this is not a portrait in which Paula's gaze meets the camera and her personality infuses the frame. Instead the picture is largely about Stieglitz, his craft, and his relationship to his subject, a carefully-designed set of metaphors about photography, photography's components, and the photographer's privileged position within Paula's life. The setting describes a camera almost perfectly: a darkened box/room, with a glass-screened aperture/window allowing light to enter. The image conveys photography's product as well as its apparatus, for photographs outnumber all other objects in the room. Photographs-within-a-photograph, *Paula* is also a case of photographer-commenting-on-himself, for it was Stieglitz who had created each of those displayed images of Paula. Thus Paula comes to us as she is shaped and controlled by the photographer, and it is only there upon the wall, in the third remove of Stieglitz's photograph-of-his-photographs, that we finally encounter her face. Art here has contained or captured actuality, and the metaphor of those prison-like bars of light falling across Paula is clearly echoed in the wire cage imprisoning the pet bird. Moreover, Stieglitz included a sign of his privileged place within Paula's life: strategically located at the photograph's center and just above Paula's head is one particular image that bespeaks his intimacy with her, a closeup of her in bed, head upon pillow and hair disheveled. Here Stieglitz built an image that was not only about the craft of photography, but which also trumpeted his special access to the subject as well as his craftsmanship. And just as Paula is the author of the letter she writes, so Stieglitz is the author of this image.[16]

Stieglitz's German sojourn came to an abrupt end. Edward and Hedwig called him home to America in 1890, ostensibly because they wanted the comfort of his presence when one of his sisters suddenly died. But they had also decided it was

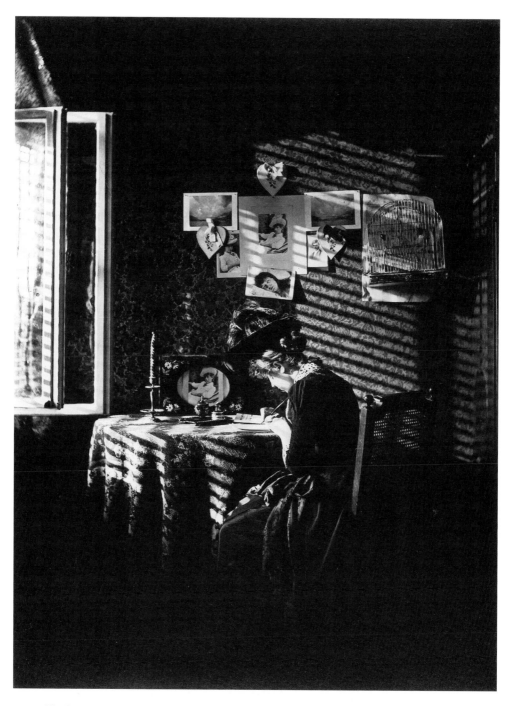

2.1. Alfred Stieglitz. *Paula, Berlin, 1889,* by permission of The Georgia O'Keeffe Foundation. Courtesy of George Eastman House; purchase from Georgia O'Keeffe.

time for their twenty-six-year-old son to grow up, and they let him know that he "had reached the age when most people began to think of being useful."[17] Edward purchased him a partnership in a photoengraving company and expected him to enter the world of business.

Stieglitz reacted with the petulance of one who had been forced to conclude a decade-long party. He railed against the provinciality of New York, fumed about the artlessness of Americans, and nearly ruined the business through his inattentiveness. He also purposefully photographed subjects quite apart from his family's genteel world—derelicts, rag pickers and teamsters. An image like *Winter—Fifth Avenue, New York* (1893; fig. 2.4) was a departure from his earlier scenes of bucolic landscapes and contented peasants, for it depicts the urban scene of a wagon and team lumbering through New York's canyons in a hard-driven snow. Such photographs anticipated the works of painters Robert Henri and John Sloan who upset genteel tastes with their ugly cityscapes. Those New York "Ash Can" painters shared Stieglitz's growing interest in some of the mundane aspects of urban life, and like him they never entirely abandoned romantic sentimentality for the more direct reportage of photographers like Jacob Riis or that of novelists like Upton Sinclair.

If Stieglitz's family hoped to see him settled in business, they also wanted him married. As he approached thirty years of age, they particularly pressed the case for Emmeline Obermeyer, the younger sister of Alfred's business partner and a friend of the family. Emmy was nearly ten years his junior, much less traveled than he, and probably less intelligent. But she owned significant shares in a prospering family business (a brewery), and also Edward promised the couple a nice allowance if they wed. These considerations made Emmy look rather more interesting, and in the spring of 1893 Stieglitz conceded—he never quite proposed—marriage; the following September he and Emmy were married.

It soon became evident that they were incompatible. The European honeymoon was a disaster, for Emmy's tastes ran to fashionable crowds and elegant hotels, while Alfred preferred his mountain hikes and artsy friends. By most accounts, theirs was an unaffectionate and strained marriage, and yet Alfred remained with Emmy for twenty-four years. Among the many factors that kept him in the marriage, one seems paramount: with Emmy he was free to pursue photography. Upon marriage, his family granted his adulthood and autonomy while still continuing its support, and Alfred's allowance together with Emmy's handsome income made for a good life. Within eighteen months of the wedding, Stieglitz had quit the photoengraving business to concentrate on his photography.

The relationship with Emmy also brought him back to earlier photographic themes. During the summer of their engagement, Stieglitz photographed Emmy during a picnic on Lake George's Tea Island. Just as he had done a few years earlier in *Paula*, Stieglitz populated this image with signs bespeaking the photographer's intimacy with, and power over, his subject. He surrounded the reclining woman with props such as a man's hat and a photographer's gear bag. All this of course refers to the maker of the image—that individual who at the instant this photograph was made stood in a commanding position above his subject, peering down as she lay open and vulnerable before his lens. Stieglitz also revisited other favorite themes during periodic visits to Europe, producing dreamy rendi-

tions of noble peasants, exercising a vision somewhere between the melancholy scenes of Jean Francois Millet and the adoring landscapes of the Barbizon school.[18]

Thus Stieglitz returned to the photographic passion he had discovered during his student days. For a brief time in the early 1890s, it looked as though that single-mindedness might be thwarted when he succumbed to family pressures, entering both a business he disliked and a marriage he did not especially want. But these proved to be mere interruptions that did not compromise the career. The marriage to Emmy provided the security and stability that made it possible for him to quit business, and his disappointment with his wife made it easier for him to ignore her and pursue his art. In short order, Stieglitz revisited his earlier romantic style, found his way back to Europe, and abandoned any pretense of earning a living. Stieglitz's subsequent career was marked by any number of dramatic turning points, but from 1895 on, there was never any doubt about the centrality of art and photography in his life.

Alfred Stieglitz was in many ways a man of his times. Ironically, this person who styled himself as the consummate individualist was actually part of a larger phenomenon in American society at the turn of the twentieth century. Eschewing the world of business for the different and seemingly "cleaner" realm of culture, Stieglitz and other middle-class Americans sought to negotiate a passage somewhere between industrial giants like Andrew Carnegie and the working-class unions and political movements that sought to limit the giants' power. Some of these middle-class people found outlets for their energies in the various Progressive reform campaigns. Others like Stieglitz turned to cultural movements and, in their reaction against the aesthetic barrenness of commodity manufacturing, helped fuel the popularity of craft styles ranging from art nouveau decoration to neo-Gothic domestic architecture. Art photography was one of these movements, and its leisured, middle-class practitioners were careful to define themselves a special social niche: they were neither tradesmen who made portraits-for-hire, nor were they among the hoards of Kodak snapshooters. Discontent with mass production and mass taste, they instead made carefully crafted images and presented themselves as artists. After 1895, Stieglitz emerged from the ranks of these middle-class photographers, and became the leading pictorial photographer of his day. He achieved this notoriety in part because of his photographs, which continued to receive awards and increasingly became examples for younger photographers. But Stieglitz's prominence owed as much to his vociferousness as to his images. He engaged in a loud campaign to secure photography's aesthetic legitimacy, the acceptance of middle-class photographers as artists, and his own place as America's preeminent photographer.[19]

Prejudice against photography was formidable. Thinker after thinker denounced it as a weak, mechanical medium that could never achieve the creative power of a true art such as painting. In 1859, only two decades after photography's inception, no less a voice than Charles Baudelaire had lambasted photography as God's retribution upon art, His gift to satisfy philistine demands for a trivial art of insignificant transcription.[20] By 1897, these denunciations reached American journals of opinion, where illustrator Joseph Pennell scorned photography as an automated process involving no real work—one more part of the cultural decay leading to the debauch of socialism. Painfully aware of these criticisms, perturbed that photogra-

phy was "looked upon as the bastard of science and art."[21] Stieglitz steamed over the allegations of photography's illegitimacy, and well into the twentieth century struggled to create a respectable aesthetic genealogy for photography.

That effort was, as one of Stieglitz's allies said, a campaign of "propaganda . . . by voice and pen."[22] Stieglitz held forth in New York photographic circles, gave interviews to the popular press, and, most significantly, served as editor for photographic journals such as *The American Amateur Photographer* (1893-1895) and *Camera Notes* (1897-1902). Stieglitz presented photographic heroes for his audiences to emulate, and published hortatory essays by writers like Charles Caffin, who praised photography's esthetic potential and chastised those who denigrated it as a mere pastime.[23] Stieglitz also took up the pen himself in this campaign, cataloging photography's scientific, aesthetic, and documentary achievements, and announcing that photography had "come to her own, and in the strength of maturity taken her place among the sister arts."[24]

There was an enormous desire for status in all this, for Stieglitz and his lieutenants craved recognition as artists. Edward Steichen, one of those younger men, seethed when an art editor advised him to devote himself to real art (painting).[25] Robert Demachy wrote with more humility, admitting to the readers of *Camera Craft* that "we have slipped into the Temple of Art by a back door," and advising them to learn quietly from painters.[26] Stieglitz was not so quiet or humble. At the conclusion of a successful 1902 photographic show, he crowed in triumph, claiming that photography had trounced "our bitterest opponents amongst the artists," and "the greatest nonbelievers amongst the critics."[27]

Thus Stieglitz viewed the art world as a contested arena, where the various genre battled each other for recognition. For those involved, the competition required "force, breadth, and strength," and like contemporaries such as Teddy Roosevelt, Stieglitz was inclined to look upon life as a set of bully contests.[28] Also like his contemporaries, Stieglitz thought of these contests in Darwinian terms, and in his version of the evolutionary struggle, some arts grew brilliant and evocative while others became pallid and uninspiring. Like John Dewey, Stieglitz recognized the vast impermanency of an ever-evolving world, and believed it possible to give some direction to the process, saying that his own kind of photography, pictorial photography, had "evolved itself out of the confusion in which photography had been born." But Stieglitz's ideas more closely approximated social Darwinism, for he was inclined to equate current dominance with qualitative superiority, and he thought of evolution as producing entities that were better, not just better-fitted for local conditions. So in his history of photography, Stieglitz spoke of a "race" for "photography supremacy" that by the end of the nineteenth century had been won by pictorial photography.[29] With the smugness of a social Darwinist, he saw his hegemony not so much as a matter of happenstance, but rather a confirmation of his own worth and merit.

In Stieglitz's view that victorious struggle had to be a virtuous one, accomplished by people with only the purest of motives and most serious of intentions. Accordingly, he denounced those who made photographs for recreation or livelihood. Professional tradesmen seemed to him a particularly cheesy lot, contaminating his precious medium by their insistence upon payment for their photographs. True photographers were "amateurs" in the best sense of the word, working for love rather than money.[30] They were also more dedicated than mere hobbyists, and

Stieglitz loathed the confluence of common taste and capitalist inventiveness that made Kodak cameras ubiquitous throughout America. For a brief time, photography was nearly as popular as that other late-nineteenth-century fad, the bicycle, and Stieglitz was virtually apoplectic when the two crazes come together in Washington, where a bicycle club profaned his art by sponsoring a photographic exhibition.[31]

Stieglitz's concerns were part of a larger, international phenomenon. Between 1880 and 1900, amateur photography groups blossomed worldwide, with a twenty-fold increase in both the United States and Britain. Elitist movements rejecting both snapshooters and professional photographers, they were populated by white-collar men who had the leisure and resources to devote to photography. Stieglitz's own circle included a lawyer, a banker, and a merchant—men of means who met in some of the best restaurants and kept up on the latest developments in art and literature.[32] With no need to pander to customers, Stieglitz and his colleagues concentrated upon making each print a unique, jewel-like product, a piece of craftsmanship beyond all price, and they had a certain affinity for William Morris's Arts and Crafts movement. Like Morris, Stieglitz favored hand-crafted items over machine products, and when Stieglitz began his own photographic journal in 1903, he adopted much the same format that Morris and his followers favored in their own publications: fine materials, select typeface, and wide margins.[33]

None of this made photography simple. The fastidiousness, careful composition, and attention to nuance took an enormous amount of energy. For Stieglitz, truly great art did not come easily, and great photography required both artistic angst and artistic labor. From the 1890s onward, Stieglitz referred to photography as "work" and to serious photographers as "workers." The earliest such references date from 1895,[34] but his most emphatic use came in 1903 when he christened his important journal: *Camera Work* (1903-1917). For Stieglitz, "work" was closely tied to fulfillment and pride, and he believed that "only the best work of which man is capable will finally satisfy."[35] When things were done well, the artist's self flowed into a finished product that received the "spark of life," and in the intermingling of creator and creation it was sometimes difficult to distinguish between self and object.[36] Ironically, given Stieglitz's political conservatism, this provided him a certain intellectual kinship to Marx. Marx, who had his own large debt to nineteenth-century German romanticism, believed that the worker's contributions infuse the final product, and that a cheapening of, or disrespect for, the product gives rise to an alienation that is spiritual as well as economic. Where Marx proposed one set of solutions to this dilemma, Stieglitz offered another. Since Stieglitz's well-crafted products were seldom offered for commercial exploitation (indeed, there may have been virtually no market at all), they remained forever objects of appreciation rather than commodities for trade. Like Marx, Stieglitz saw how alienation resulted from the marketplace; but his solution was simply to keep the self ever beyond that market.

Stieglitz sought more than a peculiar kind of status when he claimed that pictorial photography was "work." He hoped to score a metaphysical point, too. If pictorial photographs arose from "work," then certainly they must be distinct from nature. With all its connotations of human design and activity, "work" implied that his images derived from a considerable amount of conscious shaping and formation. By the turn of the century, this had become an essential principle of Stieglitz's thinking.

Visual images function in any number of ways. They may evoke emotion, explore shapes or colors, or convey likenesses—and any given image many do all at once. Certainly representation is one of the more commonly recognized functions, so much so that we often refer to a given image as "a picture of" some thing or person. Image and subject exist in a strange relationship with each other: there is kinship of a kind, for the photo is, literally, the artist's re-presentation of something originally offered up by nature. Yet the two are forever contraries, because the artist's two-dimension rendition of an apple is quite distinct from the actual three-dimensional fruit. What then is the relationship between nature and depiction within a photograph? Does the internal coherence of an image come more from nature itself, or from the cultural, ideological, and creative contributions of the artist? *These* are the crucial questions about representation, often answered according to whether one grants primacy to artist or object. As Stieglitz considered the issue during the late nineteenth and early twentieth centuries, he certainly expressed considerable affection for the world's objects. But when all was said and done, at this time Stieglitz believed that the essential nature of a photograph arises more from the photographer's contributions than from the subject photographed.

Stieglitz never completely ignored the role that subjects could play in the making of a successful photograph. During the 1890s, for example, he several times suggested that specific settings or things were particularly compelling, and that in some instances the photographer's job was to transmit those qualities without significant elaboration. Paris was one such place, "full of fascination and beauty," and he liked photos that seemed clear renditions of that beauty.[37] A few years later he condemned a younger man's eccentric and too self-absorbed photos, and by the end of the decade Stieglitz actually had good words to say for the straightforward reportage of some documentary photography.[38]

Yet with all of his respect for photography's documentary power, Stieglitz thought that it had a still higher function. He believed that the best photography could convey the shape of ideas as well as the trace of material outlines, and that in the hands of sophisticated artists, the camera was an instrument capable of imparting inner as well as outer phenomenon. In 1897, for instance, he announced that, for the images appearing in *Camera Craft*, his editorial policy was "to publish nothing but what is the development of an organic idea, the evolution of an inward principle." But that was not what people usually understood as photography, and, then as now, many equated the words "photograph" and "record": the photograph of a wedding is expected to record a particular ceremony rather than an artist's inner perception of something like a marriage principle. Stieglitz was well aware of this common equation of "photograph" and "record," and in an effort to distinguish his elite art from Kodak craft, he at one point said he wanted to make "a picture rather than a photograph."[39] He used this clumsy distinction throughout the 1890s, and by the 1900s his vocabulary had become less awkward and he adopted "pictorial photography" as his term for creative, non-record camera images.[40]

Stieglitz was surrounded by people who shared his preference for pictorial photography. Whether as photographers or writers, the intellectuals in Stieglitz's circle uniformly agreed that detailed renditions and minute records made for uninteresting images. Critic Sadakichi Hartmann was perhaps the bluntest when he

proclaimed that "accuracy is the bane of art;" and the "love of exactitude" was an underdeveloped aesthetic sense that Hartmann expected to find among savages, children, and philistines.[41] The best, most highly-evolved photography was thus the least detailed, a notion that enjoyed considerable popularity among Stieglitz's acquaintances. Even novelist Theodore Dreiser, whose books were among the most detail-ridden of any contemporary works, praised Stieglitz as an artist who managed to "manipulate and soften the cold facts of the negative," and Dreiser went so far as to use Stieglitz as the model for his novel, *The Genius* (1895).[42]

In his own pictorial photographs, Stieglitz minimized details of the subjects before his camera, and instead emphasized whatever interpretative mood he might bring to the image. This emerged particularly in his various urban photographs of the 1890s and early 1900s. Never quite willing to accept New York as it came to him, repeatedly shaping it according to his own vision, Stieglitz collected the city's scenes, tempered their particulars, and transmuted them into his own unique prints. His 1903 photograph, *The Flatiron Building, New York* (fig. 2.2) was one such image. The building was already a landmark with its terrific height (three-hundred feet) and unusual triangular shape (many likened it to the prow of a ship); the building made its way into the 1904 Baedeker, and became a subject for other pictorial photographers like Edward Steichen and Alvin Langdon Coburn. Stieglitz was determined that his own execution would not be a closely-rendered architectural study. "If such a subject were treated with any regard to detail," he wrote in 1903, "it would be pictorially meaningless."[43] So when Stieglitz composed *The Flatiron* he minimized the building's components: the upper windows and crown are only partially discernible, while the lower stories are completely lost in a veil of trees. The entire scene is set on a gray winter day, with the fuzziness of falling snow. The foremost tree stands in juxtaposition to the building, and its prominence suggests that this image may be about the relationship between technology and nature, rather than a simple presentation of one building. Finally, with those benches Stieglitz made another of his oblique references to watching—just as we are spectators of the image, the image has within it a place for spectators. In this manner Stieglitz's themes could curl about each other in an intricate, suggestive knot, and whatever the ultimate meaning of *Flatiron*, this image was *not* a simple illustration of how a particular building looked on a particular New York day.

Stieglitz struck much the same theme a few years earlier when he published his portfolio, *Picturesque Bits of New York, and Other Studies* (1897). Here his cities were rendered so as to obscure their details: New York was shrouded in darkness or snow, Paris was misted with rain, and Venice was reflected in its canals.[44] Occasionally, though, the details prevailed. Photography is vulnerable to accidents because it is tied to the outer world, and its images trace some of that world. Even an exceptionally controlling photographer like Stieglitz could become victim of serendipitous particulars that somehow or another insinuate their way into the images. Consider for example his 1893 New York photograph, *Coenties Slip, New York* (fig. 2.3). Stieglitz obviously took some care in composing this study of perspective, positioning himself so that nearest lamppost and bowsprit would appear to intersect. Together with the horizontal line of the street they form a triangle in which the remaining bowsprits march off towards the river, while to the left of the lamppost they are flanked by a set of poles likewise leading towards the

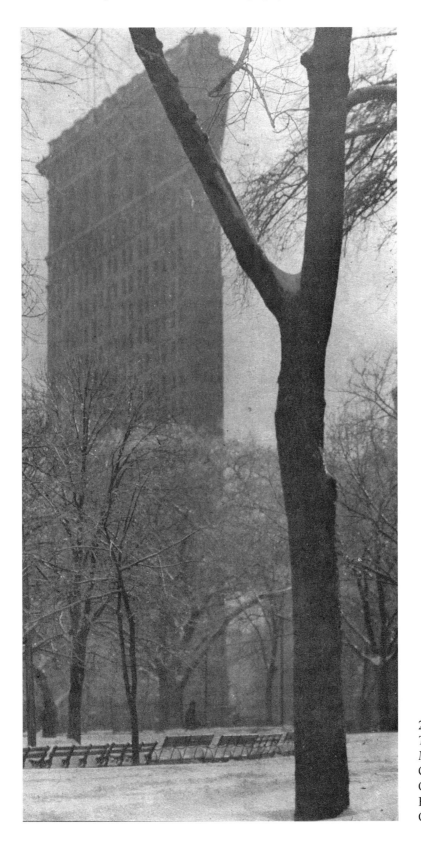

2.2. Alfred Stieglitz.
The Flatiron Building,
New York, 1903.
Courtesy of
George Eastman
House; gift of
Georgia O'Keeffe.

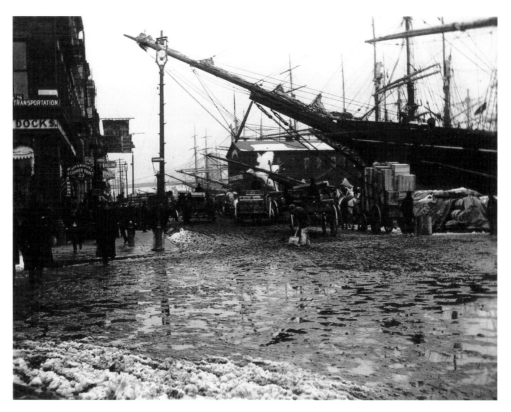

2.3. Alfred Stieglitz. *Coenties Slip, New York, 1893*, Alfred Stieglitz Collection,
© 2000 Board of Trustees, National Gallery of Art, Washington.

water. But beyond these aspects the image is exceptionally rich with quotidian details, a set of humble, lowly, and even extraneous facts that Stieglitz did not manage to soften. For instance, slightly less than half-way up the near lamp post is the sign identifying this place as Coenties Slip—an exceptional thing among Stieglitz's photographs, for seldom did his subjects get the chance to speak their own names within his images. The sidewalk is crowded with people, many caught forever in mid-step, individuals whose bustling activity is at odds with those lines that quietly slice the sky. Finally, close to the image's center is a solitary figure humbly shoveling the manure-fouled slush. There is nothing pretty in this kind of shoveling, and the fetid detail refuses to cooperate with Stieglitz's aestheticizing vision.

Coenties Slip was not the only such photograph. In any number of images that Stieglitz made between 1890 and 1910, one can find the odd detail or incongruous item interrupting composition or mood. But Stieglitz tried to minimize these interruptions, and when he showcased his work in 1897, *Coenties Slip* was not among the images making up *Picturesque Bits of New York*. Nonetheless, some people criticized him when they found seemingly superfluous detail elsewhere in his work. In 1901, for example, Charles Caffin noted that Stieglitz sometimes failed to achieve the impressionist's expressive softness, and condemned one photo as an unfortunate, "literal transcript from nature, rather than an artist's pictorial impression of it."[45] Another of Stieglitz's contemporaries was the Italian thinker, Benedetto Croce.

Croce's philosophical idealism was akin to that common in the Stieglitz circle, but unlike Caffin, Croce failed to see photography's aesthetic legitimacy. There was, he wrote in 1901, simply too much detail in any photograph, and he insisted that photography could not be art "precisely because the element of nature in it remains more or less unconquered and ineradicable."[46] Stieglitz of course took exception with any notion that photography was not art. He did however share Croce's notion that there was a contest of sorts going on within many a photograph. For Stieglitz, no less than for Croce, the image was a field in which art and nature were embroiled in struggle, and like Croce, Stieglitz never felt that the "element of nature" could be eradicated from a photograph. But there they parted company. The best photographers, Stieglitz believed, could subdue nature, could rise above the details, could make a picture rather than a photograph, could achieve art rather than record.

Much of Stieglitz's turn-of-the-century work was a late manifestation of the romanticism that flourished earlier in the nineteenth century. Like many of his romantic predecessors, Stieglitz found physical beauty alluring, but he was possessed of a potent idealism that led him to revel less in the physical experience of the beautiful and more in the mental apprehension of beauty. In his photographic practice, Stieglitz developed a visual analogue of Keats's lines that unheard melodies are sweeter than heard ones: viewed beauty may be sweet, but its unseen dimensions are even sweeter still. For Stieglitz, to photograph the people and objects of the world was to look through them and into the transcendent ideas or principles that they represented; the image became emblematic, a sort of coinage which the photographer had struck in this physical world, but which symbolized the value of a more ideal dimension.

Consider, for example, Stieglitz's *Harvesting, Black Forest, Germany* (1894). At a simple, reportorial level, this is a picture of toiling peasants hand-harvesting a crop. The backs are bent, the tools minimal, and the field large—all of which seems pretty earth-bound. But stoop labor was not the chief topic of Stieglitz's softly focused, luminous image. Instead, it conveys the sense of a life close to nature and its rhythms, a life unadulterated by the civilized accoutrements of Stieglitz's Manhattan. In these ways the photograph refashions an agricultural moment into a timeless bucolic ideal, so that the print is not necessarily bound to the actual lives of German peasants in the year 1894.

Stieglitz worked the same sort of transformation upon his own daughter, Kitty. Like many parents, Stieglitz made numerous prosaic photographs of his child, images remarkably similar to what might be found in any number of family albums: Kitty playing at the beach, or sitting in a perambulator, or holding a hideous mammy doll. But in other images, Stieglitz reconfigured Kitty so that she became part of the romantic leitmotif of childhood's innocence and wonder. Moreover, Kitty was a *girl*, and as such endowed with what Stieglitz believed was an uncanny intuitiveness that was part and parcel of every human female. All told, the things which Kitty represented were too big to fit into any one photograph, and over the years his images of her became a sequential portrait of the type he would later perfect with images of yet another female in his life, Georgia O'Keeffe.[47]

Whether of Kitty or German peasants, Alfred Stieglitz wanted to make pictures of qualities that the senses do not perceive. Innocence, or naturalness, or

mystery are apprehended more by the mind than the eye, for when we say that something looks innocent or natural, we are really saying that it fits certain mental categories. In choosing between the mind and the eye, Stieglitz during these years had a propensity for the mind, for it alone could comprehend the emotional or psychological themes he favored. Accordingly, Stieglitz was especially drawn to symbolism, one of romanticism's various offshoots. A literary and artistic movement of late-nineteenth-century Europe, symbolism also attracted a number of other Americans. As part of a broader rejection of nineteenth-century materialism, symbolists eschewed movements like literary naturalism, and in contrast to the intensely descriptive (some might say "photographic") detail of a naturalist novelist like Emile Zola, a symbolist poet such as Stephane Mallarme preferred writing with dream-like symbols that were purposefully suggestive and enigmatic. Other symbolists were intrigued with the occult, the sinister, and the hermetic, propensities exemplified by, among others, Oscar Wilde and Aubrey Beardsley. They preferred ambiguity in plot or composition, explored spirituality and medievalism, and were pulled to the kind of nameless terror expressed in Edvard Munch's *The Scream* (1893). Coupled with all this was a fascination with moral extremes, both good and evil, which led them to appreciate such divergent woman images as the pure maidens of the Pre-Raphaelites and the femmes fatales of Beardsley.

Symbolism's European heyday had passed by the early twentieth century, but it lingered in America. Painters such as Albert Pinkham Ryder and Arthur B. Davies continued to compose weirdly dreamy images, and Pamela Coleman Smith, best known for her occult designs for tarot cards, became the first non-photographer whom Stieglitz exhibited at his 291 gallery. Photographer Gertrude Kasebier was even closer to Stieglitz, and in the very first *Camera Work* he published her 1902 *Portrait of Miss N.*, a symbolist genre piece portraying the real-life femme fatale Evelyn Nisbet—who had such disastrous effects on architect Stanford White and was later the basis for a character in E. L. Doctorow's *Ragtime*.[48]

The writing in *Camera Work* also explored symbolist concerns, with frequent discussion of the relationship between art and spirituality. One of the earliest was an essay by symbolist poet and dramatist Maurice Maeterlink, published as a special insert in *Camera Work*'s second number. Writing with the passion of one who had just come to appreciate photography's symbolist potential, Maeterlink lauded photography "as a fissure through which to penetrate the mystery" of life's "anonymous force."[49] Even advertisements in *Camera Work* presented photography in similar terms, and the Anthony-Scovill Company promised that its Dallmeyer-Gergheim lens would provide an "Initiation into the Secret" of moody soft-focus photography.[50]

There were additional *Camera Work* pieces in this vein, with the most sophisticated essays written by Charles Caffin. An Englishman, Caffin had emigrated to the United States in 1892 to work in the decorative department of that great allegorical riot, the Chicago Exposition of 1893. He stayed in America, became a critic writing extensively on photography and painting, and in 1905-06 published "Of Verities and Illusions," a long, intelligent essay appearing in three successive *Camera Work* issues. In this didactic piece Caffin argued that it was best to think of the natural world as "a visible embodiment of unseen forces, seeable only through their temporary material habitation." Some artists— the best artists of the ages— realized this, and Caffin

praised a heterogeneous group of painters that included Giotto, Monet, and Winslow Homer. Despite their obvious differences, Caffin said, they all worked with a supremely important orientation: "Nature has not been to them a mirror for their own sensations, but an infinite mystery; they have passed from absorption in the concrete to some companionship with the Universal and the Abstract." Each of these artists realized the impossibility of copying the external world, realized that "behind the eye is, of course, a mind." In this business of depicting the world, Caffin insisted, spiritual resonance was much more important than mimetic transcription.[51]

If Stieglitz the editor promoted such photography, Stieglitz the photographer practiced it. Throughout the 1890s and into the next decade, he produced the sort of moody, mysterious, and allegorical images advocated in *Camera Work*. He visited and revisited some subjects in particular: working women and men.

Throughout his life, women were ciphers upon whom Stieglitz cast concerns of the moment, be they romantic, libidinous or modernist. Around the turn of the century he collected symbolist depictions of the femme fatale, but in his own images he portrayed women engaged in traditional gender-specific tasks. Like any number of his contemporaries, Stieglitz subscribed to notions that "woman's work" was somehow charged with meaning far exceeding its apparent insipidness. Hanging in a place of honor in his home was a print of his photograph, *The Net Mender* (1894), an image that he once called "my favorite picture." The scene was from Kaatwijk on the Dutch Coast, and depicted a young woman in the tedious job of mending a pile of fishing net, a mundane enough scene, but which for Stieglitz said evoked "a torrent of poetic thoughts in those who watch her sit there on the vast and seemingly endless dunes."[52] Stieglitz's portfolio of the 1890s contains other photographs of laundresses, spinners, and the like, dreamy images attempting to transmute domesticity into poetry.

Ordinary working men were another of Stieglitz's favored subjects. Whether as peasants in European fields or laborers in New York streets, Stieglitz somehow found these people more authentic than the middle class people he more often encountered. In New York he went out "walking among the lower classes," propelled by his "dislike for the superficial and artificial" and confident that he would "find less of it among the lower classes."[53] Of course superficiality and authenticity are no respecters of class, but Stieglitz assumed that the workingmen's characters were as uncomplicated as their livelihoods seemed to be. He often managed to find these men at work with horses, and his photographs change teamsters and their animals from sweaty, soiled creatures into mythical-looking, almost other-worldly figures. Atmosphere was a major portion of these conversions, as Stieglitz often provided an air of mystery by portraying his subjects surrounded by smoke or steam.

Or snow in the case of *Winter—Fifth Avenue, New York* (1893; fig. 2.4). Stieglitz made the photograph during a great February blizzard, the dark team-and-wagon standing out against the snowy background while the receding line of buildings and ever-smaller figures convey perspective. The larger topic here is not space or form, however, but mood or spirit, and the photograph has about it a looming or apprehensive quality. As it so happened, the writer Stephen Crane composed his own verbal sketch of a New York snowstorm at almost the same time, and as a literary naturalist, Crane created a detailed, almost clinical description of struggle against

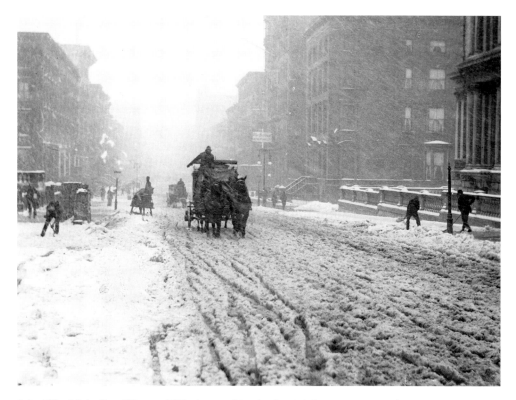

2.4. Alfred Stieglitz. *Winter—Fifth Avenue, New York, 1893*, by permission of
The Georgia O'Keeffe Foundation.
Courtesy of George Eastman House; purchase from Georgia O'Keeffe.

the uncaring natural elements.[54] But in Stieglitz's treatment—particularly of the central wagon and driver, the scene seems to speak more of the spirit world than the natural world, and the forces appear more sinister than climatic. With the white lines of snow streaking so obviously before the dark wagon, one can virtually hear the wind howl; and as the driver and team lumber along, they seem almost demonic, moving with preternatural intensity and purpose. The horses and men of Crane's story are driven along by the weather, but the figures in Stieglitz's photograph are more hauntingly and inwardly compelled along their way.

Part of the mood of *Winter—Fifth Avenue* comes from the image's blurriness. Crane had loaded his own sketch with sharp details, but Stieglitz used the snow to obscure them, reducing humans to huddled outlines and rendering street signs indecipherable. This was some of the same appearance he had pursued in *The Flatiron* (fig. 2.2) where the architecture is so softened by snow and trees that the building almost becomes lost in a suggestive haze. The effect was intentional, for Stieglitz believed that if a subject was "treated with any regard to detail it would be pictorially meaningless." On occasion, though, storm and shadow alone were not sufficient to achieve a mood-enhancing suppression of particulars, and Stieglitz resorted to direct manipulation of his images. A few years after he first made the image, for example, he apparently decided a pile of railroad ties lying just to the left

of the horses cluttered the scene, and he retouched them out of his negative. Eventually, he went on to crop the image severely, eliminating the prosaic border details of snow shoveling so as to enhance the drama and isolation of his central grouping. Stieglitz's goal was "feeling, beauty, and poetry,"[55] and he whittled away at the image until there were few details to interfere with his poetry.

Stieglitz's spiritual quest and the accompanying fuzzy images have not worn well over the years. They have about them a self-conscious artiness that at times seems almost absurd. But beyond all the straining, there was in this work an important precedent for abstractionism. For in this early symbolist mode, as in the subsequent modernist one, Stieglitz's photography was less interested in capturing a likeness and more concerned with visually rendering a set of abstract (if sometimes maudlin) notions—working women could evoke dreaminess and working men seemed mysterious.

During the first decade of the twentieth century, American amateur photography was beset with a series of acrimonious disputes. At issue was the nature, direction, and control of amateur photography, and Alfred Stieglitz was often at the center of the attacks and counterattacks. He advocated closed, elitist organizations, and struggled not only to claim the trappings of high art for photography, but also to secure his own claim to preeminence among photographic leaders. In fact, Stieglitz was so preoccupied with such issues of power and process, that he produced relatively few images in the years between 1902 and 1908.

Much of the fight took shape within the Camera Club of New York, where Stieglitz and his friends directed the Club's quarterly publication, *Camera Notes*. Exercising what they admitted was a "self-assertiveness bordering on the indelicate," Stieglitz and the others pressed a pictorial agenda that many other Club members resented.[56]

Not only did Stieglitz struggle to control rank-and-file photographers, he also sought to defeat other prominent individuals who contested his leadership of American amateur photography. For years Stieglitz was involved in a series of bitter fights with competitors like F. Holland Day and Curtis Bell. Eventually Stieglitz founded his own New York organization, and through it conducted several successful exhibitions that gave him substantial claim to preeminence.

Stieglitz decided to call his movement the Photo-Secession, a name derived from Secessionist painting movements in Vienna and Munich. Those painters had rejected what they considered the orthodox placidity of realism, and instead adopted the decorative exoticism that informed the works of artists like Gustav Klimt.[57] The Secessionists were inclined toward the sort of eerie and symbolist expressions that Stieglitz appreciated, and Stieglitz also liked their rebelliousnes. But something got lost in the transition from Klimt's Vienna to Stieglitz's New York, for Stieglitz and his followers were hardly fleeing the art establishment's museums and galleries. Instead, they desperately sought approbation, and dearly wanted photography accepted as Art.[58]

Under the Photo-Secession banner, Stieglitz created two principal elements in his quest for hegemony. One was *Camera Work*. Announced as a "mouthpiece of the Photo-Secession," the publication also claimed to owe allegiance to no organization—which was true in a certain sense, for *Camera Work* was Stieglitz's personal operation, "begun with the sole purpose of furthering the 'Cause.'"[59] The second of Stieglitz's elements

was his gallery, "291." Opened late in 1905 as The Little Galleries of the Photo-Secession, these rooms at 291 (later 293) Fifth Avenue served as his permanent exhibition space until 1917. To be sure, other people helped Stieglitz significantly in the founding of both the magazine and the gallery, and Steichen's contributions were perhaps the most important, for he motivated Stieglitz in both undertakings and was a major force in designing each of them. But in short order Stieglitz made the projects his own. On the gold-leaf announcement heralding the opening of "291," just below the words "Photo-Secession," there was a silhouette of Stieglitz. The association was appropriate, for Stieglitz's shadow hung over "291" no less than over the Secession and *Camera Work*, and it was during this time that Stieglitz routinely signed his correspondence "291". Admission to the gallery was free but not without cost, for visitors were subject to his ceaseless and various soliloquies, in which, as he himself said, "A.S. often holds forth not only on photography but on art and social conditions in America."[60]

Whether in the rooms at 291 or in the pages of *Camera Work*, Stieglitz sought to tell a story of masterpieces, to draw a lineage connecting the best photography of the past with the contemporary pictorial images that he and his associates created. One of his greatest concerns was canonicity, and he dearly wanted to demonstrate that he and his group were the legitimate and sole heirs of great photography of the past. In this way, "Photo-Secession" was again something of a misnomer; though bristly and acerbic, Stieglitz's project had less to do with rebellion than with lineage, and might have been more aptly called "Photo-Succession." In an early, substantial manuscript, Stieglitz laid out a genealogy for photography, tracing it from its 1839 origins, charting the contributions of people like Daguerre and Niepce, and concluding with his own pictorialism—"the real photography[,] the photography of today."[61]

Thus during the first decade of the twentieth century, there was a kind of assurance to Stieglitz's career. Thanks to the fortunes of marriage and birth, he had the wherewithal to practice photography without having to work for his living. Also, he had arrived at a certain kind of photography emphasizing the photographer's imagination over the subject's characteristics. Finally, with the pictures he made, and with his considerable hortatory and editorial efforts, Stieglitz had accomplished much to ensure photography's status as art and his own prominence within the province of American photography.

1. Paul Rosenfeld, "The Boy in the Dark Room," in Waldo Frank, Lewis Mumford, Dorothy Norman, Paul Rosenfeld, Harold Ruggs, eds., *America & Alfred Stieglitz* (Millerton, NY: Aperture, 1975, 1934), 38-50.
2. Sue Davidson Lowe, *Stieglitz: A Memoir/Biography* (NY: Farrar, Straus, Giroux, 1983). Richard Whelan, *Alfred Stieglitz: A Biography* (Boston: Little, Brown, 1995).
3. Lowe, *Stieglitz*, 47-48. William Inness Homer, *Alfred Stieglitz and the Photo-Secession* (Boston: Little, Brown and Company, 1983), 5.
4. Rosenfeld, "The Boy in the Dark Room," 40-1.
5. Alfred Stieglitz, "Extracts, Etc. Begun November 1884," ASA/YCAL.
6. Dorothy Norman, *Alfred Stieglitz: American Seer* (Millerton, NY: Aperture, 1960, 1973), 24-5.
7. Thomas Craven, "Stieglitz—Old Master of the Camera," *Saturday Evening Post* 216 (Jan. 1944), 14, in Homer, *Alfred Stieglitz and the Photo-Secession*, 7.
8. Norman, *Alfred Steiglitz: American Seer*, 24-29.

9. Norman, Ibid., 29.

10. "'Holiday Work' Competition, First Prize," *The Amateur Photographer*, special number, July 11, 1888. Norman, *American Seer*, 32-33.

11. Agnes Ernst, "The New School of the Camera," [interview with Stieglitz], New York *Sun*, April 26, 1908, ASA/YCAL.

12. The 1886 Vogel portrait is in "Sun Prints by Alfred Stieglitz," album 2, NGA.

13. The image is in "Sunprints," album 1, NGA.

14. Alfred Stieglitz, photo album dated "July 4th 1886. Freienwalde a. O." ASA/YCAL.

15. This *Self-Portrait* (Cortina) 1890, appears in Edward Abrams, *The Lyrical Left: Randolph Bourne, Alfred Stieglitz and the Origins of Cultural Radicalism in America* (Charlottesville: University Press of Virginia, 1986), 94-5.

16. For additional discussion, see Rosalind Krauss, "Stieglitz/*Equivalents*" (October 11 Winter 1979), 129-40.

17. Ernst, "The New School of the Camera."

18. Homer, *Alfred Stieglitz and the Photo-Secession*, 22, and 163, n11.

19. The classic discussion of middle-class anxiety is Robert Wiebe, *The Search for Order 1877-1920* (NY: Hill and Wang, 1967); for that anxiety's relationship to photography, see Ulrich F. Keller, "The Myth of Art Photography: A Sociological Analysis," *History of Photography* 8 (October-December 1984), 249-75.

20. For discussion see Alan Sekula, "The Invention of Photographic Meaning," *Artforum* (January 1975), 40.

21. Joseph Pennell, "Is Photography Among the Fine Arts?" *The Contemporary Review* 72 (December 1897), 832. [Alfred Stieglitz], "Pictorial Photography," [c. 1899], undated ms, ASA/YCAL. Portions of the article appear in Alfred Steiglitz, "Pictorial Photography," *Scribner's Magazine* 26 (November 1899), 528-37.

22. Charles H. Caffin, "Alfred Stieglitz and His Work," in Caffin's *Photography as a Fine Art: The Achievements and Possibilities of Photographic Art in America* (NY: Doubleday, Page & Co, 1901), 33.

23. Homer, *Alfred Stieglitz and the Photo-Secession*, 35-7.

24. [Alfred Stieglitz] "Photography of Today," ASA/YCAL, np.

25. Edward Steichen to AS, May 17, 1900, ASA/YCAL.

26. Robert Demachy, "What Difference Is There Between a Good Photograph and an Artistic Photograph?" *Camera Notes* 3 (October 1899), 48.

27. Alfred Stieglitz, "Extract from Letter From Alfred Stieglitz, West 29th Street, New York, to F. Dundas Todd," *British Journal of Photography* 49 (June 6, 1902), 459. Letter dated March 17, 1902.

28. Alfred Stieglitz, "The Progress of Pictorial Photography in the United States,"*American Annual of Photography and Photographic Times Yearbook for 1899*, 159.

29. [Alfred Stieglitz], "Pictorial Photography." Stieglitz, "The Progress of Pictorial Photography in the United States," 159.

30. [Alfred Stieglitz], "Pictorial Photography."

31. Alfred Stieglitz, "Pictorial Photography in the United States, 1895," *Photograms of the Year 1895*, 81.

32. Keller, "The Myth of Art Photography," 250-52.

33. Homer, *Alfred Stieglitz and the Photo-Secession*, 111.

34. Stieglitz, "Pictorial Photography in the United States, 1895," 81.

35. Dorothy Norman, "From the Writings and Conversations of Alfred Stieglitz," *Twice A Year* 1 (Fall-Winter 1938), 78-9.

36. Norman, "From the Writings and Conversations of Alfred Stieglitz," 77-8.

37. Alfred Stieglitz, [letter to the editor, from Paris], *American Amateur Photographer* 6 (June 1894), 274.

38. A[lfred] S[tieglitz], "The F. A. Engle Exhibition," *Camera Notes* 1 (April 1898), p. 120. [Alfred Stieglitz], "Photography of Today. Discovery of Photography," undated ms [c. 1899], ASA/YCAL.

39. Publication Committee, Camera Club of New York, introductory statement, *Camera Notes* 1 (July 1897), 1.

40. Alfred Stieglitz, "Modern Pictorial Photography," *Century Magazine* 64 (October 1902), 825.

41. Sidney Alan [Sadakichi Hartmann], "The Value of the Apparently Meaningless and Inaccurate," *Camera Work* 3 (July 1903), 17-18.

42. [Theodore Dreiser], "A Remarkable Art." *The Great Round World* 19 (May 3, 1902), 430-31. Carol Shloss, *Invisible Light. Photography and the American Writer: 1840-1940* (New York: Oxford University Press, 1987), 97-139.

43. Alfred Stieglitz, "Our Illustrations," *Camera Work* 4 (October 1903), 25-26.

44. Alfred Stieglitz, *Picturesque Bits of New York, and Other Studies* (New York: R. H. Russell, 1897).

45. Charles H. Caffin, "Alfred Stieglitz and His Work," in Caffin's *Photography as a Fine Art: The Achievements and Possibilities of Photographic Art in America* (NY: Doubleday, Page & Co, 1901), 23-49. Originally "Photography as a Fine Art: Alfred Steiglitz and His Work," *Everybody's Magazine* 4 (April 1901), pp. 359-71.

46. Quoted in Alan Sekula, "The Invention of Photographic Meaning," *Artforum* (January 1975), p. 43.

47. Alfred Stieglitz, "From the Photographic Journal of a Baby," *The Photographic Times* 34 (January 1902), inserted between 32 and 33.

48. For discussions of symbolism and its relation to the Stieglitz circle, see: Edward Lucie Smith, *Symbolist Art* (London: Thames and Hudson, 1972); Dennis Longwell, *Steichen, The Master Prints 1895-1914: The Symbolist Period* (New York: Museum of Modern Art, 1978), 11-22; Sarah Greenough, "How Stieglitz Came to Photograph Clouds," in Peter Walch and Thomas F. Barrow, eds., *Perspectives on Photography: Essays in Honor of Beaumont Newhall* (Albuquerque: University of New Mexico Press, 1986); Abrams, *Lyrical Left*, 140; and Melinda Boyd Parsons, "Pamela Colman Smith and Alfred Stieglitz: Modernism at 291," *History of Photography* 20 (Winter 1996), 285-92.

49. Maurice Maeterlinck, "Maeterlinck on Photography," *Camera Work* 2 (April 1903), supplemental sheet. In Jonathan Green, ed., *Camera Work: A Critical Anthology* (Millerton, NY: Aperture, 1973), 61-62.

50. "Initiation into the Secret," *Camera Work* 6, April 1904, advertising section.

51. Charles Caffin, "Of Verities and Illusions—Part II," *Camera Work* 13 (January 1906), 45. Charles Caffin, "Of Verities and Illusions. III. Self-Expression," *Camera Work* 14 (April 1906), 26-7.

52. Norman, *Alfred Stieglitz*, 41. Alfred Stieglitz, "My Favorite Picture," *Photographic Life* 1 (1899), 11-12. AS's notions date back to earlier in nineteenth century; see Barbara Welter, "The Cult of True Womanhood," *American Quarterly* 18 (1966).

53. W. E. Woodbury, "Alfred Stieglitz and His Latest Work," *The Photographic Times* 28 (April 1896), 161.

54. Stephen Crane, "The Men in the Storm," *The Arena* (October 1894), in *The Works of Stephen Crane* vol. 8, *Tales, Sketches, and Reports* (Charlottesville: The University Press of Virginia, 1973), 315.

55. Alfred Stieglitz, "Our Illustrations," *Camera Work* 4 (October 1903), 25. The untrimmed version is in NGA, as well as the "Waste Basket Collection," ASA/YCAL.

56. Alfred Stieglitz, "Valedictory," with Joseph Keiley, Dallett Fuguet, John Strauss and Juan C. Abel, *Camera Notes* 6, (July 1902), 4. Camera Club Ousts Alfred Stieglitz," *New York Times*, February 14, 1908, 1. John Francis Strauss, "Mr. Stieglitz's 'Expulsion'—A statement," *Camera Work* 22 (April 1908), 25-32.

57. Carl E. Schorske, *Fin-de-Siecle Vienna* (New York: Alfred A. Knopf, 1980), 214.

58. Keller, "The Myth of Art Photography."

59. Alfred Stieglitz and his assistant editors, "An Apology," *Camera Work* 1 (January 1903), 16.

60. AS to Heinrich Kuhn, November 17, 1906, ASA/YCAL. Translation by James Card.

61. Alfred Stieglitz, "Photography of Today. Discovery of Photography," np, ASA/YCAL.

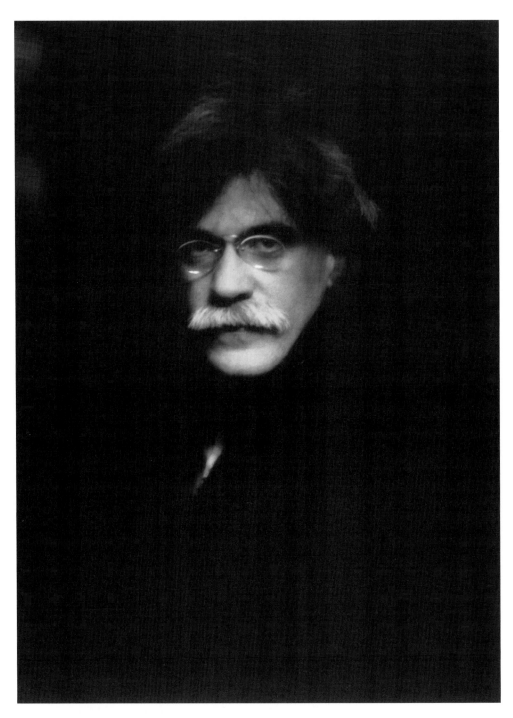

3.1. Alfred Stieglitz. *Self Portrait, 1910,* Philadelphia Museum of Art:
 From the Collection of Dorothy Norman.

3. Modern Dawn

In 1910 Alfred Stieglitz made one of his many self-portraits (fig. 3.1). In this instance Stieglitz stares back at his camera with a somber, penetrating gaze. Most of the print is dark, almost black, while the face seems to hang suspended in the upper portion of the frame; the focus is diffused, and the print employs only a limited tonal range. Carefully crafted, this moody and mysterious image is an exemplary pictorial photograph, and a portrait of *the* exemplary pictorial photographer. Stieglitz represented himself as a man of considerable significance, the firm jaw and deep eyes suggesting a powerful combination of wisdom and determination, while the graying hair and white mustache convey a sense of eminence and age. An image of the artist rendered in an art form he championed, the photograph celebrates and affirms the importance of each.

By 1910 it seemed like there was a lot to celebrate. The Photo-Secession had received unprecedented recognition and Stieglitz himself was acknowledged as the leading American voice for creative photography. The zenith came in November of that year, when the prestigious Albright Gallery of Buffalo hosted Stieglitz's International Exhibition of Pictorial Photography. But both the Albright show and the self-portrait were anticlimaxes, for by the end of 1910 Stieglitz's attention had turned away from pictorialism, and the confidence evident in the 1910 self-portrait began to wane as he puzzled over new aesthetic developments which seemed to mark the obsolescence of his romantic and impressionistic art. During his own European trips, and in the art examples he received from friends on the Continent, Stieglitz saw some of the dynamic modern paintings that were beginning to surface in France. At first perplexed and even put off by what he encountered, Stieglitz soon became infatuated with modernism, and, rather than continue his association with the seemingly outworn pictorial aesthetic, Stieglitz scurried to embrace contemporary painting in his gallery and journal, and then to examine its implications for his own field of photography.

There were big changes here as Stieglitz attempted a transition from a culture of romanticism to one of modernism. And yet there was some truth to Stieglitz's claim that his new concerns continued many of his earlier ones, to his insistence that he remained much the same man depicted in that 1910 self-portrait. Stieglitz retained lots of his earlier predispositions, and he was determined to remain photography's acknowledged leader even if his photographic aesthetic changed. Recycling his earlier message about art's high seriousness and elusiveness, adapting to what he now understood to be the latest European innovations, and adding some of his own original efforts, Stieglitz not only helped to cultivate modernism in America but also to cultivate an image of himself as one of its founders.

As the end of the century's first decade approached, Stieglitz worked his way towards closure with pictorial photography. In 1909, for instance, he resigned from the Linked Ring, a prestigious British pictorial organization, because he felt that his

own 291 had gone beyond the Ring's solely photographic interests and grown to become "a big moral force in the world of painting."[1] At the same time Stieglitz brought a sense of denouement to his Albright show arrangements, for the exhibition pointed not to the future, but instead to the past, for as the catalogue said, it strove to "sum up the development and progress of photography."[2] At each of the major turning points in his life, Stieglitz jettisoned friends, and pictorial photographers of the Photo-Secession were particularly notable among those whom he abandoned at this time. Gertrude Kasebier was one of the first, Alvin Langdon Coburn soon followed, and Clarence White's departure was notably spectacular, with the relationship rupturing in a vituperous exchange of letters.[3] As Stieglitz alienated still others, the Photo-Secession withered and *Camera Work* became increasingly unavailable as an outlet for pictorial photography.

Stieglitz turned to a younger group of associates and a newer set of aesthetic concerns. The Western art world, and particularly Paris, was alive with the movements that came to be known as modernism. Parts of the modernist project had been in place at least since the advent of impressionism and aimed to free art from the job of mimetic representation. This was of course something that Stieglitz warmed to, for he had long argued that photographs should do something much more than merely re-present the surface qualities of the outer world. But with the advent of movements like cubism, the project took on characteristics far beyond suggestive paintings or pictorial photographs, for now painters embraced keener levels of abstraction, moved farther away from representation, and replaced narration with the exploration of form. Such developments were far ahead of Stieglitz, and he was forced to become a student again in order to keep up with them. Some lessons came almost accidentally during European vacations in 1907, 1909, and 1911 as when he visited some of the innovative Parisian galleries. Other parts of his modernist education were less serendipitous, though, for Stieglitz surrounded himself with a set of willing tutors, men about fifteen years his junior who were much better versed than he in the new art. "What a youngster I was," Stieglitz later recollected, "so much younger than they."[4]

Edward Steichen (1879-1973), Max Weber (1881-1961) and Marius de Zayas (1880-1961) were chief among those teachers, and he depended upon them for news and interpretation of European art developments. In his own youth Stieglitz had been able to study and absorb symbolism firsthand. But after 1890, he was in Europe only as a visitor, never a resident, and in the ensuing decade-and-a-half, the European avant garde had moved on to newer frontiers, first with the works of Cezanne and Van Gogh, and then the even greater challenges of Matisse and Picasso. Steichen, Weber, and de Zayas helped Stieglitz separate the significant from the insignificant in these developments, and provided their student with examples that they sent for exhibition at 291. Perhaps most significantly, Steichen, Weber, and de Zayas helped Stieglitz understand what he was seeing. The articles they wrote for *Camera Work*, along with their contributions to the incessant conversations at 291, led Stieglitz to perceive, however dimly, some of modernism's main features.

Steichen had known Stieglitz the longest. They met in 1900, became close friends, and collaborated on the Photo-Secession enterprises. Living in Paris from 1906 until the outbreak of World War I, Steichen provided Stieglitz with an entree to

European artists like Picasso, critics such as Leo and Gertrude Stein, and emerging American painters like John Marin. More than any other individual, Steichen tutored Stieglitz and shaped his exposure to avant garde European painting, securing innovative works by Rodin, Matisse, Cezanne, Picasso, and Brancusi for exhibition at 291. In contrast to Steichen, Weber was a more nettlesome and explosive man, but for a time he too was quite close to Stieglitz, and during some particularly impoverished months Weber actually lived in a back room at 291. While in Europe from 1905 to 1908, he studied with Matisse, and came to know Picasso, Braque, and Rousseau; Weber was also interested in photography and helped Stieglitz hang the Albright show. Finally there was de Zayas, a Mexican caricaturist who came to the United States in 1907 when his father's newspapers ran afoul of the oligarchic, prerevolutionary Diaz regime. He first visited Paris in 1909, and returned several times over the next few years; de Zayas was acquainted with Picasso, and instrumental in drawing Stieglitz's attention to both Picasso's work and to some of the African sculpture that had inspired Picasso. Theoretically inclined, de Zayas wrote extensively, and of Stieglitz's three teachers, offered the most analytical treatments of modernism.

Stieglitz's schooling began slowly in the summer of 1907, when he reluctantly accompanied Emmy to Europe on what was to be "principally a pleasure-trip for my wife."[5] In Paris Steichen tried to relieve the tedium by taking him to exhibitions, notably one of Cezanne, but neither man came away impressed. Stieglitz said that he saw nothing but blotches of color, and Steichen later reported that the two Americans "laughed like country yokels" at Cezanne's paintings.[6] By the end of the summer Stieglitz allowed that he had had some small pleasures in Europe, but that as an art experience, the trip had been a bust: "I got *absolutely* nothing out of Paris."[7]

But the pace of Stieglitz's education soon picked up. Steichen's ambivalence toward Cezanne was replaced by his enthusiasm for Matisse. In 1908 he told Stieglitz that Matisse deserved attention as "the most modern of the moderns," singled out Matisse's drawings as "abstract to the limit," and shipped a set of them to Stieglitz. Stieglitz liked what he saw well enough to hang them at 291 during April, and those drawings, plus some lithographs, etchings and a single painting, constituted Matisse's debut in the United States.[8] This exhibition established a pattern that continued over the next several years. Steichen, or sometimes Weber or de Zayas, would bring a collection of modernist works to Stieglitz's attention, and then ship a selection to New York where Stieglitz hung them at 291 and opened the pages of *Camera Work* for discussions and reproductions of the images. A Rodin show had proceeded the Matisse exhibition by a few months, and 291 hosted the American debuts of Toulouse-Lautrec (1910), Rousseau (1910) and Picasso (1911).

Stieglitz's education also continued during subsequent summer vacations in Europe. Prior to leaving New York in 1909, Weber had helped him prepare a list of exhibitions to visit, and upon his arrival Stieglitz persuaded Steichen to introduce him to Gertrude and Leo Stein. The 1911 visit, Stieglitz's last trip to Europe, was even more intense, crowned by what Stieglitz called "a remarkable three weeks spent in Paris." Accompanied by de Zayas or Steichen or both, he visited Picasso, Matisse, and Rodin, and also went to galleries, including the Louvre, "which I really *saw* for the first time." Unlike 1907, *this* Parisian summer was a "tremendous experience."[9]

With all this attention to paintings by the likes of Picasso, photographs became increasingly rare in Stieglitz's enterprises. Prior to the Albright show, 291 presented as many as six photographic exhibits a year, but in the entire period from 1910 until 1917 the gallery hosted only three photography shows. *Camera Work* shifted less abruptly, but it too moved toward modern painting and away from photography, a change that angered and perplexed readers who understandably expected a journal calling itself *Camera Work* to concentrate on photography. The April-July 1911 issue, devoted to Picasso, Cezanne, and Rodin, was the final straw for many; cancellations flowed in and a subscription list that had once numbered nearly 1000 dropped to 304 by the following May. Advertisers fled with even greater alacrity, and yet Stieglitz offered little help to the loyal few who struggled to understand *Camera Work*'s new contents. The August 1912 Special Number, for instance, featured images by Picasso and Matisse, and Gertrude Stein's short texts on each painter. Written with Stein's characteristic shattered syntax and rolling rhythms, these pieces were not really attempts to explain Picasso and Matisse and were more like verbal efforts to replicate the painters' visual innovations.

Despite this considerable, if not always helpful, attention to modern painting, Stieglitz was not prepared to abandon photography completely. He continued to think of himself as a photographer, and actually returned to his camera for some time in 1910-11. In *Camera Work* 36 (October 1911) he reproduced ten of those recent efforts, along with a selection of photographs from earlier years. The only other visual work in the issue was a Picasso drawing, and the issue's articles dealt predominantly with modernist concerns. In this way Stieglitz reminded readers of his photography, and at least by proximity suggested an association between his work and modernism.

But the relationship ran deeper. The last time Stieglitz's own images had appeared in *Camera Work*, they had been softly-focused pictorial experiments created in conjunction with Clarence White,[10] intimate, indoor photographs that were gentle romantic portraits of an individual nude. Stieglitz's new images, though, were markedly different, and indicate his effort to establish his own claim upon what he apparently took to be some of modernism's major topical elements and formal qualities. Rather than the quiet timelessness of the misty nude, Stieglitz showed that he had begun working with timely contemporary subjects and that he sometimes associated modernism with modern subjects. He began his *Camera Work* 36 sequence with images of the bustling city of New York and its crowded thoroughfares, and continued the series with additional images of other decidedly up-to-date subjects: an airplane, a dirigible, and the gigantic ocean liner *Mauritania*. Like the authors with whom he shared the issue, Stieglitz also seemed certain that modernism was in one way or another associated with geometry, and he clearly documented his own experiments with line and shape.[11] His recent photographs depicted the strong vertical lines and massive rectangular blocks of the city's towering buildings. Even stronger geometrical themes appeared the in still another photograph, *The Steerage* (1907; fig. 3.2.)

This photograph became one of Stieglitz's most famous images. Picasso expressed admiration for the picture upon seeing it in 1913, and in 1915 one of

3.2. Alfred Stieglitz. *The Steerage, 1907*, by permission of The Georgia O'Keeffe
Foundation. Courtesy of George Eastman House; gift of GeorgiaO'Keeffe.

Stieglitz's spin-off avant garde journals devoted an entire issue to the photograph.
As the years passed, *The Steerage* attracted a wide variety of interpretations. One
common reading sees this as a poignant document of the Ellis-Island-and-huddled-
masses drama of American immigration, an interpretation which collapses with the
awareness that Stieglitz made the image during a passage *from* the United States,

and that the people in this photograph were actually *leaving* America. There is also a more generic Marxist reading, such as Paul Strand once offered, a class critique dwelling upon the apparent differences in dress and wealth that separate those in the upper portion of the photograph from those below them.[12] But given Stieglitz's general indifference to economic inequality, it is unlikely that this was much on his mind when he created the image. Some thirty years later Stieglitz offered the reading that he preferred: that this was a mirror of his own emotional dislocation.[13]

But that recollection had more to do with Stieglitz's self-perception of the 1940s than with actual events on that ship in 1907. In fact, the contemporaneous record gives no indication that Stieglitz believed he had anything significant in this image. It was created during what at the time seemed to him a trifling family vacation, and he shelved the photograph soon after his return. It was not until 1910 that Stieglitz came to see it as a potentially important image, and then only because de Zayas and Weber argued that this and other works like it were far superior to Stieglitz's earlier pictorial images.[14] The formal and geometrical qualities of *The Steerage* bore a connection to the paintings that Weber and de Zayas had been bringing to 291: within the photograph, various elements of the ship—gangway, mast, deck, ladder, spar—cut dramatic lines across the picture plane and carve it into smaller sections. Moreover, the geometry is complex, with odd angles and separate facets similar to those in the analytic works of cubists like Picasso.

By 1910 Stieglitz seems to have become determined to prove that *The Steerage* had not been a piece of casual luck. Grouped along with *The Steerage* in *Camera Work 36* is another, much less well-known image, *The Pool—Deal* (1910; fig. 3.3). Made during a summer vacation when Weber and Stieglitz joined Emmy and Kitty at New Jersey's Deal Beach, *The Pool* is topically distinct from *The Steerage*, for it depicts the relaxed tempo of middle-class recreation rather than the agonized monotony of lower-class transportation. But on a formal level the two images are remarkably similar, for each employs strong linear shapes to slice complex and busy scenes into smaller segments. Most striking is the way in which the water-slides at Deal echo the boat's gang-way; but similarities continue, for the pool's decks, posts, and railings repeat those of the boat, and the bathers even pose like the passengers. It is possible that *The Pool* was not a studied replication of *The Steerage*, and Stieglitz would hardly be the first artist to have been drawn unconsciously and repetitively to the same shapes or forms. But the selection of images for this *Camera Work* portfolio *was* a decidedly conscious business, and by placing these photographs together Stieglitz showed that he too was employing some of the motifs that he had begun to see in European painting.

The Steerage and *The Pool* underscore still other changes that were beginning to emerge in Stieglitz's photography. Both are crowded images, teeming with details that refuse to be corralled into the kind of prettiness common to pictorial photographs. On the upper deck of that boat, one man grimaces unselfconsciously as he picks at a molar (or perhaps grooms his mustache), and at the poolside a girl jabs a finger into her mouth with similar inelegance. At an earlier time, and under the influence of thinkers like Croce who voiced preferences for simplicity and beauty, there had been no place for the similarly serendipitous *Coenties Slip* within the collection *Picturesque Bits of New York*. But fourteen years later, and surrounded by the younger

voices of Weber and de Zayas, Stieglitz gave busy and not-so-pretty photographs like *The Pool* and *The Steerage* prominent places in his *Camera Work* 36 portfolio.

But still Stieglitz remained remarkably tenuous about the path of photography, and this man who so prided himself on being a leader continued to be more of a follower. At an earlier time the nature of avant garde art had seemed clear enough, and he had admired symbolism and decisively founded the Photo-Secession. Now, though, Stieglitz was less certain of art's foremost elements, and he felt compelled to study modernism more carefully and then decipher its consequences for photography. In December he described 1911 as "the most remarkable year in my career" and composed a list of the year's highlights which featured his discoveries in Parisian painting. Yet Stieglitz scarcely mentioned his new photographs of *Camera Work* 36. Indeed, he went so far as to say that his own camera work, even if expanding in new directions, was simply not that significant. He announced plans to lay aside the camera, and said "that in sacrificing my own photography" and bringing painting to the magazine and gallery, he hoped to accomplish "a bigger thing than merely expressing oneself in making photographs, no matter how marvelous they might be."[15] For the time being at least, his own work would wait.

For Stieglitz and his circle, abstract art was an exciting and integral part of a new, bold world emerging around them. Enthusiasts of both modernism and modernity, they celebrated contemporary technological and scientific, as well as artistic, developments. Stieglitz had appreciatively photographed the newfangled flying machines, and during trans-Atlantic trips he enjoyed "marconigraphing from mid-ocean."[16] But it was more than just inventions like the airplane and the radio that fascinated Stieglitz; he and his friends were thrilled by the conceptual developments and theoretical advances associated with such machines. They were keen to see that thinkers from across the American intellectual landscape began to describe a world where malleability replaced older solidities, and Stieglitz and the others considered the new abstract art to be a part of these broader developments. Just as ossified principles were discarded in other disciplines, the visual arts abandoned rules of perspective and composition, and Stieglitz agreed with the likes of William James and John Dewey that flux is a more fundamental principal than is fixity, and that we should aspire more to an ever-emerging set of truths than to some elusive final Truth. Stieglitz lacked the rigor of James and Dewey, and he arrived at their sense of indeterminacy more by haphazard meandering than by careful reflection. But he and his friends shared some of James's and Dewey's ease with the intellectual world of the twentieth century, and rather than mourn the collapse of older structures they often inclined to rejoice that things had come unstuck.

There were challenges to be overcome, though. 291 and *Camera Work* were settings not only for celebration, but also debate and puzzlement about the new art. The exchanges continued throughout 1911, and as the ideas spilled back and forth, it is often difficult to say precisely who initially voiced a particular point. Typically the issues were explored first and most coherently by the younger men like de Zayas and Weber, and then appropriated by Stieglitz as he urged still further explorations.

Some of modernism's more obvious provocations were visual. Abstractionist works were puzzling to tastes developed in an earlier era, and some members of

3.3. Alfred Stieglitz. *The Pool—Deal, 1910*, Courtesy George Eastman House; gift of Georgia O'Keeffe.

the circle, such as Charles Caffin, admitted that the works of Picasso proved a shock to the established "habit of expecting to find in pictures accurate representation of the ocular impressions."[17] But the greater challenges were conceptual, for while Stieglitz and his associates were willing to leave behind much of the nineteenth century, they also dearly wanted a replacement for romanticism, some set of ideas that would allow them to consider and portray the world with the kinds of spirituality and emotion that romanticism had fostered. It took some effort, but ultimately they found ways to accomplish this and yet remain apologists of modernism. de Zayas, for example, praised Picasso for avoiding mimesis and "the physical manifestation" of his subjects, and simultaneously lauded him for rendering a seemingly more significant manifestation, "the psychic one."[18]

There were guides who seemed to help them in these efforts. "Primitive" individuals seemed able to create art that was both intuitive and emotional, and Stieglitz and his associates particularly sought out the work of both American children and African adults. Children appeared relatively free of culture's ensnaring web, and to help the rest of the adult art world learn from such uncontaminated minds, Stieglitz held three separate exhibitions (1912, 1914, and 1915) devoted solely to children's art. In the same spirit Stieglitz opened a 1914 exhibition of African art as another demonstration of uninhibited expression.

Still, primitivism was not quite enough. Even with the psychic nourishment they supposedly offered, no one in Stieglitz's circle preferred a steady diet of children's drawings or Nigerian carvings. Stieglitz and the others located much more intriguing guides in peculiar corners of contemporary science. A decade earlier Stieglitz had gone to considerable lengths to distinguish his own work from science, and had been outright hostile when a hapless scientist dared offer opinions about art.[19] But as Stieglitz became absorbed with modernism, this earlier antipathy gave way to enthusiasm. He and his colleagues used science metaphors to describe their work, referring to their conversations, exhibitions and articles as "experiments" conducted in the "laboratories" of 291 and *Camera Work*. They were particularly intrigued by branches of physics and psychology that were later abandoned when the ideas of Einstein and Freud achieved prominence. Yet in those obscure fields Stieglitz and his friends found a monism compatible with their own penchant to amalgamate matter and spirit, a tolerance for mysticism that satisfied their residual romanticism, and notions of representation that complemented their modernist explorations.[20]

Much of the new physics had to do with a fourth dimension that stood beyond the normal dimensions of height, width, and depth. Einstein would eventually identify this dimension as time, but prior to the acceptance of his ideas there was an alternate view giving the fourth dimension a spatial identification drawn from non-Euclidian geometry. The leading advocate of this view was an inconspicuous Englishman named Charles Howard Hinton who worked in the United States patent office between 1902 and 1907 (when, ironically, Einstein was similarly employed in Switzerland). Hinton's work on the spatial fourth dimension fueled a surprising American interest in the subject, with articles appearing not only in scientific journals but also in more general magazines like *Harper's*.[21]

291 was also abuzz with talk of this fourth dimension, and Max Weber was the person most thoroughly absorbed in the subject. He wrote a piece entitled "The Fourth Dimension from a Plastic Point of View" that was laced with terminology borrowed from the new physics, and which Stieglitz published in the July 1910 number of *Camera Work*. Weber believed that the time had come for artists to abandon older rules of single-point perspective with which they had painted three-dimension representations; instead they should enter the fourth dimension and portray subjects *simultaneously* from several different view points. There were obvious similarities between this and analytical cubism, and Weber was inclined to see cubism as a promising development.[22]

Up to this point, Weber's hopes for the new art were fairly accessible. That one might want to convey more than a single aspect of an object is understandable, and generations of dubious undergraduates have warmed somewhat to cubism once they have come to see some kinship between its images and "exploded view" schematic drawings. But Weber did not stop here. He became more cryptic, and in another 1910 manuscript described the fourth dimension in terms that had more to do with metaphysics than physics, equating the qualities of his fourth dimension with an "essence of life"[23] that infused every aspect of the universe with a potent and moving glory, that "arouses imagination and *stirs* the emotion." By the time Weber had finished discussing his fourth dimension, he

had managed a terrific conflation of spirit and matter. The dualism of mind and body was nowhere to be found, and the Enlightenment's firm distinction between idea and object dissolved into a continuum of objects begetting ideas which in turn beget still more objects.[24]

Stieglitz subscribed to a similar monism, which he too accepted as a foundation of the new art. At one point Stieglitz described the great artist as an individual with "the power of discerning the psychological in...things,"[25] and his notion of a psychological dimension to inanimate objects like rocks or trees was informed by the thought of French philosopher Henri Bergson. Bergson's ideas enjoyed growing American popularity at just the time Stieglitz encountered modernism. In 1909 James had lauded Bergson's ideas ("new horizons...the breath of morning and the song of birds"), and when Bergson visited New York four years later he was greeted by enthusiastic crowds and an honorary degree from Columbia University.[26]

The most obvious indication of Stieglitz's interest in Bergson appeared in the pages of *Camera Work*. In two consecutive issues (October 1911 and January 1912), Stieglitz published extracts from Bergson's works—the first from *Creative Evolution* (1907) and the second from *Laughter* (1900)—the selections indicating something of what the editor, Stieglitz, found significant in the material. In the first, Bergson refused to make the common separation between matter and spirit, and instead insisted that they were so mutually infused that neither existed in anything like a pure form. Within this cosmic admixture there was what Bergson called an *elan vital*, or vital force, that was best understood through intuition rather than the intellect, for "it is to the very inwardness of life that intuition leads us."[27]

This appealed to Stieglitz and his friends, and it was not long before they began to use Bergsonian terminology. In December 1912, Stieglitz boasted that *Camera Work* was "a vital force" helping readers develop their intuitive faculties.[28] Stieglitz also criticized others in vitalistic terms, at one point complaining that Leo Stein's intelligence was compromised because he "does not *feel* below the surface."[29] The same *Camera Work* issue containing Bergson's *Creative Evolution* carried a lead article by Benjamin De Casseres, "The Unconscious in Art," echoing Bergson's regard for the unarticulated and intuitive dimensions of human knowledge, and in a 1913 essay, de Zayas seemed to borrow directly from Bergson's monism when he wrote that "matter cannot exist without spirit, nor can spirit exist without matter."[30]

In all of this Stieglitz and the others believed they found the mission for the modern artist. Bergson had looked forward to a time when humans "continually vibrate in perfect accord with nature," and believed it was the artist who was best prepared to lead the way by "placing himself back within the object by a kind of sympathy."[31] The men and women at 291 agreed, and described the modern artist as one who brought to the twentieth century a unity that had been so much a part of the nineteenth century's romantic synthesis, with its fusion of the physical and the spiritual. Now De Casseres described art as an "adventure of mind in matter."[32] Similarly, Stieglitz published Wassily Kandinsky's assertion that modern painters were "seekers of the inner spirit in outer things,"[33] and de Zayas praised modern art for its ability to penetrate to the very "soul of substance."[34]

In this manner Stieglitz and his friends came to their understanding of modern art's subjects. The effort began around 1910, continued for the next three or so years, and by the end of that time they described Picasso, Matisse, and others as innovative artists of the transcendent. This was a confluence of ideas and objects familiar in the Stieglitz domain. Earlier pictorial photography and the romantic warble of symbolism had attempted to minimize the divisions between mind and matter, and Stieglitz, through his photographs and writings, had described a world in which objects were suffused with spiritual import. Now Stieglitz remained certain that matter and spirit, object and idea were mutually saturated with meaning, and that the sympathetic artist produced similarly-infused images. But some things *had* changed by the beginning of 1913. Stieglitz and his friends were much more interested in and tolerant of natural objects, and those objects that had previously been stepping stones on the path to poetic insight now took on significance as fuller metaphysical partners of the spirit. Truly good modern images engaged the familiar and apparently insignificant outlines of natural objects, and through abstract exploration offered up intense readings of the inner mixture of soul and substance, idea and matter.

1913 brought a turning point in Stieglitz's exploration of modernism. Over the preceding several years he had been absorbed almost exclusively in the new, abstract painting, and he had managed a rather quiet introduction of the new European painting to the handful of people who visited 291 or read *Camera Work*. But early in 1913 the great Armory Show introduced an even greater number of such works to vastly larger American audiences, and in the clamor surrounding the show's nonrepresentational images, modernist art achieved much of the prominence (if not always the applause) that Stieglitz had sought. At this very moment when events moved so dramatically for painting, Stieglitz brought his attention to photography, embracing a new aesthetic that suited his understanding of the new art. Having done his part to establish an American foothold for the seemingly most advanced art, Stieglitz turned to establishing photography's position in that modernist vanguard.

With some thirteen hundred different works, the International Exposition of Modern Art was so large that it was housed in New York's cavernous 69th Infantry Regimental Armory (hence the common name for the exhibition). Large crowds attended the original Armory Show between February 17 and March 15, 1913, as well as later traveling versions in Chicago and Boston. Controversy helped swell the audiences, for viewers were shocked by works like Marcel Duchamp's cubist-inspired *Nude Descending a Staircase* (1912); the press and public, along with critics as diverse as Walter Lippman and Teddy Roosevelt, had a field day denouncing such nonrepresentational works.[35] Stieglitz was listed as an honorary sponsor of the Armory Show, and even attended a few preliminary planning sessions. But the Show's size and publicity were on a scale larger than he preferred, and Stieglitz limited his public role to cheering from the sidelines. But in private Stieglitz was more sour about what he called "the Big Armory International Post Impression Circus," for it seemed as though some johnny-come-latelies had trumped his own showmanship with their grander presentation of modernism.[36]

More than anything, though, Stieglitz's attention was directed back to 291 and photography. From February 24 to March 15, 1913—precisely during the second half of the Armory Show—Stieglitz hung an exhibition of his own photographs at 291. The synchronicity was no accident: 291 exhibitions were planned well ahead of time, and Stieglitz had advance notice of the Armory Show's running dates. Nor was the decision to use his own photographs a casual one; this was the only one-man exhibition of his work that Stieglitz ever displayed at 291, and one of only three photographic exhibitions hung since his turn toward modernism.

This exhibition was not a showcase of new work, and he displayed only a few of his most recent images. Instead, Stieglitz described the show as a proving ground for his entire oeuvre, and presented a chronological spread of favorites that included *The Terminal* (1892), *The FlatIron Building* (1903), and *The Mauritania* (1910). Writing to a friend about the simultaneous exhibitions at 291 and the Armory, Stieglitz said that "I am putting my work to a diabolical test" in which the master of American photography went head-to-head against the best of modern painting.[37] By May, he boasted that "my own show... really looked first class," and that it had "stood the test of time and of the memories of the little place splendidly."[38]

If anything, Stieglitz's show was more of a demonstration than a test. It was less intended to see if photography could hold its own against painting, and more designed to show photography's place within modernism. As his friend Paul Haviland noted, Stieglitz arranged for the exhibition to coincide with the Armory Show in order "to show the relative place and value of photography."[39] Critics who attended Stieglitz's exhibition certainly felt as though they had been set down for schooling; Samuel Swift of the *New York Sun* said that Stieglitz offered a "lesson clearly enforced," and J. Edgar Chamberlain of the *New York Mail* believed that Stieglitz's "purpose is to convince the instructed observer."[40] And as usual, Stieglitz did not allow the images to speak entirely for themselves. As the British visitor Ward Muir noted, "this rhetorical American" harangued his visitors with a monologue that "rushed into all sorts of the wildest illustrations and anecdotes and apparent side alleys; but always it reverted to the main theme... the Importance of Photography."[41] A portion of the theme was Stieglitz's long-established argument that photography was just as significant as painting, that an individual photograph could be just as serious as a given painting. But at the time of the Armory Show, Stieglitz added a new dimension to his discussions, for he now began to speak of a fundamental difference between photography and painting.

In the past there had been a seemingly obvious linkage between the two, for photography and painting both had appeared to share the enterprise of more-or-less recognizably depicting the outside world. Now though, as innovative painters moved toward abstract images that did not necessarily resemble the physical outlines of a given subject, Stieglitz and his associates began to speak of mimesis as a more distinctly *photographic* project. Stieglitz described Picasso and Brancusi as "painters and sculptors who decline to go on doing merely what the camera does better,"[42] and Stieglitz's friend John Marin, commenting on his own recent turn towards abstraction, proclaimed that he would no longer "copy facts photographically."[43] Of course there is nothing mandating that photography must be a literal genre, and the young photographer Paul Strand would soon create photographs

with many of the abstract qualities of cubist paintings. But Stieglitz chose not to travel that path, and continued to think of abstraction as more properly the domain of painting, not photography.

This distinction inspired some notably clumsy vocabulary in the months surrounding the Armory Show. Stieglitz and the others might have more adroitly chosen words like "representational" to refer to customary photography, and "nonrepresentational" for the kind of images Picasso was creating, but rather than such common-sense nomenclature, they used the terms "photographic" and "antiphotographic." Thus Charles Caffin informed *Camera Work* readers that mimetic painting "is in its motive essentially photographic,"[44] and Stieglitz told a correspondent that the postimpressionists were artists whose "vision is antiphotographic," and that they have "antiphotography in their mental attitude."[45]

With a 1912 letter Stieglitz sought to explain mimesis and abstraction to his apparently perplexed friend Heinrich Kuhn, providing a tortuous discussion of "photographic" and "antiphotographic" images that must have left poor Kuhn more confused than ever. In the middle of that letter Stieglitz acknowledged what was for him the most troubling aspect of the distinction he was making: "photogr. art whether attempted with camera or with brush is not the highest art."[46] For decades Stieglitz had insisted that good photography was advanced art, something just as good as painting. But now his logic seemed to carry him in a different direction. If, with the advent of abstractionism, the most advanced art was advanced because it shunned representation, and if photography was so representational that "photographic" was virtually a synonym for "representational," did this then imply that photography was *not* advanced, that photography had become a dead end in the evolution of the visual arts, a vestigial and moribund medium that did little more than transcribe things? [47]

Here was a considerable dilemma, and the "rhetorical American" had gotten himself into something of a rhetorical bind. Though he still wanted photography to have the status of fine art, Stieglitz was now almost at the point of saying that "antiphotography" was the serious art form of the moment, while "photography," practiced either with brush or camera, was insignificant. But Stieglitz found an equally rhetorical escape from the predicament and a justification for the art of photography, arguing that although camera images might be more representational than Picasso's images, there was still something he called "the deeper meaning of Photography."[48]

De Zayas provided Stieglitz and the others at 291 with an initial way around the dilemma. At the time of the Armory Show, and in the months immediately thereafter, de Zayas authored, and Stieglitz published, three articles tracing the development of Western art down through the twentieth century. With a whiggish perspective, de Zayas held that Europeans and Americans had finally realized that the true purpose, or "idea of art," was to pursue worldly understanding rather than perpetuate religious myth.[49] In his estimate, older forms of art were tragically ridden with the clap-trap of religion, and given over to "the symbolism inspired by the hallucination of faith" so that artists rendered up Madonnas rather than women, burning bushes rather than nature's plant life.[50] But things were getting better, for at the Armory Show and elsewhere there were now paintings that abandoned the perpetuation of

myth for the analytical examination of abstract design,[51] and de Zayas thought that photography could execute a similarly objective treatment of physical qualities like shape or texture.[52] Thus within a single, *modern* "idea of art," de Zayas managed to include painting as a medium dealing with ideational qualities like design, and photography as a medium concentrating more upon physical ones such as texture.

Stieglitz praised de Zayas's effort as a "gigantic work," and spoke of the younger man as "a marvel."[53] He also adapted de Zayas's phrasing to his own purposes, and beginning late in 1913 and continuing through the next year, Stieglitz peppered his correspondence with references to *"the idea photography."*[54] This formulation allowed him to retain his long-held position that good photography belonged among the best of the arts, that his kind of images were distinct from those of ordinary commercial photographers, and that, as he told Imogen Cunningham, real photography was distinct from mere "picture making."[55] More generally, there was also increasing talk around 291 about photography's superb ability to render the physical minutiae of a scene, so that with all its details an image like Stieglitz's *Steerage* obtained, in de Zayas's words, "the verification of a fact" more readily than a painting could manage.[56]

In this way Stieglitz and his friends could draw their distinctions between photography and painting, preserve photography's claim to vitality in an age of abstract painting, and distinguish superior photographs from run-of-the-mill counterparts. Next the people at 291 developed criteria for their modern photography, and eventually settled upon what came to be known as "straight" photography: images with clarity and depth that own the physicality of their subjects and that avoid the fuzzy details and shallow focus which lend a dreamy, even mythological, atmosphere to many pictorial photographs. Straight images also eschewed narration, for the straight photographer was supposed to allow subjects to speak for themselves rather than to impose his own legend upon them. All of this was to be accomplished without hand work, for the photographer who touched up his image borrowed the techniques of painting and was untrue to his own medium. Functionally, straight photography made the artist's role less obvious than it had been in pictorial photography, and by producing images that seemed unelaborated and dedicated to the subject, straight photographs appealed to the Stieglitz circle's "scientific" preferences for unbiased and open-ended investigation.

Straight photography became something of a dogma, too. The conversations at 291 sparkled with notions of a Bergsonian world without absolutes and of an evolution without end. Yet the irony is that straight photography carries with it a sense of arrest more than development, of aesthetic orthodoxy rather than diversity; with its insistence upon a certain kind of images, straight photography had the clear implication, in a term that Stieglitz once used, that other forms of photography are "crooked"—unacceptable and perhaps even dishonest.[57] To compound the irony, straight images often did not have an avant garde look about them, and with straight photography's strictures against painterly technique, convention approached the level of creed: what a (straight) photograph *should* look like was what an (ordinary) photograph *commonly* looked like, and the fine-art ideal of a clearly rendered image resembled the unimaginative sharpness of workaday photographs.

Voices favoring straight photography had been audible for some time in Stieglitz's circle. As early as 1904 Sadakichi Hartmann had authored "A Plea for Straight Photography," and the following year it was similarly advocated in the pages of *Camera Work*. But once modernism became a compelling concern at 291, the calls for straight photography surfaced more frequently, and by 1913 it seemed that Hartmann's plea had been answered by the master himself. Reviewing Stieglitz's one-man exhibition at the time of the Armory Show, Paul Haviland recognized Stieglitz's prints as "the straightest kind of straight photography."[58]

Haviland's review may have had more to do with his hopes for photography than with the photographs he actually saw at 291. Stieglitz's 1913 exhibition was a retrospective, containing many images influenced by symbolism and created well before straight photography was so prominently discussed at the gallery. Compared to many of his turn-of-the-century contemporaries, Stieglitz *had* produced relatively "straighter" images, but in an image like *Winter—Fifth Avenue* (1893; fig. 2.4), Stieglitz practiced a painterly manipulation to enhance his narrative of humanity-struggling-against-the-elements. In his urban images made around the time of *The Pool—Deal* (1910; fig. 3.3), Stieglitz had worked with greater clarity of focus and demonstrated concerns that ran more toward modernist geometry than toward romantic narrative. There was, however, a timorousness about those efforts, and at the end of 1911 Stieglitz had after all called a recess in his own photography.

The hiatus came to an end in 1914 when Stieglitz seemed more confident in his understanding of modernism and photography's place within it. Bergsonian notions and fourth-dimensional geometry made it possible to be modernistic without abandoning his long-standing concerns with intuition and emotion. If photography now seemed a more representational medium than painting, more adept at conveying physical qualities as opposed to painting's more ideational province, de Zayas had shown that good photography was nonetheless as serious and *au courant* as good painting. Straight motifs also offered a visual departure from the more impressionistic styles of pictorial photography, providing modern photography with a new appearance much as the cubists' bold innovations gave painting a new look to painting. Thus equipped, Stieglitz returned to photography, and until old age finally stilled him, there was never again a similarly purposeful break in his productivity. He went to work with a vengeance, straining the modest 291 darkroom which had adequately served him for years, and over the next three years creating some notable portraits, architectural studies, and open-air photographs.

Portraiture was a good place to begin. It was a familiar form, one he had practiced since the 1880s, and Stieglitz's archives bulge with pictures of family and friends. But with 1914 he began making portraits of a distinct set of people, those contemporary artists whose paintings and essays so excited him. Francis Picabia, Marius de Zayas, Paul Haviland, and Arthur Dove all had their faces recorded while they visited 291, and with these portraits of modernists, Stieglitz edged toward his own modernist expression of clean lines and full illumination. But his self-portraits were even more innovative. In 1916 Stieglitz made a series called

Shadows on the Lake, depicting his own shadow cast upon the waters of Lake George, the form captured as he stoops over the camera at the moment of releasing the shutter. Unlike that 1910 self-portrait (fig. 3.1), these are straight photographs, for even with some water-produced waviness, they have the sharpness of silhouette rather than the earlier image's murky outlines, and replace a soulful romantic stare with the matter-of-fact outlines of the photographer unmysteriously going about his work.

A similar, workmanly theme appeared in another image, *Portrait of Paul Strand* (1917; fig. 3.4). A young photographer who had been calling at 291 since 1907, Strand became truly serious about photography sometime around 1913. Unlike de Zayas, Haviland or the others, Strand was at this time much more a practicing artist rather than a theoretician. When Stieglitz portrayed the others he tended to depict them as witty individuals photographed during a conversational lull, showing de Zayas, for example, with a knowing twinkle in his eye, an intelligence that appears to radiate from his gleaming face, and lips that seem on the verge of yet another bon mot. But Stieglitz photographed Strand during a lull in work, with a face more of inner concentration rather than outward conversation, and with the trappings and posture of someone ready to return to his business, for Strand's sleeves are rolled up, he is outfitted with a laborer's hammer and apron, and his competent-looking arms spill out of the frame.[59] This studied rendition of Strand is emblematic of the shift in Stieglitz's orientation, for with his attention turned more toward the praxis of photography and away from the theoretical debates that had featured de Zayas, Strand the practicing photographer increasingly became the focus of Stieglitz's concerns.

Stieglitz deeply admired Strand, and may even have loved him for a time. Stieglitz demonstrated his regard by awarding Strand the highest endorsements he gave any artist, an article in *Camera Work* and an exhibition at 291. That show, in March and April of 1916, was the only photographic exhibition at 291 after Stieglitz's own 1913 show, and the last ever photographic exhibition at the gallery.[60] Stieglitz's October 1916 essay praised Strand as one who worked with "applied intelligence" and created straight photographs: "His work is pure. It is direct. It does not rely upon the tricks of process."[61] Moreover, Strand proved an adept student, and when his own essay appeared (as the lead piece in *Camera Work*'s last number), Strand summarized much of what he had heard at 291, praising straight photography and distinguishing it from "the other arts which are really anti-photographic." Scholar Abigail Solomon-Godeau has argued that Strand's visual and written work was an epiphany for Stieglitz,[62] but it was actually more of a valedictory, conveying a neat digest of much that had occupied Stieglitz since the time of the Armory Show.

Besides portraiture, Stieglitz took up still another line of work in the aftermath of the Armory Show. In the winter of 1915-16, he began a series of formal studies made through the back window of 291 (fig. 3.5). Photographs of the city at night or of snow patterns in the courtyard, these images of the piled-up boxes of city buildings demonstrate Stieglitz's attraction to some of the abstract shapes of cubism. There was a continuity between these images and his 1910 city photographs, but as Sarah Greenough has mentioned, these later photographs are more photographs of generic shape and form than of specific subjects, and their titles are more often

3.4. Alfred Stieglitz. *Portrait of Paul Strand, 1917.* © 1958, Aperture Foundation, Inc., Paul Strand Archive.

denotative *(Out of the Window, Snow on Tree* [1915]) rather than connotative, as had been the case with earlier images like *The City of Ambition* (1910).[63] Dark or snowy scenes, these photographs are compressed into the middling shades of gray and do not imply the full tonal range favored by subsequent straight photographers, but they do employ a device, the window as framing device, that would become common in straight photography. For Stieglitz, the window frame remained just beyond his photograph's frame, but as clearly indicated in his titles (*Out of the*

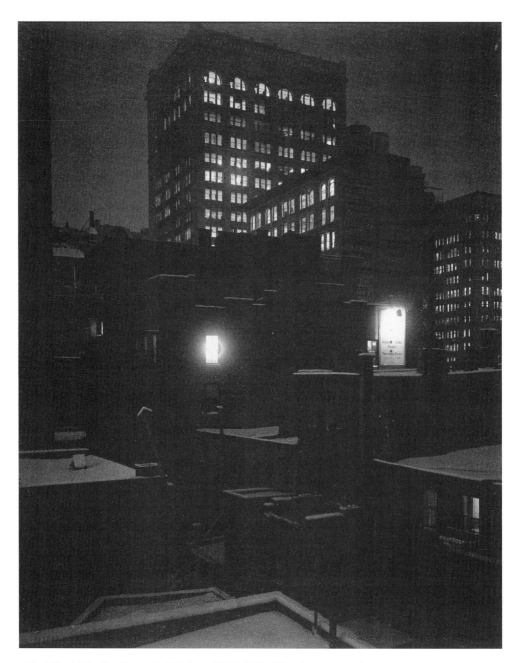

3.5. Alfred Stieglitz. *From the Window of 291, 1915.*
The Metropolitan Museum of Art.

Window, From the Window of 291) the window edge was a delimiter setting the boundaries of the view. There is yet another parallel, this one between these 1915 window images and his 1889 window photograph, *Paula, Berlin* (fig 2.1). At both times Stieglitz employed the window in an echo of the camera's aperture. But now in the midst of his discussions about photography as an art concerned with the reality of the objective world, Stieglitz constructed images that look *out* through the

window and upon physical things, whereas in the earlier image, the window cast its light *in* upon a person busy with the interior work of thinking and writing.

Shortly after his window series Stieglitz produced other images stressing the physicality of his subject. These photographs of Ellen Koeniger, composed while she was swimming at Lake George in the summer of 1916, were among the sharpest of Stieglitz's efforts at straight photography. They are also among the most keenly physical of his newer works, for while there is a certain thoughtful quality to Stieglitz's other subjects—Strand has that contemplative pipe stuck in his mouth—these images of Koeniger say little about Koeniger's mind and instead concentrate almost exclusively upon her body. She wears a bathing suit in these photographs, but the pictures actually anticipated Stieglitz's later nudes, for the wet, flimsy cloth clings to Koeniger's body, and, ill-fitting and stretched, the garment reveals much of her flesh. All of this Stieglitz treated closely, very closely, bringing the camera to bear upon the fullness of Koeniger's body, so that one image shows a chilled, erect nipple as the soaked fabric falls away from her breast, and still another photograph is an almost fetishized treatment of buttocks tightly wrapped in the shiny, wet cloth. As recently as his 1907 nude collaborations with Clarence White, the women and girls in Stieglitz's images were shown in pensive or thoughtful poses, and the corporeal lushness of their bodies was minimized in softly focused, diffused pictorial renderings. But in these later, sharper photographs, the focus is primarily upon Koeniger as a richly detailed physical object, seemingly with little more upon her mind than the bracing chill of Lake George's waters.[64]

By the end of 1916, Stieglitz clearly knew that he was embarked upon a new direction, and with characteristic lack of humility, he announced that his recent work was not only a significant departure but also a sizable achievement. Stieglitz bragged that these images had none of pictorial photography's characteristics: "Not a trace of hand work on either negative or prints. No diffused focus," and that they were "intensely honest," "just straight goods." For years there had been almost no mention of technical matters in Stieglitz's correspondence, but by late 1916 he reeled off some of the technical aspects of his recent work, particulars that underscored that he was practicing straight photography: the prints were all on platinum-based paper (providing especially rich hues), and often his lens was stopped down to a small aperture (providing a very sharp focus).[65] These features became standard characteristics of straight photography, techniques and materials designed to convey the depicted subject with intense clarity and keen respect for its physical qualities.

The next few years brought remarkable changes for Stieglitz. Between 1916 and 1918—after he had returned to his camera and adopted straight photography—Stieglitz abandoned long-standing elements of his life and career, and moved toward one of his most productive and energized photographic periods. One hesitates to make too much of this sequencing, or to offer strong claims about the liberating effects of Stieglitz's new art; some of his redirection was propelled along by events far beyond his narrow art world, and there were continuities to this life that still moved between his established poles of New York and Lake George. Nonetheless, during these few years Stieglitz left behind fixtures and relationships that he had preserved for decades, and did so with a measure of confidence and pleasure that was in part

sustained by his growing excitement with photography. He also proceeded with a certain self-conscious sense that he had come to the end of a phase in his life, and that while the process might sometimes prove painful, it was time to slough off the old.

His marriage began its final dissolution during this time. The strains had surfaced early in the relationship and an obvious rift had developed by the Photo-Secession days. The two had few interests in common, and as Alfred grew increasingly absorbed in the modernist debates swirling around 291, he became estranged from Emmy and their daughter Kitty; by 1914 his life was so distinct from theirs that the amazed sixteen-year-old Kitty learned only from a teacher that her father was a world-renowned photographer.[66] When Emmy's brewery fortunes suffered with the approach of World War I (foodstuffs were diverted from alcohol production), Stieglitz's desire to preserve the marriage had all but vanished, and in the summer of 1917 he told Strand that he could "see no solution" to what he called "the family question." But for the time being Stieglitz stopped short of a complete break, and although he moved out of Emmy's bedroom he still remained in the household.[67]

That same summer Stieglitz lost what truly were two loves of his life, 291 and *Camera Work*. The last issue of *Camera Work* was published in June 1917. Stieglitz alienated so many readers that the subscription list eventually shrunk to a paltry thirty-seven names, not nearly enough to sustain publication once Emmy's subsidy ended. *Camera Work* was missed, but he allowed it to go without a great deal of mourning. 291 was another case, though, for Stieglitz had tied his very identity to the place; with all the people and all the discussion, it had been more of a home to him than were any of the apartments he shared with Emmy. Stieglitz struggled to keep the gallery open, but his efforts were fruitless, and on July 1, 1917 the doors of 291 were finally closed.

The collapse of Stieglitz's marriage, the closing of 291 and the cessation of *Camera Work* all took place against the back drop of World War I. Within weeks of the war's beginning Stieglitz lamented that people seemed so "frightfully helpless" when they were "drawn into the terrific whirlpool of the world's forces."[68] Those forces produced significant disruptions in his life, threatening his communications with the Continent, stranding some of his circle in Europe, and eventually pulling friends like Strand into the draft. Akin to contemporaries such as Randolph Bourne, Stieglitz voiced a bitterness about wartime America, but whereas Bourne felt the war had led Americans to compromise their progressive politics, Stieglitz believed that the war underscored America's long-standing cultural failure; he was inclined to see the war as a clash between an excessively slip-shod and materialistic America, and a more workmanlike and idealistic Germany.[69] Eventually Stieglitz convinced himself that Germans would not have allowed 291 and *Camera Work* to wither, whereas Americans ignored his aesthetic achievements in their pell mell pursuit of a fast buck. So, the war only reemphasized what was for Stieglitz the lesson of the gallery and magazine closures, that "the country is not ready for me. That is certain."[70]

He was willing to ignore many of those Americans, but there was at least one whom Stieglitz hoped was ready for him. As his estrangement from Emmy grew, Stieglitz became increasingly interested in a much younger woman, the painter Georgia O'Keeffe (1887-1986). Born in Wisconsin, O'Keeffe pursued her art educa-

tion in New York, and then moved about the country as she followed teaching jobs to Virginia, South Carolina, and Texas. Stieglitz would later describe her as a naive, intuitive painter, but O'Keeffe numbered among her friends some of New York's foremost intellectuals; she was an intelligent and well-informed explorer of the new art frontiers, and by 1915 she had read some of the more significant works on modernism, including Kandinsky's *On the Spiritual in Art*.[71] Like Strand (three years her junior), O'Keeffe was a younger artist whose visual experimentations were bolder than Stieglitz's own work, and her images helped to show him some of the expressive potential that lay beyond impressionism and mimesis. Again like Strand, O'Keeffe was aware of Stieglitz's stature in the American art community, and she sought out his recognition. In the autumn of 1915 she confessed to her friend Anita Pollitzer that "I would rather have Stieglitz like something—anything I had done—than anyone else I know of…"[72]

O'Keeffe soon got her wish, and more. In January 1916 Pollitzer showed Stieglitz a selection of O'Keeffe's recent charcoal drawings, and he was immediately captivated by the work. This was apparently the first time that Stieglitz had taken cognizance of O'Keeffe, and from that time onward he conflated her art with her sexuality; not only was he intrigued with the images, saying that they were "genuinely fine things," but he also claimed to recognize them as the work of a female artist, saying that "I'd know she was a woman—Look at that line."[73] Many of Stieglitz's notions remained flavored by his earlier romantic sentiments, and O'Keeffe's images and person became for him still another incarnation of female mystery, so that he described the painter and a set of her oils as "Loveliness—Savage force—Frankness—The Woman—All in one."[74] The widening war and its "ghastliness" only encouraged Stieglitz's dreamy connection between the feminine and the beautiful, and a 1918 Red Cross parade with "thousands of girl children" all wearing white launched him into an almost orgasmic reverie about "the Beauty I feel so terrifically underlying & what I call O'Keeffe—…Woman—and Art—."[75]

Stieglitz pursued O'Keeffe as both an artist and a woman. Their first substantial meeting occurred in May 1916 when she came to protest that Stieglitz had, without permission, hung some of her drawings at 291. But he silenced her complaints, the images remained on display, and although she returned to her teaching job in Texas, Stieglitz almost immediately began a long-distance courtship that eventually produced as many as five letters a day. The following spring, in what was 291's closing exhibition, Stieglitz gave O'Keeffe her first one-woman show, and when she visited New York shortly after the show's official closing, he re-hung it especially for her. The two may have become lovers at that time. By May 1918 Stieglitz had decided that "she is the Spirit of 291," and he campaigned to bring O'Keeffe back to New York, even offering a subsidy so she could devote herself to her painting.[76] Strand was dispatched to Texas as his emissary, the entreaties proved successful, and by the first week in June O'Keeffe was installed in the temporarily vacated New York apartment of a Stieglitz niece. Appearances were preserved for a month or so, but early in July Stieglitz left Emmy and moved in with O'Keeffe.

Thus by the summer of 1918 Stieglitz had undergone a significant metamorphosis. Most of the main features of his life had changed significantly in the eight years since he had made that dreamy 1910 self-portrait. A stultifying, but nonethe-

less respectable and remunerative marriage now lay in shambles, and Stieglitz was thrown back upon his own resources as he faced the challenges of building a relationship with a woman twenty-three years his junior. Gone forever were the gallery and journal that had absorbed so much of his earlier energies. And pictorial photography, once so stridently advocated, now seemed to have taken a place in the dust along with so much of the nineteenth century.

All told, Stieglitz was more excited than sorrowful over these changes. Without the preoccupations of 291 and *Camera Work*, he found himself increasingly absorbed in the actual creation of images, and he took up straight photographic motifs inspired by the modernist debates of the preceding years. O'Keeffe compounded the joy, for unlike Emmy she shared and responded to Stieglitz's various passions, offering a companionate and intimate relationship the likes of which he had never experienced. But O'Keeffe was also more than a helpmeet artist for this artist photographer. She became his art subject, too, one that could satisfy not only his abiding romantic fascination with Woman, but also his newer preoccupation with the corporeal. Having so recently come to a straight photography that accentuated the physicality of the photographer's subjects, Stieglitz had in O'Keeffe a subject whose physical qualities he found particularly delightful.

1. AS to George Davison, April 10, 1909. ASA/YCAL.
2. Quoted in Weston Naef, *The Collection of Alfred Stieglitz* (New York: Museum of Modern Art, Viking Press, 1978), 186.
3. Clarence White to AS, May 15, 1912, and AS to Clarence White, May 23, 1912, ASA/YCAL.
4. AS to Paul Rosenfeld, October 21, 1923, ASA/YCAL.
5. AS to Heinrich Kuhn, March 10, 1907, translation by James Card, ASA/YCAL.
6. Dorothy Norman, "From the Writings and Conversations of Alfred Stieglitz," *Twice a Year* 1 (Fall-Winter 1938), 81. Edward Steichen, *A Life in Photography* (Garden City, NY: Doubleday & Company, 1963), np.
7. AS to Heinrich Kuhn, September 23, 1907, translated, ASA/YCAL.
8. Steichen to AS, quoted in William Inness Homer, *Alfred Stieglitz and the American Avant-Garde* (Boston: New York Graphic Society, 1977), 72.
9. AS to Sadakachi Hartmann, December 22, 1911, ASA/YCAL.
10. See *Camera Work* 27 (July 1909), 33, 35, 37, 39.
11. John Pultz, "Cubism and American Photography," *Aperture* 89 (1982-83), 48.
12. Paul Strand, "Stieglitz: An Appraisal," *Photo Notes* (July 1947), 7-11.
13. Alfred Stieglitz, "Four Happenings," in *Twice-A-Year* 8/9 (1942); reproduced in Nathan Lyons, ed., *Photographers on Photography* (Englewood Cliffs, NJ, 1966), 130.
14. Jonathan Green, ed., *Camera Work: A Critical Anthology* (Millerton, NY: Aperture, 1973) 342. Steichen, *A Life in Photography*, np.
15. AS to Sadakachi Hartmann, December 22, 1911, ASA/YCAL.
16. Alfred Stieglitz, "The New Color Photography—A Bit of History" *Camera Work* 20 (October 1907), 25.
17. Charles Caffin, "Henry Matisse and Isadora Duncan," *Camera Work* 25 (January 1909), 19-20.
18. Marius de Zayas, "Pablo Picasso," *Camera Work* 34/35 (April/July 1911), 66.
19. Alfred Stieglitz, "Photography of Today. Discovery of Photography," undated [c. 1899] ms., ASA/YCAL. Alfred Stieglitz, letter to the editor, *American Amateur Photographer* 13 (January 1901), 41-42.

20. Some very thoughtful work in this area has been done by Linda Dalrymple Henderson: *The Fourth Dimension and Non-Euclidean Geometry in Modern Art* (Princeton: Princeton University Press, 1983), and "Mysticism as the 'Tie That Binds': The Case of Edward Carpenter and Modernism," *Art Journal* 46 (Spring 1987), 29-37. For a time at least, they shared some of these concerns with prominent company; both James and Dewey had worked in non-Freudian psychology, and James, as he had indicated in *The Varieties of Religious Experience* (1902), believed in a coherent linkage between the mystical and the empirical. There were also personal, if passing, connections between the pragmatists and the Stieglitz circle—Gertrude Stein had studied under James some years before she met Stieglitz, and Agnes Ernst Meyer, one of the few women at 291, had been Dewey's student.

21. Henderson, *The Fourth Dimension*, xix-xx, 26-27, 41-42. Hinton studied at Oxford and Berlin (where he may have worked under Stieglitz's teacher, Helmholtz), frequented circles that included psychologist Havelock Ellis, and married the widow of the mathematician who gave us Boolean logic.

22. Max Weber, "The Fourth Dimension form a Plastic Point of View," *Camera Work* 31 (July 1910), 25-26.

23. Max Weber, [Photography] Undated ms., ASA/YCAL. Notation in AS's hand: "Written by Max Weber 1910—read before a [Clarence] White Class before the 'break' at 291."

24. Weber, "The Fourth Dimension," 25-26.

25. Alfred Stieglitz, "The First Great 'Clinic to Revitalize Art,'" *New York American* 26 (January 1913), 5CE.

26. Tom Quirk, *Bergson and American Culture: The Worlds of Willa Cather and Wallace Stevens* (Chapel Hill: The University of North Carolina Press, 1990), 44-45.

27. Henri Bergson, extract from *Creative Evolution*, *Camera Work* 36 (October 1911), 21. See also Bergson, "What is the Object of Art?" *Camera Work* 37 (January 1912), 22.

28. AS to George D. Pratt, December 7, 1912, ASA/YCAL.

29. AS to Marius de Zayas, June 22, 1914, ASA/YCAL.

30. Marius de Zayas, "Exhibition [of] Marius de Zayas," *Camera Work* 42/43 (April/July 1913), 20-21.

31. Bergson, "What is the Object of Art?", 24. Bergson, extract from *Creative Evolution*, 21.

32. Benjamin De Casseres, "Rodin and the Eternality of the Pagan Soul!" *Camera Work* 34/35 (April-July 1911), 13.

33. Vasily Kandinsky, extracts from "The Spiritual in Art," *Camera Work* 39 (July 1912), 34.

34. Marius de Zayas, "Photography," *Camera Work* 41 (January 1913), 19-20.

35. Milton Brown, *The Story of the Armory Show*, 2nd ed. (NY: Abbeville Press, 1988). The Armory Show was disturbing in other ways, too. In these days before cultural and political radicalism seemed to take different American pathways, cubism seemed to share much with organizations such as the Industrial Workers of the World, for both offered strikingly fresh and different options to the material as well as aesthetic values of established America. As Edward Abrahams and Martin Green have pointed out, New York was alive in 1913 with not just the Armory Show, but also with a huge pageant staged in support of an IWW-organized textile strike across the river in Patterson, New Jersey. Edward Abrams, *The Lyrical Left: Randolph Bourne, Alfred Stieglitz and the Origins of Cultural Radicalism in America* (Charlottesville: University Press of Virginia, 1986), 165-69. Martin Burgess Green, *The Armory Show and the Paterson Strike Pageant* (NY: Scribners', 1988).

36. AS to Sadakichi Hartmann, May 5, 1913, ASA/YCAL.

37. Quoted in Homer, *Alfred Stieglitz and the American Avant-Garde*, 171, n15.

38. AS to Sadakichi Hartmann, May 5, 1913, ASA/YCAL.

39. Paul B. Havilland, "Notes on '291,'" *Camera Work* 42/43 (April/July 1913), 19.

40. *Camera Work* 42/43 (April-July 1913), 46-47.

41. Ward Muir, "Alfred Stieglitz: An Impression by Ward Muir," *The Amateur Photographer* 57 (March 24, 1913), 285.

42. Stieglitz, "The First Great 'Clinic to Revitalize Art,'" 5-CE.

43. Commentary for Stieglitz's January-February 1913 show at 291, *Camera Work* 42/43 (April-July 1913), 18.

44. Charles Caffin, "Exhibition of Prints by Baron Ad. De Meyer," *Camera Work* 37 (July 1912), quoted in Green, *The Armory Show*, 217-18.

45. AS to George D. Pratt, December 7, 1912, ASA/YCAL.

46. AS to Heinrich Kuhn, October 14, 1912, ASA/YCAL.

47. Sarah Greenough, "Alfred Stieglitz and 'The Idea Photography'", in Greenough and Juan Hamilton, *Alfred Stieglitz: Photographs and Writings* (Washington: National Gallery of Art, 1983), 19-20.

48. *Camera Work* Special Number, June 1913, advertising section, np.

49. Marius de Zayas, "Modern Art—Theories and Representations," *Camera Work* 44 (October 1913), 13, 16.

50. Marius de Zayas, "Photography," *Camera Work* 41 (January 1913), 17-20, 19. The essay begins pretty baldly: "Photography is not Art. It is not even an art."

51. Marius de Zayas, and Paul B. Havilland. *A Study of the Modern Evolution of Plastic Expression* (New York: 291, March 1, 1913), 10-11, 24.

52. Ibid., "Photography," 13-14, 19.

53. AS to R. Child Bayley, April 15, 1913, ASA/YCAL.

54. Ibid., December 11, 1913, AASA/YCAL. AS to Alvin Langdon Cobrun, May 15, 1914, ASA/YCAL.

55. AS to Imogen Cunningham, February 20, 1914, ASA/YCAL. See also AS to W. Orion Underwood, December 16, 1914, ASA/YCAL.

56. Marius de Zayas, essay on *The Steerage*, 291 7/8 (September 1915), np.

57. Alfred Stieglitz, "The New Color Photography—A Bit of History." *Camera Work* 20 (October 1907), 23-24.

58. Sadakichi Hartmann, "A Plea for Straight Photography," *American Amateur Photographer* 16 (March 1904), 101-9, quoted in Beaumont Newhall, ed., *Photography: Essays & Images: Illustrated Readings in the History of Photography* (Boston: New York Graphic Society, 1980), 185-88. Rolland Rood, "The Evolution of Art from Writing to Photography," *Camera Work* 12 (October 1905), 30-47. Max Weber, [Photography] undated ms, ASA/YCAL. Charles Caffin, "Exhibition of Prints by Baron Ad. De Meyer," in Green, *The Armory Show*, 217-18. Paul B. Havilland, "Notes on '291,'" 19.

59. Stieglitz also made some portraits of people who really *were* workmen, and at about the same time as his portrait of Strand. One is of Hodge Kirnon (1917), the elevator attendant at 291, and the other of Emil C. Zoler (1917), a frustrated artist who served for years as AS's unpaid handyman. In the 1917 portraits neither man has tools, but both appear workman-like with their sleeves rolled up and collars open. When Stieglitz made this portrait of Strand, Strand was helping close 291 after its final exhibition.

60. It was also purposefully scheduled to coincide with the Forum Exhibition of Modern American Painters, a display of largely nonrepresentational paintings by artists from Stieglitz's circle as well as Man Ray and others. Just as Stieglitz's own 1913 show had made it possible to judge photography against abstract painting, the scheduling of Strand's 1916 exhibition made it possible to continue the comparison. Just as Stieglitz had earlier tried to place himself within a certain canon of photography, he also inserted his protege Strand into that same lineage and assured his readers that Strand's "work is rooted in the best traditions of photography." Alfred Stieglitz, "Photographs by Paul Strand," *Camera Work* 48 (October 1916), 11-12.

61. Ibid. Stieglitz gave plenty of room to those who agreed with his perception of Strand. Among the reviews that Stieglitz reproduced in the same *Camera Work* number was one by Charles Caffin, in which Caffin noted that Strand's photos provided a Bergsonian pleasure from external things: "They are…an unanswerable witness to the pleasure and interest the objective holds for us." Charles Caffin, "Paul Strand in 'Straight' Photos," *The New York American* (March 20, 1916), 17; *Camera Work* 48: 57-58 (1916).

62. Abigail Solomon-Godeau, "Back to Basics: The Return of Alfred Stieglitz," *Afterimage* 12 (Summer 1984), 25.

63. Greenough, "Alfred Stieglitz and 'The Idea Photography,'" 20.

64. For reproductions of some of the Ellen Koeniger images, see John Szarkowski, *Alfred Stieglitz at Lake George* (New York: Museum of Modern Art, 1995), 42-45.

65. AS to R. Child Bayley, November 1, 1916, ASA/YCAL. Platinum paper proved an especially difficult item to find; see AS to Alfred Clements, December 26, 1916, ASA/YCAL.

66. Alfred Stieglitz, "Ten Stories," *Twice -A-Year* 5-6 (1940-1941), 160-61.

67. AS to Paul Strand, August 18, 1917, PSC/CCP.

68. AS to John Marin, August 12, 1914, ASA/YCAL.

69. Abrams, *The Lyrical Left*, 198-203. AS to R. Child Bayley, November 1, 1916, ASA/YCAL.

70. AS to Julius Stieglitz, May 22, 1917, ASA/YCAL.

71. O'Keeffe's reading also included Arthur Jerome Eddy's *Cubism and Post-Impressionism*, Clive Bell's *Art*, Willard Huntington Wrigth's *Creative Will* and *Modern Painting: Its Tendency and Meaning*. Sarah Greenough, "From the Faraway," in Jack Coward and Juan Hamilton, *Georgia O'Keeffe: Art and Letters* (Washington: National Gallery of Art, 1987), 136.

72. GOK to Anita Pollitzer, 11 October 1915, in Coward and Hamilton, *Georgia O'Keeffe: Art and Letters*, 144

73. Stieglitz quoted in Pollitzer to GOK, January 1, 1916, in Sarah Greenough, "From the Faraway," 138 n3.

74. AS to PS, November 17, 1918, PSA/CCP.

75. Ibid., May 23, 1918 (second letter of this date), PSC/CCP.

76. Ibid., May 17, 1918 (first letter of this date), PSC/CCP.

4. Master Days

Stieglitz now entered what he called the "Master' Days" of his career. By his reckoning, the period began in the last half of 1918, just after he and O'Keeffe began living together, and continued until the summer of 1929, when O'Keeffe made the first of her prolonged visits to the Southwest.[1] Understandably referred to as his "Georgian" period,[2] this was a time when O'Keeffe's sharp mind, strong character and innovative vision all influenced Stieglitz's outlook. Thanks also to O'Keeffe, in these years Stieglitz experienced a sexual springtime. She enabled both a passion fixated upon her beauty (and that of other women, too), as well as an expansive set of portraits, many of them frankly sensual nudes, as she and other women modeled for him.

There were also men who were important figures for Stieglitz during this time. Artist friends like Paul Strand, Marsden Hartley, and John Marin continued sharing their ideas and images with him, while younger writers like Waldo Frank, Lewis Mumford and Paul Rosenfeld brought their thoughts and essays to Stieglitz. Compared to his correspondence of earlier years, his letters to these younger men contain a greater depth and expressiveness, qualities accompanied by a new light-heartedness that also surfaced in humorous photographs of subjects like long underwear flapping upon a clothes line or dinner guests gnawing upon corn cobs.

This new jocularity did not displace continuing dimensions of Stieglitz's character. His well-exercised hypochondria and his monumental egotism remained intact, and although Stieglitz took note of world events (the influenza epidemic of 1918-19 and the Versailles treaty) as well as domestic developments (women's enfranchisement and "the greatest of all Sports[,] Bootlegging"[3]), his primary attentions remained focused upon the visual arts. Many of his impulses to control and shape the American art world remained intact, and by 1921 Stieglitz had made arrangements for yet another gallery space where he began to mete out praise and condemnation much as he had once done at 291.

There were differences, though, and important ones. During these master days Stieglitz was an increasingly productive artist, churning out a tremendous number of new images. The pace that had begun to accelerate after the Armory Show quickened dramatically with 1918, so that the late teens and 1920s are arguably the most productive years of Stieglitz's career. This abundance was accompanied by a frequently elevated mood, and Stieglitz was often like an artisan absorbed in the flow and day-to-day concerns of a beloved craft. The perfectionist impulses that had once been devoted to the finely worked volumes of *Camera Work* were if anything stronger now, and, freed of the chores of publication, Stieglitz fussed over his prints with a fixation that he admitted "borders on mania."[4] Thus, as he approached age sixty, Stieglitz was an absorbed, exuberant, and fruitful artist—and an exhibitor, too. In all the years of 291, Stieglitz had held only one show dedicated to his own photography, but now in quick succession he mounted three major solo exhibitions (1921, 1923, and 1924), and allowed himself a large representation in an important group show (1925).[5]

Stieglitz's images created during these master days reflect concepts and techniques acquired over the course of his photographic career. Some were new additions, and his works of the late teens and twenties exhibit recently-adopted modernist elements—most notably straight photography's emphasis upon sharp focus and glossy prints. But unlike contemporary intellectuals and artists who manifested what Joseph Wood Krutch famously called *The Modern Temper*, Stieglitz was not interested in portraying a world of fractured discontinuities. Nor, despite Stieglitz's quotidian subjects, detailed images and at times libidinous executions, was he willing to share completely modernism's abiding preoccupation with the physicality of art subjects.[6] Instead, Stieglitz's images of these years amalgamated modernist concerns with more romantic notions from his earlier work. As such his efforts stressed continuities—continuities not only between his various subjects, but also between those subjects and the artist himself—and Stieglitz employed the camera as an instrument that plumbed those subjects' spiritual qualities as well as recorded their physical properties. In the relationship between artist and subject, Stieglitz still celebrated the photographer's perceptive and transformative powers, and when his subjects proved recalcitrant, when they resisted his photographic designs or manifested their own wills, Stieglitz abandoned them for other, more malleable subjects.

All this surfaced in Stieglitz's two great projects of the late teens and 1920s: his many photographs of women (especially O'Keeffe), and his many pictures of clouds. These topics were repeated so often and so compulsively that the archives veritably bulge with near duplicates. They are often sharp images, modern with their appreciation of corporality and their frequently fragmentary treatments. But Stieglitz composed them with a more romantic belief that unities lay behind the fragments, ideals behind the objects.

Stieglitz continued to think that good photography was something akin to physiognomy. The superficial bumps and lumps of his subjects could provide some understanding of the subjects' less physical and, he believed, more profound dimensions. At the time of the Armory Show he had spoken about "discerning the psychological in...things," and now he began to think about that enterprise as an actual photographic project. In 1922, he wrote of making "portraits of eggs," photos executed with an intensity such that it might be possible for the final prints to "differentiate between a rotten egg & a fresh one." Continuing along these lines, Stieglitz concluded that he would be satisfied only when he had achieved an image so lucid "that as you look at the picture you'll get the psychology of the particular...egg."[7]

There was a seriousness behind the whimsy. Now more than ever Stieglitz stressed that it was important for artists and writers to probe such nonphysical dimensions. His friend Waldo Frank proposed writing about the character of America by "reaching down to the hidden vitals,"[8] and Stieglitz employed similar terms during the 1920s. He once said that when he approached a subject he wanted to be "in the centre of that thing digging into that centre's centre."[9] Ultimately, though, the location of Stieglitz's goal mattered little, and his talk of hidden innards was metaphorical rather than actual, for his quest was more spiritual than physical, a quest for dimensions that "were truly alive & beyond the tangible," qualities both vital and impalpable.[10]

Nor were those qualities diverse. When Stieglitz probed various new subjects in the period after World War I, he continued to insist, as he had in the earlier Bergsonian days, that there were contunities beyond the physical world's apparent varieties, what he called "that Supreme Oneness which includes everything."[11] O'Keeffe was one of his favorite subjects in this quest for oneness, and over the years his portfolio grew to include hundreds of portraits of her, photographs of her face, hands, feet, and torso—images conveying what he called "bits of universality in the shape of Woman."[12] Speaking in these terms, Stieglitz lost some of his earlier interest in distinguishing painting from photography. If all workers were sincere seekers, then their art, whether it be photographs, or paintings, or books, was also concerned with the universal flow. And so in the work of Constantin Brancusi, the Rumanian abstract sculptor who employed a radical economy of style, Stieglitz saw the expression of "an Absolute."[13]

As he brought these ideas to bear in his own photography, Stieglitz often concentrated on a particular chestnut tree at Lake George. Chestnuts truly are ubiquitous trees, growing throughout the northern hemisphere, and they are humble, too, sheltering the occasional village smithy but seldom becoming the stuff of a true cross. Over the years, though, Stieglitz lavished considerable attention on one tree, and some of the resulting images, such as *Dying Chestnut Tree* (1919; fig. 4.1), are dramatic compositions. This is more of an abstract shape than a conventional rendition, and at first glance one might not recognize this as a tree; the image's representational weight depends in part upon the caption which tells us what we are seeing. With the three branches rising up from a "palm" of a trunk, the tree looks something like a hand, and as such suggests some of the universality to be found within nature's forms. Photographed from below, dark and sharp against the background, the image here demonstrates Stieglitz's concern for isolating his subjects so that the tree hovers apart from its surroundings.

Just as Stieglitz's straight image raised this chestnut out of obscurity, details about the tree helped infuse it with personal significance. It was one of the cherished subjects depicted in his father's paintings, and Stieglitz came to regard it and other Lake George chestnuts as a particularly charged patrimony. By this time in the twentieth century, American chestnuts were beset by a blight that wiped out whole forests, and like so many others, this tree was a dying chestnut, marked by that romantic wistfulness which regards death as both a sad event and a possible bridge to transcendent realms. Over the next few years he continued in this artistic sounding of the chestnut's spiritual depths, photographing the tree repeatedly, and all the while "wondering how can I get the It down."[14] Eventually Stieglitz believed that had managed the job, and he offered his 1924 exhibition as a series of "Secrets…revealed by my Camera," images offering "direct revelations"[15] of mysteries that he found in trees and other subjects.

Intuition rather than intellect seemed the better source for such insights. Never one for precise analysis, Stieglitz virtually fled from rigorous thought during the 1920s; emotion seemed the far superior conduit to truth, so that in the fall of 1923 he said that "I just *feel*—& let that do my 'thinking.'"[16] Stieglitz's reading tended to confirm this orientation, and he was drawn to a far-flung set of 1920s' discussions that emphasized humans' instinctual or unconscious dimensions over

4.1. Alfred Stieglitz. *Dying Chestnut Tree, 1919*, Alfred Stieglitz Collection,
© 2000 Board of Trustees, National Gallery of Art, Washington.

their rational consciousnesses. A contemporary novel like D. H. Lawrence's *Lady Chatterley's Lover* (1928) was attractive with its mixture of mysticism, sexuality, and scandal, and Carl Jung's *Psychological Types* (1921, tr. 1923) appealed less for the schematics of introversion and extroversion and more for the underlying themes of the collective unconscious.[17] A more significant portion of Stieglitz's reading was steeped in poetic and mystical idealism which resonated with an earlier

romanticism. The complex visionary poetry of William Blake was a favorite, and Stieglitz also responded to the work of German-Estonian mystic Hermann Keyserling, whose *The Travel Diary of a Philosopher* (1919, tr. 1925) circulated widely among Americans inclined toward the occult and Theosophy. Finally, Stieglitz continued to read Goethe, perhaps even more than he had as a youth.

Yet for all this, Stieglitz voiced his respect for the physical domain, and held that spiritual elements required their material complements. "Photography," he said at one point, "does need 'Two,'" and he thought that the good photograph was a coupling of spirit and matter.[18] But matter also got transformed in the process, for Stieglitz described photography as a kind of latter-day alchemy, and regarded the photographer as someone who precipitates the ideas out of matter, or, in another way of putting it, the photographer was one who interprets facts about the physical world into ideas for the mind. Waldo Frank came to believe this also, and in a hagiographic 1926 essay, described Stieglitz as "a thaumaturgist" (miracle worker) who "brought the wonder and the glory of the world...into the minds of men."[19] Elsewhere Frank described this process as the "creative collation and interpretation of fact into truth," and Stieglitz quickly agreed with him.[20]

Once contained or re-presented in some sort of creative piece, the original subject is obviously transformed and distinct from its original self. Yet such distinctions are not always so clear when it comes to photography, and in looking at a photograph of Paula, we sometimes slip into saying "This is Paula." Of course, though, the photograph is not Paula; she is a living, breathing person, while the photograph is a set of shades on a piece of paper. Stieglitz explicitly made this point about one of his 1922 Lake George photographs, *Apples and Gable* (fig. 4.2). "That—what you see—is not an apple tree nor raindrops nor a barn," Stieglitz told his viewers. Instead, he said that the image is a set of "shapes in relationship, the imagination playing within the surface."[21] The photograph certainly owes something to material things beyond itself, and Stieglitz could not have made this particular image without a set of physical circumstances—apple, gable, raindrops—that came together one day at Lake George. But the shapes on that paper are also the product of the photographer's imaginative vision and his work with chemicals, light, and lenses.

The phenomenologist Maurice Merleau-Ponty once said that "inspiration" correctly describes artistic creativity, for, in "a mystery of passivity" the breath of life passes from subject to artist.[22] But that passivity was *not* how Stieglitz or his friends regarded the best of photography; they thought of good photography as active, what Frank called "a powerful man's control of...the material apprehended by his mind."[23] During these years Stieglitz continued to voice his allegiance to straight photography, but he increasingly described it as the means through which he achieved this sort of mental control over his material. Yes, Stieglitz allowed, straight images were clear and sharp, outlining many physical qualities of his subjects. But he chose to emphasize the relative lack of physical operations in the making of his straight photographs: "my negatives are perfect...untouched," he said, and his prints likewise had "no manipulation."[24] Since there was so little physical work involved in these images, it seemed logical, at least for Stieglitz, to regard them as the products of largely mental work, and so he described his growing pile of O'Keeffe portraits as "mentally digested bits."[25] These were traces of

O'Keeffe's body, and with his intellectual processing he had turned the outer reality into what seemed to him the greater reality: *Stieglitz's* O'Keeffe, his rendition of womanhood, and whatever larger universalities (perhaps symmetry? perhaps fecundity?) he might have seen in the female form.

In many ways, that processing was what Stieglitz's photographs of the 1920s were "about." The vital play of lush details within his prints won him the admiration of contemporaries like Sherwood Anderson and William Carlos Williams, novelists and poets who likewise strove to bring the world's quotidian elements into their creative works. These writers were reacting against Victorian inclinations toward the metaphor, against the habit of loading women or apples with the weighty symbolic associations of "temptation" or "sin." But it is mistaken to see too much autonomy for the subjects of Stieglitz's straight photography,[26] for although the subjects were respected in this work, the larger significance was not so much the clearly-delineated apples, as it was what Stieglitz did with the apples. As Miles Orvell has indicated, for Stieglitz, Williams and others, the topic was not so much the things represented—the things signified—as it was the process of signification, processes of art work and the artistic apprehension.[27] To cast this in parts of speech, the art here was less about nouns than about verbs, and Stieglitz's photography was less about the things he had photographed, and more about the fusing, the seeing, and the other preternatural activities which he believed occurred when he made photographs.

In Stieglitz's photographs of women, especially the nudes, and in his relationships with O'Keeffe and the other women who modeled for him, we can see much of the complex combination of idea and impulse that inspired his photography of the late teens and 1920s. When photographing women's bodies, Stieglitz exercised his fascination with abstract, modernist images, and yet in those same bodies he saw some of the romantic content against which modernism had rebelled. With his nude work Stieglitz took his place in a long and often misogynistic art-historical tradition, and simultaneously evinced his own particular need to dominate his subjects. Finally, there was a frankly libidinous dimension to Stieglitz's new photography.

Earlier, when Stieglitz was much less productive, the painter Francis Picabia had caricatured him as impotent, a broken machine/camera with its bellows in the posture of a flaccid penis. The caricature had been a fitting one in the years around World War I, when Stieglitz's marriage failed and his work lagged. But the image was less appropriate after 1918, once his photography became invigorated and once O'Keeffe entered his life. Just as Picabia saw a connection between sex and art in Stieglitz's earlier photography, Lewis Mumford found much the same linkage in the artistic explosion of the late teens and into the 1920s: "It was his manly sense of realities of sex, developing out of his own renewed ecstasy in love," that accounted for a large portion of Stieglitz's photography in the postwar years.[28]

Sexuality and the female body were themes that had been foreshadowed in Stieglitz's earlier life. As a student in Europe, he had found in Reubens not only a compositional model, but also a celebration, as Mumford said, of "the health, the animal vitality, the unashamed lushness of sex."[29] Later, when Stieglitz began to photograph, he made images of women that lingered upon their bodies and spoke of the photographer's sexual access to them, whether the pictures-within-the-pic-

4.2. Alfred Stieglitz. *Apples and Gable, 1922,* by permission of The Georgia O'Keeffe Foundation. Courtesy of George Eastman House; purchase from Georgia O'Keeffe.

ture of *Paula* (1889; fig. 2.1) or the hat-as-marker of *Emmy Obermeyer, Tea Island* (1893).[30] Still later, in 1907, Stieglitz collaborated with fellow photographer Clarence White to produce several soft-focus studies of the nude Miss Thompson.

But images such as *Georgia O'Keeffe [Torso]* (1919; fig. 4.3) were a major departure for Stieglitz. The forthright nudity in these photographs far surpassed that of his earlier work, for now his straight renditions allowed less of the fuzziness that

obscured or softened the bodies in the 1907 pictorial nudes. Images like this torso are also more obviously and openly sexual than his earlier work. *Paula* and *Emmy* tell their stories by quiet innuendo, whereas there is little sexual subtlety to images such as this one; and the veil of artiness covering the earlier nudes becomes much thinner in the O'Keeffe nudes—and at times drops altogether. Conventions of drapery and modest posing gave way to the artist's expression of delight in his subject, and in *Torso* there is a kind of proud and athletic sexuality in the taut thighs and abdomen, the breast accentuation of the upstretched arms, and the openly presented pubic hair. Rather than claiming aesthetic significance through the repetition of iconographic custom, these images convey a certain seriousness as they testify to the artist's willingness to linger over a beloved subject. And as the growing number of images indicated, Stieglitz lingered often.[31]

He lingered closely, too. There are only a few full-length nudes of O'Keeffe, and even with the missing head and legs, *Torso* is one of the fuller treatments. Stieglitz more frequently chose to make details of breasts, or thighs, or buttocks, as well as less-eroticized treatments of O'Keeffe's neck or her hands. These close-ups facilitated modernist expression, for as Paul Strand had demonstrated, decontextualization can accentuate abstract shape and line. But there was also another goal in making all these separate and discrete images—Stieglitz's project of getting down some of those "bits of universality in the shape of Woman."[32]

The project was not entirely a new one. Earlier in the century Stieglitz had made that adoring photographic diary of his daughter, Kitty, a series intended not as an exhaustive treatment of her every minute, but rather as a series that reached toward the continuities amidst the many varied moments of Kitty's life. Likewise, Stieglitz was now interested in making separate entries in his catalogue of Woman, rather than in fashioning some eventual mosaic composite from the entries. There was to be no single *O'Keeffe* complied from the various bits and pieces of O'Keeffe; and while he made partial images of still other women (Helen Freeman's feet, Katherine Dudley's legs, etc.), Stieglitz did not intend to take a leg here and a breast there, and then paste together the ideal woman. Instead, he hoped to reach the ideal through the individual (or the individual part), and not by adding up pieces of individuals into one ideal whole—a program that distinguished Stieglitz from his contemporary Charles Dana Gibson and the Gibson Girl project.[33] For Stieglitz, the universalities presented themselves to us in bits.

If Stieglitz had his preferences among women, he also had his preferences among the parts of women's bodies. Hands were among his most favored features (fig 4.4, *Georgia O'Keeffe: A Portrait—Hands* [1918]). O'Keeffe's hands seem to have fascinated Stieglitz almost from the very beginning of their relationship, and this image is an early product of that beguilement. The photo keenly illustrates the medium's ability to crop and select, a disembodiment that enhances the etherealness of these hands that seem to float in space, particularly in this rather poorly focused and seldom reproduced image from the collections of the George Eastman House. In their pose, too, the hands seem to have lost O'Keeffe, for they look almost like clay figures that Stieglitz first molded and then arranged to his satisfaction. The generic shape here was one of Stieglitz's favorites, a central-mass-and-branches that he found repeatedly in subjects such as chestnut trees.

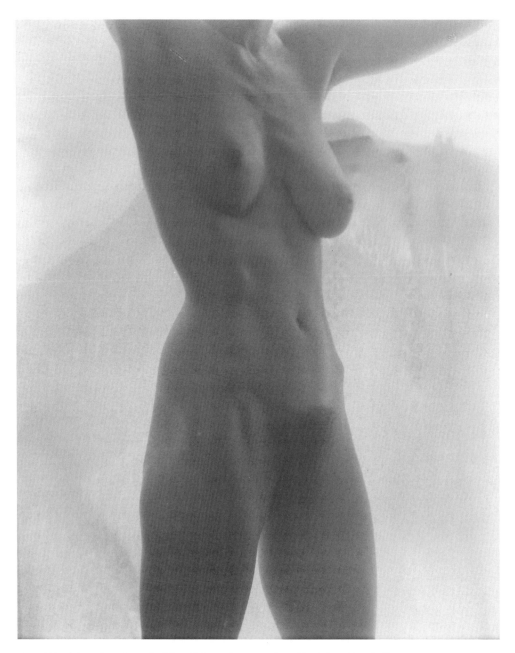

4.3. Alfred Stieglitz. *Georgia O'Keeffe [Torso], 1919,* The Alfred Stieglitz Collection, 1949.761.
Photograph © 2000, The Art Institute of Chicago. All rights reserved.
Photography courtesy of The Art Institute of Chicago.

But these hands were full of meaning as well as shape, for they were a *painter's* hands, representing Stieglitz's oft-repeated emphasis on the connection between "work" and creativity.

But for all the opportunities Stieglitz had over the years, he appears not to have made such a close-up of O'Keeffe's hands while they were busy with the brushes or other tools of her work. As with any two people, the relationship between O'Keeffe

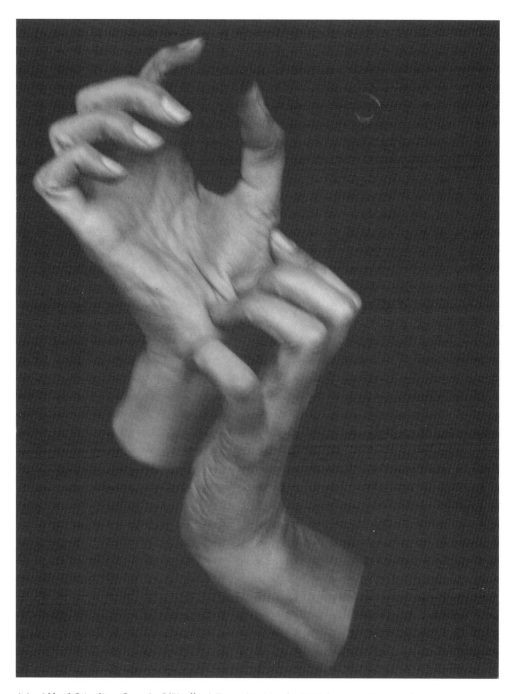

4.4. Alfred Stieglitz. *Georgia O'Keeffe: A Portrait—Hands, 1918,* by permission of The Georgia O'Keeffe Foundation. Courtesy of George Eastman House; purchase from Georgia O'Keeffe.

and Stieglitz involved issues of power and the inequity of power. These were played out in many of his photographs of her, and in the various dimensions of their relationship: artist-artist, mentor-novice, and artist-model. As the relative levels of power ebbed and flowed between them, one constant remained—Stieglitz believed that the bulk of it ought to be his. This primacy was his by right, Stieglitz thought, not only because he was the male, but also because he had "discovered" and promoted her. One of Stieglitz's nieces neatly expressed this portion of Stieglitz's attitude toward O'Keeffe, saying that he envisioned himself as Pygmalion, and O'Keeffe as his Galatea—a creation that he had brought to life.[34]

Stieglitz believed that he had awakened O'Keeffe artistically and sexually, something he emphasized in early photographs of her. When Stieglitz first presented his images of O'Keeffe, he showed her not as the cool and commanding producer of paintings, but instead as a lush and languid nude posed before those very paintings. Thus for some of its early views of O'Keeffe's art, the American public had to peer beyond Stieglitz's sensuous depictions of her body, visual arrangements metaphorically repeating Stieglitz's notion that his lover's creative work followed her body's lead. Moreover, these images seemed clear evidence of an intimate relationship between O'Keeffe and Stieglitz, and so enhanced the aura of his own potency by demonstrating that his lover was not only a young and sensuous woman, but also an artist—something of considerable significance for this man whose associates were mostly male and predominantly artists and intellectuals.

The record does not tell us if Stieglitz exercised any bragging rights he might have felt were his. But it is clear that these O'Keeffe nudes had a good deal to do with his needs for power and domination. Operating within Western patriarchy and its traditionally structured imbalance between the sexes, Stieglitz participated in a set of conventions placing men in dominant positions over women. Laura Mulvey and Ann Kaplan have shown a visual or iconographic dimension to this imbalance, arguing that the instinctual erotic pleasure of viewing a desirable person/object ("scopophilia" in Freud's terminology) has been transformed into a male gaze which has found repeated expression in Western visual arts. In this gaze men are active and women passive, and the male view possesses a female object which can return the gaze but is unable to act upon it.[35] Transfixed like deer in the headlights, women illuminated by the male gaze can merely stare back, while the definitions (willing partner, bad girl, etc.) flow strictly from the male view. Western art repeats many of these conventions—the woman as open, vulnerable, and unprotected—and the O'Keeffe portraits often reify them. In a good number of the nudes, O'Keeffe lies prone, while the photographer/viewer hovers above her nude or semi-nude form. At other times, it is literally impossible for O'Keeffe to meet, much less return, the gaze, for in images like *Torso*, her head is cropped completely out of the frame.

Fraught with sexual impulses, this earthy gaze seems quite different from the transcendental vision that Stieglitz so often claimed as his goal. But in fact there was much in common between the two, and Stieglitz's spiritual seeing closely resembled the controlling male gaze. With his determination to get below the surface of objects and to reach their very center Stieglitz employed a vocabulary of power with the explicit sexual connotations of probing and penetrating. Moreover,

there was in Stieglitz's discussions a strong sense of artistic control, in which the photographer's vision enables him to produce an image deriving more from his ideas than from the subject's qualities. His photographs of O'Keeffe, and especially those of her posed before her paintings, work to dominate both the woman and her art, and as with his images of apples, the final photograph was largely a product of his vision—or fantasy. Her art work, once appropriated into his photograph or exhibitions, likewise became his to claim as well as hers. Moreover, Stieglitz tried to exercise actual control over O'Keeffe's career for a number of years. By encouraging a particular critical consensus, he formed the public perception of her; with his scheduling of her exhibitions and the selection of works for those shows, Stieglitz exercised an editorial direction of her work; and by moving her back and forth between his New York and his Lake George, he circumscribed the visual material she encountered.

The evolving portrait gradually reflected other developments, for the locus of power in this relationship slowly shifted towards O'Keeffe. In some ways this shift was a simple matter of age, for she was considerably younger than he and maintained her vitality as his faded. Moreover, after the mid-1920s, O'Keeffe was a critical and financial success, and the family breadwinner. Likewise, while she continued modeling for Stieglitz, the photographs of her changed markedly over the years; the faceless nudes of the late teens and early 1920s faded away and more of the images became clothed portraits featuring her face. The clothing, of course, was O'Keeffe's, items that she chose to wear. But the face was also hers. Particularly weighted with qualities belonging to the person photographed rather than to the photographer, the face is much more resistant to the seer or gazer than are the breasts or buttocks; visually, one's face is more one's own than are other body parts.

In the early period of their life together, Stieglitz's photographs of O'Keeffe's hands were, like the nudes, frequently characterizations of Stieglitz's vision. As in figure 4.4, they were often isolated from surroundings, or when he actually showed O'Keeffe's hands doing something, they were not seen painting, but busy with the traditional woman's work of sewing. Yet like the nudes, such hands were but a phase in the multi-image *Portrait*, emerging between 1918 and 1921, and then passing. Once O'Keeffe's career began to take off, the hands disappeared, only to reemerge later in a much different expression. In photographs from the 1930s, O'Keeffe's hands appear along with props that were positively *hers*, things over which Stieglitz could make no claim: a sun-bleached skull from the Southwest that Stieglitz never visited but which inspired O'Keeffe to an imagery that had little to do with his New York or Lake George; or the wheel of a powerful V-8 automobile, that O'Keeffe easily piloted but which was completely beyond Stieglitz—who never learned to drive.

Alfred Stieglitz was hardly alone in bringing a charged eroticism to his art. Virility and domination were significant themes throughout early twentieth-century vanguard art, and Stieglitz's photographs echo the images of painters such as Matisse or the Fauves who also depicted faceless nudes with well-delineated breasts or buttocks.[36] Other American photographers created in a similar mode, and Edward Weston developed an aesthetic that arose from the loins as well as the heart. Members of Stieglitz's New York circle also believed that aesthetic and sexual plea-

sures were closely connected, and Paul Rosenfeld praised Stieglitz's nudes of O'Keeffe because they were "intimate, intense," flowing with "subterranean streams."[37] Along with Rosenfeld, Matisse, and others, Stieglitz held a common conception of the avant garde artist as both a heroic and lusty creator, a figure whose instincts and intuitions subdued older visual styles—and perhaps his models, too.

For Stieglitz and his friends, this was a polymorphous sexuality. Although they most often extolled (and appropriated) the female form, theirs could also be a Whitman-like celebration of sex that escaped the bounds of convention. Sherwood Anderson was a member of Stieglitz's circle who believed that American culture was in peril, and thought that Stieglitz offered the country a form of sexual reclamation. In a 1922 article, Anderson sang the praises of what "one thinks of as maleness" which was, he thought, on the wane in an America succumbing to the "impotence that is the natural result of long illness." Yet Anderson believed there was still hope because Stieglitz was just what the nation needed, "a lover of life and a lover of men," with an aesthetic that had become all too rare in contemporary times, the "old male love of good work well done." In this way Anderson described Stieglitz as something of a sexual savior, redeeming the country through an infusion of the supposed manliness of his work.[38]

If Anderson interpreted Stieglitz sexually, Stieglitz returned the favor. A month or so before the article went to press, Stieglitz received a draft just as he was about to take a swim in Lake George. As he told Anderson, Stieglitz read it while resting beside the lake, "Alone. Au naturel. The water & I—& the sun.—And what you had written." There, naked in the clear sunlight, Stieglitz had a peculiar narcissistic moment as he saw himself mirrored and praised in the words of his friend.[39] During these master days Stieglitz's world was charged with energies ranging from the spiritual to the sexual, a domain where the differences between those energies was often unclear, and where the erotic boundaries, no less than the metaphysical ones, could become blurry.

Horses were by far Stieglitz's favorite animals, and he was drawn to them because of their vitality, their power, and their open sexuality. One of his greatest thrills was to see the stallion Man o' War race at Saratoga, and he collected people who shared these interests, such as Anderson, whose 1923 book *Horses and Men* was laced with equine themes, or Rebecca Salsbury Strand, whose father had organized Buffalo Bill's Wild West Show. Lewis Mumford was another who, in an essay about Stieglitz, explained that his friend saw the horse, especially the thoroughbred, as a "symbol of sheer animal vitality."[40] Stieglitz's interest was not solely symbolic, though, for by his own account equine sexuality was a powerful magnet for him. In Paris some fifteen years earlier he had once seen teams of black stallions in a scene so impressive that he still remembered in the 1920s. "The horses stood throbbing, pulsating," Stieglitz said, "their penises swaying half erect—swaying—shining." Then, as at other times, Stieglitz's art and his scopophilia were intermingled: "I stood transfixed, wishing I had a camera."[41]

Though the sexual boundaries were hazy, Stieglitz's eroticism was largely human and heterosexual. Yet here, too, circumstances were often indefinite, for the focus of Stieglitz's desire shifted quickly from one aspect to another. Now it settled upon a woman who might be his model, now upon the photograph of that woman,

and now upon the act of photographing that woman. For Stieglitz, sex act and art act were at times intertwined, and there was some truth within the hyperbole of his claim that "when I make a picture I make love."[42] Successful photography, he said, was a product of "ardor," and an imperfect photograph, one that did not reach great enough lengths, was for Stieglitz "like an incomplete erection—a sort of 7/8— I know the difference!"[43]

As we might expect from one whose appetites were so encompassing, Stieglitz did not remain photographically loyal to O'Keeffe (nor sexually loyal, for that matter). Two women stand out among his other models: Georgia Engelhard and Rebecca Salsbury Strand. In the summer of 1922 and (probably) the following summer, these women posed for some of Stieglitz's most explicit nudes. Engelhard, his teen-age niece, at first posed for what are sometimes rather matter-of-fact photos of a person who happens to be naked; in one photo Engelhard stands calmly in ankle-deep water and makes no effort to hide a decidedly uncomely appendectomy scar. But at other times Stieglitz created more polished images that bore a full erotic charge. Consider *Georgia Engelhard* (1922; fig. 4.5), a carefully-composed photograph in which the body traces the axis between two opposing corners, and the left arm, in a pose otherwise reminiscent of Manet's *Olympia*, obscures the surgical scar. Resting on a cloth (Stieglitz's cape?), Engelhard is not only before the photographer, she lies vulnerably below him. Reclining on her right hip, the model is also open to the camera, with her thighs partially spread and with a welcoming smile coaxed onto her face. Her torso has been angled so that the breasts point squarely at the photographer, and unlike the partially shaded face, both crotch and breasts are exposed in brilliant sunlight. This full-frontal nude has a kinship with any number of pornographic images, the subject in this photo having less to do with the complexities of young Engelhard's person, and more with male fantasies of sexual access and aging men's desires for youthfulness.

There is power, even exploitation, at play in this image of a sixteen-year-old, though the smile may function to disguise some of its presence. But power was what Stieglitz exercised in making such photographs of his niece, and we have an unmistakable example of it in still another photograph. For this better-known image (fig. 4.6), Stieglitz posed Engelhard in the open window of a cottage, nude and clutching a double armful of apples just below her breasts. There are many things to be read from this image, and one of the clearest is a story of triumph over ancient fear: The combination of apple and naked female is a familiar symbol of male sexual terror, but in this image any danger is neatly and obviously contained by doubly boxing the Eve-figure, first in a window frame and then within the camera's frame. Even more than this, Stieglitz's male vision braced this woman in a painful and awkward pose, one he then tyrannized her into holding. The intensity of that moment was still with Engelhard her some twenty years later, and she remembered that "when I became cramped and tried to shift my position, or when I wriggled because a fly was slowly parading down my face, he would roar at me until I was ready to weep with rage and discomfort."[44] The bullying continued for over an hour in order to satisfy the compulsiveness of Stieglitz's temperament, his desire for just the right composition, and the slowness of his photographic materials.

4.5. Alfred Stieglitz. *Georgia Engelhard, 1922*, Alfred Stieglitz Collection,
© 2000 Board of Trustees, National Gallery of Art, Washington.

Someone called a halt to such sessions. Perhaps it was Engelhard herself, perhaps her parents, or perhaps the incestuous and abusive aspects of the photography simply became too much for all to bear. At any rate, Stieglitz turned to another nude model, Rebecca ("Beck") Salsbury Strand, the thirty-one-year-old wife of Stieglitz's protégé, Paul Strand. Nearly twice Georgia Engelhard's age, Rebecca Strand also had a personality better suited for parrying Stieglitz's demands. An intelligent and gregarious woman who preferred trousers to skirts, Strand was an uninhibited individual given to nude sunbathing and spontaneous yodeling. Strand's work with Stieglitz involved greater artist-model collaboration than the Engelhard portraits, but still the photographs carry more of his imprint than hers.

Stieglitz once told Waldo Frank that "I'm hypersensitive about Woman & Breast,"[45] and he was at times quite open in the photographic expression of this fixation. In 1922, for instance, Stieglitz photographed Georgia Engelhard as her breasts were about to spill out of her loose dress, and posed Claudia O'Keeffe nude with an African mask clasped over her right breast. More dramatic though, was a 1923 nude of Rebecca Strand lying half-immersed in water, her torso occupying the full frame, her flesh goose-bumpy and her nipples erect from the chill (fig. 4.7). With one hand she cups and lifts the breast from just below the nipple, seeming to offer it to the photographer and his camera. (This print from George

74

4.6. Alfred Stieglitz. *Portrait [Georgia Engelhard], 1922*, The Alfred Stieglitz Collection, 1949.716.
Photograph © 2000, The Art Institute of Chicago. All rights reserved.
Photography courtesy of The Art Institute of Chicago.

Eastman House is unique; unlike his other renditions, Stieglitz here reversed his negative before printing.) In other images Stieglitz repeated some version of this pose: here an open-bloused Georgia O'Keeffe proffers both breasts, there Georgia Engelhard holds her right nipple in display, and in still another instance Rebecca Strand stands in the water and lifts both breasts towards the camera. Such poses were repeated too often to have been spontaneous, and in one 1923 image, Strand

holds her breast and stares back at the camera in close concentration, the look on her face asking Stieglitz, "Am I getting this pose as you want it?"[46]

Two streams of interpretation flow from these directed images. In one, Stieglitz has configured the women as available and willing, literally offering themselves to him. Alternatively, this proffered-breast pose echoes a nursing posture, a posture in which the offer is more of nurture rather than sex, and Stieglitz's breast images may have involved a good deal of sublimation. Karen Horney and subsequent psychoanalytically inclined critics have argued that fetishism can be a way to neutralize fears,[47] and events of the 1920s certainly added an element of terror to Stieglitz's notions of motherhood. It may well be that his breast photographs, composed at almost exactly the same time, were a response to those threats, and in some ways an effort to redeem his own vision of the sheltering mother.

His mother, Hedwig Stieglitz, suffered a serious stroke in 1920. The onset of her illness was a harsh blow for Alfred, and he anguished until she died late in 1922. The next year brought an even more calamitous shock. Shortly after giving birth to her only child, Stieglitz's daughter Kitty experienced a postpartum depression so severe that she never recovered and remained institutionalized with mental illness for the rest of her life. The news, which Stieglitz called "the ghastliest I ever received," left him devastated.[48] About a month after Kitty's collapse, he wrote to Sherwood Anderson, circling, but not quite confronting, the "great source of Worry" that had beset him, a sadness "connected with woman—love—my own flesh & blood...."[49] Three years later Stieglitz was still struggling to come to terms with these two tragedies, a process that led him to interpret a photograph he made during that awful time. Stieglitz agreed with a viewer who found a good deal of mystery and sorrow in figure 4.2, his image of rain-splattered apples photographed against a windowed gable. "Perhaps the raindrops are tears," Stieglitz wrote. "And perhaps that dark entrance that seems to you mysterious is the womb, the place whence we came and where we desire when we are tired and unhappy to return...That is what men desire, and thinking and feeling and working in my way I have discovered this for myself."[50]

Exploring the womb, illuminating the female body with his camera, this was one of Stieglitz's major projects during the early 1920s. Eventually, though, the effort collapsed, and in large part because of the orientation that Stieglitz brought to it. In one howlingly sexist (even for Stieglitz) passage, he said that "Woman receives the World through her Womb. That is the seat of her deepest feeling. Mind comes second."[51] A tractable, nurturing, and rather mindless being—this was the subject of Stieglitz's fantasy photography. But the real women around him were not so pliable as he may have wished, and they came and went, died or became insane in their own good time. O'Keeffe's career steadily led her beyond his prospect, Strand turned away from skinny dipping and toward molding her own identity, and Engelhard shaped a maturity of her own design rather than Uncle Alfred's vision of Woman. By 1924 or so, the number of Stieglitz's nudes fell off sharply, and the obvious erotic elements faded from his photography. But, still striving to achieve union and to exercise his will, Stieglitz turned his camera upon subjects much less substantial than O'Keeffe, Strand, or Engelhard.

4.7. Alfred Stieglitz. *Rebecca Strand, 1923*, by permission of The Georgia O'Keeffe Foundation. Courtesy of George Eastman House. Purchase from Georgia O'Keeffe.

Late in the fall of 1923 Stieglitz complained that "my photography of late is like a lame duck—I don't seem able to entirely connect."[52] But within five days all this had changed. A terrific storm dumped mounds of snow at Lake George, and Stieglitz told Sherwood Anderson he was now "photographing like [one] possessed."

Tinged with the odd passion that the snowfall had evoked, Stieglitz's letter to Anderson is an ecstatic catalogue of delights. Lake George abounded with an entrancing glory and purity: "Beauty everywhere—Nothing but Beauty," Stieglitz wrote, "& soft & clean." The landscape was full of shapes that caught the modernist eye—"maddening shapes—the whole world in them"— and the hues seemed made to match a photographer's palette: "White—White—White." For someone who so often sought significance in the quotidian, the storm illustrated the extraordinary mystery to be found within the ordinary: "I'll never forget the barns that I saw in the moonlight. Talk about the Sphinx & pyramids—there was that barn—nothing could be grander—The austere dignity of it." Finally, too, the snow scene seemed to yield the sort of unity Stieglitz desired, a communion between artist and surroundings, between Stieglitz and that barn, "as if it could have understood me if I had spoken to it."[53] The 1923 snow pictures are a hitherto unrecognized milestone in Stieglitz's career, marking both the point at which he discerned an unrealized potential in landscape, and also the point at which his gaze turned away from the women around him.

Stieglitz's scenery work took place largely at Lake George. An established, urbane resort, Lake George was no wilderness; and Stieglitz with all of his hypochondria was not about to pursue the rugged backpacking of a youthful Ansel Adams. Nor was he much interested in what we usually think of as landscapes. During these years Stieglitz was more often fascinated by the arch of the sky than the lay of the land, and he most often trained his camera upon the wonders of the heavens. At one time the skies put on a Wagnerian display "more intoxicating than a fine performance of Tristan or Meistersinger," an opera that seemed full of sexual power, "a wild force spending its passion."[54]

The sky, and particularly clouds, became *his* topic. These pictures were almost a signature of his later career, and he created many of them. Stieglitz had photographed clouds as a student in Europe and his earlier images of aircraft contained background clouds; but now as the nude began to elude him, he was, as he said, "never so ready to look."[55] He started working with these subjects in the summer of 1922, and at first quietly displayed his images in April 1923: "Clouds" were in the middle of the show list and "Women" at its head. By that fall, though, clouds had become a much greater concern for Stieglitz and he photographed them madly. Writing to Sherwood Anderson, he said that "after many days of passionate working—Clouding!—I stopped. I had to catch my breath."[56] By the following spring, Stieglitz was ready to turn his third exhibition into a showcase for these photos, and uncharacteristically assigned a title to one of his shows: "Songs of the Sky." There were indeed "Other Prints" on display—O'Keeffe portraits and snow photographs—but of the sixty-one images in the exhibition, forty-four of them were "Songs." Stieglitz had publicly and unmistakably claimed a new subject.

Taking stock of this new work, Stieglitz offered an explanation of "How I came to Photograph Clouds." First, Stieglitz indicated that he had turned to these heavenly subjects when the earthly world offered up only tragedies such as the death of his mother. Next Stieglitz said that he had taken up clouds in response to Waldo Frank's assertion that Stieglitz's photos were powerful simply because he had privileged access to compelling subjects such as the bodies of Georgia O'Keeffe and Rebecca Strand. But Stieglitz contended that it was *his* talent, not arresting material like the nude, that made an image powerful, and so he had photographed clouds in order "to show that my photographs were not due to subject matter." After all, "clouds were there for everyone," and it was Stieglitz's contribution that made the images masterful.[57]

Stieglitz eventually settled upon the word "Equivalent" for his cloud pictures, and he used it routinely after 1925. His antecedents for the term are murky, but in part Stieglitz drew from earlier ideas of French symbolism and German romanticism. Also, some of the qualities in his notion of the Equivalent resemble the intensity and ineffability of the self/subject relationship that Martin Buber described in 1923 as the "I and Thou" tandem.[58] But whatever Stieglitz's sources, the correlation that he intended with each of his Equivalents varied considerably, so that he might say that a given photograph was the equivalent of anything from Stieglitz's momentary inner state to his enduring "vision of life,"[59] and by the 1930s he even referred to some non-cloud photographs as Equivalents. But there was

some consistency within this, for with his Equivalents Stieglitz continued in his effort to erase the line between the mental realm and the physical one, and he usually said that the physical prints he produced were in some manner the equivalent of his psychological or spiritual state.

The metaphysics of all this were not particularly sound or profound. But the Equivalents were a cunning if seldom successful effort to enhance the power of Stieglitz's photography. Since inner and outer were the same, and since Stieglitz was (he believed) the master of his own soul, then by implication his mastery extended to the print and even to the worldly stuff that had been his subject for the photograph. Picking an Equivalent for discussion involves a necessary arbitrariness; there are so many and so many different ones, that it is virtually impossible to say that any one is a "typical" Equivalent. Still, though, *Equivalent* (1925; fig. 4.8) can serve as something of an example.

In a photograph such as this, Stieglitz achieved a slyly ambiguous play upon time. On the one hand, the evanescence of some willowy clouds is arrested here. Such clouds must be among of the most fleeting of things—even a human smile can be posed for some moments—but here Stieglitz has held a virtually ungraspable thing and produced a tangible print of an almost intangible subject.[60] On the other hand, the cloud images are also timeless in the sense that by themselves they are impossible to date, there is nothing in this Equivalent that inherently associates it with 1925 (or 1952, or even 1592 for that matter).

Lewis Mumford was usually an astute observer. But at times Mumford simply missed the mark, as when he said that Stieglitz's Equivalents were full of the same proud erotic content as his nudes.[61] Given Stieglitz's considerable libido, it is impossible to say that there was not some sort of sexual dimension in his cloud photography; but in the larger sense, Stieglitz's transition from nudes to clouds reflected a broader assessment in American culture of the 1920s. Stretching from Fitzgerald's Jay Gatsby to Hemingway's Jake Barnes, to the protagonists of lesser-known novelists like Waldo Frank and Nathan Asch, there were frequent reports that love and sex had become problematic. In Stieglitz's case, it is fair to say that his clouds crowded out his nudes, that Eros gave way to the Equivalents, and that the artist strove more for transcendence than for climax. Georgia O'Keeffe certainly thought so. Writing in 1924, the year Stieglitz made most of his last nudes of her, she described his new work as "way off the earth."[62]

For Stieglitz, recognition was an important part of mastery, and many of his efforts of the twenties were directed toward securing his place in art photography's historical canon. Some of his increased photographic output may have arisen from a desire to stake such a claim, and Stieglitz insured there was ample documentation of his efforts. He spent considerable time arranging the papers so assiduously accumulated during his career, and "worked like hell at the letter-files" that particularly seemed to establish his prominence in photography's history.[63] He also became concerned about the preservation and exhibition of his images, and in 1924 gave to the Boston Museum of Fine Arts a set of his prints, framed and mounted exactly as he desired, and accompanied by precise stipulations on their display.

4.8. Alfred Stieglitz. *Equivalent, 1925,* by permission of The Georgia O'Keeffe Foundation. Courtesy of George Eastman House. Purchase from Georgia O'Keeffe.

This was repute on his own terms, and part of Stieglitz's drive involved his younger generation of friends. People like Paul Strand were not only supposed to tend the flame of fine photography, they were also to let the world know that Stieglitz had been one of its prime kindlers. Stieglitz watched closely to make certain their writings acknowledged his place in the genealogy of photography, and fumed when Marsden Hartley, Waldo Frank, and Charles Sheeler each failed to give his story just as he thought it should be.[64] By a certain point he even had younger photographers policing each other's writings to make certain that Stieglitz had been properly credited, so that in 1928 Strand tattled to Stieglitz that Edward Weston's published diary excerpts failed to acknowledge "the time and more which you gave him."[65]

There was considerable paternalism in these relationships between Stieglitz and these younger friends of the 1920s, more so than there had been with de Zayas and Weber in the teens. He helped them out with expenses, bought their meals at restaurants, and offered plenty of (often unsolicited) fatherly advice. Stieglitz referred to them as his diligent children ("all my 'babies' are producing good work"[66]) and they responded in kind (Strand: "your babies haven't been loafing"[67]). These people esteemed Stieglitz, and the respect often flowed in both directions. During the 1920s Stieglitz made a number of portraits of the men in his circle, images that pay homage

to his friends' accomplishments. These works, though not nudes, echo some of Stieglitz's photography of women, and he apparently envisioned an O'Keeffe-like serial portrait of Anderson. But where the female face (and the subject's identity) is often obliterated in Stieglitz's photographs of women, the face usually dominates his pictures of men, appearing squarely before the camera with the sitter's stare comfortably meeting the photographer's peering intensity. Stieglitz plumbed the depths of his friends' eyes, searching for spirit in much the same way that he had earlier spoken of peering deeply into an egg. In one portrait, Stieglitz photographed Waldo Frank busily eating apples on Lake George porch. The metaphor is clumsy, but Stieglitz hoped to get to the core of Frank with this oft-reproduced portrait.

Although Stieglitz's photographs might obscure the creativity of a female painter like O'Keeffe, these portraits of men could accentuate their work. In one portrait, Rosenfeld sits at a desk surrounded by his writer's tools—notebook, paper, typewriter, and a packet of notes—while close by rests one of his own recent books. Stieglitz also included some indicators of Rosenfeld's intellectual milieu, arranging things so that Waldo Frank's *Our America* (1920) and Van Wyck Brooks' *The Ordeal of Mark Twain* (1920) also appear in the frame.

There was an important context to these books. During the 1920s writers like Frank and Rosenfeld drew upon Brooks and others, repeated challenges dating back to Emerson's time, and issued their own pleas for an independent American culture.[68] Stieglitz believed that this was an inspiring campaign. This man who had earlier been so loud in his praise of German culture, now found worth in American culture and called for its autonomy.[69] Stieglitz saw himself as a part of this broad exploration, and in 1923 told Hart Crane that "this country is upper most in my mind," and that he wanted to see "what it really signifies—what it is."[70] The project was decidedly ambitious (perhaps even futile—how can a nation signify?), but Stieglitz was confident that he could understand what in 1926 he called "the Consciousness of America."[71] He gathered around him individuals concerned with the peculiarity of American themes, replacing international figures like Marius de Zayas with a heartlandish Ohioan like Sherwood Anderson.[72] In the process, Stieglitz appropriated the term "American" for the places and people of his circle, referring to his gallery as "an American Room," and advertising the artists whom he exhibited as "Americans" ("Alfred Stieglitz Presents Seven Americans," read one brochure). In a mantra repeated throughout the twenties, Stieglitz grasped the American identity for himself, for his friends, and for O'Keeffe, insisting that "She *is* American. So is Marin. So am I,"[73] and announcing "I was born in Hoboken. I am an American."[74]

But this absorption with things American was to a large degree rhetorical. Stieglitz often reverted to his more typical deprecating descriptions of American culture as paranoidly democratic, perpetually materialistic, and hopelessly provincial. Thus, Stieglitz retained much of his habitual elitism during the 1920s, and if anything, his isolation intensified as the decade progressed. By 1929 he was forced to shut his American Room gallery, and found himself without a place to preach or exhibit.

The isolation was personal, too. Though Stiegiltz refused to join them, his friends actually did venture beyond New York and into America. At the same time the gallery closed, O'Keeffe left for an extended stay in New Mexico, soon to be

joined by Rebecca Strand and John Marin. Other events conspired so that Stieglitz's siblings were unable to join him for the customary summer vacation, and Stieglitz found himself alone at Lake George. Awash in self-pity, Stieglitz told Lewis Mumford, "this summer was a fiendish one. The Room gone.—O'Keeffe gone. I alone in Lake George the first time in 54 years!"[75] In his pain Stieglitz chased first one anodyne and then another: magazines, books, and music. But these were short-lived palliatives, followed by bouts of anguish during which his life seemed nothing but an empty disappointment. During one episode, Stieglitz built a huge bonfire that he fed with prints, negatives, and issues of *Camera Work*; the blaze lasted seven hours, and for a time, Stieglitz said, "the cameras came near going."[76]

Of course this was not the end of Stieglitz. O'Keeffe eventually returned to New York, Stieglitz made plenty of photographs during the next decade and a half, and the occasional new acolyte continued to come his way. But still the summer of 1929 demonstrated that the goals of his master years were ultimately elusive. Alfred Stieglitz had sought a spiritual art of both connectedness and dominion, only to find himself unproductive, alone, and in a terrible funk.

1. AS to PS, October 25, 1919, PSC\CCP. Alfred Stieglitz, "A Statement," in *An Exhibition of Photography by Alfred Stieglitz* (New York: Anderson Galleries, 1921), np.
2. Waldo Frank to AS, April 14, 1920, ASA/YCAL.
3. AS to PS, May 9, 1919, PSA/CCP. AS to PS, June 8, 1919, PSA/CCP. AS to RSS, July 6, 1923, ASA/YCAL.
4. AS to Waldo Frank, July 3, 1920, ASA/YCAL.
5. Stieglitz's bounteousness seems to substantiate the old chestnut that artists, particularly visual artists, are often most prolific during their mature years. Certainly this seems the case for our other American art photographers, for Paul Strand, Edward Weston, and Ansel Adams were all exponentially more productive in their later working years.
6. For more on these distinctions between Stieglitz and modernism, see Joel Smith, "How Stieglitz Came to Photograph Cityscapes," *History of Photography* 20 (Winter 1996), 324.
7. Alfred Stieglitz, "The First Great 'Clinic to Revitalize Art,'" *New York American* 26 (January 1913), 5-CE. AS to RSS, July 15, 1922, ASA/YCAL.
8. Waldo Frank, *Our America* (New York: Boni and Liveright, 1919), 4.
9. AS to PS, July 26, 1922, PSC/CCP.
10. AS to RSS, May 30, 1927, ASA/YCAL.
11. AS to EW, March 13, 1923, ASA/YCAL. For a discussion of this spirituality which links Stieglitz to a tradition extending from Plato down through Kant, Swedenborg and Emerson, see Marianne Fulton, "Stieglitz to Caponigro: An American Photographic Tradition," *Image* 26 (June 1983), 10-24.
12. AS to Anne W. Brigman, December 24, 1919, ASA/YCAL.
13. AS quoted in Herbert J. Seligmann, *Alfred Stieglitz Talking: Notes on Some of his Conversations, 1925-1931, with a Foreword* (New Haven, CT: Yale University Library, 1966), 69.
14. AS to Sherwood Anderson, May 21, 1924, ASA/YCAL.
15. Alfred Stieglitz, *The Third Exhibition of Photography by Alfred Stieglitz* (NY: Anderson Galleries, 1924).
16. AS to Sherwood Anderson, October 11, 1923, ASA/YCAL.
17. AS to Waldo Frank, August 20, 1924, ASA/YCAL. Stieglitz was also oddly attracted to nineteenth-century British authors, relishing John Stuart Mill's *Autobiography* and saving Lord Macaulay's biography of Warren Hastings to read while he was on the toilet. Gertrude Stein, whom he had once published in *Camera Work*, now seemed given over to "inane writings."

18. AS to RSS, August 9, 1923, ASA/YCAL.

19. Search-Light [Waldo Frank], "The Prophet," in *Time Exposures* (New York: Boni & Liveright, 1926), 179.

20. Waldo Frank to AS, November 1, 1920, ASA/YCAL. AS to Waldo Frank, November 17, 1920, ASA/YCAL.

21. AS quoted in Seligmann, *Alfred Stieglitz Talking*, 61-2.

22. Maurice Merlau-Ponty, "Eye and Mind," (1961), Chapter 5 in *The Primacy of Perception, and Other Essays on Phenomenonological Psychology, the Philosophy of Art, History and Politics*, John Wild, ed., Northwestern Studies in Phenomenology and Existential Philosophy (Evanston, IL: Northwestern University Press, 1964), 175.

23. Waldo Frank, "A Thought Hazarded," *MSS* 4 (December 1922), 5.

24. AS to R. Child Bayley, October 9, 1919, ASA/YCAL.

25. AS to Anne W. Brigman, December 24, 1919, ASA/YCAL.

26. For readings that are inclined to find such autonomy, see R. Richard Thomas, "Photography and Literature: An Introduction to Stieglitz and His Literary Admirers," *Journal of American Culture* 4 (Spring 1981), 144-48, and Bram Dijkstra, *The Hieroglyphics of a New Speech: Cubism, Stieglitz, and the Early Poetry of William Carlos Williams* (Princeton, NJ: Princeton University Press, 1969), 101-06.

27. Miles Orvell, *The Real Thing: Imitation and Authenticity in American Culture, 1880-1940* (Chapel Hill: University of North Carolina Press, 1989), 240-50.

28. Lewis Mumford, "The Metropolitan Milieu," 37.

29. Ibid., 36.

30. Stieglitz also collected pictorial nude photographs, and at least one piece of pornography, *The Intermission*, in which a woman lies nude before a fully-clothed lover (patron?) who refreshes himself with a pipe and stein.

31. We do not, cannot, know all that goes on between sex partners, or between artist and subject; but both relationships often involve a considerable amount of cooperation. For Stieglitz and O'Keeffe, there is undeniable evidence of this cooperation between artist and model; if nothing else the sheer volume of images testifies to O'Keeffe's willingness to pose, and to a collusion between artist and model. Although we cannot go so far as to speak of equal authorship, the O'Keeffe portraits underscore Stieglitz's notion that photography takes two, and hint that with some images it may be appropriate to speak of the photographer as something like the principal, rather than singular, author of an image.

32. AS to Anne W. Brigman, December 24, 1919, ASA/YCAL.

33. Judith Fryer, "Women's Camera Work: Seven Propositions in Search of a Theory," *Prospects* 16 (1991), 57-117.

34. Sue Davidson Lowe, *Stieglitz: A Memoir/Biography* (NY: Farrar, Straus, Giroux, 1983), 250.

35. Laura Mulvey, "Visual Pleasure and Narrative Cinema," originally in *Screen* 16 (Autumn 1975), 6-18; here from Brian Wallis, ed., *Art After Modernism: Rethinking Representation* (New York: The New Museum of Contemporary Art, 1984), 361-73. E. Ann Kaplan, "Is the Gaze Male?" in E. Ann Kaplan, *Women and Film: Both Sides of the Camera* (New York: Metheun, 1983), 23-35. For more, see John Berger, *Ways of Seeing* (New York: Pelican, 1973, 1972), 46-87.

36. Carol Duncan, "Virility and Domination in Early Twentieth-Century Vanguard Painting," *Artforum* (December 1973), here from Norman Broude and Mary D. Garrad, eds., *Feminism and Art History: Questioning the Litany* (New York: Harper & Row, 1982), 293-313.

37. Paul Rosenfeld, *Port of New York: Essays on Fourteen American Moderns* (New York: Harcourt, Brace and Company, 1924), 275.

38. Sherwood Anderson, "Alfred Stieglitz," *New Republic* 32 (25 October 1922), 215-17.

39. AS to Sherwood Anderson, September 23, 1922, ASA/YCAL.

40. Mumford, "The Metropolitan Milieu," 34.

41. Dorothy Norman, *Alfred Stieglitz: American Seer* (Millerton, NY: Aperture, 1960, 1973), 240 n7. Stieglitz last visited Paris in 1911, and he shared this memory with Norman some time after

1927. Horses could also be used to represent virility's absence. In 1923, Stieglitz created his best known horse photograph, *Spiritual America*. Focused upon the hindquarters of a harnessed horse, the image has considerable modernist interest; its formal composition contrasts the lines of rigging with the animal's curves, and the texture of the leather sets off the fine detail of his coat. But the significance of this image lies less with its form than with its content and caption. This was a gelded horse, good for drudgery but not for creation or action, quite different from a "race or rut" stallion like Man o' War, and the title, *Spiritual America*, announced Stieglitz's indictment/comparison—here was a fitting representation of the impotence and boredom of America culture. We do not know if Stieglitz sought out this subject or if he came upon it spontaneously, but subsequently he made careful use of the image in exhibitions. Employing metaphor (something he claimed to shun), Stieglitz created a title encompassing some of his more familiar equations: America and impotence, animals and humans, sex and spirit.

42. Quoted in Norman, *Alfred Steiglitz: American Seer*, 13.

43. AS to Herbert J. Seligmann, September 15, 1920, ASA/YCAL. Stieglitz used similar vocabulary to describe what he saw as the inadequacy of Paul Strand's photography: "I do hope he has a few really living things—living in the big sense. Whether passion is necessary to produce such a thing or not, all I know is that no half or three-quarter erection will puncture a real virgin... I do know that Strand has not realized as yet the significance of his mount—or his papers etc, etc." AS to Herbert Seligmann, October 8, 1928, ASA/YCAL.

44. Georgia Engelhard (Cromwell), "Alfred Stieglitz," *Popular Photography*, no. 46 (1944), 9ff. Quoted in Lowe, 180.

45. AS to Waldo Frank, July 10, 1921, ASA/YCAL.

46. Some of this posing may owe a debt to nineteenth-century German pictorialism. In one depiction of a dying Amazon, for instance, the nude female cups her right breast in something akin to the poses in Stieglitz's photographs. See Loraine Herbert, "Alfred Stieglitz's Apples," *History of Photography* 20 (Winter 1996), 341.

47. See Kaplan, "Is the Gaze Male?" 31, and Mulvey, "Visual Pleausre and Narrative Cinema," 363.

48. AS to Hart Crane, June 25, 1923, ASA/YCAL.

49. AS to Sherwood Anderson, July 23, 1923, ASA/YCAL.

50. Quoted in Seligmann, *Alfred Stieglitz Talking*, 61-2.

51. AS to S. Macdonald Wright, October 9, 1919; in Norman, *Alfred Stieglitz: American Seer*, 137.

52. AS to RSS, November 23, 1923, ASA/YCAL.

53. AS to Sherwood Anderson, November 28, 1923, ASA/YCAL.

54. AS to Paul Rosenfeld, October 2, 1921, ASA/YCAL.

55. AS to Hart Crane, November 28, 1923, ASA/YCAL.

56. AS to Sherwood Anderson, September 25 1923, ASA/YCAL.

57. Alfred Stieglitz, "How I Came to Photograph Clouds," *The Amature Photographer and Photography* 56, no. 1819 (September 19, 1923), 255. Quoted in Eugene Lyons, ed., *Photographers on Photography* (Englewood Cliffs, NJ: Prentice-Hall, 1966), 112. Stieglitz also said that music was what he was after. He wanted to create photos which would make a composer like Ernest Bloch say that Stieglitz's images *were* music. Music is of course the least representational of art forms, and at least since the time of the Armory Show Stieglitz had been familiar with Kandinsky's charge that the true artist should strive for music's nonmimetic expression of emotion. Stieglitz believed that his cloud pictures managed to do this, and in December 1923 he boasted that "I have done something that has never been done—Maybe an approach occasionally in music." AS to Hart Crane, December 10, 1923, ASA/YCAL. See also Sarah Greenough, "Alfred Stieglitz and 'The Idea Photography'," in Sarah Greenough and Juan Hamilton, *Alfred Stieglitz: Photographs and Writings* (Washington: National Gallery of Art, 1983), 23.

58. Mike Weaver, "Alfred Stieglitz and Ernest Bloch: Art and Hypnosis," *History of Photography* 20 (Winter 1996), 293-303. Mike Weaver, "Curves of Art," in Peter C. Bunnell and David Featherstone, eds., *EW:100: Centennial Essays in Honor of Edward Weston* (Untitled 41) (Carmel, CA: The Friends

of Photography, 1986), 89. Sarah Greenough, "How Stieglitz Came to Photograph Clouds," in Peter Walch and Thomas F. Barrow, eds., *Perspectives on Photography: Essays in Honor of Beaumont Newhall* (Albuquerque: University of New Mexico Press, 1986), 158. Kenton S. Hyatt, "Stieglitz, Martin Buber, and the Equivalent," *History of Photography* 16 (Winter 1992), 398-400.

59. AS to J. Dudley Johnson, April 3, 1925, here from Greenhough and Hamilton, eds., *Alfred Stieglitz: Photographs and Writings*, 208-9.

60. Although there are a few Equivalents resembling the towering substantial thunderheads that Ansel Adams photographed, Stieglitz's clouds tend to be much less substantial, either compact and globular, or wispy and thin, clouds that seem to offer little substance to resist Stieglitz's commanding vision.

61. Mumford, "The Metropolitan Milieu," 37.

62. GOK to Sherwood Anderson, February 11, 1924, in Jack Coward and Juan Hamilton, *Georgia O'Keeffe: Art and Letters*, (Washington: National Gallery of Art, 1987), 175-76.

63. AS to PS, October 25, 1919, PSA/CCP. He especially cherished Dorothy Norman for her willingness to arrange his paperwork.

64. AS to Marsden Hartley, October 26, 1923, ASA/YCAL. AS to Waldo Frank, April 4, 1927, ASA/YCAL. AS to PS, June 28, 1923, PSC/CCP.

65. PS to AS, August 30, 1928, ASA/YCAL.

66. AS to Waldo Frank, November 26, 1920, ASA/YCAL. AS to RSS, October 22, 1929, ASA/YCAL.

67. PS to AS, September 20, 1926, ASA/YCAL.

68. Rosenfeld and Frank shared many similarities (virtually the same age, both New York Jews, both graduates of Yale), published in the similar magazines (*New Republic*, *Vanity Fair*, *The Dial*), and were part of the editorial team for *The Seven Arts*. See Wanda M. Corn, "Apostles of the New American Art: Waldo Frank and Paul Rosenfeld," *Arts Magazine* 54 (February 1980), 159-63.

69. AS to Paul Rosenfeld, September 5, 1923, ASA/YCAL.

70. AS to Hart Crane, July 27, 1923, ASA/YCAL.

71. AS to Waldo Frank, August 13, 1926, ASA/YCAL.

72. Corn, "Apostles of the New American Art."

73 AS to Paul Rosenfeld, September 5, 1923, ASA/YCAL.

74. Alfred Stieglitz, brochure accompanying his 1921 exhibition, ASA/YCAL.

75. AS to Lewis Mumford, August 28, 1929, ASA/YCAL.

76. Ibid.

5. RHINOCEROS

In 1934 art critic Ralph Flint took stock of America. This was a common project dur-
ing the Depression years, and a variety of diagnoses and prescriptions filled
American books and journals. Many thinkers made appeals to Marx, but Flint
placed his hopes elsewhere, and concluded that what the country needed was what
he called "one true-blue solitary rhinoceros," a mighty yet distant figure as "sour-
faced" as Schopenhauer, as "indigestible" as Tolstoy, and as "insufferable" as Ibsen.
And Flint thought he had found the man to fit this bill: Alfred Stieglitz.[1]

It is doubtful that America *needed* Alfred Stieglitz during the Depression. But
Flint's characterization of Stieglitz was nonetheless telling. Throughout the 1930s,
and until his death in 1946, Stieglitz remained as insufferable and indigestible as he
had ever been (though perhaps age sweetened him just a bit). And increasingly
during these final years, Stieglitz became a solitary figure. In earlier times Stieglitz
had usually managed, despite his elitism and obscurantism, to gather a set of devo-
tees and exercise an influence upon American art. With the 1930s, though, there
were fewer friends and there was less influence.

Much of this was Stieglitz's own doing, for, as in the past, he drove away even
his best friends. After Stieglitz's gallery closed, Rebecca and Paul Strand worked with
Dorothy Norman to locate a new place and arrange the necessary financial backing.
Their task proved enormous, for not only was space difficult to locate, but the stock
market crash of 1929 also jeopardized funding. A still greater obstacle proved to be
Stieglitz himself, for he had wild mood swings, behaved (in his own words) "like a
brute," and even halted arrangements for a while.[2] There was considerable anger on
all quarters, but once it subsided the gallery opened as An American Place, and for a
time it looked as though everyone had been reconciled. But things changed with a
1932 show that Stieglitz gave Paul and Rebecca Strand, and what should have been
an honor proved to be a fiasco for the Strands. It was a combined exhibition of Paul's
recent photographs and Rebecca's paintings, but presented unflatteringly and with
unflattering remarks. This was devastating treatment for a protégé to receive from his
mentor, and by some accounts quite intentional—Dorothy Norman thought
Stieglitz's behavior was "diabolical." The Strands were humiliated and hurt, and
their friendship with Stieglitz never fully recovered.[3]

O'Keeffe also became more distant. During the early 1930s there were some
episodes of intense closeness, and her famous 1930 paintings of a phallic-looking
Jack-in-the-Pulpit have with some legitimacy been taken as intentionally erotic
love notes to Stieglitz. But over the decade she drifted further and further from
his life. She spent increasingly longer periods away, especially in New Mexico
where she eventually purchased a separate home for herself. Stieglitz's portraits
of her reflect this growing remoteness, as she began to appear more heavily
clothed, more distant from the lens, and enclosed, alone, in her car. Stieglitz tried
to make Dorothy Norman a replacement, yet between them there was never the
deep intimacy and artistic excitement that had marked his early years with

O'Keeffe. Norman always remained something of an understudy, and his portraits of her seem like technical exercises in the composition of light and dark, and lack the feeling of the O'Keeffe images.

If Stieglitz alienated some people, other friends found that he no longer seemed to fit into their contemporary world. In 1934 Frank, Mumford, Rosenfeld, and others edited and published *America & Alfred Stieglitz: A Collective Portrait*. This was a *festschrift*, more lyrical than many and offering some good analyses of Stieglitz's cultural contributions. But much of it is a summation of earlier accomplishments with little speculation about future directions, and there is a clear sense in this volume that Stieglitz's prime was past, that the end of his career was at hand. A few of the authors tired to examine Stieglitz in terms relevant for the contemporary America of the Depression, but the results were ill-fitting and even comical, as when Harold Clurman, fresh from the Soviet Union and his own Group Theatre, labored to present Stieglitz and his circle as what "we today call *collective*."[4]

If anything, Stieglitz was more withdrawn than ever from larger events during the 1930s and 1940s. He tried to ignore the Depression, denounced New Deal efforts to aid the arts, and dismissed the Spanish Civil War as an trifling affair. Always enamored of Germany, Stieglitz only belatedly recognized reports of Nazi brutality as something other than anti-German propaganda. He came to regard Hitler as an evil eccentric who misled Germans, and, oddly enough, a natural product of America's corrupting influence upon Germany.[5] When the war itself came, Stieglitz gradually moderated his pro-German statements and slipped into a silence that set him apart from the larger chorus of intellectuals and artists determined to defeat fascism.

After 1929, Stieglitz's photography also had an isolated quality. The spaces in his Lake George images became increasingly depopulated, with houses and barns all seeming to have lost their tenants. There was a similar loneliness in one of his last series, a set of photos of New York. Made from the window of his twenth-eighth floor apartment or from the seventeenth-floor windows at An American Place, these were in some ways a continuation of the images that he had created earlier from the windows at 291. But in these later pictures, it was not so much that Stieglitz peered out as it was that he looked down upon the city, creating compositions of squares and rectangles punctuated by towering shafts of alternating white and black. The ascendancy that Stieglitz had strained toward with his cloud pictures now seems achieved in these late works, for rather than reaching like the rest of earthy mortals he instead looks down from a lonely perch amidst the god-like heights.

The pace of Stieglitz's photography slowed markedly in the late thirties. In the spring of 1937 he told Ansel Adams that he had "run 'dry'" and lost "the necessary urge" to make images,[6] and in 1938 he permanently retired his large cameras, although he continued to work for a while with borrowed small-format ones. By 1940 he had given up printing, too.

Much of Stieglitz's career had been marked by stubbornness and by stubborn adherence to certain principles. There had been changes to be sure, for Stieglitz had moved from pictorialism to straight photography, had come to a greater acceptance of the physical and the coincidental in his art, and had tempered a nineteenth-cen-

tury romanticism with twentieth-century modernism. But the constancies seem the greater part of his story. From quite early on he insisted that photography was an art equal to any other. Never did he accept mimesis as a major part of his photographic project, and he instead strove for an imagery of transcendent qualities, of the universal psychological or spiritual aspects of subjects both human and otherwise. He sought dominion of the art world in which he worked, and through his art sought dominion of the things and people that he photographed.

There is a certain truth to the cliché that we all die alone, especially for creative people who live long enough to see their accomplishments become dated. Stieglitz lived a long life—he had been born in the midst of the Civil War—and during that lifetime American photography absorbed his contributions and then went beyond them, so that the self-styled prophet became something of a living relic. But the distance, and even the loneliness of Stieglitz's last years were not merely the products of aging; they were also qualities he had chosen. In his quest for mastery of the objects and people of his world, Stieglitz had alternated between embracing them and holding them at arm's length, between intimacy and distance. In the end he was more distant than intimate. This man—who had wanted to penetrate to the heart of things, who had described photography as love-making—spent his last years in increasing remoteness. Like an old rhinoceros on the veld, Stieglitz stood alone in New York and at Lake George, huffing his familiar themes. So armored, so bristling, so belligerent was Stieglitz that it is no surprise he was alone when his fatal stroke occurred on a summer's day in 1946. He never regained consciousness during the remaining three days of his life.

1. Ralph Flint, "Post-Impressionism," in Waldo Frank, Lewis Mumford, Dorothy Norman, Paul Rosenfeld, Harold Ruggs, eds., *America & Alfred Stieglitz: A Collective Portrait* (Millerton, NY: Aperture, 1934, 1975), 88.
2. AS to RSS, October 22, 1929, ASA/YCAL.
3. Nancy Newhall, "Alfred Stieglitz: Notes for a Bibliography [Biography]," in Nancy Newhall, *From Adams to Stieglitz: Pioneers of Modern Photography* (New York: Aperture, 1989), 115, 132-33.
4. Harold Clurman to AS, summer 1934, ASA/YCAL. Clurman's article is "Alfred Stieglitz and the Group Idea," in *America & Alfred Stieglitz*, 134.
5. Sue Davidson Lowe, *Stieglitz: A Memoir/Biography* (NY: Farrar, Straus, Giroux, 1983), 333-35, 352.
6. AS to AA, May 9, 1937, ASA/YCAL.

PART TWO

Paul Strand

6. Early Years

In the months after Alfred Stieglitz died in 1946, Paul Strand eulogized his mentor several times.[1] Strand was a sensible candidate for this memorialist's job, for he had known Stieglitz for over thirty-five years and achieved considerable status in his own right. Like most of Stieglitz's associates, Strand had felt the sting of Stieglitz's acerbity, and there had been long stretches of alienation in their relationship. But Strand was also a decent man, disposed to speak kindly of the dead and to praise famous men rather than to settle scores; in his eulogies Strand said nothing about Stieglitz's maliciousness. Instead, he praised lavishly and expressed his own indebtedness to Stieglitz, saying that it was Stieglitz who had first exhibited the images that made Strand want to be a photographer, who had taught him how to previsualize a subject, and who had helped him think of photography as an art independent of painting.

For a good part of his career Strand's identity had in one way or another been associated with Stieglitz's aura. Even now that Stieglitz was dead Strand presented himself as the great man's student. But in fact Paul Strand had become very much his own man, with ideas and images quite distinct from Stieglitz's, and Strand's eulogies tell us almost as much about the person that Strand had become as about the person Stieglitz had been. Strand's politics placed him solidly on the Left, and unlike the more conservative and apolitical Stieglitz, Strand was an active participant—even a leader—in the political battles of his day. When Strand praised Stieglitz as an active defender of civil liberties and the rights of artistic self-expression, he was actually speaking more about himself than about Stieglitz, and when Strand referred to Stieglitz as "one of the great engineers who helped to build" America's soul, his terminology arose more from the leftspeak of his own times than from Stieglitz's self-image.[2]

There were also differences in the two men's photography. Like Stieglitz, Strand believed in photography's revelatory powers, and like Stieglitz he was inclined to subjects that were more invisible than visible. But unlike Stieglitz, Strand was concerned with economic and social forces rather than with metaphysical ones, and where Stieglitz preferred transcendent subjects like Woman or the Equivalents, Strand was interested in worldly ones like commodity relations and community ties. Strand was an innovator, as was Stieglitz, but Strand had stories to tell, stories of community and struggle that still photography sometimes could not convey to his satisfaction. Accordingly Strand's experiments led him toward the cinema and photo-books, and he aspired to audiences larger than any that Stieglitz envisioned. Eventually, Strand felt that he could not tell his stories in the United States, and he spent the last years of his life as an expatriate, preserving a studied progressive optimism despite the gloominess and treachery of cold war Europe.

Paul Strand came from a prosperous middle-class family. He was the descendent of Bohemian Jewish immigrants who had settled in nineteenth-century America. His grandparents and parents had successfully adapted to a secular, urban

life in New York City; his father shed the family name of Stransky shortly before Paul's birth in 1890. Paul was the only child in an extended family that included not only his parents but also his maternal grandparents and a maternal aunt. After his birth the household moved to the brownstone on West 83rd Street where Strand made his home into the early 1930s. Though not wealthy, the family kept servants, vacationed in the country, and exchanged nice gifts (like cameras—Strand received his first one at age twelve). Jacob Strand, Paul's businessman father was his principal source of affection in a household of frequently preoccupied adults.

For his secondary education, Strand attended New York's Ethical Culture School (ECS) between 1904 and 1909. This was a choice made perhaps because of pedagogical principle, and perhaps too because of a certain cachet associated with the School. It was a portion of Felix Adler's Ethical Culture movement, a broad program drawing upon late nineteenth-century welfare thought, and evincing some of the ethos of social morality that surfaced in other Progressive-era reform campaigns and cultural programs. Though originally intended to include a heterogeneous mix of students, by the early twentieth century the student body had evolved to include a significant group of individuals much like Strand: the children of secular, middle-class Jewish parents who had selected for them a humanistic and socially minded education.[3]

The Ethical Culture School provided Strand with an introduction to photography, and to notions that photography should be involved with both beauty and society. His art appreciation course was taught by Charles Caffin, Alfred Stieglitz's compatriot—who was busy during these years writing about photography as a legitimate and highly aestheticized form of artistic expression. Another of Strand's teachers was Lewis Hine, a reformer and sociologist who turned to photography as a tool for documenting the exploitation of child labor. Hine directed the ECS photography program, with exercises intended to sensitize students aesthetically while helping them simultaneously recognize social and economic patterns.[4] During 1907, ECS displayed a loan exhibition of Photo-Secession photography, and Strand and other ECS students also took a field trip to 291. There in the works of Stieglitz, Steichen and Clarence White, Strand saw what Hine and Caffin had been saying in the classroom, that it was possible to make photographs with weighty and serious aspirations.[5]

After he graduated from ECS, Strand continued making photographs. Some of his images were made in 1911 during an eight-week tour of Europe, where he photographed Venice, Nice, and Versailles in conventional pictorial fashion. But in other images Strand reached beyond established taste, exploring the visual qualities of scenes which might seem more prosaic than meaningful, such as sheep upon the Canterbury plain.[6]

Strand never shared Stieglitz's notion that a photographer would sully the art of photography by making a living with the camera. In his younger days Strand concocted a series of money-making schemes, like marketing some of his prints of picturesque European scenes, or selling photographs of college campuses as mementos for students and alumni. But these enterprises seldom earned much more than his expenses, and Strand made do by living at home, where at least he had his father's encouragement.

Critical success was more forthcoming. Strand's photographs won prizes and honors in pictorial photography contests, and pictorially inclined Photo-

Secessionists like Gertrude Kasebier and Clarence White praised his work. There were few bold experiments in this work, and when Strand traveled he manifested little interest in avant garde art. While in Europe in 1911, he bypassed the futurists, Picasso, and Braque, and instead sought out the classic offerings of the Louvre and Uffizi Gallery.[7] Even as late as 1915 he seems to have been just as conservative as he photographed college campuses around the country. He visited San Francisco's Panama-Pacific Exposition, but apparently ignored Italian Futurist paintings, John Marin canvases, and Lewis Hine photographs for a Wagner concert and a haphazard look at some Japanese prints.[8]

But things were different in New York where de Zayas and others at 291 provided modernist direction. Gradually Strand moved away from pictorialism. He recognized "the great Armory show of 1913" as a watershed event, and later said that the "new controversial developments in painting, Picasso, Braque, Matisse" were influences in his own artist development.[9] By 1913 he was making routine visits to 291 and showing his prints to Stieglitz, who "terrified everybody, me included." But with time his terror subsided, and Strand began to appreciate Stieglitz's critiques. Early in 1915, for instance, Stieglitz examined some of Strand's recent images and said that Strand's soft-focus technique inappropriately compressed textures and allowed insufficient differentiation between the elements of grass, sky and water. Strand listened, and adjusted his lens aperture to achieve sharper definition.[10]

As Strand labored on his photography, the work became straighter, more formal and more intense. Photographs made during that campus trip of 1915 showed some of this evolving vision. In an image such as *Telegraph Poles, Texas* (1915), he provided visual tension by framing a small white house with utility poles, the poles and wires cutting the image with strong vertical and horizontal lines, and giving it the effect of cubist planes. In New York he likewise worked with increasing boldness, so that earlier fuzzy depictions of Central Park foliage gave way to more sharply defined images of Park thoroughfares. Stieglitz's influence was evident in still another photograph, *Snow, Backyards, New York* (1915), which echoes the snow scenes that Stieglitz made the same year.

But some of Strand's most successful images of 1915 were also his most original. In photographs that brilliantly combined geometry, movement, and city architecture, he managed a sense of urban alienation at odds with the buoyancy of Stieglitz's busy New York waterfront images of 1910. In one such image, Strand photographed a single figure in white, alone and framed by the massive arched doorway of St. Patrick's Cathedral. Even more powerful was his photograph of people walking past the Morgan Trust Company Bank, *Wall Street, New York* (1915; fig. 6.1). Here Strand managed to capture movement on the city street, a notable technical achievement given the slowness of the period's photographic materials. But there is more than movement here, for with its strong formal components, the photograph's subject in some ways seems to be geometry rather than a city scene, and Strand deftly used angles in crafting the image. Choosing to make the photograph when the sun was low in the sky, he achieved dramatic contrast with the deep and long shadows that make up so much of the image. Strand situated his camera so that it was at an angle to the building, just enough to add a surreal dimension to the photograph without destroying its representational qualities; with this angle, Strand arranged the image so that his pedestrians

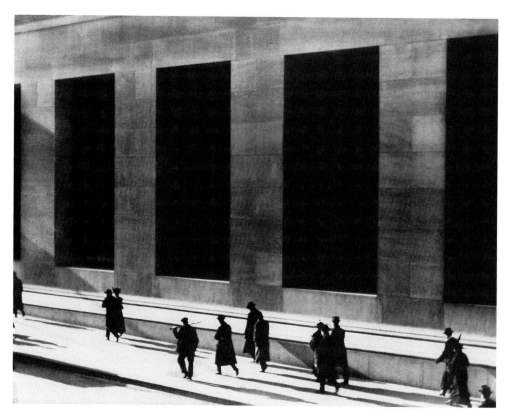

6.1. Paul Strand. *Wall Street, New York, 1915,* © 1971, Aperture Foundation Inc.,
Paul Strand Archive.

do not merely go past the viewer but move toward some unspecified destination on missions that seem all the more futile for their lack of specificity. Thanks to the lighting, the people appear almost as silhouettes, robbed of their three-dimensionality.

But of course the image is dominated by what Strand called "those huge, rectangular, rather sinister windows."[11] Blind, stony, and foreboding, the windows of this building neatly symbolized the condition of individual humans before the massive institutions of the twentieth century, and while Strand claimed that at the time he intended no political commentary, the title, *Wall Street*, drives home the social point by identifying the particular setting and institution as capitalist ones.[12] It is not clear if these people are the economy's victims, servants, or masters, but in this rendering their errands seem particularly unhealthy.

Wall Street by itself was a remarkable achievement. Strand's other photographs from the same year confirmed that this was no isolated fluke, that it was part of a larger body of solid photographic work. As Strand described it, his prior development had been slow and incremental. But then in this year of 1915 came what he called a "strange leap into greater knowledge and sureness," and from then on Strand confidently identified himself as a photographer.[13] It was also at this time that Stieglitz embraced him as a photographer. Toward the end of 1915, Strand bundled together his recent prints and took them to Stieglitz at 291. Surprised and delighted by the development he saw in the portfolio, Stieglitz called other artists from the back

room and conducted an impromptu initiation into the circle. Showing Strand's prints to Steichen and the others, Stieglitz told Strand that he should now think of 291 as his artistic home, a place where he was not only welcome but where he *belonged*.[14]

Having Stieglitz display one's work was one of the greatest validations for any photographer, and Stieglitz presented Strand's work thrice in quick succession. A one-person exhibition at 291 during the last half of March 1916 was followed by the reproduction of six photographs in the October 1916 *Camera Work* (alongside the formidable modernist company of Brancusi, Picasso, and Braque), and then eleven more Strand photographs were published in the June 1917 *Camera Work*. These were grand honors in themselves, but Stieglitz heaped on still more laurels as he personally praised Strand in letters and essays. Strand, he said, was the most formidable photographic rookie to emerge in the past decade, and there was "no work outside of Strand's which was worthy of 291." As Stieglitz explained, the timing of Strand's one-man show was carefully planned to accentuate Strand's status as a modernist whose photography was comparable to anything painting had to offer. Just as Stieglitz had contrived for his own exhibition to coincide with the Armory Show, so he now arranged for Strand's 291 debut to run simultaneously with New York's next big modern painting show, the Forum Exhibition of Modern American Painters.[15] All this constituted a carefully designed set of claims by juxtaposition: photography was no less an art than painting, modernism knew no boundaries of media, and Strand's work was of a caliber comparable to Stieglitz's. There was yet another set of compliments, unplanned ones. As events played out, Strand's show was the final photographic exhibition ever held at 291, and *Camera Work* ceased publication with the issue devoted to his eleven photographs. Strand was the journal's and the gallery's last word on photography.

A good deal of Stieglitz's commendation had an air of relief about it, a sense that he had found something of an artistic heir just when his gallery, his journal, and even his own photography seemed in eclipse. Young and vital, Strand provided Stieglitz with a link to photography's future when so much (pictorialism in particular) seemed to be fading into the past, and Stieglitz lauded Strand's photography as "straight all the way through; in vision, in work and in feeling."[16] Stieglitz published an essay by Caffin calling Strand's art "an unanswerable witness to the pleasure and interest that the objective holds for us."[17] In that same issue of *Camera Work* Stieglitz said that Strand's images were "pure," without "tricks of process," and demonstrated that "there is an applied intelligence in whatever he does."[18] With these words Stieglitz introduced Strand with something of a commission: to go forward as a straight photographer working with an actively engaged intellect. Thus embraced, confirmed, and chartered, Paul Strand launched his public career in art photography.

He was also ready to experiment daringly. In the later part of 1916, Strand made a stunning set of candid portraits of people on New York's streets and sidewalks. Prowling places such as Five Points Square, he returned with a set of closely cropped portraits which isolated people from their surroundings and presented them so that their faces loom hauntingly and often slightly off-center within the frame. Some of these portraits are studies of emotion—quiet, inward-dwelling emotions ranging from the pensiveness of a severely wrinkled older woman to the

moroseness of a watery-eyed man beneath his brimmed hat. Strand was most often drawn to photograph poorer individuals, such as one ill-groomed man carrying a sandwich-board, but he also photographed the well-to-do, like a well-fed man wearing a derby and carrying a polished cane. Strand made these images surreptitiously, using devices that allowed him to stand at right angles to his subjects so that he appeared to be aiming his camera elsewhere. The results were photographs such as *Blind Woman, New York* (1916; fig. 6.2), confronting and insistent images that Stieglitz aptly called "brutally direct," and which Stieglitz felt compelled to print without the dainty tissues he habitually used with other *Camera Work* reproductions.[19]

Strand had few direct precedents for these images, and the influences that inspired them are not completely obvious. Louis Hine would seem one apparent model, for Hine had long photographed workers and immigrants, and Strand was doubtlessly familiar with his former teacher's portraits of dazed and haggard people. But there were important differences. Unlike Strand, Hine often provided some context with his portraits, framing a Jewish immigrant with the windows of Ellis Island, or placing a Slavic laborer among his comrades. Moreover, Hine's subjects almost always knew they were being photographed, and unlike Strand's, had opportunities to arrange themselves for the camera. To a certain degree Strand's own earlier photography had presaged these new photographs, for in making images like *Wall Street* he had become accustomed to working with material from the city streets. But still those earlier photographs were much more contextual and much less direct, anonymous city scenes rather than these newer, intimate individual portraits.

Nonetheless *Blind Woman* provides clues to the motives that led Strand into this portraiture. In part he seems to have worked out of empathy. Like others of the subjects in this series of portraits, this woman has had a rough life, and Strand's photograph would seem to indicate a degree of compassion for her condition, for rather than allowing her to melt unnoticed into the cityscape, he has chosen to accentuate her circumstances. As in *Wall Street*, he once again enlisted the verbal to enhance the visual, for although the woman's right eye is unquestionably compromised, the left one is less obviously so, and by including her BLIND placard within the image Strand managed to convey the extent of her handicap. The photograph may in some ways ask us to come to the aid of this woman, and it certainly says that her story is worth taking seriously; like the literary naturalists or the Ash Can painters who had preceded him by just a few years, Strand turned his attention to social types that might seem "below" art. Beyond this, the image provokes one's anger at the larger social system, for it is outrageous that the community would send this disadvantaged woman out to peddle on the street and then demand that she be licensed to do so.

But Strand was exploitive as well as empathetic. With candid photographs like this he invaded his subjects' privacy, appropriating their likenesses at what were frequently awkward and unbecoming moments, and creating in the process unflattering images that would endure for ages. The invasion seems all the greater with this *Blind Woman*, for unlike the sighted individuals who could at least see some of what Strand was doing, she presumably had less indication that there was a stranger on the prowl in her vicinity. Not quite a voyeur, but still peeping, Strand found this kind of work "nerve-racking" because at any moment the subject or some bystander might "realize that you were up to something not quite straight."[20]

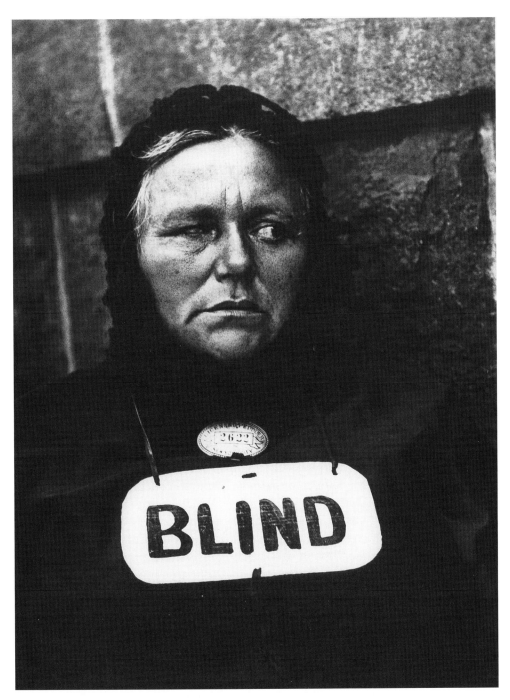

6.2. Paul Strand. *Blind Woman, New York, 1916*, ©1971, Aperture Foundation Inc., Paul Strand Archive. Courtesy George Eastman House.

Clearly Strand had doubts about the legitimacy of such furtive photography. Clearly, too, some people on the street objected, for he once quickly fled when "two toughs" saw through his subterfuges, and threatened him for sneaking photographs.[21] Yet despite such obstacles and despite his conscience, Strand was drawn to make these images, and their apparent veracity was a part of the attraction. Some of candid photography's appeal is quasi-scientific, a sense that the undetected observation is somehow a truer observation, and that such veracity legitimates deceptions used in making the image. Of course the ethics of this are dubious, but the individuals around 291 were fascinated by these and other peculiar notions of science, experimentation, and objectivity. In his essay reviewing Strand's first one-person exhibition, Stieglitz claimed that such 291 shows were less like conventional art exhibitions and more like demonstrations or experiments, "virtually in a scientific sense."[22] The following year Strand himself characterized photography as science's first contribution to the arts and "an absolute unqualified objectivity."[23] Candid photography had the advantage of dispelling even more clouds of subjectivity, ignoring any wishes that the blind woman and others might have to appear in a certain way, or even to avoid being photographed altogether.

Blind Woman illustrates still other innovations Strand made in 1916 and 1917. This is a strange, almost surrealistic picture, a disquieting play upon the closeness between photography and vision. The image's clearest, brightest, most obvious element is the word "BLIND," so that one of the first things one registers is a sign of sightlessness, a signifier of eyes that do not work. Quickly, too, this image sends the mind looping back to photography itself, as though Strand were asking us to assess photography's ability to see truly, and perhaps even weigh our own handicaps as viewers.

In his other surreal and self-referential images, Strand experimented with framing as well as with light and shadow. Photographs like *Abstraction, Porch Shadows, Twin Lakes, Connecticut* (1916; fig. 6.3) have familiar subjects (in this instance porch railing shadows as they fall across a stoop) but depict them from angles or distances that often manage to obscure the subject in a play of light and dark. It is difficult to date these images precisely—he made many during the summers of 1913 to 1918. But 1916 was a particularly productive year, and by the end of August Strand was writing to Stieglitz that "it has been a summer of work...and I think I shall have some things to show you."[24] Stieglitz liked those "things" very much, and when he decided to print them along with the candid portraits in that second Strand *Camera Work* issue, he called the new work "a series which goes far ahead of this one just published,"[25] for the geometric concerns of these later works surpassed even the strong spatial themes of earlier ones like *Wall Street*.

In these abstract images, virtually anything would do for a subject—chairs, bowls, fruit. Strand worked with verve and excitement that were reflected by another New York photographer, Alvin Langdon Coburn, who that same year spoke of "the joy" of producing images that "would be impossible to classify, or to tell which was top or which was bottom."[26] Strand wanted to produce similarly challenging photographs, moving from the squeamishness one feels about *Blind Woman*, and toward images that are something more like visual puzzles, pictures that do indeed set one to wondering what the subject might be. These images thwart conventional expectations

that photography is a square-on representational medium, and to enhance the effect Strand sometimes even used orthochromatic film, producing prints with an odd, black rendering of the reddish hues of apples and oranges. These images also stand as Strand's effort to interpret modernism photographically, to accomplish with the camera some of what he had seen in the work of cubist painters.[27] Often he achieved more geometry than representation, and worked toward a level of abstraction that Strand acknowledged in titles within the series: not only *Abstraction, Porch Shadows*, but also *Chair Abstract* and *Abstraction—Bowls*. As he said toward the end of 1915, when painters Francis Picabia and Marcel Duchamp were helping him appreciate cubist and other abstract paintings, his own images had "no recognizable content."[28]

But for all the influence of these painters, Strand remained a photographer, and strictly insistent about photography's independence from painting. Nestled among the abstractions and street portraits in that last issue of *Camera Work* were two other items that he created, a photograph and an essay, which together indicate Strand's regard for boundaries and the autonomy of his medium. Situated among his abstract images, *The White Fence, Port Kent, New York* (1916; fig. 6.4) was obviously more representational than were the shadow images. Occupying the lower half of this horizontal composition, the nine pickets and their connecting rail form a clear line separating the viewer from the less sharply focused barn and house in the background. Doubtlessly such formal elements were a large measure of what drew Strand to photograph this scene, but the image rests comfortably within representational conventions and, unlike *Porch Shadows*, is not so concerned with abstractionist fields that painters had already explored. *Here*, Strand seems to be saying, was the kind of formal work suited to photography. He made the photograph at about the same time Robert Frost had published his poem "Mending Wall," and it is understandable that *The White Fence* would lead historian Sally Stein to think of that poem, for in their separate ways both photo and poem are concerned with fences and with keeping things in their places.[29]

Like *The White Fence*, Strand's accompanying essay was also about boundaries. He entitled it "Photography," and therein accepted straight photography as photography's one true form, one proudly independent of painterly techniques. He also stressed the "complete uniqueness" of photography, that the camera did what was impossible to achieve through pencil or brush.[30] As Strand indicated with his one-word title, this was a medium all to itself, separated from painting by the sort of boundaries that straight photography acknowledged and accepted. For decades now Stieglitz and his compatriots had insisted on photography's parity with painting, first striving for visual parallels to impressionist painting and then engaging in the verbal gymnastics of distinguishing "anti-photography" from "photography." But Strand had little inclination to re-fight these particular battles. He accepted photography as a field fenced off from painting, and once he had proved that the camera could create images just as unrepresentational as the cubists paintings, Strand left behind experiments like *Porch Shadows* and went on to an imagery more closely akin to *The White Fence*. Indeed, this humble scene in upstate New York became something of an Ur-subject in Strand's career, repeated year after year, and in locale after locale, so that the picket fence became almost a visual cliché in Strand's work. It is also something of a trope. In most of the images, fences are configured like this one, as foreground devices separating the photographer from other

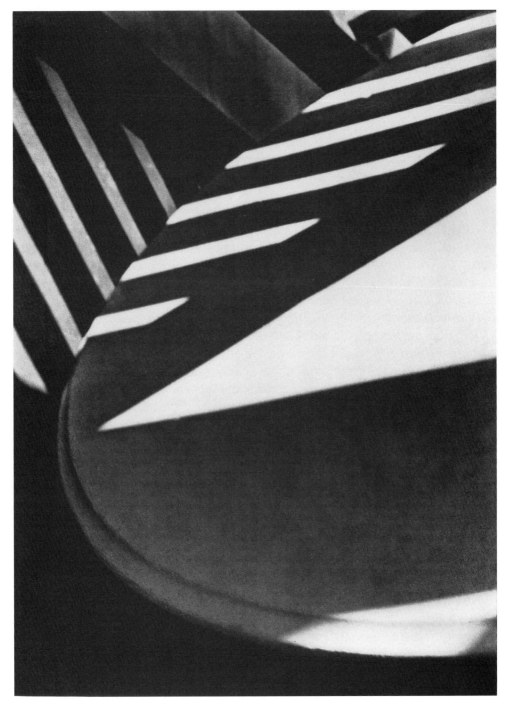

6.3. Paul Strand. *Abstraction, Porch Shadows, Twin Lakes, Connecticut, 1916,*
 © 1971, Aperture Foundation Inc., Paul Strand Archive. Courtesy George Eastman House.

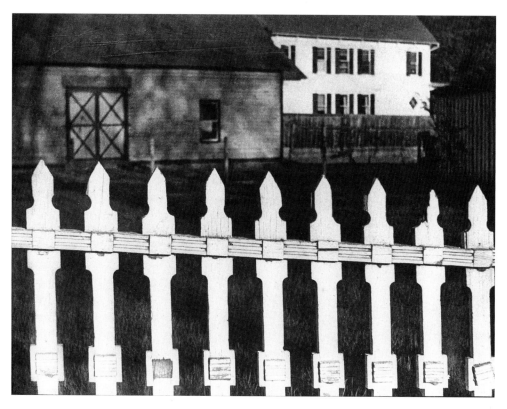

6.4. Paul Strand. *The White Fence, Port Kent, New York, 1916*, © 1971, Aperture Foundation Inc., Paul Strand Archive. Courtesy George Eastman House.

elements within the composition. These images are indicators of the remoteness, the distance, the coolness that came to characterize Strand's photography, for try as he might, he never quite managed an intimacy and warmth with his subjects.

Strand's circle expanded considerably during 1917 and 1918. He garnered connections outside of 291, and his photographs placed well in the prestigious Wanamaker Competition. There were new friends and even a few patrons, one of whom introduced him to Georgia O'Keeffe, who had briefly come from Texas to New York to visit Stieglitz in May 1917. She and Strand were intensely attracted to each other, with O'Keeffe being decidedly less reticent than he ("I despised you for sitting...and simply telling me that you felt instead of acting,") and probably more experienced ("I felt you hadn't thought as much of as many women as I had men").[31] During its early phases this relationship was a jumble of personal attraction and respect for each other's work. One of Strand's essays, for instance, left O'Keeffe feeling "that I love you like I did the day you showed me your [photographic] work—love you arms full—or is it what you say that I love."[32]

The situation was complicated enough with just the two of them. But Stieglitz was also in the picture, openly pursuing O'Keeffe and at the same time confiding to Strand about both his infatuation with O'Keeffe and his marital woes. In all quarters there seems to have been considerable affection, intense respect, and gnawing

uncertainty. Then, to compound things even further, in May 1918 Stieglitz asked Strand to go to Texas where he was to convince O'Keeffe to leave her teaching job and return to New York where Stieglitz would (explicitly) support her art and (implicitly) be her lover. Incredibly, Strand accepted the assignment, and in doing so undertook what seems in many ways a peculiar form of pandering as this protégé secured for his mentor the very woman he himself loved. It was also a dangerous triangle for Strand, one in which he risked not only the loss of friendship and love, but also the loss of sustaining aesthetic relationships.

When Strand arrived in Texas, it became apparent that he and O'Keeffe were still attracted to each other. He hid little of this from Stieglitz, at one point writing him that "she lets me touch her—wants me to." In turn Stieglitz bombarded them both with his own letters, and it is no small wonder that Strand came to feel that "everything seems unspeakably twisted."[33] He wrote poetry about trees shrieking to the sky, and at one point outfitted himself with a pistol and bull whip and assaulted a hapless Texas farmer who had insulted O'Keeffe.[34] Eventually O'Keeffe accompanied Strand back to New York, where she chose Stieglitz as her lover and where Strand was left to his own devices.

Among the things Strand gave O'Keeffe during their involvement was *The Life of Nietzsche* (1912-15) by Nietzsche's sister Elisabeth. It is tempting to think, giving all the turmoil in Strand's life during these years, that Strand was particularly drawn to the notions of personal triumph in Nietzsche's Superman; certainly Strand's poetry made a friend think of William Ernest Henley's proclamation that "I am master of my fate: / I am the captain of my soul."[35] But the appeal in Nietzsche was of a different sort, something Strand shared not only with O'Keeffe (she told Strand that she wanted "to crawl into your Life of Nietzsche—and shut the cover tight on myself and stay there"[36]), but with others of their generation. For many of these younger American artists and writers, Nietzsche seemed to hold out the promise that one's life, and life in general, could be guided according to forceful and creative principles, and that it was possible to supplant the seeming lethargy of an older generation. These people found outlets for their ideas in a number of small, often short-lived magazines such as *The Seven Arts*, edited by Randolph Bourne, a lively journal that counted Strand among its contributors.[37]

In an essay called "Twilight of the Idols" (the title came form Nietzsche's work of the same name), Bourne described World War I as a terrific mess created by the older generation and he called upon young Americans to dissent from the war. Strand was the kind of young person Bourne had in mind, and he solicited ideas from Strand and like-minded individuals such as Paul Rosenfeld. Bourne then amalgamated their responses into his own 1917 essay, "Below the Battle," featuring a young man who was a composite character drawn from Strand, Rosenfeld, and others. The young man was of an intellectual bent, so that "when he reads, it is philosophy—Nietzsche, James, Bergson—or the novels about youth," works by the likes of Romain Rolland or Gilbert Cannan. This composite fellow had once had high hopes for the nation, but was now distraught by the elders' squandering of America's promise and was left with little more than "a smoldering resentment."[38]

"Smoldering resentment" neatly describes Strand's attitude toward World War I. During the summer of 1917 he tried to distract himself by photographing in the

Connecticut countryside. But even the beauty and tranquility of Twin Lakes seemed spoiled by the jingoism that raged through the country following America's entry into the war that spring. Strand found it "impossible to thoroughly detach myself from... this damn [coun]try. I seem to be atta[ched to the] navel of it." No matter how mightily he tried, it was "impossible to get away from the war," for the slaughter had loosed a destructiveness and morbidity that ranged far beyond the battlefield.[39]

The war seemed to have a particularly insidious effect on America's small creative communities. "There was," Strand later remembered, "a general disintegration in the impact of the war," something that was also painfully clear at the time, as in August 1918 when Stieglitz wrote to him saying "these are days of great readjustments—splittings up."[40] Many groups faltered as their members were drafted, imprisoned for war resistance, or caught in other large currents. The various small magazines were particularly vulnerable, and Strand blamed the patriotic hysteria for the demise of *The Seven Arts*, saying that "the war cut it short, snuffed out like a light the Seven Arts."[41] 291 seemed similarly smothered. In his 1917 obituary for the deceased gallery, Strand unhesitatingly assigned the responsibility for 291's closing, saying that "the immediate compelling cause was the war."[42]

The war threatened Strand's self as well as his institutions. He was liable for the draft, and in ways familiar to almost anyone who has been in similar circumstances, his anxiety mounted as those around him were drawn into service. Rosenfeld found himself in the Army, bored and resentful. Steichen was an oddity, serving enthusiastically and even meaningfully in a photographic unit. Picabia had been drafted into the French Army, but managed to evade the call by fleeing to the United States. Strand, too, hoped to avoid the draft, and for a time managed to get himself classified as an exempted agricultural worker on the pretense that he was laboring at painter Arthur Dove's Connecticut farm. But the ruse could not be sustained and eventually Strand was called. He was inducted in September 1918, when the demand for soldiers was low and the Selective Service System had determined that men of Strand's age (he was 28) were not good candidates for combat assignments. But the Army had other needs, and Strand was pressed into the medical corps.

The November 1918 armistice was only weeks away when Strand was inducted. He never saw combat nor did he even leave the United States. Yet he experienced plenty of the military, and before Strand was discharged he had keenly felt the horrible human costs of both the war and the countless tragedies arising from it. Events of those years had a monumental and compelling quality to them, and Strand struggled to maintain some of the artistic sensitivities that he had developed over the last few years. But in a surprising and quite unexpected set of circumstances, Strand's wartime experiences also provided him with an aesthetic orientation and photographic praxis that he continued to develop well into the 1930s.

As a draftee, Strand experienced the Army's time-honored tedium of fatigue work, as well as newly devised curiosities such as IQ testing. There were hilarious episodes when Strand tried to mold his uncomprehending comrades into his own version of 291, as during boot camp when he pressed copies of *Camera Work* upon his doubtlessly incredulous barracks mates. He had hopes for a commission and some kind of photographic work, but his requests were refused; the best that Strand

could manage was a short course of X-ray training that did little to spare him from the dreary medic's work of collecting sputum and urine samples.[43] When things were not dull they were terrible, for the usual tragedies of combat casualties were compounded by maladies seemingly unique to this particular war, and some of Strand's patients were victims of the disorder that had only just acquired a name, "shell shock." Military medicine seemed incapable of doing much to help such patients, and in his frustration Strand at one point gave himself over to transcribing one poor man's demented ravings.[44]

Some of Strand's disgust was tempered by his fascination with the war's drama. In this, Strand bore a kinship with other artists and intellectuals of his generation, people drawn to witness the very fighting that they detested. Like Ernest Hemingway, John Dos Passos or even John Reed, Strand had an itch to see the war but not the yearning to be a warrior. He retained a visceral sense that wars and warriors were both fundamentally wrong, yet he was also fascinated by the combat in Europe and at one point clamored "to get across and really touch the reality of it."[45] Even after the Armistice there was a possibility that his unit would still be deployed overseas, the potential for what he called "a great experience[,] one I would very much like to get."[46]

But Strand seemed destined be a mere private moldering away in Minnesota army posts. Then, unexpectedly, the Army provided a surprisingly satisfying way to touch some of the reality Strand craved. He was sent for additional training at Rochester, Minnesota's Mayo Clinic, the famed surgical center that had been militarized and integrated into the larger war effort. He was to learn surgical procedures in the expectation that he would become an operating room assistant, and this middle-class, city-reared man, who seems never to have cleaned a fish or cut up a chicken, paled at the prospect of working in a theater of blood, tissue, and viscera. In letters home to his parents in New York, Strand expressed his fears, confessing that "I got a bit sick...in a mere lecture on surgical instruments."[47]

But he came through fine. After his first surgical experience, Strand told his parents that it was "all tremendously interesting," and that "the repellent aspects...never have been comparable to its interest."[48] The earlier trepidation turned to boasting, and he soon bragged that he had seen cancer, brain, kidney, hernia, and bone operations, that "all the blood etc. didn't affect me in the slightest degree."[49] As the end of his training approached, he looked forward to his turn in a particularly ghastly sounding portion of the program, to be conducted in what was called "the vivisection room."[50]

The Clinic surgeons impressed Strand with their assurance, deftness and creativity, and he was enthralled as they worked "with all the sureness of...artists."[51] Throughout his life Strand was attracted to maestro figures, and those months at the Clinic were no different; the propensities that led Strand toward Stieglitz now drew him to the Mayos themselves, and Strand pulled strings to secure an assignment assisting one of the brothers.[52] Within those operating rooms, distinctions between surgeon's gown and artist's smock began to disappear and Strand came to believe that "the scientific and the artistic spirit are very closely related." In terms that reveal much about the emerging qualities of Strand's own aesthetic, he went on to say that science and art have this affinity because "they are both creative and impersonal." He said that "it seems to be the impersonality of the operating room that makes the unpleasant side

almost negligible," and he liked the way that "the humanity of the particular individual is lost in the problem which the surgeon has to solve—which he is to master."[53] This man who loved the sharp-edged, unsentimental images of straight photography now registered his regard for the impersonal precision of surgery; the humanity, the emotions, "the unpleasant side," all these were submerged in the intellectual exercise, became "lost in the problem"—and that problem was not just solved, it was mastered.

Once the Clinic staff recognized Strand's aptitude, he was allowed to propose projects, and his request to photograph actual surgeries in the operating room was granted. "The idea is pregnant with the greatest [potential]," he told Stieglitz,[54] and he began fussing over technical details—of course there would be plenty of light, but a good view might be difficult in the cramped quarters. Finally the anticipated day came and Strand "made some exposures of Dr. Charles Mayo doing a cancer operation—and had a great time."[55]

Strand was, in the terminology of the 1930s, a mind worker, and that was in part why he enjoyed the Mayo Clinic so much. Medicine's appeal lay more in the probing and understanding offered in the surgical theater than in the care-giving provided on the wards, and as he told his parents, "I know I could more easily be a surgeon than a nurse—because ideas interest me more than the routine of bringing people back to health."[56] Strand's equation here between surgery and the mind is not a fully apt one—dexterity matters in the operating room—but the dichotomy between ideas and routine was important for Strand, and at the Mayo Clinic he found that stimulating the mind was greater pleasure than salving the body.

But once he left Rochester, Strand's choices became less interesting and the body proved impossible to deny. He was shipped out to a filthy Army hospital in Minneapolis where his assignments were monotonous even by Army standards. Things grew worse at the end of 1918 when Strand himself became a patient in the hospital—a victim of the great influenza epidemic that had spread from the western front, where it accounted for more than half of the American war deaths, and then to the United States with the same devastating consequences, causing an estimated half million deaths. Randolph Bourne was among the dead, expiring on December 22, and for a time Strand's own condition appeared so serious that his parents were notified and they rushed to his Minneapolis bedside. When his crisis passed Strand was granted a recuperative furlough, and plans were made for the entire family to go back to New York.[57] But then his mother came down with the flu, her condition turned grave, and Strand—the probable source of her infection—told Stieglitz that "I feel almost like a murderer…ghastly."[58] She died a few days later.

Later in his life Strand remarked that World War I produced "many casualties."[59] Some were naturally to be expected in the course of battle, but what seemed most disturbing was how many of those casualties were non-combatants—291, *The Seven Arts*, Bourne, and Strand's own mother. Strand never saw combat, nor the death of a comrade, and his time in uniform was brief. Still, by the time his hitch was up in August 1919, Paul Strand had had his share of loss, seen his allotment of suffering, and acquired his own measure of guilt ("almost like a murderer"). There were plenty of rougher war experiences, but Strand's was rough enough. His few consolations had been at the Mayo Clinic, where he had come to think of creativity as impersonally cool, intellectually driven, and surgically probing.

1. There were at least three eulogies. The first was Paul Strand, "Alfred Stieglitz: 1864-1946," *New Masses* 60 (August 6, 1946), 6-7. He also gave a speech in Chicago—Paul Strand, "Life and Work of Alfred Steiglitz," September 23, 1946; transcript, VSC/CCP. In turn, that speech was the basis for Paul Strand, "Steiglitz: An Appraisal," *Photo Notes* (July 1947), 7-11 (originally in *Popular Photography* 21 {July 1947}, 62ff).

2. Strand, "Alfred Stieglitz: 1864-1946," 7.

3. Maria Morris Hambourg, *Paul Strand: Circa 1916* (New York: Metropolitan Museum of Art, 1998), 12-13.

4. Alan Trachtenberg, *Reading American Photographs: Images as History, Mathew Brady to Walker Evans* (New York: Hill and Wang, 1989), 192-93. See also Maren Stange, *Symbols of Ideal Life: Social Documentary Photography in America 1890-1950* (New York: Cambridge University Press, 1989), 47-87; Lewis Hine, "Photography in the School," *Photography Times* 40 (August 1908), 227-32; Lewis Hine, "The School Camera," *Elementary School Teacher* 6 (1906-7), 343-47; Miles Orvell, "Lewis Hine: The Art of the Commonplace," *History of Photography* 16 (summer 1992), 87-93; Peter Seixas, "Lewis Hine: From 'Social' to 'Interpretive' Photographer," *American Quarterly* 39 (Fall 1987), 381-409.

5. Naomi Rosenblum, "Paul Strand, The Early Years, 1910-1932," PhD Dissertation, City University of New York, 1978, 23-41. Paul Strand, "Life and Work of Alfred Stieglitz." Paul Strand, "Art in New York," transcript of radio interview over WNYC, April 25, 1945, PSC/CCP. Paul Strand, "Photography to Me," *Minicam Photography* 8 (May 1945), 44. Sarah Greenough, "An American Vision," in *Paul Strand* (New York: Aperture, Washington: National Gallery of Art, 1990), 165 n22.

6. PS to Matilda Strand (his mother), April 25, 1911, PSC/CCP. Sarah Greenough, "An American Vision," 34-5.

7. PS to Matilda and Jacob Strand, April 4, 1911, PSC/CCP. PS to Matilda Strand, April 19, 1911, PSA/CCP.

8. PS to Matilda Strand, May 3, 1915, PSC/CCP.

9. Paul Strand, "What was 291?" October 1917, unpublished manuscript, PSC/CCP. Strand, "Photography to Me," 44.

10. Strand, "Life and Work of Alfred Stieglitz," 7. Rosenblum, "Paul Strand," 48-9.

11. Calvin Tomkins, *Paul Strand: Sixty Years of Photographs* (Millerton, NY: Aperture,1976), 19.

12. PS to Walter Rosenblum, May 21, 1952, in Rosenblum, "Paul Strand," 47.

13. Strand, "Photography to Me," 46.

14. Strand, "Art in New York." Also Nancy Newhall, "Paul Strand: Photographs, 1915-1945," (1945), in Nancy Newhall, *From Adams to Stieglitz: Pioneers of Modern Photography* (New York: Aperture, 1989), 73.

15. Alfred Stieglitz, "Photographs by Paul Strand," *Camera Work* 48 (October 1916), 11-12. See also AS to R. Child Bayley, April 17, 1916, ASA/YCAL.

16. AS to R. Child Bayley, April 17, 1916, ASA/YCAL.

17. Charles Caffin, "Paul Strand in 'Straight' Photos," *The New York American* (March 20, 1916), 17; here from Stieglitz's reprinting in *Camera Work* 48 (October 1916), 57

18. Stieglitz, "Photographs by Paul Strand," 11-12.

19. Alfred Stieglitz, "Our Illustrations," *Camera Work* 49/50 (June 1917), 36.

20. Paul Strand, tape-recorded interview, November 1971, interviewed by Milton Brown and Walter Rosenblum (Archives of American Art, New York), in PSC/CCP, 3.

21. Ibid.

22. Stieglitz, "Photographs by Paul Strand," 11-12.

23. Paul Strand, "Photography," *Camera Work* 49/50 (June 1917), 3.

24. PS to AS, August 28, 1916, ASA/YCAL.

25. AS to R. Child Bayley, November 1, 1916, ASA/YCAL.

26. Rosenblum, "Paul Strand," 57. Alvin Langdon Coburn, "The Future of Pictorial Photography," *Photograms of the Year 1916* (London: Hazel, Watson & Viney, Ltd, 1916), 23.

27. John Pultz, "Cubism and American Photography," *Aperture* 89 (1982-83), 58.

28. Quoted in Rosenblum, "Paul Strand," 65-67, from Rosenblum's interview with PS, July 6, 1975.

29. Sally Stein, "'Good Fences Make Good Neighbors,' American Resistance to Photomontage Between the Wars," in Maud Lavin, et al., *Montage and Modern Life* (Cambridge, MA: MIT Press, 1992), 129-189.
30. Strand, "Photography," *Camera Work* 49/50 (June 1917), pp 3-4.
31. GOK to PS, June 25, and July 23, 1917, PSC/CCP.
32. Ibid., October 24, 1917, PSC/CCP.
33. PS to AS, May 26, 1918, ASA/YCAL. PS to AA, May 23, 1918, ASA/YCAL.
34. See Strand's poem of June 1, 1918 included in letter of that date to AS, ASA/YCAL. PS to AS, May 29, 1918, ASA/YCAL.
35. The poem itself, "Sunset," has not survived, but Strand sent it to Herbert Seligmann, who was, as he said, a good reader of Strand's moods; Seligmann said that the conclusion reminded him of these lines for William Ernest Henley's poem, "Invictus." Herbert Seligmann, to PS, August 18, [1918], PSC/CCP.
36. GOK to PS, June 12, 1917, fourth letter of this date. PSC/CCP.
37. The piece was "Photography," which *Camera Work* simply reprinted.
38. GOK to PS, July 24, 1917, PSC/CCP. Randolph Bourne to PS, August 16, 1917, PSC/CCP. Randolph Bourne, "Below the Battle," *The Seven Arts* 2 (July 1917), 270-77; here from Carl Resek, ed., *War and the Intellectuals: Essays by Randolph S. Bourne* (NY: Harper and Row, 1964), 15-17.
39. PS to AS, July 3, 1917, ASA/YCAL.
40. AS to PS, August 22, 1918, PSC/CCP.
41. Strand, "Life and Work of Alfred Stieglitz." The record is silent on *Camera Work*; its last issue appeared in April 1917, but there is no indication that Strand believed the war was responsible for its demise.
42. Strand, "What was 291?" 7-8.
43. PS to Matilda and Jacob Strand, December 21, 1918, PSC/CCP.
44. Ibid. PS to AS, October 22, 1918, ASA/YCAL.
45. PS to AS, November 3, 1918, ASA/YCAL.
46. PS to Jacob and Matilda Strand, November 12, 1918, PSC/CCP.
47. PS to Matilda and Jacob Strand, October 14, and October 16, 1918, PSC/CCP.
48. Ibid., October 25, 1918, PSC/CCP.
49. PS to AS, November 3, 1918, ASA/YCAL.
50. PS to Matilda and Jacob Strand, November 12, 1918, PSC/CCP.
51. PS to AS, November 3, 1918, ASA/YCAL.
52. PS to Matilda and Jacob Strand, November 28, 1918, PSC/CCP.
53. Ibid, October 25, 1918, PSC/CCP.
54. PS to AS, November 25, 1918, ASA/YCAL.
55. PS to Matilda and Jacob Strand, November 25, 1918, PSC/CCP.
56. Ibid., October 25, 1918, PSC/CCP.
57. PS to AS, January 24, 1919, ASA/YCAL.
58. Ibid, February 6, 1919, ASA/YCAL.
59. Strand, "Life and Work of Alfred Stieglitz."

7. MATERIALISM

During the 1920s Paul Strand charted out the general course that he followed for much of the remainder of his career. These were also emotionally satisfying years during which Strand acquired a spouse and a livelihood, both of which proved supportive of his blossoming artist's life. At an early point in that growth, Strand gave deep and serious thought to the nature of photography and to the relationship between photographs and the subjects that they represent. Drawing upon his experiences at the Mayo Clinic, Strand worked his way toward what could be called an objective, corporeal, or materialistic aesthetic, a kind of investigatory photography that was sometimes exploratory and at other times analytic. Although Strand never quite said that this emerging orientation was a rebellion against Stieglitz, his outlook set him apart from Stieglitz's romanticism and Bergsonian sense that art was a subjective encounter with a spirit-infused world. Unlike Stieglitz, and the younger art photographers Edward Weston and Ansel Adams, Strand insisted upon photography's secularity.

But none of this meant that Strand came dispassionately to his photography. During the early part of the 1920s he created images that were excited explorations of beloved individual subjects. That enthusiasm continued into the later part of the decade as he began to look at the interconnections between those separate subjects. At first he considered natural processes linking the landscape and its denizens, and then went on to a more sociological outlook as he photographed the historical and cultural forces that helped to shape human communities. Eventually, Strand's eagerness became tinged with wistfulness, a melancholy sense of distance from the communities he photographed.

Once discharged from the Army, Strand returned to New York and photography. He picked up again with Stieglitz, apparently accepting the reality of the Stieglitz-O'Keeffe relationship as well as the overt intimacy of Stieglitz's images of her. By the spring of 1920, Strand was romantically involved with Rebecca Salsbury, who had also attended Ethical Culture School. Like Strand, she was mature (28 to his 29), unemployed and at loose ends when they met. She was intelligent and creative, uninhibited and vivacious, capable of posing for Stieglitz's starting nude photographs (fig. 4.7) or challenging Strand to a game of mumbletypeg.[1] They married in January 1922.

She moved quickly into Strand's circle. Rebecca Strand had artistic goals of her own, and was welcomed at Lake George where Stieglitz photographed her. She also accompanied Strand as he vacationed with other artists, and was for a time O'Keeffe's traveling companion. As always around Stieglitz, maintaining one's independence was a project, and there was the danger that the Strands might disappear into ghostly reflections of the more famous couple. Rebecca recognized the danger quite early and cautioned Paul that he was "absorbing too much of Stieglitz." He

would have done well to heed her warning, and so perhaps have avoided making portraits of his wife that were painfully derivative of the Stieglitz-O'Keeffe series.[2]

But in another of his choices, Strand ventured where Stieglitz never went. He took up film. In this, Strand shared a growing interest with other innovative younger artists such as Marcel Duchamp, who in 1922 told Strand that "moving pictures is my dada now."[3] Strand himself collaborated with Philadelphia photographer Charles Sheeler in the making of a nine-minute film entitled *Manhatta*, shot in 1920 and premiering in 1921.[4] The film's title was derived from Walt Whitman's 1860 poem, "Mannahatta," as was its romantic appreciation of New York; but Strand and Sheeler contributed a modernist perspective achieved with high camera angles.[5]

Strand most likely regarded *Manhatta* as a pilot or what he called "an entering wedge," and said that "if we can get into the field at all the film will have done its work."[6] The "field" that Strand had in mind was commercial film, but not mainstream box office movies. Instead, he envisioned more narrow niche films, such as medical training films that might benefit from his Mayo Clinic experience, or athletic training films that he could sell to team owners.[7]

In the summer of 1922 Strand scraped together the funds to purchase a costly and highly adaptable Akeley movie camera. Thus outfitted, Strand became an independent movie contractor, taking jobs wherever he could find them and joining with other Akeley photographers to set a uniform fee schedule. The work was diverse, extending beyond sports to include newsreels, weddings, and even the laying of water pipe. The work was also demanding, for the gear was heavy, the weather sometimes foul, and paperwork always insistent. Eventually it provided a good living, but Strand's first love remained still photography: virtually the first thing that he did once he purchased his new movie camera was to make a series of eloquent still photographs of it (see figure 7.1).

Strand also wrote about still photography with particular seriousness from 1921 to 1923. He hoped to produce a book about aesthetics and photography, and as he worked his way toward that larger goal he wrote five major articles, a short story, a humorous essay, and a number of substantial letters-to-the-editor.[8] Although the book was never realized, this project was a studied attention to aesthetics, a more thorough and thoughtful effort than Stieglitz ever attempted.

Some of the writing is weak. Strand had no formal philosophic training, and he always worked better in visual than print media. He never seems to have settled upon the overall structure for his work, and his criticisms of mainstream culture were as ill-willed as the Babbitry he deplored; his *ad hominem* attacks were so bitter that readers and editors alike were inclined to see him as an eccentric crank.[9] But although Strand could be sophistic, tendentious, and petty, he was also humorous, ingenious, and intelligent. When he moved beyond a dogmatic celebration of the Stieglitz canon, he crafted creative treatments of large epistemological and representational issues, and he also brought this theoretical work to bear upon his own camera work.

Strand took his model from science, even though his exposure to actual science had been minimal. Very little, if any, of his reading ventured into fields like physics or chemistry, and he had nothing like Stieglitz's German laboratory experiences. Medicine was about as close as Strand ever came to science, and he believed that at the

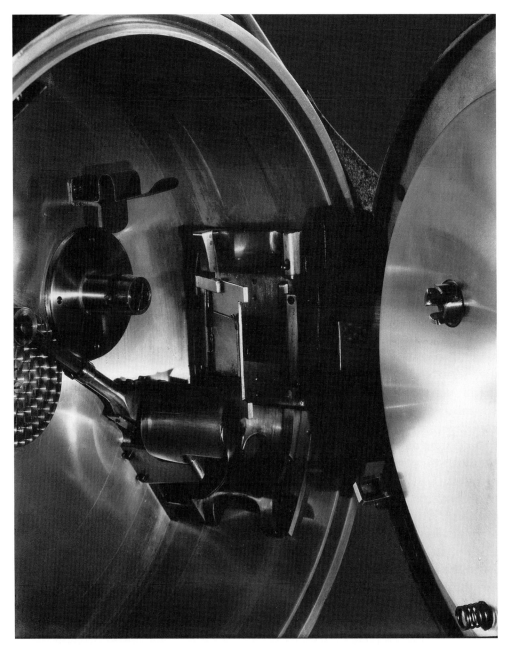

7.1. Paul Strand. *Akeley Motion Picture Camera, New York, 1923*, © 1971, Aperture Foundation Inc., Paul Strand Archive.

Mayo Clinic he had seen the work of true scientists laboring away with seriousness, rationality, and objectivity. That last quality, objectivity, was particularly significant for Strand, and the term had occasionally surfaced in his pre-war statements. He used "objectivity" not only in reference to dispassionate and unbiased procedures, but also to describe the outlook which characterizes events as having material rather than supernatural causes. When his mother lay in her death struggle with influenza, for

instance, Strand said that he had "an absurd desire to pray to something," an urge he fought back because "I know its a fight between vitality and those damnable germs."[10]

Scientific inquiry approached things directly and honestly, and Strand believed that these were among photography's strongest qualities. He thought straight photography was especially good in this regard since it worked with "no tricks of material, no diffusion or evasion of the objective world."[11] Accordingly he praised the photographer who could work with "a full acceptance of the thing in front of him."[12]

But this did not mean that Strand thought the photographer was powerless before the things he photographed. In the very same sentence where he said that the photographer "can never evade" the external order, Strand also insisted that the outside world had an "objectivity which the photographer must control." Strand's photographer accepted the world, yet was decidedly not its passive transcriber, and he admonished photographers that confrontation and control were necessary dimensions of photography. "You must," he told them, "use and control objectivity through photography."[13] Thus there was a careful balance to all this, for too much control or manipulation of the image would violate the object, and yet too much regard for the object could lead to simple transcription and a forfeiture of artistry.

Metaphor seemed one particular threat to that balance. For Strand, metaphor damaged the object by applying an external reference to an object and by failing to accept the object as itself. One could, for instance, photograph a young woman and accept her for what she was; or one could proceed as pictorial photographers did, giving her a virginal rendition and setting off a chain reaction of associations from virginity to purity to goodness, abandoning the actual person in a climb up Plato's ladder. Making comparisons of this sort was unwarranted, Strand believed, for metaphor wrapped too much around the object. Women should be women, apples should be apples, and both should be spared extraneous Edenic associations. Without disciplined use, words broke loose of their objects and floated into all sorts of inappropriate attachments—a problem that may well be as old as language itself, but, for Strand, it was a problem that seemed to have blossomed into a veritable epidemic in the 1920s. "One of the obvious facts of our time," he said, was "the almost complete dilution and vitiation of language" and he believed that through "indiscriminate use and perversion, words, concepts and ideals" had lost much of their ability "to image or communicate objective realities."[14]

Some of this sounded like Stieglitz, and during the early 1920s both men took stands against metaphor. But not quite in the same way. This was the period when Stieglitz began making his Equivalents. These cloud pictures were not metaphors, for Stieglitz did not *compare* the clouds to his emotional state; they were (he insisted) *the same as* that state—*identical* in ways that even most heartfelt metaphor ("a mighty fortress is our God") never assumes. Strand, though, went a step further. He believed that a good photograph should not make any associations with something beyond its frame. Accordingly, as photo-historian Nancy Newhall reported, "for the 'Equivalents' Paul had nothing but contempt." In Strand's view, those photographs had nothing to do with anything else, such as Stieglitz's emotions. "They are cloud photographs and nothing else," he said.[15]

Of the two men, Strand was much more the materialist. His concern for the object and his respect for science were part of his larger determination to look only

in this world for his explanations or for his art. Although Stieglitz was not religious in any ordinary sense, he still peppered his conversations on photography and art with references to transcendent forces and pervasive spirituality. In contrast, Strand was determined to keep his discussions rooted in the here and now, and a fair portion of Strand's thinking about photography might be best described as an atheistic aesthetics.

Strand had an almost visceral reaction against miraculous creation. Perhaps he arrived at this more from his work habits than any theological study, for as he described the production of his art, there was no genius-like moment when art was willed into existence; instead the making of a photograph was a set of step-by-step processes of his own doing and without any boost from muses or miracles.

In a broader perspective, Strand thought of religion as little more than an outworn, cumbersome, and obstructive fiction. He knew something of Nietzsche, shared Nietzsche's genealogy of religion, and sometimes even sounded like Nietzsche. Strand wrote that "man having created the concept of God The Creator," it was therefore man and not God who was the source of Western religions; humans had simply concocted myths and rituals to explain the unknown and to assuage their fears.[16] Religion seemed a head-in-the-sand effort to avoid reality, and Strand had particularly strong feelings against "the old generalized repudiation of 'the world,' which is part and parcel of Christian dogma." He insisted that we "cannot evade…everything that goes to make up empirical experience,"[17] and with conscious irony, Strand called Christianity immoral, for with its bias against the physical, Christianity befouled "the innocence of the senses."[18] In this way there was a sort of epistemological waywardness to Christianity, something Strand thought he also detected in a romantic "mystical streak" in people like Waldo Frank and Paul Rosenfeld.[19]

For Strand, reality was made of matter, not ideas. But this was strictly philosophical materialism, and Strand made it clear that he was not a "materialist" in our everyday sense of the phrase. He opposed greed and selfishness just as much as he opposed idealism. As Strand told Sherwood Anderson, he was horrified by "the crassness and brutality of the American scene," and by "the increasing ruthlessness of the material drive."[20] When Strand took the moral pulse of the nation, it seemed to him that laissez-faire greed had supplemented the Christian creed, and that both of them were epistemological failures. While one "insists upon measuring all reality in terms of sin and salvation," the other does its measuring "in terms of money and money power."[21]

As Strand brought these ideas to bear upon photography, he concentrated on one particular kind of object, the machine. In a 1922 essay, "Photography and the New God" (1922), he employed a running analogy of the machine as civilization's new God, a "God the Machine" that had replaced an older "God the Creator." Strand probably borrowed much of his structure from the enigmatic Herman George Scheffauer, who two years earlier had described an evolving set of attitudes toward the machine, saying that people first regarded it as their slave, then as master, and finally even worse—their god.[22] Strand continued from there, saying that the technologies unleashed in the recent war showed that humanity faced "the alternatives of being quickly ground to pieces under the heel of the new God."[23] But Strand thought that the photographer showed how one could retake command

through what he called "the immense possibilities in the creative control of one form of the machine, the camera." In this way Strand described the photographer as a kind of atheistic redeemer, or a theocide of sorts who took the new God of the machine, left it "shorn of its God-hood," and used it as an instrument it for expression or knowledge, and not for mysticism or aggrandizement.[24]

Strand's dislike of the old God of religion was sincere, but his anxiety over this new machine god was feigned. He was more interested in explicating photography than subduing machines. If anything, Strand liked machines (especially the camera—understandably so), and he criticized people who feared machinery. He believed that Thoreau had been too ambivalent about machinery, and instead thought that the rail lines which cut through Walden Pond and elsewhere were actually something to celebrate, indications that humans had "harnessed the machine" within a web of rails.[25] Like his contemporaries Lewis Mumford and Van Wyck Brooks, Strand granted that the machine was something new on the cultural landscape, but Strand shared very little of these other thinkers' apprehension. Instead he was inclined to share the favorable orientation of precisionist artists like his friend Charles Sheeler, who enthusiastically painted and photographed machines.

Strand's affection for machines found expression in his photography. He allowed that machines seemed to him "not only useful, but also beautiful." The forms, surfaces, and lines attracted his eye, and so he was drawn "to photograph the power and marvelous precision" of their shapes.[26] Prior to this time there had been only a few machine images in his portfolio, images eclipsed in the 1920s by his striking photographs of his Akeley camera, a series that he began during the summer of 1922—the same year that "Photography and the New God" was published. *Akeley Motion Picture Camera, New York* (1923; fig. 7.1) is one of these photos, and it is a gleaming, glowing image; others in the series show the camera closed, but here it is open, really open, so that we see not just a spring, a clip and an armature, but also the shutter itself. Lovingly, splendidly the photograph pauses over the parts and pieces. Arguably the machine here may be a fetish object, but assuredly it is not a threatening New God. Strand worked hard on his Akeley images, sometimes exposing for as long as a half hour, and he liked what he got. So satisfied was Strand that he sought out the Akeley factory and there photographed still other machines, the progenitors of his camera: a lathe, a drilling machine, or even something simply entitled *Machine, Akeley Shop*.

Photography offered hope, and hope without a New God. As Strand looked at his era, there seemed too little optimism and too many sullen new gods on the landscape. William Butler Yeats offered up but one example with his 1924 poem, "The Second Coming," with that infamous rough new deity slouching towards Bethlehem. Strand admitted that the misplaced materialism of war and business had made a mess of things, yet he had some confidence that the useless old gods had really died. The Enlightenment and science seemed to have destroyed religion, and he hoped that a similarly mystical "art" had followed it to the grave: "Perhaps 'art' died with God." He was also hopeful that "a more vivid, more realistic and living thing . . . is already growing out of the ashes of a smoldering world." In Strand's scenario, photography would have a leading role in the development of that more vivid realism.[27] God and "art" were dead, greed and war had scorched the earth, and what the future needed was an unmystified way to observe and appreciate

shape and form and objects. Photography provided this. Rather than slouching and rough, this was a dry-eyed medium striding off promisingly, leading the way towards a material, nonutopian future.

During the 1920s Strand not only worked his way toward a materialistic art theory, he also put these ideas to work in his photography. He thought that differentiation and detail helped art reflect the material uniqueness of individual real-world objects, and he said that painter John Marin accomplished this superbly with a "particularized awareness" of real-world skyscrapers and seascapes. This was particularization, in that one sought to convey the subject's smallest particle, what Strand called the "atomic uniqueness" or "atomic reality of the object."[28] Of course this was exaggeration, for Marin never painted atoms nor did Strand attempt to photograph them. But his point was that subjects have a uniqueness arising from their physical constituents, and he thought that good images should convey those particularities.

Strand further believed that art should be penetrating as well as particularized. He wanted an art that got below the surfaces of things, and repeatedly used the term "penetration" (or some derivative) for this aesthetic of a piercing and revealing vision. He had begun to move in this direction during the war, when the X-ray work had proved so compelling and he had reported his pleasure that X-rays allowed him "to see kidney stones—enlarged heart, etc."[29] Similar concerns had been part of the atmosphere at 291, where Stieglitz had spoken of "digging into that centre's centre," and where de Zayas praised "the camera as a means to penetrate the objective reality of facts."[30] And now when Strand wrote about Marin in 1921, he praised this painter as one who had managed an "imaginative penetration of reality."[31]

Photographic penetration was a big part of Strand's Akeley images. Almost from the very start, it seems, his impulse was not just to photograph the camera, but to photograph its *interior*: "I opened it up to load it and saw how beautiful it was inside, so I said I have to photograph it."[32] He may not have caught the atomic structure of the steel in Figure 7.1, but he certainly captured steel's sheen, and by carefully placing that shutter right in the very center of his image, Strand arguably penetrated to the very innermost mechanism of the camera. Probing into the laid-open camera, Strand demonstrated that its inner qualities were free of the hocus pocus of mysticism and that they were instead wonderfully mechanical and material.

But Strand wanted to do more than peer profoundly into the inner workings of things. He also wanted to understand the origins of his subjects. He said that a good portrait shows both a person and "the causative forces" behind that person, and he thought that a good landscape image likewise managed "to register the forces which animate" the given scene.[33] Where his talk of penetration and particularization had an analytic emphasis, this focus on process was more synthetic. He was inclined to describe the present as a synthesis or culmination of past circumstances, and spoke of how the actuality of contemporary subjects was full of future potentiality. Such notions echo the ideas of Aristotle and Hegel, though Strand knew them, if at all, only at second hand. But this mattered little, for Strand was not too worried about the antecedents for his thinking here; he *was* concerned about the material antecedents of the subjects he photographed. Strand's machine photography demonstrated some of this concern for origins. His pictures of the Akeley seemed incomplete without some

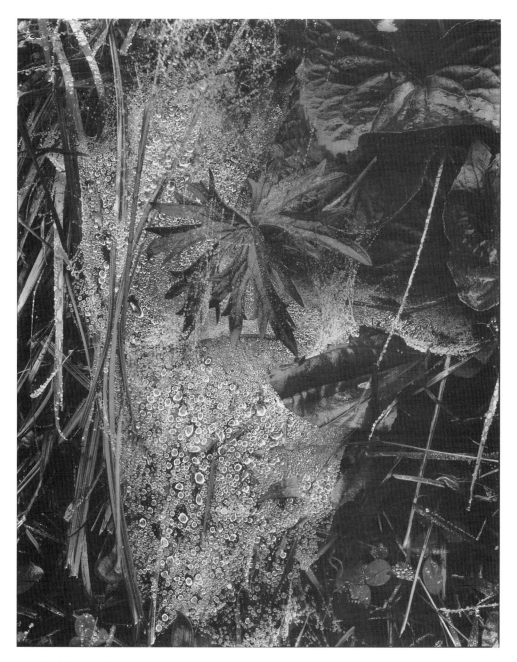

7.2. Paul Strand. *Cobweb in Rain, Georgetown, Maine, 1927*, © 1950, Aperture Foundation Inc., Paul Strand Archive.

attention to the camera's sources, and photographically interpreting the camera seemed incomplete with out photographing its material causes. Accordingly he visited the Akeley factory and photographed its lathes.[34]

For the remainder of the decade following those 1922-23 machine images, Strand photographed a more fluid, organic set of subjects. His treatment changed

too, as he became less a visual dissector or penetrator of solitary subjects, and more an examiner of those subjects' origins and relationships to their environment. This transition took some time, and it was not until around 1925 or so that Strand launched confidently into this new work (and also abandoned his book project).

Strand ranged outside New York, visiting the mountains, woods, and seashore. During these trips, he began to make images exploring dynamics and shapes that flow; the patterns within his images remained complex and vigorous, but the complexity became one of organic curves rather than machine geometry. Also, it was process more than movement that Strand wanted to photograph, nature's slower flowings and growings as opposed to its fits and starts. This was in part why rain drops (or dew drops) became a repeated dimension to his plant images, for the jewel-like drop glimmering on the leaf suggested a cycle of replenishment and sustenance, and did so much more pleasingly than a splashy, smudgy photo of an actual downpour. In some of Strand's plant images, the drops are small, almost hidden details on an iris or fern, while in others such as *Cobweb in Rain, Georgetown, Maine* (1927; fig. 7.2), the beads of water appear throughout the image. This photo is perhaps the dampest of these images, and a favorite that Strand often included in retrospectives and collections. The rain drops here are not only vital for the continuing growth of these plants, but they also accentuate the message which some spider has left behind: all the living things of this delicate tableau are strung together by a web of interrelations.

Strand depicted other natural processes in pictures of weathered trees and roots, and he also began to move away from closeups and work with the broader landscape. Some of his early landscape efforts came in 1926 when he and Rebecca traveled to Colorado and New Mexico for the climate that they hoped would cure her apparent tuberculosis.[35] The air may have been good for Rebecca, but it was the view that captured Strand, and his correspondence erupted with ardent enthusiasm for the Southwestern landscape. He gushed over the vistas and cried over their degradation—the "towering rock mountains" and "flying stream," of Big Thompson Canyon marred by the hot dog stands and the motels with names like Wanda Inn.[36] It would be some time, though, before Strand converted his enthusiasm into successful photographs. In 1929 he first made an extended series of landscapes on Quebec's Gaspe Peninsula, and thereafter concentrated on the desert Southwest. In 1930, 1931 and 1932 the Strands were in Taos, New Mexico for visits that were initially summer vacations but which eventually stretched to six-month stays involving plenty of photography.

In this manner Strand spent more and more time away from New York. Malcolm Cowley once noted a general exodus as 1920s' intellectuals left New York for the Catskills or Bucks County, but Strand was part of a more specific movement to the Southwest, especially the area around Taos and Santa Fe. Attracted by the cheapness of the living, the distinctiveness of the culture, and above all the starkness of the visual setting, painters, writers, and photographers had created a thriving artists' colony in northern New Mexico. There were writers like D. H. Lawrence among those creative people, but the area held a particularly strong fascination for visual artists connected with Stieglitz—not only did O'Keeffe and Strand work in the area, so did John Marin and Ansel Adams. All these people at some time encountered Mabel Dodge Luhan, whose boozy parties set a certain tone for social life in the growing colony. Strand was not entirely aloof from other goings-on (Adams remembered

one day of Southwestern-style recreation when he and Strand "motored down to Santa Fe together and shot at tin cans with a revolver on the way"[37]). But he seems to have been exceptional in his absorption with his work and his disinterest in partying. Photographer Dorothea Lange, also working in Taos at the time, remembered Strand in Taos as unique, a "very sober, serious man...so methodical and so intent."[38]

Some of Strand's intensity was a response to the challenges of the New Mexico landscape. For Strand and other Easterners, the Southwest's vastness was both impressive and difficult, because in this land where roads might run straight for dozens of miles, and where far-off mountains appeared quite close by, scale and proportion became problematic. Strand's friend, the art critic Elizabeth McCausland, grappled with "the spatial zeitgeist of New Mexico," until she finally surrendered and confessed that "the world stretches wider here than the mind can encompass." Strand, too wrestled with the vastness, and it was only at the end of his second year in Taos that he felt he had achieved some mastery over it.[39]

In that landscape photography, Strand sought to integrate sky with soil, to tether heaven and earth. In this way his project was almost the opposite of Stieglitz's Equivalents, which increasingly cut the sky loose from earthly referents. But Strand complained that a "picture goes to pieces" when the sky and land had no relationship to each other, when one appeared monotonous and empty while the other is varied and full. Working there in New Mexico, Strand found that "the solution of this problem lies in the quick seizure of those moments when formal relationships do exist between the moving shapes of sky and...or land."[40] In other words, one needed to photograph quickly when the sky contained clouds that complemented or opposed shapes below them.

It took him some time to achieve the integrated landscape photography he wanted. In early photos a horizon line slices the bottom quarter of the image off from the rest, and clouds are blotchy, undigested billows in the sky. By 1932, though, Strand was much more successful, and with the photograph *Rinconada, New Mexico* (1932; fig. 7.3) he achieved something that gave him lasting satisfaction. In this image there is no straight horizon, but rather the border between earth and sky is formed by undulating bluffs in the middle distance. The two rock shoulders, symmetrically arranged one on the left and one on the right, form a natural frame within Strand's own frame, a basin that seems to embrace and hold the sky rather than separate it off from the ground. That unity is further enhanced by the complementary shades of sky and earth; both contain light and dark, and those brilliantly lit cliffs, swollen on the right and tapering toward the left, are repeated in the white clouds above them.

But white clouds are not the only ones in *Rinconada, New Mexico*. In the middle left, and again on the upper right are darker, closer ones, and they help to account for much of the effectiveness of this photograph, for their darkness repeats the darkness of the desert below. Strand realized that white, puffy clouds did not always fit with his project of integrating sky and land, for the earth could offer nothing similar; one of Strand's contemporaries remembers him cursing the brilliant and billowing clouds that appealed to Ansel Adams—Strand dismissed them as just too cottony, "Johnson & Johnson" clouds.[41] Instead, Strand sought out other kinds of clouds in the desert, low, heavy ones like those of one particu-

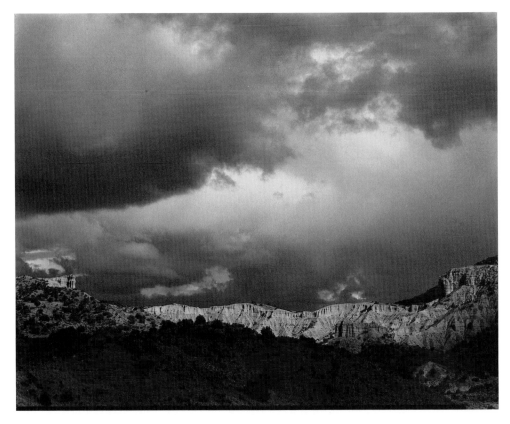

7.3. Paul Strand. *Rinconada, New Mexico, 1932*, © 1971, Aperture Foundation Inc.,
Paul Strand Archive.

larly memorable evening: "great black storm clouds coming this way over Taos mountain—thunder rumbling, sudden gusts of wind make the trees sound like rushing water."[42]

Such sudden storms were, for Strand, part of Taos's allure. Taken together with the sun's baking calm, they made the country "beautiful in serenity and in violence."[43] This contrast, that lurking potential for an abrupt eruption, was a promise of excitement, and a dose of apprehension that thrilled Strand and kept him attached to New Mexico; in this "strange and miraculous country," he told Stieglitz, there was "everyday brilliant sun and this black violence usually somewhere on the horizon."[44] Such storms also underscored that the desert landscape was a grand work in progress. "The black area of the rain, clearly defined as tho cut with a knife," would slice through the fragile arid soil, turning roads into swamps, gullies into roaring rivers, and giving vivid testimony to the forces that shaped the face of the New Mexican earth.[45]

Over time Strand's interest in process and context developed a cultural dimension, and he began to assess human communities as well as the natural landscape. Strand had made images of people prior to the war, but now he edged away from closeup portraits like *Blind Woman* (fig. 6.2) and turned

instead to the social contexts in which people lived. He began to speak of "the naked vitality in the American rhythm,"[46] and to say that it was an artist's duty to work among her or his own; he excoriated John Singer Sargent as one who traveled "about the world to record . . . places in which he has not really lived,"[47] and James McNeill Whistler, as one whose "expatriate perceptions . . . become more and more esthetically remote."[48]

With this interest in things American, Strand shared some of a broader cultural search for a usable past which preoccupied Van Wyck Brooks and other intellectuals of the time.[49] It was with considerable interest that Strand read contributions to the genre such as Waldo Frank's *The Rediscovery of America* (1929) and Sherwood Anderson's *Dark Laughter* (1925). But for all Strand's respect for these other thinkers, during the 1920s he was less interested in exploring American peculiarities than he was in observing how American places and American peoples had come together over time.[50] He called for artists to show the "extensive integrations" of American life in the same way that his cobwebs and rain photo showed the interlinkages on a forest floor. As he looked at his contemporaries, Strand thought that Marin had brilliantly accomplished just this kind of integration, saying that Marin's paintings showed "relationships between things and things, between people and things, between people and people are . . . interdependent in their particularity, and not . . . isolate[d], fragmented and discontinuous."[51]

Strand watched as other authors and artists of the 1920s assessed those relationships with multi-image portraits, and he considered their work as models for his own project. There was of course Stieglitz's ongoing portrait of O'Keeffe, and also literary composites such as Paul Rosenfeld's *Musical Portraits: Interpretations of Twenty Modern Composers* (1920). But Strand found more inspiration in Sherwood Anderson's *Winesburg, Ohio* (1919), which he thought was strong, sensitive, and beautiful.[52] Anderson's book naturally resonated with the photographer, for it is a collection of vignettes connected by location rather than narration, and does not reach a resolution; the effect is rather like a gallery of still photographs taken in a single a small town.

An even more direct influence was *Spoon River Anthology*, by Edgar Lee Masters (1914, with a sequel in 1924), which Strand said he encountered around 1926. Masters created a series of free-verse monologues in which the ghosts of Spoon River recollect lives of meanness and bigotry, lives that stand in marked contrast to the official pieties of their gravestone epitaphs. In these discrete but interconnected speeches, Masters showed that appearances can mask realities and that the past could have something to say to the future.

Working from models like *Spoon River* and *Winesburg*, Strand began his own creative treatment of community, and fashioned a photographic mode that lay somewhere between the anthropological and the archaeological. Strand's earliest explorations evinced an antiquarian interest, a fascination with the relics and remains of communities, and an interest in those artifacts which, like Spoon River's graveyards, stand as present witnesses of an earlier life. Photography of this sort appears to have been on Strand's mind in 1926 when he made plans for his first Southwestern trip, for he made certain to visit Mesa Verde National Park, well-known for its dramatic cliff dwellings of the ancient Anasazi. Before embarking on that trip Strand read Waldo Frank's *Our America* (1919), and had his own interests

confirmed as Frank spoke of the "buried cultures" of earlier, indigenous Americans, "the ruins of [whose] greatness... are not hard to read."[53]

Strand was apparently impressed by the greatness of Mesa Verde, for he worked fervidly, photographing ruins by day and then at night processing the images in his hotel's cellar.[54] The intensity and concentration of his effort emerge in photographs such as *Mesa Verde, Colorado* (1926), a scene of high contrast between the dwellings' very light walls and very dark interiors, and with vertical and horizontal lines reminiscent of Strand's New York architectural studies. In this image, Strand employed doorways and a window to get the effect that he had earlier achieved by opening up the Akeley, a sense that he has managed to peer deep within his subject. There seems to be a promise in the ruin, too, as though the Anasazi had left a poetic message for the twentieth century—and an enigmatic one, too, for a single dark window lends mystery to the image.

Strand's photographs of living communities were just as quiet, but less lyrical and more anthropological. In 1929, he photographed the hardscrabble fishing and logging villages of Canada's Gaspe Peninsula. One image is virtually a social map of a fishing village, with fences delineating private property, class indicated by obvious differences between upland and lowland houses, and the entire community aligned on an axis between faith and nature—upward to the church on the hill and downward to the beach and ocean.

But Strand's greater efforts and more arresting images came later when he worked in New Mexico. Around Taos, he said, there were "three distinct things... which interest me, in addition to the landscape," the region's three major ethnic communities: "the Indian quality of life—the Mexican—and those vestiges of the white pioneer."[55] In actuality, though, Strand worked very little with Indians, and had only minimal contact with them; with the possible exception of Mabel Dodge's Pueblo husband, Tony Luhan, Strand's closest interactions were with the Pueblo girl who was his servant. One of his photographs of an Apache festival neatly summarized Strand's distance from these people, for the dancers and singers all stand in a closed circle with their backs to the photographer.

Strand had more success in photographing the region's Anglo past. He was fascinated by what he imagined to be "a kind of life that once lived and lived hard in America," and the New Mexico locals fed Strand stories of those supposedly golden days, telling him how the ghost town of Red River once had fifteen raucous saloons, several booming gambling joints, and plenty of money from the mines. The thought of all this fascinated Strand, and he said that "I would like to have seen that town in its heyday and that lopsided life," a place "so raw and brutal, I suppose," with plenty of the violence to be had in a desert thunderstorm and a lot more spice than the pabulum of Strand's contemporary culture. Yet it was more than a vicarious thrill that drew Strand to photograph the likes of this ghost town. Continuing to think of himself as something of a camera archaeologist, Strand was on the lookout for "vestiges" or relics, and at one time contemplated photographing the bodily remains still cluttering a nineteenth-century massacre site.[56] Ultimately, though, it was less gruesome subjects, "the false front houses of the mining towns," that proved more appealing, and in the ghost towns of New Mexico and Colorado, Strand photographed the weathered siding, broken win-

dows and sagging roofs that to him seemed the "last traces" of western America's earlier, hard life.[57]

Part of this was familiar visual material. In "those few false fronts," with "the wood rich reds or silvery from snow and rains of the years" were subjects that had drawn his eye for a number of years. Images like *Ghost Town, Red River, New Mexico* (1930; fig. 7.4) were more closely focused versions of the treatments of weathered lumber that he had made on the Gaspe, and the strong vertical quality lent by the window and door had been one of Strand's themes since before the war. But for Strand there was more than form or texture, or even the climate, behind this knotty facade of *Ghost Town, Red River, New Mexico*. "Are the rains and snows entirely responsible for its quality of life?" he asked rhetorically, and then went on to answer himself in the negative, "I don't believe it." More than the weather, he said, it was the *character* of former inhabitants that had first shaped and then saturated these buildings, and just as he imagined that those by-gone miners had lived lives of rawboned gusto, so now the buildings "seem to me to stand there with a kind of courage and an undeniable dignity." And in *Ghost Town, Red River, New Mexico* Strand managed to convey some of those qualities, for though obviously battered about by the passing seasons, the building seems to have withstood those elements and maintained a fairly erect carriage. In this manner Strand aimed for a sort of transference in the image, a slippage from the physical qualities of the buildings that he could photograph to the characters that he imagined for the frontiersmen.

There is also a tension to the photograph, for some of Strand's nostalgia seems unwarranted. In their own day these buildings were the structural equivalent of a strip mall, thrown up quickly during boom time and then abandoned when things went bust. These stores were not much different from the Wanda Inn that he had found so objectionable. Strand knew that he had seized upon a problematic emblem for frontier integrity, for as he put it, "a false front with dignity sounds like a paradox." But nonetheless Strand stuck by his symbol. The processes that he wished to document, the effects of time and weather that had transformed the past into the present, also seemed in Strand's perspective to have had something of a meliorative effect, converting the tackiness and affectation of an earlier era into present-day solemnity and honesty.

Strand retained this architectural focus when he moved away from Anglo culture. In a land of little water and few trees, adobe is a common building material, used for homes, businesses, and churches, and the sun-dried bricks are often hand-plastered for a smooth surface affording protection from wind and water. The effect is sometimes photogenic, for with their deep openings and smooth walls, adobe structures also offer sharp and dramatic shifts between areas of light and shadow. Strand considered these adobe buildings as Hispanic contributions, what he called the "Mexican spirit" of the land. Strand photographed a good number of adobe homes around Taos. He stressed the Hispanic qualities with titles like *Hacienda* or *Mexican House*, and in others he included distinctively non-anglo features like conical outdoor ovens. He showed buildings zigging and zagging along at angles such seldom seen in Manhattan, and homes hunkering into the protective hillsides.

But it was the churches that gave Strand a way to examine the Catholicism that seemed to him yet another "Mexican" contribution to the Southwest. He pho-

7.4. Paul Strand. *Ghost Town, Red River, New Mexico, 1930,* © 1971, Aperture Foundation Inc., Paul Strand Archive.

tographed them with some of his usual touches, framing scenes through gates or doors, and accentuating details with a sky backdrop. His favorite church was Taos's Saint Francis Church, and it is easy to see the attraction, for as it appears from the rear in images like *Ranchos de Taos Church, New Mexico* (1931; fig. 7.5), this massive white bulk also has a flowing quality that arises from the original architecture and has been further rounded and accentuated by countless hands in annual re-plaster-

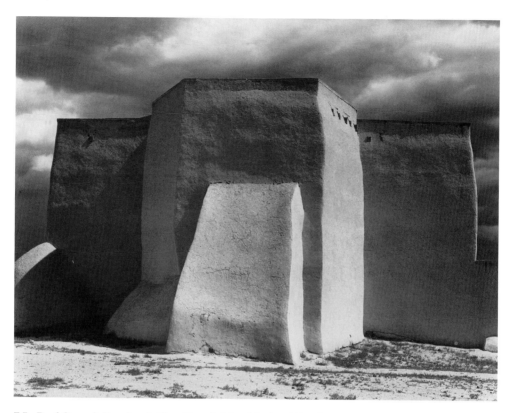

7.5. Paul Strand. *Ranchos de Taos Church, New Mexico, 1931*, © 1971, Aperture Foundation Inc., Paul Strand Archive. Courtesy George Eastman House.

ings of the exterior. Strand was not the only artist to feel the pull of this building; Ansel Adams photographed the same setting in 1929, O'Keeffe likewise painted it in 1929 and 1930, and still others have made the view almost a cliche.

In Strand's depiction the building sits between earth and sky, elevated in the frame so that it has a towering quality. Those buttresses are obviously functional and yet their tapering and undulating quality makes it seem as though they almost of their own accord grew between building and soil. The Hispanic church also has an organic asymmetry with its slightly off-square angles. It seems simple, unadorned, and unobstructed, an appearance that Strand assured when he paid a village boy to removed a couple of basketball backboards that initially cluttered the scene.[58]

Thus for Strand Hispanic Catholicism was like adobe architecture, a part of New Mexico's soil. He further stressed that integration of place and belief with the various graveyards he photographed, showing where dust had gone to dust and then been memorialized with markers hewn from native rock. Such connections between faith and place were ripe for photographic exploitation, a local version of Spoon River scenery and which he photographed repeatedly.

Perhaps part of this transition can be accounted for by the desert's peculiar cleansing effect. The regional atmosphere which for Strand transformed the avariciousness of those Red River miners into something dignified seems to have had a similar effect upon religion; and what Strand had once regarded as a mistaken per-

version now in New Mexico seemed more organic and acceptable. But Strand's transition was a matter of orientation as well as geography. In New York he had objected to religion's apparent ability to fool sophisticated people like himself with its quite unscientific assertions. But by the time Strand photographed in New Mexico, his perspective had become more anthropological, so that he worked with a kind of respect for the faith of others, and even a condescending willingness to leave primitive folks to their myths.

Strand's New Mexico work aimed to explore landscape and people, suggesting a series of connections and processes that bound all together in a material world. Some of his scenic images managed this desired integration, bringing together land and sky, serenity and tempest within a single frame, and his "Mexican spirit" images sometimes achieve an association of buildings and land. And yet this photography of the Southwest is not quite successful. Strand wanted his work to be about humans and to be of use to humans, but he seldom managed to get humans into his images; he opted instead to photograph buildings, oddly choosing to convey the qualities of dignity and courage with facades rather than faces.

Moreover, Strand's images were consistently more focused upon the dead past than in the living present. His photography had a greater resemblance to the funereal community of *Spoon River* than to the vital one of *Winesburg*. Early in the 1920s Strand had spoken of photography as a force in the present day, commending the camera as a redeeming device in a world plagued by false gods. But as the 1930s dawned, his photography had acquired an elegiac tone, becoming more of a wistful lament of things past than a force for making things happen. There is respect in this New Mexico work, yet it is admiration for ways of life that in the present had faded or become marginal, and the potentiality, especially the potentiality for a world fallen into Depression and fascism, is not apparent in Strand's Southwestern images. The boarded up towns were dead remnants, the Indians were not to be found, and the churches turned their backs to the world.

1. RSS to PS, June 15, 1920, PSC/CCP. RSS to PS, September 23, 1920, PSC/CCP. For a sketch of RSS, see Belinda Rathbone, "Portrait of a Marriage," *The J. Paul Getty Museum Journal* 17 (1989), 85-87.
2. RSS to PS, June 8, 1920, PSC/CCP. Rathbone, "Portrait of a Marriage," 84n7. Naomi Rosenblum, "Stieglitz and Strand," *Photographic Journal* 3 (May-June 1986), 12.
3. Marcel Duchamp to PS, August 8, 1922, PSC/CCP.
4. Paul Strand, press release for *New York The Magnificent*, undated typescript [c. 1920], PSC/CCP.
5. For discussions of the movie see Scott Hammen, "Sheeler and Strand's *Manhatta*: A Neglected Masterpiece," *Afterimage* 6 (January 1979), 6-7; and Jan-Christopher Horak, "Modernist Perspectives and Romantic Desire: *Manhatta*," *Afterimage* 15 (November 1987), 8-15.
6. PS to AS, August 3, 1921, ASA/YCAL. Strand and Sheeler were not alone in their praise for the city. Once Lewis Mumford bragged that he was not an academic but instead a product of "Mannahatta, my university," quoted in Lewis Perry, *Intellectual Life in America: A History* (NY: Franklin Watts, 1984), 436.

7. PS to AS, August 3, 1921, ASA/YCAL.

8. The longer pieces are:
 —Paul Strand, "Alfred Stieglitz and a Machine," New York: Privately Printed, 1921. PSC/CCP.
 —[Brooklyn Museum Review], manuscript, December 20, 1921, PSC/CCP. This was published as Paul Strand, "American Watercolors at the Brooklyn Museum," *The Arts* 2 (December 1921), 148-52.
 —"John Marin," typewritten manuscript [c. 1921], PSC/CCP. Published in abbreviated form as Paul Strand, "John Marin," *Art Review* 1 (January 1922), 22-23.
 —"Photography and the New God," *Broom* 3 (November 1922), 252-58. Here from Nathan Lyons, *Photographers on Photography* (Englewood Cliffs, NJ, 1966) 138-144.
 —"The Art Motive in Photography," *British Journal of Photography* 70 (October 5, 1923), 613-15. Here from Lyons, *Photographers on Photography*, 144-54
 —"Georgia O'Keeffe," manuscript [late 1922 or early 1923], PSA/CCP. Published in *Playboy* 9 (July 1924), 16-20.
 —"Fire," undated short story manuscript, PSC/CCP.
 —"The Artists' Home-Foundling Asylum," undated manuscript, PSC/CCP.

9. "The Art Motive in Photography: A Discussion," *The Photographic Journal* 65 (March 1924) 129-32. John Tennant to PS, May 10, 1923, PSC/CCP.

10. PS to AS, February 6, 1919, ASA/YCAL.

11. Strand, "Alfred Stieglitz and a Machine."

12. Strand, "Photography and the New God," 142.

13. Strand, "The Art Motive in Photography," 146-47. For an argument that sees Strand not as balancing between objectivity and subjecivity, but as taking a self-contradictory stand, see Estelle Jussim, "Praising Humanity: Strand's Aesthetic Ideal," in Maren Stange, ed., *Paul Strand: Essays on His Life and Work* (NY: Aperture, 1990), 184.

14. Paul Strand, "Aesthetic Criteria," *The Freeman* 2 (January 12, 1921), 425-27. Paul Strand, "The Subjective Method," *The Freeman* 2 (February 2, 1921), 498.

15. Lines from a 1959 letter by Nancy Newhall, written after she and Beaumont Newhall had visited Strand in Orgeval, France; quoted in Beaumont Newhall, *Focus: Memoirs of a Life in Photography* (Boston: Little, Brown and Company, 1993), 142.

16. Strand, "Photography and the New God," 138.

17. Strand, "John Marin," 24-25.

18. Strand to Editor [Suzanne La Follette], *The Freeman*, March 3, 1923; published as Paul Strand, "The New Art of Colour," *The Freeman* 7 (April 18, 1923), 137.

19. PS to AS, August 3, 1921, ASA/YCAL.

20. PS to Sherwood Anderson, July 20, 1920; quoted in Sarah Greenough, "An American Vision," in Paul Strand (New York: Aperture, Washington: National Gallery of Art, 1990), 50.

21. Strand, "John Marin," 24-5.

22. Herman George Scheffauer, "The Machine as Slave and Master," *The Freeman* 2 (May 12, 1920), 209.

23. Strand, "Photography and the New God," 139.

24. Ibid. 139, 142, 141.

25. Strand, "John Marin," 22-23.

26. Paul Strand, "Photography to Me," *Minicam Photography* 8 (May 1945), 86. Naomi Rosenblum, "Paul Strand: The Early Years," Ph.D. Dissertation, City University of New York, 1978, 68, 307.

27. Strand, "Alfred Stieglitz and a Machine."

28. Strand, "John Marin," 14, 11. Paul Strand, "Marin Not an Escapist," *The New Republic* 55 (July 25, 1928), 254-55.

29. PS to Matilda and Jacob Strand, November 9, 1918, PSC/CCP.

30. AS to PS, July 26, 1922, PPSA/CCP. Marius de Zayas, "Photography and Artistic Photography," *Camera Work* 42/43 (April-July 1913), 13-14.

31. Strand, "John Marin," 10, 14, 18.

32. Paul Strand, interview with Naomi Rosenblum, March 15, 1975, quoted in Rosenblum, "Paul Strand, The Early Years, 1910-1932," 165 n4.

33. Strand, "Alfred Stieglitz and a Machine." PS, "John Marin," 22.

34. Paul Strand, Tape-Recorded Interview with Paul Strand. November 1971. Interviewed by Milton Brown and Walter Rosenblum. Archives of American Art, New York, 13.

35. Harold Jones, "The Work of Photographers Paul Strand and Edward Weston: With an Emphasis on Their Work in New Mexico," MA Thesis, University of New Mexico, 1970, 89-90. Rebecca's brother actually had the disease, and traveled to the Southwest with them. It eventually became clear that Beck was not tubercular.

36. PS to AS, August 13, 1926, ASA/YCAL.

37. AA to PS, September 12, 1933, AAA/CCP.

38. Dorothea Lange, "The Making of a Documentary Photographer," interview by Suzanne Riess (Berkeley: University of California Regional Oral History Office, 1968), 138-39.

39. Elizabeth McCausland, *Paul Strand* (Springfield, Mass: Privately Printed, 1933), unpaginated. PS to AS, August 22, 1931, ASA/YCAL. Others found the distances appealing; when John Marin returned home, he complained that "the East— looks *Screened in*." John Marin to PS, September 20, 1930, PSC/CCP.

40. Paul Strand, "Photography to Me," *Minicam Photography* 8 (May 1945), 90.

41. Calvin Tomkins, *Paul Strand: Sixty Years of Photographs* (Millerton, NY: Aperture, 1976), 24.

42. PS to AS, August 22, 1931, ASA/YCAL.

43. PS to John Marin, September 28, 1930 and August 8, 1932; quoted in Greenough, "An American Vision," 42.

44. PS to AS, August 22, 1931, ASA/YCAL.

45. PS to Herbert Seligmann, July 29, 1931, quoted in Greenough, "An American Vision," 76.

46. PS to Matilda Strand, April 19, 1915, PSA/CCP. PS, "John Marin," 7, 10.

47. Paul Strand, "American Watercolors at the Brooklyn Museum," *The Arts* 2 (December 1921), 149.

48. Strand, "John Marin," 7.

49. Fraser Cocks, "Paul Strand: The Search for a Usable Past," *History of Photography* 16 (Spring 1992), 18-27.

50. There was an almost geological or geographic flavor to his concerns as he praised Anderson for giving "a sense of America, particularly of the land itself as part of the people," and Marin for suggesting that "that something which we call America lies not so much in political institutions as in its rocks and skies and seas." Strand, "Marin Not an Escapist," 254-55; PS to AS, September 28, 1925, ASA/YCAL. Strand, "John Marin," 23. Strand told one editor that "The word 'nationalism'…means nothing to me." PS to Mr. Field, Editor, *The Arts* 2 (February 1922), 333.

51. Strand, "John Marin," 1, 23.

52. PS to Sherwood Anderson, July 20, 1920, quoted in Greenough, "An American Vision," 50.

53. Waldo Frank, *Our America* (New York: Boni and Liveright, 1919), 107-8; Cocks, "Paul Strand: The Search for a Usable Past," 23-4.

54. PS to AS, September 20, 1926, ASA/YCAL.

55. PS to Herbert Seligmann, July 29, 1931, quoted in Greenough, "An American Vision," 76.

56. Ibid. PS to AS, August 22, 1931, ASA/YCAL.

57. PS to Herbert Seligmann, July 29 1931, and PS to John Marin, August 7, 1931, both quoted in Greenough, "An American Vision," 76, 42.

58. Jones, "The Work of Photographers Paul Strand and Edward Weston," 94-110.

8. Narrative's Lure

History had a way of touching Paul Strand's life. Important events quietly bypassed Stieglitz, but Strand was often drawn into major currents that also swept along countless other Americans. He was one of World War I's conscripts, and a victim (doubly so) of the great flu epidemic. In the 1920s he prospered, and then with the Great Depression he became one of the many American artists and intellectuals drawn to the political left. During the Depression, Strand's earlier materialism changed as he moved away from Nietzsche's denial of God and embraced the economics, ideology, and activism of Marx. These changes had profound ramifications in Strand's art, for he abandoned vestigial communities for living ones, and began to incorporate human beings into his photography. His interest in stories also changed. Throughout the 1920s he had been concerned with Spoon River tales of the past such as might be read from the ruins of Mesa Verde or the ghost towns of New Mexico; but with the 1930s he became more interested in social contests of the present. Eventually the narrative ability of still photography seemed insufficient for the dynamism of working people's struggles, and Strand left the still photograph for the political movie.

All of Strand's Taos photography had been accomplished during the growing economic crisis of the 1930s. He was aware of those broader developments, for the stock market crash complicated his efforts to raise funds for Stieglitz's newly opened American Place gallery, and some of his own investments turned sour. But the Depression did not hurt him seriously. He was prosperous enough to afford long sabbaticals from his film business, his father's hardware concern continued successfully even during the downturn, and both he and his father somehow managed to keep most of their resources sheltered in the crisis.[1] When the Depression reached its worst in 1932-33, Strand's agonies were more personal than economic. In the months between the spring of 1932 to the fall of 1933, he severed relations with the two most important people in his life, first Alfred Stieglitz and then Rebecca Salsbury Strand.

It had always been a pretty lopsided relationship between Strand and Stieglitz. Stieglitz provided imprimatur and advice, while Strand contributed economically to the gallery, did lots of leg work, and was consistently solicitous for Stieglitz's well-being. As the 1920s passed, Stieglitz increasingly moved beyond thanklessness and into hostility, making scurrilous remarks about Strand's photographic ability,[2] and bristling over Strand's campaign for the new gallery. Such things hurt Strand, and then there were the ever increasing warnings that he was too close to Stieglitz.[3] Finally the break came in the spring of 1932, when Stieglitz presented that joint exhibition of Strand's New Mexico photographs and Rebecca's paintings. At some point in the show, Strand became furious with Stieglitz for reasons that are still not completely clear. Witnesses

said it was because the exhibition and Stieglitz's commentary suggested that the Strands were but mediocre talents trying to pass themselves off as "simulacra" of the true articles, Stieglitz and O'Keeffe.[4] Perhaps. Stieglitz was certainly capable of such unkind remarks, but they were usually off-handed ones, and the arrangement of a show only for the purposes of ridicule seems more premeditatedly malicious than even Stieglitz could manage. Perhaps, too, Strand had simply had enough of Stieglitz's incessant critical commentary, and his anger reached the boiling point.

For whatever reason, or combination of reasons, Strand left. He went to Stieglitz, handed over his key to the gallery, and departed—all in silence.[5] Strand's sense of relief seems to have been immense. Later he recalled that day as the end of a chapter in his life, a chapter that had opened grandly but was now overdue for closure. "The day I walked into the Photo Secession 291 in 1907 was a great moment in my life," Strand wrote, "but the day I walked out of 'An American Place' in 1932 was not less good. It was fresh air and personal liberation."[6] The split was not absolute, for the two men continued to correspond, and in later years Strand felt comfortable eulogizing Stieglitz. But in the spring of 1932, Strand ceased thinking of himself as Stieglitz's protégé.

Soon thereafter he also ceased being Rebecca's husband. The Taos years had been productive ones for Strand's art but not so good for his marriage. His increasing commitment to photography came at the expense of things that she wanted—a child and a home—and his talent increasingly grew beyond her more modest achievements.[7] The mounting tensions are apparent in his Taos portraits of her, where a suddenly gray-haired Rebecca no longer faces her husband-photographer, and instead stares into space. They separated late in 1932 and Strand moved to Mexico. The final split came the next year when Rebecca traveled to see him, and after a final round of what he called "the most tearing, wrenching suffering for both," they agreed to divorce.[8] By 1933 there was little that Paul Strand could do but have a new beginning. He had left his mentor, his wife, and his country. Photography remained a constant in his life, and even that grew in unexpected directions.

By moving to Mexico, Strand joined a world-wide migration of creative individuals who flocked to the country in the 1920s and 1930s. For many of these people, the principal attraction was what has come to be known as the "Mexican Renaissance"—a cultural up-welling that was in part the product of creative energies released by the Mexican Revolution, and in part the result of political energies tapped by radical muralists such as Diego Rivera, David Alfaro Siqueiros, and José Clemente Orozco. Mexico's culture and its Revolution were closely entwined, but outsiders tended to be drawn by one or the other. For photographer Edward Weston and writers D. H. Lawrence, Katherine Anne Porter, and Hart Crane, the Mexican hinterland offered lessons to more industrialized countries, reminding North Americans and Europeans of important modalities their own cultures had left behind. Sharing some of the same quasi-anthropological inclinations that had also motivated Strand in Taos, these visitors were inclined to see spontaneity, closeness to the land, and simplicity as Mexican virtues.

For other visitors, Mexico's politics were the greater attraction. The Mexican Revolution was an on-going affair, one in which figures like Rivera embraced Marxist politics, occupied important official positions, and at times even armed themselves in anticipation of violence. North American progressives like John Reed had started coming to Mexico in the years before World War I, and still even more visitors appeared in Strand's era. One was novelist John Dos Passos, who arrived in 1926 fresh from his efforts to free Sacco and Vanzetti, and who found Mexican justice preferable to what he had just experienced in Boston.[9]

Originally Strand was drawn to Mexico by aesthetic opportunities, and only later was he captivated by its left-wing politics. He came at the invitation of Carlos Chavez, a Mexican composer whom Strand had met in Taos, and who had risen in the revolutionary government to become head of the Department of Fine Arts in the Secretariat of Education. As a fan of American art photography, he believed that Mexican audiences should see something in addition to Weston's photographs, and arranged for Strand to hang an exhibition in Mexico City.

So it was that Strand came to Mexico with some fifty-odd fine prints. In the first two weeks of February 1933 he exhibited these landscapes, architectural studies, and a few portraits—images mostly created in New Mexico over the past two years—and the show received favorable notices in local papers.[10] Such success must have been gratifying, yet it was also hardly new, because Strand had been receiving the praises of discerning, literate viewers since 1916. But there was something unusual about this exhibition, for the images received unprecedented *popular* response which Strand found immensely gratifying. These were people such as had seldom come through the doors of 291, ordinary working people whom Strand proudly listed: "workmen in blue jeans, women with children, government employees" (a few months later he added "soldiers, Indians" to his list).[11] As Strand admitted, he had no way of knowing for certain what drew this tide of the demos to his images, but he interpreted the attendance as a sign of respect and acceptance, an indication that these ordinary people resonated with his photography.

He repaid the compliment, too. During his time in Mexico Strand moved toward the workers and peasants who seemed so interested in him. He began to make images of humble people who resembled his descriptions of the throngs at his exhibit, and he found work in government agencies sympathetic with their social and economic conditions. There were also considerable theoretical dimensions to these new interests, as Strand developed a heartfelt Marxism that accompanied his new imagery.

Strand had always been something of a liberal, and his sympathies for working people had been clear since his student days under the progressive Lewis Hine at New York's Ethical Culture School. But between the autumns of 1932 and 1933 Strand became much more radicalized, and by the end of the metamorphosis he had formally embraced Marx. All the factors in the transition are not entirely obvious, but Strand clearly had important encouragement from friends far away in the United States. One was Harold Clurman, who penned him long letters on art and politics, and another was art critic Elizabeth McCausland, who said America needed "a dictatorship...on some such lines as

Russia."[12] There was additional cheering from the wings by radical novelist Philip Stevenson (aka Lars Lawrence), who sent along word that prominent left figures like Josephine Herbst and Clifford Odets also admired Strand's work.[13] While no direct evidence links Strand with the American leftists resident in Mexico, he certainly absorbed ideas from Mexican progressives with whom he worked (like Carlos Chavez or Narciso Bassols at the Secretariat of Education) and with whom he traveled (the educator Augustine Velasquez Chavez, Carlos Chavez's nephew).

Somehow Strand got a reading list that also encouraged him along his leftward journey. The books were not particularly exotic; one was *The Communist Manifesto* and another was John Strachey's *The Coming Struggle for Power* (1933), commonly read by other American intellectuals thrashing about for some alternative to capitalism during the early 1930s. Still another was Sidney Hook's *Towards The Understanding of Karl Marx: A Revolutionary Interpretation* (1933), which amalgamated Marx and Dewey, suggesting that Marxism was not so much a lock-step chart of social development as it was a pragmatic and revisable plan. Strand especially liked Hook's analysis of Marx on machinery, for according to Hook, Marx had much the same position that Strand had taken earlier in his "New God" discussions—that oppression arises from human social relations, not the machine.[14] Strand grew increasingly appreciative of such readings during the course of 1933, and told his friend, the American photographer Kurt Baasch, that "the ideas of Marx which I have been reading" had become "very true to me."[15]

Strand moved leftward quickly. As late as the second half of 1932, when others like Malcolm Cowley and Matthew Josephson were declaring themselves for the Communist presidential ticket, Strand favored the example of an obscure Indianapolis cooperative because "it seems to me that America could go this way rather than via communism."[16] Indeed, his sentiments resembled those of his friend John Marin, who wished for a future with "no Democratic party no Republican party no Bolschevic [sic] no Fascist no Intelligenchist [sic]," a place where there would be "just a few simps...a minding their own business," and where artists like Marin would be left in peace to "paint my picture.[17] But by 1933 Strand was enveloped in more intense political concerns, and this man who had once denounced ideology as a trap now sought it as a liberation. One mid-October letter to Ansel Adams is shot through with Strand's urgency and engagement, his belief that "the world itself [is] in profound process of change— social change," and unlike Marin he now found such change compelling, as would any conscientious artist who "has not insulated himself in some 'esthetic' rut—away from the world." Over the next six weeks there was a growing timbre of obligation in Strand's letters and an increasing weightiness in his assessment of "the social forces of today." In a world full of depression and repression, it seemed to him, there was a "war which is everywhere going on in one form or another." Unlike World War I, which he had tried to avoid, this fight was truly compelling, and "I don't see," Strand wrote, "how anyone[,] the artist particularly, can stand aside, be completely above this battle." So, by late November 1933 Strand had reached the conclusions that would sustain him over much of

the next decade: that "capitalism is doomed," fascism was its putrid last itera-
tion, and the Soviet model appeared "the only one left that has any hope in it for
a decent human life."[18]

Strand chronicled his development in a series of impassioned letters to Kurt
Baasch, his friend back on Long Island. The last of these was an ardent political
confession written during the third week of December 1933. There Strand
emphasized that he had come a long way, that he had put aside earlier notions
in which humanity's great hope lay in magisterial figures like Stieglitz, and that
he now placed his faith in broadly based social movements. "I used to feel,"
Strand wrote in December 1933, "as Nietzsche did that the hope of the world is
through a kind of aristocracy of the spirit." But Superman seemed increasingly
less capable in the 1930s, and Strand admitted that "I can't believe in that any
more." Indeed, he felt he had been duped, that he had trusted in a bankrupt indi-
vidualism which fooled him and so many other artists and intellectuals. In
words that eerily anticipate lines of Allen Ginsberg's "Howl," Strand said "I see
the best spirits of my own generation, isolated—powerless—neurotic or egotis-
tic, and that is all." For both Ginsburg and Strand, the best minds of their
respective generations had fallen before a false god, but where Ginsberg found
an escape from Moloch in drugs, sex, and mysticism, Strand's was a quite dif-
ferent epiphany, a new vision in "the realization that human life must be
collective," and "that people will only be whole human beings when they work
together."[19] Here was power greater than that of any blonde beast, and fulfill-
ment far beyond the exercise of will.

"This is my credo," Strand said as he ticked off more particulars. Capitalism
and individualism led only to injustice, exploitation, and fascism, and Marx
offered a laudable plan for action in the world. But Strand reached still deeper,
offering what he tellingly called "a kind of profession of faith." Strand had seen
plenty of religion since arriving in Mexico, but Catholicism was not the right faith
for the Strand, not one that adequately addressed his need for hope without mys-
tery. As he now told Baasch, "people need a new religion, not of
gods—heavens—hells and all that stuff." Instead, what they needed, what *he* need-
ed, was "a new ideal to work for—struggle for—one intensely human, of this
earth, earthy." His Mexican experiences, his reading, the events of the 1930s, now
brought him to that new ideal, that "some form of communism is the only hope of
humanity." Not focused upon any other-worldly afterlife, this was a hope for this
world, "a faith in human beings—and in a better human world than this one we
happen to have been born into." That new world had its seer, Marx who was "a
great man, spiritually and intellectually—a real prophet," and one of Marx's great-
est qualities was that "he was a materialist," one who made his prophecies, and
found his solutions, in this world. In this manner Strand arrived at a materialistic
and earthly faith that "a new spirit is painfully being born," and which would con-
tinued to grow for centuries.[20] Here then was Strand at the conclusion of
1933—apocalyptically hopeful, and materialistically so.

Strand's art kept pace with his ideology. As his political ideas evolved during
that first year in Mexico, his images and his aesthetic concerns likewise shifted. He

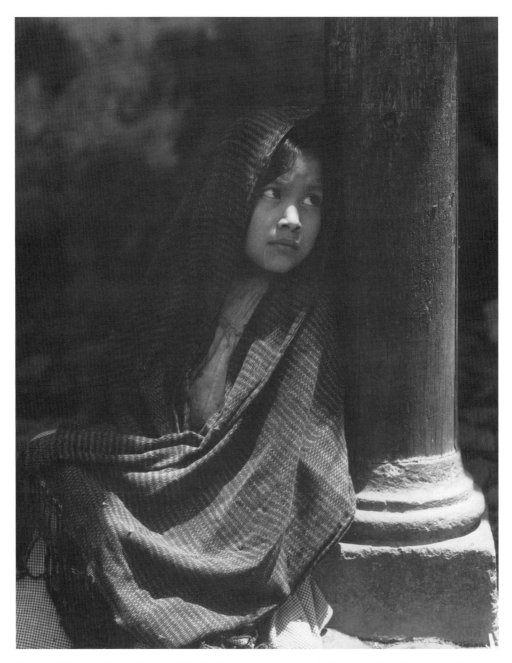

8.1. Paul Strand. *Child, Mexico, 1933*, © 1971, Aperture Foundation Inc., Paul Strand Archive.

became interested in issues of authenticity and exploitation, and his photographs came to include people as well as their artifacts. He worked especially hard during the spring and summer of 1933, photographing as he accompanied Augustine Chavez in a government-sponsored assessment of arts and crafts education in the provinces surrounding Mexico City. He accomplished a considerable amount of photography while "going over so much of Mexico in Fifi my Ford," and these images were the basis for his first published portfolio, *Photographs of Mexico* (1940).[21]

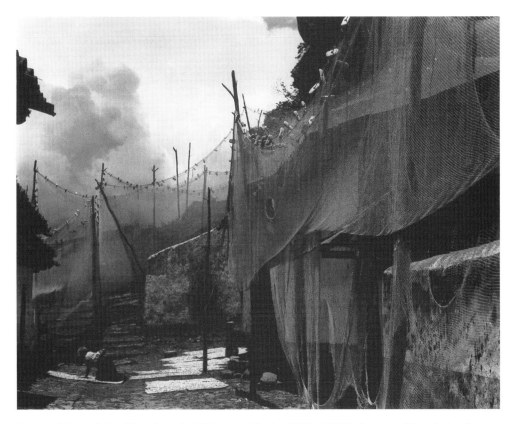

8.4. Paul Strand. *The Nets, Janitzio, Michoacan, Mexico, 1933*, © 1971, Aperture Foundation Inc., Paul Strand Archive. Courtesy George Eastman House.

Edward Weston. Weston had preceded Strand to Mexico and departed before Strand arrived. Like Strand, he conducted field work in Mexico, but whereas Mexico was the place of Strand's leftist awakening, Weston managed to bob along fairly unmoved by Mexico's powerful political currents (ironically so, given that the gregarious Weston had more contact with cultural radicals like Rivera). The trinkets and toys which moved Strand to sorrow often evoked Weston's joy, and what Weston saw as authentic design and cunning adaptation, seemed to Strand only a pitiable pandering.

These differences emerge in their Mexican images. During his visit Weston developed one of his fortes, the photography of objects so as to decontextualize them and explore the beauty of their form, a photography of things like toilets and toys that emphasizes undulating universal shapes rather than prosaic particular functions. Strand, though, was moving along a different arc, away from abstraction, toward renditions stressing people's humanity, and eventually into a narrative of revolt such as Weston never attempted. It is even possible to make a direct comparison between Strand and Weston, for each photographed and commented upon the fishing village of Janitzio, located on an island in Lake Patzcuaro in the state of Michoacan.

Both photographers were taken with the place's picturesqueness. The fishing here was by net, and the sight of the long ribbons of netting drying in the midst of

the village was an irresistible lure for most any passing photographer. Strand saw "the fish-nets hanging in lovely designs," and Weston likewise noted the "yards of mesh stretched on poles to dry, sunlit and sparkling." The unintentional designs of the drying nets, the poles at intervals supporting the fabric, the sunlight reflected off the lake—here were combinations that Strand and Weston both registered as beautiful, and they both thought that the beauty was compromised by the fisher-folks' degradation. Looking at the same villagers, however, the two artists saw the degradation through quite different eyes. Strand was politicized, and believed that the people of Janitzio were "horribly poor," spiritually and intellectually benumbed. Weston, though, was less sympathetic. He arrived in the midst of a festival, found half the villagers drunk, and was tempted "to knock down the filthy beast" who accosted him.[31] Where Strand saw a village of victims, Weston found a debased binge that spoiled his own visit.

Such distinctions continued into the photographers' images of the village. Consider the point of view in Weston's *Janitzio, Patzcuaro* (1926; fig. 8.3), an image that, like many other of his Mexico images, was made from a remote, elevated prospect, as though the photographer has held himself aloof from a given scene, removed from the place he's visiting, and in this case even losing sight of the nets which were the village's most visually arresting feature. In contrast, Strand's photograph, *The Nets, Janitzio, Michoacan, Mexico* (1933; fig. 8.4) is in the very midst of the village streets, and so close to the nets that they appear to droop over the upper right corner of the image. Moreover, Strand's image is populated, for there in the lower portion a person is involved in some back-breaking job, caught in an economic web of poverty just as surely as the netted fish were likewise entrapped. Weston's village stands uninhabited, a jumble of abstract shapes that give little clue to its economy or its denizens' plight, a village apparently less beset by the economic forces Strand found, and more by natural ones represented by the water, hills and sky that seem to press upon the village.[32] Strand was primed to see exploitation, and in the case of these two images, the more sociological eye led to the stronger image.

Strand also had an eye for tableaux. Throughout Mexico he photographed scenes of momentary pause, some involving actual people and some the religious sculptures known as *bultos*. These were ubiquitous in both Mexico and the southwestern United States, frequently located in village churches, and often displaying the diverse and obscure syncretic meld of Christianity and indigenous belief that was such a vibrant part of the region's religious life.[33] But Strand focused upon more central and orthodox figures or episodes of Roman Catholicism, such as the crucifixion, the virgin, or Christ himself. Strand further concentrated on particularly emotional sculptures such as *Calvario, Patzcuaro, Michoacan, Mexico* (1933; fig. 8.5).

Initially photographs like *Calvario* are a puzzling part of Strand's Mexican work. This was, after all, the time when his atheism had matured, when he understood that outmoded faith in the magic of Christianity should be replaced by the more useful belief in Marx. Additionally, this image of Jesus, Joseph, and the two Marys seems at odds with Strand's concern for authenticity; although executed by native artisans the scene is decidedly not indigenous. Most obviously, these

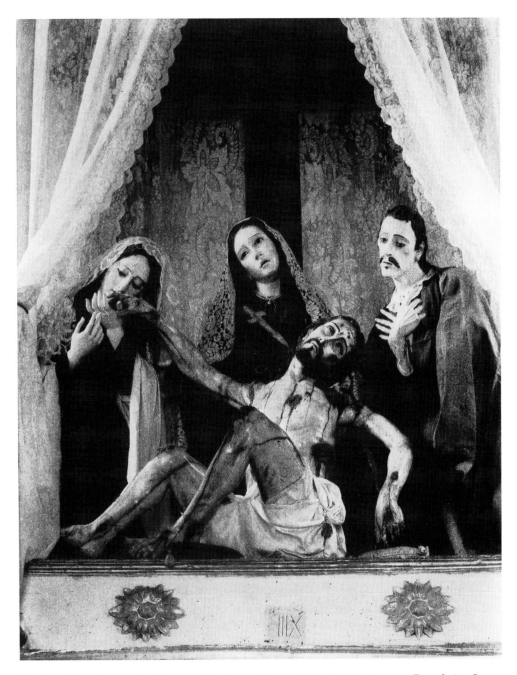

8.5. Paul Strand. *Calvario, Patzcuaro, Michoacan, Mexico, 1933*, ©1940, Aperture Foundation Inc., Paul Strand Archive. Courtesy George Eastman House.

are European faces, likenesses more akin to the conquistadors than to the Patzcuaro Indians. Iconographically, the scene also borrows heavily from Europe with its tripartite composition, the stylized gestures, and the central female figure's head inclined in a Botticelli tilt. And of course the religion itself was an import—decidedly so in the way that Strand chose to photograph it, for scenes like the *Calvario* exhibited little of the dynamic combination of Christianity and

native belief that one might find in items like the skeletons that were such a prevalent part of the Feast of the Dead celebrations.

But Strand had his reasons for photographing these subjects. To him they seemed organic outgrowths of local culture much like the Taos church had been. First, the small sculptures were heartfelt executions, unlike the routinized products of Michoacan, they were "alive with intensity of the faith of those who made them," even if it was "a form of faith, to be sure, that is passing."[34] Additionally, the *blutos* were not commodities and they stood outside the cycle of exploitation. Like the incense burners and candle holders created for the Feast of the Dead, these were cast without a thought of tourists; lovingly created by the Indians, these were "things which they made for themselves," and as such objects they "immediately take on beauty, dignity, and meaning."[35]

Finally, Strand was even able to find a theme of outright resistance in the figurines. Even though such religious expressions were befogged and anachronistic, they had some truth to their messages; for Strand the *blutos* were an older, more magical faith's rendering of something he too could express in more contemporary materialistic, Marxist terms: the message that suffering can be born with great dignity, and the promise that great suffering is not eternal. In more political terms the statues also represented a principle of tenacious resistance. Strand's friend Edwin Rolfe recognized as much, and published a poem about Strand's photographs of "Christ / in sixty different tortured poses" which Strand later incorporated into the catalogue of his largest retrospective exhibition. The poem describes Strand's photography not as a celebration of sacred icons, but instead as a means to "ferret out / a race's history in a finger's curve." In that history were the episodes when "peons crucified conquistadors," and a pride that "Coronado never conquered." There was a future as well as a past, for Strand's images seemed to shout " in prophetic / thunder" about a time when "We shall rise, / conquerors."[36] In this manner there were intransigent, never quite subdued, qualities that Strand found among the Indians' images and then conveyed through *his* images. And although it was not yet redeemed as such, they held out a promise, more of rebellion than of afterlife.

During much of the time his political vision was developing, Strand was also engaged in the most extensive single creative undertaking to that point in his career. For about a year and a half, from mid-1933 through December of 1934, Strand was writer, producer, and photographer of *The Wave*, a movie set in the Gulf-coast Mexican village of Alvarado. As he conducted his research, crafted the script, and photographed on location, the film project became a neat complement of his evolving political consciousness. His study of the fishing industry helped concretize the abstractions in his evolving Marxist credo, his contact with the fishermen strengthened his faith in ordinary humans, and the movie itself became a confession of that faith. For the first time in his life Strand worked artistically as part of a group, a production team bearing some semblance to the collectives he was coming to admire. When *The Wave* was finished, Strand had produced a moving call for working people to rise against their bourgeois oppressors, a cry for action more obvious and more rousing than anything in his earlier still photography.

The original idea for the movie was not Strand's. He had planned to concentrate on still photography in Mexico, and initially left his movie equipment in New York. It was Chavez and his boss, Education Minister Narciso Bassols, who conceived the movie. As leftists, Chavez and Bassols had decided to make educational films about "the production of wealth in Mexico in its different forms," agriculture, fishing, and mining.

They would be movies of indoctrination, too. Chavez and Bassols believed that their Education Ministry should conduct political education, teaching peasant audiences that the wealth of Mexico's mines, fields, and waters came from *their* labor, and that it was only later appropriated by the middle- and upper-classes.[37] Familiar with Strand's political and film background, Chavez asked him to lead the Ministry's movie project.[38] Strand accepted, and signed on, he said, to make movies akin to the political dramas that Harold Clurman's Group Theatre was creating in New York.[39]

At first Strand had difficulty finding his theme. But sometime during the first half of 1933 Strand visited Alvarado, and in that small coastal village he came to see a story, for there was something in that little town that, much like Janitzio with its photogenic nets, captured Strand's imagination. Perhaps fishing gear exercised some peculiar attraction for Strand, or perhaps there were especially resilient individuals in Alvarado, or perhaps Strand's work with Christian symbols had primed him to see the audience appeal in a fishing story. For whatever reason, in the fishing village of Alvarado Strand glimpsed a production-of-wealth narrative, and so it came to be that the first of his proposed films focused upon the fishing industry.

Throughout the first half of July, Strand made his preparations. He developed a script with the help of Augustine Chavez (his companion from the Michoacan craft survey), assembled a crew largely imported from the United States, and drew his cast mostly from local villagers. With the help of these people, Strand created a pretty good movie. In the story line, local fishermen, together with the protagonist, Miro, are a productive and industrious lot, their capabilities evinced by scenes of brawny muscle and comradely work. But they are also at the mercy of local buyers, including the villain, Don Anselmo. Miro organizes a strike that is only partly successful—until he is martyred when Don Anselmo's spy assassinates him. Now inspired, the men achieve a unity symbolized in a funeral cortege of massed fishing boats bearing Miro's body, and their nascent power is represented by a mighty wave (hence the film's title) that grows slowly until it crashes upon the shore in the movie's finale.

From the onset Strand maintained a commitment to high photographic standards, and strove for the well-composed and exquisitely-lighted scenes that characterized his still images. Indeed, at times he seems almost to be quoting himself in *The Wave*, pausing in tableaux that resemble his earlier still photographs: here is a wide-eyed girl looking much like his *Child*, there a steely and determined visage reminiscent of *Man, Tenancingo*. And although there are some moments of tightly executed action in *The Wave*, its strengths are when the camera quietly pauses, and at those moments *The Wave* resembles a still photographer's portfolio which has been filmed.

But Strand relied upon more than his own earlier work, and drew upon additional sources in the dramatic arts. Charlie Chaplin showed how seemingly weak characters could ultimately triumph, and Harold Clurman's Group Theatre was a

model progressive production team. Strand also drew generally upon the example of Soviet film makers, whose work seemed a "conscious projection of the communistic concept," and particularly upon Sergei Eisenstein, whose example showed Strand how to establish visual relationships between subjects by cutting back and forth from one subject to another.[40] Strand had another, decidedly less ideologically-informed source, the American film maker Robert Flaherty, best known for that 1922 curiosity, *Nanook of the North*.[41] Flaherty was a one-trick pony, making film after film about primitive peoples struggling with nature, a theme Strand adapted for his own particular needs. As Strand wrote in the fall of 1934, he was less interested in "a people's struggle against the forces of nature," and more concerned about economic ones, "their struggle against exploitation."[42] Having learned from Flaherty that struggle could provide a narrative thread for film, Strand went on to say that the class struggle was just as ubiquitous as the struggle with nature.

The goal then was an economic tale with a moral, what Strand called "a criticism of capitalism[,] a system I detest." Yet there was more, for he hoped that by the movie's conclusion his audiences would be motivated, ready to act against capitalism and prepared with some idea of how to attack it. Thus it was that Strand wrote his script so that the fishermen banded together and *The Wave* ended "on the note of collective action...something I believe in."[43] Frankly provocative by design, the movie was intended to be simple enough to be effective, what one reviewer called "Lesson Number 1 in the organization of labor, a kindergarten exercise in class struggle."[44]

Art intended to reach and move people—a movie arising from the desire to preach a large message and executed in the belief that "a certain crudeness of statement is necessary."[45] Much of this sounds like the stuff of proletarian literature, Depression stories that were often both blunt and propagandistic—and which shared a good deal with *The Wave*. In books like Jack Conroy's *A World to Win* or Clara Weatherwax's *Marching! Marching!*, Strand's contemporaries joined him in using themes that became virtual stereotypes in the 1930s: the labor leader's martyrdom, the wavering worker's conversion into activism, or the climax of a massed uprising. If anything, Strand was a trailblazer in such themes, for much that went into the 1933-34 creation of *The Wave* anticipated one of the better martyr/rebellion stories, the 1935 play *Waiting for Lefty*, written by Clifford Odets, a member of the Group Theatre.

Yet *The Wave* is not a thoughtless and artless propaganda piece. Later in the 1930s Strand made such movies, but for the moment this film about Mexican fisherman was a hybrid, a political message melded within an art movie. Strand did not abandon aesthetics with the growing intensity of his politics, and some scenes have a striking beauty along with Strand's characteristic concerns for spatial balance and harmony within the frame. For all of his bluntness, Strand refused the ham-fisted delivery of a narrative voice, and although there was a triteness to some of his imagery, parts of the message were far from hackneyed. At one point, for instance, Strand had his protagonist insist that the economic world is one of our own construction, something we may reconfigure as we choose. As Miro put it, "poverty isn't like the tide, we can fight it."

Ironically, though, *The Wave* did not reach intended audiences of Mexican peasants. A more conservative Mexican regime came to power, Strand's education department patrons were replaced in December of 1934, and the film languished in

Mexico. It eventually did better in New York, where, as Strand later said, "it seems to have interested the intellectuals".[46] Katherine Anne Porter praised the cast in the pages of the *New Masses*,[47] and upon seeing the film Clifford Odets reportedly shouted "this is it! This is the future!"[48] Strand was lionized all over left New York. The Nykino film collective conducted an invitation-only showing of *The Wave*, proclaiming the movie as "the first feature-length workers' film made on the American continent," and billing Strand as the "outstanding American photographer."[49]

There was even louder acclaim, if perhaps less comprehension, from closer to the cultural mainstream. After its opening at the small Filmart Theatre, *The Wave* moved uptown to the much larger Apollo, where it was trumpeted in a scene captured by Strand's fellow photographer, Weegee. There at the very top of the marquee are the words "PAUL STRAND'S PHOTOGRAPHIC TRIUMPH," a blazing acclaim of a sort his still photography never received, words shouting his name to crowds whose numbers doubtlessly surpassed those that saw any of his exhibitions. Strand must have been warmed.

The Wave marked a turning point in Strand's career. Once he began work on the movie, it was a decade before he returned to still photography in any sustained way. Part of the reason is that Strand could not find his way to a still photography that fit the apocalyptic politics he had acquired while in Mexico. With the still camera, he could surely celebrate human dignity, and in a Spoon River sense convey something about individual people. But he also wanted to do other things, too, to complain when humans were exploited like animals, to extol solidarity, to underscore capitalism's vulnerability and to celebrate communism's eventual triumph. Of course there is no inherent reason why still photography might not do such things, but cinema's narrative capacity, its action and dialogue, are well adaptable to such ends, and for a time Strand found himself more comfortable with the moving medium. With his appetite whetted by the crowds that had attended his Mexico City exhibition, Strand wanted to reach audiences, and the audience for movies is exponentially larger than that for art photography. Moreover, cinema seemed more capable of hastening the coming world, of allowing the artist who had seen the future to quicken its arrival—cinema seemed made for preaching or cajoling. Having come to a new political vision while in Mexico Strand also settled upon a new visual art with which to render that vision.

By many outward indicators, the next years were the most radical of Paul Strand's life. In the time between his departure from Mexico late in 1934 and his ultimate return to still photography a decade later, Strand staked out positions far in advance of his own earlier ones and well beyond those of many Americans. Joining a permanent creative team for the first time in his life, Strand became the most prominent member of a vibrant artistic collective that produced polemical and vociferous films. But when Strand himself became more publicly red during the mid- and late 1930s, his film message became less revolutionary as he concentrated more upon maintaining bourgeois civil liberties than upon advancing the proletarian cause of economic equality. There was an accompanying change in Strand's aesthetics, with his narrative interests moving beyond the allegory of a small fishing village and aspiring to a sweeping account of actual events throughout the United States. In this move from the fictional to the factual, Strand's epic aspirations ultimately exceeded his talents.

Strand returned to New York at end of 1934, and Clurman soon introduced him to the swirling social life centered around the Group Theatre. Among his new acquaintances was Virginia Stevens, a twenty-three-year-old Group actress (he was forty-six) who was moved by Strand's tenderness and shared his politics; the relationship blossomed and they were eventually married in 1936.[50] If the social life was to Strand's liking, so too was the creative one, for these were, in Clurman's phrase, the "fervent years" for a thriving progressive culture in the city, and Strand quickly became connected with New York's left-wing photographic community—especially Ralph Steiner and Leo Hurwitz, filmmakers who were members of Nykino (the name came from the initials NY plus the Russian word for camera).[51] Though younger than Strand, Hurwitz and Steiner had considerably more experience with political film, and had honed their principles through reading and debate. For his part, Strand offered his superbly developed eye, something the Nykino filmmakers welcomed as they added to their ranks yet another art photographer, Edward Weston's protégé Willard Van Dyke.[52]

As part of Strand's immersion in left culture, he made the common, if not quite obligatory, visit to Moscow. Throughout the 1920s there had been a steady stream of curious Western intellectuals, who, like Lincoln Steffens ("I have been over into the future, and it works") had gone to witness the socialist experiment for themselves. The flow of visitors increased as capitalism tottered during the 1930s, and included writers Edmund Wilson and Anna Louise Strong, photographers Margaret Bourke-White and Jay Leyda, and novelists John Dos Passos and Josephine Herbst. Many of these visitors were attracted to Communism and arrived in Moscow with a sense that they had come to the source—which was particularly the case for Strand, who regarded Soviet filmmakers like Sergei Eisenstein and Alexander Dovzhenko as models of progressive cinematography.[53] Strand visited Moscow in May and June of 1935, and his reputation—headlines in the *Moscow Daily News* welcomed this "famous U.S. photographer"—was sufficient to get him a meeting with Eisenstein on his first night in town.[54] Strand took along some prints and film clips for review, but he was also looking for work, and this time (unlike in Mexico) he arrived with his Akeley. Eisenstein was impressed enough to invite Strand to join him on an upcoming film, but Stalinist authorities were displeased with the too-independent Eisenstein, refused to give the necessary permissions, and a disappointed Strand eventually returned to the United States.[55]

It was then that Strand, Hurwitz, and Steiner began filming as a team. One of their projects was *The Plow that Broke the Plains* (1936), an on-location New Deal film about drought on the Great Plains. With their shared ideology, the three men planned to film the infamous dust storms as the "result of the ruthless, planless exploitation of the land by ruggedly individualistic practices,"[56] but project director Pare Lorentz ("an imbecile," Strand concluded[57]) shared neither their Marxism nor their talent. Lorentz ordered the men to film his way, there were terrific disagreements, and the three very nearly quit the film. This experience convinced them that they needed to form their own independent production company, and in 1937 they announced that they were in business as Frontier Films. The list of staff and consultants for Frontier Films was a Who's Who of the New York left, including names like John Howard Lawson, Malcolm Cowley, and, Elia Kazan. Hurwitz

and Steiner were vice presidents, and Strand president,[58] but Steiner soon withdrew, leaving Strand and Hurwitz as the core of Frontier Films. This was something quite new for Strand. Like other artists of his generation, men like Stuart Davis, Philip Evergood and Ben Shahn, he had long thought of himself as an aesthetic leader. But in the insistent environment of the 1930s, Strand and the others found themselves in the leadership of left organizations like the Artists' Union, the American Artists' Congress, and Frontier Films.

Frontier Films was particularly committed to shaping the social order. The film collective relished cinema's ability "to mold the minds of the nation," and, believing that Hollywood only used film's power to perpetuate myths of glamour and success, Strand's organization now promised to "wield this power consistently on the side of progress." Frontier's goals were to mold minds and shape society, but the filmmakers also pledged to work with real-life situations, and at the outset vowed to film the "reality of our everyday lives" as opposed to Hollywood fantasies. In this way Frontier Films took on the project of simultaneously describing reality and shaping it, twin goals that for some people might seem to violate supposed rules of objectivity and representation. But this was not a problem for Strand, Hurwitz, and the others. From their 1930s perspective, "objectivity" was a bourgeois concept, one which drew an artificial line between the observer and his world. To their way of thinking, simply to be in the world was of necessity to take a role in shaping it—and a sure license for concurrently reporting and forming that world.[59]

In *The Wave* Strand had worked with fictional characters and a made-up setting. But in the later 1930s, he came to work in a more documentary mode, operating with "the materials of actual events, the very stuff of reality."[60] Strand was not alone in this, for there was a pervasive fascination with immediacy throughout American culture of the 1930s, a common penchant for documentary expression that led the Federal Theatre Project to appropriate its production material from the headlines and fill its stages with "living newspapers."[61] Such immediacy was accompanied by expressive difficulties, though, one of the larger ones being continuity. Like the headlines on a given day, "the documentary film," Strand said, "by its very nature tends to be fragmentary."[62]

Facts were in this way refractory, inclined toward incoherence if left to themselves. After *The Wave,* Strand had turned away from the fictional story line as a way of holding things together, yet he believed there were other binding tools available. For decades he had argued that photography should be done aggressively, and believed that too many documentary filmmakers had become passive, forgetting that "it is the photographer who tells the audience where to look...He literally controls the eye of the audience." To exercise that control, for instance, the photographer must make certain that important action in the foreground was not unthinkingly overwhelmed by a too-busy background, and must work to shape a confusing actual scene into a more comprehensible filmed scene.[63] Hurwitz agreed that the photographer should be the master of the setting, and he also recognized that at times this was a very difficult thing to do. "The visible world is...harshly recalcitrant," he said, a place of considerable bustle and complexity that might not clearly convey the photographer's message.[64]

One of the most recalcitrant aspects of reality was that people so frequently failed to behave just as the filmmaker needed. Real-life workers might insist upon smiling when their misery was the intended message, and the nastiest of capitalists might behave benignly in front of the camera. Dramatic recreation was a way around such difficulties, and with Strand's prior experience in *The Wave* and Frontier's connections to the Group Theatre, it was not long before these documentary filmmakers concluded that acting was consistent with nonfiction film. The advantages were many—actors maintained appropriate expressions, the action took place within camera range—and these benefits perhaps made it easier to slide over the distinction that while a real event had actually happened, the event-as-filmed was not precisely that reality itself. Art, the dramatic art of acting and stagecraft, could tame reality so that it fit the filmmakers' truth, a conclusion that Strand and the others reached not through some legerdemain by which they convinced themselves that it was permissible to create facts to fit their politics, but instead because they recognized that some sort of mediation is always necessary on the journey from reality to truth.

In addition to acting, the Frontier filmmakers believed that structure was another way to achieve control in their work. They adopted what Strand referred to as "dynamic realism," or, perhaps even more fittingly, "contrapuntal progression,"[65] a practice of juxtaposition, so that distinct elements of a film might be brought together to achieve something like a story line. By arranging scenes so that a newsreel shot of a breadline was followed by a close-up of a haggard-looking actor, for instance, Strand said the hope was to "move the audience emotionally," putting an individual face on the broader problem of hunger.[66]

But despite these efforts to tame facts with structure and acting, Frontier Films never had its own sense of direction. Most of its products were in accord with someone else's vision, a progressive version of work-for-hire, just as Strand's earliest filming of sports and weddings had been done under contract, and even *The Wave*, though eventually his film, had originally been sketched by others. When Strand and the others formed their collective, they presented themselves to the world more as artisans than artists, announcing that "Frontier Films places itself at the disposal of progressive organizations and agencies in all fields."[67] This lack of institutional focus was evident in the diversity of Frontier's first films, such as *Heart of Spain* (1937), supporting medical aid for Spanish Civil War loyalists and celebrating pioneering methods of blood transfusion, or *People of the Cumberland* (1938), a fund-raiser celebrating Tennessee's Highlander Folk School. Such diffuseness was in keeping with the Popular Front of the later 1930s, when Communists, recognizing the need for allies in the coming fight against fascism, buried their ideological differences with other progressives, and pursued antifascist unity at the price of political purity.[68] Strand's personal politics were likewise diffuse, and he was a contented fellow traveler in these years. He joined the American Labor Party in 1937 (it remained his political home for most of the next decade), repeatedly voted for FDR, worked for the New Deal, and lent his signature and person to a bewildering number of progressive petitions and platforms.

That kind of expansiveness characterized *Native Land*, Frontier Film's most ambitious production and the one most imprinted with Strand's contributions. Inspired indirectly by the fatal police riot known as the Memorial Day Massacre of 1937, *Native Land* drew more directly from the resulting Senate investigation

chaired by Robert M. La Follette, Jr. The LaFollette report described how corporate America used blacklists, espionage, and even private arsenals to defeat unionization, and *Native Land* originally focused on the rights of American workers to organize free of surveillance and terrorism. But this movie was a grassroots political project which acquired additional worthy causes like the imperatives of free speech, the perils of fascism, and the evils of Hollywood. Swelling with each accretion of expectations, *Native Land* came to be something that Strand and the others thought of in monumental terms and which they eventually described as embodying "Civilization's Hopes, Fears, Tragedies and Triumphs."[69]

"Nothing is glossed over," screamed the promotional material for *Native Land*. Apparently someone on the production team believed that facts can be titillating, for viewers were promised a close look at "what life really is in the raw!"[70] If the evil facts were abundant, so was the progressive talent arrayed against them; Paul Robeson gave the narration, Mark Blitzstein composed the music, and the Almanac Singers performed the songs. If there were people galore, so were there symbols, and in characteristic Popular Front conflation of patriotism and communism, this left-wing labor movie acquired the title *Native Land* and a decidedly unproletarian references: proud scenes of Christopher Columbus and his troops, good words for a Constitution that enshrines private property, and warm evocations of the memory of John (rather than Sam) Adams.

Native Land is an ungainly hodgepodge, and consequently, as Strand admitted, "it was too late historically."[71] He and Hurwitz had set out to make a relevant movie, steeping it in some of the most dynamic events of the Depression years. But after all their reshooting and reediting and retelling, those very issues seemed passé by the time the filmmakers finished. In fact, their timing was atrocious: the first completed and corrected print came back from the laboratory the day after Pearl Harbor. When *Native Land* actually debuted some five months later, national preoccupation with World War II precluded any significant attention to the film. Strand and Hurwitz saw their blunder, and in desperation tried to make the film up-to-date by adding a prologue and epilogue equating the labor cause at home with fighting fascism overseas. But the effort was too little and too late. Having set out to document and direct history, Strand found that he had missed the historical moment.[72]

Nor could he find his place in the next moment. Strand thought that World War II was a much different kind of conflict than World War I, and believed that this time around art and war belonged together. Strand believed that he could make films that would foster Americans' "will of victory," and in the first months of the war he repeatedly announced his readiness to make motivational war films.[73] He also directly offered himself to the military for overseas work, and to the civilian Office of War Information. But there were almost no takers. In part this was because Strand, fifty-one at the time of Pearl Harbor, was simply too old; but the larger fact was that America wanted little to do with him.

This was a burning ideological disappointment, for the rejections came when America had finally entered the battle against fascism, one that he had been fighting for years. Yet in official eyes Strand had joined that fight too early, and he was

in the parlance of the times a "premature anti-fascist," a euphemism meaning that his long-standing communism made him seem unreliable. Indeed, Strand had never distanced himself from Moscow. There were plenty of moments—such as the Moscow trials of 1935-38 or the ignominious Nazi-Soviet pact of 1939—when other American leftists of good conscience denounced the Soviets. But not Strand; at each point he continued to toe the indefensibly wavering Party line, and his reputation suffered accordingly.[74]

But if Strand's politics made him suspect, his aesthetics made him uninteresting. He failed to see that *Native Land*'s problems were more than timing, and never quite acknowledged that its tell-everything orientation was a weakness. He kept singing the same song, and when he offered himself as a war-time movie-maker, he rather awkwardly promised the "kind of reality which dramatizes the real problems, hopes and aspirations of real people...the kind of reality for which we have worked in *Native Land*."[75] Strand's movie career had begun promisingly enough in Mexico where he discovered a Marxist narrative of class conflict which he then wove into the fictional story of a simple fishing village. But by the early 1940s he had lost that story line, exchanging the narrative of class for one of civil liberties, and exchanging manageable imagined scenarios for the overly complex factual ones of an industrial nation. Strand had wanted to say things sensibly, but eventually he tried to say too much, and he too often allowed inchoate and undigested bits of reality to speak for themselves.

1. Naomi Rosenblum, "The Early Years," in Maren Stange, ed., *Paul Strand: Essays on His Life and Work* (NY: Aperture, 1990), 271. PS to Calvin Tomkins, September 7, 1973, PSC/CCP.

2. Stieglitz suggested that Strand lacked potency as a photographer, and managed a "half or three-quarter erection," insufficient for the job of making real photographs. AS to Herbert Seligmann, October 8, 1926, ASA/YCAL.

3. McCausland wrote that Stieglitz's "world has no population except himself and his own creatures," and Clurman more bluntly cautioned that "unless you can be close to Stieglitz without being absorbed by him—he is not healthy." Elizabeth McCausland to PS, March 31, 1932, PSC/CCP. Harold Clurman to PS, November 21, 1932, PSC/CCP.

4. Nancy Newhall, "Alfred Stieglitz: Notes for a Bibliography [Biography]," in Nancy Newhall, *From Adams to Stieglitz: Pioneers of Modern Photography* (New York: Aperture, 1989), 114-15, 132-33.

5. Ibid. "Alfred Stieglitz: Notes for a Bibliography [Biography]," 133.

6. PS to RSS, December 13, 1966, PSC/CCP.

7. Belinda Rathbone, "Portrait of a Marriage," *The J. Paul Getty Museum Journal* 17 (1989), 96.

8. PS to Kurt and Isabel Baasch, November 26, 1933, Kurt Baasch Collection, CCP.

9. Helen Delpar, *The Enormous Vogue of Things Mexican: Cultural Relations between the United States and Mexico, 1920-1935* (Tuscaloosa: University of Alabama Press, 1992). James Oles, *South of the Border: Mexico in the American Imagination 1914-1947*. With an essay by Karen Cordero Reiman. (Washington: Smithsonian Institute Press, 1993). Henry C. Schmidt, "The American Intellectual Discovery of Mexico in the 1920s," *South Atlantic Quarterly* 77 (1978), 335-51.

10. PS to AS, February 5, 1933, ASA/YCAL. Katherine C. Ware, "Photography of Mexico, 1940," in Maren Stange, ed., *Paul Strand: Essays on His Life and Work* (NY: Aperture, 1990), 111.

11. PS to AS, February 5, 1933, ASA/YCAL. PS to AA, October 14, 1933, AAA/CCP.

12. Elizabeth McCausland to PS, March 26, 1932, PSC/CCP. Harold Clurman to PS, December 15, 1933, PSC/CCP.

13. Philip Stevenson to Paul Strand, May 29, 1933, PSC/CCP.

14. Warren Susman, *Culture as History: The Transformation of American Society in the Twentieth Century* (New York: Pantheon, 1984), 152. Sidney Hook, *Towards the Understanding of Karl Marx: A Revolutionary Interpretation* (New York: The John Day Company, 1933). See also Christopher Phelps, *Young Sidney Hook* (Ithaca: Cornell University Press, 1997). PS to Kurt and Isabel Baasch, December 17, 1933, Kurt Baasch Collection, CCP. Richard Pells, *Radical Visions and American Dreams: Culture and Social Thought in the Depression Years* (New York: Harper & Row, 1973), 121-40.

15. PS to Kurt and Isabel Baasch, November 26, 1933, Kurt Baasch Collection, CCP.

16. *Culture and the Crisis* (League of Professional Groups for Foster and Ford: New York, 1932). PS to Kurt and Mabel Baasch, July 6, [1932], Kurt Baasch Collection, CCP.

17. John Marin to PS, September 11, 1932, PSC/CCP.

18. PS to AA, October 14, 1933, AAA/CCP. PS to Kurt and Isabel Baasch, November 26, 1933, Kurt Baasch Collection, CCP.

19. PS to Kurt and Isabel Baasch, December 17, 1933, Kurt Baasch Collection, CCP.

20. Ibid. In a later letter, Strand described that December 17 letter as "a kind of profession of faith." PS to Kurt Baasch, May 7, [1934], Kurt Baasch Collection, CCP.

21. PS to John Marin, September 1, 1933, quoted in Sarah Greenough, "An American Vision," in *Paul Strand* (New York: Aperture, Washington: National Gallery of Art, 1990), 88. Paul Strand, *Photographs of Mexico* (New York: Virginia Stevens, 1940).

22. PS to John Marin, September 1, 1933, in Greenough, "An American Vision," 88.

23. Ibid.

24. PS to Olga Baasch, September 17, 1928, private collection. Harold Jones, "The Work of Photographers Paul Strand and Edward Weston: With an Emphasis on Their Work in New Mexico," (MA Thesis, University of New Mexico, 1970), 100-105.

25. PS to John Marin, September 1, 1933.

26. Paul Strand, "A Picture Book for Elders," *Saturday Review of Literature* 8 (December 12, 1931), 372. This is a review of Heinrich Schwarz, *David Octavius Hill: Master of Photography* (NY: Viking, 1931).

27. Harold Clurman to PS, Autumn 1934, PSC/CCP.

28. Paul Strand, "Engel's One Man Show," [reprinted introduction to catalog, *Photographs of People* by Morris Engel (New York: New School for Social Research, 1939)], *Photo Notes* December 1939, 2.

29. Katherine C. Ware, "Photography of Mexico, 1940," in Stange, ed., *Paul Strand*, 119.

30. Paul Strand, "Report of Paul Strand on Trip to Michoacan, June, 1933," typescript, PSC/CCP.

31. Weston, DBI, July 1926, 177-8. PS, "A Note on Cine," 3.

32. Weston, DBI, July 1926, 177-8. PS, "A Note on Cine," 3.

33. Ware, "Photography of Mexico, 1940," 115-118.

34. PS to Irving Brown, September 29, 1934, PSC/CCP; here from Greenough, "An American Vision," 96.

35. Strand, "Report of Paul Strand on Trip to Michoacan, June, 1933," 6.

36. Edwin Rolfe, "Prophecy in Stone (On a Photograph by Paul Strand)," *New Republic* 88 (September 16, 1936), 154. Rolfe was a board member for Frontier Films, the cooperative that Strand headed after his return to the United States, as well as a poet best known for his *Permit Me Voyage* (1955) and for his poetry about and analyses of American combatants in the Spanish Civil War.

37. Paul Strand, interview with Milton Brown, Calvin Tomkins, *Paul Strand: Sixty Years of Photographs* (New York: Aperture, 1976), 156.

38. Ibid.

39. PS to Kurt and Isabel Baasch, November 26, 1933, Kurt Baasch Collection, CCP.

40. Paul Strand, "A Note on Cine," 1. William Alexander, *Film on the Left: American Documentary Film from 1931 to 1942* (Princeton, NJ: Princeton University Press, 1981), 71.

41. Richard Barsam, *The Vision of Robert Flaherty: The Artist as Myth and Filmmaker.* (Bloomington: Indiana University Press, 1988). Brian Winston, "The White Man's Burden: The Example of Robert Flaherty," *Sight and Sound* 54 (Winter 1984/85), 58-60.

42. PS to Irving Brown, September 29, 1934, in Greenough, "An American Vision," 96. PS to Kurt and Isabel Baasch, November 26, 1933, Kurt Baasch Collection, CCP.

43. PS to Kurt and Isabel Baasch, November 26, 1933, Kurt Baasch Collection, CCP.

44. Archer Winsten, "'Redes' (The Wave) Opens at the Filmarte Theatre," *New York Post*, April 21, 1937, 15.

45. PS, "A Note on Cine." Sidney Meyers, "*Redes*," *New Theatre* (November 1936), 21; in William Alexander, "Paul Strand as Filmmaker, 1933-1942," in Stange, *Paul Strand*, 151-2.

46. Paul Strand, unpublished interview with Milton Brown and Walter Rosenblum, November 1971, Archives of American Art, transcribed, 30.

47. Katherine Anne Porter, "On *The Wave* (letter), *New Masses*" May 18, 1937, 22.

48. George Sklar to William Alexander, July 4, 1975, in Alexander *Film on the Left*, 145.

49. League of American Writers and Nykino, invitation to a private showing of "Redes," PSC/CCP.

50. Virginia Stevens, autobiographical notes; undated [c. 1980s], fragmentary typescript, Virginia Stevens Collection, CCP, 11.

51. Harold Clurman, *The Fervent Years; The Story of the Group Theatre and the Thirties* (New York: Hill and Wang, 1957), 148.

52. Harold Clurman to PS, October 19, 1934, PSC/CCP. Strand was also a good friend to young still photographers in the Photo League, offering instruction for their classes, contributions to their journal, and his prestige to their fundraisers. Whether with these novices or the more advanced still photographers, Strand assumed a role similar to the one he played within the Nykino group. He chose to act as something of an aesthetic conscience for individual photographers who seemed to allow the fervidness of their protests and criticisms to overcome the necessary (for him at least) aesthetic dimension of their images. (Anne Tucker, "Strand as Mentor," in Stange, *Paul Strand: Essays on His Life and Work*, 122-35. Walter Rosenblum, "A Personal Memoir," also in Stange, 140.

53. It was in the January 1935 issue of *New Theatre* (assembled by Leyda in Moscow), that Eisenstein sounded the optimistic note. Alexander, *Film on the Left*, 50-53, 89-90.

54. Joseph Losey, "Famous U.S. Photographer in Moscow," *Moscow Daily News*, May 17, 1935. Many of the details were arranged by Clurman who at the time was also in Moscow (and in the midst of his second extended visit). For details of Clurman's and Strand's activites in Moscow, see "The Soviet Diary of Harold Clurman," edited and introduced by Joan Ungaro, *American Theatre* 5 (March 1988), 14-54.

55. Tomkins, *Paul Strand*, 157-58. Harold Clurman, *All People Are Famous* (New York: Harcourt, Brace Jovanovich, 1974), 90. Rosenblum, "A Personal Memoir," in Stange, *Paul Strand: Essays on His Life and Work*, 138-47. Mike Weaver, "Dynamic Realist," also in Stange, 199.

56. Paul Strand, Ralph Steiner, and Leo T. Hurwitz to Pare Lorentz, October 17, 1935, PSC/CCP.

57. PS to AS, October 9, 1935, ASA/YCAL.

58. Frontier Films, Inaugural announcement, 1937, PSA/CCP.

59. Ibid.

60. Paul Strand, "American Documentary Film Tradition and the Making of Native Land," undated typescript [c. 1949], PSC/CCP—portions of this text are very close to his introduction speech at the showing of *Native Land* at an international film festival in July 1949.

61. William Stott, *Documentary Expression and Thirties America* (NY: Oxford University Press, 1973).

62. Strand, "American Documentary Film Tradition and the Making of Native Land."

63. David Platt, "'Photographer Must See, Think'—Strand," *Daily Worker*, May 18, 1937, 7.

64. Leo Hurwitz, "On Paul Strand and Photography," reprinted introduction to the Mexican portfolio, in *Photo Notes* (July-August 1941), 4.

65. Leo Hurwitz, "*Native Land*: An Interview with Leo Hurwitz," by Michael and Jill Klein, *Cineaste* 6 (1974), 5. Strand, "American Documentary Film Tradition and the Making of Native Land."

66. Strand, "American Documentary Film Tradition and the Making of Native Land."

67. Frontier Films, Inaugural announcement.

68. Pells, *Radical Visions and American Dreams*, 294-96, 313-14.

69. "Frontier Films presents 'NATIVE LAND'", promotional package, PSC/CCP. According to Strand the film contained nine (!) separate plots. (Irene Thier, "Paul Strand and Leo Hurwitz Offer Data on *Native Land*," *New York Post*, May 9 1942, 13.) There was documentary footage and reenactment of murderous suppression in the Midwest, Arkansas and Cleveland. Fact upon fact piles up like a prosecutor's case, along with speculation about how these little-known deeds may have been covered up. In his still photography Strand had been concerned with revealing less-than-obvious dimensions of the world, but unlike that metaphysical probing of natural objects, *Native Land* was a social document moving incident by incident to unmask a vast conspiracy.

70. "Frontier Films presents '*NATIVE LAND*'", 1.

71. Strand, Brown - Rosenblum interview, 46.

72. Hurwitz interview, November 21 1974, with Alexander, *Film on the Left*, 182.

73. Paul Strand, "A Photographer Talks about War Films," *Daily Worker*, June 20, 1942, p. 7. Paul Strand, Statement for Press Conference at the National Press Club, prior to screening of *Native Land*, 1942, PSC/CCP. Thier, "Paul Strand and Leo Hurwitz Offer Data on *Native Land*," 13.

74. Department of Justice, Federal Bureau of Investigation. Materials released under a Freedom of Information-Privacy Act request submitted by Professor Mike Weaver, 1986-1987. Paul Strand Miscellaneous Collection, CCP).

75. Strand, Statement for Press Conference at the National Press Club, prior to Screening of *Native Land*, 1942, PSC/CCP.

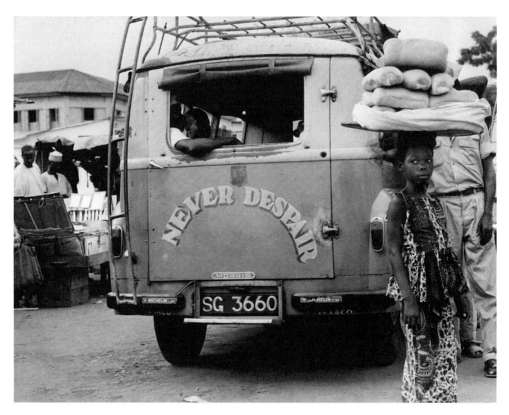

9.1. Paul Strand. *Never Despair, Accra Bus Terminal, Ghana, 1963*, © 1976, Aperture Foundation Inc., Paul Strand Archive.

9. Never Despair

Paul Strand visited the West African nation of Ghana during 1963 and 1964. In the capital city of Accra, he photographed the busy market scene around the city's bus terminal (Figure 9.1), a place where goods were displayed in stalls, vendors paraded with loves of bread, and passengers waited for departure. In this particular image, Strand focused upon the back of a singular mini-bus, the words "Never Despair" painted on its door in an asymmetrical arch. Strand adopted those words as the title for that photograph, and they also could have served as the motto for the last years of his career.

He returned to still photography during World War II, and over the next several decades traveled extensively and photographed expansively across three continents. During much of that time, Strand lived and worked with a conscious, determined, even willful optimism. Of course he encountered a fair measure of wretchedness in war-wrecked cities and impoverished villages, and he became an expatriate who could not work in his own land. But Strand would not publicly lose heart, and he made certain that both his audiences and his compatriots got the full taste of his progressive dreams and his buoyant faith in humanity. "Never Despair" was more than a comforting thought for Strand. It was an admonishment he offered others and an imperative in his own work and life.

Strand returned to still photography in 1943. At first he worked more slowly than had been his habit, for some of his skills had become rusty during the decade of cinema, and wartime shortages made photographic supplies very scarce. He began photographing in New England, particularly Vermont. This was familiar territory, for Strand had worked in New England during the teens and 1920s.

Yet from the very beginning, Strand's New England work was distinct from his earlier projects. He photographed buildings that were weathered and worn like his southwestern ghost towns, but the Vermont images speak little about abandonment and more about human continuance; they show very old houses and barns—some considerably older than those ghost-town buildings—that were still being used. More importantly, Strand backed away from the narrative structure of his film work. Almost from the outset he determined that his New England images would not tell a story but instead constitute "a portrait of a particular American environment in terms of the character of the land itself, the people who live on it, the things which they have made."[1] Ceasing to arrange images in a narrative flow, he employed them to survey, and appreciate, character.

Also from the start, Strand relied upon others as he shaped his vision of New England. Painter Marsden Hartley, together with novelists Chenowyth Hall and Miriam Colwell introduced him to Maine's Prospect Harbor, and for a time Strand lived with John Marin at Cape Split, also in Maine. More significant was the poet

Genevieve Taggard, an artist of unimpeachable progressive credentials: a former member of the Frontier Films board, she had published in the old *Masses*, and on the local scene supported striking quarry workers. Together with her husband Kenneth Durant, American reporter for *Tass*, Taggard introduced Strand to Vermont's West River valley, and it was she who supplied the title Strand used when he published his new photographs, *Time In New England* (1950).[2]

These people helped Strand in his work, but his central influence was Nancy Newhall. A New Englander herself, Newhall had an undergraduate background in art and art history, and became a writer about American photography. Together with her husband, curator Beaumont Newhall, she made a career of insuring the cannonicity of not only Strand and Stieglitz, but also Ansel Adams and Edward Weston. Though a more gifted writer than Beaumont, she had fewer credentials than he, and had been in his shadow in the male-dominated art world. But when Beaumont went off to World War II, Nancy temporarily replaced him as curator of the Museum of Modern Art's Photography Department. When she proposed an exhibition of Strand's New England work, he agreed, and the two commenced their symbiotic relationship. He needed the forum Newhall provided to re-establish his claim upon still photography and to reassert his reputation after the *Native Land* debacle. For Newhall, here was the chance to step into Strand's reflected prominence and to demonstrate that she was doing much more at the museum than simply minding the store. The exhibition was a success, and Newhall suggested they collaborate further, on a book of Strand's New England photographs—existing images and others yet to be made—with a text that she would edit from historical and contemporary New England sources.[3]

This project eventually became the book, *Time in New England* (1950). Strand came to it with some models of what a photo book might be, for his own *Mexican Portfolio* had appeared in 1940, and during the late 1930s there had been a number of photo-text collaborations between teams like Walker Evans and James Agee, or Margaret Bourke-White and Erskine Caldwell.[4] Strand was farther to the left than Newhall, and *Time in New England*'s political flavor reflects his more advanced sensitivities; one of its largest omissions was also his doing, for the book contains no images of Boston, New England's principal city, because Strand refused to work in the city that had executed anarchists Sacco and Vanzetti.[5] The text was Newhall's contribution, and although evocative, the documents are rather standard fare, such as John Winthrop's sermon aboard the *Arbella* and William Lloyd Garrison's manifesto inaugurating *The Liberator*—the kind of pieces one would find in Newhall's Smith College curriculum. As the project proceeded and Newhall located likely documents, she sometimes pointed Strand toward the kind of images that she believed should accompany the text.[6] Accustomed to such direction from his work in film, Strand often accepted her advice and photographed along the lines she requested.[7]

The two collaborators paired text and images carefully, adapting Strand's "contrapuntal vision" from film to their new photo-text format. They often managed an enriched product in this, for the text acquired poetic dimensions by its relationship to the photograph, and the individual photograph was elevated beyond its subject's quotidian qualities. On one side of a two-page spread, for

instance, they placed Strand's photograph of granite being split in a New England quarry. Opposite it is a 1770s' letter to the royal governor of Massachusetts Colony, written in the name of Crispus Attucks, the African-American murdered by British troops in the Boston Massacre. One is the photo of a quarrying operation, the other a complaint against supposedly premeditated acts of malice. But when Strand's image of *Splitting Granite* (1945) and Attucks's ominous warning to the Governor— "You will hear further from us hereafter"—are placed together, the combination conveys some of the terrific tensions that led to the American Revolution and eventually split apart such a seemingly rock-solid entity as the British empire.[8]

Other juxtapositions are less dramatic but function similarly. In the midst of texts dealing with education and the founding of Harvard College, Strand and Newhall placed the photograph *Meeting House Window* (1945). The image depicts a window almost perfectly centered in the frame, looking in upon a darker interior and across the room to still another window on the opposite wall. Such scenes had been scattered among Strand's photographs since the 1920s, but here, surrounded by documents dealing with education in New England, the vague mysteriousness of those earlier photographs acquires a more definite meaning: Light can be brought into the darkness through projects like the founding of Harvard.[9]

With some of his New England photographs, Strand began to use a new camera orientation. In earlier work, he had either photographed his subjects head-on, or elevated the camera above them in scenes like *Cobweb in Rain* (fig. 7.2). Now, though, he often employed a lower camera angle, giving his subjects a heroic or magisterial posture in the final image. *Church on a Hill* (1946) is one such image—Strand photographed the building from below so that it seems to soar above its surroundings. Of course that had long been the intent behind much church architecture, but Strand's emphasis was not ecclesiastical, and unless one reads the captions, his town halls are difficult to distinguish from his churches. Again and again this posture repeats itself in Strand's work from 1945 and 1946, so that bits and pieces of New England—churches, town halls, steeples, ships, doorways, even grave stones (fig 9.2)—tower commandingly in the images. There is a degree of theatricality in some of these heroic subjects, but only occasionally, and the more persistent effect is one of deep respect, and a respect distinct from that in Strand's earlier photographs. He liked many of his earlier New England subjects, but those mullens and cobwebs were presented as precious jewels, things neatly held within the frame and offered to the viewer. Now, though, the sense is different, more like a humility in the presence of something which cannot be so readily contained.

There was a similar change in Strand's photographs of people. In the early 1940s he made several images of Genevieve Taggard's Vermont neighbors, the Bennetts, including a particularly well-know image of the begrizzled Mr. Bennett. But these were only a prelude, for in 1946 Strand began portraiture in earnest and produced a number of works such as *Belle Crowley, New England* (1946; fig. 9.3). These are large portraits, but not in the sense of the print itself, for many of them are simply 5" x 6" contact prints. Rather, they are portraits of large people, individuals depicted with such stature that the frame barely encompasses them. Like his town halls and churches, these New Englanders dominate the frame, and,

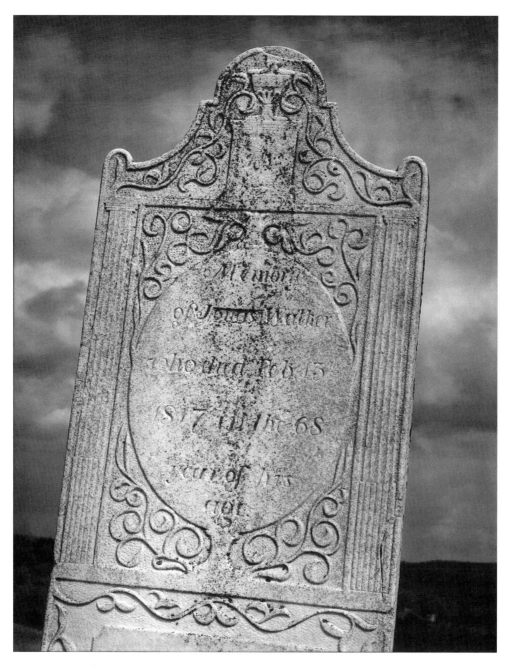

9.2. Paul Strand. *Tombstone and Sky, New England, 1946,* © 1950, Aperture Foundation Inc., Paul Strand Archive.

unlike Strand's more distanced and less engaged Mexican portraits of the previous decade, these photographs are close and involved renderings: It is possible to count the beads in Belle Crowley's necklace, discern the cut of that hairnet as it creases her left ear, and see that her eyeglasses (bifocals we note) are as cleanly kept as the rest of her.

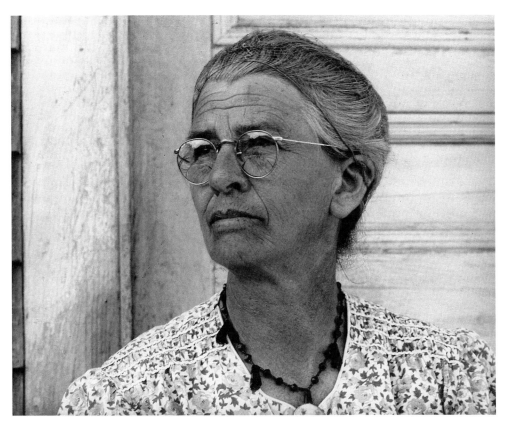

9.3. Paul Strand. *Belle Crowley, New England, 1946,* © 1950, Aperture Foundation Inc., Paul Strand Archive.

This photograph illustrates some of the other characteristics of Strand's New England portraits. There is a uniformity to these images, for when he decided to photograph a New Englander, he most often had the person stand outdoors, beside a building—which of course in New England was often clapboard or shingled. That common background of evenly spaced horizontal lines, together with the camera's closeness, had the potential to produce something like the police mug shot, a treatment that almost literally captures the subject. Yet Strand overcame this format, for his New Englanders possess identity rather than identification numbers, and the text of *Time In New England* reinforces this by telling us more about the subjects' lives. Mr. Bennett was terminally ill at the time Strand photographed him; Belle Crowley was the widow of a sea captain and now making it on her own at Cape Split. These were people who had perseverance, one of the New England characteristics Strand wanted to emphasize in his portraits. He had long managed to give people an air of resolve and strength by having them look away from the camera (frequently to the right), so that they appear to be farseeing individuals with their eyes upon the horizon. Belle Crowley does this, too, but by having her peer into the brightness, a brightness reflected in her spectacles, Strand made sure that she would have that added squint which suggests that hers is a particularly long and penetrating vision.

Man, Tenancingo (1933; fig. 8.2) was an earlier example of this kind of portrait, and the New England images so resemble it that it is clear Strand had settled upon a favored pose. In New England he continued to coach his subjects into the same posture, but now he told people like Belle Crowley to turn their heads just a bit more away from the camera and to raise their chins just a touch more. The effect was an enhanced monumentality, and more grit, too.

Strand's New England images and *Time in New England* were created against the backdrop of the contentious politics and the politicized art debates of the early Cold War. There was an intense conflict between two camps in the American art world, and the air was filled with barrages of accusations and denunciations. In one group were left-wing representational artists like Strand, Philip Evergood, and Ben Shahn, who called themselves realists, and in the other were artists and curators who favored less-engaged, nonrepresentational fields such as abstract expressionism. Name-calling and shouting were common, beginning as early as 1943 when Evergood claimed that representational work was the only art with integrity.[10] By the early 1950s the battle was thoroughly joined, and when representational artists founded a testy journal which they called *Reality*, Museum of Modern Art officials warned *Reality*'s editorial board that its efforts demonstrated dangerous communist tendencies.

For his part in the debate, Strand came out repeatedly in favor of representational work. Never would he go so far as to advocate simple transcription ("the mere copying of something is not sufficient"[11]), and he allowed that abstractionism might be a helpful learning tool. But still, he told a Chicago audience in the summer of 1946, clear representation was important because if one's subject became obscure, the message was also frequently foggy.[12] Stieglitz was very much on Strand's mind when he said this, for Stieglitz had died only a few weeks before, and Strand thought that Stieglitz had been quite mistaken when he had created those Equivalents, as Stieglitz said, "to show that my photographs were not due to subject matter."[13] Strand was willing to grant that Stieglitz's cloud images might express emotion, but he thought they failed to work clearly enough with "the stuff of reality."[14]

Strand went on to charge the photographer with creating an activistic art and with making politically relevant images. Never, Strand insisted, should realism be confused with anything like a dispassionate or uncommitted vision in which one assumes the posture "of a man who thinks he stands above life, above good and evil." Such supposed objectivity was not only existentially impossible—simply by being alive one was implicated in the conditions of life—but when those conditions involved good and evil there was a moral imperative to do one's part for good. As Strand told a 1949 gathering of photographers, "we take sides...and align our art and our talents on the side of...the plain people of the world."[15] For Strand, art should shape and mold the world, and representational art was particularly good in pushing it in the progressive directions he favored.

He also sought to shape that world through his politics as well as his art. During the years he was involved with *Time in New England*, Strand was terrifically active, having "so much time taken up in political, cultural" work, that his life often seemed to consist of "meetings, meetings and more meetings."[16] Strand

labored within small political organizations, but the candidates and issues he embraced were national ones. During FDR's 1944 re-election campaign, Strand designed and produced an eighty-foot-long photo mural "Tribute to the President,"[17] and he was cast in a silly campaign skit that, if it ever occurred, had Strand and an odd collection of other celebrities, including Orson Welles, Vincent Sheehan, Fay Wray, and Louis Untermeyer, declaring themselves aboard the FDR train while a chorus chugged along in locomotive-like rhythm.[18]

Strand was even more active in the 1948 Progressive Party presidential candidacy of Henry A. Wallace. He had continued as a member of the American Labor Party, which became the New York unit of the Progressive Party, and he also joined the affiliated Progressive Citizens of America (PCA). Strand rose to become an important figure in the cause; he attended the January 1948 PCA convention in Chicago, and together with Ben Shahn was co-chair of PCA's arts division.[19] Most significantly, Strand drafted the Progressive Party's platform plank on fine arts. Several years in the making, this plank stressed that art can benefit the nation, insured that there would be plenty of those benefits by establishing a Federal Bureau of Fine Arts, and called for a permanent national photographic project along New Deal lines.[20]

There was a certain urgency to all this activity. Although Strand remained hopeful for his causes, each passing month seemed to bring distressing news that his allies and values were under conservative assault. The 1946 Taft-Hartley act was a horrendous violation of labor rights, and the absence of due process in the loyalty purges indicated that America had come to what Strand called "Nazi justice."[21] In a similar vein Strand hinted that responsibility for Beaumont Newhall's dismissal from the Museum of Modern Art should be laid at the feet of Museum board member Nelson Rockefeller, because, Strand said, "he [Rockefeller] and his ilk are fascist-minded people."[22] Less darkly and probably more accurately, Strand also noted the House Un-American Activities Committee hearings on the Hollywood Ten writers. It was tragic enough, Strand said, that the subsequent blacklist meant John Howard Lawson, Dalton Trumbo, and the others were denied their careers. But even more ghastly was the clear indication that this intimidation "can lead anywhere ... writers, the publishing industry, the radio industry, theater, every single thing in America can become involved in a gigantic blacklist."[23]

Strand was justifiably concerned. The presence of a giant American blacklist was confirmed on December 4, 1947, when Attorney General Tom C. Clark issued the infamous list of "Totalitarian, Fascist, Communist or Subversive" groups. It was little surprise that organizations like the Klan or the Communist Party were on the list, but there were also other, seemingly benign organizations: the Civil Rights Congress, the Joint Anti-Fascist Refugee Committee, and the Veterans of the Abraham Lincoln Brigade. And the Photo League.

The Photo League was an organization of still photographers that shared some of the same communist roots as Nykino. Most of the other members were younger than Strand and he acted more like their elder adviser than their colleague. Many had no knowledge of the club's leftists origins, and were astounded to find themselves blacklisted. They groped for some effective response: an attorney was consulted, a protest telegram was fired off to Washington, a petition drafted, and a meeting called.

It was Strand whom the League chose to define the moment, and he gave the protest meeting's keynote speech. He told the members that they were victims of "reactionary forces" that patterned themselves after the Nazis, individuals who "were afraid of artists," and, like their fascist forebears, the American "reactionaries are reaching for their guns." But after all these dire remarks, Strand's concluding advice was a curiously mild lesson in good citizenship: he told the young photographers to go forth, vote Progressive, and reject the now obviously untrustworthy Republicans and Democrats.[24]

But if anything, good citizenship was one of Strand's overarching cold war themes. His leftist faith remained intact, to be sure, but he was preoccupied with matters such as civil liberties, and that preoccupation helps to explain his choice of New England as his photographic subject in the late 1940s. Like playwright Arthur Miller, Strand had come to see a special contemporary relevance in New England history. Miller's 1953 play *The Crucible*, was outwardly about the 1692 Salem witchcraft trials, but its emphasis on freedom of conscience and the persecution of dissidents obviously referred to the red scare of Miller's own time. Strand had a similar reading of the New England past, and *Time in New England* drew some of the same parallels. He described New England as "a battleground where intolerance and tolerance faced each other," and told his readers that it was this "concept of New England that, like a scenario, gave the clues to the photographs in this book and brought them into relationship with the text."

But to show such relationships, Strand foreswore "literal juxtaposition."[25] He would not merely photograph a broken pulpit as his contribution to the section of Roger Williams' religious persecution. Accordingly, in the finished book Strand's photographs tend more to resonate with the various texts than to illustrate them.

Consider the section devoted to the 1692 Salem witchcraft mania. The book presents this as a civil rights case, arranged so that the issue is not some problematic right to cast spells on people, but rather the undeniable right to a fair trial. The documents follow each other chronologically, ultimately showing the hanging of nineteen individuals despite dubious evidence and recanted testimony. At first Strand's two accompanying images do not seem part of this tissue; *Dead Tree* (1945) and *Window, Abandoned House* (1944) are lonely scenes, with an emptiness that seems ill-fitted to Salem's tumultuous spectacle. But Strand aimed for the quiet rather than the blatant relationship. The lifelessness of the tree, its broken and naked limbs, the starkness against a beautiful sky—these are all poignant accompaniments, evocative of the blatant pathology that silenced and killed people in Salem, and constitute a somber reference to the tree from which those victims hung. The window functions in a similarly indirect manner. Unlike the Harvard window that had preceded it, this one has an interior that appears completely unilluminated, suggestive of the inner darkness which can give rise to persecution. In this way there is a sort of purposefully enigmatic quality to Strand's images within *Time in New England*, forcing audiences to puzzle out just why a given photograph is situated among particular documents. The ciphers act as something of a brake upon the reading, slowing one so that more of the past event—more of the horror of Salem—can seep in.

This contrapuntal dimension appears throughout *Time in New England*. From words to picture and back again, the contents are arranged so that they play off each other in an effort to deepen the book's message. The section dealing with the prominent abolitionist, William Lloyd Garrison, contains Garrison's resounding pledge to be uncompromising and clamorous in his denunciation of slavery: "I will not equivocate—I will not excuse—I will not retreat a single inch—AND I WILL BE HEARD." Opposite these words is Strand's *Steeple* (1946), another of those heroic New England buildings, towering as though from a hill top and rather evocative of Garrison's determination to take the high moral ground. Moreover, as the steeple dominates Strand's frame, it comes to seem almost a twin of Garrison, for both are loud, proud and undeniable.

And Garrison was this way even though mobs of New Englanders brutally tried to keep him quiet. Similar episodes from New England's past and are likewise noted throughout *Time in New England*: Quakers are whipped, witches hung, and strikers threatened. Certainly this was the "battleground" of tolerance and intolerance, where minority voices were often silenced.

But not always in utter tragedy. In this book, victims of civil liberties abuses attain a kind of martyrdom, and the very last section of the volume, pointedly entitled "Affirmations," contains *Tombstone and Sky, New England* (1946; fig. 9.2), which is by far the largest and most towering of Strand's tombstones. Photographed so that the engraving is barely discernible, this image leads to a message other than the inscription, the conclusion that death *can* be proud, like this noble tombstone standing against the dark landscape and the lowering sky.

Accompanying that tombstone are other "Affirmations," letters by Nicola Sacco and Bartolomeo Vanzetti. These were America's best-known labor martyrs, often memorialized by Strand's contemporaries such as painter Ben Shahn and novelist John Dos Passos. From the moment that they were arrested, it was obvious that Sacco and Vanzetti would be executed, and their trial, a predictable product of Massachusetts' prejudices against Italian anarchists, was an utter travesty of due process. Yet in their last months both men saw that this persecution gave them a voice they would not possibly have had otherwise, and the book reproduced Vanzetti's recognition that "we are not a failure," that the approaching executions were actually "our triumph. Never in our full life could we hope to do such work for tolerance, for joostice, for man's understanding of man as now we do by accident."[26]

Vanzetti's circumstances are repeated throughout *Time in New England*. In this book, people do gain a voice, and to paraphrase Garrison, they are heard. One might understandably feel that the cost of that speech was too high, but Strand and Newhall tried their best to lead readers to a different conclusion. With its insistent optimism, *Time in New England* always counsels against despair, repeatedly indicating that despite ignominious and cowardly suppression of freedom, principles of justice and truth will prevail. The book thus reifies a "usable past" when American civil liberties were imperiled, showing that dissent and tolerance were in the very fabric of America's oldest region and not some foreign or subversive concepts. With such a message, Strand's book was intended to deliver hope in the age of McCarthyism and to be a fulcrum for levering the nation toward greater tolerance.

In the late forties Strand's attention shifted from New England to Europe. Part of this was simply opportunistic, for in 1949 he was invited to film conferences in Czechoslovakia and Italy. During the interval between those two conferences Strand visited France, where he scouted locations for his next project. Still remembering *Winesburg, Ohio* and *Spoon River Anthology*, Strand had in mind an extended photographic survey of a village. It was of course odd that one would go to Europe to execute a project inspired by fictional American communities, but several factors help explain Strand's decision. One was simply wanderlust; after sixty years of photographing North America he had an urge to work elsewhere. Another has something to do with an habitualized handling of life's milestones; Strand had gone to Mexico when he split with Stieglitz and divorced Rebecca, and now he decided to photograph France after the death of his father and his divorce from Virginia. Perhaps Hazel Kingsbury also had something to do with the choice. She was a photographer who had traveled extensively in Europe while serving in the Red Cross during World War II. Kingsbury and Strand met in 1949, she accompanied him to France when Strand began photographing there, and they eventually married there a few years later.

More importantly, though, Strand's interest in Europe was associated with his disappointment in the United States. As the 1940s drew to a close, even Strand had some difficulty feeling sanguine about his native land. Henry Wallace had not only suffered a stunning defeat in the 1948 election, he had also received even fewer votes than the reactionary Strom Thurmond. That same year Congress passed the Subversive Activities Control Act, placing more restrictions on organizations like the Photo League and precipitating a host of resignations from the League as timorous individuals like Nancy Newhall and Ansel Adams rushed to save their own necks.[27] Such cowardice seemed rampant, and Strand began to feel as though the "moral climate" of the country had become "poisoned."[28] For his village portraits Strand wanted faces of dignity and character, but with hatred loose upon the land, there was little hope that American villages of the moment would supply what he wanted. Nor did it seem likely that he could photograph freely. These were suspicious times, difficult for anyone, much less a person with Strand's prominent radical background, to undertake a project requiring one to prowl about and photograph small-town America.[29]

There were good reasons to be fearful. His *Native Land* colleagues Leo Hurwitz and Paul Robeson had been added to the growing number of blacklisted artists, and Strand faced the very concrete prospect that there would be serious official obstacles to his work in the United States. In 1949 there was additional talk in Washington of legislation restricting the travel of dissidents (deemed "subversives"); with his earlier visits to Moscow and Czechoslovakia, Strand seemed a likely potential target, and the possibility loomed that he might not be able to leave the country either. Deciding to leave while he still could, Strand departed for France in 1950.[30]

His apprehensions proved to be justified. In September came the McCarran Act, which enabled the federal government to register and intern progressives, a set of sweeping powers which, as Walter Rosenblum said, "takes...fears out of the realm of fantasy and makes them pretty plain fact."[31] Under provisions of that Act, in 1951 the Federal Bureau of Investigation began compiling a secret dossier on

Strand, employing resources and information from agencies as diverse as the State Department and the Office of Naval Intelligence. Strand's background in Frontier Films, his political activities of the 1940s, and even his recent support of Henry Wallace were all duly noted. American officials in Paris were asked to monitor Strand's activities, and mechanisms were established which would provoke a security alert should Strand attempt to re-enter the United States.[32] American officials subsequently asked Strand to surrender his passport, after which he could not return to the United States until his case was adjudicated in the late 1950s.[33] Nor was he allowed to roam unwatched in France, for in October of 1953 the FBI Director ordered the legal attaché of the American embassy in Paris to monitor his activities.[34]

France was something of a haven for Americans during these treacherous years. Perhaps the best known expatriate was novelist Richard Wright, who in 1947 settled permanently in Paris after having been invited by the French government. Strand, though, was more of an inadvertent expatriate. A victim of some of the very civil liberties abuses that he condemned, Strand had left America when the getting seemed good, and then found that the cascade of events made return impossible for years. In 1951 he and Hazel were married in one small French town, and then four years later, in another French village, they purchased what became Strand's final house. He never renounced his United States citizenship, and eventually made several visits to America. But at some point in the early 1950s, France became Paul Strand's home.

In the years between 1950 and his death in 1976, Strand produced negatives as never before. His output far exceeded that of the first thirty-five years of his career, so that like Stieglitz, his last years were particularly fecund ones. Like Edward Weston, Strand made many of these images during the course of wide-ranging photographic expeditions, and although there had been a peripatetic aspect to Strand's earlier work in Mexico and Canada, after 1950 he ranged to ever-more remote destinations, first in Europe and eventually in Africa. Finally, Strand's subjects changed, too, for his art now became largely an art of portraiture.

Strand's first project was a failure. He came to France looking for a village to photograph, but without much sense of what it might look like or how he might photograph it once found. Traveling about the countryside, without a plan for how to look, as Strand said, he "began to photograph ad lib."[35] Back in 1921 Strand had complained that painter John Singer Sargent, whom Strand called "one of our expatriates," had failed during his own travels because his vision was "unorganized and formless."[36] Precisely the same could be said for Strand in France, and although he managed to publish a book of the images, *La France de Profil* (1952), it is a dark and gloomy work that says little about the French beyond the fact many of the males seem to wear berets.[37]

Subsequent efforts were more successful. Strand had pretty much gone it alone in France, relying only on Hazel's help. But for his next project, and indeed for the rest of his career, Strand relied heavily on other people to form and direct his photographic expeditions and the books that came from them. Strand turned to Italian filmmaker Cesare Zavattini, co-creator (with Vittorio De Sica) of *The Bicycle Thief*, and practitioner of a cinematic realism. Strand had shared a platform with Zavattini at one of those 1949 film conferences, and he persuaded Zavattini to write

the text for his next project, still another book about a small community.[38] Strand asked for help in selecting a village to photograph, and Zavattini made a quick and easy choice—his own home town of Luzzara.

The work progressed between 1952 and 1954, and was eventually published in 1955 as *Un Paese*.[39] Strand managed to give this effort some of the structural strengths the French book had lacked. He created the feel of cinematic "pans," alternating long shots, close-ups and medium shots so that the succession of images seems repeatedly to zoom in upon the village, establishing context before moving to individual cases. Additionally, there is a contrapuntal arrangement of images, sometimes topically, as when an agricultural worker, posed before a large pile of hay, is faced on the opposing page by scythes hanging on a wall, and sometimes formally, as when Strand paired photographs of a sinuous vine and a twisted old man. Within this framework, Strand also used visual clues to convey something of the village's economic structure, and the text describes the scars of the preceding decades under Fascism.

But Strand was also interested in things beyond a sociological or historical survey, and as in New England he continued to pursue qualities such as character and perseverance. Strand came to Luzzara ready to like the people, and apparently they liked him, for he was the collaborator of their beloved favorite son. Understandably, Strand's portraits were flattering as he photographed these "fine people." With his portraits such as *Young Man, Luzzara, Italy* (1953; fig. 9.4), he created images that give a strong sense of his affections for the villagers, and would, he hoped, "make others care about them by revealing the core of their humanness."[40] Like *Young Man*, many of Strand's subjects meet the camera with a confident gaze. As in New England, a good number were photographed against a wall of some kind or another, and again they seem more riveting than riveted, more as though they are in command of things than as though they were affixed to a background. The jaw line of this man appears repeatedly; straight forward and only slightly lifted, it has nothing of the tucked-into-the chest attitude that might convey meekness or uncertainty, and likewise none of the haughtiness that a more lifted chin might convey. The eyes have a sense of command and assurance, while that slight wrinkle to the brow suggests the inquisitiveness of one who can approach the world with an open mind. The clothing is humble—worn and soiled—but those rolled-up sleeves are the mark of a man who is ready to get to work. Finally, that posture compounds the overall impression of engagement, for the man leans forward into the camera, arm resting on his leg and that stick held comfortably in his hand. Nicely lit, and well-framed, Strand gave the image just enough contrast to emphasize the man's piercing dark eyes, echoed in the details of the wall behind him.

By the late spring of 1954, with *Un Paese* mostly ready for publication, Strand traveled through England and into Scotland, interviewed a new prospective collaborator in Edinburgh, and arrived at his next photographic target, the island of South Uist in the Outer Hebrides off Scotland's west coast. Strand had selected this community after hearing Alan Lomax's BBC radio broadcast about folk songs of South Uist. Like Strand, Lomax was moving from work in the American hinterland to record out-of-the-way European locales, and he too had well-established progressive credentials—as a folklorist, he had recorded, among others, Woody Guthrie.

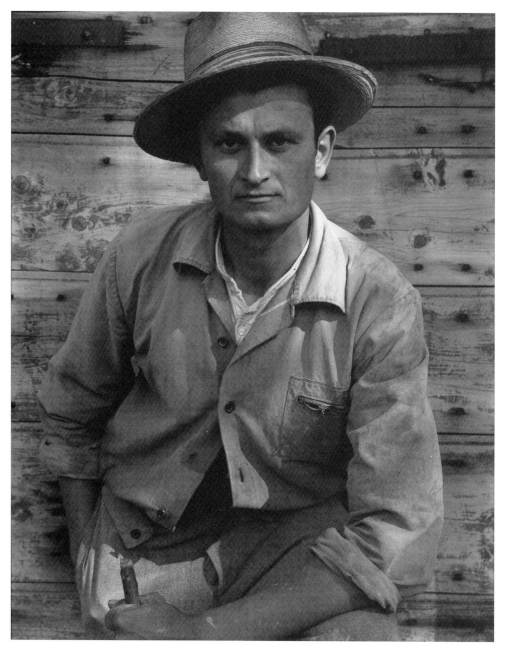

9.4. Paul Strand. *Young Man, Luzzara, Italy, 1953,* © 1976, Aperture Foundation Inc., Paul Strand Archive.

Thus when Lomax visited South Uist and, in Strand's words, "talked glowingly of his experience there," the island received a considerable endorsement.[41] Moreover, Strand's willingness to act upon a *radio* program was not so odd given his new portraiture, for things like character and sturdiness may be conveyed aurally as well as visually, and as Strand listened to the mix of Lomax's commentary and the singers' music, he concluded that this place had much of what he sought.[42]

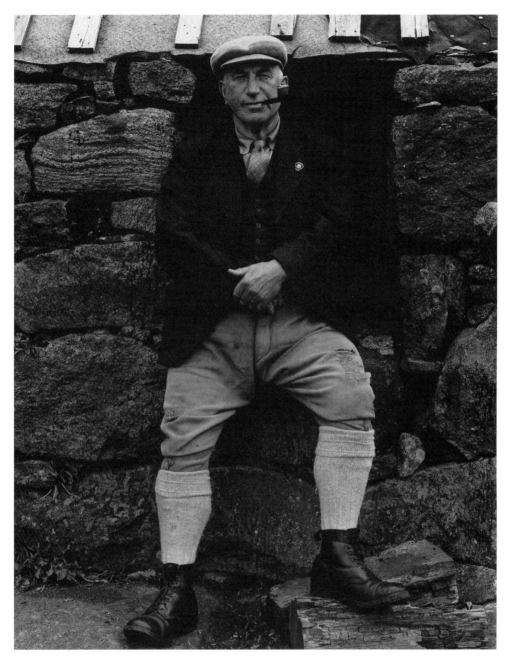

9.5. Paul Strand. *Archie MacDonald, South Uist, Hebrides, 1954*, © 1962, Aperture Foundation Inc., Paul Strand Archive.

The hills of South Uist were uninteresting, "absolutely bare and treeless, rock and heather covered."[43] Yet Strand had come to photograph something besides landscape, and when he arrived on South Uist the local doctor gave him "a list of names of people all over the island...whom he thought had good character in their faces." Again Strand worked with the direction of a native, like Zavattini in Luzzara, and again felt he had chosen well. The physician's "judgments turned out to be first rate,"

for "he had a fine eye and everybody that we met was photogenic."[44] The Hebrideans played their Brigadoonish parts well, too, offering tea and cakes, and displaying themselves as "a darling people."[45] Crisscrossing the islands, photographing the people and their places, Strand's project was less an assessment of the island and more a veneration of what he called "the fine basic character of these folk." He honed and polished these sentiments over a period of years, but always felt that the "central theme of these islands" was the islanders themselves: "their dignity and sturdiness, and the *tenacity* with which they hold on to their barren wind swept isles."[46]

Once more faces were at the heart of the matter. Fully a third of the images in *Tir A'Mhurain* (1962)—(the title is Gaelic for South Uist)—were portraits. Again Strand used his juxtapostional scheme in pairs such as *Donald MacPhee* and *Root, Lock Skiport*, the root clinging to its hard-won station, and the man similarly attached to his stone home, conveying some of Strand's notion that the Hebrideans were "tenacious in the face of all hardships, rooted in their island."[47] In a slightly more serene version of the same posture, Strand portrayed *Archie MacDonald, South Uist, Hebrides* (1954; fig. 9.5), pipe likewise clinched in teeth, backside likewise pressed up against still another stone wall. MacDonald seems well enough in command of things, but not given to excessive exuberance; his eyes have a look of keen concentration, his head has a slightly inquisitive lean to it, and that pipe is carried at just the right angle, not drooped in any way that might convey weakness or moroseness, nor too high with that air of unbounded optimism that made FDR's cigarette holder so comical. MacDonald took some pains in dressing for whatever occasion brought him to this wall; his tie is knotted close against his neck, the jacket appears brushed and clean, and in his lapel there is an insignia pin of some sort. Yet for all these concessions to civility, MacDonald also presents himself as a thoroughly practical man. Those pants and socks are gathered tight for navigating the island's heather, and the considerable patching on the trousers suggests that he is not a person to discard anything too quickly. Perhaps most striking, though, are the boots which he wears so confidently and has laced according to his own tastes. Well-maintained—what else from this man?—they are also thoroughly unfashionable, sensible shoes if there ever were such things.

The same year he made this portrait, Strand said that his larger photographic effort was "to arrive at the common denominator which makes us all kin."[48] Judging by his Italian and Hebridean work, Strand had come to believe that resolve and decency were universal qualities that knew no cultural barriers. Nor was he alone in his fascination with this theme. In one of those odd cases of synchronicity, Edward Steichen almost simultaneously developed a large and extraordinarily popular exhibition (and book, too) known as "The Family of Man." Steichen was the curator rather than the photographer for this 1955 show, and he drew upon a diverse number of international photographers to create a display of a human "family" that for all of its differences was knit together by endurance and kindliness. Given Strand's own vision it is little surprise that he liked "The Family of Man" when he saw it at its French venue.[49]

If it strived for universality, the exhibition was not universally popular among photographers. Some, such as Ansel Adams, had long sided against Steichen in art photography's civil wars. Others could not get past its blatant sentimentality. And even others resisted "The Family of Man" on the solid critical ground that the show

was hackneyed, too willing to ignore the many conflicts that actually wrench apart the human family, and too much a product of that 1950s impulse to find everywhere a consensus, a commonality. Of course many of the same critiques could be leveled at Strand's work after he left the United States, and perhaps the most compelling critique has to do with his (and Steichen's) celebration of human endurance. Certainly (the argument goes) people deserve credit for surviving the likes of Italian Fascism or the North Atlantic weather, yet simply lauding that endurance, as was Strand's inclination, does little to help other people avoid subsequent predations and deprivations. Endurance is an important virtue, but there are others more useful in directing and molding the future.

Ordinary individuals like Belle Crowley and Archie MacDonald were not the only people on Strand's mind. During the late 1950s he also turned his attention to Western intellectuals. As the Cold War grew more ominous with events such as the 1956 Suez Crisis, and as reports reached him of continuing red-baiting in America,[50] Strand came to believe that artists and writers had been jarred into senselessness by events. "It is as though they knew for years where north was," Strand said late in 1956, "and suddenly find themselves with no compass, having either lost it or thrown it away."[51] But Strand was not willing to let his compatriots wander aimlessly. He had his own notions of a pole star worth following, and so he worked hard at offering his fellow intellectuals the guidance he thought they needed. Some of his contributions were public, such as his remarks at a 1956 Paris film conference, and others were in private correspondence, including one remarkable November 1957 letter to his ex-wife Virginia.[52]

Strand said he was "overwhelmed by the arrogance of intellectuals."[53] Too often it seemed as though they had taken advantage of troubled times to turn inward, and in doing so ignored the fundamental social duty of creative individuals. As Strand described it, there was a sort of never-ending, always-changing draft facing the intellectual; here he *must* be a critic, there a celebrant, sometimes violent and at other times peaceful.[54] In terms reminiscent of John Dewey, Strand said that one's intellectual efforts should function in the here and now as instruments, pursuing truth not just for its own sake, but "as truth which sees and understands a changing world and in turn is capable of changing it."[55] Strand called for the intellectual to be an audacious yet sincere cheerleader, whooping humanity along with creations and discoveries leading to constant improvement, a booster who remained confident about final victory even if the current contest was not going so well. He admitted that the job he had assigned was a tough one (cheerleading *is* hard work), but said this was an assignment "which has nothing in common with vulgar optimism or self-deception."[56] Without lying to themselves, without minimizing the difficulties facing humanity, Strand believed it was possible for thinkers and artists to present their work so that it envisioned—and pushed toward—an improved future.

This was of course a version of the old leftist good fight. And it seemed to Strand that some of his former comrades had gone over to the other side. Harold Clurman's efforts to minimize the earlier radicalism of the Group Theatre seemed to Strand a "slimely clever" effort at "falsification of history by omission," while others in the Group provoked even greater anger as they cooperated with the red-hunters

and made "the transition to stoolie. Pfui!"[57] But Strand also thought there were good guys among the intellectuals, folks who remained true to the struggle and whom he decided to portray in a photographic pantheon of progressive French intellectuals. Strand envisioned this as a large project of about one hundred portraits, far more than in any of his earlier books, and by the time he abandoned the project (around 1959), he had photographed at least forty-eight people working in six broad fields: film, music, science and medicine, theater and performance, the visual arts, and writing.[58] In some cases he seems to have selected individuals of a certain prominence in French culture, like Marcel Marceau and Jean Pierre Rampall, and other selections reflect his own pet interests, as when he photographed those who discovered and analyzed the Lascaux cave paintings. Strand also liked the grand innovators—Picasso and Braque were prominent in his collection—and he had a regard for the versatile talents of individuals such as Alberto Giacometti and Jean Cocteau.

But beyond this was another common thread. Repeatedly Strand sought out and photographed intellectuals and artists whose lives and work embodied the sort of qualities that Strand hoped to promote—optimism, social conscience, progressive politics, and a determination to keep fighting the world's fight. Strand's search for optimism may well have led him to photograph Jacques Prevert, whose emphasis on social hope and sentimental love had made him well known, and Prevert, like others in the collection (and like Strand himself) had been drawn to the Soviet Union in the 1930s. Strand also photographed the writer Louis Aragon, who had broken with surrealism in the 1920s to become a Communist, and during much of the 1950s was editor of a Communist arts and letters weekly. There were also tales of terrific personal heroism behind Strand's portraits of individuals such as Frederic Joliot-Curie. Son-in-law of Marie Curie, Joliot-Curie had with his wife won the 1935 Nobel chemistry prize for the discovery of new radioactive elements. Joining the Communists and then the Resistance, he stayed in Nazi-occupied Paris where he organized the clandestine production of explosives for the underground. First welcomed in the postwar French nuclear program and then banished for his progressive politics, by the time Strand photographed him, Joliot-Curie was suffering from what proved to be a fatal case of hepatitis.

If any one individual encapsulated Strand's themes, perhaps it was Jean Paul Sartre (Figure 9.6). In this image the philosopher is portrayed as quite the serious man, his face turned in just the right way to obscure that misaligned eye that so many people found distracting. Sartre's claim to intellectuality is substantiated by many of the familiar props: the books, the black-framed glasses, and, de rigueur for the period, the cigarette. Sartre seems comfortable in his position, for he sits not at attention but leans comfortably into his chair. Other nonvisual traits helped make Sartre appealing for Strand. He was a persistent communist, who had put his principles to work in the undeniably good cause of the Resistance. Sartre's existentialism must have registered well, too, something Strand understandably would have recognized as a close cousin to his own hopeful realism. Sartre was willing to assess situations negatively, to see the pain and absurdity of the human condition; but like Strand, he was a materialist who denied that those circumstances were permanent ones assigned by any larger transcendent force, and who held that for all our present difficulties humans can also define what our essence, our condition, shall henceforth be.

Eventually Strand abandoned this "very large and difficult project."[59] It is tempting to say that intellectuals like Sartre were not as photogenic as the people on South Uist. But its probably more accurate to say that it was the *qualities* rather than the people which were not photogenic. In the Hebrides he had been after characteristics such as tenacity, something that can come across on film. But other characteristics, say the ability to discover radioactive elements, are not so camera-friendly. Also, Strand came to his intellectuals with more criteria in mind than he had with his earlier portraits. Almost any one can appear tenacious; there is nothing that gives Hebrideans a monopoly on the look. But the look of art is different. The day that Strand came to photograph Picasso, for instance, he was disappointed to find the man was not wearing his old, paint-splattered clothes, and moreover the painter's preoccupation with his next appointments seemed to mask the visual qualities Strand had hoped to find in his face.[60]

Strand's project also placed considerable demands upon the viewer, which may be the ultimate reason for Strand's decision to abandon the work. For one to "get it" with the Hebridean or Italian books, for one to realize a message about decency and perseverance, it is not necessary to know much about the complexities of either location. But "getting it" with the intellectuals book would have required much more, it would have required that one know something about Curie, Rampall and Sartre. Beyond the ability to read faces, one also needed a little music, a little science, a little philosophy to catch the drift of these portraits. Presumably there might have been some readers who could do this, and Paris of the 1950s was probably one of the few places where public intellectuals might actually have been recognized. But even that audience was small, and given the limited market, it is understandable that Strand's publishers were wary of the project.[61]

From the later 1950s onward, Strand led much of the life that he had prescribed for other intellectuals. He kept working away, maintained his progressive dreams, and, apparently, never despaired. Most of his projects were not terribly innovative, and there was little departure from what became his travel-book formula, and the persistent cheerfulness is sometimes numbing. But still the photography continued, with four more photographic trips involving exhausting months of travel over tens of thousands of miles and then hundreds of hours of darkroom work upon his return to France. Strand maintained his political commitments, and he was an articulate, concerned witness to the turbulent events of the 1960s. His optimism, though it had much of the naïveté he tried to deny, was likewise an abiding part of Strand, and he retained his sense that hope was not just a necessity for human endurance but also a legitimate outlook on the human future.

The continuity of Strand's visual interests in these last years was impressive. The white fences, the doorways, and the portraits continued, and machinery, directed by strong human will, makes a reappearance. Many of his negatives were made during the course of four major trips, to Egypt in 1959, to Romania in 1960, Morocco in 1962, and Ghana in 1963-64. He was a terrific stranger in all these places, and continued to rely upon guides who doubtlessly orchestrated much of what he saw—whether as collaborators upon the books, or

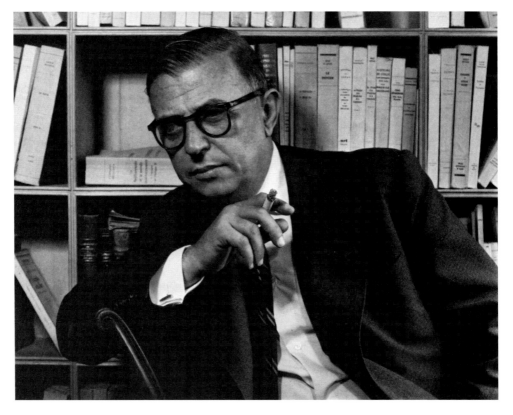

9.6. Paul Strand. *Jean Paul Sartre, Paris, 1956,* © 1971, Aperture Foundation Inc., Paul Strand Archive.

as the officials, journalists, and drivers who accompanied him in the field. Strand's travel ceased only toward the very end of his life, when his photography became restricted to his garden

There was a certain political flavor to the destinations Strand selected. Romania was of course an Eastern-bloc country, but there was a socialist dimension elsewhere. Strand visited Egypt when it was under the leadership of Gamal Abdel Nasser, who was steering a course that led his country not only away from the colonial yoke but also towards a socialist alignment at odds with American Cold War goals. Similarly, Ghana was emerging from colonialism under the socialist direction of Kwame Nkrumah, and much of Strand's introduction to the country came from American socialists W.E.B. Du Bois and his wife Shirley Graham Du Bois, who were then living in Ghana.[62]

In his trips, Strand managed to produce consistently upbeat images from some of the more depressed countries on earth. Such work stirred the incredulity of viewers who thought it had been one thing when Strand's images highlighted anachronistic ways of life in European backwaters, and something quite different when he seemed almost to exalt deprivation in the Third World.[63] Other critics noted Strand's coziness with the Soviet bloc, where he sometimes managed to find publishers for books that were orphaned in the West, and where he had pride of place

for the 1961 Prague May Day parade.[64] It is probably unfair to call Strand a Stalinist, but his critic and former colleague Ben Maddow was correct when he said that none of the Soviet abuses ranging from the Moscow trials of the 1930s to the deprivations behind the Iron Curtain ever "provoked a single signature of protest from Strand."[65]

But Strand did protest the way that the West did things. His early satisfaction with Lyndon Johnson was eroded by the war in Southeast Asia, so that when the White House invited him to an arts festival in June 1965, Strand joined with other artists like Robert Lowell to decline the invitation in protest of Johnson's escalation of the war.[66] That White House invitation had itself been an indication of Strand's growing public stature, and despite some lingering concerns, the FBI finally closed its files on him in 1966.[67] During the 1970s Strand attained the kind of blockbuster recognition that American venues often reserve for artists approaching the end of their careers. In 1971 his massive retrospective exhibition opened in Philadelphia, and after a triumphant tour through Boston and St. Louis, in 1973 it came to New York's Metropolitan Museum of Art. This was grand recognition, crowned the following year when *The New Yorker* selected Calvin Thomkins to make Strand the subject of one of its Profiles.

Strand worked until the very end. In the early 1970s his eyes gave him increasing troubles, making photography quite difficult. He photographed narrowly, restricting himself to the area around his quarters and the confines of his garden. But the projects continued, with the appearance of two significant portfolios that were in preparation during late 1975 and early 1976. In March 1976 Strand gave these portfolios the final touch of his signature, and with this last piece of work completed, he died.

————————

1. PS to Henry Allen Moe, October 15, 1943, PSC/CCP.

2. Elinor Langer, *Josephine Herbst* (Boston: Little, Brown, 1984), 67-8, 339n. Genevieve Taggard, *A Part of Vermont* (East Jamaica, VT: The River Press, 1945).

3. Paul Strand, Tape-Recorded Interview with Paul Strand, November 1971, interviewed by Milton Brown and Walter Rosenblum. Archives of American Art, New York; here from Calvin Tomkins, *Paul Strand: Sixty Years of Photographs* (Millerton, NY: Aperture, 1976), 163.

4. Strand had given particularly careful attention to another collaboration between photographer Dorothea Lange and economist Paul Taylor. Paul Strand, "An American Exodus by Dorothea Lange and Paul S. Taylor," *Photo Notes* (March/April 1940), 2-3.

5. Beaumont Newhall, *Focus: Memoirs of a Life in Photograph* (Boston: Little, Brown and Company, 1993), 139.

6. NN to PS, June 1, 1946, in Sarah Greenough, "An American Vision," in *Paul Strand* (New York: Aperture; Washington: National Gallery of Art, 1990), 167, n106.

7. Nancy Newhall, "Paul Strand, Catalyst and Revealer," *Modern Photography* 33 (August 1969), 75.

8. Paul Strand and Nancy Newhall, *Time in New England* (New York: Oxford University Press, 1950), 80-81.

9. Ibid., 29-30. Mike Weaver is inclined towards a more Freudian reading describing Strand's windows as feminine, his poles and trees as masculine. Mike Weaver, "Paul Strand: Native Land," *The Archive* 27 (1990), 12-13.

10. Philip Evergood, "Sure, I'm a Social Painter," *Magazine of Art* 36 (November 1943), 254-59.

11. Paul Strand, "The New Vision in Photography," seminar, Institute of Design, Chicago, July 30-31, and August 1-2 1946, PSC/CCP, 79.

12. Ibid., "The New Vision in Photography," 79.

13. Alfred Stieglitz, "How I Came to Photograph Clouds," *The Amature Photographer and Photography* 56 (September 19, 1923), 255; here from Nathan Lyons, ed., *Photographers on Photography* (Englewood Cliffs, NJ: Prentice Hall, 1966), 112.

14. Paul Strand, "Stieglitz: An Appraisal," *Photo Notes* (July 1947), 10.

15. Strand, speech at Perugia, Italy, September 24-27, 1949, PSC/CCP.

16. PS to EW, January 18, 1949, EWA/CCP. PS to Virginia Stevens, April 23, 1946, VSC/CCP.

17. "Tribute to the President," typed outline with notes for photomural, 1944, PSC/CCP. Elizabeth McCausland, "Artists' Tribute to President Roosevelt," *Springfield Sunday Union and Republican*, October 29, 1944, 4C.

18. "'Get Out and Vote' [-] N. Y. Passenger Section," undated [1944] typescript memo, PSC/CCP. The celebrities were scripted to take places as passengers after announcing themselves: "Elmer Rice, Playwright." "Arthur Rubenstein, Pianist." "Photographer—Paul Strand!" (Where possible, the script called for some humor as people proclaimed their opposition to the Republican presidential nominee, Thomas E. Dewey: "John Dewey—I said John! Philosopher!")

19. Mike Weaver, "Dynamic Realist," in Maren Stange, ed., *Paul Strand: Essays on His Life and Work* (NY: Aperture, 1990), 199-200. Paul Strand, Department of Justice, Federal Bureau of Investigation, materials released under a Freedom of Information-Privacy Act request submitted by Professor Mike Weaver, 1986-87, Paul Strand Miscellaneous Collection, CCP.

20. Strand, "The New Vision in Photography," 94. Paul Strand, "A Platform for Artists," *Photo Notes* (Fall 1948), 14-15.

21. Paul Strand, "Address by Paul Strand" [keynote address at meeting protesting the Attorney General's blacklisting of the Photo League], *Photo Notes* (January 1948), 2-3.

22. PS to AA, June 20, 1946, AAA/CCP.

23. Strand, "Address by Paul Strand," 3.

24. Ibid., 1-3.

25. *Time in New England*, vii, vi.

26. *Ibid.*, 244.

27. Newhall and Adams actually resigned twice in their effort to make certain that their distance from the League was sufficiently documented. Walter and Naomi Rosenblum to PS, October 14, 1949, PSC/CCP. Walter Rosenblum to PS, September 13, 1950, PSC/CCP.

28. Tomkins, *Paul Strand: Sixty Years of Photographs*, 31.

29. PS to Jean Purcell Neininger, December 17, 1952, Paul Strand Miscellaneous Acquisitions, CCP.

30. Naomi Rosenblum, "Paul Strand: Modernist Outlook/Significant Vision," *Image* 33 (Fall 1990), 7-8.

31. Walter Rosenblum to PS, September 13, 1950, PSC/CCP.

32. See Weaver, "Paul Strand: Native Land," 5-15. Strand Freedom of Information materials (n22 above).

33. Rosenblum, "Paul Strand: Modernist Outlook/Significant Vision," 12, n17.

34. Strand Freedom of Information materials.

35. PS to NN and BN, May 2, 1958, quoted in Greenough, "An American Vision," 123.

36. Paul Strand, "American Watercolors at the Brooklyn Museum," *The Arts* 2 (December 1921), 149.

37. Paul Strand, *La France de Profil* (Lousanne, France: Guilde du Livre, 1952), text by Claude Roy.

38. Paul Strand, statement to unknown correspondent, dated March 1954, PSC/CCP.

39. Paul Strand with Cesare Zavattini, *Un Paese* (Torino, Italy: Giulio Einaudi, 1955).

40. PS to BN, April 28, 1953, in Greenough, "An American Vision," 128.

41. PS to Basil Davidson, January 7, 1956, quoted in Basil Davidson, "Working with Strand," in Stange, ed., *Paul Strand: Essays on His Life and Work*, 215.

42. PS to Virginia Stevens, June 27, 1954, VSC/CCP.

43. Ibid.

44. PS to Virginia Stevens, July 17, 1954, VSC/CCP. Paul Strand, Transcription of 1972 interview at the Institute of Contemporary Arts, London; *Camera Craft* 141 (March 1976), 84.

45. PS to Virginia Stevens, July 17, 1954, VSC/CCP.

46. PS to Basil Davidson, May 2, 1957, quoted in Davidson, "Working with Strand," 216, 219-220.

47. PS to Davidson, May 2, 1957, in Stange, *Paul Strand: Essays on His Life and Work*, 216. Paul Strand, *Tir A'Mhurain: Outer Hebrides*, text by Basil Davidson (New York: Aperture, Grossman Publishers, 1968, c. 1962.)

48. Paul Strand, "Italy and France," *U.S. Camera Yearbook 1955* (New York: U.S. Camera Publishing Corp., 1954), 13.

49. PS to Kurt and Isabel Baasch, February 26, 1956, Kurt Baasch Collection, CCP.

50. PS to Jean Purcell, November 14, 1956, Paul Strand Miscellaneous Acquisitions, CCP. Leo Hurwitz to PS, April 30, 1955, PSC/CCP.

51. PS to Virginia Stevens, December 4, 1956, VSC/CCP.

52. Ibid., November 17, 1957, VSC/CCP. Strand began it on November 17, but found his ideas so much in ferment that he had to put it aside for a week's worth of thought. Returning to the topic again on the 25th, he still was not able to say all that he wanted, and came back to it yet once again as he continued to develop his ideas.

53. Ibid.

54. Ibid.

55. Strand, speech at the International Congress of Cinema, Pergua, Italy, September 24-27, 1949.

56. PS to Virginia Stevens, November 17, 1957, VSC/CCP.

57. Ibid., January 23, 1955, VSC/CCP. PS to Jean Purcell, October 21, 1963, Paul Strand Miscellaneous Acquisitions, CCP.

58. PS to Kurt and Isabel Baasch, January 28, 1958, Kurt Baasch Collection, CCP. PS to Virginia Stevens, July 25, 1955, PSC/CCP. PS to Virginia Stevens, July 9, 1956, VSC/CCP.

59. PS to Kurt and Isabel Baasch, January 28 1958, Kurt Baasch Collection, CCP.

60. Tomkins, *Paul Strand: Sixty Years of Photographs*, 170.

61. Newhall, *Focus: Memoirs of a Life in Photograph*, 141.

62. Shirley Graham Dubois to Paul and Hazel Strand, August 18, 1963, PSC/CCP. *Ghana: An African Portrait*, photos by Paul Strand, commentary by Basil Davidson (Millerton, NY: Aperture, 1976), 7-8. Rosenblum, "Paul Strand: Modernist Outlook/Significant Vision," 10.

63. Robert Adams, "Strand's Love of Country: A Personal Interpretation," in Stange, *Paul Strand: Essays on His Life and Work*, 247. See also Ulrich Keller, "An Art Historical View of Paul Strand," *Image* 17 (December 1974), 11.

64. PS to Jay Leyda, July 28, 1967, PSC/CCP. PS to Virginia Stevens, May 9, 1961, VSC/CCP.

65. Ben Maddow, "A View from Below: Paul Strand's Monumental Presence," *American Art* 5 (Summer 1991), 57.

66. PS to Social Secretary, White House, June 12, 1965, PSC/CCP. PS to editor, *Herald Tribune*, June 14, 1965, PSC/CCP. "Paul Strand, Photographer, Declines White House Bid," *New York Times* (14 June 1965), 44.

67. Strand Freedom of Information materials, Paul Strand Miscellaneous Collection. Letter of September 21, 1966 from New York office to Director FBI.

PART THREE

Edward Weston

10. Gestating Modernist

In 1939 Henry Allen Moe, president of the Guggenheim Foundation, wrote a long letter to Max Farrand, director of the Huntington Galleries. The subject at hand was Guggenheim Fellow Edward Weston, and Moe hoped that the Huntington would be persuaded to accept a collection of Weston's photographs. Moe spoke warmly of Weston's work, describing him as a perfectionist who painstakingly composed his photographs and a purist who struggled to keep his images free of social and political commentary. But what most impressed Moe was Weston's dedication to photography. Weston, he said, had adopted simple accommodations and simple fare in order to pursue his work. Moreover, "this guy is no Stieglitz surrounded by his admirers, but *all* photographer."[1]

There were some exaggerations in this portrait. Weston nearly always had his admirers, and at times his tastes ran to the ostentatious. Still, Weston could work with a self-reliance that Stieglitz never knew, and with a social detachment that Strand seldom accomplished. Weston may not have been "*all* photographer," but once he settled upon photography as his life work, he pursued it with a single-mindedness involving the sacrifice of both creature comforts and personal relationships. In the process Weston achieved a uniquely modern expression, his abstractions both more organic and more confident that Paul Strand's, and his nature subjects rendered with little of Ansel Adams's patent mysticism.

Edward Weston (1886-1958) was born into a middle-class family of polite eccentricity. His father, Edward Burbank Weston, was a Chicago-area physician who maintained a general practice and also taught obstetrics at a local college. Weston's mother died when he was five, and his sister, Mary ("May"), assumed much of Edward's rearing; with their father's remarriage May and Edward lived in a virtually separate household under the same roof.[2]

Life in this family seems to have been well-mannered, though hardly staid. There was a cultivation of wryness and wit in the busy Chicago home, and Weston's father read to him from sophisticated satirical magazines like *Puck* and *Judge*. Dr. Weston also had a love of nature that extended back to his own childhood, and there was a familial inclination toward athleticism and physicality. Weston's paternal grandfather, Edward Payson Weston, was an endurance walker known as "The Great Pedestrian," and similar willfulness characterized Weston's father, who labored to become an accomplished archer.[3]

Weston himself took up running. Short and rather frail as a child, he nonetheless fashioned himself into a local champion. Boxing also attracted him, and as he prepared for track and ring, Weston acquired dietary habits that remained with him throughout his life. Loving fruits, vegetables, and breads, and disliking meat, he became a moderately strict vegetarian. He also fasted frequently, and at times had difficulty breaking his fasts. With all this attention to the body (and perhaps

with low blood sugar), it is little wonder that Weston was a mediocre student, and he later described his schooling as a time of dream and drift.[4]

The directionlessness seemed to end in 1902 when Weston received his first camera. His father gave him a rudimentary Kodak, and within days the boy was framing images in his mind. But the Kodak soon proved inadequate and he scraped together the cash to purchase a more complex camera along with processing and printing apparatus. "Suddenly my whole life changed," he said afterwards, and in his "joy" over his new camera he found that "I needed no friends now—I was always alone with my love." Decades later Weston still remembered the ecstasy, "the tightening-choking sensation in my throat—the blinding tears in my eyes" as he made his first image and "danced for joy into my father's office with this initial effort." He said that he now routinely played hooky and heroically pursued images even in the frigid Chicago winterscape.[5]

It is difficult to know how much of this story to believe. *Eventually* photography became Weston's obsession and arguably the great "love" of his life. But the quickness of this adolescent conversion seems dubious, a retrospective and dramatic theme that the adult photographer read back into the more serendipitous events of his youth. But even if Weston was loose with details of his youth, he nonetheless seems to have been accurate in the larger picture. Sometime in his mid-teens Weston dropped out of school, became an errand boy at Marshall Field, and thenceforth gave most of his principal energies to photography. He also made plans to move to southern California, where May had relocated after marrying an engineer named John Seaman. At the end of May 1906, a month after the great San Francisco earthquake and fire, Weston arrived in California, moved in with May and John in the suburb of Tropico (later Glendale), and with John's help found work surveying desert railroad routes. Following close upon his embrace of photography, the move to California was another defining episode in Weston's life, for the state and its culture became interwoven with his life and art.

Perhaps the most obvious and immediate California influences upon Weston were the climate and landscape. For this visually attuned midwesterner, the combination of sky, sun, and clean desert lines made for a brilliance unmatched by the haze and maze of Chicago. One of Weston's earliest efforts to convey these qualities was a short essay laden with visual descriptions of the Mojave Desert. He portrayed it as a wonderfully linear and uncluttered domain, where the general view was unblushingly "naked," and the light made things seem "weird…bewitched." Weston was hardly the first camera artist to become fascinated with California, but unlike Carleton Watkins, Eadweard Muybridge and others, he was drawn more to the sparseness of the arid regions than to Yosemite's busy vistas. California also satisfied other Weston passions. In the desert emptiness he could freely indulge his nudist penchants while enjoying the delights of a lonely stream.[6] California's culture likewise suited Weston's fascination with health and the body; locals boasted of the healthful environment, someone introduced Weston to *Physical Culture* magazine, and he became a devotee of the local rites of sunbathing.

If Weston's early days in California confirmed many of his enthusiasms, they also underscored what became abiding ambivalences about the state and its society. His survey job enabled lots of skinny dipping, but it also opened the land to settle-

ments which eventually made privacy difficult. Likewise the beauty that he found in such landscapes became more precarious when his art subsequently popularized those fragile scenes. Weston's relationship to California's people had similar ambiguous qualities. May played matchmaker upon his arrival, introducing him to her best friend, Flora Chandler. Weston accommodatingly fell in love with this woman who was six years his senior, yet found himself at odds with her confirmed bourgeois tastes, and her background as a member of the politically powerful and conservative Chandler family (her cousins published the *Los Angeles Times*).[7]

The need to satisfy Flora and her family probably drove some of Weston's career decisions. He had quit the railroad to become an itinerant photographer. But this was hardly the kind of life to support a Chandler daughter; Weston refashioned himself into a studio portraitist, and in January 1909 he married Flora. For a time Weston seems to have accepted the regime of family and business. By 1911 he was settled with Flora in Tropico (her relatives were its developers), the father of two sons (two others followed in 1916 and 1919), and the proprietor of his own portrait studio (situated on Chandler land).[8]

But below the business bonhomie there was a sense that peddling portraits was not completely satisfying.[9] Although he published his own work in shopkeepers' magazines such as *American Photographer*, elsewhere in journals like *Camera Work* he saw pictorial images by Stieglitz and by Weston's fellow Californian, Anne Brigman. By 1913 or so, Weston was also producing his own noncommercial pictorial photography, and the awards he received from various competitions offered artistic affirmation that his Glendale customers could never match.[10]

But the art receiving this recognition was passé. Biographically, Weston was a trumpeted novice, emerging into the art world with some of the fanfare accompanying Paul Strand's almost simultaneous arrival. Aesthetically, though, Weston was often old-fashioned. Working in the backwater of southern California, he made fuzzy, low-contrast pictorial images while in New York, Strand was producing crisp modernist photographs.[11]

Topically, too, Weston's images were part of older patterns, the stuff of pictorial competitions and awards. Some are carefully staged, cloying renditions of childhood, such as *Let's Play Hookey* (1912), and his *Toxophilus* (a prize winner at the 1917 Wanamaker contest) offered a fuzzily-depicted male model in the pose of a mythical archer. These images and their numerous cousins were painful aesthetic strainings. Although his prewar writings indicate that he had some inclination toward straight photography,[12] Weston was more strongly drawn toward what he called the "artistic expression" of images such as *Toxophilus*.[13]

If Weston wanted his photographs to resemble Art, he also wanted to appear an artist. As he outfitted his images, so he outfitted himself, and here too Weston's notions were an off-the-shelf variety, as well as rather out-of-date. First came the costuming. Weston wore the Windsor tie, cape, tweed hat (often knickers, too) familiarly affected by other poseurs such as Frank Lloyd Wright. There were also quarters to accompany such clothing. Weston's studio, with its vines and tree-trunk pillars, seems inspired by William Morris's arts-and-crafts aesthetic. Finally there was the setting, and Glendale—selected for him, first by May, then by Flora—was hardly a bustling center like Stieglitz's New York. But still there was a handy

model. In 1907 writer Ray Stannard Baker had assumed the pen name of David Grayson and published a series of placid country stories extolling a certain kind of creative life led far away from the excitement, power, and confusion of the city. By 1915 Weston had read these sketches and incorporated much of them into the artist-role he played. One reporter, traipsing out to Glendale for an interview with Weston in his "little shack," found the photographer to be "a David Grayson kind of man," working quietly and contentedly in a countryside untroubled by too much rent, too many people, or too many distractions.[14]

The persona proved remarkably short-lived. Beginning in 1916 or 1917, and continuing for the next half-dozen years, Edward Weston assumed a distinctive new direction in his work and life. Rejecting the retiring contentment of David Grayson, he consciously strove for a biography and an art that were animated, vital, and daring. This called for extensive remodeling, and to that end Weston built himself a new set of social relationships, extended the breadth of his intellectual horizon, and experimented with elements of modernist aesthetics. He continued to think that the artist must be an exceptional individualist, but he turned away from a model of quiet retreat and instead moved toward one of dynamic agitation, away from the Horatian countryman and toward the Nietzschean superman.

Weston's new friends were a gregarious and lively lot, artists and intellectuals with bohemian flamboyance. They offered a titillating blend of culture and scandal, putting together evenings that could began with the Philharmonic or a reading of Eliot's *Waste Land*, and end at a Greek coffee house where black musicians played the saxophone, gay sailors made dates with locals, and waitresses picked drunks' pockets.[15] Akin to so many Midwesterners of his generation—Sherwood Anderson in Ohio, or Floyd Dell in Iowa—Weston felt the magnetic pull of bohemia, although he preferred daytriping into its Los Angles variants while the others more permanently settled into New York's Greenwich Village.

There were some prominent people in Weston's new circle. One was Stieglitz's friend Sadakichi Hartmann, now settled in southern California, and another was photographer Imogen Cunningham, whose reputation extended beyond her native West Coast. But most of Weston's new friends, and particularly the closest ones, were more obscure individuals whose influence upon Weston usually outweighed their notoriety. Margrethe Mather was the earliest of them and so significant in his redirection that Weston called her "the first important person in my life." Mather and Weston may have met as early as 1912, and she eventually became his studio assistant and frequent model. Vivacious and gregarious, she introduced Weston to books and music, and assisted his photography to the point that she co-signed some of his portraits; he was infatuated with Mather, craving a psychological and physical intimacy that she refused.[16] Her complement was Johan Hagemeyer, a Dutch immigrant who lived with Weston irregularly over the years. After visiting Stieglitz and the 291 circle in New York, Hagemeyer took up photography himself. He read extensively in Jung, guided Weston's introduction to the music of Bach and others, and became a confidant trusted with Weston's enthusiasms and anxieties.[17]

The written word was also an important part of Weston's metamorphosis, and he specifically recommended that other photographers take to the books if they,

too, wanted to be what he called "unconventional."[18] His reading seems to have expanded significantly in the years around World War I, and there is evidence that he took up authors like Wassily Kandinsky and Roger Fry who wrote about the contemporary art world, as well as nineteenth-century writers, including Emerson. Weston encountered these thinkers through their books, but it seems likely that he also found their ideas in the "little magazines" that were such a vital part of the cultural flowering of the period. Strand's *Seven Arts* was one, and in another, *The Dial* (edited by Randolph Bourne), Weston read the letters of William James. Less widely known, but more important for Weston, was *The Little Review*, where editor Margaret C. Anderson flaunted obscenity regulations by printing excerpts from James Joyce's still unpublished *Ulysses*. *The Little Review* became a significant modernist conduit for Weston, who would "eagerly await" and then "devour" each issue, furiously underscoring passages by Ezra Pound and others.[19]

Pound, Joyce, and James were formidable thinkers, and Weston worked hard to digest their ideas. But he also tried to set down some thoughts of his own. Around 1918 Weston began his Daybooks, a series of daily journals that he kept with considerable regularity until 1934. Habitually writing in the predawn hours, coffee and cigarettes at hand, Weston used this journal to record daily events, vent pent-up emotions, and conduct an incessant self-inventory.

Weston placed great importance upon these journals. They were a crucial brooding ground in which he nurtured his growing thoughts and maturing art, and where he gauged that growth as he repeatedly revisited earlier entries. Moreover, much of this was written for the future, recorded or expunged so that history could see not only his growth but also see that growth in his own light. As much as Stieglitz or Strand, Weston was adept at preserving the kinds of documents attractive to historians and biographers, and he kept a remarkable number of them over the course of an increasingly unsettled life. Weston was ready to discard material, too: the existing Daybooks bear the marks of his own editing and that of several friends, and around 1925 he destroyed three years' worth of the early journal.

At about the same time he started the journals, he also began to collect quotations—sometimes written on odd scraps of paper, and at other times copied onto bond paper. These quotations have a flavor similar to those that Stieglitz jotted in his own notebook, but where Stieglitz's was a youthful and systematic effort, the collection now residing in the Edward Weston Archive was more casually accumulated over the course of a lifetime. It is also decidedly eclectic, with notes drawn from authors as diverse as Goethe and Herbert Hoover, and subject matter ranging from short quips on painting to three pages of astronomical facts about "The Known Universe." If there is an intellectual axis to the collection, it runs between the poles of Emerson and Nietzsche, both attractive to Weston with their disdain for consistency, their appreciation of creativity, and their preference for aphorism. These quotations, the surviving Daybooks, Weston's correspondence, and his increasingly complex photographs—all enable us to chart the development of Weston's thinking and his art in the years between 1916 and 1922.

A certain gravity characterized that development. What had once been an enchanting career became increasingly serious, and the photographic enterprise that had seemed pretty and pleasing gave way to one that was arresting and sig-

nificant. Increasingly Weston described art as a *sine qua non*, and those people who created art or wrote about it were characterized as something like noble beasts. Some of this came from Nietzsche, whom Weston noted as opting for "Art and nothing else!" because art was "the great means of making life possible." Weston recorded a similar idea from Margaret Anderson of *The Little Review*, that art should be the end of humanity: "Life for Art's sake."[20] But if art was a universal end, the necessary talent and character were rare, and Weston photographically portrayed his friends and acquaintances as patrician individuals with magnificence equal to art. These images in some ways resemble Strand's noble New England tombstones and churches, and the photo-busts have come to be known as Weston's collection of "heroic heads," close portraits made in profile and from below so that the subject dominates the frame in ways that convey assurance, competency, and majesty. Commonly associated with Weston's photography of the mid-1920s, these images actually commenced in the late teens and early 1920s as part of Weston's larger valorization of creativity. In one example, a carefully posed and closely framed portrait of photographer Imogen Cunningham, Weston depicted his subject in aristocratic profile, her chin lifted and hand poised at her neck. If Weston's artist was grand, his creative individual was also self-absorbed, distant from commonplace concerns. In one 1919 image, for instance, Sadakichi Hartmann, wearing a kimono, leans against a wall, left hand on his hip while the right one holds a mirror into which he gazes. There was for Weston a necessity to the narcissism, and he noted Kandinsky's insistence that "the artist must be deaf to the transitory teaching and demands of his particular age," listening instead only to the words of his own "inner need."[21]

But individuality and self-absorption were not supposed to produce solitude. Gregariousness and vitality were necessary parts of Weston's model artist, and he and his friends did their best to meet the standard as they partied and visited. One portrait in particular merits discussion in this regard. In 1920 Weston photographed Johan Hagemeyer in the Glendale studio, outfitted in something much like Weston's own artist uniform: cape, cane, and bow tie. And in the portrait's title, *Jean Christophe*, are further indications of the artist-identity that Weston imagined. *Jean Christophe* was an exceptionally popular series of ten novels by Romain Rolland, published between 1904 and 1910, and in these stories protagonist Jean Christophe is a musician wandering about Europe offering art and freedom as antidotes for moral distress. "Jean Christophe" was also Weston's nickname for Hagemeyer, used in correspondence as well as in the title of this portrait.[22] Much as he had in the David Grayson episode, Weston again borrowed artistic identity from contemporary literature. But whereas the 1915 model had been the reclusive and mellow David Grayson, by 1920 it was the peripatetic and agitated Jean Christophe.

Thus in these years Weston was persistently concerned with the artist's posture and role in society. Alternating between the substantive and the superficial, he explored and then re-explored issues of identity, costuming, and responsibility. Yet there was also an aesthetic dimension to Weston's efforts, and with his attraction to action and boldness, he was rather naturally drawn to that broad cluster of aesthetic trends that we have come to know as modernism.

It is difficult to say precisely how Weston became aware of modernism. For him there appears to have been no dramatic Armory Show, no moment such as that instant when Stieglitz finally understood the Cezanne watercolors. Instead, it is more likely that he experienced a series of less vivid introductions. Certainly the pages of *Camera Work* were one place where reproductions of Picasso, Matisse, and Rodin were available. Another avenue was Arthur Jerome Eddy's enthusiastic endorsement of modernism, *Cubists and Post-impressionism* (1914); Weston had read the book by 1922, and said it was "amazingly fine." It is also possible that he saw the Italian futurists and Edvard Munch when he (like Paul Strand) visited San Francisco's 1915 Panama-Pacific International Exposition,[23] and finally there were among his friends nonvisual modernists like musician Leo Ornstein and poet Alfred Kreymborg.[24]

Whether through books, visual examples, or his friends, by 1917 or 1918 Weston was acquainted with a cluster of modernist principles, and began to incorporate some of them into his work.[25] Chief among Weston's early modernist experiments was a series of light and shadow studies that he began in 1918 and continued through 1922. Technically these are portraits, but they minimize the person depicted within the frame so that the sitter is often obscured. The true subjects of these images are form and shape, and the ways in which light and shadow work within interior spaces. Some of these images were made in his studio, "a room full of corners—bright corners, dark corners, alcoves! An endless change takes place daily as the sun shifts from one window to another."[26] Attics, though, were Weston's favorite. That single-story studio had some "alcoves!", but attics offered a wealth of eccentric lines and odd slopes. Weston made a number of portraits of his friends in their own attics, and among them is *Ramiel in His Attic* (1920; fig. 10.1), depicting dancer and designer Ramiel McGehee. (It is easy to chuckle over these images and the lives they bespeak: Weston and his friends seem like great bohemian wannabes, who somehow managed to find the requisite garrets despite southern California's bungalow architecture.)

McGehee was an important person in Weston's life, yet here he is but a minor part of the image, the curve of his head an interruption in what would otherwise be a photograph of the straight lines of wall, bookcase, and pillows. Clean and uncluttered (when it came to decorating, Weston's friends shared his minimalist taste), the room offers none of the visual distractions that might keep the eye busier than the mind. The response, at least from one quarter, was supremely gratifying. Imogen Cunningham saw this photograph in the summer of 1920, and she not only liked it, but immediately understood that it would give Weston some claim to avant garde status, and would surely, she wrote, "make old near sighted Stieglitz sit up and look around." Free of Weston's earlier allegorical figures, this image played, as Cunningham realized, to "the mind . . . not emotions or fancies." Moreover, she continued, the attic image had "all the cubisticly inclined photographers laid low," for unlike images such as "Paul Strand's eccentric efforts," Weston's attic images are more straightforward than Strand's cockeyed porch shadows.[27]

Ultimately Weston abandoned these attic images and other such geometric compositions. Like Strand's porch shadows, they were part of a passing phase, and Weston's disposition was never very close to the coolness associated with ana-

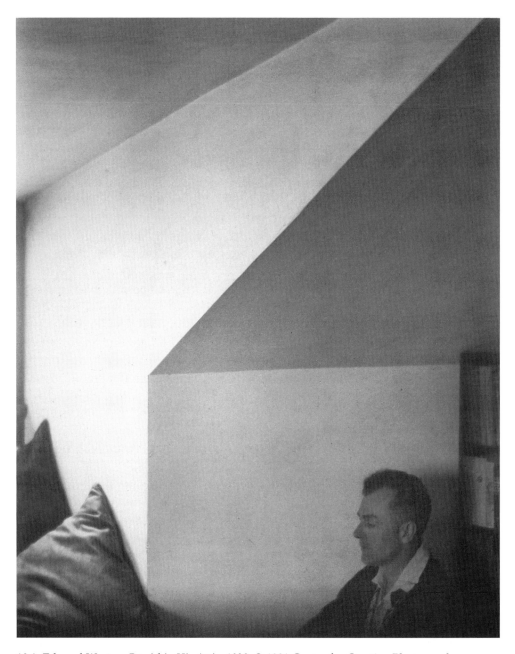

10.1. Edward Weston. *Ramiel in His Attic, 1920,* © 1981 Center for Creative Photography,
Arizona Board of Regents. Collection Center for Creative Photography,
The University of Arizona.

lytic cubism. Instead, he shared Stieglitz's attraction to qualities like Bergsonian
vitalism. Geometry might be interesting, but, as he quoted Margaret Anderson, his
more pressing concerns were not so much with the "old Greek ideal of proportion
and moderation," but rather with a *"New* Hellenism" that seeks a "higher vibra-
tion" and "dares abandonment." He became interested in what he understood
Nietzsche to mean by animal vitality, and was intrigued with art and with life

styles that explored sexual energies.[28] Accordingly, Anne Brigman seemed fascinating, with an air of the libertine to her life and a touch of sensuality to her photographs. He found a similar elation and ardor in his friend Paul Jordan-Smith, a sexual psychologist from the same circles as Havelock Ellis, whom Weston applauded for writing about sex "with such gusto."[29]

Weston brought a similar relish to his own work with sexual subjects. During the late teens and early 1920s he began seriously photographing the female nude, and through a set of evolving motifs brought greater frankness and greater sexual charge to his images. In the most technical of senses, the nude was not a new Weston subject, for he had photographed an unclothed Flora shortly after their marriage, and made numerous nudes of his young sons. But now he began to explore the nude outside of the household, using friends and even strangers for models as he sought sexual images that were vibrant and universal rather than safe and familial. A few of the models were men, but most of his work was with women.

The earliest of those nudes are the most softly-focused. They repeat pictorial convention, and stylistically they hearken back to Stieglitz's earliest nude studies.[30] Linking beauty, femininity, and softness in a common romantic equation, such images also obscured sexual content with fuzziness or drapery. But Weston abandoned the effect as his photography moved toward a more vivid sensuality. Beginning in 1921 the models shed their remaining clothes and the photographer discarded his coyness. Faces tended to disappear in the bargain, too; as Weston sought a more universal and generic sexual force, it becomes more difficult to identify individuals within the resulting photographs, and titles like *Betty Brandner* gave way to ones such as *The Breast*. Weston's lighting techniques changed, too, as bodies rather than light now became his subjects.

This growing emphasis on openness, anonymity, and light is illustrated in a particular series of nudes Weston made in 1922. These images, including *Breast [with Window]* (1922, fig. 10.2), are truly impersonal studies, for not only is the face entirely cut out of the frame, but also Weston never learned the name of the stranger who posed for this nude sitting. Nor is there much effort at the earlier modesty in what is a more straightforward pose. *Breast* shows Weston's concerns with light and windows, for the model was actually backed up against the window, coached to lift her arm so that body and shadow create the geometry of triangle-and-rectangle, and turned so that a narrow strip of reflected light traces and accentuates the outer edge of the breast. In earlier images Weston had been less assertive so that a nipple might barely peek from the corner of the frame; here, though, the nipple virtually stares from the center of the composition. Open, frank, and appreciative, Weston aimed toward a visual counterpart of Jordan-Smith's verbal treatments.

Weston's concern with the female body and with sexual vitality was not limited to aesthetics. As his art moved away from bourgeois suburban tastes, so too did his intimate life, and just as his new friends enabled a trajectory leading away from Flora and Glendale, they also propelled him toward new sexual mores. As Weston described himself, he was a novice among the initiated, a naif with "practically no experience with drinking and smoking, never had a mistress before marriage, only adventures with two or three whores." But with Hagemeyer, Mather, and the others, he found himself, he said, in the company of people who could "quote Emma

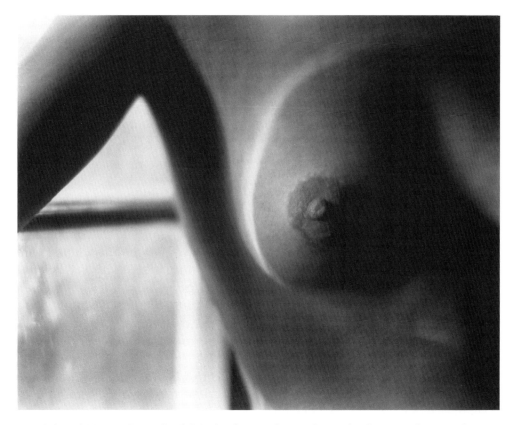

10.2. Edward Weston. Breast [with Window], 1922, © 1981 Center for Creative Photography, Arizona Board of Regents. Courtesy George Eastman House.

Goldman on freelove: they drank, smoked, had affairs."[31] The details of Weston's sexual embarkation are murky, but we do know that during these years Weston furtively pursued Mather,[32] and that his experimentation included some breadth, too, for there was an encounter with the homosexual McGehee.[33]

Most of Weston's affairs were heterosexual, though, and the more he embraced other women, the less he turned to Flora. By the end of 1923 he had flatly told Flora that he was no longer sexually interested in her.[34] The emotional distance increased at a similar pace, yet even though there were terrific scenes between them, they refused to dissolve the marriage and continued a perverse hold upon each other. Some of that perseverance was ugly calculation on Weston's part, for Flora's estate was significant.[35] Part, too, was genuine affection for the mother of his four sons. Additionally, Flora provided some stability in what was an increasingly tumultuous life, maintaining the mundane assurances of a home for the children, and, in one of the odder aspects of this odd separation, even a refuge for Weston himself. During the great flu epidemic that had so devastated Strand, Flora, though sick herself, nursed Weston and the boys through their own bouts with the terrible illness.

But in the other great crisis of these years, World War I, Weston relied more on friends than family. For men like Strand, the draft made the issue even more pressing, but at four years Strand's senior, Weston was just old enough to escape liability.

Still, though, he followed the lead of friends like the pacifist Hagemeyer in opposing the war, a stance, he said, that left him "the target for all sorts of abuse and criticism."[36] Indeed, a portion of Weston's education during these years was political as well as aesthetic and sexual, as his friends introduced him to socialism. Weston's politics were never as intense or progressive as Paul Strand's but he still flirted with the left and made portraits of leftists like *Masses* editor Floyd Dell.

During 1922 and 1923 Weston began to position himself within American art photography. He extended the scope of his concerns as he assessed photography in a more thoughtful vein, and considered the relationship between his own photography and that of Stieglitz, Strand, and others working outside of California. As he continued making new kinds of images, Weston also dipped into recent literature on the nature and quality of photography, and made his own forays by composing pieces that were more analytic and considered than his earlier writings.

Weston's concern with literature was part of a larger phenomenon of the early 1920s, a flurry of essays, such as Strand's, that weighed photography's potential. As he recognized, there was a center to this material, for it was "written around Stieglitz and what he symbolizes."[37] One of those essays was particularly important reading for Weston, Paul Rosenfeld's "Stieglitz," which appeared in *The Dial* of April 1921. In this appreciative, poetic, and at times mystical review, Rosenfeld praised Stieglitz for finding loveliness and significance in ordinary objects.[38] Weston first read this piece in February 1922, and next to Rosenfeld's printed assertion that "with the exception of Stieglitz, not one of the photographers" had recognized the medium's potential, Weston saw that some previous reader had penciled a correction in the margin: "Yes—one—Edward Weston." Touched, Weston told Hagemeyer that "I am moved…and I have tears to brush away," for Weston accepted that anonymous comment as something of a commission for "a heritage we have to carry on—from Stieglitz and his group."[39] This misty moment registers the evolving qualities of Weston's artistic aspiration, first the increasing specification as he came to identify himself not only as an art photographer but also as a particular species ("Stieglitz and his group") of art photographer, and, secondly, the grandness of Weston's ambition as he tried to insert himself into that particular lineage.

Once his tears had dried, Weston borrowed portions of Rosenfeld's article for his own essays on photography. In June 1922 Weston employed it as he attacked pictorialism and praised straight photography, and he likewise borrowed when he praised Stieglitz as one who managed to capture life's vitality and majesty. On his own, Weston also emphasized that the photographer must organize and arrange an otherwise chaotic nature.[40]

As Weston continued to work with such ideas, he made an extensive cross-country trip late in 1922. Traveling eastward, he stopped in the industrial city of Middletown, Ohio, where his sister May Seaman now lived. This was a serendipitous chance for Weston to exercise his developing photographic vision at the steel mill where May's husband worked. He had seen mills and refineries in California, but with a vision now primed by modernist concerns, the towering smoke stacks and huge curving pipes held an aesthetic potential that had previously gone unrecognized, and he created a set of compositions that long remained among his

favorites. Some elements of these Ohio images were already in Weston's expanding repertoire: closely framed treatments emphasizing line and curve.[41] There are no people in these images, and as such they represent a change in Weston's orientation toward his subject, an assertion of the photographer's primacy over his material. Human subjects lend photographs compelling qualities: faces often suggest personality, nudes carry their own special charge, and there is something mysterious about people in odd locations like attic corners. By abandoning such subjects and focusing instead on deserted industrial material, Weston claimed (much like Stieglitz with the clouds) that *his* vision was paramount, that by selection and framing he could find the clean lines that were of interest within a seemingly prosaic display of hardware.

Ohio was only a stopover. From there Weston went on to New York, May and John having paid his way. The extension may have been unplanned, but Weston's desire to see New York was hardly new. The city offered attractions that had long appealed to Weston, and he quickly threw himself into a round of sight-seeing (the Brooklyn Bridge, the skyscrapers, the museums) and visiting (photographers such as Gertrude Kasebier). But for a while it seemed that the New York trip might be a disappointment, for Weston's larger purpose was to meet Alfred Stieglitz. As he told Stieglitz in a letter of self-introduction, "you are the one person in this whole country (and photographically this surely means the world) with whom I wish a contact at this important time of my life."[42] Yet he had arrived just as Stieglitz's mother was dying, and Weston worried that his shrinking resources would force him to return home before Stieglitz had the time or spirit for a meeting.

Eventually Hedwig Stieglitz expired, and the two men finally met in an atmosphere tinged by grief and relief. Weston was a terrific note-taker, and he closely recorded the many small details of a full life. Yet in all of Weston's surviving archives, there is no event treated in more detail or more often than his visits with Alfred Stieglitz. (It appears there were two meetings, one soon after Hedwig's death and another just before Weston left New York.) In this way, New York and the Stieglitz visits became a well-recorded ratifying moment in Weston's construction of his identity, the dramatic indication of his arrival in the world of art photography.

According to Weston, Stieglitz played his role well. He acted the Nietzschean figure, speaking "brilliantly—convincingly…with all the idealism and fervor of a visionary."[43] This seems to have been what Weston wanted, for he had not crossed a continent in order to chat with a self-effacing milquetoast.[44] Yet Weston was not willing to fall to his knees. As he told Hagemeyer, "I do not accept Stieglitz absolutely."[45] Instead, he went to considerable lengths to assure others, and the historical record, that Stieglitz had not *transformed* him or his art; he described the sessions as more of a benediction than a conversion, writing that "Stieglitz has not changed my direction, only intensified it, stimulated me."[46]

When Stieglitz reviewed Weston's portfolio, he ruthlessly discarded one image after another. But—at least as Weston described the scene—these rejections produced little pain, for the dismissed images were early works for which Weston's own enthusiasm was already waning. The photos that Stieglitz liked were recent works and among Weston's favorites: a sharply focused breast, torsos from that anonymous nude sitting, and Ohio refinery images that were only weeks old.[47]

There could hardly have been a more prestigious endorsement of Weston's new direction, and he wrote to Hagemeyer that Stieglitz's critique had "given me more confidence and sureness."[48]

The confirmation continued in still another way when Stieglitz in turn showed Weston examples from his own portfolio. Weston had doubtlessly seen Stieglitz's early work in the pages of *Camera Work*, but this was his first chance to see newer pieces such as the O'Keeffe nudes. With their close-up detail and lingering appreciation, those photographs stunned Weston, and even months later his reactions remained visceral: "I turn alternately hot and cold" at the memory of the more erotic of the photographs "those based on the mons veneris—the breasts…"[49] Here were possibilities of a visual lexicon that Weston was just beginning to explore, images assuring him that he was not alone in his tastes, and, because they were made by none other than the great Stieglitz, images that gave the modernist nude an imprimatur of high art which might also legitimize the libidinousness associated with its making or its viewing.

After his weeks in New York, Weston went back to California. Home seemed cheerless and sour, and he told Stieglitz that he had "returned to a ghastly anti-climax of disillusionment—bitter intestine war."[50] Ironically, the details mirrored circumstances of Stieglitz's own marriage—a spouse little appreciative of his art and deeply suspicious of her husband's women friends—and in apparent sincerity Stieglitz told Weston that "I wish that I could have spared you some of the pain awaiting you upon your return home." Clearly drawing upon his own flight from marriage, Stieglitz recommended "pulling up roots" as a way to end such "messiness & strangling torture,"[51] but Weston had already settled upon just that course. So, while we cannot say that Stieglitz inspired Weston to leave his family, Stieglitz was a sympathetic and understanding ear for what was in many ways an abandonment scheme. Weston decided to leave the children and Flora, for, as he told Stieglitz, they "drag—hold back—involve—destroy a certain singleness of purpose." Writing as one photographer to another, and one deserter to another, Weston employed the terms of photographic modernism to describe his sons as impedimenta that "clutter up the background—barricade the foreground." In the events that unfolded, it is difficult not to think of Weston as something of a self-centered scoundrel. But if there was one who understood the compelling pull of photography, one who understood the "singleness of purpose" that placed art ahead of family, it was Alfred Stieglitz.[52]

Stieglitz had merely moved across town when *he* left home. But Weston left the country and went to Mexico. Many factors influenced his move, and perhaps his most compelling urge was simply to flee, to cut himself off from old work and an old life, and get on with new versions of both. If that much was certain, Mexico's attractions were, in contrast, various and diffuse. In part Mexico seemed familiar, for Weston had received word of a thriving Mexico City art community of interesting extroverts resembling his Los Angeles friends. Beyond this, Weston was drawn by some of the same circumstances that later attracted Paul Strand to Mexico.

Weston had significant contacts with Mexican art officials. In 1921 and 1922 he had met Ricardo Gomez Robelo, director of Mexico's Department of Fine Arts, and Xavier Guerrero, a muralist who organized a Los Angeles exhibition of Mexican

arts and crafts; Weston photographed both men, and they promised to help him settle in if he came to Mexico.[53] Through these and others, Weston learned something of the Mexican Renaissance and its emphasis on indigenous cultures.

Two people were closely involved with Weston's transition to Mexico. Tina Modotti and Roubaix de l'Abrie Richey were members of his Los Angeles circle, and had probably met him sometime in 1921. Richey was a textile designer who had become a prominent California bohemian. Modotti was an Italian immigrant whose parents had settled in California; by the time she met Weston she was a model and actress with several small silent film parts to her credit. Modotti and Richey were married in 1918, and they shared leftist politics that helped introduce them to Mexican progressives visiting in California.[54]

Richey moved to Mexico City in 1921, where he established a studio which he then invited Weston to share.[55] Writing to Weston, Richey described the country in terms virtually irresistible for a photographer, describing it as a visual feast a-waiting. The sun cast a warm and golden hue, the costumes were poetic, and the skin tones bronze. Lapsing into uncontrolled liquid metaphors (perhaps for cause: "tequila is cheap"), Richey told his friend that "the place drips with colour and overflows with character and 'life' ... One becomes drunk with the subject matter." Mexico could satisfy other appetites as well, for it was a land of "heavy lidded senoritas," who were accommodatingly flirtatious.[56] It is difficult to imagine a portrait that might more effectively lure Edward Weston to Mexico.

If Richey and Weston shared certain tastes, they also shared a love for Tina Modotti. She began modeling for Weston soon after they met, then became his photographic pupil, and was romantically involved with him by the spring of 1921.[57] Weston was infatuated with Modotti over the course of many years, and at least for a time she too was smitten with him. When this relationship first flourished, Richey was in Mexico and perhaps similarly occupied; but he was soon stricken with a fatal case of smallpox (apparently Mexico was not quite the paradise he described). Loyal to Richey in her own way, Modotti went to Mexico to attend to his burial. She also took along some of Weston's photographs which she arranged to show while there.[58]

Modotti wanted to move out of Los Angles after the burial, and for a time it looked as though she and Weston might be parted. But sometime before the fall of 1922 another plan was hatched. Since Weston's work had been well received in Mexico City, it was decided that the two of them would move there together and jointly run a photographic studio. If Richey's descriptions had made Mexico attractive to Weston, the prospect of Modotti's company must have made it virtually irresistible.

But Weston delayed. Once he returned from New York, he took over half a year to complete his arrangements. This dawdling perhaps indicates some hesitancy about pulling up roots, but it also reflected a personal housekeeping as he resolved his relationships with the women currently in his life. By this time Weston had developed the curious sense of fidelity that would subsequently characterize his connections. He was capable of sustaining relationships, sexual and otherwise, with several women at once, juggling commitments and bedrooms with considerable aplomb if not always complete comfort. At this point in the early 1920s, he was painfully married to Flora, the mother of his sons, pursuing Mather, his studio

assistant, and intimate with Modotti, his prospective Mexican partner. Such simultaneity became common throughout the rest of Weston's life, much as he would be artistically infatuated with several different photographic subjects at a given time. Yet in his life as in his art, there was usually a single subject or individual with principal claim on his affections. Loving widely and photographing widely, seldom cutting himself off completely from his subjects or his women, Weston nonetheless kept a primary, if evolving, focus for both his camera and his heart.

By the first half of 1923, Flora was relegated to the background and the question now became which of the other two women was truly closer to Weston. His relationship with Modotti was already a sexual one, but as the Mexican departure loomed, Weston and Mather likewise became lovers during ten April days spent together at Redondo Beach. In that interlude, Weston made a series of bold nudes of Mather as she reclined on the beach. In these images the male artist seems to delight in his female model, fashioning highlights so that her breasts gleam and arranging shadows so as to accentuate her pubic area. In many ways these images fall within the genre of the rapacious male gaze, staring down upon a supine and seemingly helpless female figure. But pleasure hardly seems a male monopoly in the photographs, for Mather too enjoys the flesh; in one image she appears to burrow into the warmth of the sand, and in another stretches herself languidly in the drenching sunlight. The boldness in these nudes is technical as well as sexual, and they are exercises in straight photography; in comparison to Weston's earlier nudes there are few props and few shadows to obscure the scenes, and there is a wealth of texture in the luxurious combinations of hair, skin, and sand. Compositionally, they are considerably advanced even over nudes which Weston made just a few months before, for here the subject is thoroughly owned, allowed to occupy much more of the frame, and rather than being a small, timidly centered figure, it forms emphatic lines stretching from corner to corner. Finally, there is a new boldness to the artiness of these nudes, because where Weston had once created effects through props like fans and flowers, he now used incongruity to the same ends. In one of the beach images, a nude and recumbent Mather is joined by a fully clothed Ramiel McGehee, and by Weston's symbolic stand-in, his tripod-mounted camera. The effect of this photograph is much like Manet's *Le Dejeuner sur l'Herbe* (1863), to which it bears considerable resemblance, startling in its discontinuity between clothed and unclothed figures, puzzling with the ambiguity of what seems an art experience and yet more.

Perhaps the relationship between Mather and Weston could not sustain such ambiguities. When Weston went off to Mexico with Modotti (and on to make even more remarkable nudes of *her*), the affair with Mather ended. Mather and Weston remained civil, and she continued to operate the Glendale studio for a time, but Weston brought the romance to a conclusion. He was fairly gentle in taking his leave from Mather, but in other instances he was brutal, going to extraordinary lengths to tell off the good folk of Glendale.[59] And Flora, too. Weston flaunted his affairs, wrote her letters full of "bile," and from Mexico promised to pursue "some dark-skinned senorita."[60] Weston usually parted decently enough with his lovers, but his middle-class community and his middle-class wife were different matters. With Flora and Glendale, he was loud and crude.

Some of this may have been contrived histrionics. But the rancor of Weston's comments bespeaks some of the character of this period in his life, for it was an expurgative moment, a time for lopping off those portions of his life and his art that had become intolerable to him. He later said it was a time that "enabled me to destroy much of my past," and a good deal of his behavior had the quality of a destructive binge.[61]

Weston would not deny the necessary continuity between past and future. But he was a photographer, one who necessarily selects and edits. The Weston legend is ripe with stories of his destructive episodes during these years. One is inclined to believe some of them, and the evidence suggests that he really did feed his early Daybooks to the flames at some point during the Mexican years. Other tales, though, have too much the hint of construction, too much the neatness of metaphor rather than the messiness of truth. In one such incident, Weston reportedly scraped the photographic emulsion from old award-winning glass negatives and then made a window with the naked panes. Certainly it is apt that a champion of modernist sharpness would abandon romantic fuzziness for the transparent aperture, but like other great window stories—one thinks of Goethe's deathbed call for more light— this one seems an after-the-fact contrivance.[62]

But behind these legends lies a truth, for Weston purposefully discarded portions of his earlier life. Modotti and modernism, confidence and persona, and even one of his sons—all these were on the boat with Weston when he sailed from California on 30 July 1923. But much was purposefully left behind: Flora, Glendale, and pictorial portraiture.

1. Henry Allen Moe to Max Farrand, January 21, 1939, HL.

2. DBI, March 3, 1924, 53. May Weston Seaman to Edward B. Weston, March 22, 1915, EWA/CCP.

3. Edward B. Weston, "Play Days. Incidents in Early Life," Chicago, December 1915, EWA/CCP. May Weston Seaman to EW, August 19, 1950, quoted in Ben Maddow, *Edward Weston, His Life and Photographs: The Definitive Volume of his Photographic Work* (Millerton, NY: Aperture, 1979, rev. ed.), 28. Edward Payson Weston to Stephen W. Jessup, April 25, 1870, HL. Edward Burbank Weston, Archery Notebooks, HL. Amy Conger, *Edward Weston: Photographs from the Collection of the Center for Creative Photography* (Tucson: Center for Creative Photography, University of Arizona, 1992), "Biography," 47, n106.

4. DBII, October 29, 1931, 232. Edward Weston, Daybook Manuscript G, EWA/CCP.

5. EW to Edward B. Weston, August 20, 1902, EWA/CCP. DBI, undated, pre-1923, 3. Weston, Daybook Manuscript G, EWA/CCP. DBII, May 14, 1929, 122.

6. EW to Flora Chandler, 28 October 1907, Getty Collection.

7. For more on the Chandler family, see Amy Conger, "Edward Weston's Early Photography, 1903-1926," PhD Dissertation, University of New Mexico (Albuquerque), 1982, 16-17.

8. G. C. Henderson and Robert A. Oliver, "Tropico, The City Beautiful," (Los Angeles: Michael Hargraves, 1986, 1914), photographs by Edward H. Weston. Edward Weston, "Photographing Children in the Studio," *American Photography* 6 (Febuary 1912), 83-88; here from Peter Bunnell, ed., *Edward Weston on Photography* (Salt Lake City: Gibbs M. Smith, 1983), 4-7. Edward Weston, "A One-Man Studio," *American Photography* 7 (March 1913), 130-34, here from Bunnell, ed., *Edward Weston on Photography*, 11-13.

9. Edward Weston, "Shall I Turn Professional?" *American Photography* 6 (November 1912), 620-24; here from Bunnell, *Edward Weston on Photography*, 8-10.

as in the more northerly "Greek" world. "The phrase I love," Weston wrote in his 1924 Daybook, "'form follows function'—is applicable to these charros [cowboys] as it is to the smoke stacks and grain elevators of industrialism."[16] Whether north or south of the border, here was a principle worth elaborating in photography, and he now turned his camera away from the lines of American factories and brought it to bear upon the rounded volumes of Mexican water jugs.

Such examples seemed like lessons against the unnecessary gesture. The ease of Mexico's potters and cowboys became an inspiration for Weston's own photography, and as he worked with new subjects he sought a more direct and facile expression of his own. He continued to labor just as intensely over his images, but now, as Weston put it, he tried for a different type of expression so that "the sweat[,] though expended[,] does not show in the prints." The level of obvious contrivance began to decrease in his images as he abandoned the props and peculiar lighting of his earlier images. At the end of his first year in Mexico, Weston thought that he had made considerable progress in this regard, and that "the old effort to startle or attract with the unusual in light or theme has been replaced by a more simple yet more subtle attitude."[17] Much as Paul Strand had himself abandoned a cubist-inspired experimentation with surreal angles, Weston now also turned away from the odd light patterns of his attics and windows. This is not to say that Weston discarded conscious design in his images nor that he ceased to arrange the subjects he photographed. But in Mexico he shifted the concentration within his images so that their content seemed to derive less from a pattern contributed by the artist and more from the shapes of the subjects themselves.

Weston's Mexican subjects particularly manifested a curving, free-form geometry. This was keenly presented in the country's clouds, which attracted Weston almost from the moment he arrived in Mexico and were the subject of his first Mexican art photograph. Sometimes clouds tempted him to new venues, as when he photographed "a gorgeous cloud mass from the azotea [flat roof]."[18]

One day in July 1924 Weston was again on the roof, working patiently as he struggled to capture the swiftly changing, elusive cloud formations. "My eyes and thoughts were heavenward indeed," Weston wrote in his Daybook, "until, glancing down, I saw Tina lying naked on the azotea taking a sun-bath." Weston's attention moved quickly from the billowing clouds to Modotti's rounded body: "My cloud 'sitting' was ended, my camera turned down toward a more earthly theme," and in the course of that afternoon Weston produced what he felt was "the best series of nudes I have done of Tina."[19] By the end of the session he had composed at least five images, one of which is *Nude on Azotea* (1924; fig. 11.3).

At first Weston's roof-top transition from clouds to the nude may seem a remarkable inversion of Alfred Stieglitz's virtually simultaneous transition from nudes to clouds. Stieglitz abandoned his work with the nude, and abruptly turned to his Equivalent series of cloud photographs in a movement away from the earthy sexuality of Georgia O'Keeffe and other women who slipped beyond his control; he moved towards other, less willful subjects which his vision could more readily shape. It is tempting to regard Weston's episode as a direct reversal, part of an ever-swelling erotic content in the oeuvre of this artist whose life was marked by increasingly numerous erotic adventures. But things were not that neat, for, unlike Stieglitz, Weston continued to photograph *both* nudes and clouds, and often in

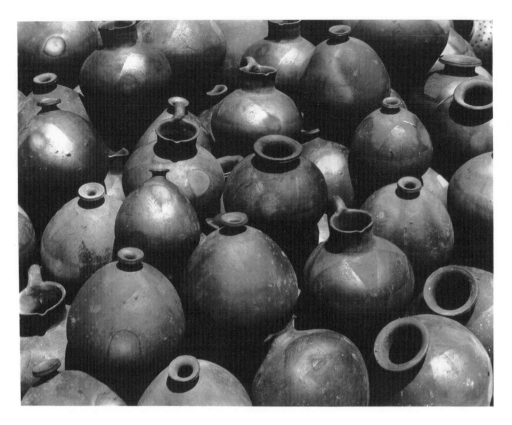

11.2. Edward Weston. *Pottery, Oaxaca Market, 1926,* © 1981 Center for Creative Photography,
Arizona Board of Regents. Collection Center for Creative Photography,
The University of Arizona.

ways so that they resembled each other. Moreover, Stieglitz's Equivalents show wispy, thin clouds, often framed so that they have no connection to the earth, but Weston's clouds are dense, bulging, rounded things, anchored to the horizon much as the sinuous Modotti rests upon the azotea. There is a transition represented in Weston's Mexican nudes and clouds, but it is a movement away from a geometry of line and plane, and toward a geometry of curve and camber.

A change in available subjects may account for some of Weston's move toward such swelling forms. It is possible that the clouds of Mexico and those of Los Angeles were simply different, and Modotti certainly was more full-breasted than Mather, the model for his last California nudes. But Weston's presentations suggest that he not only found new Mexican subjects but also that he came to regard subjects differently while in Mexico. This azotea photograph (fig. 11.3) presents the body by itself, without the linear props (window shadows, umbrella ribs) that had characterized Weston's studio and beach nudes. Lines here have been made into curves as the shifting body has rearranged the blanket's pattern, and the posture complements this curving quality as the raised arms accentuate the breasts. In others of his roof-top nudes, Weston coaxed Modotti into still more poses likewise emphasizing her curves; in one she lies face up, arms underneath

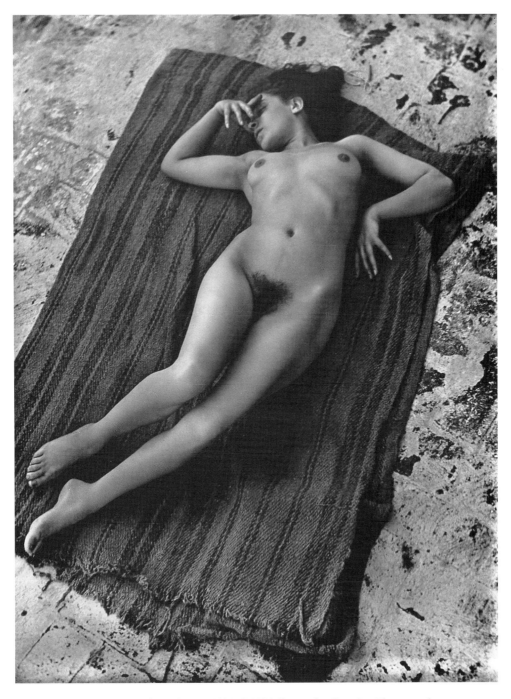

11.3. Edward Weston. *Nude on Azotea, 1924,* © 1981 Center for Creative Photography,
Arizona Board of Regents. Collection Center for Creative Photography,
The University of Arizona.

her back so as to raise her breasts, and in another she kneels upon that blanket, buttocks to the camera.[20]

There is also in these photographs a quality of light that is different from Weston's California work. Even though the Mather images had been made on a sunny beach, they seem cooler than the azotea images, for the light merely falls upon Mather's body; but Modotti's body has a radiance about it, and, like Weston's Mexican clouds, it seems more to be gleaming from within than lighted from without. The lighting here is of course arranged, no less so than the more quirky lighting of the attic angles. But the consequence is a less contrived appearance, and in this land where things seemed so natural, Weston worked toward a photography emphasizing his subjects' inherent glow rather than the illumination he brought to them.

The company, the surroundings, even the fruits of Mexico were delightful to Weston, and he photographed them all. But there was in things Mexican, be they Aztec artifacts or contemporary water jugs, the example of a seemingly indigenous aesthetic that not only stressed the graceful expression but that also led away from the linear and toward the curvaceous. Mexico helped change Weston's photography with its offerings of new subjects. It also encouraged a new vision as he enhanced the warmth and voluptuousness of his images.

Weston was particularly inspired by the apparent rusticity and purity of ordinary Mexican artists. In their "fineness of conception and execution" it seemed to him that they had long operated with the "simplicity and economy of approach" that modernists had only recently adopted. But the Indian artisans offered something even more than just technical examples, for they possessed elemental and primitive qualities which he believed more sophisticated artists sorely needed.

Much of this was a self-conscious rejection of expressive models that had earlier seemed so exciting. Artists and writers whom he had once admired in those little magazines now seemed contrived, affected, and trendy. In the meantime, he believed, his own photography had grown more authentic and direct, an improvement owing "not so much [to] the contact with my artist friends as [to] the less direct proximity of a primitive race." In the United States he had known nothing of "simple peasant people," but now, he thought, his vision had been invigorated by Mexico's Indians: "I have been refreshed by their elemental expression."[21] As he pursued these artists of "the soil," much of Weston's Mexican sojourn had the quality of an extended art lesson, though it was an odd instruction, for he seldom observed those "primitive" artists at work and only rarely did he speak with them. But Weston devoured their examples, studied their seemingly purer expression, and through those pieces sought a connection with the earth.

Fortunate circumstance made some of those lessons possible. Another foreign intellectual in Mexico at the time was anthropologist Anita Brenner, who hired Weston to illustrate her book on Mexican popular arts. Apparently Brenner had little notion that Weston was a photographer with artistic aspirations, but in her need for an illustrator she gave him an opportunity analogous to Strand's survey expedition for the Education Ministry—a work-for-hire project that took him out of Mexico City and into the hinterland.[22] The survey project was extensive, with a contract calling for four hundred images (more than all the rest of Weston's Mexican

output). Weston undertook the work during the spring and summer of 1926, traveling extensively with Modotti (as interpreter and assistant), and experiencing the challenges of strange plumbing, hungry bedbugs, and improvised darkrooms.

Many of the survey images are mundane record shots. But there is also an inquisitive and attentive quality to the work, substantiating Weston's claim that he tried to be "keenly observant, open to impression" during the project. Each stop offered "new food to try, new costumes to note, new types to discuss," and there were comparisons to be made between the various towns: Oaxaca's green walls, "plain or carved," seemed superior to the muraled walls of Puebla. Elsewhere he discovered artifacts echoing his other Mexican themes, as in Chupicuaro where he photographed a well-rounded fertility figurine reminiscent of his Modotti nudes.

But in that figurine, as in much else Weston saw, there was an additional appeal. Like Strand, who was entranced by the combinations of old and new world traditions in the Mexican *blutos*, Weston became fascinated with the syncretism of Christianity and Indian religion, and he was likewise delighted when native forms subverted the symbols of the transplanted faith. He eagerly described one example, a church that "was Catholic in name only,—it was completely Indian" and marveled at the motifs of what he called its "barbaric splendor." Nearby he found carved crosses and angels, "Christian symbols done with pagan mind,—and stronger for the pagan interpretation!"[23] Weston was disappointed that so few other visiting intellectuals seemed to share his appreciation for things heathenish. Whether it was a movie-maker who sugar-coated the savagery of bull fighting, or D. H. Lawrence who seemed terrified by the intensity of Mexican passions, Weston thought he often detected the "neurotic Anglo-Saxon" among his all-too-delicate fellow artists and writers.[24]

If others' squeamishness may have struck Weston as absurd, much of his own affection for earthy Mexican things was comically dotty. Weston's obsessiveness surfaced one morning in Patzcuaro when he bolted from the breakfast table and rushed to the market to purchase a peculiar type of clay water bottle for sale in the market. Upon another occasion, it was the "appalling beauty" of some mummified, naked corpses that aroused his cravings; he proposed making photographs "of contorted hands, of shrivelled breasts and gaping mouths," and was disappointed when an understandably reluctant caretaker refused to move the dusty bodies into better light.[25]

But it was "Loza—crockery!" that was Weston's most beloved product of the Mexican earth. As he traveled about the country he wildly photographed the pottery, producing images such as *Pottery, Oaxaca Market* (fig. 11.2) in his fascination with this "race of born sculptors!" who so often made "use of the essential quality of a material." But if his photography was extensive, Weston's purchases verged on the compulsive. He went on binges, buying plates, jars, and toys—pound upon pound of crockery products. In the Oaxaca market where he photographed those water jugs, he virtually salivated at the sight of "great hills of piled up loza," and then desire gave way to satisfaction as he "bought and bought."[26] He acquired huge baskets full of crockery during his trips around Mexico, schlepping them from train to train under the disapproving glare of his fellow passengers. Here then was Weston's earth-fetish at its most ironic as this celebrator of simplicity negotiated his way with an ever-growing encumbrance of dish ware.

There was also an exploitive, or even brutal, dimension to Weston's appreciation of Mexican earthiness. He went to the bullfights often, and in his bloodthirsty enthusiasm noted scenes like one horribly gored horse that "streamed pink guts onto the sand and dropped to his death." He admitted that there might be sadistic overtones to all this, but still it seemed to him an unflinching "pageant with death," staged by people who were unafraid of confronting death's primitive qualities…blood, gore and sand.[27] Still other Mexicans seemed to understand the simple qualities of love, and one of these was Elena, his fifteen-year old servant and sometimes lover. In her plainness she presented none of the challenges of "the mental meanderings of emancipated women" like Modotti, for "all she knows well, is how to love."[28] Rather than the skillfulness of a woman negotiating her way through the complexities and powerlessness of a relationship with her boss, Weston chose to see here a case of simple sexual accommodation, a counterpart to the bullring's forthright display of death.

In this way there was a kind of haughtiness to Weston's outlook, and to his art, during the Mexican years. While celebrating Mexican warmth, Weston also regarded the country with a certain coolness and reserve, remaining an outsider who saw a quaint ungainliness in things Mexican. Likewise, as much as he might lusciously depict a nude or amorously hold a lover, there was a persistent remoteness to Weston's dealings with people, for the beloved other was often also the exploited art object.

Weston once outlined his principles for portraiture. He said that it was essential for the photographer to "be in complete control of the sitter at all times," and recommended that the photographer should "disarm the sitter." Weston perfected this kind of portraiture during his Mexican years, photographing a number of individuals in moments of striking vulnerability. In contrast to the pistol-wielding Galván, he photographed his son Neil, cringing in the midst of a migraine, or the clearly depressed Hagemeyer, captured, as Weston put it, in "the gripping depths of…neurasthenia."[29]

Even Modotti had her fragile moments, and Weston moved in upon her like a photographic raptor. It was a troubled time in their relationship, and after a particularly difficult night Weston insisted upon making her portrait. Thinking that "the Mexican sun…will reveal everything," he hoped to capture "something of the tragedy of our present life" in her face. He backed Modotti against a white-washed wall, and as she stood there in her pain, "lips quivering—nostrils dilating—eyes heavy," Weston pushed her over the emotional brink: "I drew close to her—whispered something and kissed her—a tear rolled down her cheek—and then I captured forever the moment—let me see f.8—1/10 sec. K1 filter—panchromatic film."[30]

Such detachment became a trait of Weston's Mexican photography. His aloofness was sometimes mirrored in his physical point-of-view, an elevated rooftop vantage from which he repeatedly peered down upon Mexican scenes. Weston said that he had "felt the soil," but in this regard his photography was more inclined to hover above the earthiness of Mexico. Typically, he "worked from the azotea…looking down on nearby roofs and houses." On one such day he took to the heights on the island village of Janitzio, the same place were Paul Strand made those dramatic images of sun-drying nets (fig. 8.3) while Weston's own image, (fig. 8.2), has little feel for the life or livelihood of Janitzio.

There is a spying quality to some of these rooftop images as Weston's camera gazes down upon unwitting subjects, a snooping most obvious in 1924 images from Tepotzotlan. To compose some of these, Weston set up his tripod in a church tower and then stared down on the noonday plaza, peering at the unsuspecting people as they walked, relaxed or visited below. But the most striking photograph of the series (*Calle Mayor, Tepotzotlan*—often referred to as *Pissing Indian*, fig. 11.4), was directed at a quiet side street where Weston composed a formal study, with rectangles of baked-mud walls echoed by bricks stacked along the roadway. Just as Weston was about to make his exposure, a man emerged from the door and began urinating on the bricks. Clearly the man had no suspicion that he was being photographed as he "stood there serenely," and Weston could have granted the man a measure of privacy by wait-ing—the image Weston had composed and framed would hardly change at all during the few moments it would take for the man to complete his business and move along. But Weston was inclined otherwise: "I uncapped the lens and have him, stream and all." Pleased with the results, what he called "a fine print technically" that also "has humor," Weston promptly put it on public view in his next exhibition.[31]

Much about Mexico appealed to Weston. The clouds seemed so rounded, the bullfights so visceral, the crockery so subtle. Yet for all his infatuation Weston was always reserved to some degree, and his enormous affection for the primitive never completely supplanted his civilized tastes. Much of Mexico was grand, but not wholly grand, and Weston's appreciation was tempered by his selectivity.

During his Mexican years Weston completed his transition to modernism. Mexicans seemed to have a superb appreciation for shape and form, and the physi-cal nature of their country seemed marvelously suited to the illumination of contour, line, and figure. Like Rivera, Charlot, and other modernists earnestly pursuing their new art in Mexico, Weston was absorbed in the excitement of his growing vision.

Sharpness had become the single most common identifying quality of mod-ernist photography. This was certainly nothing new by the 1920s, for Stieglitz and Strand had long abandoned soft-focus work, and, even before sailing for Mexico, Weston himself had moved toward straight photography. But Weston finally aban-doned pictorialism during his first months in Mexico. In an account that is doubtlessly exaggerated, he described the final transition as a sharp, cathartic, and particularly Mexican episode.

In the spring of 1924 he was outside Mexico City, attempting to photograph the maguey cactus, a large succulent agave with dramatic spiky limbs. Weston struggled, for subject and setting seemed to call for a treatment beyond his existing gear. "Sharper and sharper I stopped down my lens," but the results proved unsatisfacto-ry and Weston finally jury-rigged his equipment for a still sharper aperture. The work continued through what proved to be an exhausting day, and the vision of that maguey so haunted Weston that he was unable to sleep until he had developed his negatives. To his delight there were fine exposures in the group—sharp, clear images that managed to "express well my reactions to Mexico." With its atmosphere and sub-jects, Mexico now utterly invalidated pictorialism, for as Weston wrote in his Daybook, "how ridiculous a 'soft focus' lens in this country of brilliant light, of clean cut lines and outlines." Within a few weeks Weston had re-outfitted himself, pur-

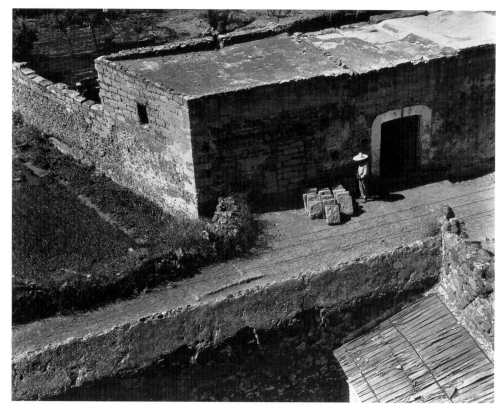

11.4. Edward Weston. *Calle Mayor, Tepotzotlan, 1924,* © 1981 Center for Creative Photography,
Arizona Board of Regents. Collection Center for Creative Photography,
The University of Arizona.

chasing a new lens that "should satisfy my craving for depth of focus," and conclud-
ing that "my several diffused lenses seem destined to contemptuous neglect." Thus
equipped, Weston believed he had completed a process begun in the United States,
and announced that "now I start a new phase of my photographic career."[32]

If Mexico's brilliant light and dramatic plant life seemed essential for Weston's
modernist education, so too did its folk artists. Not only did he appreciate their use of
earthy, bulbous forms, he also studied them as inveterate decorators who embellished
almost anything: dishes, saddles, hats, baskets, and more. Many of these offered
"object lessons" for visiting modernists, and he found his own most valuable teachers
among Mexican toy makers.[33] The markets were full of *juguetes,* or toys, made of all
sorts of materials—gourds, reeds, clay, tin, dough—and in all sorts of shapes—birds,
fish, dolls, horses, and bells. Fascinated with these figures, Weston purchased them
almost as avidly as he did crockery, and his ever-growing collection became "an inex-
haustible source of pleasure." Many of his toys were fanciful, with a humor ranging
from the Rabelaisian joke (a pig devouring human excrement at the moment of its
deposit) to the enchanting fantasy (toys in the shape of dancing coyotes).[34]

But more than their humor, it was these anonymous artists' seemingly intuitive
fusion of subject and material that most impressed Weston. "These Indians never

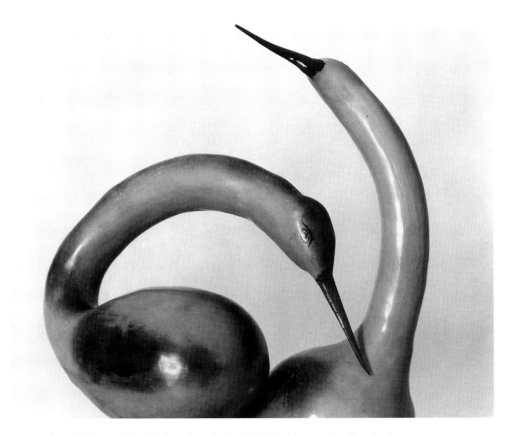

11.5. Edward Weston. *Two Birds—Gourds, 1924,* © 1981 Center for Creative Photography, Arizona Board of Regents. Collection Center for Creative Photography, The University of Arizona.

went to 'Art School,'" he wrote, but they worked "with fine feeling for essential peculiarities of form"—particularly when making figurines from dried gourds. One such gourd was transformed into a bird, a creature with its long neck curving gracefully over its back. The bill and eyes were painted in a contrasting color, and once Weston had acquired another similar bird-gourd, he arranged the two together, worked several intense hours on focus and lighting, and then finally made a number of negatives, including *Two Birds—Gourds* (1924; fig. 11.5). Here again he had some of the rounded and curving shapes that seemed so abundant in Mexico. More compellingly, though, the gourd-bird was "a lovely thing in line, but done by nature (albeit improved by man)."[35] Weston photographed the birds in part as a homage, the expression of his admiration for the accomplishment of some anonymous artist. But the image also showed that Weston could work in a similar manner and effect a similar improvement. Weston took the lines given him, and then accentuated them by posing the two gourds against each other and framing them as a pair of parentheses.

Still another of his gourd-toys was an intricate fish with surprised eyes, fat body, and "most perfectly logical tail." Here as with the birds, "nature attended to the form, but some Indian, noting her incomplete effort, decided to 'gild the lily.'"[36] Grasping

the qualities of nature's various essential forms, that artist had taken those forms to their logical conclusion and rendered the gourd into a fish. It is understandable that a modernist would like these toys, for the craftsmen seemed engaged in some of the same project as the artist Marcel Duchamp, taking found objects, giving them a quick interpretive riff, and then presenting the resultant work of art. Perhaps the most famous of Duchamp's "ready-mades" was a urinal laid on its back and then offered as a sculpture entitled *Fountain* (and photographed by Stieglitz). The Indians' found objects were usually organic rather than manufactured, and offered without the provocation of Duchamp's dadaism. Still, though, both Duchamp and the gourd artists worked acts of whimsy upon commonplace objects, transporting them from the world of the ordinary into the world of the aesthetic with a minimum of effort.

For Weston, those Mexican toys were lessons in an art of accentuation, examples particularly relevant to photography. They showed how one could take a found form—often a natural form like the curve of a gourd—and then, by one's own contribution, highlight some inherent qualities of that form. "Gilding the lily" is usually a derisive phrase, but for Weston, gilding lilies (or gourds, or whatever) was a fine project, and with their decorative touches those Indian artists accentuated beauty, form, and curve which might otherwise have gone unheralded. Theirs was a soft touch, too, a dab of color here, a little line there. As a photographer, Weston's own touch could be even lighter, an accentuation of nature by gilding his subjects, vegetables or nudes or whatever, with light and shadow.

Surrounded by the creations of those who managed to see beautiful form in the found object, Weston discovered that his own greatest creative excitement was likewise a response to form. From late 1924 until he left Mexico at the end of 1926, Weston often worked in this vein, producing photographs of gourd toys, images of rounded pots, portraits of faces that looked like rounded pots, and some particularly ambitious nudes. But the most riveting formal efforts were condensed into three intense weeks during October and November 1925.

On October 15 Weston wrote to one of his nude models, saying that he missed her both photographically and personally. "Perhaps," he mused, "I shall turn for solace to the clouds again—or the Mexican *juguetes* (toys)!"[37] The solace came, but from quite an unanticipated quarter. Sometime around October 21, Weston began photographing his *Excusado* (1925; fig. 11.6), "that glossy enameled receptacle of extraordinary beauty." For some time he had off-handedly considered working with the toilet, but it was only when he saw it on the focusing screen of his camera, inverted and isolated from its surroundings, that Weston suddenly realized an art potential in this mundane object. (It is possible to share some of Weston's reaction by turning Fig. 11.6 upside-down: common toilet associations fade, and the fixture's shapes become more compelling.)

"Form follows function." Once again Weston quoted the phrase. And as before, function was decidedly the lesser of Weston's concerns on that October day, for he had little to say about modern hygienic plumbing or the mechanics of swirling water. Instead, "my excitement was absolute aesthetic response to form"— and there was an abundance of form here, as much as with any of his nudes, for with its own surprising charms the toilet seemed to offer "every sensuous curve of the 'human form divine.'" Thus the equal of nature, it also seemed as grand as any creation from the past. "Never did the Greeks reach a more significant consumma-

tion to their culture," and in that toilet with "its chaste convolutions and in its swelling, sweeping, forward movement of finely progressing contours," Weston saw a sculptured execution that "reminded me . . . of the Victory of Samothrace."[38]

Weston worked to bring those qualities of sweep, contour, and convolution into his own image. He used shading and camera position to give the toilet a sense of thrust, as though it were pushing out from the picture plane and towards the viewer. He chose to direct some of the lighting from above and some from straight-on, with a resulting shine that accentuates the smooth glaze of the surface and a shadow that traces the curve of the bowl's lip. Thus lit and viewed, Weston indeed gave the toilet a Nike-like pose. The object already was aestheticized by a visual medium that precludes the sounds and smells normally associated with a toilet, but Weston's framing furthers the process, presenting the toilet in glowing isolation from the sanitary accoutrements—paper, brush, towel—that might remind one more of filth than form. This image, like the others in the series, is also the product of considerable fiddling, for over the course of several days Weston worried about framing, stray objects in the background, camera placement, and more. Yet there was a limit to his manipulations. For a time he thought of unbolting the wooden seat, but then decided not to do so because that "would make it less a toilet, and I should want it more a toilet rather than less." Just as the toy-painters did not attempt to carve their curving gourds into rectangular shapes, so too Weston in this instance would respect the integrity of the subject before him.[39]

Weston's toilet images, and the work to get them, provoked considerable reaction. There was an understandable domestic stir, for Weston and his bulky equipment occupied the room for hours on end, prohibiting others from more conventional uses of the privy. But the household also participated: a servant polished the bowl, someone else suggested placing red roses in it, and Weston's son, Brett, offered to pose on the toilet, demonstrating it use. When Weston's artist friends saw the image, they were more serious and appreciative. Charlot and O'Higgins thought it one of Weston's most sensitive observations, and Rivera called it the most beautiful photograph he had ever seen. It is possible that these artists might have viewed the toilet in the light of other recent works, and that Weston himself drew inspiration from the likes of Duchamp's urinal or Morton Schamberg's 1918 plumbing sculpture, *God*. But given the record's silence, it seems likely that Rivera and the others regarded the toilet series as Weston himself did, "a direct response to form," inspired by the subject before the lens rather than the work of other artists.[40]

Toilets, like gourds, are not what might ordinarily seem compelling art subjects. But Weston brought to the work his growing willingness to see formal beauty in the commonplace. Within a few days of making his last toilet image, Weston continued such formal work as he photographed a female nude. Of course the nude is a traditional art subject, but unlike Modotti, Weston's model for *this* sequence was not traditionally attractive. She was Anita Brenner, and although the same age as Weston's other models, she not only lacked their youthful athleticism, but had blotchy skin and was more than a bit pudgy. Just as the toilet was an unusual still life subject, so Brenner was an unorthodox nude.

Weston began working indifferently, as he had with the toilet. It was a cold, drizzly day when Brenner arrived for their scheduled session, and in his listlessness

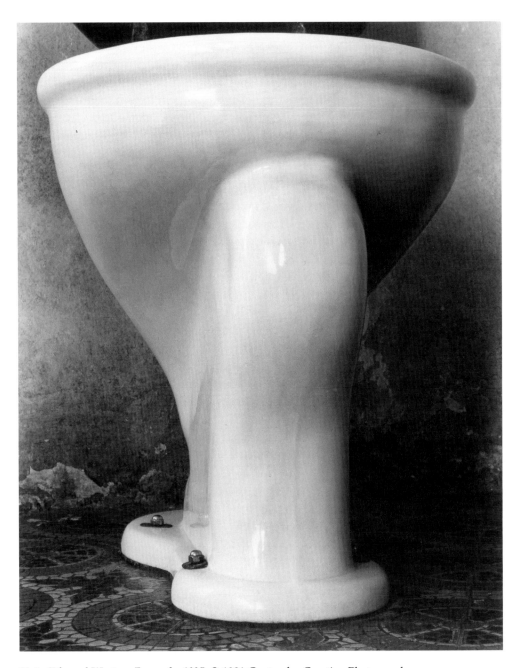

11.6. Edward Weston. *Excusado, 1925,* © 1981 Center for Creative Photography,
Arizona Board of Regents. Courtesy George Eastman House.

Weston tried to dissuade her. But she would take no hints and began undressing while he reluctantly prepared his camera. As had happened with the *excusado*, the aesthetic reaction came unexpectedly and the photography went wonderfully: "And then appeared to me the most exquisite lines, forms, volumes—and I accepted,—working easily, rapidly, surely." By the end of the sitting, Weston had made fifteen negatives, what he called "my finest set of nudes," images distinct from earlier nudes in that they lacked "any human interest which might call attention to a living, palpitating body." Far from sensual reactions, these images were a modernist exercise, an "approach to aesthetically stimulating form." And form was what Weston rendered, for in one of the images Brenner sits with her back to the camera, and leans forward as she clasps her knees. The effect is, as Weston recognized, "pear-like," for Brenner appears more like a large, white fruit, suspended in space and slightly cloven at the base. The image was soon one of his favorites ("I could hug the print in sheer joy"), and he counted himself lucky to have made it when he did, for the following evening Brenner was in an automobile accident that left her broken and hospitalized, with a set of quite unphotogenic contusions and cuts which even Weston could not have disguised.[41]

Those brief weeks of the *excusado* and Brenner images became a milepost in Weston's career. On the day after his session with Brenner, he wrote of the sense that he had begun working with "a more introspective state of being, a deeper intellectual consideration of subject matter." Indeed, during the brief remainder of his stay in Mexico, Weston conducted a considered reflection on the nature of photography and his own aspirations within the medium. As historian Amy Conger has noted, those few weeks saw the nascent development of notions which later emerged more maturely after he returned to the United States.[42] Rather like the rest of his packing during those weeks, this was an effort to tidy and trim his Mexican ideas before carrying them home to California.

Weston's own photography was clearly one stimulus to this thinking. His excitement was keen and the images arresting, and he was compelled to plumb his reactions to both his subjects and his hugable photographs. There was also the example of his Mexican artist friends who had begun to write seriously about photography. In particular, David Siqueiros's review of Weston's photography struck Weston as "an exceptionally understanding treatise," and a few months later he envied the clarity of expression that Rivera achieved in still another essay.[43] Finally, Weston began to do some reading from his expanding library of art books, and also picked up authors like the contemporary American critic Van Wyck Brooks and the eighteenth-century German poet and dramatist Friederich von Schiller.

Much of what he found in these sources had to do with the nature of representation. In a creative work which refers to the external world (i.e., a photograph), what should be the relationship between the artist's imagination and the real world? How much of a visual image should derive from the artist's mind, and how much from the objects upon which that mind trains its focus? Schiller said there should be a balance between the two, that the artist "must rise above literal reality, yet he must nevertheless remain within the sensuous." Siqueiros thought that Weston's images nicely attained such a balance, for they were pictures that dwelt within the "transcendental" realm of the mind, and yet were also true to the "material qualities of

things and of objects that they portray." Weston himself recognized this duality that Schiller and Siqueiros described, and believed that he was developing the skills needed to work well in both realms. At one point he bragged that "I can now express either reality, or the abstract, with greater facility than heretofore."[44]

But as Weston's Mexico stay drew towards a conclusion, it is clear that he had little concern in maintaining an even proportion between "reality" and "the abstract." His rhetoric was more inclined toward the real than the abstract. For one thing, he recognized that there could be nothing like a purely imaginary piece of art, for as he put it, even "the most abstract line or form, of necessity is based on actuality—derived from nature." There was, he said, a very close association between the photograph and the subject, and he thought of the photograph, in the terms of later scholarship, as a "trace" of that outer world. If it were possible to keep that relationship always in mind, to recognize that what we call abstractions are really only simplified versions of natural forms, then, Weston said, he would have no quarrel in designating photography an abstract art. But the recognition was seldom maintained, and in common usage "abstract" had lost connection with nature and instead become "something apart, something metaphysical." Weston said that artists working in the abstract were "grop[ing] for the very spirituality which they lack," and as such were befuddled characters leaping "with wildly kicking legs towards the unattainable." Weston, though, preferred to remain earthbound, for "to keep one's feet firmly planted on terra firma is to keep the head poised and receptive." His own goals had moved toward this solidity, so that while "once my aim was interpretation, now it is presentation." The mood of pictorial softness was abandoned in Mexico, and he adopted straight photography as a means by which his subjects could more clearly speak for themselves.[45]

Weston allowed that it was possible "to record interesting abstractions." But he insisted instead "that the camera should be used for a recording of *life*, for rendering the very substance and quintessence of the *thing itself*, whether it be polished steel or palpitating flesh."[46] Rather than exercise the over-interpreted style of pictorialism, one had an obligation to "the *thing itself*." That phrase has quite a ring to it, and one is inclined to think that Weston may have borrowed it from some other source. Shakespeare is one possibility, but the use in *King Lear*—the equation of human and animal—doesn't quite fit Weston's context. Kant's famous *Ding an sich* (thing-in-itself) might seem the more likely source, for we know that Weston was at this time quoting Schiller (himself influenced by Kant), and as Alan Trachtenberg has noted, Weston's images, like Kant's philosophy, are laden with ontological issues about reality-and-representation. But the Kantian reference seems dubious (or perhaps Weston got Kant wrong), for Kant's *Ding an sich* is completely beyond human experience, whereas Weston's aspiration was to know the subject thoroughly, to render "the very substance and quintessence of the *thing itself*."[47] There is a still more likely source for Weston's phrasing. In the midst of his archive there is a single page containing several quotations from Vincent Van Gogh. In one of these, Van Gogh seems to be saying something quite close to Weston's notion that mere decoration was an insufficient appreciation of subject; that, as he quoted Van Gogh, "a feeling for things in themselves is much more important than a sense of the pictorial."[48]

And so Weston summarized his thinking on photography. Some of this was a declarative reiteration of notions that had become commonplace in modernist,

straight photography—that photographers should not imitate other media, and should be content to explore photography's subtle possibilities without resorting to fuzziness, manipulation, or cropping. Other portions, though, were more original and more epistemological. Photography was an art of knowing subjects, a kind of knowing that must be both intense, without the casualness of impressionism, and clean, without the kind of biases that might lead one to denigrate a toilet. Finally, Weston concluded with something of a creed, proclaiming that his photography "recorded the quintessence of the object or the element in front of the lens," and that he did this without "offering an interpretation or a superficial or passing impression" of the object before the camera.[49] As Weston perceived them, the lessons of Mexico were the lessons of simplicity, to be found in the shape of gourds, the materials of the earth, and the purity of passion. The particular lesson for the photographer was likewise one of simplicity, that the good image presented objects with the fewest possible agglomerations of interpretation or of the artistic self.

Edward Weston came back to the United States at the end of 1926. The eventuality of that return, if not its exact timing, had been assured from early on. As much as Weston felt the pull of a primitive and earthy Mexico, he was always more of a Marlow than a Kurtz. He was thrilled by the bullfights, the pottery, and the women, but he never went native. He got inspiration and lessons from Mexico, and when the time was ripe, he gathered up his Daybooks and his images and his ideas, and came back to California.

1. EW to AS, March 3, 1925, ASA/YCAL.
2. DBI, September 4, 1926, 190.
3. Amy Conger, *Edward Weston in Mexico, 1923-1926* (Albuquerque: University of New Mexico Press, 1983), 11-19. Laura Mulvey and Peter Wollen, "Frida Kahlo and Tina Modotti," in Laura Mulvey, *Visual and Other Pleasures* (Bloomington: Indiana University Press, 1989), 81-88.
4. See Henry C. Schmidt, "The American Intellectual Discovery of Mexico in the 1920s," *South Atlantic Quarterly* 77 (1978), 335-51; and James Oles, *South of the Border: Mexico in the American Imagination 1914-1947* (Washington: Smithsonian Institute Press, 1993).
5. For such a characterization, see Hilton Kramer, "Edward Weston's Privy and the Mexican Revolution," *New York Times* (May 7, 1972), here from Beaumont Newhall and Amy Conger, eds., *Edward Weston Omnibus: A Critical Anthology* (Salt Lake City: Gibbs M. Smith, 1984), 155-157.
6. DBI, March 30, 1924, 60. EW to Flora Chandler Weston, October 16, 1923, EWA/CCP. DBI, Summer 1924, 82.
7. Tina Modotti to EW, July 7, 1925, in Amy Stark, "The Letters from Tina Modotti to Edward Weston," *The Archive* 22 (January 1986), 39-40. DBI, August 20, 1923, 15.
8. DBI, February 3, 1924, 46-47. EW to Johan Hagemeyer, November 24, 1924, Weston-Hagemeyer Collection, CCP. EW to AS, March 3, 1925, ASA/YCAL.
9. EW to Weston family, March 29, 1924, EWA/CCP. EW to Weston family, September 1, 1923, EWA/CCP.
10. DBI, October 30, 1923, 26. DBI, December 7, 1923, 35. DBI, 1926, 182. Also, Galván was generous with his attentions and his money, proving a good friend to Weston and Modotti. Galván died much as he lived, shooting and killing his assassins even as he fell dying from his own wounds.
11. EW to Van Dyke, 18 April 1938, Willard Van Dyke Archive, CCP.

12. DBI, February 3, 1924, 47. DBI, February 24, 1924, 51.

13. EW to Brett Weston, September 6, 1923, EWA/CCP. The letter was written to his son in Californian and was, as Weston recognized, "pretty strong stuff to hand an eleven year old boy." The letter goes to lengths about noble individualism, and in it Weston seems to have been shouting down his own qualms about abandoning Brett and the other two boys in his pursuit of artistic fulfillment.

14. For more on Weston's geometric preferences, see Mike Weaver, "Curves of Art," in Peter C. Bunnell and David Featherstone, eds., *EW:100: Centennial Essays in Honor of Edward Weston* (*Untitled* 41) (Carmel, CA: The Friends of Photography, 1986), 81-91; and Mike Weaver, "The Spiral and the Pentagram," in Mark Johnstone and Jonathan Green, *The Garden of Earthly Delights: Photographs by Edward Weston and Robert Mapplethorpe* (Riverside: University of California, Riverside, CA: California Museum of Photography, 1995), 20-27.

15. DBI, September 13, 1923, 21. DBI, March 10, 1924, 55. DBI, October 31, 1924, 99.

16. DBI, February 24, 1924, 51.

17. EW to his family, October 7, 1924, EWA/CCP.

18. Conger, *Edward Weston in Mexico, 1923-1926*, 7. DBI, August 6, 1923, 15; DBI September 12, 1923; EW to his family, October 7, 1924, EWA/CCP.

19. DBI, July 9, 1924, 83.

20. One should note that in one of the more commonly reproduced of the azotea nudes, Modotti is on all fours and in wedge of sunlight, an image that echoes the attic angles series.

21. DBI, September 4, 1926, 190.

22. Brenner's book, containing Weston's photographs, was titled *Idols behind Altars* (New York: Payson & Clarke, 1929). The pairing of Brenner and Weston was providential in that she too deeply respected the folk arts, and believed that in Mexico, unlike more industrialized countries, the nation's values and its arts were still organically produced.

23. DBI, 1926, 164.

24. Weston was particularly disappointed with Lawrence, perhaps because the sensuality of novels like *Women in Love* (1920) led Weston to regard Lawrence as a kindred soul. EW to Ramiel McGehee, September 30, 1926, EWA/CCP. DBI, 1926, 181. Edward Weston, "Lawrence in Mexico," supplement to *The Carmelite* (March 19, 1930), ix-x; here from Amy Conger, *Edward Weston: Photographs from the Collection of the Center for Creative Photography* (Tucson: Center for Creative Photography, University of Arizona, 1992), figure 149.

25. DBI, 1926, 172, 185.

26. DBI, 1926, 165, 167. Weston was not the only American visitor to be so enthusiastic for the crockery. Even John Dewey fell under its spell. Dewey called the native pottery "beautiful" and said that "the patterns, while not identical with the primitive, are genuinely indigenous, observing a traditional type with spontaneous individual inventions." John Dewey, "Mexico," in his *Impressions of Soviet Russia and the Revolutionary: Mexico-China-Turkey* (New York: 1929), 169-70.

27. DBI, 4 Nov 1923, 29.

28. EW to Johan Hagemeyer, [June 1926], Hagemeyer Papers, CCP. Daybook quoted in Maddow, *Edward Weston*, 63. DBI, September 23, 1926, 192.

29. Edward Weston, "Thirty-Five Years of Portraiture," *Camera Craft* 46 (September 1939), 399-408 [Part I], and (October 1939), 449-60 [Part II]; here from Peter Bunnell, ed., *Edward Weston on Photography* (Salt Lake City: Gibbs M. Smith, 1983), 105, 110. DBI, September 29, 1925, 129. The images of Neil and Hagemeyer were made in California.

30. DBI, January 30, 1924, quoted in Ben Maddow, "Venus Beheaded: Weston and His Women," *New York* 8 (February 24, 1975), 50-51.

31. Ibid., April 1924, 65. DBI, April 29, 1924, 68.

32. Ibid., April 1924, 64. DBI, June 21, 1924, 80.

33. Ibid., December 11, 1923, 38.

34. Ibid., April 24, 1926, 157. Daybook typescript, GEH/IMP, July 24, 1924, 139. DBI, January 12, 1926, 228.

35. DBI, September 22, 1924, 93, and September 30, 1924, 93-4.

36. Ibid., summer 1926, 167.

37. EW to Miriam Lerner, October 15, 1925, EWA/CCP.

38. DBI, October 21, 1925, 132.

39. Ibid., November 4, 1925, 134-5.

40. Amy Conger, "Edward Weston's Toilet," in Peter Walch and Thomas F. Barrow, eds., *Perspectives on Photography: Essays in Honor of Beaumont Newhall* (Alburquerque: University of New Mexico Press, 1986), 167-83. DBII, April 23, 1927, 17.

41. DBI, November 12-14, 1925, 136-7; and January 15 1926, 147-8.

42. Ibid., November 13, 1925, 136. Conger, *Edward Weston: Photographs from the Collection of the Center for Creative Photography*, "Biography," 17.

43. DBI, September 22, 1925, 128-9, and January 10, 1926, 147.

44. DBI, December 26, 1925, 143-44. David Alfaro Siqueiros, "A Transcendental Photographic Work: The Weston-Modotti Exhibition," *El Informador* (Guadalajara: September 4, 1925), 6; here translated by Amy Conger in Beaumont Newhall and Amy Conger, *Edward Weston Omnibus: A Critical Anthology*, (Salt Lake City: Gibbs M. Smith, 1984), 19-20. DBI, February 8, 1926, 150.

45. DBI, February 8, 1926, 150. DBI, April 14, 1926, 156.

46. DBI, March 10, 1924, 55.

47. Alan Trachtenberg, "Weston's 'Thing Itself,'" *Yale Review* 64 (1975), 109.

48. Edward Weston collection of quotations, EWA/CCP. Weston also used the phrase in an exhibition catalogue upon his return to the United States—Edward Weston, Statement in Exhibition Catalog, "Edward Weston, Brett Weston Photographs," Los Angeles Museum, October 4 - November 2, 1927, Weston-Hagemeyer collection, CCP. As Marianne Fulton as noted, Emerson also used the phrase. Marianne Fulton, "Stieglitz to Caponigro: An American Photographic Tradition," *Image* 26 (June 1983), 11. Of course it is impossible to say precisely that Van Gogh stimulated Weston's thinking, but circumstantial evidence leads one to think that Weston, going about his work in Mexico, may have responded sympathetically to Van Gogh in still other ways. In another of those quotations on that same page, Van Gogh lent legitimacy to Weston's own food fetishism, drawing a relation between cooking and one's capacity for thought and the making of pictures. Then, in still another quotation, the Van Gogh of those terrifically productive months in Arles seems to be directly addressing a similarly productive Weston in Mexico: "In the South the powers of the senses are intensified; one's hand is more nimble, one's eyes are more acute, and one's brain is clearer. On this account I venture to declare that he who would fain devote himself to artistic work will find his capacities increase in the South."

49. Edward Weston, "Conceptos del Artista" ["Concepts of the Artist"], *Forma* 2 (1928), 15-18; here from Conger, *Edward Weston: Photographs from the Collection of the Center for Creative Photography*, "Biography," 17.

12. Scrutiny: Appetite, Subject, and the Mind

From his 1926 return to California until the mid 1930s, Weston's life and career were both intensely focused and richly textured. Photographically and conceptually, he explored and re-explored important visual themes, producing a set of classic images that achieved a unique identity for his art. Geographically, Weston moved between the axes of northern and southern California, returning first to Glendale, then in 1928 opening a studio in San Francisco, and in 1929 still another one in Carmel; as much as anywhere, Carmel was Weston's home from 1929 until 1935.

Weston was inclined to describe himself as leading a life of aesthetic rustication, isolated from the rest of America and devoted singularly to his own development. But in fact his was not a hermit's existence. Although Carmel was a small coastal town of little commercial importance, it was a cultural crossroads of some significance. It had once been the home of photographer Arnold Genthe and writers Jack London and Sinclair Lewis, and in Weston's day the residents included his friends the Nietzschean poet Robinson Jeffers and the muckraking journalist Lincoln Steffens. Weston took in his share of the town's culture, with plenty of music (Beethoven, Bach, and Mendelssohn, and contemporaries Stravinsky and Ernest Block), lots of dance (including the German modernist Harold Kreutzburg), numerous plays (O'Neill was a favorite), and always films (including ones by Fritz Lang and Sergei Eisenstein). Also, there were opportunities for conversation with the creative people who came to him for portraits, including e. e. cummings, Igor Stravinsky, and James Cagney.

Weston developed additional relationships with people who were more intimately connected with his art and career. During these years he got to know Merle Armitage and Albert Bender, businessmen whose patronage and connections provided widening outlets for Weston's images. Younger photographers such as Willard Van Dyke and Sonya Noskowiak came to him for apprenticeships that evolved into life-long friendships, and Noskowiak, like her predecessors Mather and Modotti, was also for a time Weston's lover. Still another of these younger photographers was Ansel Adams, whom Weston met over supper at Bender's house. Although the two men eventually became fast friends with immense respect for each other's work, on that 1928 evening neither was impressed. Adams thought Weston's images "hard and mannered," while Weston concluded that Adams should concentrate on the piano rather than the camera.[1]

The late 1920s and early 1930s were for Weston a time of keen absorption. Engrossed with his work (and spared the distractions of crockery markets and the bullring), Weston devoted long hours to posing his subjects in the studio and developing new negatives in the darkroom. Some of his efforts went into the commercial portraiture by which he made his living, but it was Weston's art photography that preoccupied him. He tried "to 'train' for this job I face" first by placing the household "under a system of work, saving and schedules comparable to Russia's five year plan," and secondly by following a dietary regimen of "intestinal purity."[2]

Neither program was a complete success—Weston's bohemian friends and adolescent sons wrecked many a schedule, and his love of coffee and cigarettes subverted the health scheme—but his focus was nonetheless sharp and his photography had considerable critical success. By 1930 Weston had entered the artistic big leagues with his first one-person show in New York, favorably reported in the *New York Times Magazine*, and then in 1932 his work reached an even wider audience with the publication of his first book.

The first significant influence of these years was an unrenowned West Coast artist, Henrietta ("Henry") Shore (1880-1963). This Canadian-born painter had studied under Robert Henri and William Merritt Chase in New York, where she exhibited with her fellow student Georgia O'Keeffe. In 1913 Shore moved to southern California, where she developed a style accentuating abstractions with the kind of curves and heft that Weston had found so appealing in Mexico.

Weston first saw Shore's paintings in February 1927, and over the next eight months Shore and Weston became close friends (though not lovers—one of the many ways in which Shore was a singular woman in Weston's life). They exhibited together and made each others' portraits; but shells were Shore's greatest gift to Weston.[3] He had never before seen a chambered nautilus, and when he encountered Shore's paintings and the shells she used as models, Weston fell, and fell hard, for the subject. In a scenario repeated many times over the next several years, Weston first had a moment of stunning visual excitement as he suddenly realized the art potential of some commonplace subject, and then with a bout of furious activity photographed and produced images like *Shells* (1927; fig. 12.1). As Weston said, he was "awakened to shells by the painting of Henry," and he declared that "the Chambered Nautilus has one of the most exquisite forms, to say nothing of color and texture, in nature."[4] He began working with Shore's shells, and made plans to acquire some of his own.

One of Weston's shell images shows a solitary nautilus standing upright, balanced on edge with its opening facing the camera. Symmetrically placed, and almost exactly in the middle of the frame, the shell is situated so that one can look straight into its cavity. In this image Weston also depicted the shell in splendid, modernist isolation, with little hint of the seas in which a nautilus lives, or even that a living creature had once formed and inhabited this object. A singular, gleaming white figure standing prominently against a dark background, this first of Weston's shells is reminiscent of his *excusado*, swelling up from a narrow base to a broader bowl at the top. A similar isolation characterizes figure 12.1, and again the brilliant subjects stand out vividly from the background, filling the frame and virtually forcing the viewer to confront the shells. With highlights and shadow Weston stressed that these were not simply two-dimensional curves but instead swelling, three-dimensional shapes that seem to spiral into each other. Unlike his solitary nautilus this composition is characteristic of Weston's images from the period in that it is asymmetrical, and with an unsettling ambiguity about where one shell leaves off and the other begins. This image is also a greater departure from nature than the single nautilus, for it has been even more studiously arranged by the artist's hand. Balancing the shells in such compositions proved difficult (apparently Weston never thought to use a dab of putty); ruinous shifts occurred during long exposures, and sometimes left Weston "on the

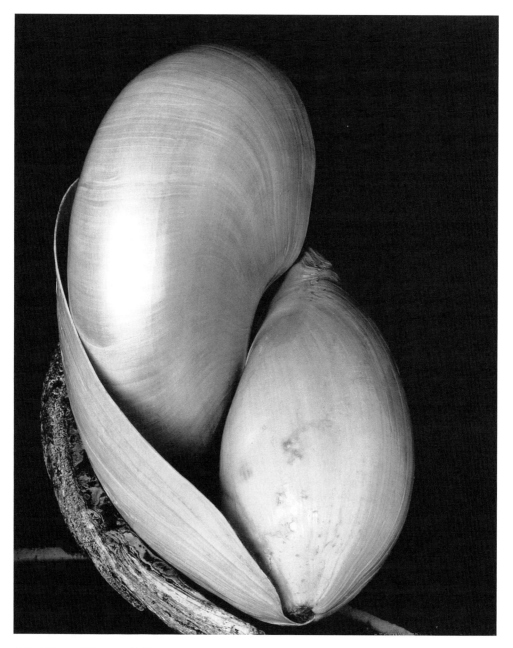

12.1. Edward Weston. *Shells, 1927*, © 1981 Center for Creative Photography,
 Arizona Board of Regents. Collection Center for Creative Photography,
 The University of Arizona.

verge of tears from disappointment."[5] Usually, though, things came together and the
excited Weston felt "absolutely enthusiastic!" as he went about this work.[6]

Weston's interest in shells was keen but not exclusive. In the first months of
1927 he fell into equally eager work with fruits, vegetables, and nudes. Unlike the
shells, these were hardly new enthusiasms, but now he re-envisioned them so that
they became his most striking subjects of the late 1920s and early 1930s.

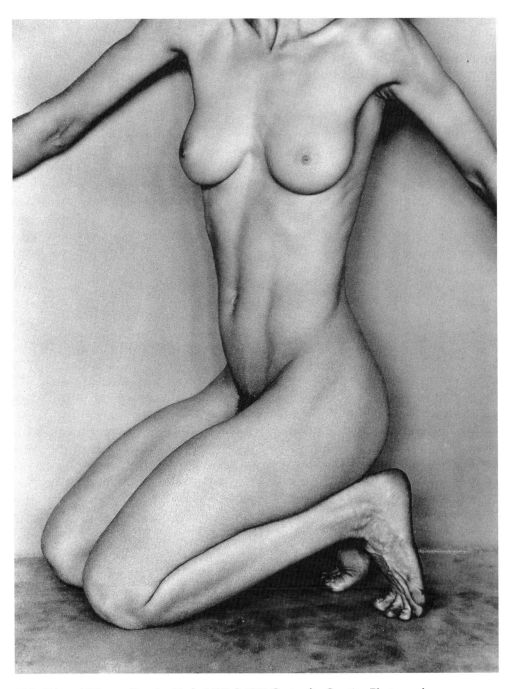

12.2. Edward Weston. *Dancing Nude, 1927,* © 1981 Center for Creative Photography, Arizona Board of Regents. Collection Center for Creative Photography, The University of Arizona.

Bertha Wardell was the model for Weston's most significant nudes of this period. A dancer and acquaintance of Barbara Morgan, Wardell visited an exhibition of Weston's photographs in February 1927, was impressed most with his nudes, and promptly offered to model for him; Weston accepted and made at least fifty exposures of her between March and June. Dancers had long been a part of Weston's life, and as early as 1916 he had made an award-winning series of images of dancer Violet Romer. But the Wardell images, such as *Dancing Nude* (1927; fig. 12.2) were quite different from the earlier work, for these were dramatic renditions of a vibrant body whereas the preceding images had the theatrical stiffness of a movie still. Weston called these "dancing nudes," and with the taunt torso, extended arms, and splayed toes, figure 12.2 indeed possesses a quality of movement. These were not true action shots—Wardell would strike and hold a pose—but they also have none of the languor found in earlier images like Tina on the azotea. This was "a kneeling figure...but kneeling does not mean it is passive,—it is dancing quite as intensely as if she were on her toes!"[7]

Formally this image echoes some elements of his shell photographs. The body is seated in the center of the frame and extends to (or beyond) the edges. The symmetry of a central line is counterbalanced by an asymmetrical twist of the torso and bend of the legs. The cropping here would become typical of Weston's nudes as he began, Stieglitz-fashion, to slice portions of the body out of his images, and in many of the Wardell nudes he placed his cut somewhere at the shoulders or lower, so as to accentuate the dancer's legs. The tension in these toes and arms was a natural enough effect from a dancer, but it also became a standard part of Weston's treatment of the nude—the portrayal of a poised rather than a resting body, an effect that he here accentuated with lighting that makes the body stand out from the background. The curves of nudes such as this have much in common with his contemporaneous shells, and, as Weston said, Wardell's legs made "lines forming shapes not unlike great sea shells."[8]

The photographing and posing led to other things. Weston became ever more impressed with Wardell's "sensitive body and...responsive mind," and Wardell wrote him that "what you do awakens in me so strong a response that I must in all joy tell you." As March passed into April, Wardell and Weston became lovers.[9] Dancing and camera work gave way to kisses and embraces, and Weston's visual descriptions of Wardell took on a tactile quality complementing his visual images: the skin was so "refined, sensitive, it was to the touch, like the inner surface of a sea shell."[10]

Wardell and the shells were part of a larger pattern in Weston's life and work. His desires and infatuations became rather hectically intermingled as a variety of women and other subjects cycled through his affections and before his camera. In early April 1927, just as his affair with Wardell was blossoming, Weston wrote that he was "torn between two new loves,—bananas and shells," and that an ardorous sleeplessness had him "awake at 4:00, with my mind full of banana forms![11] The bananas were followed by a veritable salad bar over the next few years as Weston photographed onions, celery, cantaloupe and more. As the word (and doubtlessly the snickers) about Weston's infatuation spread among his friends, they became his procurers, "bring[ing] me vegetables to work with, as the Mexicans used to bring me toys."[12]

By the summer of 1927 Weston's enthusiasm had moved on to green peppers ("amazing in every sense of the word"), and here he found subjects that would become closely identified with his photography, something in the manner of Stieglitz's clouds or Strand's peasants.[13] Over the next several years Weston's Daybooks describe what might be called a serial romance with peppers: "now I have another as fine or finer," "I am working now with two green peppers of marvelous convolutions," "now I have two new peppers of quite amazing contours,—unintentionally discovered while shopping."[14] He experimented extensively until he achieved images with the intensity of *Pepper No. 35* (1930; fig. 12.3), the lovely deep green of the peppers rendered beautifully in a black-and-white medium, and looking, in Weston's words, "like sculpture, carved obsidian."[15]

Oriented in the frame like his *Shells*, this pepper also occupies most of the frame with its bulk, and though he included a stem in the lower left frame, many viewers were unable to identify the subject matter. Formally, the presentation here is closer to the Wardell series than to the shells, for like a kneeling nude the pepper offers a busy selection of curves, lines, and dimples. The flat lighting that accentuated a human body at the distance of some feet was inadequate for this much smaller subject, and Weston experimented until he found that by placing a pepper within a tin kitchen funnel he could obtain the enveloping light he desired. As much as any of his peppers images, this photograph in particular satisfied Weston. He called it "my favorite," and awarded it the title of "a peak of achievement." And the pepper itself also came in for Weston's favors, for it was trundled off "to the kitchen, the end of all good peppers," where it would eventually "grace a salad."[16]

Something remarkable was going on in all of this. What had begun with the shells of 1927 continued over the next several years in a terrific outpouring of images, most notably photographs of nudes and vegetables. Simultaneously, Weston exercised his unbounded heterosexual and vegetarian affections for both the women and the foods he photographed. The relationship among Weston, his art, and his subjects was complex. His vegetables were art objects in the studio and gustatorial delights in the kitchen, contributing both to health and inspiration ("they become part of me, enrich my blood as well as my vision").[17] Similarly, his models routinely made the transition from studio to bedroom. In either case it seems that desire seldom went unfulfilled for long; Weston fairly accurately described himself as experiencing a "tide of women," and the green grocer who had Weston in the neighborhood was a lucky retailer.[18] Appetite and art, creative impulse and visceral urge coursed together through Weston's photography of this, his classic period.

Weston's attraction to vegetables was the more comical of these currents. Food had of course long been a key concern in Weston's life, but what had earlier manifested itself in bouts of excessive fasting now emerged in what was probably Weston's period of most robust vegetarianism. In the Daybooks good days are characterized by lusciously described vegetarian meals, such as one evening when Weston and Wardell settled in for a feast of "aguacates [avocados], almonds, persimmons, dates, and crisp fresh greens. A steak is sordid beside such food for the Gods."[19]

But Weston was also inclined to think of vegetables as art objects. Throughout the post-Mexico Daybooks he described them in aestheticized terms:

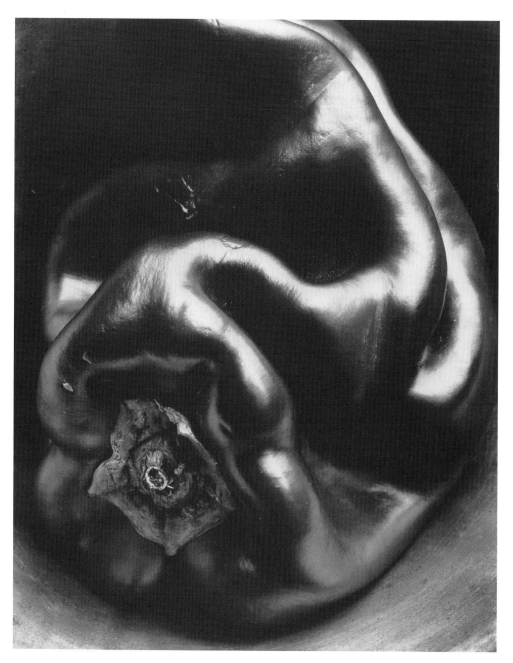

12.3. Edward Weston. *Pepper No. 35, 1930,* © 1981 Center for Creative Photography,
Arizona Board of Regents. Collection Center for Creative Photography,
The University of Arizona.

one pumpkin was "exquisite as a Brancusi," a cabbage was "a beauty," and a
Swiss chard had "a solid, sculpture-like head."[20] There were special challenges in
capturing those qualities on film, for lettuce might wilt during a long exposure,
and his sons could quickly devour a bunch of Weston's banana-subjects. [21] More
often, though, the subjects came to a timely end, like one compliant pumpkin

that, after sitting resplendently before Weston's camera, achieved "its final glorification, in a pumpkin pie."[22]

Weston's vegetable photographs evoked his friends' laughter, but his nudes usually seemed more serious. Almost from the start those nudes (and the shells, too) puzzled and discomforted viewers. In 1927 he sent a bundle of the images to Modotti in Mexico, and she said that the sight of them made her uncomfortable, threw Rivera into a sweat, and made Rene D'Harnoncourt weak in the knees.[23] The images were just a touch too strange for his friends, for although these people generally favored sexual openness, the sensuality in the images seemed to them almost pathological.

Weston denied this ("I am not sick"[24]), but the sexual dimensions of his art and life had a kind of studied frankness that verged upon the boastful. Among the toreadors and charros of Mexico his masculinity had seemed marginalized, but now as a rousting California photographer of the nude, Weston's virility appeared manifest. His young protégé Willard Van Dyke, for instance, thought Weston led the very epitome of the "artistic life," one in which "you had a lot of girls."[25] It was not only the numbers of those model/lovers, but also their ages, that enhanced Weston's reputation, for each one was younger than her predecessor and this succession of women on Weston's arm and within his images seemed testimony of a virility unhampered by the artist's advancing years.[26]

There is no indication that Weston manifested a hostility towards women, nor that his heterosexual appetites of these years were coupled with anger. Indeed, women like Wardell and Noskowiak remained his friends long after they ceased to be his lovers. Nor was there a driving maliciousness in his photography of women, and although Weston usually omitted women's heads from his photos, he was not, as Benjamin Maddow has suggested, driven by misogynistic urges of decapitation. There are clear similarities between Weston's images and those by Robert Mapplethorpe, for both have a sculpted eroticism which lends a cool presentation to hot topics, but Weston's images lack the sadistic bite of Mapplethorpe's work.[27]

More than anger or sadism, there was another impulse at work within Weston's nude photography. For him art was frequently a precursor for sex, so that he often first photographed the women who become his lovers. There are echoes here of the story of Pygmalion, who fell in love with his own sculpture of Galatea and then had his prayers answered when the statue came to life.[28] Weston lacked Pygmalion's prayerfulness, but still his photography frequently followed Pygmalion's sequence, with art-making preceding love-making.

There was then a strange triangular relationship among Weston, his subjects, and his images of those subjects. Although Weston salivated over vegetables, he also had a distinctly more cerebral appreciation for their formal qualities, and his images of those vegetables seem imbued with both physical appetite and aesthetic appreciation. Similar complications exist in the relations among Weston, his models, and the nude images. The photographs seem both cerebral and libidinal, and it is sometimes difficult to tell if Weston was referring to a woman or a photograph when he said things like "I am in love with this nude."[29]

In his own way Weston was again embroiled in a perennial question of representation: What is the relationship between subjects drawn from the world, and the

images or descriptions of those subjects? Weston's answer to the question varied during these years. At times he was propelled by his enthusiasm for the peppers and nudes before his camera, and inclined to say that his images were quite closely related to the subjects, and that the compelling aspects of his photographs were due to the beauties of certain women or peppers. At other times, though, he was more the egoist, emphasizing his own artistic contributions to those images and saying that their power arose more from his mind than from the subjects upon which he had focused.

This tension permeated Weston's work of the late 1920s and early 1930s. The issue was whether his images tended more towards the creation or the copy, and Weston vacillated almost from the beginning. In the first exhibition catalogue published after his return to California, he broadcast a preference, developed in Mexico, for something like the copy, and he quoted Van Gogh's inclination toward "things in themselves."[30] Yet at virtually the same time Weston praised artistic interpretation in his Daybook. Writing to the accompaniment of mockingbird singing outside his window, he was struck by the parallels between the bird's song and his own photography. Declaring "the greatest admiration" for mocking birds, he denied that they merely mimicked, and instead said that "they most certainly recreate the stolen song, give forth in their own way, and I dare say improve upon the original version."[31] Thus in 1927 Weston articulated the positions between which he oscillated over the next few years, pledging his loyalty to things in themselves while also saying that representations (re-presentations) can be improvements on the original.

Let us first turn to Weston's admiration for his subjects. At times he almost seemed ravished by the objects before his camera, and he could be overcome by the monumental strength of "those last new peppers! They are powerful!" Nor was the visual infatuation limited to such better-known subjects, and when he once encountered an old bed pan, he "took one look, and fell hard."[32] In this way there was a kind of passivity in Weston's photography, so that he would gather "shells, bones, eggs, wood, dried kelp, whatnot . . . to see what these things, or one of the[m], or combinations *will do to me*."[33] The subject was therefore necessary not only in the mundane spatial sense—that the camera must be pointed at something like a pepper—but also in something like Merleau-Ponty's inspirational sense—that the image originates in the artist's response to the stimulus of the pepper's beauty. To accommodate such stimuli, Weston liked to say, he approached his subjects with an empty mind, "with my mind as free from an image as the silver film on which I am to record."[34] Of course the empty mind is an impossibility—Descartes' *cogito* rests on that simple truth—but when Weston was engrossed with the obvious beauty of his peppers or shells or nudes, he was inclined to discount the ideas and expectations that he brought to those subjects.

He likewise discounted artistic creativity during these years. Writing to Ansel Adams in 1932, Weston denied the possibility of true originality, saying that artists only borrow here and there from the outer world and still never achieve a new shape or form: "We cannot imagine forms not already existing in nature,—we know nothing else." Limited to nature's ur-vocabulary, neither painter nor photographer could achieve a truly novel expression, and even an unconventional artist like sculptor Constantin Brancusi was really only reemploying shapes derived from nature. So, a

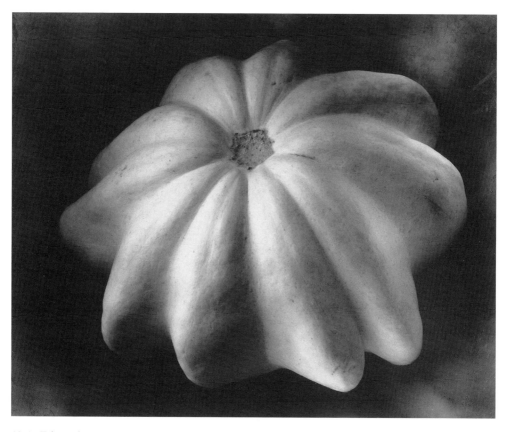

12.4. Edward Weston. *Winter Squash, 1930*, © 1981 Center for Creative Photography, Arizona Board of Regents. Collection Center for Creative Photography, The University of Arizona.

photograph such as *Winter Squash* (1930; fig. 12.4), was not only replete with natural angles and curves, it also illustrated that even something so seemingly stylized and artificial as a cartoonist's star-burst shape actually had its antecedent in nature.

Mexican artisans, with their rusticity and gourds, had ready access to such shapes. But the access seemed more difficult in the United States, "a civilization severed from its roots in the soil—cluttered with nonessentials." Fortunately there was photography and its immediacy with subjects, "a means to rediscover and identify oneself with all manifestation of basic form,—with nature, the source."[35] In this way Weston arrived at the same irony that Paul Strand had developed in that 1922 essay, "Photography and the New God"—the camera-machine provided escape from the machine age because it allowed ready connection with nature's basic lexicon and sustaining essentials.

Weston's affection for nature's essentials and his disdain for civilization's clutter connected him in ways to the Transcendentalists of the preceding century. Though Carmel was no Concord and Weston never achieved the intellectual depth of Emerson or Thoreau, Weston's yearning for "greater simplification of life" echoed Thoreau's famous call, and he too dreamed of a Walden-like homestead, "a shack far away," where he might live deliberately with "a few books, a chance to

play, and to develop oneself."[36] But Weston drew more directly from Emerson, and his quotation collection contains carefully copied excerpts in which Emerson lambasted those who would despise matter and love only ideas. He noted Emerson's call to "make friends with matter,"[37] and at times Weston's photos almost take that friendship to the level of sexual union or eucharistic communion.

Often beloved, sometimes even revered, Weston's subjects were not to be profaned. Good photography gave objects their due, and when it involved too much of the mind, the process became sullied; too much subjectivity, too much of the artist's personality could be ruinous, and Weston urged photographers toward "an *impersonal revealment* of the objective world."[38]

Additionally, Weston shared Strand's belief that ordinary words could also profane the world's objects, and he sought to keep his art free from the trappings of language. He maintained that photography should not be a metaphorical craft in which one cunningly drew implications like "the woman is like a shell," for this would substitute some sort of verbal construction for what should be photography's mute reverence. Early one morning he was studying the series of images that included *Winter Squash*, which he called "Marvelous cream white forms—one like a starfish—one like a pointing comet sweeping through space—another, fluted like a Greek column." But then Weston came up short as he realized how metaphorical he was being: "So! I am in the same class I rebel against?"[39] It seemed to him that if words somehow got loose in one's image-making, they became like a greasy smudge upon the photograph and "the print is sullied thereby!"[40]

Even titles proved too much for Weston. Many of his images originally had no title at all, seemingly in a conscious effort to lose what was, in the words of poet Kenneth Rexroth, "father Adam's name for the objects of Weston's prints."[41] In his logbook for these years, Weston chose not to keep track of negatives by name, date, or location, and instead he grouped them under broad categories: rocks, shells, vegetables, nudes, and the like. The first rock on the list became rock number one, the second number two, and so on. Over the years some of these notations, like *Pepper No. 35*, began to function as titles, but this was more by default than by design, for the original designations had no meaning other than that this particular negative happened to be filed between pepper negatives 34 and 36.

Language was downplayed if not dismissed, for Weston believed that "art begins where words end."[42] Titles and nouns were bad enough, but even more problematic were the more complex arrangements of theories and concepts. As the 1930s proceeded Weston became especially leery of political theory, for while others like Strand found liberation in the decade's leftist political ideas, Weston saw only a restraining dogmatism in the decade's Marxist hopes.[43] He was well aware of the leftward drift of other California photographers like Dorothea Lange, who abandoned studio portraiture for street documentary, and Willard Van Dyke, who eventually found his way into Strand's Frontier Films. For a time even Weston himself felt the pull of the left, and in what might be called the high-water mark of 1930s radicalism, Weston (of all people) attended a meeting of the John Reed Club in Carmel (of all places), where he was saluted as "'Comrade' Weston."[44]

As early as the beginning of 1932 Weston felt the pressure from Communists and others who argued that photography and the other arts should address Depression

issues like unemployment. But Weston preferred the less overtly applicable lessons of "fluid Life" to be found in vegetables or shells. By the end of 1934 he and Ansel Adams were exchanging a kind of curmudgeonly consolation, reassuring each other that it was fine to continue depicting a serene natural world at a time when the social order was so tumultuous. Responding to Adams, Weston said that "I agree with you that there is just as much 'social significance in a rock' as in 'a line of unemployed.'"[45]

Yet for all this, Weston and Adams still sometimes expressed themselves in left-wing commonplaces of the 1930s. Their photographs were far removed from Strand's political films, but Weston cast himself as a "radical" because his sharp images had "cleared away the haze," showing people what they might otherwise have missed.[46] So, in an era that valorized the radical, Weston managed to see radicalism in straight photography's by now quite mature campaign against pictorial fuzziness. Nor was he alone in this. Late in 1932 he was joined in an effort by Adams, Van Dyke, Noskowiak, son Brett Weston, and Imogen Cunningham. They called themselves Group f/64, the title coming from a very small lens opening which would produce sharp images, and, as was *de rigueur* for emergent groups in the 1930s, they wrote themselves a manifesto and affected a rebellious posture.

It is a little difficult to comprehend what these photographers were rebelling against, for even in many conservative quarters their straight aesthetic had vanquished older pictorial practices. There was, though, a passionate center to the Group f/64 photographers, their shared respect for the subject. The "Group f/64 Manifesto" of 1932 is a pretty milkish document, but there is a touch of fire as the signers pledge themselves to a photography of "simple and direct presentation."[47] For the signatories of this manifesto, the "thing itself" deserved photography's utmost attention, and practices which might obscure that thing, like the fuzziness and obscurity of pictorial photography, were assigned to the dungheap.

Yet Weston was not consistent in his allegiances. Throughout the late 1920s and early 1930s he praised the physical grandness of things in themselves and denigrated interpretive minds that might employ language or ideology. But he almost simultaneously glorified qualities far beyond those of any individual subject, and he lauded the minds that could register those qualities. When photographing in this mode, Weston hoped to move beyond a subject's unique qualities and instead to convey his own visionary realization of broader universals. In these instances, he was less the materialist and more the idealist.

It was toward the end of 1929, just after he started working with green peppers, that Weston began this examination. Statements by the painter Walt Kuhn and the critic Aline Kistler led him to consider the abstract as well as representational qualities of his images,[48] and the following summer Weston thought he had reached "a peak of achievement" for it seemed to him that *Pepper No. 35* was "completely outside subject matter" (a statement remarkably similar to Stieglitz's 1923 statement, "my photographs were not due to subject matter"). With its glowing indentations, dark recesses, and undulating curves, Weston's photograph, figure 12.3, seemed to go beyond any immediate vegetable and instead conveyed forms and shapes found throughout nature. The picture was, Weston said, "a pepper—but more than a pepper."[49]

He continued to stew on this matter, and in January 1932 revisited some of his earlier statements about peppers. He told Adams that he had not meant to imply that his images were "'different' than a pepper," and he now said that those photographs constituted "a pepper plus,—seeing it more definitely than does the casual observer, presenting it so that the importance of form and texture is intensified."[50] As he considered his earlier Daybook entries and letters, Weston developed this "pepper plus" designation for what seemed to him the larger subject in images like *Pepper No. 35*. The process showed him how much his thinking had changed since Mexico of 1926, and he concluded that "when a few years ago I wrote that I was no longer interested in interpretation, but in presentation, I was only stating a half-truth."[51] Thus for all of his enthusiasm for vegetables or female bodies, Weston's photography also aspired beyond physical representation and toward metaphysical interpretation, and his "pepper plus" was more a transcendental than a physical thing.

Weston had been spurred to this transition in part by his own images, but also in part by the people in his life. His model-lovers of the late 1920s and early 1930s were precisely the kind of "modern women—intellectuals" whom he had denounced when pursuing simple physical pleasures in the arms of his Mexican servant.[52] Bertha Wardell had a "responsive mind," Sonya Noskowiak was "thoughtful" and the anonymous "A." was "mentally wise."[53] In particular these new women encouraged Weston's growing appreciation for mysticism. Cristel Gang helped him toward "vistas of the metaphysical,"[54] while Henrietta Shore's paintings were "the affirmation of a mystic" and revealed what he called "transcendental force."[55] Shore introduced him to the writings of Peter Ouspensky, a Russian disciple of mystic George Ivanovitch Gurdjieff,[56] and Weston also read German-Estonian Hermann Keyserling's *Travel Diary of a Philosopher* (1919, tr. 1925).[57]

Still another influence was William Blake. In the summer of 1930 Weston quoted Blake to the effect that "man is led to believe a lie, when he sees with, not through the eye."[58] Elsewhere in Weston's archive those same words by Blake share a page with a similar line attributed to Plato: "It is not the eyes that see, but we see by means of the eyes." The vision that Weston wanted was more than ocular, the vision of "the seer (see-er)" as "one who sees with the inner eye and is able to give concrete expression to his knowledge of facts, things."[59] The photography accomplished by such an individual was likewise more than optical, for when used by such a visionary, "the camera—the lens...enable one to see through the eye, augmenting the eye, seeing more than the eye sees."[60] For this reason Weston rejected impressionism, and its insistence on capturing the momentary appearance of things, as a mistaken concentration on "the transitory instead of the eternal."[61] His own work with vegetables in their freshness and nudes in their youth was part of this effort to move beyond the wilting of cabbage or the sagging of flesh, and to enter an arena of timeless forms, perhaps strange turf for the often instantaneous art of photography but familiar territory for Plato. Yet where Plato spoke of the inferiority of the visual arts (mere shadows of the already shadowy physical world), Weston held that the art photographer who brought enough "*plus*" to the photograph had accomplished something "more real and comprehensible than the actual object."[62]

It was just that kind of greater reality that Weston sought to achieve with images like *Pepper [No. 32]* (fig. 12.5). Not only did he select an almost grotesque-looking veg-

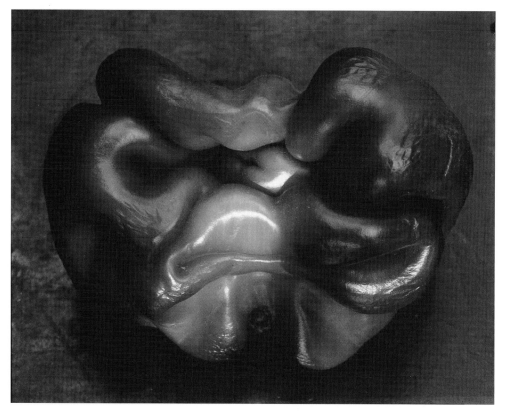

12.5. Edward Weston. *Pepper [No. 32], 1930*, © 1981 Center for Creative Photography,
Arizona Board of Regents. Collection Center for Creative Photography,
The University of Arizona.

etable, but he also arranged and lighted the subject so as best to convey its undula-
tions. And just as Blake drew spirits that the eye could never see, so Weston too aimed
to portray things that are truly invisible: "I have brought attention to the dual force
in this hybrid, the outer covering and inner lining of different contractile forces inher-
ited from diverse ancestral sources."[63] What Weston had "seen" or understood was
something both too minute and too remote for the eye to register, and he had tried to
convey that understanding in his image. As such, an image like *Pepper [No. 32]* is a
challenging experience for viewers. First it demands that one overcome an initial
vague nausea at encountering something resembling a piece of used chewing gum,
and then asks one to consider rather obscure horticultural principles. Yet Weston
believed that the rewards for such efforts were great, for he thought that an image
such as this "takes one beyond the world we know in the conscious mind," and then
into "the absolute,—with a clear understanding, a mystic revealment."[64]

 Like so many others who pursue that absolute, Weston believed nature is uni-
form rather than discrete, timeless rather than changing.[65] Demonstrating that
uniformity became something of a crusade for Weston. His images of different cat-
egories of subjects, and then separate subjects within each category, were not to be
understood as an immense catalogue of nature's individualize peculiarities.
Instead, he explained in a 1930 exhibition statement, his various subjects "are but

interdependent, interrelated parts of a whole, which is Life."[66] The artistic mind might focus on particulars, say a cabbage such as that in figure 12.6, but its highest achievement was to perceive universals. In such a subject the uninteresting photographer merely "sees a cabbage as an unrelated fact, devoid of interest except as a means to sauerkraut"; but Weston wanted art reaching beyond the facts and to the pattern, a photography that would show "the reason for the cabbage form, its significance in relation to all forms."[67]

There was an old-fashioned quality to this pursuit of universals. Contemporary thinkers were often more inclined to agree with John Dewey that such universal understanding is impossible, and that at best we can only truly know smaller, particular facts. Likewise, where Dewey and others readily accepted the contingent world of flux that Darwin had sketched, Weston resisted the principle of evolution because fundamental change seemed impossible for this artist of a timeless "*plus*" realm. When he fumed about the wilting of some vegetable subject, he was doing more than just complaining about recalcitrant materials, for there was little tolerance for decay in an art that sought to depict what Weston called "the eternal, basic quintessence each object has and its relation to *the* great whole."[68] Thus the nature that Weston pursued was a peculiar nature, a place of perfections beyond change and designs beyond revision, and he wanted an art "touching the real,—the object unaffected…by weather."[69] There was then an absurd aspect to Weston's project, for just as it is hard to have a day without weather, so it would be difficult to find an object not in some way affected by its environment.

At least he acknowledged how difficult this might be. Getting past ephemerals and to eternals, past the cabbage to cabbage forms, required that Weston's photography be a very active art, one in which subjects were "transformed from things (factually) *seen*, to things *known*…"[70] The visionary, photographic act of "seeing" was in no way a passive, contemplative "beholding." As a transformative art, Weston intended for photography to be closer to molding than beholding, and he mentioned sculptors like Brancusi so often because he thought of photography as something like a sculpting activity: just as the sculptor transforms marble into more than mere stone, so Weston's photographer took the visual subject and transformed it into an expression of universal, abstract shapes.

There were various techniques available for such photographic sculpting. By using lenses of varying focal lengths, altering lighting angles, or varying printing times, the photographer could exaggerate or minimize any number of physical qualities. At other times Weston described photography as a distilling process in which the camera resembled a chemist's retort, refining substances into their purest forms.[71] Weston had once claimed that he worked lightly with his subjects, approaching them gently so as to "dominate in a very subtle way."[72] But boiling subjects down to their essences was hardly a subtle treatment, and there is little lightness in others of his comments from this period. During one of his sessions with shells, Weston struggled for hours to get exactly the desired arrangement, until finally things were right, with "my camera focussed, trained like a gun, commanding the shells not to move a hair's breadth."[73] Some of his hours-long exposures were akin to intense staring matches in which Weston tried to defeat his subjects. At other

times he imagined using a microscope to peer into his subjects' secrets.[74] But even that was too passive, and Weston more readily regarded photography as a matter of penetration than staring. Lengthy exposures allowed him "to penetrate for hours into the very essence of the thing before the lens," and he took to describing the photographer's gaze as a "penetrating, decisive camera vision."[75] Stieglitz and Strand had used similar terms of probing or piercing, and Strand's references were grounded in actual surgical and X-ray experiences. Although X-rays did not suit Weston (he fainted over a fluoroscope of his own moving organs[76]), he took to the knife without a touch of the squeamishness Strand initially manifested at the Mayo Clinic.

In the summer of 1930 Weston began to slice into his subjects before photographing them. A number of vegetables fell victim to his blade: artichokes, kale, onion, cauliflower, celery.[77] But there was a more favored subject, and on 22 August 1930 he marked an "important event—the start with halved and quartered red cabbage."[78] *Red Cabbage Halved* (1930; fig. 12.6) was one of the images from that remarkable day, and like others of his sliced-vegetable images, the photograph is an intense, closely focused composition with the subject completely filling the frame. Not satisfied with his initial penetration of the cabbage, Weston sliced away at it throughout the session, keeping his surface fresh by paring away a thin layer before each exposure.

The red cabbage was a superb choice for Weston's penetrating black-and-white photography. Ordinary green cabbage would register blandly on his film, but here is a subject with exceptional contrasts, with the reddish-purple recorded as a vivid black, tracking the lines of the leaves and setting off the pristine whiteness of the stalks. Like his photos of whole vegetables there is a sensuous undulating quality to this image, but here Weston was restricted to a single plane; unlike his peppers (or nudes or gourds) this image has the effect of presenting lines for the finger to trace rather than curves for the palm to cup. At times the image works as a kind of maze, holding the eye inescapably as it traces the convulsing lines, yet the monotony of the smaller folds is offset by the comparatively massive ribs. With its body opened to the very innermost, and with no secrets left hidden, the inert cabbage reveals a seemingly visceral motion, like an obscene set of roiling intestines. Weston was understandably pleased with this photograph, for it was a striking execution of his program. Having selected one of the most prosaic of vegetables (in contrast, peppers seem noble, artichokes downright exotic), Weston had with his penetrating, powerful photography worked a transformation, beginning with the modest subject and ending with an image that is, he said, "extraordinary, significant,—more than cabbage."[79] Though one remains skeptical about any transcendence here, the photograph does manage to go beyond cabbage. Without the verbal clue of a title, audiences frequently fail to see anything cabbage-like in *Red Cabbage Halved*, recognizing it instead as the image of some peculiar hydra or a strange organic candelabra.

Weston also took his penetrating photography to human subjects. In 1932 he bragged that his art conveyed "more than the exterior of a beautiful girl," and although he was partly referring to portraiture's supposed capability for revealing character, many of Weston's nudes suggest a more explicit sort of probing.[80] In some images, clothing has been pulled back to reveal the torso or a portion of the torso. In others the model sits or stands with her arms held above her head, fully

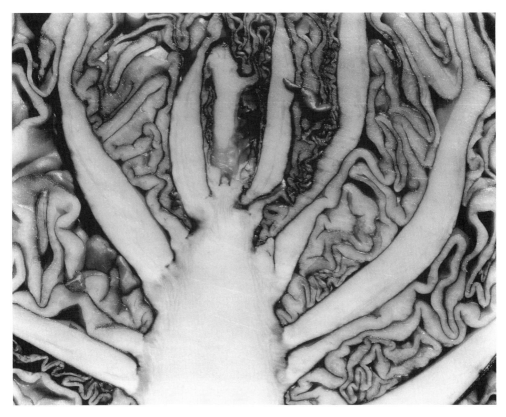

12.6. Edward Weston. *Red Cabbage Halved, 1930,* © 1981 Center for Creative Photography, Arizona Board of Regents. Collection Center for Creative Photography, The University of Arizona.

exposing the breasts. In still others, her legs are splayed open for the peering camera. The most gynecological of the lot was a 1928 image of Fay Fuque, and Weston recorded the session in his Daybook. As she stood facing away from him, the nude Fuque bent forward acrobatically, breasts touching thighs, hands grasping ankles, and Weston "made a posterior view...great buttocks swell from the black center, the vulva, which is so clearly defined that I can never exhibit the print publicly."[81] Certainly Weston's nude photographs were collaborative efforts, with models like Fuque cooperating in ways that none of his vegetables could manage. But still the preponderance of the power rested with the photographer rather than the model. Domination was an unmistakable element in his work, and there was little subtlety in the slicing of those vegetables or in Fuque's pose.

Weston claimed to demonstrate common traits, particularly common formal traits, in his various subjects. But with his reductivist slicing or probing, Weston eschewed plural subjects to focus upon individual ones, and his expression of universals was at best indexical. Weston made print after print of individual vegetables, shells, and nudes; seldom at this point in his career did he use the camera frame to demonstrate that particular forms echoed throughout a scene. Indeed Weston actually avoided the larger view, and he continued to make still lifes when presented

12.7. Edward Weston. *Cypress, Point Lobos, 1930,* © 1981 Center for Creative Photography, Arizona Board of Regents. Courtesy George Eastman House.

with the Pacific coast vastness. Point Lobos State Park lies close to Carmel, and in 1929 Weston began photographing on its beaches and headlands with an enthusiasm that virtually explodes in his Daybook descriptions of "Point Lobos!" Weston worked some with eroded rock and bits of kelp, but it was "the cypress!—amazing trees"—that most excited him.[82] Yet rather than photograph whole trees silhouetted against the sky, Weston continued to focus closely in the belief that "an area of a few

square feet or even a few square inches would provide a whole universe of exquisite form and movement."[83] Results such as *Cypress, Point Lobos* (1930; fig. 12.7) are magnificent, with weathered wood's grain giving the image a writhing texture. The image is also superbly decontextualized, referencing wood shapes that have no demonstrable connection to the particular place of Point Lobos.

This tendency toward detail emerged elsewhere, and Weston's nude studies became more fragmented as the 1930s wore on. Having noted Noskowiak's habitual way of sitting with one leg twined around the other, Weston decided to photograph her legs in the summer of 1930. The negative satisfied him, suggesting "a whole series in a new vein. Maybe I'll travel legwise up to other fragments."[84] The project waited until February 1933,[85] though, and then for the next two years he photographed a number of women, most often Noskowiak, and produced images like *Nude* (1934; fig. 12.8). These new images are adeparture from *Dancing Nude* (1927; fig. 12.2), for now the bodies are even more closely cropped. These later nudes are also more contorted than the earlier ones, and although some of the poses were likely the models' own doing, their frequency shows that the photographer coaxed his subjects into repeated themes: Virginia twists her legs like Noskowiak's, Mary and Gretchen stand for profile "portraits" of their left breasts, and Gretchen assumes a posture almost identical to the one in figure 12.8.

Weston's series was to be expansive, each bit of the model extending toward the woman "*plus,*" the sum of the pieces leading not to an exhaustive treatment of one woman but toward an expressive treatment of womanhood, and then beyond. Those twisted poses are also often carefully arranged so as to hide birthmarks or surgical scars that might otherwise individualize one of these universalizing woman-images—Noskowiak, for example, had on her left hip a prominent birthmark which is just beyond the frame of figure 12.8.[86] Through such cropping and posing, through his slicing and distilling, Weston hoped to achieve a photography presenting what he had seen in his own mind's eye. If successfully imbued with that transcendent quality, *Nude* went beyond Noskowiak and toward the more generic female form, and perhaps conveying "its significance in relation to all forms."[87]

Weston's loves, residences, and images tended to come in complementary bundles that distinguished the separate stages of his life. During 1933 and 1934, the major aspects of his classic period—the photography of still lifes and fragmented nudes, the residence in Carmel, and the relationship with Noskowiak—all came to an end.

The process commenced late in 1932 with the publication of Weston's first book of photographs, *The Art of Edward Weston.*[88] He used the book as a chance to showcase his recent work—most of the images in it had been made between 1930 and 1932. And he decided to leave such work behind. Leafing through the freshly printed volume in January of 1933, Weston acknowledged "each plate [as] an old friend," but he concluded that the book "marks the end of a period…I must go on."[89] It now seemed time to quit that intensely peering photography, so paradoxically executed with both a respect for the subject's physical autonomy and an assertion of the artist's great mental prowess.

Looking at those prints, he resolved to "leave them as I leave my love affairs, still loving them, but with no regrets."[90] Indeed, that was pretty much how he ended his relationship with Noskowiak. She had been his most consistent (and only

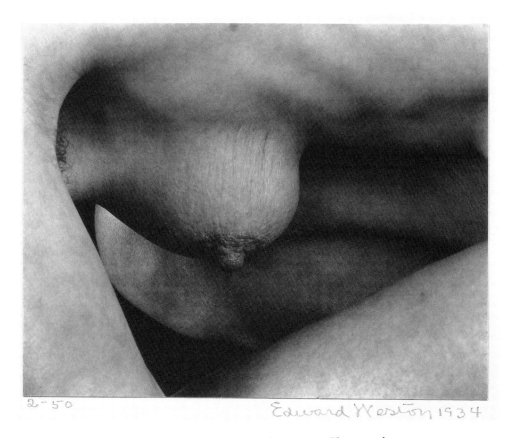

2-50
Edward Weston 1934

12.8. Edward Weston. *Nude, 1934,* © 1981 Center for Creative Photography,
Arizona Board of Regents. Collection Center for Creative Photography,
The University of Arizona.

live-in) lover since the return from Mexico, but his attachment weakened and in
1933 he carried on several affairs behind her back. Finally on April 17, 1934, the fifth
anniversary of their relationship, Weston broke things off with a note as heartless
as it was unoriginal: "I must have my freedom."[91]

Five days later Weston had a new lover, Charis Wilson. Charis was twenty when
she met the forty-eight-year-old Weston. A graduate of Hollywood High, she had
briefly been an actress in San Francisco before moving to Carmel where her family
lived. Her mother ran a dress shop and her brother was one of Weston's friends; her
father was Harry Leon Wilson, author of children's novels, collaborator with Booth
Tarkington, and one-time editor of *Puck* magazine. Charis met Weston at a concert and
accepted his invitation to drop by and see some of his prints. When she arrived the fol-
lowing Sunday, Weston was out of the house and Noskowiak conducted the showing;
the nudes were particularly appealing to Charis, and she accepted Noskowiak's invi-
tation to model. (The ironies are compounded—Noskowiak had also brought Weston
many of his vegetable subjects.) The first session went smoothly, Charis overcoming
the studio's chilliness and her own self-consciousness, and a date was set for a second
modeling session on April 22. But as Weston said, "photography had a bad second

place" on that Sunday.[92] The two became lovers that day, initiating a passionate relationship which lasted a decade. As Weston noted, "A new and important chapter in my life opened on Sunday afternoon, April 22, 1934."[93] Domestic arrangements resolved themselves with remarkable smoothness as Noskowiak exited graciously (she remained Weston's life-long friend). The next summer Weston closed his studio, left Carmel, and set up residence with Charis in Santa Monica.

Weston turned away from even more than his lover, his art, and his home. He also closed his Daybook. Forever. The published version contains only two more entries after that fateful date. Weston left few clues to explain this abandonment, forcing us to account for it without much help from him. Certainly he was more compatible with Charis than he had been with other women, and it is possible that their conversations met the needs once fulfilled by the diary-keeping, or that this new daily life with her somehow precluded the quiet moments necessary for reflection.[94]

More significantly, though, there is the sense that Weston had concluded the projects that the Daybooks had supported. After 1934, he displayed few of the uncertainties that had been such a feature in the Daybooks and his other writings, and the younger man's unsteadiness over his art and masculinity give way to the sureties of late middle age. Moreover, this was a man for whom art and life were always intermixed, and much of his photography of the 1920s and early 1930s resembled the work carried out in the Daybooks. The absorption and close focus of his images parallel the intensity and self-examination of the Daybooks, constituting what may be thought of as one large scrutinizing project. Once the time had come to leave one set of old friends—his prints of shells, cypress, and vegetables—it also seemed time to leave another old friend—the Daybooks.

In this way Edward Weston continued to lead a life with many of still photography's episodic qualities. Frame by frame, discrete unit by discrete unit, he continued a pattern evident much earlier in his career. When he closed the chapter on pictorialism in the 1920s, he had buned the early Daybooks, abandoned Flora, and taken off with Modotti to explore the organic forms of Mexico. Now in the mid-1930s, he left Noskowiak, took up with Charis, ceased his Daybooks, and decided to leave his studied, modernist studio close-ups.

1. Beaumont Newhall, *Supreme Instants: The Photography of Edward Weston* (Boston: New York Graphic Society, 1986), 29. Ansel Adams, *An Autobiography*, with Mary Street Alinder (Boston: Little, Brown and Company, 1985), 237.
2. EW to Johan Hagemeyer, April 13, 1931, Weston-Hagemeyer Collection, CCP. DBII, September 1, 1927, 38.
3. Roger Aikin, "Henrietta Shore and Edward Weston," *American Art* 6 (Winter 1992), 43-61.
4. DBII, May 1927, 20-22.
5. Ibid., May 13, 1927.
6. Ibid., May 17, 1927, 23.
7. Ibid., May 14, 1927, 23.
8. Ibid., March 24, 1927, 10.
9. Ibid., March 24, 1927, 10, 11.
10. Edward Weston, Daybooks, manuscript B, 1927-28, EWA/CCP.
11. DBII, April 4, 1927, 13.

12. Ibid., November 14, 1930, 195.

13. Ibid., August 25, 1927, 37.

14. Ibid., August 29, 1927, 37; July 8, 1929, 128; July 13, 1929, 129.

15. Ibid., August 3, 1929, 131.

16. Ibid., Autust 1, 3 and 8, 180-81.

17. Ibid., August 1, 1930, 180.

18. Ibid., February 10, 1927, 4.

19. Ibid., November 12, 1927, 41. Weston was not a solitary food fetishist, and he at times found company among others who shared his interests, as when Ramiel McGehee edited *The Merle Armitage Book of Food*, where Weston's photographs appeared along with recipes from Louis Untermeyer, Lewis Mumford, and Rockwell Kent, all of whom had joined the enterprise "because we love food." Merle Armitage, *"Fit for a King": The Merle Armitage Book of Food*, edited by Ramiel McGehee (New York: Duel, Sloan and Pearce, 1939), np.

20. DBII, January 8, 1928, 43. DBII, August 16, 1928, 35.

21. During one of the pepper sessions "a *tragedy* took place. Brett ate two of them!" DBII, August 25, 1927, 37.

22. Ibid., January 24, 1928, 46.

23. Tina Modotti to EW, June 25, July 4, and July 7, 1927; in Amy Stark, "The Letters from Tina Modotti to Edward Weston," *The Archive* 22 (January 1986), 51-54. Jean Charlot to EW, August 15, 1927, EWA/CCP.

24. DBII, July 7, 1927, 32.

25. Michel Oren, "On the 'Impurity' of Group f/64 Photography," *History of Photograph* 15 (Summer 1995), 123.

26. For more on the issue of possessiveness, see Trudy Wilner Stack, "An Appetite for the Thing Itself: Studio Vegetables and Female Nudes," in Giles Mora, *Edward Weston: Forms of Passion* (New York: Harry N. Abrams, 1995), 140. Flora Weston had been seven years older than Weston; Margarethe Mather was his own age; then came Tina Modotti, ten years his junior; she was followed by Sonya Noskowiak, fourteen years younger than he; and last among the principals was Charis Wilson, twenty-eight years younger than Weston.

27. Ben Maddow, "Venus Beheaded: Weston and His Women," *New York* 8 (February 24, 1975), 44-53. Mark Johnstone and Jonathan Green, *The Garden of Earthly Delights: Photographs by Edward Weston and Robert Mapplethorpe* (Riverside: University of California, Riverside, CA: California Museum of Photography), 1995.

28. Others have noted the similarity. See Theodore E. Stebbins, Jr., *Weston's Westons: Portraits and Nudes* (Boston: Museum of Fine Arts, 1989), 35.

29. DBII, May 14, 1927, 23.

30. Edward Weston, Statement in Exhibition Catalog, "Edward Weston, Brett Weston Photographs," Los Angeles Museum, October 4 - November 2, 1927, Weston-Hagemeyer Collection, CCP. The phrase became something of a credo for Weston during these years, as he repeatedly stressed his allegiance to "*things* in *themselves*." See Edward Weston, Statement for unpublished book by Samuel Kootz, June 26, 1931, EWA/CCP, and Edward Weston, Statement, *The San Franciscan* 5 (December, 1930), 23, in Peter Bunnell, ed., *Edward Weston on Photography* (Salt Lake City: Gibbs M. Smith, 1983), 62-63.

31. DBII, March 29, 1927, 11-12.

32. Ibid., August 7, 1930, 181. DBII, January 31, 1930, 140.

33. Ibid., February 23, 1931, 206.

34. Edward Weston, "Photography—Not Pictorial," *Camera Craft* 37 (July 1930), 313-20, here from Bunnell, *Edward Weston on Photography*, 59.

35. DBII, February 22, 1932, 246.

36. EW to Miriam Lerner, March 13, 1932, EWA/CCP. DBII, September 6, 1928, 71. EW to Willard Van Dyke, March 5, 1932. In Leslie Squyres Calmes, *The Letters Between Edward Weston and*

Willard Van Dyke (Tucson: Center for Creative Photography, University of Arizona, 1992), 5-6. A difference, though, was that Weston also wanted "a few friends."

37. Edward Weston collection of quotations, EWA/CCP. For more on this connection, see Ralph Bogardus, "The Twilight of Transcendentalism: Ralph Waldo Emerson, Edward Weston and the End of Nineteenth-Century Literary Nature," *Prospects* 12 (1987), 347-64; and Oren, "On the 'Impurity' of Group f/64 Photography," 123.

38. Edward Weston, *Photography* (Pasadena, CA: Esto Publishing Co., 1934), np.

39. DBII, September 14, 1930, 186.

40. Weston quotation collection, CCP. DBII, September 11, 1930, 185.

41. Kenneth Rexroth, "The Objectivism of Edward Weston: An Attempt at Functional Definition of the Art of the Camera," ca. 1932, EWA/CCP.

42. EW to Seymour Stern, May 3, 1931. EWA/CCP.

43. Edward Weston, Statement for unpublished book by Samuel Kootz, June 26, 1931, EWA/CCP.

44. DBII, April 23, 1932, 257.

45. EW to AA, December 3, 1934, AAA/CCP.

46. DBII, March 21, 1931, 211.

47. For discussions of Group f/64, see Theresse Thau Heyman, *Seeing Straight: the f.64 Revolution in Photography* (Oakland: The Oakland Museum, 1992), and Oren, "On the 'Impurity' of Group f/64 Photography," 119-27.

48. Walt Kuhn to EW, December 22, 1929, EWA/CCP. DBII, December 29, 1929, 139.

49. DBII, August 8, 1930, 181. Alfred Stieglitz, "How I Came to Photograph Clouds," *The Amature Photographer and Photography* 56, no. 1819 (September 19, 1923), 255; here from Nathan Lyons, ed, *Photographers on Photographers on Photography* (Englewood Cliffs, NJ: Prentice-Hall, 1966), 112.

50. EW to AA, January 28, 1932, AAA/CCP.

51. DBII, August 14, 1931, 221.

52. EW to Johan Hagemeyer, [June 1926], Hagemeyer Collection, CCP.

53. DBII, May 31, 1927, 26; November 7, 1928, 89; and October 14, 1931, 227.

54. Ibid., May 31, 1927, 26. For more on the relationship with Gang, see Lori Pauli, "Edward Weston and Christel Gang: Silent Communion," *History of Photography* 19 (Autumn 1995), 263-268.

55. Weston, Daybooks, manuscript B, February 14, 1927, CCP. DBII, March 24, 1927, 11.

56. Shore lent Weston *Tertium Organum* in which the author advanced claims for spiritual understanding that would replace the empiricism of Francis Bacon's *Novum Organum* as well as the logic of Aristotle's original *Organon*. This book was read in Stieglitz's circle, too; see Richard Whelan, *Alfred Stieglitz, A Biography* (Boston, Little Brown, 1995), 444.

57. DBII, July 16, 1931, and August 9, 1931, 219-220.

58. Weston, "Photography—Not Pictorial," 57.

59. Weston quotation collection, CCP. DBII, August 21, 1931, 222.

60. Weston, "Photography—Not Pictorial," 57.

61. DBII, April 26, 1930, 154.

62. Edward Weston, "Seeing Photographically," *The Complete Photographer* 9 (January 1943), 3200-3206, here from Bunnell, ed., 143. Miles Orvell has made this observation, too, in *The Real Thing: Imitation and Authenticity in American Culture*, 1880-1940 (Chapel Hill: University of North Carolina Press, 1989), 220.

63. DBII, March 26, 1932, 252. Of course these genetic forces are more physical than metaphysical, the counterparts of Strand's Marxian forces.

64. Ibid., August 8, 1930, 181.

65. Indeed, it is not surprising that at least one of Weston's contemporaries associated his photography with the philosophy of Alfred North Whitehead. Anne Hammond, "Ansel Adams and Objectivism: Making a Photograph with Group f/64," *History of Photography* 22 (Summer 1998), 171-72.

66. DBII, April 24, 1930, 154.

67. Ibid., August 14, 1931, 222.
68. Ibid., January 24, 1928, 46. For Weston's resistance to evolution see DBII, July 3, 1930, 172-73.
69. Ibid., January 24, 1928, 46.
70. Edward Weston,"A Contemporary Means to Creative Expression," in Merle Armitage, ed., *The Art of Edward Weston* (NY: E. Weyhe, 1932), pp. 7-8; here from Bunnell, ed., 68. The phrase is borrowed from Dora Hagemeyer, Carmel librarian and Johan's sister-in-law, who wrote as "D.H." in a local organ, *The Carmelite*—Weston quotes her in DBII, August 21, 1931, 222, and also uses the phrase without attribution in his letter to AA, January 28, 1932, AAA/CCP.
71. The trope was chemical. Weston vowed that he was determined "to know things in their very essence," and believed that he could photograph a thing and "reveal the essence of what lies before his lens." (DBII, February 1, 1932, 241. Edward Weston, "Photographic Art," in *Encyclopaedia Britannica* [NY: Encyclopaedia Britannica, 1940], 14th Edition, vol. 17, 796-99; here from Bunnell, ed., *Edward Weston on Photography* 132.) This was ambitious enough terminology, but at times Weston ratcheted up his superlatives to say he was looking for something more—*quintessences*. (DBI, March 10, 1924, 55. Weston, "Conceptos del Artista," 47. See also Estelle Jussim, "Quintessences: Edward Weston's Search for Meaning," in Peter C. Bunnell and David Featherstone, eds., 51-61.
72. This comment came after a nose-tweaking incident in which sculptor Jo Davidson claimed that *he* could dominate Mussolini. DBII, May 19, 1930, 161.
73. Ibid., May 1927, 22.
74. Ibid., April 26, 1930, 155. DBII, September 18, 1930, 187.
75. Weston, statement for unpublished book by Samuel Kootz, June 26, 1931, EWA/CCP.
76. EW to Flora Chandler Weston, February 20, 1924, EWA/CCP.
77. Those earlier shells might have been Weston's inspiration; in 1927 he photographed a nautilus sawn length-wide to expose its spirals.
78. DBII, August 23, 1930, 184.
79. Ibid., August 23, 1930, 184.
80. Ibid., January 29, 1932, 200.
81. Ibid., March 6, 1929, 111.
82. Ibid., March 21, 1929, 114.
83. Edward Weston, "I Photograph Trees," *Popular Photography* 6 (June 1940), 20-21, 120-123; here from Bunnell, *Edward Weston on Photography*, 116.
84. DBII, June 28, 1930, 172.
85. At that time Weston acquired a smaller camera which allowed him to work more closely and nimbly with his models.
86. There are similarities to Stieglitz's efforts to hide the appendectomy scar on his own model, Georgia Engelhard. But unlike Stieglitz, whose posing avoided the uncosmetic, Weston's goal was to avoid the individualistic.
87. DBII, August 14, 1931, 222.
88. Weston, *The Art of Edward Weston*, np.
89. DBII, January 19, 1933, 269.
90. Ibid., January 19, 1933, 269.
91. Ibid., April 20, 1934, 281.
92. Charis Wilson, remembrance in *Edward Weston Nudes: His Photographs Accompanied by Excerpts from the Daybooks & Letters* (New York: Aperture, 1977), 6-12. DBII, December 9, 1934, 283.
93. DBII, December 9, 1934, 283.
94. Charis thought it was merely a habit that Weston lost. When they first became lovers, they could meet only in the early-morning hours when Weston had habitually written; she believed that he abandoned the Daybooks for the trysts. Charis Wilson and Wendy Madar, *Through Another Lens: My Years with Edward Weston* (New York: Farrar, Straus & Giroux, 1998), 89.

13. Epic Reach: The Years of Travel

By the summer of 1936 Weston had established a home with Charis in the Los Angeles area. Southern California remained his base until the summer of 1938, when the couple returned to Carmel where they built a modest house. As the relationship with Charis flourished, Weston abandoned his carefully arranged nudes and vegetables, ventured beyond the studio, and developed a much more expansive photography. This new work involved extensive travel, funded in large part by the Guggenheim foundation. As the first photographer to receive the prestigious Guggenheim fellowship, Weston traveled some 24,000 miles between April 1937 and April 1939, almost always with Charis. There were twenty separate photographic expeditions, all made by automobile. Some were as long as six weeks and 3,000 miles, others as short as three days and 400 miles; driving throughout California and the West, the couple roamed from Vancouver to the Mexican border and as far east as Taos. Weston used his large 8 X 10 camera exclusively for the Guggenheim work, and by the end of his second year had made in the neighborhood of fifteen hundred negatives. He then retreated to Carmel to print from this massive number of negatives and prepare a book from the work. But Weston had become committed to wide work, and in 1941 he secured a commission to travel while photographing for a special edition of *Leaves of Grass*. Once more with Charis at his side, Weston again photographed at a furious pace, this time in a nine-month expedition across America and back.

Weston quite consciously intended this new work to be a departure from the images he had created in the immediately preceding years. Where his earlier photography had been a closely focused concentration on subjects within the confines of his studio, the new project was to examine larger subjects less intimately and more distantly. But he also saw the new work as continuing some of the formal qualities of the earlier period, accomplished now in an expansive rather than an intensive mode; where he had once illuminated certain fundamental forms, he now wanted to demonstrate their ubiquity. "My work-purpose, my theme," he said at the beginning of the project, was "the recognition, recording, and presentation of the interdependence, the relativity, of all things,—the universality of basic form."[1] Even in its early stages, Weston saw landscape imagery as the heart of his new project, and he anticipated photographing a "tremendous panorama" that included "the Mojave Desert, Death Valley, the high Sierras, the coast, the Pacific itself."[2]

The new project was vast, envisioned as a photography of epic dimensions. The work was also a reach for Weston as he sought to convey in the sprawling American landscape some of the visual grandness he had earlier depicted in objects more closely at hand. At times these efforts succeeded, and particularly in his work with landforms there is a continuation of both the strengths and executions of his vegetables and nudes. But as Weston moved ahead in his work of the late 1930s and early 1940s, he left behind many of the orientations and habits that had been vital

to his earlier work. When he no longer felt the need to situate subjects neatly within his frame, Weston's images acquired a certain disarrayed (granted, more life-like) look; the carefully sculpted forms of a Constantin Brancusi gave way to the messy lines of a Franz Kline. With a larger income Weston was able to satisfy his desire to make more negatives, but he did so with less of the precision that had once gone into those earlier compositions. As something of a stranger to photographic satire, he had not honed the skills of subtlety and containment, and a humor that had once been largely confined to costume parties was now indulged in increasingly bizarre visual explorations of American eccentricities. For much of his earlier photography, Weston had been the solitary worker, sweating away in isolation with his subjects; now, though, he had lots of advice as he traveled the countryside. Finally, Weston abandoned the discipline that had once gone into his Daybooks and his other pieces. He had left those exercises with a sense of release, but freedom from the chores of writing did not mean a freedom from writing. Into the vacuum once occupied by his Daybooks and other writings, now came the influence of other writers, first Charis and then Walt Whitman. Although their words did not have quite the sullying effect Weston had earlier predicted, there were consequences for his originality. Once Weston surrendered the self-construction and self-direction arising from those Daybook sessions, his imagery began to reflect the direction and narratives of the writers joined to his projects.

There was an admirable innovativeness about Weston. His was both a conscious and conscionable determination to press ahead with his work, to explore new motifs and subjects. The reach was also grand, for he sought to go beyond the intense peering of his earlier work and move into the capaciousness of a photographic epic. Yet ultimately it proved a bigger stretch than he could manage.

Weston's new photographic vision began developing 1936. He became interested in subjects that were more open and fluid than his earlier ones, photographed them from a greater distance than before, and often created images dealing more with lines than with the solid forms of his peppers. Some of this was accomplished among the sands of Oceano beach, up the coast from Los Angeles. Working in the open air, he photographed the dunes as abstract flowing shapes, depicting the sinuous lines of illuminated crest and shadowed valley, the wind-traced rills and gills upon the sandy slopes, and the multiple planes created by the dunes as they marched, wave-like, toward the distant horizon.

There was a sense of liberation and openness in this new work, a quality conveyed in a series of nude images of Charis, also made at Oceano. The quiet, warm beauty of the rolling sand gave Charis what she described as "an exhilarating sense of freedom," and which Weston managed to convey in images such as *Nude* (1936; fig. 13.1).[3] As the couple worked together, Charis would fling herself tumbling down the face of a dune, while Weston waited on the opposite dune and trained his camera on her as she came to rest in postures as various as the dunes themselves. His most recent nudes of Noskowiak (figure 12.8) had been tightly wrapped affairs, the arms and legs wound in upon each other like the innards of a cabbage, but these Oceano nudes are markedly more expansive, the entire torso brought into the composition, with arms and legs trailing out in all

13.1. Edward Weston. *Nude, 1936,* © 1981 Center for Creative Photography,
Arizona Board of Regents. Collection Center for Creative Photography,
The University of Arizona.

sorts of different directions. Once again Weston's nudes had a dance-like nature
to them, but unlike the Wardell nudes (figure 12.2), where muscles are tensed in
straining pirouette, the body here has the relaxed abandonment of a springtime
cavort. The ease and fullness are more than just formal. These images include the
woman's face, that most individualized part of the body, as openly and
unabashedly displayed as her pubic hair, and without the contrived modesty of
Weston's earlier poses. Finally, there is a sense of context in these images.
Working at a distance, Weston situated Charis in a broad and seemingly bound-
less expanse of sand, rather than confining her, as he had with the more recent
nudes, in a narrow slice of studio light.

After the decades of studio work there was a strong attraction in the new
peripatetic style, for it was not just the largeness and freshness of new landscapes
that appealed but also the excitement of packing up and moving on. Weston's
yearning for travel was part of a larger phenomenon in 1930s America. Like him,
a host of other American intellectuals took to the road and then returned home to
produce reflective accounts of their experiences. Some writers had prior associa-
tions with creative photography; Stieglitz's friend Sherwood Anderson
abandoned fiction for traveling and writing, and Weston's friend Anita Brenner

estimated that "there were quite a lot of us riding around the country in buses or flivvers."[4] Weston lacked the social and political emphasis of those other travelers, but he shared their interest in federal patronage. At one point he believed he had found Interior Department funding that, he told Ansel Adams, "will take me all over America photographing the effects of wind & water erosion on soil; a job made for me!"[5]

The job fell through, but the Guggenheim Foundation proved a more tractable patron. Californians close to the foundation, including photographer Dorothea Lange, went to exceptional lengths as they coaxed Weston toward an application that the fellowship committee could justifiably fund. The process took some months, but Weston finally got down on paper the "epic" project he hoped to accomplish as a Guggenheim fellow. He would make fine, straight 8 X 10 images, and the work aspired to a magisterial and extensive photography of the West, but not a photographic analogue of the regionalist paintings of Grant Wood and John Stuart Curry. Instead, the West was only the subject at hand, the locale where Weston worked and which he loved, but a local example of universal qualities. Also, from the first gloss there was a satiric intention to the project, not only in Weston's written application and but also in the sample prints he submitted: a strange cement-worker's glove and an odd monument from Wilshire Boulevard. Finally, Weston said that his way of working would be art rather than documentary, and *not* "photography dealing with social welfare or social problems."[6]

Weston moved quickly, and was on the road three weeks after the award was announced. But for all the precipitousness, this first trip, like the rest of Weston's Guggenheim excursions, was a well-considered effort. His plans were flexible and allowed for the sudden discovery and unexpected weather, but there were also planned destinations, route maps, and a careful accounting of expenses. Although Weston railed against middle-class ways and liked to characterize himself as a danger-flouting bohemian, much of the planning and publicity surrounding the Guggenheim travel occurred in alliance with a thoroughly bourgeois organization dedicated to minimizing risks of the road, the Automobile Club of Southern California. There was help with maps and itineraries, and in exchange for monthly photographs, the club paid Weston enough so that he could buy the car necessary for the trip. With subsequent extensions from both the Foundation and the Automobile Club, the Guggenheim period lasted two full years.

These where charmed years for Weston and Charis, reminiscent of the best times that Stieglitz and O'Keeffe spent together at Lake George. Compatible souls, the couple delighted in the shared experiences and out-of-the-way places, whether it was the antics of Death Valley's tooth-brush devouring burros, or the company of a crusty New Mexico tourist cabin proprietor.[7] And always there was photography, the thrill of magnificent vistas and glorious details, the challenges of desert heat or coastal fog, the joy over some unexpected view—and the exasperated realization, after hours of work, that the truly interesting view lay not ahead, but back over the shoulder.

Seldom, though, did Weston and Charis register the Depression. They might have taken to the road like other intellectuals of the time, but they had little reaction to the deprivation and destitution that inspired other writers and artists. Perhaps most striking were the differences between these two Guggenheim travel-

13.2. Edward Weston. *Manly's Trail, Golden Canyon, Death Valley, 1938*, © 1981 Center for
Creative Photography, Arizona Board of Regents.
Collection Center for Creative Photography, The University of Arizona.

ers and their fellow Californian, John Steinbeck. When Weston and Charis returned
to California from Taos in 1938, they found themselves sharing the road with
drought-stricken Oklahomans making the westward trek that Steinbeck portrayed
in *The Grapes of Wrath* (1939). But whereas Steinbeck had transformed those people
into the salt-of-the-earth Joads, Weston and Charis saw only unkempt, droll hillbil-
lies whose rickety cars annoyingly broke down in the middle of the road.[8] During
these years Weston kept abreast of the social culture of the 1930s, viewing Strand's
Wave and other social films, but he practiced a studied, at times even unpardonable,
blindness toward the plights of his fellow Americans, for although his scope was as
geographically broad as Steinbeck's, his view was more panoramic than historic.

Apolitical in nature, Weston's Guggenheim work retained much of the for-
malist emphasis of his recent work. At most of the places he worked, he continued
with his concern for nature's shapes, and some of his most intense work in this
regard was accomplished at Death Valley, a fruitful destination which he visited
three times. There he made images such as *Manly's Trail, Golden Canyon, Death Valley*
(1938; fig. 13.2) and *Corkscrew Canyon Entrance, Death Valley* (1938; fig. 13.3). Both
photographs display Weston's abiding interest in the play of light and shadow, his

13.3. Edward Weston. *Corkscrew Canyon Entrance, Death Valley*, 1938, © 1981
Center for Creative Photography, Arizona Board of Regents.
Collection Center for Creative Photography, The University of Arizona.

fascination with the variety of natural forms, and his concern for composition—in each image the main subject in the middle of the frame is carefully bordered with secondary shapes at the top and bottom.

But there is also much that distinguishes this Guggenheim work from Weston's vegetables and nudes, and from the even earlier Mexican images. As

Weston traveled he brought to the photography a certain sprawl. The earlier shells and nudes, and Galvan's head, too, are surrounded by a border of empty space, a neutral zone isolating the subject and holding it boxed under the photographer's control, so that the images seldom acknowledge the existence of a world beyond the frame. But Guggenheim landscapes like *Manly's Trail* function much different-ly, for here the lines invite the eye to continue moving off to the left, or down and to the right, following the contours of a mountain which is not completely bound by the frame. On the right is still another mountain, only partially explored, and the photo clearly aims to render only a portion of Death Valley's spaciousness rather than to achieve an exhaustive penetration.

The images became busier, too, more complex as Weston dwelt upon a greater number of lines and more intense textures. The hills of *Corkscrew Canyon Entrance*, for instance, have the leathery and intricate look of craggy, aged skin, fold follow-ing upon fold, dimple upon dimple. The tendency toward these convolutions had emerged in Weston's halved cabbage, had grown during his work with the rills of the Oceano sand dunes, and now came to its fullest complexity in collections of pat-terns. In *Manly's Trail* he traced a set of intricacies as the two main masses form separate triangles each composed of smaller parallel lines, and with those lines run-ning at right angles to each other. This regularity became even more explicit in other landscapes which concentrated upon human-made forms like fences, orchards, and furrows.

Marching as they do toward the horizon, those agricultural photographs emphasize still another new dimension to Weston's work, depth and distance. Of course the peppers and nudes had possessed *some* depth, depicting as they did three-dimensional subjects with shadows and highlights. From 1937 onward, though, depth is registered to a much greater extent than before, with an image such as *Manly's Trail* having no fewer than five major planes: the foreground of a white ridge, next the dark mountain, then a mountain in full light, followed by a desert wash behind it, and then still another set of hills rising in the distance. Like the pepper images, *Manly's Trail* has about it a visual drama, but here one draws a slight gasp in recognizing the distances involved in the beauty of the setting, whereas with the peppers one gasps with the realization of the beauty to be had in common subjects.

So it was that place, location, and context became more significant elements of Weston's subjects. His earlier sea shells were photographed completely apart from the sea, and the nudes suggested little about the model's life. But in the Guggenheim landscapes like *Manly's Trail, Golden Canyon, Death Valley*, context matters—these two mountains stand in a certain relation to each other and the val-ley beyond, and Weston's more explicit title helps us to locate the scene with even greater specificity. Other, non-landscape, images showed a similar emphasis on location. Weston's 1925 *Excusado* had been photographed close up, floating in iso-lation, but his 1939 photograph of another toilet, this one at the Golden Circle Mine in Death Valley, portrayed the toilet and its environment, begrimed in its closet and located beneath a shattered window.[9] Sometime in 1938 Weston acknowledged this transformation of his vision. Three years earlier he had left Carmel with the feeling that he had said all there was to say about the coastal cypress. But after a round of

Guggenheim work, Weston "saw the cypress with new eyes," and he said that "for the first time, I treated [the trees] as elements of the larger landscape," backing away to photograph them against their cliffs or with a backdrop of the ocean.[10]

"I have felt the soil," Weston had written back in 1924, referring to his work with indigenous Mexico.[11] Now, though, soil became a much more literal aspect of Weston's work, and he repeatedly photographed soil subjects. That Interior Department project had been designed to photograph soil erosion, and although Weston's motives had doubtlessly been more formal than illustrative, *Corkscrew Canyon Entrance* might well have satisfied the publicity needs of some soil conservation agency. This soil emphasis had emerged at Oceano during 1936, where sand and nude were complementary subjects. But by 1937 soil had supplanted the nude in Weston's interests. Between Los Angeles and Death Valley, Weston and Charis stopped to work among some dusty formations, with plenty of opportunities to revisit the Oceano nude themes, for Charis had decided to "sunbathe and wander around clotheless." But Weston's mind was elsewhere, and Charis was told to watch her step and "cautioned not to bob up in the midst of a picture."[12]

It was not just any soil that appealed to Weston. Some of his earliest exposure to the California landscape had come during that desert surveying job, and he never lost his love for arid regions. There was a peculiar sense of cleanliness to the desert, but there were other, photographic, reasons to love deserts, for the light there was not hidden by clouds nor was the landscape's outline obscured by foliage. Weston thought the foggy northern California coast was "muffled ... uninteresting" compared to "the strong contrasts and brilliant sunlight of the southern deserts," and the interior mountains under their cloak of trees were "too confused and undefined compared with the stark and simplified forms of the desert."[13]

If the desert was clean and well-lit, it had still another appeal. At an earlier time he had been concerned with life forces, whether in the surging energies animating the "palpitating flesh" of his nudes, or in the "contractile forces" that lent his peppers such strange and beautiful forms.[14] But by the late 1930s Weston was more mindful of different kinds of powers, not so much forces emanating from within the subject, but instead those that molded or pushed the subject from without. Rather than life forces, Weston began photographing geo-forces, the workings of tectonics and weather. *Manly's Trail* depicts the upward-thrusting forces that had heaved up two hills, and in *Corkscrew Canyon Entrance* weather has had its way with the hills. Weston also photographed smaller scale earth forces. Parts of the California desert are littered with concretions, curious rock formations in which the sandstone has coalesced into strange, rounded slabs of soft rock. In some places the fields of stones stretch for acres, and there Weston, Charis and an accompanying son went scuttling around for them. "Like gold searchers we zigzag back and forth across the fields," Charis said, "our eyes glued to the ground, and every few minutes a yell of triumph from one or another indicates good findings."[15] Some concretions were pried loose and propped up so Weston could photograph them, while others were whisked off and photographed *in situ* as he pointed his camera down at the ground. Many of the images, like *Concretion, Salton Sea* (1937; fig. 13.4), bear considerable resemblance to the earlier peppers and nudes in their naturally rounded, yet peculiarly abstract shapes. But here of course the subjects were

13.4. Edward Weston. *Concretion, Salton Sea, 1938*, © 1981 Center for Creative Photography, Arizona Board of Regents. Courtesy George Eastman House.

formed by geologic forces, external rather than internal dynamics, and those were now the same kinds of forces Weston portrayed even when he photographed living subjects. The High Sierra junipers were cousins of the cypress he had once photographed at Point Lobos. But where he had once been inclined to close-ups of wood grain, he now backed off, photographing his trees against the sky, in order to emphasize the effects "of violent weather—their trunks are twisted and gnarled, bent down by snow, lashed by wind, often blasted by lightning."[16]

Along with this emphasis upon transience and process, there were additional qualitative changes in Weston's photography of the Guggenheim years. With their greater sense of movement, the images lost a degree of Weston's earlier solemnity and acquired some of irony's imprecise humor. If his prints once sung loudly, they now hummed softly, no longer displaying that engrossed communion of photographer and subject, for as the work became more spacious, it also became less intense.

Some of this reflected a change in Weston's way of working. He called his Guggenheim project an exercise in mass-production seeing, and from the beginning he planned to make large numbers of negatives. But this new emphasis on quantity, coupled with the requirements of field work, had other consequences which were probably less intentional but nonetheless significant. Once Weston released

his shutter, months could pass before he had returned home, processed the negative and finally produced a fine print. Quick work for some photographers, this was slow by Weston's earlier standards when mere days, sometimes hours, separated the shutter release from the fine print. The delays allowed plenty of time for the dissipation of any initial amazement experienced under the dark cloth. The lapses also bespeak a diminished excitement that made the delays tolerable. The Daybooks conveyed an earlier intensity—"I could hug the print in sheer joy"—not to be found in his scarcer later writings, and the Guggenheim landscapes have less of the immediacy and intimacy that had once propelled him in the furious production of close-ups.

More than merely a change in the processing, this new photography also involved a change in the circumstances of Weston's seeing. After 1936, his photography was less a private episode between subject and photographer, and more an experience had in the company of other parties. Although there were fewer human subjects (a handful of nudes and portraits) during the Guggenheim years, there were actually more people involved in the making of his images, sometimes directly present when the images were made, and sometimes as more removed map-drawers and direction-givers. No longer did Weston spend hours alone with his still life arrangements, the door barricaded against visitors. Thus, although it is legitimate to consider Weston the principal author of the Guggenheim images, his work now took on a collaborative dimension.

Some of the collaboration was simply a product of traveling. Automobile trips with companions are necessarily collective affairs, with the decisions about restroom breaks and other pauses becoming mutual ones. And Weston never traveled alone. Charis was along for all but one of the trips, and there were other companions, including their friend Zohmah Day, Charis's brother Leon, or one of Weston's sons, Brett, Cole, or Neil. Weston could not drive, but one suspects that he wanted these people along as something more than chauffeurs, that he welcomed them as companions and additional sets of eyes to help him scout the landscape. In their companionship, these people helped direct Weston toward certain subjects. At a Death Valley mining camp, for example, it was Leon who located, and then began "rapturizing over," the interior of an abandoned shack; and when Weston eventually caught the excitement, *then* he began to photograph the scene.[17]

Nor was it just the people in the car who shaped Weston's experiences. At any given stop there was often a local to help out; before some trips a geographer on the Guggenheim board offered guidance; and as Charis said, "we were always being directed by friends to their own favorite sights or view or formations."[18] Thus much of what Weston photographed was in some way selected and previewed by others, and indeed a fair number of his destinations were such commonplace attractions that they exhibited the tackiness or scars of popular taste: in Death Valley he photographed from a road known as "Artist's View Drive," and his concretion beds bore the tire marks of curio-hunting predecessors who had hauled away truckloads of the stones.

A considerable number of those who helped direct Weston's vision were photographers themselves. Willard Van Dyke accompanied Weston during a long

trip up the northern California coast, and there were joint photographic excursions with Frederick Sommer in Arizona and Ted Cook in southern California. But by far the most significant of Weston's photographer companions was Ansel Adams. The two men had been acquaintances for a decade, and their relationship now blossomed into friendship as Weston moved into Adams's genre of landscape photography. They were together often, and on one terrible night Weston and Charis helped Adams rescue his negatives from a darkroom fire that threatened to consume much of his his work.[19] In their times together, Adams helped ease some of Weston's qualms over "mass-production in photography," convincing Weston that there could be "beautiful seeing and recording" even among "bushels" of unprinted negatives.[20]

He also introduced Weston to new subject matter—mountains. Sometimes the introductions came in a passive way, as in the winter of 1938 when Weston was Adams's house guest at Yosemite, and a sudden blizzard kept them stormbound in the Valley and yielded Weston's only extended set of snow photographs. At other times Adams's influence was much more direct, as when he led his friend to the sites, sometimes the very subjects, that Weston photographed.[21] In none of this did Adams actually aim Weston's camera for him, nor did he plant the feet of Weston's tripod. But some of Weston's Guggenheim innovations—the interest in mountain subjects, the distanced views—were signature characteristics of Adams's photography.

For all of Adams's significance, Charis was the largest influence upon Weston's Guggenheim work. She asserted her self into Weston's life to a greater extent than had any woman since Flora. Mather and Modotti may have been Weston's lovers and putative business partners, but from the start Charis was a life partner, and the two of them were sincerely and exclusively bonded to each other. (She nudged him and he finally began divorce proceedings against Flora in 1937.) Fellowship and relationship grew increasingly intertwined, and Weston and Charis were married on the last full day of Guggenheim travel in April 1939, with the ceremony performed in a Western ghost town by a crusty judge who had himself once been a portrait photographer.[22]

Charis had been involved with Weston's photography from the early moments of their relationship, posing nude for him on their second meeting. But when they moved to Los Angeles, she became more active and exchanged her modeling before the camera for a stronger clout behind it. She took charge of Weston's chaotic record-keeping, devising the new system under which the Guggenheim work was filed. Her role continued to expand during the trips. After Weston made an exposure, he would often invite her under the focusing cloth to see and comment upon his composition—a favor occasionally extended to others but never so frequently as with Charis. With more experience came a greater sense of thrill—she called it "the kind of excitement sometimes generated in a gambling casino"—and she believed her eye and sense of landscape were so attuned to his that she could spot "Weston country" with with no difficulty.[23]

Charis did not compose Weston's images or release the shutter, but she played a very active role in selecting the scenes that he photographed. In that Yosemite

snow, so deep as to make one flounder, she and Neil tramped ahead through the drifts, beating down paths to subjects that seemed worthy of Weston's consideration. In the Mojave, she was more like Weston's shepherd than his scout, finding "a beauty of an upright rock," and then proceeding to "chase Edward toward it." In none of this did Charis play the heavy, nor is there any evidence that she had subversive designs upon Weston's work. In fact, the youthful energy of this woman in her mid-twenties helped to sustain and propel the Guggenheim work of this photographer who was now in his early fifties.

Even with all this photographic activity, Charis did not make pictures herself. Jokingly she said it was because she wanted to avoid the fate of her predecessors, for Mather, Modotti, and Noskowiak had passed from Weston's life as they each grew into photography. The more significant reason was that Charis had another art in her bones: she was an aspiring writer. Her father was a novelist, and she initially planned to write a novel of her own during the Guggenheim trips. But as her enthusiasm for Weston's photography grew, her energies were absorbed into the camera work, and her own project remained uncompleted as his marched along. Yet the absorption also functioned in reverse, for although Charis's novel was lost along the way, she became the writer for the Guggenheim project, and in so doing gave it a voice and texture more characteristically hers than his. She was the author of their "Journal of the Guggenheim Years," and her treatment was exhaustive, eventually comprising 413 typescript pages about their journeys, the photographs, and the thinking that went into them. In 1940 a version of her text was published together with Weston's images as the book about the Guggenheim work, *California and the West*. Charis also became Weston's ghost writer, and well into the 1940s she penned articles that appeared over his name. Weston's ideas could still be seined out of these pieces—Charis interviewed him and borrowed from his earlier writing—but as he said with regard to one 1939 article, "Charis does all the writing."[24]

Weston had never before surrendered the writing to someone else. Even though he considered writing his second-best medium, the Daybooks and essays had served an important role, allowing him to sharpen ideas and formulate expressions that might otherwise have remained only fuzzy, unexpressed sentiments. But things were different in the Guggenheim period. On one desert evening early in the fellowship, Weston turned his back on writing with almost as much finality as when he had consciously closed the book on his photography of vegetables. Sitting under the stars, drinking coffee and talking, he, Charis, and Zomah Day considered the beauty of their surroundings. According to Zomah's record of that evening, "Edward said [that] when he used to write there were not enough words for beauty." Now, it would seem, there was too much beauty for words, and the conversation drifted on to the question of "how can a writer write. How when he comes up against a place like the desert...can he speak of it with words[?]"[25] With the ample glory of subjects like the landscapes he now photographed, Weston wanted an infinite glossary with which to work, which appeared possible with his light-sensitive chemicals but impossible with the poet's seemingly more limited lexicon. Thereafter Weston seldom wrote much of anything but letters. He would "laughingly blame Ch[aris] for cramping my style

as a writer," noting that once she came into his life he seldom had the "necessary aloneness for keeping an intimate journal." But the greater truth was that Charis was willing to do the work, and that Weston left the writing to her. When he later summarized his life, Weston took a bye on the years of travel, and instead referred to Charis's *California and the West*, "so well-told that I need not recount any of the Guggenheim period."[26]

The Guggenheim photography occurred against a background of constant narration. As they traveled during the day or camped for the evening, Charis and Weston read aloud to each other, sometimes from lurid detective magazines, and sometimes from books like Robert Louis Stevenson's *The Wrecker* (1892). This was a charming domestic ritual, and an entertainment suited to an artist's pocketbook. But the practice meant that their experiences took place within the context of stories. A good deal of that narration was the story of the trips themselves, for, in one of the oddest features of these journeys, the couple passed many an evening reading from earlier portions of Charis's log. Some of this may have been simply editorial practice as they made running corrections to the day's account. Yet it also continued one of Weston's own habits, for he had continually returned to his earlier Daybook entries when considering his work of the moment. In this way, Charis's words doubly influenced the Guggenheim photography, for not only did she first explain in writing what had happened as Weston encountered a scene or made a photograph, but the spoken rendition of that account continually echoed about Weston as made himself ready for the next day's work.

Charis's influence is probably clearest in the odd humor that characterizes Weston's Guggenheim imagery. There had been a sardonic quality to some of his earlier photographs, and in Mexico that derisiveness had given rise to images such as the one frequently called *Pissing Indian* (fig. 11.4). The occasional snideness still surfaced in the Guggenheim work, but more often Weston expressed a winking appreciation for the ironies, intentional and otherwise, to be found along the American roadside. This same brand of ironic commentary characterized Charis's Journal and her text for *California and the West*. Hers was a voice that could have some bite, but was still more jocular than mordant.

One of Weston's images depicts an enormous mock cup advertising "Hot Coffee" in the midst of the barren Mojave sands—and at a place known as Siberia, California. Another photograph was made at the Oregon town of Bandon, which had been virtually obliterated by a disastrous 1937 fire. Weston photographed a ruined building, its one still-standing wall bearing an advertisement for fire insurance amidst the wreckage of charred business machines and melted glass. In another abandoned community, the mining town of Leadfield, California, someone sharing Weston's sense of humor had placed a sign warning about high explosives on the front of a large outhouse. Other jokes were purely visual, as in the case of the "Yuma Nymph," a life-size, silver-painted statue of a nude native American woman, designed to lure passers by to a roadside tourist trap.

Charis once said that "the Guggenheim trips were like elaborate treasure hunts."[27] For Weston and Charis, those "treasures" were the unusual discoveries

13.5. Edward Weston. *Old Shoes, Mojave Desert, 1937*, © 1981 Center for Creative Photography,
Arizona Board of Regents. Collection Center for Creative Photography,
The University of Arizona.

such as the Nymph. Weston was of course no stranger to the bizarre, for the pecu-
liar shadow, strange vegetable and contorted nude had graced his earlier work. But
now his treasures seemed to have stories to tell. His eye continually fell upon scenes
thrumming with some not-quite-disclosed narrative. Once he photographed the
odd juxtaposition of a pink girdle thrown over a barbed wire fence, another time
there was a pair of black women's gloves draped on the bail of a battered metal
bucket, and time and again he photographed discarded shoes—almost always
worn, curled, and cracked. The images insinuate questions containing the germ of
some story line: Why are these gloves so delicately placed? What kind of stride
would have worn these shoes just so? How came that girdle to be across that
fence—was it a crude joke, a brutal crime, or a simple misplacement?

One December day in the Mojave, the couple came upon a burned, aban-
doned house where they set to exploring the trash heaps, and found drawings,
paint brushes, a single ballet slipper—speculative evidence, or as Charis put it,
"proof of artistic occupants." Weston made a few negatives, one of a stranded chim-
ney and the other of a burned car, and had just about decided to leave when he
came upon a "gold mine," fifteen old shoes lying in a hollow—plenty of material to
beget a story, but too indistinct in their shadowy pit. So Weston collected the mess,

heaved the shoes into a ruined fireplace, tweaked the arrangement here and there, and then photographed the result—figure 13.5. Like many of these images, this one is visually challenging. Formally, it is separated into two distinct areas, one a very busy area in the top two- thirds of the frame, and the other a more linear row of bricks at the bottom. Both building material and wearing apparel are a-jumble; indeed, they are almost indistinguishable in the wreckage of stones and the disorder of shoes. With things scattered every which way, the image suggests some moment of crisis, and is also something of a family portrait of that chaos, with men's shoes here, women's shoes there, and one baby shoe in the front. Again, the photograph suggests stories, and in his arrangement, Weston may have aimed toward something like poignancy: there was a child somehow involved in the confusion of this ruined, burned place, and the isolation of that shoe lends the child a sad and lonely quality.[28]

Old, worn, and soggy shoes are foul things. But decay and decomposition were persistent themes for Weston and they occur often in the Guggenheim work. In part this was simply an expansion of his long-standing penchant for finding beauty in toilets and other seemingly ugly subjects. Yet Weston photographed dead or decayed things with increased frequency during the Guggenheim years, and some of the appeal of such subjects lay in their strangeness. There was, for instance, a road kill rabbit in the middle of an Arizona highway (a tough subject, given on-coming traffic and Weston's longish exposures). With its pelvis broken, the rabbit had one hind leg extended over its head as though in a strange kick-dance.

Decay and debris seem to hint at stories and call the imagination to complete the narrative, presenting us with the evidence of what once was and hints of how the demise came about. Ghost towns of the desert were just such subjects. Earlier in the decade Strand had been drawn to old mining towns in New Mexico, photographing their deteriorating false fronts as he speculated about their frontier past, "that lopsided life—so raw and brutal."[29] Weston likewise began to photograph abandoned and crumbling buildings during his Guggenheim years. He eagerly photographed in places such as Rhyolite, Nevada, a town that had been quickly thrown up during a gold boom and then died just as quickly in the bust of 1906. When Weston arrived in the spring of 1938, the masonry buildings were largely tumbled in upon themselves, leaving only corners and doorways outlined against the desert sky.

Some of Weston's Rhyolite images are reminiscent of Strand's villages, with empty doorways framing secondary scenes beyond the portals. Others are more like *Rhyolite, Nevada* (1938; fig. 13.6), where portions of the buildings stand like craggy teeth. In this image the regularity of windows and bricks is complemented by the irregularities of the crumbling walls. The light here comes from behind the camera, so that none of the lines in the front building are lost in shadow, and it is possible to see into the open windows of the back building, through the empty space and then to the opposite walls beyond. This is a very carefully composed image, arranged so that the shapes of the two buildings are repeated, rather like blips of an oscilloscope chasing each other across the horizon.

Weston's enthusiasm for Rhyolite was great. He said that "this is Nevada's Athens, and really there is no need to go on to the Acropolis now."[30] Like the ruins

13.6. Edward Weston. *Rhyolite, Nevada, 1938*, © 1981 Center for Creative Photography, Arizona Board of Regents. Collection Center for Creative Photography, The University of Arizona.

of the Acropolis, Rhyolite's walls were testimony to both a certain era and to the passage of time since that era. One is witnessing history, registering time's passage and the mystery of the past's remoteness. One is presented with a puzzle in these ruins, triggering a mental reconstruction of the way Athens looked in the fifth century B.C. or the way Rhyolite looked at the turn of the twentieth century.

An actual human corpse provoked much the same reaction. At Carrizo Creek in the Colorado desert, Weston and Charis found a man lying dead beside a stunted tree, his eyes staring into the sky. He was a short, emaciated middle-age fellow, wearing battered shoes, worn corduroys, and a dirty denim jacket. There are any number of understandable reactions (take flight, dig a grave) upon finding such a corpse, and simple good citizenship would seem to compel one to call the police immediately. But Weston and Charis were more interested in puzzling out the man's story than in registering his death, and in an amazing display of callousness, their energies went into inventorying the man's belongings and his surroundings. Charis recorded what she could see—the clothes, the lie of his hands, the enigmatic bottle of fresh milk near by. Then she moved on to the man's bindle, and untied it to find still more clues to his identity. Weston's reaction was to photograph the man, and his excitement was so high that he made

one of his rare double exposures. Eventually Weston and Charis did report the corpse to authorities, but they continued for days to puzzle over how and when the man had died.[31]

Not long before this Weston had sought a timelessness in his photography, a set of "plus" qualities quite apart from the quirkiness and trash of his new photography. Those earlier quintessences had supposedly existed in a transcendent realm where neither moth, nor rust, nor maggot corrupt; like Plato's forms, they do not have stories, and in their grandness they just *are*. But things had changed in Weston's life, and he had closed the chapter on timeless subjects. He had taken up company with a woman interested in stories, and increasingly his photographs also called out for stories and bespoke the passage of time. There was quite a change here from the ever-young nudes of his studio work to the clearly aging corpses of the Guggenheim project. Critic Andy Grundberg has seen in this transition the arrival of a death obsession, a case of "Thanatos replacing Eros."[32] More properly considered, Weston's new fascination had more to do with time and narrative, with Chronos more than Thanatos. Nor were the stories here the stuff of epics. They were isolated matters of relatively small significance—this one dead man, those few shoes—and they were not woven together into anything like the universality or interdependence that Weston had envisioned in his Guggenheim application.

Once the Guggenheim fellowship ended, Weston settled into Carmel and spent nearly two years printing from his negatives. He was able to make new images, too, continuing Guggenheim themes of strangeness and time's passage. Weston's expansive inclinations also continued, but his now-limited resources kept him close to home. He made a few images at Carmel-area locations such as Point Lobos, some in the Hollywood back lots of Twentieth-Century Fox, and a few others in Yosemite.

Then in February 1941 Weston seized an opportunity that allowed him to exercise his vision even more grandly than with the Guggenheim. George Macy, director of the Limited Editions Club, approached Weston with the idea of adding fine photographs to a deluxe edition of Walt Whitman's *Leaves of Grass*. Macy originally believed that the photographs could be made quickly and in the vicinity of southern California, but Weston thought otherwise. Whitman had conceived *Leaves* grandly ("The United States themselves are essentially the greatest poem") and Weston used the vastness of that conception as he wheedled Macy toward a larger photo project, arguing that the photographer's vision must likewise encompass the entire nation, and telling Macy that "I don't see anything short of a round trip that would give me a chance to see and record the diversified multitudes that Whitman sings and catalogues." Yet Weston's interest in Whitman was sincere as well as self-serving, for he aspired to a Whitmanesque scale in the 1930s. The dimensions had been large enough when Weston originally envisioned his "epic series" of the West, but as the decade wore on Weston's expansiveness grew and the aspirations that had once been contained, first in the studio and then in the region, eventually grew to encompass the nation.[33]

After several months of negotiations, Weston got what he wanted, leveraging a smallish publishing project into a major photographic expedition. He and Charis

left Carmel in May 1941 and by the time they returned in January 1942, they had driven 25,000 miles through twenty-four states, and Weston had made seven hundred negatives. Their travels took them first down the Pacific coast to Los Angeles, then east and south to the Texas gulf coast and New Orleans, up through the central part of the country to Ohio, then into Pennsylvania and New England, and finally back through the deep South before returning to California.

As Weston photographed he continued to work with grand spaces, and formal qualities of line and shape. But while these qualities had been defined by mountain or dune or canyon in the Guggenheim work, Weston now concentrated more on landscapes that had been transformed by the human hand. The fields he photographed were fenced into individual farms and pastures, the coastlines bore the geometry of petroleum refining and other commerce, and his rivers had been spanned by bridges or blocked by the likes of Boulder Dam's grand concrete arch.

Weston's taste in weirdness went through similar transformations. He still photographed oddly twisted plants and strange trash heaps, but increasingly he depicted the efforts of his fellow connoisseurs of the strange. The champion of them all was Winter Zero Swartzel, whose Ohio "bottle farm" displayed black-painted, life-size silhouettes of people and animals, groupings of hundreds of bottles affixed to wire trees or old bedsteads, and perhaps most attractive of all to Weston, a clothes line draped with cow bells and *old shoes.*

Decay and decomposition were other continuing themes. Weston discovered that America's photogenic ruins were not restricted to Western ghost towns, and he began to portray something like a nation of Rhyolites, all with their secret histories to be told: deserted farm houses in New Jersey, fire-damaged structures in Pennsylvania, and crumbling plantation houses in Louisiana.[34] The *Leaves* project contains more gravestones and graves than any earlier portion of Weston's oeuvre. In ways that the West had still not managed, New England offered gravestones and cemeteries as local attractions, and Weston, like Strand, was among those visitors of the era who became entranced by the region's tradition of tombstone carving. But the bulk of Weston's graven images was made in New Orleans cemeteries. Celebrated because of their unusual above-ground tombs, the cemeteries were among the common tourist stops that Weston's friends suggested. With remarkable variety in design and decoration, and with their jumble of stone work and their heterogeneous symbols, these sites were great places for Weston to exercise both his concern for formal assemblies and his interest in quirky arrangements.[35]

There were also fine incipient narratives to be found among the cemeteries, and one of the best provided Weston's subject for *"Willie", St. Roch Cemetery, New Orleans, Louisiana* (1941; fig. 13.7). The image indicates that Weston's minimalist interests had not completely evaporated in the midst of his more intricate, busy photographs. This is a simple composition, both in Weston's framing, and in the subject itself—two slabs of stone separated by a simple shelf upon which rests a fern that obscures the more complicated background carving so as to give prominence to the more direct, darker name right in the center of the image. There is somberness here to be sure, particularly accentuated by the dead and shriveled fern, but it is countered by the casualness of the material, for this is no dignified

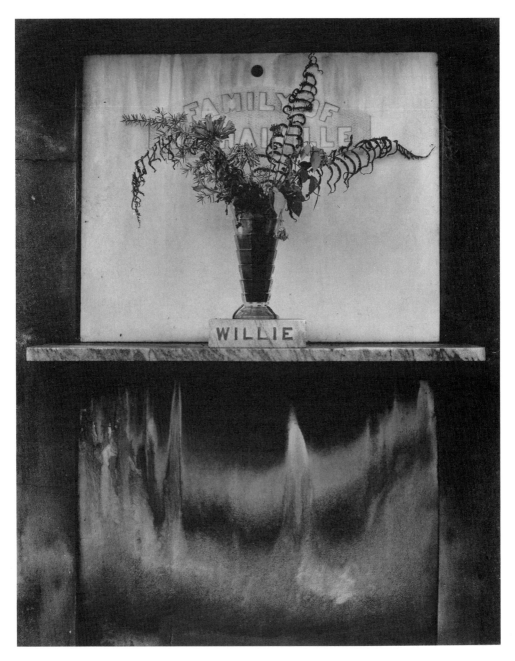

13.7. Edward Weston. *"Willie," St. Roch Cemetery, New Orleans, Louisiana, 1941,*
© 1981 Center for Creative Photography, Arizona Board of Regents.
Courtesy George Eastman House.

urn or vase, but instead an ordinary ice cream glass. The image bespeaks some
of Weston's sense of balance, for it is framed so that the shelf between the two
vaults neatly provides two portions, one light and angular in its shapes, the
other darker and flowing with the natural stone patterns; but it also speaks of the
compositional sense of those who have come to visit Willie, placed that glass pre-

cisely in the middle of the vault face, and arranged the ferns so neatly framed by the white rectangle. The name, Willie, may be the single strongest element of the image, simple, poignant and evocative. It renders the photograph an effective and humble invitation to the imagination, to story-telling: Who was Willie? How did he pass his days? What were the qualities that made him "Willie" rather than the more formal "William" or the more blunt "Bill"? How is it that his story continues, that his memory remains a part of life and someone continues to decorate his grave?

If solemnity was not one of Weston's larger concerns, autonomy most certainly was. From the very outset of his trip, Weston was keenly aware of, as he put it, the issue of "Whitman versus Weston vision." Although his contract called for the joint publication of his images and Whitman's words, Weston strove for an independence in his work and aimed for a photography of "*my* America," images made with "no attempt to 'illustrate'...no effort to recapture Whitman's day."[36] When editor Macy began to clamor for illustrations, Weston resisted, claiming self-direction for the photography and pointing out the impossibility of rendering the exhaustive specifics of Whitman's catalogues.[37] With the actual images themselves Weston tried to steer his way around Whitman, giving renditions that asserted his artistic distinctiveness. Nowhere is this clearer than in Weston's images of New York City. Strand's *Manhatta* film was much more beholden to Whitman than were Weston's pictures, for Strand photographed the surging masses whom Whitman had described as they departed the Brooklyn ferry. Weston, though, chose instead the more visually compelling Brooklyn Bridge, which was more his than Whitman's, for the Bridge was completed two years after the *Leaves* attained their final sequencing.

Yet for all of Weston's assertiveness, his photography tended to be overcome by Whitman's poetry. *Leaves of Grass* was part of Weston's reading as he crossed the country, much as Charis's Journal had been in the Western trips, and his correspondence indicates some close attention to the poems.[38] There was also on Weston's part an effort at coverage of Whitman's America, a sort of work-to-order aspect in which he trained his camera upon some quite un-Weston-like subjects. Whitman of course sang many songs of urban America, but earlier, in the midst of the Guggenheim work, Weston had written disparagingly of "the excrescences called cities."[39] Now, though, Weston photographed Whitman's brawny, eastern industrial landscape in Cincinnati, Pittsburgh, and New York. He also brought into his images the human beings who had been mostly absent from the Guggenheim work, photographing a set of plain folk reminiscent of Whitman's democratic masses, individuals more akin to Strand's laborers than Weston's earlier subjects. In these ways it seems that the text of *Leaves* became something of a shooting script for Weston as he crisscrossed the country.

But the issue of autonomy, the question of "Whitman versus Weston vision," was most intense at the time of publication. Ever wary of words, Weston had begun with the understanding that his images would be separated from Whitman's text, with no captions or titles, an arrangement which, he said, permitted him "great freedom."[40] Yet in the contest between the vision of poet and photographer, the final publication decisions worked in favor of Whitman's text

and to the disadvantage of Weston's images. For some reason the book was print-
ed with green ink on green paper, revolting colors that Jean Charlot called
"Spanish bathroom Nile green."[41] Whitman's printed words stood unaffected,
but when surrounded by a green mat, Weston's black-and-white images lost their
snap and vitality.

More troubling was the actual arrangement of words and images.
Apparently editor Macy began to have doubts about the project at some late date,
and to assure him that there was a significant if indirect resonance between the
photography and the poetry, Charis submitted each of the final prints with a few
accompanying lines from the poems. She offered these not as captions, but rather
to highlight some of the subtle relationships which she saw between the words
and pictures. Unfortunately, though, Macy misunderstood Charis's submissions,
printing them as captions with each image and doing so completely without
Weston's knowledge or permission. Weston was devastated when the final volume
arrived as a *fait accompli*—so green, so unexpected, and so wrong.[42]

Weston had been wise in trying to separate text and image, for the strength of
Whitman's words overpowered Weston's photographs in that final version of *Leaves
of Grass*. One pairing is illustrative. In Weston's photograph, there is a low horizon
of dark hills in the foreground, topped in the remaining seven-eights of the frame by
a sky populated with cottony clouds. Below the photograph appear Whitman's
words: "Smile O voluptuous cool-breath'd earth! / Earth of the limpid gray of
clouds brighter and clearer for my sake!" Weston's photograph manages detail and
specificity (*these* clouds, *this* place) much better than any of Whitman's lists, but
Whitman's poetry, with its cadences, its exclamations, and its chunky apostrophes
accomplished an associational mystery and enthusiasm that were well beyond any-
thing Weston's photography accomplished. In the early stages of his negotiations
with Macy, Weston had used Whitman's words to get the project expanded beyond
California. Now in the final product, Whitman's words trumped Weston's images.

There was a commendable boldness to the project that extended through the
Guggenheim work and the *Leaves of Grass* effort. Weston realized the necessary
association between art and innovation, and he was determined to press ahead
with his photography, leaving older themes and motifs as he explored newer ones.
His earlier work with vegetables and nudes was crisp, joyous, and even stunning,
though there had been casualties involved, for even with all of Weston's love for his
subjects, much of that earlier vision had been a praxis of domination and control.
There was probably no less love involved in the work that began in the late thir-
ties—Death Valley seemed wonderful to Weston—but the expanse of the American
landscape was more difficult to control, and this new photography was more dif-
fuse, less excited, and not so compelling.

He aspired to vastness, but the epic may simply have not been Weston's
métier. He had hoped to build upon an early photography that depicted uni-
versals in the commonplace, basic forms illuminated in some of the most
ordinary subjects. But as Weston set out to photograph the pervasiveness of
those forms, first in the West and then throughout the country, particularity
won out over universality in his work, and he returned not with an epic but

with a collection of small narratives about the likes of Willie. As always for Weston, his work and his biography were complements, and this time ironically so; during that earlier period of intensely intimate imagery he had spun almost compulsively through a series of lovers, but now in the midst of the single most meaningful and companionate relationship of his life, a distanced feel replaced the intimacy of that earlier photography. Once there had been many women and relatively few negatives; now things were reversed, and there were perhaps too many negatives. When Weston submitted the Guggenheim application, he expressed some doubts about "the amount of work a man can produce and still keep to a standard of importance."[43] The concerns were well taken, for although the stacks of negatives became much higher in these years, the truly commanding image becomes more difficult to find amidst the photographs of old shoes and desert brush.

None of this was because Weston became lazy. Indeed, he continued in many of the same work habits that had long had him awake before dawn or sweating away for hours with his camera. Yet Weston began to work in ways that proved ill-suited for him, for he left behind the focus and conceptualization of his Daybooks, and he spent more of his time moving his camera and less of his time thinking, or at least writing, about his compositions. His contemporary James Rorty had similar epic aspirations during the 1930s, and traveled across the nation in search of America's meaning. At the end of his own extensive trip, Rorty found himself with lots of information but little understanding, and felt he had only managed "to substitute physical motion for motions of the mind which might be expended more profitably at home."[44] Like Rorty, Weston reached grandly for his subject during these years, yet he did so without those motions of the mind which had once held him to the studio and the Daybook.

1. EW to Henry Allen Moe, February 4, 1937, HL.

2. Edward Weston, Guggenheim Application, HL. Edward Weston, "Plan for Work" part of Guggenheim application draft, scrapbook "B," EWA/CCP.

3. Edward Weston, *Edward Weston Nudes: His Photographs Accompanied by Excerpts from the Daybooks & Letters*, remembrance by Charis Wilson (New York: Aperture, 1977), 12.

4. Strand's friend Harold Clurman looked around him and concluded that "all America's young writers were going on bus and motor trips through the country," Harold Clurman, *The Fervent Years: The Story of the Group Theatre and the Thirties* (NY: Alfred A. Knopf, 1945, 1950), 83; Anita Brenner, "Rorty Reports America," *Nation* 142 (February 1936), 194.

5. EW to AA, [March 1935], AAA/CCP. EW to AA, [Fall 1935], AAA/CCP.

6. Weston, Guggenheim Application, HL. EW to Henry Allen Moe, January 22, 1937, February 4, 1937, and March 24, 1937, all at HL. This was an important distinction to make at a time when FSA works were becoming widely known, and during a year when Weston's Guggenheim class mates included social painters William Gropper, Joe Jones and George Grosz.

7. There was also a California waiter who turned out to be the brother of camera inventor Carl Akeley, the maker of Strand's much-beloved movie camera.

8. Charis Wilson, "Journal of Guggenheim Year, 1937-1938," Typescript, 413 leaves, HL; January 1-3, 1938, 275-78. In the spring of 1938 California experienced torrential rains that left droves of migrant workers suffering and sick in make shift camps. The conditions politicized Steinbeck,

angering him to write against the politicians and landlords who tolerated this suffering and making him determined "to put a tag of shame on the greedy bastards." But for Weston, the chief consequence of the flooding was that the impassable roads made it necessary for him to exchange the pleasure of travel for the aesthetic experiences of the darkroom, and "so I have been printing. And what an exciting time!" Steinbeck to Elizabeth Otis, March 7, 1937, in Elaine Steinbeck and Robert Wallsten, eds. *Steinbeck: A Life in Letters* (New York: Viking, 1975), 162. EW to Henry Allen Moe, received May 26, 1938, HL.

9. Shelley Rice, "The Daybooks of Edward Weston: Art, Experience and Photographic Vision," *Art Journal* 36 (Winter 1976/77), 128.

10. Edward Weston, "I Photograph Trees," *Popular Photography*, 6 (June 1940), 20-21, 120-23; here from Peter Bunnell, ed., *Edward Weston On Photography* (Salt Lake City: Gibbs M. Smith, 1983), 117.

11. DBI, March 6, 1924, 54. DBI, September 4, 1926, 190.

12. Wilson, "Journal," April 16, 1937, 41.

13. Edward Weston, "Photographing California," *Camera Craft* 46 (February 1939), 55-64 [Part I], and 46 (March 1939), 99-105 [Part II], here from Bunnell, *Edward Weston on Photography*, 94. Charis Wilson and Edward Weston, *California and the West* (Millerton, NY: Aperture, 1978, 1940), 101.

14. DBI, March 10, 1924, 55. DBII, March 26, 1932, 252.

15. Wilson, "Journal," May 2, 1937, 54-55.

16. Weston, "I Photograph Trees," in Bunnell, *Edward Weston on Photography*, 117.

17. Wilson, "Journal," January 1, 1939, 384.

18. Ben Maddow, *Edward Weston, His Life and Photographs: The Definitive Volume of his Photographic Work* (Millerton, NY: Aperture, 1979, revised edition), 212.

19. Wilson, "Journal," July 27, 1937, 122.

20. Weston, "Photographing California," 88. Wilson, "Journal," July 28, 1937, 123.

21. Twice in 1937 and once again in 1938, Adams guided Weston to favorite locations like Lake Ediza and Iceberg Lake. At the Meyers Ranch, the two photographed an old slaughterhouse, and at Mono Lake Weston photographed the exact dead white willows that Adams had recommended.

22. Milestones in the Guggenheim work also marked increased levels of commitment between the two. When the fellowship was extended for a second year, the couple began building a home on a piece of Carmel property belonging to Charis' father. At the same time, Weston wrote Guggenheim director Moe, announcing plans to marry Charis, saying that "this is not entirely a Guggenheim romance, but last year certainly cinched matters!" (EW to Henry Allen Moe, May 31, 1938, HL.)

23. *California and the West*, 17.

24. EW to Neil Weston, June 10, 1939, EWA/CCP.

25. Zomah's log, in Wilson, "Journal," June 4, 1937, 85.

26. DBII, April 22, 1944, 287.

27. Ben Maddow, *Edward Weston, His Life and Photographs*, 212.

28. Wilson, *Journal*, December 7, 1937, 249.

29. Paul Strand to Herbert Seligmann, July 29, 1931, in Sarah Greenough, *Paul Strand* (New York: Aperture, Washington: National Gallery of Art, 1990), 76.

30. Wilson, "Journal," March 20, 1938, 344.

31. Ibid., May 17, 1937, 68-70.

32. Grundberg, "Edward Weston Rethought," 31.

33. EW to George Macy, February 28, 1941, in E. John Bullard, "Edward Weston in Louisiana," in *Edward Weston and Clarence John Laughlin: An Introduction to the Third World of Photography* (New Orleans: New Orleans Museum of Art, 1982), 11.

34. The new qualities of subject and execution in these images might be explained, as Alan Trachtenberg does, by saying that Weston had become melancholic and his photographs more elegiac. (Alan Trachtenberg, "The Final Years," in Mora, *Edward Weston: Forms of Passion*, 289).

But these images also represent the reworking of existing themes according to local circumstances. The *Leaves of Grass* images on the whole tend to be darker than the Guggenheim photographs, perhaps indicative of a growing somberness, but also certainly an indication that Weston had left his sun-drenched deserts as he headed northward during the ever-shortening days of late summer and fall. Weston's subjects are older than those of *California and the West*, perhaps reflecting the fifty-one-year-old artist's preoccupation with aging, but also certainly the product of America's cultural geography, a difference between the East's older and more civilized vistas as opposed to those of a younger and more raw-boned West: Death Valley provided a fresh corpse for speculation and photography, but Old Deerfield, Massachusetts, only yielded an eighteenth-century tombstone, etched with the lines of a mother and her nesting new baby, both tucked into the same coffin.

35. B. Ullrich-Suckerman, "With Edward Weston," *Photo Metro* 5:43 (October 1986), 3.

36. EW to BN and NN, April 28, 1941, Beaumont and Nancy Newhall Collection, CCP.

37. EW to George Macy, August 15, 1941, here from Amy Conger, *Edward Weston: Photographs from the Collection of the Center for Creative Photography* (Tucson: Center for Creative Photography, University of Arizona, 1992), "Biography", 35.

38. EW to George Macy, August 15, 1941.

39. EWW to Willard Van Dyke, April 18, 1938, in Leslie Squyres Calmes, *The Letters between Edward Weston and Willard Van Dyke* (Tucson: Center for Creative Photography, University of Arizona, 1992), 35.

40. EW to BN and NN, April 28, 1941, Beaumont and Nancy Newhall Collection, CCP.

41. Zomah and Jean Charlot to Edward and Charis Weston, April 15, 1943, EWA/CCP.

42. Alan Trachtenberg,"Edward Weston's America: The *Leaves of Grass* Project," in Peter C. Bunnell and David Featherstone, eds., *EW:100: Centennial Essays in Honor of Edward Weston* (*Untitled* 41) (Carmel, CA: The Friends of Photography, 1986), 103-113.

43. EW to Henry Moe, January 22, 1937, HL.

44. James Rorty, *Where Life is Better: An Unsentimental American Journey* (New York: Reynal & Hitchcock, 1936), 33.

14. LIFE AND ART: ENDINGS

In the 1920s Edward Weston had counseled Tina Modotti to "solve the problem of life by losing...[herself] in the problem of art."[1] For most of his life Weston had tried to follow his own advice. He had concentrated upon his photography rather than the public turmoil of the First World War, the Mexican Revolution or the Great Depression, and he tried to keep his art likewise secure against the more private problems associated with two marriages, four sons, and a raft of lovers.

But by the 1940s the formula of art-over-life no longer worked so well for Weston. On New Year's Eve 1942, he wrote a long, reflective letter to his son Neil, and complained that "it is the uncertainty of my direction which disturbs."[2] Weston never quite found that direction after the *Leaves of Grass* project, and his art meandered through a set of compositions that were freakish even by his own standards and which for a time inhabited the maudlin terrain of pet photography. On occasion he returned to familiar topics like the coastal landscape, but Weston's late work was dark and tenuous, without the light and confidence of earlier times.

If there was no longer an assurance to Weston's art amidst the problems of life, the problems of his life proved devastating for his art. Photography is a craft of precision as well as imagination, and despite his studied insouciance, Weston's greatest accomplishments were products of fastidious, exacting effort. But as his imaginative vision became less certain during the 1940s, his hand also grew less reliable. Tremors racked his body and he became the prisoner of a terrible, debilitating disease. The devastation was compounded, for as the illness insidiously progressed, his marriage also began to fail, and Weston eventually lost the woman who had become a partner in his art as in his life.

These tragedies took place against the backdrop of World War II and in some ways the war's uncertainties and challenges further complicated Weston's miseries. But the conflict was also something of a welcome relief with its compelling news flashes and its opportunities for war work. Certainly Weston acknowledged the gravity and destruction of the war, but still he embraced it with an enthusiasm born of his own misfortune, for it offered both the assurance of a good cause as his other commitments grew ambiguous and the satisfaction of meaningful activity when so much else seemed futile.

When Pearl Harbor was attacked, Weston and Charis were traveling in the East as part of the *Leaves of Grass* project. Weston cut short the trip and the couple returned home months before they had planned.[3] At earlier stages in Weston's life, few things had drawn him away from photography and forced an early termination of a project. But as his surety within his art weakened, and as he struggled to remain independent of Whitman's vision, Weston manifested an uncharacteristic attachment to Carmel and the home that he and Charis had built on Wildcat Hill. Overlooking the Pacific, that house seemed vulnerable and

exposed, and though it is difficult to image any practical defense that Weston might have mounted, he was nonetheless preoccupied with notions of protecting Wildcat Hill from invasion.[4]

By the time Weston and Charis arrived home in January 1942, it was pretty clear that the Japanese were not going to attack mainland North American. Still, though, there was disturbing talk of evacuating civilians from immediate coastal areas, and although nothing eventually happened, the general mobilization had other unsettling consequences, for the five younger men in Weston's life—his four sons and Charis's brother Leon—all faced the call to arms. Cole and Chandler served in the Navy, Brett was a cameraman in the Signal Corps, Neil was a commercial fisherman, and Leon became an imprisoned conscientious objector. With all the "farewells and farewells, and then visits on leave," Weston said that he had "seen more of boys since inductions than I have in years,"[5] and he marked the occasions with a series of photographs made in the vicinity of Wildcat Hill, warm portraits of young men in their prime. Reminiscent of the familial, scrap-book images Weston had made when the sons were children, these were not art photographs and instead register a quite personal anxiety over those being drawn into harm's way.

War had other troubling implications that related more directly to Weston's photography. The turmoil made him concerned about the safety of his life's work, and he dispersed some of his prints, sending one set to curator Nancy Newhall at the Museum of Modern Art in New York. In addition, wartime rationing curtailed civilian use of photographic chemicals and papers, rationing of gasoline and tires effectively ended Weston's photographic travel, and even nearby Point Lobos was closed when the Army made it a military reservation.

In the face of such restrictions, much of the excitement that had earlier gone into photography now surfaced in an enthusiastism for the war effort. Where the Daybooks had been filled with discussions of images and the jargon of camera and darkroom, Weston's correspondence now brimmed with war issues and was peppered with the V-for-Victory symbols. He was jealous of younger men who served in uniform, and announced his desire "to be in a plane with a machine gun heading for Tokyo."[6] He tried unsuccessfully to find civilian war work as a photographer, but eventually he and Charis became coastal observers in the Army's Aircraft Warning Service, "watching from a rock promontory within walking distance of our house…with compass and phone…reporting each & all planes & ships."[7] World War II was a remarkably participatory affair for Americans, with so many volunteer jobs and boosterish programs that even an unlikely character such as Edward Weston could feel that he was making a contribution to the cause. Even vegetarianism took on a patriotic flavor during the war, and Weston bragged about the hours he spent in his Victory garden.[8]

The war also moved Weston to an uncharacteristic awareness of and involvement in political matters. He engaged in letter-writing campaigns that he thought of "as part of my war effort," denouncing Congresswoman Claire Booth Luce for her isolationism, praising Congressman Bill Rogers for his stand against red-baiting, and demanding the resignation of State Department officials reportedly sympathetic to Franco's Spain.[9] Long on outrage, quirky in analysis, and insulting in tone, these letters are the work of a naïve crank, someone with more bile than

political savvy. But it was soft drink companies that received the worst of Weston's wrath. He was outraged by Pepsi's claim that a bottle of soda held more food value than a potato. These advertisements were, Weston wrote, "a stinking low ebb in decency and deceit," and he called the opportunists of "the Pepi Wunki group" a bunch of "bastards."[10]

Such concerns surfaced in Weston's wartime photography, imagery as angry and eccentric as his letters. These were some of the most contrived photographs of Weston's career; even he thought of them as "bitter" and "very symbolic."[11] In truth, though, these might better be described as odd and cryptic images, with the strangeness of the Guggenheim shoe pictures ripening into an inadvertent surrealism as Weston ventured into the unfamiliar territory of social commentary. One image, for instance, depicts a carefully constructed but baffling arrangement of Kotex box, dry-cell battery, table salt, and a daisy. Another image was entitled *Good Neighbor Policy* (1943) in reference to Franklin Roosevelt's foreign policy affirming Latin American autonomy, suggesting that the policy had been corrupted by wartime profiteering. *Good Neighbor Policy* depicts a small, Latin-American statue, arms outstretched receptively, or maybe even pleadingly. Yet rather than receiving some useful American product, the figure has between its arms a six-pack of Dr. Pepper emblazoned with bogus nutritional claims, and the product's trademark clock face stands indicted by a broken watch that Weston included in the composition. There is a bitter symbolism to such images, but of a very private kind, for only if one is familiar with Weston's quirky complaints is it possible to tease his message out of this strange work.

Similar strangeness occurs in Weston's wartime images of Charis. In some of these images, the combination of props and captions makes the war rather than Charis the more prominent part of the image. One is called *7 A.M., Pacific War Time* (1945), an early-morning photograph made at Wildcat Hill, with misty woods beyond the roof of the house. Charis's arm, just barely included at the bottom of the frame, is turned so it is possible to make out the time (seven o'clock) on the watch she wears. Two other images, both entitled *Civilian Defense*, depict a nude Charis, posed on the couch and wearing only the gas mask issued with the aircraft warning job. These are sinister-looking images, and despite Weston's disavowal of surrealist commentary, they have the appearance of a critique upon the horror of war and the way that war's ugly accoutrements can obscure the body's beauty. More directly, these images are an indication of Weston's artistic awkwardness at the time; trying to adopt an unfamiliar subject into an established motif, Weston found that the visual impact of the mask overpowered the body, and his efforts to balance the mask with additional props—peaches, a fern—were unsuccessful. More subtly, these images also give some indication of Charis's place in Weston's photography and life of the war years; she is obscured, and in the case of the wrist-watch photograph, almost out of the picture.

According to Charis, this distance was of her own choosing. She threw herself into the war effort, working not only at the observation post, but also volunteering for shifts at the local fish cannery, and designing training aids for other coastal observers. Patriotism was among her motives, but it was not the only one, for as she told an interviewer, "Edward was simply not himself in the war

years," and so "I tried to stay out of the house with various volunteer jobs as much as I could."[12] Thus civilian defense provided a mask in more ways that one, a set of jobs and enthusiasms both Weston and Charis could assume to hide the pain of a troubled marriage.

The tension between them had existed for some time. Weston believed that they "began to break down as a team as far back as the Whitman trip."[13] They kept trying, though, to maintain the relationship and somehow to work photography back into it. The nudes were Weston's effort, and Charis went along with his ideas. Charis was the more serious cat-fancier of the two, and *her* project was a photo-book depicting the amazingly large number of cats that shared the house with them. This time it was Weston who went along, and as he said "I started photographing cats because Charis goosed me on."[14] Finally, though, nothing worked. On November 15, 1945, three months after the Japanese surrender, and when the war no longer provided distractions, Charis left Weston and within a year they were divorced.

Parkinson's Disease was one of the ways Weston was not himself in the war years. Parkinson's is a degenerative and irreversible brain disorder, slowly and inevitably leaving its victims with tremors, rigidity, and the inability to control voluntary movements. Victims typically live for years, even decades, with the disease, and usually with little mental impairment: in one of its most hideous qualities, advanced Parkinson's leaves the fully-aware mind trapped within an uncontrollable body.

By 1945 Weston's handwriting began to show signs of tremor, and in portraits of the time his face also manifests Parkinsons' typically mask-like appearance. He complained of weakness, another common symptom, and a local physician claimed to recognize Weston's peculiar gait as the characteristic Parkinson's shuffle. The definitive diagnosis was not made until 1948, but by the end of 1945 Weston and those around him knew that he was seriously ill.[15]

The horror of Parkinson's is compounded for the photographer. Other vocations and activities can be maintained for some time in spite of the tremors, but not this art that is so dependent upon manual precision. To an individual such as Weston, for whom life and photography were inseparably combined, Parkinson's was a sentence to an early, living death. Photographer Margaret Bourke-White, another Parkinson's victim, described it as a disease that "works its way…into all that is graceful and human and outgiving in our lives, and poisons it all."[16] Weston never wrote quite as directly about Parkinson's, but in 1944, at about the time when his own symptoms began to surface, he said that his sister May had suffered "something almost worse than death" when she was paralyzed with a stroke.[17] Soon photography became more difficult for Weston, and then finally impossible. Weston's last composition was made in 1948 and by 1953 the cameras were put away for good.

Parkinson's exerted an ever-constricting grip on the remainder of Weston's life. His medical treatments were limited to marginally effective antispasmotic drugs. By 1948 his voice had grown weak, and although his interest in women continued, at some point sex became an impossibility. Writing required exhaustive concentration, and after 1948 Weston's letters became shorter, the lines shakier, and the pages dotted with ambiguous but tragic stains: perhaps they are marks from the sweat of his effort, perhaps they are from the tears of his frustration, or perhaps they indicate the

drooling typical of some Parkinson's victims. As if all this was not enough pain, Weston also underwent a series of three unsuccessful hernia operations, and during the same years his sister May died, and son Neil's wife and baby were both stricken with polio. Weston went through understandable reactions, including anger, denial, and despair—"Wouldn't you be depressed?" he asked Beaumont Newhall.[18]

Weston's disease meant that there was a vicarious quality to much of the last decade of his life. Toward the end of the war he had embraced the progressive politics he had once eschewed, joining the Progressive Citizens of America, and looking forward to 1948 and the presidential candidacy of Henry Wallace. But as that election approached, Weston could only cheer from the sidelines. In the spring of 1948 he was scheduled to make a portrait of Wallace during the candidate's swing through California. But, as Weston said, "my sitting of him a flop," and the most that Weston managed to do for the campaign was to honor Paul Strand's request and donate some prints for a fund-raising art auction (Strand: "Do take care of yourself and never capitulate—").[19] There was a Weston presence in the 1948 California elections, but it was Cole, running for Congress on the Progressive ticket.[20] There was a similar work-by-proxy in other less political arenas of Weston's last years. Nancy Newhall began editing his Daybooks for publication, Willard Van Dyke created a film about Weston and his photography, and Merle Armitage and Virginia Adams each published books of his photographs. In the last great project of his life, Weston supervised as Brett and Cole used his negatives and printed a large number of images destined for museums or other such institutions.

Edward Weston's life and art were intertwined with each other. The interrelationship was played out with a particular vividness, with the biographical most often subordinated to the aesthetic. With his one-track mind and his commitment to photography, Weston set himself upon a life of simplicity, a life pared of the distractions of both material possessions and familial relations. The appetites of the man and the longings of the artist were tangled with each other, so that the women he loved and the foods he relished were often indistinguishable from the subjects he arranged and the models he posed. Throughout much of his career, the phases of Weston's photography and his biography moved along in accompaniment with each other. Flora and family life fit in nicely with his early portraiture, Mexico and its folk artists complemented an emerging interest in simplified form, and Charis and the car meshed well with that later concern for the lay of the land.

This simultaneity was something Weston recognized—indeed he often managed it—and from time to time he worried that life and art might fall out of phase with each other, that one might end before the other was completed. Over the years Weston wrote about the relationship between completion and conclusion, with repeated reference to a poem by his friend Robinson Jeffers. In this piece about the timeliness of death, one particular line caught Weston's eye: "We are safe to finish what we have to finish." When Weston first read the line in his mid-forties, he understood Jeffers to be offering a guarantee that death will not arrive prematurely before our life's work is completed—that, as Weston paraphrased him, "we live on until our reason for existence ends, until we have finished our work."[21] This was a reassuring promise for an artist then in the full flush of his work.

In the end synchronicity deserted Weston. In his forties he had been fearful that he might die before he was finished with his photography. But the truth of his sixties was much different—his art had ended long before his life. Writing to Adams in 1952 and again in 1954, he returned to that Jeffers poem. The issue remained one of timeliness, but now Weston was concerned about the premature end of work rather than premature death, and the line that had once seemed to promise that things would turn out well now reminded Weston that he had been cheated out of a timely finish. "Was I cut off from my creative work at just the right time?" he asked Adams, "Was I through? I don't think so..."[22]

On New Year's Day 1958, Edward Weston died alone at his home in Carmel. His four sons spread his ashes at Point Lobos.

———

1. Tina Modotti to EW, July 7, 1925, in Amy Stark, "The Letters from Tina Modotti to Edward Weston," *The Archive* 22 (January 1986), 39.
2. EW to Neil Weston, December 31, 1942, EWA/CCP.
3. Already there was tension between the two, and now Charis favored a more leisurely trip back to California. But Weston prevailed, and as he put it, "when war broke out we scurried home. Charis did not want to scurry. I did." DBII, April 22, 1944, 287.
4. EW to BN and NN, December 27, 1941, Beaumont and Nancy Newhall Collection, CCP.
5. EW to Willard Van Dyke, [July 1941], in Leslie Squyres Calmes, *The Letters Between Edward Weston and Willard Van Dyke* (Tucson: Center for Creative Photography, University of Arizona, 1992), 41-42.
6. EW to NN and BN, September 20, 1942, Beaumont and Nancy Newhall Collection, CCP.
7. EW to BN and NN, March 2, 1942, Beaumont and Nancy Newhall Collection, CCP.
8. Charis later said that the garden was hers, not his, and that Weston's claims were inflated. Charis Wilson Weston and Wendy Madar, *Through Another Lens: My Years with Edward Weston* (New York: Farrar, Straus & Giroux, 1998), 324.
9. EW to Willard Van Dyke, March 8, 1943, Van Dyke Collection, CCP.
10. EW to Neil Weston, May 7, 1942, EWA/CCP. EW to "My boy," 1944 or 1945, EWA/CCP.
11. EW to NN and BN, July 13, 1943, Beaumont and Nancy Newhall Papers, CCP.
12. Theodore E. Stebbins, Jr., *Weston's Westons: Portraits and Nudes* (Boston: Museum of Fine Arts, 1989), interview with Charis Wilson, August 10, 1989, 36.
13. EW to BN and NN, November 16, 1945, here from Amy Conger, *Edward Weston: Photographs from the Collection of the Center for Creative Photography* (Tucson: Center for Creative Photography, University of Arizona, 1992), "Biography," 41.
14. EW to Minor White, [ca. 1946], EWA/CCP.
15. Charis underlined the symptoms of Parkinson's in a family health book sometime before she left in November 1945, and in February 1946 Cole realized that his father was sick. Conger, Edward Weston, "Biography," 41. Cole Weston, afterword in Ben Maddow, *Edward Weston, His Life and Photographs: The Definitive Volume of his Photographic Work* (Millerton, NY: Aperture, 1979, rev. ed.), 286-88.
16. Margaret Bourke-White, *Portrait of Myself* (New York: Simon and Schuster, 1963), 364. Vicki Goldberg, *Margaret Bourke-White: A Biography*, (New York: Harper & Row, 1986), 345-61.
17. DBII, April 22, 1944, 288.
18. EW to BN and NN, March 18, 1948, Beaumont and Nancy Newhall Collection, CCP.
19. EW to Chandler Weston, May 21, 1948, EWA/CCP. PS to EW, October 12, 1948, EWA/CCP.
20. Edward Weston, Family Albums, compiled by Flora Chandler Weston, J. Paul Getty Museum.
21. DBII, March 27, 1932, 252.
22. EW to AA, May 20, 1952, and March 28, 1954, here from Conger, *Edward Weston*, "Biography," 44.

PART FOUR

Ansel Adams

15. Hard Rock Transcendentalist

Though the artistic accomplishments of Ansel Adams (1902-1984) were middling compared to those of Alfred Stieglitz, Paul Strand, or Edward Weston, he shared much of their tradition and many of their qualities. Like them, he was mesmerized by certain subjects, and where Weston was transfixed by peppers and nudes, Strand by certain faces, and Stieglitz by O'Keeffe and then clouds, Adams had a similarly arresting, though perhaps more intense or even mystical, relationship with the mountains and granite of the American West. Like Stieglitz at Lake George, Strand at the Gaspee, and Weston at Point Lobos, Adams staked an artistic claim to his own particular place: Yosemite Valley and the Sierra. Adams worked tenaciously and reverentially in the California mountains, and he was singular in his life-long devotion to landscape photography.

By the 1960s and 1970s, Adams had achieved what Stieglitz so dearly sought at the century's dawn. Thanks in large part to Adams's stunning marketplace and popular successes, photography became accepted as a fine art; if Stieglitz's method had been to trumpet photography from supposed pinnacles of American culture, Adams managed to achieve its recognition from the bottom up. He accomplished this by offering images that were not nearly as challenging as Weston's nudes or Strand's abstractions, photographs that often reified nineteenth-century notions of nature spirituality. Up through the 1930s Adams demonstrated all the reluctance of Stieglitz and Weston to become involved in American politics, but by the 1960s his political involvement and leadership equaled that of Strand at his most active. But Adams's was a politics of the environment, and though his praise of community and his critique of individualism echoed some of Strand's left-wing positions, Adams's efforts were much less ideologically charged. Like his art, Adams's politics were safe and approachable, and his environmentalism was enormously more popular than Strand's socialism.

Adams knew each of the other three photographers—Weston especially well. He was more affable than the others, less a prima donna than Stieglitz, and more gregarious than Weston. Yet his ego was no less sizable, and he shared their concerns for claiming a place within an American art canon. Even more than his compatriots, Adams insured that his record would be available for history. He generated an immense pile of documents and images over the course of a lifetime, and then created the archives to preserve and display them; he closely cultivated historians, and when they proved inadequate for the job, produced his own deathbed autobiography. Keenly aware that his was one of the thinner reputations among American art photographers, Ansel Adams went to extraordinary efforts to cast the longest shadow.

Ansel Adams was born and raised in San Francisco. His maternal grandparents had moved west from Baltimore in the 1860s, settling first in Nevada where his grandfather prospered as a businessman. A few years earlier his paternal grand-

parents had settled in northern California, where his grandfather became a very successful lumberman, creating a large company that razed acres of Pacific Northwest forests and supplied much of the lumber that built the booming town of San Francisco. The greatest familial influence upon Adams was his father, Charles Adams; from early childhood Adams had a deep affection for the man and craved his approval, and well into adulthood sought his father's benediction for choices of career, marriage, and art.

Charles Adams loved nature and science, and dearly wanted to be an astronomer. But after months of travel in Europe and two years at the University of California, he assented to parental pressures and entered the family lumber business. In 1896 he married Olive Bray, who in 1902 gave birth to their only child, Ansel. Under Charles's direction the lumber business spiraled into disaster, its mills succumbing to fire and its fleet to shipwreck; by 1907 most of the enterprise had collapsed, and the final demise came when fraudulent partners ruined a scheme to manufacture wood alcohol. For the rest of his career Charles supported his family by selling life insurance, all the while festering with resentment against the business world.

Yet Charles also managed to provide his son with a life of middle-class gentility. The collars were high and tight, the nanny and cook both slept in the house, and the boy's questions about sexuality were deflected. In Ansel's childhood books, domestic crises ended happily with all the proprieties preserved, and technology was a benign and fascinating presence. There was also an air of intellectual tolerance in this household where Charles remained an active member of the regional astronomical society. Undoctrinaire in many regards, he encouraged Ansel's curiosity and provided an intellectual atmosphere conducive to the growth of what Adams later called "my particular amorphous sense of deity."[1]

Adams's childhood home was located in an isolated spot on the Pacific side of the San Francisco peninsula. In a 1903 photograph that Charles Adams made looking northward from the residence, a fence snakes its away from the house along a crest line of dunes, and in the background there is a magnificent view of the Marin Highlands across the Golden Gate channel. The house was one of the first built in the area, and later in life Adams would describe the location as an idyllic natural area where he could roam freely; but the life of the bustling city was not far back of the dunes, and Charles commuted daily to his work in San Francisco. House and family survived the great 1906 earthquake and fire with only minimal damage; the breakage was limited to plaster, crockery, chimneys, and Ansel's nose—fractured when an aftershock threw him against a wall. Never reset, the nose remained crooked for the rest of his life, tracing between Adams's eyes a crooked line resembling the ridge line beyond the house.[2]

A hyperactive child inclined toward prowling thickets and collecting insects, the fidgety Ansel proved a difficult student and unpopular classmate. His elementary teachers eventually sent him packing, and thereafter he was taught at home where the curriculum was an odd mix of the classic and unconventional. His father instructed him in French, Algebra, and astronomy, and oversaw a reading list of standard English texts, while a tutor was retained for

instruction in Greek. But Charles was flexible (or perhaps frustrated), and the 1915 lesson plan was nothing more than a pass to San Francisco's Panama-Pacific Exposition. There Ansel wandered among the fountains and statuary, visited the science displays, and played at the business machine exhibitions. As a youngster he also discovered music, and Adams took to the piano with perseverance and considerable natural talent. He proved to be very good, and committed himself to a career as a professional pianist, foregoing college to concentrate on musical studies.

If art came to Adams early in his life, so too did his particular bit of geography. When he was ill in the spring of 1916, an aunt gave him a copy of James Hutchings's *In the Heart of the Sierra* (1888). This embossed, fusty nineteenth-century guide to Yosemite Valley, written by a hotel proprietor, presented schemes for developing the valley along with morally uplifting entertainments for snowbound winter evenings. But there were also elements in the book that would appeal to a fourteen-year-old male: sections on insects, lizards, and birds, and the illustration of an "Indian Marriage Ceremony" complete with bare-breasted bride. There were also verbal descriptions of the landscape, and whether these sections appealed to Adams's nascent interests or primed him for his early exposure to the valley, this romantic orientation would later echo strongly in his own Yosemite imagery.[3]

Fascinated with these descriptions, Adams insisted that the family vacation in Yosemite. And so it was that in June 1916 he first encountered the undeniable grandeur of the magnificent waterfalls, terrific heights, and wondrous granite giants. But Ansel Adams never knew an undeveloped Yosemite; by the time he arrived it was at best a well-worn, well-known portal to wilderness. As early as 1902 there were phones, a school, a power plant and a complement of photographers' and painters' studios; in that summer of 1916, young Adams's accommodations included bus transportation, a dining hall, and maid service. There was also a range of ghastly attractions for visitors, including passageways cut through the living heart of giant trees, and a nightly "firefall" of burning logs cascading to the valley floor.

None of this seems to have dampened Adams's excitement over Yosemite. During that first summer, and then continuing in subsequent family vacations over the next few years, he embraced the place with a hyperkinetic enthusiasm. He hiked the valley floor, swam in its waters, and darted through its waterfalls. There in 1916 he received his first camera and made his first photographs, and he soon became a regular visitor to a Yosemite photo-processing studio. In the next several years he ventured into the back country, augmenting his valley experiences with climbing, packing, and camp cooking.

As Adams grew into young manhood, Yosemite became the enchanted treasure spot of his most intense and even essential scenes and experiences, a place keenly beloved—even to the point of fixation. In San Francisco during the spring of 1919 Adams became, like Paul Strand's mother, a victim of the great flu epidemic. Fortunately he recovered, though the recuperation was lengthy. Once again people gave him books to read, one of which was an account of Father Damien, the priest who cared for lepers in Hawaii and eventually contracted a

fatal case of the disease. Apparently Adams's friends and family had not realized how suggestible he could be when ill, and in this instance Adams became convinced that he too was in danger of contracting leprosy, and that Yosemite was the one place safe from disease. Though still very weak, he insisted on summering there, and as his strength returned and his phobia receded, Adams concluded, as he later said, that "Yosemite had cured me!" Adams closely tracked his recovery that summer, monitored his pulse and respiration rates even into the next year, and became convinced that "the mountains...will be a lasting influence over my health."4 Thereafter Yosemite was like an essential tonic for Adams, a place not only of natural beauty but also preternatural succor, and until late in his life he contrived to spend at least a portion of each year in the Valley. The most immediate of those strategies involved the Sierra Club, which ran a summer lodge in the valley. In 1919, while still recovering from the flu, Adams landed himself the job as summer custodian of the lodge, and the following year he began the first of his four seasons as resident caretaker. No longer just a visitor to Yosemite, he had joined the clan of concessionaires and others who had greater claim upon the valley.

But at this point in the early 1920s Yosemite was still only a summer place for Adams. In the future he saw before him, he imagined a life dedicated not to the mountains but to the piano. He particularly enjoyed the music of Bach and Beethoven, finding in them qualities that he later tried to bring to his own photography. In Bach he saw that strong architectural dimensions can still provide for a sense of swelling and transport, and in Beethoven he saw that overpowering majesty can still maintain the detail and delicacy of a soft solo. There was also in Adams's dedication to the piano a certain deferential resolve, a feeling that music might furnish him with a life of serious purposefulness and aesthetic accomplishment while fulfilling an unambiguous filial obligation. Charles let it be know that he expected lofty achievements from his son, and, given Charles's terrible experiences, those expectations understandably flowed in directions other than business. Ansel later told a friend there was "a certain 'unworldly' quality about the point of view that was drilled and dynamited into me." Presumably there were a number of other noble and unworldly occupations that Charles might have blessed—science seems a likely one—but art met the criteria nicely, and once the selection was made, Charles so exalted the choice that it became almost impossible for Ansel to renege. "Trained with the dominating thought of art as something almost religious in quality," Ansel seems to have taken a compelling, if secular, set of vows.5

From all indications, he received the charge willingly enough. Adams accepted music as the center of the life ahead of him, recognizing that, although the piano gave him much joy, there would be years of intense practice before he achieved the desired concert-level skills. The other portions of his life were to be secondary to this larger pursuit. He envisioned photography as a gentlemanly hobby that might even generate a little income (by this time he was making school photographs). Yosemite and the Sierra might be essential, but only for restful interludes in his San Francisco life of practice (and the occasional performance). Over the next decade Adams struggled to keep these elements of this life in their allotted places. He sel-

15.1. Ansel Adams. *Lodgepole Pines, Lyell Fork of Merced River, Yosemite National Park, 1921,*
Copyright © 2000 by the Trustees of the Ansel Adams Publishing Rights Trust/CORBIS.
All Rights Reserved.

dom doubted that his would be a life of seriousness and art, but it took consider-
able effort to maintain music as his priority, for there were plenty of temptations
leading him away from the piano.

One of the temptations was a woman. To keep his fingers limber during
those long Yosemite summers, Adams began practicing on a piano located in the
studio of landscape painter Harry Cassie Best. As a young man Best had become
enamored with Yosemite, and settled there after marrying a woman who worked
in one of the Yosemite photographic concessions. Adams promptly fell in love
with Best's daughter, Virginia, who was studying to be a singer. By the summer
of 1922 the two were deeply involved, and the following year they became
engaged. Virginia had some doubts about Adams's commitment to the piano. He
seemed to spend so much time making photographs rather than working towards
the concert bookings that might support them. Responding to her concerns in
1922, and again in 1923, Adams promised to concentrate on his music, with pho-
tography just "a means of incidental income until I find my music is filling my
time; thereafter the photography will become a hobby only." But he would not
concede that photography was a frivolous pastime, and he insisted that his own
images would be fine works, conforming "to the best standards of the art—for
photography *is* an Art."[6]

Thus even in the early 1920s Adams hoped that his photography would aim beyond mere pictures and achieve the significance and weight of a recognized Art like music. Some of his early photographs were commonplace snapshots, visual records of his trips to Yosemite or excursions along the Pacific beaches. Yet his photography no less than his music was imbued with lofty expectations, and by the early 1920s he had acquired many of the conventions of pictorial photography. He adopted processes which yielded soft prints, and poetic pretensions appeared in mountain scenes with titles like *Abode of Snow*. Such works evinced a romantic love of obscurantism, the kind of thing one sees in an images like *Lodgepole Pines, Lyell Fork of Merced River, Yosemite National Park* (1921; fig. 15.1). Here the soft focus conveys a mood of quiet dreaminess. Adams employed water in the lower portion of the image to repeat the dreaminess above, reflecting the softness of the scene. The lighting is more diffused than directed, with small diamond-like sparkles ticked out here and there in the photo. Throughout the image, the details are difficult to discern, individual stones or grasses are hard to see, and the photograph is more one of forest than of trees.

This was Art, and it took work. Adams's aspiration, as well as the thought and effort necessary to achieve it, were documented in a 1920 letter to his father where he described still another softly focused stream image. Adams explained that the image had been framed in his mind for several days, and that, when it came to making the exposure, he waited yet an additional four hours for just the correct light. The triangular composition was carefully considered, and Adams sent not only the photograph but also a sketch of his intentions, the triangle's points neatly labeled in the best geometrician's fashion. He had purposefully chosen the soft-focus rendition because "a cold material representation" overwhelmed the cascade's essential character with too many details. "What I am trying to do in pictorial photography," he wrote, was to accomplish a "suggestive and impressionistic" interpretation through images like *Lodgepole Pines*, what he described as "the representation of material things in the abstract or purely imaginative way."[7] With its verisimilitude thus toned down, Adams's photography could approximate some of the less representational and more purely abstract qualities of his primary art, music.

If photography and Virginia lured Adams away from music, the mountains were an even greater temptation. Yosemite and the Sierra worked a kind of spell upon him, and even with the practice arrangements at Best's studio, Adams's playing inevitably became rusty during his Yosemite summers. Adams voiced some guilt ("my conscience troubles me") over the self-indulgence of "spending the summer in so wonderful a place" when he could be practicing in San Francisco.[8] In the summer of 1922 he expressed these concerns to his father in a letter that was only a slightly oblique request for approval of all the mountaineering, and when Charles replied by blessing the summer arrangements, Adams's relief was almost palpable.[9]

During the summer he increasingly ranged beyond the immediate Yosemite area and into the more remote Sierra above the valley. Some of these were solo trips, and for years afterward Adams continued to relish "the wondrous experience of wandering completely alone (except, perhaps, for my

donkey).["10] At other times he had human company, for he gradually moved from being a Sierra Club employee to become an active participant in its distinctive alpine culture. Club members annually ventured into the back country on High Trips, massive expeditions that could involve hundreds of people, mountains of supplies, and dozens of pack burros. Adams's first High Trip came in the summer of 1923, and his enthusiasm for music seldom equaled the excitement of his trail experiences. One day he found himself beside "a placid lake, rimmed with a rich evergreen forest." Another time, at night, staring up from his blankets, "I watched the stars slowly stream over the earth" and saw "the Galaxy, a vaporous plume of white fire, poured down the southern sky." Nor were his descriptions purely visual, for the Sierra offered a music Beethoven and Bach could not rival, "the primal song of the wilderness."

As Adams described them, these high country experiences had the classic attributes of mystical moments. There were trance-like states brought on by exhaustion after "the days of dusty toil, the weary miles of laborious climbing and descent." Consequently Adams could end the day "in a stupor" and at night find himself lying beneath stars that proceeded across the sky "with almost hypnotic persistence," transfixed in the midst of his mountains and transported in "a delicious process of unearthly experiences." In such instances, Adams said, he achieved a stillness "discounting civilization and chronological time."[11]

Adams had help in attaining this blissfulness. His experiences were in part shaped by companions who guided his vision as well as his footsteps, and also by a broader tradition that conferred special status upon the landscape he trod and legitimized the transport he experienced. Yosemite, along with much of the rest of the Sierra, was well-aestheticized by the early 1920s, and for decades had been accepted as both an art subject and the locus of art creation. The very first painter entered Yosemite a mere four years after the earliest whites, the first photographer four years after that, and resident studios were in place by the 1880s. Adams was well aware of this art tradition, and of the more accomplished, non-resident artists who visited and worked in Yosemite: photographers Eadweard Muybridge and Carleton Watkins, painters Thomas Moran and Albert Bierstadt.[12]

These were romantic artists, inclined to bring notions of the sublime to their images of the mountains. Throughout the early 1920s Adams resonated with this romantic appreciation of Yosemite and the high country, and at times he too experienced his own moments of sublime frisson, as on one hypnotic Sierra night when "the stars loomed with terrifying brilliance, the darkness beyond them throbbed with unseen light."[13] Adams hoped to bring some of that mood into the photographs he made with "my first funny plate-camera...that I animal-packed and back-packed over unimaginable miles or rocks and roughness and pointed at amazed landscapes." The mountains' peculiar light, shimmering waters, and magnificent views called out for photography's representational powers, for it seemed to him that "there was no imaginative experience with which to compare this magic actuality."[14]

Yet for all this sentiment there was little magic in Adams's early mountain photographs. A few have soft-focus intimacy akin to *Lodgepole Pines*, but the larger effect is one of remoteness and detachment. His mountains appear in a far-to-mid-

dle distance, screened by some tree or bit of shrubbery. The images are busy, too, so that a granite peak appears not in isolated majesty but instead becomes lost in a cluttered horizon. By the middle part of the 1920s Adams had not yet managed to translate the intimacy of his ecstatic, timeless mountain experiences into the black-and-white surfaces of his prints.

There were additional ideas, some scientific and some poetic, that further complemented Adams's growing alpine enthusiasm. His early life had in part prepared him for these new influences, for his father's astronomy had acquainted him with the relatively smallness of things human, and in his reading of Shelley's idealism and Thomas Paine's deism he had encountered a teleological universe suffused with basic goodness and drifting along a benign course. Such notions of cosmic scale and cosmic optimism were reinforced by the thinkers and ideas Adams discovered in the 1920s.

John Muir (1838-1914) was one of them. As founder of the Sierra Club and a prolific nature writer, Muir was an enduring force in California's alpine culture. Muir's childhood Protestant fundamentalism evolved into a nature pantheism, and when Muir came to Yosemite he grew to regard the valley as a kind of natural cathedral. He had a keen interest in geology, and in the intense geological debates of the century; it seemed to him that Yosemite's granite forms supported the glaciation theories of "uniformitarians" like Charles Lyell rather than their biblically inspired "cataclysmic" opponents who accepted the Flood and other stories. Also, Muir believed that humans should revere rather than exploit nature, and he was a leading voice in conservation causes of his day.[15]

Adams first read Muir in the early 1920s. It is not clear precisely which of Muir's many works he encountered, but he later published his own photographs with excerpts from 1916 editions of Muir's *The Mountains of California* and *My First Summer in the Sierra*. In such writings, Adams found legitimization for his own countless hours spent in the mountains, and as he later said, "on first reading his texts on the Sierra I became more confident of the validity of my own experience in nature."[16] Indeed, like Adams, Muir relished first-hand encounters with the Sierra. When Ralph Waldo Emerson had visited Yosemite in 1871, Muir tried to correct what he called Emerson's "indoor philosophy," to "steal him" from his party for "a month's worship with Nature."[17] The effort failed—Emerson only took time for a day trip—but when Muir founded the Sierra Club in 1892, he created an institution largely dedicated to getting people into the California mountains.

Muir was Club president until his death, and under his influence it developed a companionable mountain ethos. It attracted Bay Area intellectuals, and academics from Berkeley and Stanford. In Muir's time the membership included Joseph LeConte I, a renowned geologist who believed that nature offered divine revelation (the Yosemite Lodge was a memorial to him), and in his day there were other, similarly inclined members, such as Joseph LeConte II, a geologist like his father, or Jessie Whitehead, daughter of Alfred North Whitehead. Adams savored "the spirit of comradeship and sympathy of ideals" to be found in club outings, and he became particularly close to Cedric Wright, twelve years his senior and something of an older brother to him.[18] Wright shared many of Adams's interests, for he too was a musician (the violin) and a hiker who made photographs in the mountains.

Sometime between 1923 and 1925, Wright introduced Adams to the work of English author Edward Carpenter (1844-1929), including Carpenter's book-length poem, *Towards Democracy*. Carpenter's ideas were drawn in part from the *Bhagavad Gita*, which he began reading during an Indian sojourn, and also from Walt Whitman, whom he visited in 1877 (*Towards Democracy* was modeled upon *Leaves of Grass*).[19] Carpenter granted no important distinctions between mind and matter or, between humanity and nature; a monist but not a materialist, he thought the natural world was full of spirituality, and *Towards Democracy* portrayed a "Voice of the Woods" that was indistinguishable from the voice of humanity.[20] Almost completely forgotten in subsequent years, Carpenter was better known in his day, influencing British writers like E. M. Forster, and the wartime generation of Wilfred Owen and Siegfried Sassoon. Carpenter's ideas surfaced elsewhere in American art photography circles: Weston found Carpenter quoted extensively in Ouspensky's *Tertium Organum*, and Max Weber used Carpenter in his influential 1910 *Camera Work* essay.[21]

Towards Democracy became an important work for Adams. When he built his first home, he carved a line from the poem above his hearth, and he quoted from the book throughout his life. Adams's greatest resonance with *Towards Democracy* came in the summer of 1925, when he read the work during an extended hiking trip in the Kings Canyon area of the High Sierra. There in the midst of his magic mountains, Adams had a peculiar kind of granite-induced, philosophically tinged epiphany, and in the flush of the experience wrote a quick note to Virginia from his Sierra campsite. "I have never felt that I would find a *religion*," he told her, "but I have done so. The Carpenter book has established a real religion within me." Over the next six weeks he sorted through these experiences, and in a second, more carefully drafted letter to Virginia, he described his Carpenter-inspired "religion" as a kind of rudimentary and polyglot idealism, variously besprinkled with elements reminiscent of Plato, Hegel, and Emerson.

Adams began with a consideration of the constructed urban landscape. Blueprints and designs had preceded all those buildings and machines, and he said that in earlier times he had no difficulty understanding that "these things existed in the mind of man in the form of ideas before they were expressed in the physical world in the form of matter." Now, though, Adams believed he had arrived at a much grander understanding, so that he could see "the lines and forms of the mountains and all other aspects of nature as if they were the vast expression of ideas within the Cosmic Mind." Concluding that "there is nothing in the Universe that is not the expression of mind or of life," Adams was comforted, "assured," for where he might once have viewed the world as a confused and dissonant jumble, he was now an initiate who could behold "the meaning of the world and sense the unity of all things."[22]

That summer of 1925 provided relief as well as revelation. Thanks to his trailside reading of Carpenter, Adams came to think he was not drawn to his mountains out of mere self-indulgence, but that the mountains attracted him because they were particularly bulky expressions of the Cosmic Mind. Trips that he made into the hills might offer "a good, long soul-building rest," but they were also more than recreational, something like pilgrimages in which the supplicant might immerse himself in "the wonderful Spirit of the Mountains."[23]

Even with all its wonder, that Spirit could not resolve some of the concrete problems in Adams's life. At the end of that eventful summer of 1925, Adams was still "having the deuce of a time" as he attempted "to adjust myself and consider my future!" As he considered his obligations to Virginia, the demands of musicianship, and his craving for the mountains, Adams came to feel that "I shall explode unless I eliminate a considerable amount."[24] Away from the calm unities of his mountains, and facing his day-to-day life in San Francisco, Adams fretted about his future and decided to pare back his commitments.

Of all the possibilities, it might have made most sense for him to discard music. Unshackled from his bulky piano, Adams would be free to roam with burro and camera through the mountains—and incidentally be close to Virginia's Yosemite home. The difficulty was that Adams remained committed to Art, and in Carpenter Adams had aligned himself with someone who celebrated music as a particularly noble and idealistic art form. "Music is a flame of Love mounting to the Skies," Carpenter had written, and Adams adopted some of the same vocabulary for his own purposes.[25] In this way music seemed even more precious and more necessary, and it also became more conflated with obligation. If he abandoned the piano at the juncture, when he had done little more than take on a few students, he would be defaulting on promises and shirking "my duty to my mother and father." Though the imperative to please his parents was seldom far from Adams's consciousness, at this juncture it seemed particularly insistent and he cried that "I must present them with *accomplishment*. I must prove worthy of them."[26] Accordingly, when he made adjustments in his life in the early autumn of 1925, it was not music that got discarded.

Virginia was an astute woman. One easily imagines her anxiety rising during August and September as she began to receive from her fiance letters speaking about "new outlooks, new ideas, new possibilities," and quoting lines from Carpenter about the glories of freedom and the difficulties of misunderstood genius. Finally, at the end of September 1925 came the long letter breaking off their engagement. Claiming that it would be criminal for him to neglect his talents, Adams announced that he had spent his marriage savings on an expensive piano, and pledged himself to music rather than her: "I dedicate my life to my Art."[27]

Beginning in the mid 1920s, Adams's circle of acquaintances gradually widened beyond his musical and mountaineering friends. Among those new people was Albert Bender, the well-to-do San Francisco businessman and art patron who arranged for the production and sale of a limited edition of Adams's photographs.[28] Bender also ushered Adams into the thriving art scene of the American Southwest, and beginning in 1927 Adams got to know many of the individuals in the vibrant Taos-Santa Fe community. Some, like D. H. Lawrence, were part of the international crowd that for a time drifted through the area, while others like Strand and O'Keeffe were Stieglitz-circle members who developed more lasting attachments to the area. Others were Southwestern writers like Mary Austin and Frank Applegate, and still others such as Mabel Dodge Luhan and Witter Bynner introduced Adams to the community's rambunctious social scene. These people gave him an intriguing taste of previously unimagined possibilities within the life

of art, that it need not be the tedious or monastic affair Adams had imagined during his hours of piano practice.

With such models, it apparently became easier for him to envision a life that included Virginia. Adams had never broken off communication with her, and when he picked up the relationship in spring of 1927, he pressed his case quickly. Adams proposed when he visited Yosemite at the end of the year, Virginia accepted, and the couple married in Best's Studio on January 2, 1928. Apparently he had come to envision a life of mutual dedication to Art, and he entertained the dream of living and working with Virginia in a sort of art nest, a studio/conservatory of their own design, a place "acoustically correct, and with wall space for my prints" and which would "be a suitable setting for the things we live and work for."[29] Their house got built in San Francisco—next door to Adams's parents—but despite Adams's incredible nagging ("my love for you is directly proportional to your creative work"), the musical parts of the dream were elusive. Virginia proved to be more interested in housekeeping than singing, and she resisted his efforts to mold her life to fit his vision.[30]

Moreover, the appeal of landscape only grew as the music world began to seem petty and narrow, and while the visual arts became increasingly exciting and expansive. The success of painters like O'Keeffe and Marin showed that landscape imagery had an audience. The Southwest showed him new delights, and Taos seemed "a great place...Such MOUNTAINS!!!!"[31] And New Mexico appeared to be a niche that Adams might exploit, for unlike the much-photographed Yosemite, New Mexico had received relatively little treatment. His new friends urged him on, and as he wrote his father from Santa Fe in the spring of 1929, "everyone agrees that I am the only photographer that has come here really equipped to handle the country." Presented with such a chance to make his mark, "I would be a complete chump to disregard it."[32]

Accordingly he collaborated with Mary Austin on what became his first book, a text-and-photo volume published as *Taos Pueblo* (1930). With its attention to cultural documentation, the book had some of the same quasi-anthropological themes evinced in the Mexican work of Weston and Strand.[33] But Adams was clearly more interested in nature than culture, and in his photographs of the pueblo, he took the "great pile of adobe five stories high," transformed architecture into landscape, and depicted the pueblo so that it more resembles a tumbling mountain range than a collection of buildings.[34] He accomplished something similar with his photograph of the same adobe church that O'Keeffe painted almost simultaneously and which Strand later photographed as *Ranchos de Taos Church, New Mexico* (fig. 7.5). Adams lowered his camera so that the small church rises mountain-like in the frame, and managed his lighting so that the building's rounded adobe buttresses resemble talus slopes falling away from the church's base.

The Taos book and his recent photographs were well received. Delighted by the attention, Adams allowed that his camera had become "a serious rival" for his piano. Although there is no inherent reason why one might not pursue both photography and music, it still to him seemed impossible "to keep both arts alive," and he felt increasingly as though the two were competing for his future.[35] In this con-

test, the momentum lay with photography. It was beginning to pay in ways that music never had, for while his piano lessons generated only a minuscule income, his photography landed him a contract to make advertising images for a large Yosemite concessionaire.[36]

Beyond this, photography was better fitted than music to Adams's aesthetic yearnings. Music is of course one of the more abstract of art forms, powerfully capable of communicating emotion or mood, evoking awe or power. But Adams's fascination with the concrete qualities of nature increasingly led him toward a representational art that could trace the details of those beloved objects in ways that music never could. "How I long," he wrote to Virginia, "to feel the contact of everyday, commonplace, material, primitive things—Rock—Water—Wood... I want to make pictures."[37] Representational longings such as this lay behind a remarkable episode, which Adams termed "an experiment," but was actually more of an effort to give music a claim to representational ability. Sometime before the end of October 1928, Adams made the acquaintance of Alfred Richard Orage (1873-1934), another eclectic British thinker like Edward Carpenter. Orage tinkered with social and economic ideas, had mystical proclivities, and after World War I became a devotee of Russian mystic George Gurdjieff. Orage believed, as Adams put it, "that ideas, visual and abstract, and the emotions, could be conveyed... from the musician to the auditor." In the experiment, Adams played for Orage a selection Adams knew to have been inspired by the legend of Odysseus and the sirens. After the performance, Adams asked Orage "what was his ideovisual impression," and when Orage replied that the performance had led him to think of the sea, a shore, and ships, Adams was satisfied that his playing had "convincingly" represented the legend, and that things visual would be "communicated through music."[38]

But the effort was strained, an attempt to make music into something it was not. Try as he might, Adams could not find within it the powerful representational qualities that made photography so satisfying for him. Nor could he bring to music another of his emerging concerns. Consistent with his interest in the likes of Orage and Carpenter, Adams had that growing appreciation for the mystic's sense of timelessness. Music, though, seemed just the opposite: proceeding measure by measure, it is an art imbrued with chronos, ill-suited for conveying experiences such as Adams's Sierra Club trip when "time stood quietly." Of course the individual photograph of nature cannot help but have timely elements to it—erosion, decay, or growth, for instance—yet those qualities are suspended, forever stopped in the blink of a shutter, and in the case of some subjects that were dear to Adams's heart, subjects like his massive granite mountains, time's scale comes closer to infinity than even the most expansive musical composition can manage.

Nor could the musician's career satisfy another of Adams's aspirations. Drawn to enduring subjects, he also wanted an enduring art reputation. From quite early he had begun to collect the materials that future historians might need to document the career and reputation he was hoping to build. By the 1920s his files had begun to swell with carbon copies of his carefully typewritten letters. A difficulty, though, was that Adams had chosen a performance art—he was a musician, not a

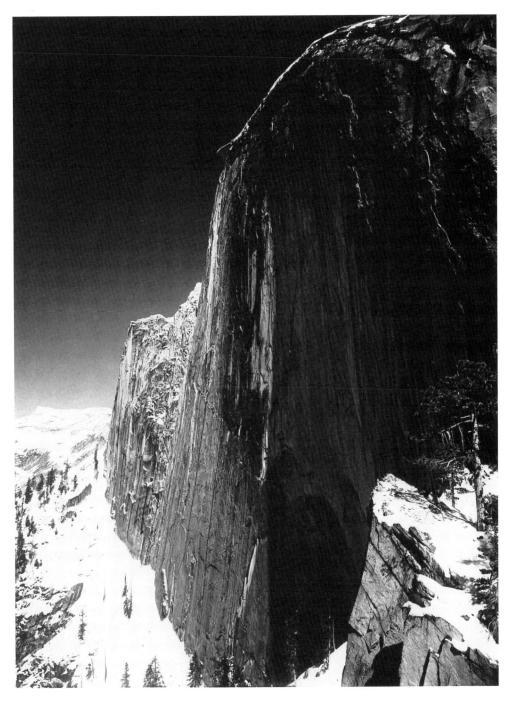

15.2. Ansel Adams. *Monolith, The Face of Half Dome, Yosemite National Park, 1927,*
Copyright © 2000 by the Trustees of the Ansel Adams Publishing Rights Trust.
All Rights Reserved. Courtesy George Eastman House.

composer—and his piano accomplishments would be ephemeral, available to the future in only very inadequate ways: reviews were only second-hand reports, and audio recordings of the day were of poor quality. In contrast, the photographer's craft offered a more ready claim on history, allowing one not only to leave behind original works but also to insure the survivability of those works by peppering the archives, as Adams would do, with multiple renditions.

Yet even with these considerations, it was not easy for Adams to choose photography over music. He had pledged himself to Art, and for all the accomplishments of Stieglitz or Weston, and for all his friends who accepted photography as art, in many parts of Adams's bourgeois world photography was still viewed as a mere hobbyist's craft, lacking the spiritual status and uplifting qualities of Art. Members of that world huffed when they realized that Adams preferred the camera over the piano, and his father added to the pressure when he let it be known that Adams really should stay the course in music. It is no wonder that, as Adams later put it, he felt as though "my soul was on trial during the years around 1930."[39]

Finally, the process that began early in 1927 had run its course by the end of 1931. At the conclusion of this four-year period, Adams chose photography as his career and his art, and relegated music to the status of a cherished but secondary pastime. As he retold the story of this transition, Adams indulged his penchant for portraying his life as a series of decisive episodes, accounts that accentuated drama and sometimes sacrificed accuracy.

One of Adams's dramatic moments came in Taos during August 1930. He was the house guest of Paul and Rebecca Strand, and spent an afternoon viewing some of Strand's negatives. In Adams's retelling, that session acquired monumental significance; "my understanding of photography," he said in the 1980s, "was crystallized that afternoon as I realized the great potential of the medium as an expressive art."[40] (Contemporaneously, neither Adams nor Strand mentioned the episode in their exchange of letters, nor did Adams mention Strand when he wrote Virginia that "something inside me has clicked and I have a new perspective on many things concerning my work."[41])

Another of Adams's putative milestones probably was a significant episode for him. This was the making of *Monolith, The Face of Half Dome, Yosemite National Park* (1927; fig. 15.2), the brilliantly rendered image that became a classic in Adams's oeuvre. On an early spring day, he, Virginia, Cedric Wright and others went on a Yosemite hike. Adams's goal was to make an image of the immense helmet of Half Dome, and after several hours on the trail, he and his friends reached what seemed like an ideal spot. Adams waited another hour or two for just the right light, and then made his exposure with standard settings and a standard, yellow filter. But then it suddenly occurred to him that he could heighten the drama of his image by using a non-standard red filter, producing the deep contrast, black sky, and glowing outline of this print—a strikingly more vivid image than its standard yellow-filtered twin. This episode was what Adams called "my first conscious visualization," supposedly the first time when he had seen the desired image "in my mind's eye" and then, through techniques

of lighting and the use of apparatus, produced an image not so much of the scene itself but of the scene in his imagination.[42]

During this same period, Adams's reading also helped fuel his growing mountain aesthetic. In the late 1920s he devoured a good deal of alpine literature and reviewed some of those books for the *Sierra Club Bulletin*. There were plenty of disappointments, but Adams believed he had at last found good mountain prose in the autobiography of Geoffrey Winthrop Young, a heroic figure still climbing despite the loss of a leg in World War I. Young's writing had "the actual tang and radiance of the high peaks" and echoed "the slithering tinkle of ice upon ice." Moreover, he was accurate and passionate, giving "precise and inclusive observation" while also writing "in the manner of one who loves deeply the object of expression."[43] In Young, then, Adams found a model for alpine representation: sharp renditions lovingly conveyed.

In *Monolith* Adams was working his own way toward a similar kind of intimate aesthetic. He had come to love the material of his mountains and "the cold material representation" he had once eschewed now seemed to vivify rather than deny emotion. By abandoning the soft-focus lens used for *Lodgepole Pines*, Adams achieved a version of the crystalline clarity of Young's prose, and by adopting new techniques like the special filtration in *Monolith*, he achieved a high contrast that makes texture and detail snap out of the background. In this photograph the trees stand out with such individual definition that one could actually count them. Likewise, it is possible to trace the rock fissures that slant in two major directions, framed so that they meet almost precisely in a line down the middle of the image, while still other veins of the rock go swooping out of the frame on the upper right. With this image, one *experiences* granite.

Adams's combination of filtration and sharp focus gives Half Dome a theatrical quality, stirring together a portion of Bierstadtian magic along with the actuality of Yosemite, while the filter-darkened sky turns the snow on Half Dome's crest into a brilliant outline of its sculpted form. Composing from below the hulk, Adams did not have his camera planted on some safely remote height, but instead located himself rather perilously beneath the mountain, "an abyss...on my left, rocks and brush on my right."[44] He added to the effect by filling his frame with the mountain, so that Half Dome looms over and above, and seemingly close to, the viewer. There *is* something in the foreground, but that minor promontory does nothing to obscure the larger subject of Half Dome (indeed many viewers do not initially register the snowy cliff and its three trees). Instead, the outcropping lightens an otherwise dark corner of the image, its shape complementing the outline of Half Dome and its whiteness echoing the talus slope on the left. The effect of this image is emotional, a kind of insistent immediacy and immanence, a sense that the mountain's details demand the kind of respect with which Adams rendered them and a recognition of the awe which seems so clearly a part of that rendition. On another day in 1928, when Adams was again photographing the Yosemite cliffs, he spoke of "the strange intimate glimpses...of crags and pines and snow."[45] Through the intimacy of images such as *Monolith*, he strove for an art that vibrated brilliantly, not obscurely, to the mountain landscape.

The turn to photography had a doubly liberating effect on Adams. As never before he got down on paper, sometimes in words as well in images, the vibrancy of his mountain moments. Moreover, once he settled on photography, he paused more readily in his mountain surroundings, indulging them as photograph-like moments of stasis rather than moving through them as one might proceed through a musical score. In the midst of that 1928 photographic session of the intimate glimpses, Adams wrote that "I have never been in Yosemite when I felt the real mountain spirit as I do now." Working with his camera among the Yosemite cliffs, he said, "I am at home. I can forget the people, the [music] studios...and wander off into the oak shaded rocks and be happy."[46] Once Adams accepted the camera, he seemed ready to experience the Sierra with the kind of ebullience and ecstasy Edward Carpenter had found in nature, and with photography as his chosen medium, Art and the hills no longer seemed to be tugging Adams in opposite directions—here was Art that not only justified mountain experiences but also propelled one into those mountains in order to produce it.

During earlier Sierra Club outings there had been mountain moments of transport. But such episodes came in superabundance once Adams embraced photography, and the 1931 Sierra Club outing inspired some of the most intense and impassioned writing of his life. Published as the lead essay in the *Sierra Club Bulletin*, the piece conveys the intensity of Adams's remarkable summer. The mountains seemed like holy places, "high altars" where "a great Presence hovers over the ranges" and lingers "all about you as some rare incense in a gothic void." Far surpassing human art as expressions of abstract line and shape, the Sierra abounded with "pure forms in craven granite of precise and appropriate textures." Some of the glories were particularly physical. Repeatedly quoting Whitman, Adams noted that he had experienced not only "the clean brilliance of the summit," but that he also wallowed in "the virile tang of high tarns and plateaus," and tingled to "the tiny flagellations of the rain." This was a phenomenal trip, with the Sierra strumming away on Adams's senses as well as upon his formal and religious sensitivities. The call of a monolith was compelling—"a huge granite mountain cannot be denied"—and on one special evening, Adams had a particularly intense episode, what he described as an instant when "space becomes intimate...and you mingle your being with the eternal quietude of stone."[47]

If 1931 delivered Adams into the bosom of his mountains, it also delivered him finally and fully into straight photography. When a selection of his pictorial photographs returned from exhibition at the Smithsonian Institution, Adams rejected the fuzziness of those earlier images. The transparency and clarity of photography, and its beholdingness to the depicted subject, were not so much, as he once thought, weaknesses that made it less of an art and the photographer less of an artist; instead they now seemed qualities of "a tremendously potent pure art form."[48] As his images moved closer to the clear and precise motif of *Monolith*, Adams believed that they became more than just gleaming records of subjects like Half Dome. During these years when he had been busy "becoming intimate with the spirit of wild places," his images had undergone a transfor-

mation too, he said: "My photographs began to mean something in themselves; they become records of experiences as well as places."[49]

Adams may be thought of as a hard rock transcendentalist. For a more conventional transcendentalist such as Emerson, Yosemite had been only mildly interesting. But Adams was in the tradition of John Muir or Joseph LeConte, men fascinated by what the Sierra granite could tell them not only about glaciation and erosion, but also what it could tell them about grander and other less material principles of nature. Like them, this young Ansel Adams was an inveterate hiker, prowling Yosemite's trails, staring at its crags, and experiencing *more*. One hesitates to call him a granite fetishist, but by the early 1930s he had developed a special if unusual fondness for the rock, and as a student of Edward Carpenter he thought that matter and spirit were not two separate things but instead parts of a larger, humming principle. By the early 1930s, Adams was convinced that photography was an art, one that could bring him to his mountains, and that straight photography was a way to bring to his images the physical intimacy of large slabs of granite such as Half Dome.

1. Ansel Adams, *An Autobiography*, with Mary Street Alinder (Boston: Little, Brown and Company, 1985), 18. For Adams's early life see Nancy Newhall, *Ansel Adams: Volume I, The Eloquent Light* (San Francisco: The Sierra Club, 1963), 22-27; and James Alinder, "Ansel Adams: American Artist," in James Alinder and John Szarkowski, *Ansel Adams: Classic Images* (Boston: Little, Brown and Company, 1986), 1-8.

2. Oddly enough, Stieglitz's nose was also broken and disfigured in a childhood accident; at the age of six months he landed on his nose when his mother dropped him. Richard Whelan, *Alfred Stieglitz: A Biography* (Boston: Little, Brown, 1995), 261.

3. James M. Hutchings, *In the Heart of the Sierra* (Yosemite and Oakland: Pacific Press, 1868, 1888).

4. Adams, *Autobiography*, 54. AA to Charles Adams, June 24, 1920, AAA/CCP.

5. AA to Willard Van Dyke, Spring 1936, here from Newhall, *Eloquent Light*, 126.

6. AA to Virginia Best, October 3, 1922, in Newhall, *Eloquent Light*, 42. AA to Virginia Best, September 28, 1923, in Mary Street Alinder and Andrea Grey Stillman, eds., *Ansel Adams: Letters and Images 1916-1984* (Boston: Little, Brown, 1988), 18.

7. AA to Charles Adams, June 8, 1920, *Letters*, 6-7.

8. Ibid., June 30, 1922, *Letters*, 9-12.

9. Charles Adams to AA, July 5, 1922, *Letters*, 14. AA to Charles Adams, July 7, 1922, *Letters*, 16.

10. Ansel Adams, *Yosemite and the Range of Light* (Boston: Little, Brown and Company, 1979), foreword; here from Ansel Adams, *Yosemite and the High Sierra*, Andrea Grey Stillman, ed. (Boston: Little, Brown and Company, 1995), 126.

11. Undated fragment describing events of the first Sierra Club High Trip of summer 1923, in Newhall, *Eloquent Light*, 36. AA to Virginia Best, July 17, 1922, *Letters*, 17.

12. For a discussion of art in Yosemite, see David Robertson, *West of Eden: A History of the Art and Literature of Yosemite* (Yosemite: Yosemite Natural History Association, 1984).

13. Undated fragment, in Newhall, *Eloquent Light*, 36.

14. AA to AS, October 9, 1933, *Letters*, 61. Undated fragment, in Newhall, *Eloquent Light*, 36.

15. For an examination of Muir in relation to American environmentalism, see Stephen Fox, *John Muir and His Legacy: The American Conservation Movement* (Boston: Little, Brown and Company, 1981).

16. Ansel Adams, *Yosemite and the Sierra Nevada*, photographs by Ansel Adams, and selections from the works of John Muir (Boston: Houghton Mifflin, 1948), xv, 131.

17. Fox, *John Muir and His Legacy*, 5. Muir kept proposing such trips for Yosemite visitors. In 1889 he took Century Magazine editor Robert Underwood Johnson camping in the back country, and in 1903 it was Teddy Roosevelt, Muir's equal in effusiveness, who was enticed on another expedition; thanks in large part to the ensuing publicity and policy, Yosemite eventually became a National Park and huge chunks of the West similarly came under federal protection.

18. AA to Virginia Best, July 17, 1922, *Letters*, 17.

19. Part of the attraction in *Leaves* was Whitman's unconventional sexuality, for Carpenter was a homosexual seriously involved in the sexual politics of his day; he was a good friend of Havelock Ellis, providing much of the information for Ellis's *Sexual Inversion* and publishing his own parallel work, *Love's Coming of Age* (1896). Though Adams read Ellis during the 1920s, he left no comment upon the celebrations of "the great ocean of Sex … the beloved genitals" that were to be found in Carpenter's *Towards Democracy*.

20. Edward Carpenter, *Towards Democracy* (London: George Allen and Co. Ltd. at Ruskin House, 1911), 186, 383. AA to Charles Adams, June 1, 1929, AAA/CCP.

21. Linda Dalrymple Henderson, "Mysticism as the 'Tie That Binds': The Case of Edward Carpenter and Modernism," *Art Journal* 46 (Spring 1987), 29-37. Sheila Rowbotham, *Socialism and the New Life: The Personal and Sexual Politics of Edward Carpenter and Havelock Ellis* (London: Pluto Press, 1977). Tony Brown, ed., *Edward Carpenter and Late Victorian Radicalism* (London: Frank Cass, 1990). Scott McCracken, "Writing the Body: Edward Carpenter, George Glissing and Late Nineteenth-Century Realism," in Brown, *Edward Carpenter*, 178-200. The essay referred to is "The Fourth Dimension from a Plastic Point of View," *Camera Work*, 1910.

22. AA to Virginia Best, August 3, 1925, *Letters*, 22. AA to Virginia Best, September 22, 1925, *Letters*, 23-24.

23. Ibid., June 6, 1926, *Letters*, 27.

24. Ibid., September 22, 1925, *Letters*, 23-24.

25. Ibid.

26. Ibid., September 30, 1925, *Letters*. 25.

27. Ibid., September 22, 1925, *Letters* 23-24. Ibid., September 30, 1925, *Letters*, 25-26. According to Mary Alinder, Adams had also become interested in another woman, a violinist, at the time he broke off the engagement to Virginia. Mary Street Alinder, *Ansel Adams: A Biography* (New York: Henry Holt, 1996), 56.

28. Bender thus became Adams's first patron, and Adams's letters to him ooze with the unctuous flattery that Adams was inclined to use with older, more powerful men who were in positions to benefit him. But there was also a measure of sincerity in the matter when Adams thanked Bender "for the new lease on life your interest and friendship have given me." AA to Albert Bender, July 27, 1927, AAA/CCP.

29. AA to Virginia Best, April 25, 1927, *Letters*, 30. Ibid., July 1928, *Letters*, 38.

30. AA to Virginia Adams, February 28, 1930, *Letters*, 42.

31. AA to Virginia Best, 1927, in Newhall, *Eloquent Light*, 48-49. AA to Cedric and Rhea Wright, April 1929, *Letters*, 39.

32. AA to Charles Adams, April 4, 1929, *Letters*, 39.

33. For a time Adams and Austin were in competition for a site with Robert Flaherty, Strand's model for documentary filmmaking.

34. AA to Albert Bender, April 29, 1929, *Letters*, 40. Ansel Adams with Mary Austin, *Taos Pueblo* (San Francisco: Grabhorn Press, 1930).

35. Adams, *Yosemite and the Range of Light* 127.

36. Jonathan Spaulding, *Ansel Adams and the American Landscape: A Biography* (Berkeley, University of California Press, 1995) 53, 96-97. Robertson, *West of Eden*, 131.

37. AA to Virginia Best, March 11, 1927, *Letters*, 29.

38. AA to Albert Bender, October 1928, in Newhall, *Eloquent Light*, 54.

39. AA to Cedric Wright, 1928, *Letters*, 37. See also AA to NN, July 15, 1944, Beaumont and Nancy Newhall Collection, CCP. Charles Adams to AA, January 30, 1928, *Letters*, 36. Adams, *Yosemite and the Range of Light*, 127.

40. Adams, *Autobiography*, 109.

41. AA to Virginia Adams, late August, 1930, *Letters*, 46. According to a June 4, 1944 letter from NN to BN, it was only at *that* late date that Adams for the first time seriously examined Strand's work. See Beaumont Newhall, *Focus: Memoirs of a Life in Photography* (Boston: Little, Brown and Company, 1993), 120.

42. Ansel Adams, *Examples: The Making of 40 Photographs* (Boston: Little, Brown and Company 1983), 4. For all his claims, *Monolith* was not in fact Adams's first previsioned image—*Lodgepole Pines* and other images from the early 1920s were carefully planned.

43. Ansel E. Adams, "On High Hills," *Sierra Club Bulletin* 14 (1929), 98-99. The work under review was Geoffrey Winthrop Young, *On High Hills: Memories of the Alps* (New York: E. P. Dutton, 1927).

44. Adams, *Examples*, 4

45. AA to Cedric Wright, 1928, from *Letters*, 37.

46. Ibid.

47. Ansel Adams, "Retrospect: Nineteen-Thirty-One," *Sierra Club Bulletin* 17 (February, 1932), 1, 5-10.

48. Quoted in Newhall, *Eloquent Light*, 69. See also Mary Street Alinder, "The Limits of Reality: Ansel Adams and Group f/64," in Theresse Thau Heyman, *Seeing Straight: the f.64 Revolution in Photography* (Oakland: The Oakland Museum, 1992), 43-44.

49. Adams, *Yosemite and the Range of Light*, foreword in *Yosemite and the High Sierra*, 127.

16. ART THERAPY

Ansel Adams could be so easily distracted. He never quite outgrew the freneticism of his childhood, and as an adult he bounded from one interest to another, leaving behind one half-finished project to pursue another. By 1930 he had voiced a commitment to spiritually charged mountain photography, but for much of the rest of the decade he was diverted by other concerns. One of those diversions was Art. The status hunger that had made it difficult for Adams to abandon music now had him pursuing the avant garde in the belief that the truest Art is accomplished when older genres (like landscape) are sloughed off and newer orientations (like modernism) are taken on. Adams also succumbed to the lure of fame, for unlike Weston, he was unwilling to labor in obscurity. An outlander drawn to the nation's cultural hub, intent upon making a reputation for himself in American art photography, Adams was imitative, slavishly copying Stieglitz's gallery-keeping methods rather than following his own considerably more peripatetic inclinations.

Much of Adams's story of the 1930s has the flavor of manic indecisiveness as he flew from one project to another. Ultimately he proved to have taken on too much, and too much that was not his own, because in 1936 he suffered a collapse that was both physical and psychological. This was a grave matter, not a mere artist's funk, for the episode left him hospitalized and seriously depressed, and it was compelling enough to penetrate Adams's formidable denial mechanisms. He was provoked to a significant stock-taking of both his life and his art, and came to believe that with all his roiling about he had drifted a good way from his mountains and his alpine art—that he had exchanged the simple for the frenetic. Adams also devised his own self-prescribed cure: it was time to re-embrace both the Sierra and landscape photography.

Adams may seem to have wasted several years, for with the late 1930s he returned to much the same location and location-based art that he had accepted at the start of the decade. But along the way something had happened. Although his mountain photographs continued in their spiritual and emotional associations, there was now an additional biographical dimension. Scenes that had earlier been rendered as mystical were now also described as curative. For Adams, photography became charged not only with enlightenment but also therapy.

During the early 1930s, Adams envisioned himself as a critic, publishing a number of articles about photography. Like Strand a decade before, he was a relative novice who wrote with a shrill, pretentiously authoritative tone. Moreover, Adams was decidedly a Johnny-come-lately, making bold claims for the revolutionary qualities of a straight photography which was by this time three decades old. During this process he also reviewed other Bay Area photographers, including Imogen Cunningham, Willard Van Dyke, and Edward Weston (his critique that Weston's subjects were "*more* than they really are," provoked Weston's long dis-

cussion of the "pepper *plus*"[1]). Together with Weston, Van Dyke and others, Adams formed that loose collection of West Coast photographers known as Group f/64. Adams claimed that the very idea of the group was his own, something he proposed one evening during a party at Van Dyke's home, and he probably was the principal author of the organization's central document, the "Group f/64 Manifesto" of 1932. Certainly Adams accounted for much of the grandiloquence within the Manifesto, particularly those descriptions of the Group's "missionary zeal" in battling a supposed "tide of oppressive pictorialism."[2]

Adams wrote on behalf of Group f/64 several times during 1932 and 1933,[3] but his efforts were not limited to articles and manifestos. Using his camera as well as his typewriter, he explored new areas such as semi-abstractions, wood details, and stone close-ups. Adams never completely abandoned landscape photography and continued to make Sierra images throughout the early 1930s; but he was inclined to accentuate the newer works, and only two of his ten pieces in the 1932 Group f/64 exhibition might qualify as landscapes—one of the Golden Gate and another of a Yosemite waterfall. Instead, there was an emphasis on modernist, abstract studies like *Factory Building, San Francisco* (1932). Adams had made architectural photographs before, but unlike his images of the Taos pueblo, where he had depicted buildings as rather like a range of weathered hills, in this photograph he portrayed a factory as something like a cubist assemblage. Scattered details—windows, a chimney, a gable—make it possible to identify the subject as some sort of industrial structure, but such identification becomes more difficult in other, more abstract images like *Dawn, Mount Whitney, California* (1932; fig. 16.1). Unlike the earlier *Monolith* (fig. 15.2), where Adams situated the mountain huge and glowing within his frame, here he rendered Mount Whitney as a mere elbow-like silhouette jutting into a lower corner; most of the image is of dawn sky, an emptiness relieved only by the small sliver of a moon that Adams included at the very top of his photograph. Were it not for that tiny visual clue (and the help of Adams's title), *Dawn, Mount Whitney* might be mistaken for a microscope slide of some laboratory culture.

Even more startling is *Frozen Lake and Cliffs, Sierra Nevada, Sequoia National Park* (1932; fig. 16.2). Perhaps the most abstract of Adams's images from the early 1930s, Adams regarded it as representative of "my transitional period into Group f/64 philosophy." At first encounter, the image seems as though it could be a tonal exercise, some sort of darkroom experiment where the photographer tested his paper to see if it could convey clotted shapes in the full range of shades from brightest whites to deepest blacks. But in truth the scene comes from actual life, a partially frozen mountain lake tucked up against vertical cliffs which have snow banks at their base. The shift to a horizontal composition in the photograph's lower quadrant represents the frigid lake that was before Adams's camera that day; though they may look like the broad brush strokes of some abstractionist canvas, the white band actually depicts the floating ice while the black band shows open water.

Adams would claim that it was not his intention to make an abstraction out of *Frozen Lake and Cliffs*. Yet he achieved just that effect in the darkroom, for in printing this image, he darkened the band of open water along the lower edge, further obscuring the already-dim cliff reflections and obliterating the few visual clues that could orient the photograph by identifying that dark swath as open water. Through

16.1. Ansel Adams. *Dawn, Mount Whitney, Californian, 1932*, Copyright © 2000 by the Trustees of the Ansel Adams Publishing Rights Trust/CORBIS. All Rights Reserved.

16.2. Ansel Adams. *Frozen Lake and Cliffs, Sierra Nevada, Sequoia National Park, 1932,*
Copyright © 2000 by the Trustees of the Ansel Adams Publishing Rights Trust.
All Rights Reserved. Courtesy George Eastman House.

such darkening and his other manipulations during printing, Adams worked a transformation upon his subject, moving it away from a particular mountain scene on a particular day, and toward a vivid rendition of light and dark shapes that seems to float independent of any specific subject matter.[4]

Abstract as it was, *Frozen Lake and Cliffs* was still made in one of Adams's distant mountain locations. Increasingly, though, his f/64 images were composed in less remote places, depicting more commonplace scenes and subjects. Often these images were made closer to home, for unlike Adams's high country trips, which could resemble big-game expeditions with their mounds of gear, his f/64 photographic sessions were more akin to walks in the neighborhood. His subjects were different, too, thistles, or boards, or beach debris—undramatic things with little apparent connection to the sublime traditions of mountain art. The resulting images were too much of a departure for Sierra Club members who had grown accustomed to Adams's landscapes and granite peaks, and at least one took him to task for these new photographs.[5] Like so much of the rest of twentieth-century modernism, f/64 photography concentrated on the fragmentary and the ordinary, challenging the aesthetic expectations of Club members and others who wanted something more like the accustomed monumentality. Adams instead offered mundane pine cones and thistles.

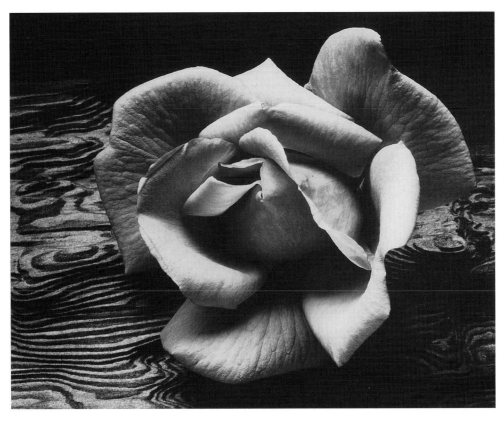

16.3. Ansel Adams. *Rose and Driftwood, San Francisco, California, c. 1932*, Copyright © 2000
by the Trustees of the Ansel Adams Publishing Rights Trust.
All Rights Reserved. Courtesy George Eastman House.

Or a rose. *Rose and Driftwood, San Francisco*, California (c. 1932; fig. 16.3) was
one of his more delicately considered images from this period. Adams claimed that
the image was not inspired by any of Georgia O'Keeffe's large, contemporaneous
flower paintings, and in many ways it has more in common with Stieglitz's 1922
[Georgia Engelhard] (fig. 4.6), where the voluptuous young woman was posed nude
in a weathered wooden window. Both Adams's rose and Stieglitz's nude are obvi-
ous contrivances of placement and arrangement. The images share a kind of
incongruity, too, for although the rose-on-driftwood is not nearly so striking as the
nude-in-the-window, both images place their central subjects beyond anything like
a normal context. Even more similar are the tactile juxtapositions within the two
photographs, both employing roughly textured wood to offset the softness of flower
petals or youthful flesh. But whereas Stieglitz's eroticism is blatant in his depiction
of Engelhard clutching apples to her breasts, Adams's image works more indirectly
and suggestively, with a quieter evocativeness of the type that fellow f/64 photog-
rapher Weston had brought to his own similarly close-focused images of peppers.

Indeed *Rose and Driftwood* demonstrates Adams's closeness to the other f/64
artists. With something similar to Adams's affection for granite, those photogra-
phers were inclined toward the weathered wood of cypress trees, or barn walls or

old fences. For Adams it was driftwood, and he placed this rose upon a piece of wave-worn plywood that he had lugged up to the studio from the Pacific beach. Thus, like so many f/64 scenes, *Rose and Driftwood* was not a "found" image, but rather a carefully contrived still life of the sort Weston constructed with his precariously balanced shells. With a depth of field that keeps petals and wood in sharp focus, and the fine detailing of wood grain and petal vein, Adams's photograph celebrates the materiality of modest subjects without achieving an apotheosis of the ordinary, for there is no figurative halo or other spiritual allusion to the image. With its dramatic isolation and decontextualization, the image compels the eye to concentrate on this particular subject. The image seems a photographic rendition of Gertrude Stein's modernist insistence that we concentrate on *this* subject and go no farther: "A rose is a rose is a rose." Celebrating what others might take to be the ordinary (a rose is, after all, just a rose), Stein hoped to hold the reader within the vortex of her repeated phrasing, and Adams likewise composed so that the petals repeat each other and draw the eye inward toward the flower's center.

Modernism's shallow spaces were difficult to reconcile with Adams's brand of landscape photography. In a 1934 article, Adams wrote that one of the problems of landscape photography was what he called "subject-domination."[6] What just a few years earlier he had enjoyed so much, the experience of standing rapt before an undeniable mountain like Half Dome in *Monolith*, had now become problematic. At the same time Adams was inclined away from the domineering likes of Half Dome and towards the more controllable likes of roses and pine cones. There is an intimacy to these f/64 images, but it is an intimacy more akin to that of Weston with his vegetables, where the photographer probes the folds of his subjects, and quite different from the intimacy of Adams's Sierra experiences, where the mountains seemed to ravish the photographer.

Early in the spring of 1933 Adams traveled to the East with Virginia, making stops in Chicago, Detroit and Boston before reaching their ultimate destination of New York. This was during the deepest part of the Great Depression, but the couple suffered relatively little; their only inconvenience during the trip was an unexpected delay in Santa Fe where they had to sit out the national bank closings before they could cash some of their substantial roll of travelers checks.

The primary purpose for the trip was to visit Stieglitz. Having propelled himself into regional prominence as a leader within Group f/64, Adams now sought the even greater national notoriety to be had by developing an association with Stieglitz. A decade earlier Weston had come to New York seeking Stieglitz's example and critique, but Adams approached Stieglitz differently, in what was a calculated pursuit of a relationship with the master. He went to some lengths to record his version of that meeting, and it is clear from those recollections that he was not too interested in Stieglitz's images.[7] What seemed to matter more for Adams was the chance to know Stieglitz and lay claim to a closeness with him. In the months after their meeting, Adams wrote Stieglitz several times in a campaign to envelop him in a web of gratitude and responsibility ("my meetings with you touched and clarified many deep elements within me").[8] Much of this was a

transparent effort to cultivate Stieglitz's affection. In his direct dealings with Stieglitz over the next few years, he maintained a persistent flattery that could slide into obsequiousness; at one point he said Stieglitz's An American Place was "the most remarkable institution in American," and at another time told Stieglitz "I wish I could come be your janitor."[9] Adams played the fawning novice, ready to please and quick with deference.

And quick to imitate. Once Adams returned to San Francisco, he went about establishing himself as something like the Stieglitz of the Bay Area. Although he had had almost no curatorial or gallery experience, and though he was still only a few years into his art photography career, Adams launched his own gallery within a few weeks of his return from New York. Aiming for "something that would touch more deeply the general current of art than my own local attempts with the camera," Adams took a big step back from making photographs when he opened The Ansel Adams Gallery in downtown San Francisco.[10] After his visit to An American Place, he had realized that a gallery could be complementary to his writing and Group f/64 efforts, that it could be still another opportunity to shape the aesthetics of photography and, as he told Stieglitz, "to define what *is* right." Seeing himself as an arbiter who would set not only high standards, but *the* standards, Adams thought it important to start on the right note and hoped to open his gallery with an exhibition of Stieglitz's photographs.[11] Beginning thus with the paragon of American art photography, Adams's plans for the rest of that first season were equally ambitious, and his scheme included a Paul Strand show for the spring. As planned, then, The Ansel Adams Gallery would demonstrate not only the best of American photography, but also Ansel Adams's position and pull among the best of American art photographers.

These were grand plans, but ill-fated. To begin with, both Stieglitz and Strand denied Adams the shows necessary to set his definitions and establish his reputation. Then there was Adams's growing realization that his was not the constitution of a gallery operator. He was a fidgiter who wandered outdoors; but The Ansel Adams Gallery was located where a cultural center like An American Place had to be—smack in the heart of the city—and the influence that Adams sought required a day-to-day presence such as Stieglitz gave to his various New York galleries. Adams's tolerance for the project was quickly exhausted—"to hell with that" he told a friend—and he left the Gallery after a mere eight months.[12]

Adams turned to another means for defining photography. Over the following two years he remained in San Francisco and still made relatively few art photographs, but he wrote a good deal. In articles, letters, and even a book he expounded upon the nature of American photography. Occasionally he sounded like an advocate of what a later generation would call diversity; in one 1934 piece he spoke of a variegated art: "Many men, many minds; many minds, many photographs."[13] But such remarks were rare, and in the mid-1930s Adams was more intent on achieving a single standard within photography than in celebrating its heterogeneity. Publishing articles in a photography magazine called *Camera Craft*, he reached a wider audience than before, but continued with his hortatory delivery of earlier themes: photography was a serious art capable of great emotional expression, and it should not borrow from other media like painting.[14] Adams authored

an apology for straight photography,[15] and he twice submitted Guggenheim applications proposing to trace true photography's Stieglitzian pedigree and explain its "aesthetic rationale."[16] Neither proposal was successful, but Adams had better luck with a successful how-to-do-it book, *Making a Photograph* (1935). Much of the book was given over to arcane technical procedures, but Adams's larger agenda was to inculcate true photography as he understood it. This arrow hit at least one of its intended marks; when Stieglitz read *Making a Photograph*, he proclaimed it a thoroughly acceptable and orthodox work.[17]

Adams was not content to limit his standard-setting to essays or a handbook. During these years he began to develop his idea of "a center for photography," a dream finally realized four decades later with the 1975 founding of the Center for Creative Photography at the University of Arizona.[18] With a variety of facilities he aimed to confront the "divergent uncertainties" and "confusion" within photography, and then with his "central institute" achieve uniformity in an art were there seemed to be too much variety. Adams was ambiguous about how he would staff such an institute, but he was certain of the members would arrive at an orthodox consensus as they conducted "a practical correlation" of texts, displayed only "the most significant photography, past and contemporary," and promulgated "the fundamental aesthetic and technical principles."[19] There might be many people and many photographs at Adams's institute, but he believed they would be of one mind about the nature of true photography.

If Adams imagined these means for advancing his own definitions of photography, he also defended his art against definitions offered by others. With his campaign against pictorialism, Adams was in many ways re-fighting an earlier day's battle, but he was also drawn into other contentious disputes that were more distinctly a part of the 1930s. To Strand and many of Adams's other contemporaries, it seemed as though the Great Depression heralded the arrival of a long-anticipated class struggle, and in one of the commonplaces of the day, art was but one more weapon to be deployed on the side of the working class. But not for Adams.

A number of his associates simply took it for granted that he would be on the other side of the barricades. For example, during the great San Francisco general strike of 1934, Adams and members of the city's business and political elite shared their own kind of fellowship as they hiked in the Sierra high country and followed the strike by shortwave radio. Later, in the aftermath of the strike, Ansel's father Charles helped to organize a vigilante-like organization that created loyalty oaths and other mechanisms for punishing those who had honored the strike. As Charles told Ansel, "I expect you to be with me in this; I expect you to … Abide by the faith of your mother and your father."[20]

The record tells us nothing about Adams's response. But he obviously bridled over similar expectations from his acquaintances at the other end of the political spectrum, and particularly resented the left-wingers' insistence that he not only join the cause but bring his photography along with him. He was aghast that, as he put it, artists "are asked to do 'Proletarian' work … to photograph May Day celebrations, old human derelicts in a dingy doorway, evictions, under-paid workers, etc. etc."[21] As we have seen, Weston shared Adams's sentiments, and in

1934-35 the two men exchanged letters expressing their mutual outrage about photography for a purpose. "Goddam," Adams wrote when Weston said that a friend expected him to play the "good Bolshevik and photograph all the plants in the vestibule of Revolution."[22]

Adams particularly feared that social photography would slip into propaganda. Given the manipulative potential of photography, and in a particularly charged era when almost anything but the sunniest of social photographs was widely understood as a critique of capitalism, Adams was inclined to regard most documentary photographs as leftist propaganda. To him, "the work of the creative artist—the free and intimate expression"—seemed much more important than any social benefits derived from "direct propaganda of artistic medium." So, while others like Strand might be interested in helping to shape what Adams called a "vaguely understood future 'order,'" Adams's priority was the independence of art: "Jezuz Kriste!!!—I want to keep the work *clean*."[23] Just as Weston had argued that an image might be sullied by too much verbiage, Adams likewise feared that too much ideological purpose would befoul an otherwise pure, straight image.

But this is not to say that Adams was immune to those impulses giving rise to documentary photography of the 1930s. He too made political photographs, although he used a visual vocabulary more adapted to the insinuation of a generalized human folly than to the Proletarian artists' indictment of specific evils, and he was more inclined to be sardonic than somber. Like so many photographers, he sharpened the thrust of his comments by using juxtaposition. Dorothea Lange did this famously by photographing a pair of hitchhikers trudging down the road under the looming presence of a sign proclaiming the comforts of train travel which seemed completely beyond their means.

But that kind of bite was missing in Adams's juxtapositional compositions, such as *Political Circus, San Francisco* (1931; fig. 16.4). This image has a political message, but it is a satire upon politics, and Adams's juxtaposition works less as indictment and more as mockery. Both elections and circuses are populated by lumbering and comic entities. Each show comes to town only occasionally, and although there's considerable hoopla surrounding those brief appearances, neither performance seems to leave in its wake much besides decaying posters and plenty of manure.

Political Circus was among the forty-five Adams photographs that Stieglitz displayed at An American Place during October and November 1936. After several years of hints from Adams, Stieglitz finally decided the younger photographer was worthy of a show, granting him the most awesome platform possible for an American art photographer. New York was the nation's cultural capital and Stieglitz was the demigod of American photography; other than Strand and Stieglitz himself, Adams was the first photographer Stieglitz had exhibited since 1913. With this grand opportunity and formidable test before him, Adams used exceptional care in selecting and sequencing images for the exhibition.

He demonstrated his versatility and technical ability with images showing that he could work in the most demanding of lighting conditions. Other images indicated that he was at ease in the various motifs of architecture, portraiture,

16.4. Ansel Adams. *Political Circus, San Francisco, 1931,* Copyright © 2000
 by the Trustees of the Ansel Adams Publishing Rights Trust/CORBIS.
 All Rights Reserved.

landscape, and even advertising. Most of these were earlier images, made in the years prior to his hiatus with The Ansel Adams Gallery, but he also fleshed out the exhibition with some more recent work. In the months before he sent the show to New York, Adams scurried about California in a burst of image-making. One cannot say that these 1936 photographs which Adams sent to An American Place were specifically created for the exhibition, but they seem calculated to prove a continuing originality and power, demonstrating that he was working vigorously and sometimes in previously unexplored themes. There were some vividly lit mountains to show that he had not become a complete stranger to landscape. Another set of images depicted picket fences, establishing his ability to handle abstract themes of rhythmically repeated shapes—and his familiarity with the iconography of American art photography, for the images echo Strand's pivotal *White Fence* of 1916 (fig. 6.4).

But Adams's single largest group of recent images had a quite different feel. Included in the American Place exhibition were a number of cemetery photographs, most made at Laurel Hill Cemetery. The material of these subjects was a part of their attraction for Adams, for the monuments of Laurel Hill were some of the most readily available granite during this city-bound period. Additionally, he recognized, as had Strand, that such monuments can have narrational qualities. "Tombstones are magnificent photogenic things," Adams wrote a friend, and he pursued them for their mystery and "nostalgic connotations."[24]

The cemetery and other 1936 negatives were but a part of Adams's intense efforts in preparation for the American Place Exhibition. He also made new prints of earlier images, and all the darkroom time left him feeling "etherized."[25] Finally, though, the images were ready and he shipped them to New York for the October 27 opening. Originally Adams had not planned to attend the exhibit, but his curiosity got the better of him, and he found excuses to travel to New York. What he saw at An American Place delighted him: the presentation was superb, the attendance gratifying, and the comments warming. But most importantly, Stieglitz approved. For years Adams had been angling for just this moment, and as he wrote to Virginia, "I am now definitely one of the Stieglitz Group...In other words, the show is quite successful!!!"[26]

The success quickly seemed hollow. Almost immediately upon his return to California in mid-December 1936, Adams collapsed and even photography seemed impossible. Writing to Cedric Wright, he said that "I have said my say in photography," and felt so completely unstrung that he doubted he could manage another exhibition "if my life depended on it."[27]

Domestic tensions contributed significantly to the collapse. Adams was a fairly good provider for his family, but he was an inattentive husband and father whose absences and disloyalties severely tested the family bonds. When his son Michael was born in Yosemite village in 1933, Adams was off in the high country with the Sierra Club, and two years later he likewise missed daughter Anne's San Francisco birth because he was again away in the hills. More significantly, in the summer of 1936 Adams's marriage became strained when he began a love affair with another woman.[28] Dynamics within the household became even more intense later that fall when Virginia's father, Harry Best, suddenly died, leaving the family

to deal not only the tragedy of his passing but also with the gruesome circumstances of his death: while tucking Anne to her bed, Best had been stricken with a fatal heart attack, and fallen across the girl's cot before sliding to the floor.

Then came the last-minute preparations for the Stieglitz exhibit, the abrupt decision to go east for the exhibition, and the extra burden of additional projects he undertook along the way. The frazzled and drained Adams was approaching his limit when, as he returned to San Francisco, he stopped to photograph New Mexico's Carlsbad Caverns. This should have been a routine enough assignment, but for the agitated Adams it provoked a combination of revulsion and horror. His metier was the soaring Sierra, but there in the caverns "the mountains are turned inside out—where there should be mass there is space, where things should grow there are phallic stalagmites and stalactites." Dripping and wet, the place seemed "an illuminated stomach," evoking a nauseating sensation of a Jonah-like captivity.[29]

"When I arrived home," Adams said, "I felt at the breaking point."[30] Already stressed by his American Place debut and his work on the way home, Adams arrive to an ultimatum—perhaps from Virginia, or from his mistress, or even from both—to choose between the two women. Under such circumstances, in December 1936 Adams collapsed and was hospitalized for exhaustion, influenza, possibly pneumonia,[31] and certainly depression. In letters to Stieglitz and Cedric Wright, Adams owned his despair ("I am so goddam low emotionally") and displayed some of depression's classic symptoms, a sense of emptiness ("everything is dead—flat—without reason or purpose"), an inability to act ("I *know* what I should do and feel...but..."), and an aura of futility ("there are so many responsibilities...all of which could probably get along perfectly all right without me").[32] These psychological maladies proved more disabling than the physical ones, for although he was discharged in a matter of weeks, it was not until the summer of 1937 that his depression began to lift.

During the those months Adams undertook a quite conscious and largely self-prescribed recovery scheme. Realizing that he had seriously overextended himself, he set about returning to fundamentals. He significantly curtailed his commercial work, dropped his mistress, renewed his commitment to Virginia, and tried to give more of himself to the children. But this was a man for whom mood and location were closely linked, and his curative efforts were also geographical. At first he moved the family only a short distance, abandoning San Francisco's fog for "a simpler and sunnier life" in Berkeley. But if there was to be a true psychic retreat for Adams, it had to be still further east: Yosemite. Earlier, during the General Strike, he had advised his parents to pack off to Yosemite "should things get panicky in San Francisco," and now, feeling rather panicky himself, Adams followed his own advice and in May 1937 withdrew to Yosemite along with Virginia and the children.[33]

As in his youth, Adams once again sought the curative qualities of Yosemite. This time, though, he came for more than the season, and there were trappings of a permanent relocation: letterheads were printed, schools explored, and a Valley darkroom outfitted. Yosemite was to be a place of hearth and healing, and two of his photographs captured some of Adams's hopes for the new home. In *Redwood*

Tree, Mariposa Grove, Winter, Yosemite National Park (c. 1937), he depicted a small cabin snuggled up against one of Yosemite's immense trees, a giant that not only dominates the snowy scene but also extends its enduring shelter over the building (and presumably its inhabitants). Even more direct was Adams's *Rainbow Over Yosemite Valley* (c. 1938), an image that exists in at least two versions and depicts a lustrous rainbow streaming across the Valley and coming to rest at the foot of El Capitan. This photograph has clear antecedents in Albert Bierstadt's *Rainbow over Jenny Lake* (c. 1870) and Frederic Church's *Rainy Season in the Tropics* (1866), but in the midst of his recovery Adams was probably more interested in the photograph's symbolic qualities rather than its compositional forebears: With this rainbow Yosemite delivered a promise that his personal storms had run their course.

In the years following his breakdown, much of Adams's energy was devoted to plaiting together the previously disparate strands of his life, joining family, livelihood, and place as they had not been in San Francisco. Virginia had inherited Best's Studio when her father died, and now she, Ansel, Michael, and Anne moved back to the spot where she and Ansel had married. Paintings were removed from the studio, the darkroom installed, and the business turned into a more specialized photographic concession where they hoped to sell photographs and souvenirs. Even the children were brought into the enterprise, serving as the models for a children's photo book created for sale at the studio.[34] Another part of the plan was for Adams to stick close to home. He restricted himself largely to projects that could be accomplished in Yosemite, and he hosted friends like Weston and O'Keeffe rather than traveling to meet them.

There was a tenuousness about all this, understandably so, given the misfortunes that multiplied during the transition from San Francisco. The Berkeley house had been unfortunately located astride the Hayward Fault, and shortly after settling there the Adamses were hit by an earthquake of explosive force. The sanctuary of Yosemite was no less immune to nature's destructiveness. At one point torrential rains wiped out roads, cut off the electricity, and left a crowd of refugees camped on the high ground near the studio; at another time his assistant, Ronald Partridge (Imogen Cunningham's son) was struck by lightning as he helped Adams photograph from a Sierra summit.[35] Perhaps the worst blow came in the summer of 1937 during the first of Weston's visits. The family had only recently completed its move, and Adams was still in the midst of his recovery; then, as he told Stieglitz, "on top of a rather jittery state of mind we had the misfortune to suffer a fire which consumed half of our new darkroom." Many negatives were saved thanks in part to Weston and Charis, but much of Adams's work was nonetheless destroyed.[36] So there was a disconcerting irony about Adams's move to Yosemite, for the return to nature was fraught with natural disaster, and Yosemite's calamities were a match for its rainbows.

Like so much else, Adams's art was also affected by his collapse and recovery. During the early, darkest episodes of his depression, Adams at times felt as though he was washed up as an artist. But as the months passed he was more frequently inclined to re-orient rather than abandon his photography. He thought that his art, like his life, he had become seriously misdirected, and vowed to concentrate more

on the creation of images rather than reputation, to work with "a joy that has nothing to do with conquest, superior accomplishment, fashionable fame."[37] It also seemed necessary to change the nature of his photographs themselves, to revisit fundamental themes that he had neglected in the process of creating f/64 images and preparing for New York audiences. He found his feelings captured in lines from a Robinson Jeffers poem, a piece significantly entitled "Return":

> A little too abstract, a little too wise,
> It is time for us to kiss the earth again,
> It is time to let the leaves rain from the skies,
> Let the rich life run to roots again.[38]

With a sense that the last few years had been a hectic Icarus-like flight, ending unfortunately if not fatally, Adams opted for the familiar ground of landscape work and earthy subjects.

Friends provided sustaining examples as he went about this work. Jeffers seemed to be a properly grounded artist, with a poetry of austere themes composed in a roughly textured style, leading a solid life in his hand-hewn granite home. During one particularly dark episode Adams buoyed himself with the prospect of Jeffers's approaching visit, when, Adams said, he would be glad to "see the Jeffers and take a good big bite of granite."[39] An even closer inspiration was Weston, and Adams purposefully cultivated the friendship of this fellow photographer whose life appeared to be going so splendidly just as Adams's had come unstrung. Weston seemed a model of simplification at a time when complexities had prostrated Adams, "eliminating everything that is not essential and going ahead with his creative work," while avoiding "complex tie-ups with people and things." Morever, Weston also provided an aesthetic confirmation, for it was at this very time that he too turned from abstraction to the landscape.[40]

One project in particular helped bring Adams back to mountain photography. A wealthy Sierra Club member commissioned him to make a photographic book about the Sierra's John Muir Trail, a memorial for his son who had been killed in a mountaineering accident. Adams was given carte blanche in producing the book (which reminded him of the substantial patronage available for mountain photography). When the project was published as *Sierra Nevada: The John Muir Trail* (1938) the critical reactions were assuring, with praise coming from the chiefs of the Forest and Park Services, and from Stieglitz—who declared that Adams had achieved "perfect photography." But *Sierra Nevada* did more than demonstrate that mountain photography could support both patronage and prestige. As Adams made his images and prepared the text during 1937 and 1938, the project became his means for revising the intense meaning that mountains had held earlier for his art.

In part he returned to notions developed a decade before when he had first read Edward Carpenter. In language remarkably similar to his earlier statements, he now called the Sierra not only "an inexhaustible well of esthetic and spiritual stimulation," but also a place where "the mystical and creative elements in man" were concretely expressed "in the remote fastness of these mountains."[41] But there were also in Adams's language new elements reflecting the psychological turmoil

of his life and his determination to kiss the earth again. Yosemite was not just big, he told Stieglitz, it had "a beauty that is as solid and apparent as the granite rock in which it is carved." His keenness for granite again approached fixation; he spent months searching for just the right typeface for the *Sierra Nevada* title page, finally choosing one modeled after chiseled stone, because, he said, "the Sierra is granite and the selected font had the formal simplicity of carving in such stone."[42] In his own photographs of the mountains, Adams similarly sought "a certain austerity...accentuating the acuteness of edge and texture," for the Sierra were among the "most enduring and massive aspects of the world," and, in what was a slap at his f/64 work, he said that those aspects demand "more than an abstract and esoteric interpretation." Stark and sharp though they might be, he did not want his images to be a coolly clinical catalogue of the mountains. In his foreword, Adams said that "the emotional interpretation of the Sierra Nevada...is the prime function of the present work."[43] At this particular time in his life, endurance and solidity seemed particularly good qualities, and in the images of *Sierra Nevada*, Adams lingered with evident affection upon his enduring mounds of stone.

As 1937 passed into 1938 and Adams gradually emerged from his depression, he made analogues of his rainbow photographs, a series of landscapes that were metaphors of his psychological state. Light is of course a major dimension to photography, but with his rising mood, Adams's absorption with light only grew. He became interested in the *arrival* of light, in processes which were emblematic of the growing glow in his spirits. In his foreword to *Sierra Nevada*, Adams noted that John Muir had characterized the Sierra Nevada as a "Range of Light," and then Adams went on to describe the Sierra in his own words; these mountains were not mere passive recipients of light, but instead a range that gloriously "rises to the sun as a vast shinning world of stone and snow and foaming waters."[44] The emergence of light, and the concomitant retreat of darkness, became Adams's intertwined psychological and photographic themes. In August and September of 1937, he had described life in paradigmatic terms of depression, saying that he felt as though he was "in a kind of box with cast-iron sides," and then also noted that with his recent images he had tried to achieve a quality of "lifting-up-the-lid."[45]

One of Adams's favorite moments of enlightenment-cum-photography was dawn, laden as it is with connotations of hope and renewal. Of his early-morning images, he was particularly pleased with ones he made in the Owens Valley, a large plain situated on the eastern side of the Sierra where he could photograph the full blaze of sunrise upon the mountains. Among those photographs was *Mt. Whitney, Dawn, Sierra Nevada, California* (c. 1937; fig. 16.5), a particularly telling image that presaged some of the treatments he would later develop. This was a familiar setting, for his earlier photograph, *Dawn, Mount Whitney*, California (fig. 16.1), had portrayed the same subject at the same time of day. But that earlier, abstract treatment had been a very dark image, depicting the mountain as a mere against a barely lightening sky. Now, though, Mt. Whitney is awash with sunlight, gloriously occupying much of his frame, and gleaming as the last shadows retreat down its face. Adams's earlier 1932, image employed the shallow space of modernism, but here he indicated a full depth of field with his alternating bands of shadowed foreground, shining mountain, and sky soft background.

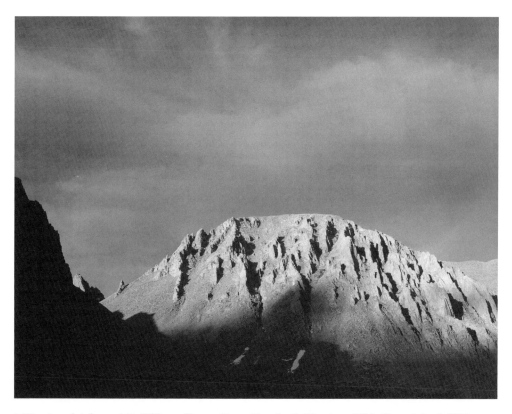

16.5. Ansel Adams. *Mt. Whitney, Dawn, Sierra Nevada, California, c. 1937,* Copyright © 2000 by the Trustees of the Ansel Adams Publishing Rights Trust/CORBIS. All Rights Reserved.

In Yosemite Valley itself, Adams employed clouds in other images of emotional illumination. With is updrafts and temperature gradients Yosemite constantly gives birth to clouds, and the boiling thunderclouds of summer were some of Adams's perennial subjects. But during this period, he also worked with winter clouds, and particularly clouds in the process of lifting from valley. In *Sentinel Rock and Clouds, Winter, Yosemite National Park* (c. 1937), he depicted one of Yosemite's huge monolithic crags as the clouds part from it. With other images Adams backed up for a more panoramic view, looking across fields of freshly fallen snow and peering up the Valley as clouds gradually disappear. *Clearing Winter Storm, Yosemite National Park* (c. 1937; fig. 16.6) was the most dramatic of the lot. This is a fine vista from a narrow location known as New Inspiration Point, the view greeting visitors upon their arrival at Yosemite; it has tempted countless other photographers over the years, and Adams periodically rephotographed the scene throughout his life. But as this early December storm lifted, Adams achieved one of the greater operatic treatments of his career (although this particular print from George Eastman House is a murky rendition). The newly-fallen snow combines with the dark trees and stone to achieve heightened contrast, and the startling white ribbon of Bridal Veil Falls serves as a fine visual detail. Compositionally inviting, the image draws the eye onward, over the threshold of the valley floor, past the

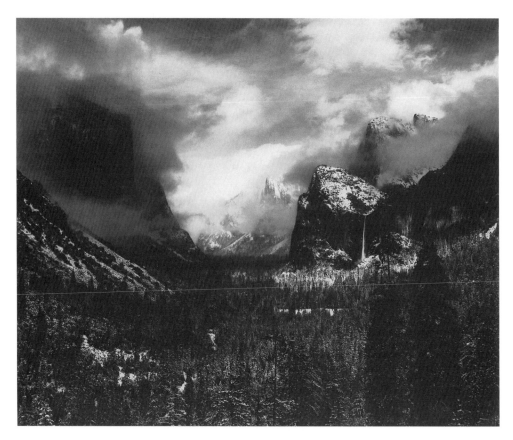

16.6. Ansel Adams. *Clearing Winter Storm, Yosemite National Park, c. 1937*, Copyright © 2000 by the Trustees of the Ansel Adams Publishing Rights Trust. All Rights Reserved. Courtesy George Eastman House.

portal of the granite shoulders and into the scene beyond. The swirling clouds and dramatic lighting give some indication of Adams's mystical feel for Yosemite, and among his images this is one of the most reminiscent of the treatments by nineteenth-century romantics like Bierstadt. The instant of exposure is one of the more critical of the components to *Clearing Winter Storm*. Had the shutter been released at an earlier moment, the image of completely beclouded valley would be visually boring, and if snapped at a later moment this would have been one more rendition of a standard view. At this instant, though, the Valley offered up a reflection of Adams's dreams, mirroring as it did a period of envisioned recovery when he hoped the storm clouds of his life would begin to clear.

It was the pursuit of recovery that had brought Adams back to Yosemite in early 1937. But by the end of 1938 he had begun to relapse into old ways: too many diversions, too little time for photography. Yet this was not complete recidivism, for although Adams reverted to many of his restless ways, he gradually lost some of his manic qualities. He also lost some of his earlier need for approval, became less insistent upon the hegemony of straight photography, and demonstrated greater willingness for intermediaries to handle some of his pro-

jects. Though Adams continued to clutter, not simplify, his life, by the end of 1940 his depression had almost completely lifted, and he was a mellower, more self-confident man.

He still very much wanted to claim a prominent spot in Stieglitz's photographic lineage. But Adams increasingly referred to Stieglitz as a man whose day had passed, a historical figure to be revered more than a contemporary to be placated, and Adams came to think of himself as Stieglitz's heir: "his mantle falls on me."[46] In that role, Adams continued to manifest his pre-collapse impulses to shape and mold the American art world. Some of these were educational efforts, including an annual Yosemite photo seminar and his (eventually ubiquitous) Zone System method for calibrating exposure and processing.

Larger efforts were directed toward exhibitions and institutions, the sorts of molding instruments he had sought to use before his collapse. But Adams's tolerance had grown apace with his increased sense of secure status in the art world, and he now displayed a greater breadth of images. He organized a 1939 San Francisco exhibition, the "Pageant of Photography," a huge enterprise which he aspired to make "a major event in the world of *Art.*" But rather than the single definition of true, straight photography that he had promulgated at the Ansel Adams Gallery, this exhibition illustrated the complexity and growth of photography, and the pictorialism that he had once characterized as a serious photographic heresy now became more of a youthful indiscretion.[47] In addition Adams's exhibition attracted the attention of photo historians Beaumont and Nancy Newhall. Adams and Beaumont developed plans for a Department of Photography and an inaugural exhibition at the Museum of Modern Art.[48] The Ansel Adams Gallery and his other earlier efforts had been designed "to define what *is* right," but now that inaugural show was "intended not to define but to suggest the possibilities of photographic vision."[49]

By 1941 Adams had found his way to something that might be called influence through indirection. For some years he had been on the Sierra Club board of directors, expressing his opinions about policy and personnel, but leaving day-to-day execution to office staff and an executive director. At MOMA, similarly, Adams was crucial for forming department policy, but someone else opened the mail and answered the phone. None of this meant that Adams's intense energies had abated; instead it meant that he could devote them more to his strengths: making photographs and writing letters. In the years following the foundation of the Department of Photography, Adams turned to making art photography with unprecedented productivity, and there was a parallel explosion in his correspondence.

Through these two mechanisms Adams would achieve the influence he had sought. His contemporaries were flooded with letters and the exhibit halls of his day were deluged with Adams images. Some of these were mediocre specimens, but as Lenin recognized when he said that quantity has a quality of its own, Adams's voluminousness made him a force to be noted and even reckoned with.

1. Ansel E. Adams, "The Fortnightly: Section of Photography," May 17, 1932, typescript, AAA/CCP. Ansel Adams, "Photography," *Fortnightly* 1 (December 8, 1931), 22. EW to AA, January 28, 1932, AAA/CCP.

2. Mary Street Alinder, "The Limits of Reality: Ansel Adams and Group f/64," in Theresse Thau Heyman, *Seeing Straight: the f.64 Revolution in Photography* (Oakland: The Oakland Museum, 1992), 42-50. Michel Oren, "On the 'Impurity' of Group f/64 Photography," *History of Photography* 15 (Summer 1915), 119-27. Ansel Adams, *An Autobiography*, with Mary Street Alinder (Boston: Little, Brown and Company, 1985), 110.

3. Ansel Adams, statement for *Camera Craft*, c. 1933, in Heyman, *Seeing Straight*, 55. The "Group f/64 Manifesto" appears in Adams, *Autobiography*, 111-12. AA to William Mortensen, 1933, *Autobiography*, 114.

4. Indeed, so intense was Adams's re-working of his material that the print did not represent the scene that his companion Sierra Club members had witnessed on that day in the mountains. Cedric Wright was among Adams's companions on that hike, and we know that he studied this particular view, for in something of a parody of his friend's technique, Wright watched Adams make the image and then set up his own camera in that very location. But when Wright saw *Frozen Lake and Cliffs*, he was startled by the print and wondered why he had not perceived the vision that Adams conveyed; Ansel Adams, Examples: *The Making of 40 Photographs* (Boston: Little, Brown and Company, 1983), 11-13.

5. Adams, *Autobiography*, 147.

6. Ansel Adams, "An Exposition of My Photographic Technique: Landscape," *Camera Craft*, 41 (February 1934), 72.

7. AS to AA, June 28, 1933, in Ansel Adams, *Ansel Adams, Letters and Images 1916-1984* (Boston: Little, Brown and Company 1988), 52-54, hereafter *Letters*. Weston had visited Stieglitz when Stieglitz's mother was dying. Adams came at a stressful time, too. The preceding November, O'Keeffe had collapsed while installing a Radio City Music Hall mural, and in February 1933 she had been hospitalized in a mental hospital. She was discharged shortly before Adams arrived, and promptly left Stieglitz alone in New York as she traveled to Bermuda.

8. AA to AS, June 22, and July 6, 1933, AAA/CCP.

9. Ibid., October 23, 1933, and May 16, 1935, AAA/CCP.

10. Ibid., September 12, 1933, AAA/CCP.

11. Ibid., June 22, 1933, AAA/CCP. See also AA to AS, October 23, 1933, AAA/CCP; and AA to PS, September 12, 1933, AAA/CCP.

12. AA to William Zorach, November 20, 1933, in Nancy Newhall, *Ansel Adams: Volume I, The Eloquent Light* (San Francisco: The Sierra Club, 1963), 96.

13. Adams, Ansel "An Exposition of My Photographic Technique: Landscape," 78.

14. Ibid. Ansel Adams, "An Exposition of My Photographic Technique," *Camera Craft* 41 (January 1934), 19.

15. Ansel Adams, "The New Photography," *Modern Photography 1934-5* (London: Studio Publications, 1935), 12.

16. Ansel Adams, Guggenheim application of 1934, in Newhall, *Eloquent Light*, 109. Ansel Adams, 1933 Guggenheim application in Sandra S. Phillips, "Ansel Adams and Dorothea Lange: A Friendship of Differences," in Michael Read, ed., *Ansel Adams: New Light. Essays on His Legacy and Legend* (San Francisco: Friends of Photography, 1993, *Untitled* 55), 54.

17. Ansel Adams, *Making a Photograph: An Introduction to Photography* (New York: Studio Publications, Inc., 1935), 15. AA to AS, May 16, 1935, *Letters*, 77, 79.

18. AA to AS, June 22, 1933, *Letters*, 51.

19. 1934 Guggenheim application, in Newhall, *Eloquent Light*, 109. Adams, *Making a Photograph*, 14.

20. Charles Adams to AA, July 21, 1934, AAA/CCP.

21. AA to AS, May 20, 1934, *Letters*, 70.

22. AA to EW, August 6, 1935, *Letters*, 79.

23. AA to EW, August 6, 1935, *Letters*, 79.

24. AA to David McAlpin, February 3, 1941, *Letters*, 126. Apparently such photographs appealed to Adams's viewers. His image of Lucy Ellen Darcy's stone, *The White Tombstone*, Laurel Hill Cemetery, San Francisco (1936) sold for three or four times the average price of his other photographs in the show, and was purchased by none other than the discerning collector and patron, David McAlpin.

25. AA to AS, October 11, 1936, *Letters*, 84.

26. AS to AA, December 16, 1936, *Letters*, 86. AA to Virginia Adams, November 16, 1936, *Letters*, 84-85.

27. AA to Cedric Wright, late December 1936, *Letters*, 92.

28. Ibid. AA to AS, December 22, 1936, *Letters*, 90. See Newhall, *Eloquent Light*, 129; Jonathan Spaulding, *Ansel Adams and the American Landscape: A Biography* (Berkeley, University of California Press, 1995), 138-9; and Mary Street Alinder, *Ansel Adams: A Biography* (New York: Henry Holt, 1996), 123-124.

29. AA to AS, November 29, 1936, *Letters*, 87.

30. Ibid., December 22, 1936, *Letters*, 90.

31. Ibid., January 15, 1937, AAA/CCP.

32. AA to Cedric Wright, late December 1936, *Letters*, 92-93. AA to AS, December 22, 1936, *Letters*, 90-91.

33. AA to AS, February 10, 1937, AAA/CCP. AA to "Pa, Ma, and Aunt Mary," "Sunday" [early March, 1933], AAA/CCP.

34. Ansel Adams with Virginia Adams, *Michael and Anne in Yosemite Valley* (New York: Studio Publications, 1941).

35. AA to AS, March 21, 1937, AAA/CCP. Adams, *Autobiography*, 150-51.

36. AA to AS, July 29, 1937, *Letters*, 97. As though all this was not enough, the Yosemite Park and Curry Company published a booklet of Adams's photographs without his permission, and then when *LIFE* magazine reprinted the images—yet again without permission—the accompanying byline identified Adams as a resort photographer. AA to AS, November 12, 1937, *Letters*, 101-103. Spaulding, *Ansel Adams*, 158.

37. AA to AS, November 27, 1936, *Letters*, 86.

38. Ibid., December 22, 1936, *Letters*, 90. The lines originally appeared in *The Selected Poetry of Robinson Jeffers* (New York: Random House, 1935), 576.

39. AA to Cedric Wright, late December 1936, *Letters*, 93.

40. Ibid., Summer 1937, in Newhall, *Eloquent Light*, 143. For further comparison, see Spaulding, *Ansel Adams*, 155.

41. AS to AA, December 21, 1938, *Letters*, 111. Ansel Adams, Foreword, *Sierra Nevada: The John Muir Trail* (Berkeley: The Archetype Press, 1938), np.

42. Ibid., November 12, 1937, *Letters*, 102. AA to AS, December 26, 1938, AAA/CCP.

43. Adams, *Sierra Nevada: The John Muir Trail*, foreword, np.

44. Ibid.

45. AA to Cedric Wright, Summer 1937, in Newhall, *Eloquent Light*, 143. AA to AS, September 21, 1937, *Letters*, 98.

46. AA to David McAlpin, July 2 and July 11, 1938, AAA/CCP.

47. AA to AS, April 13, 1940, AAA/CCP. Ansel Adams, *A Pageant of Photography* (San Francisco: Crocker-Union, 1940), np.

48. AA to David McAlpin, February 14, 1939, *Letters*, 114. Beaumont Newhall, "The New Department of Photography," *The Bulletin of the Museum of Modern Art*, 8 (December-January, 1940-41), 5. David McAlpin to AA, September 7, 1940, *Letters*, 119.

49. "The Exhibition: Sixty Photographs," *The Bulletin of the Museum of Modern Art*, 8 (December-January, 1940-41), 5. AA to David McAlpin, September 9, 1940, AAA/CCP.

17. NATION'S NATURE

The 1940s and 1950s were the most productive years of Adams's photographic life. He created the classic images of his career, a set of expansive, reverential and immensely popular renditions of the American landscape. He learned to pace himself somewhat, balancing his photography against his other interests, and his family learned to do without the inattentive and often absent husband and father. During these decades there was a subtle shift in Adams's attitude toward nature, for what had once been a kind of mysticism now became something more like pantheism, and the trance-like moments of an earlier day gave way to venerative celebrations as Adams concentrated more on nature's holiness than its ineffability. These changes were reflected in his imagery, as he sought to evoke the spirituality of the American landscape, trace its primordial qualities, and examine its interconnections with humans. As he celebrated the land, Adams began to issue carefully sequenced collections of his images, striving for cadence as the books progressed from image to image, and enhancing the rhythms by intermingling poetic text with the images.

Nature and nation were peculiarly associated in this work. Patriotism certainly motivated Adams as he celebrated the American landscape during World War II and the Cold War. But this was not just geographic chest-thumping. In his nature nationalism, landscape was a key part of Americans' identity, a shared locus unifying an otherwise disparate people. Moreover, Adams wanted to evoke something in addition to pride and identity; he wanted to prod the nation's conscience, to make Americans feel that the land is *ours* and that we must therefore become its stewards. Thus Adams's emerging conservation message had a kind of nationalism at its base, something that helped to make his environmentalism as popular and accessible as his art.

By the summer of 1941 Adams had abandoned any pretense of a life of quiet retreat in Yosemite. With renewed energy he threw himself into a round of activities even more diverse and dispersed than those of the 1930s. He traveled to New York as a MOMA consultant, to Los Angeles as a photography instructor, and to far-flung locations for clients like Standard Oil and the U. S. Potash Company. As in the 1930s, there were domestic consequences to all these absences. His children became cool and distant, and Virginia had the unwanted responsibility of single-handedly operating the Yosemite studio. In 1941 she went so far as to file for divorce, but she acquiesced to his pleadings, withdrew her petition, and the family settled into a strained relationship which preserved outward social appearances.[1]

In his photography, Adams became increasingly committed to panoramic views, and experimented with over sized prints rendered as murals or free-standing decorative screens. These works came to the attention of Secretary of Interior Harold Ickes, who in the summer of 1941 hired Adams to photograph the National

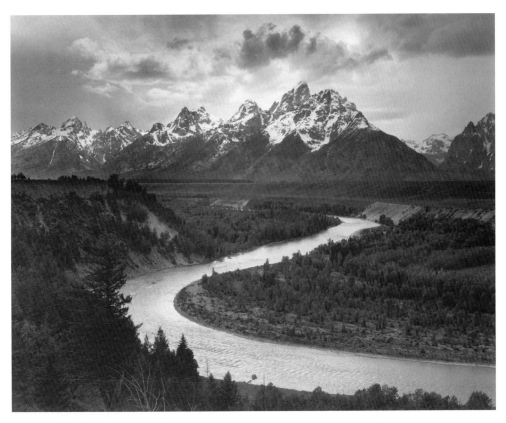

17.1. Ansel Adams. *The Tetons and Snake River, Grand Teton Nation Park, 1942*, Copyright © 2000
by the Trustees of the Ansel Adams Publishing Rights Trust/CORBIS.
All Rights Reserved.

Parks and Monuments and produce large murals for the Department's Washington
headquarters. This was a sweet assignment, for Adams was paid well, allowed
expressive freedom, and given artistic control of the government-owned negatives.
He began his travels in October 1941, and by the project's termination the follow-
ing June, he had ranged through much of the West, going beyond California and
into Montana, Wyoming, Colorado, and New Mexico.[2]

Some of these photographs are humdrum and conventional. He saw the
usual sights, and like other visitors to the National Parks, returned home with
pictures documenting his presence at Old Faithful's eruption or the Grand
Canyon's rim. But other more dramatic images show the emerging interests that
would mark Adams's best photographs over the next two decades: a concern for
majestic scale, a fascination with the relationships between humans and the
earth, and a determination to convey what he thought of as nature's spiritual
qualities. *The Tetons and Snake River, Grand Teton Nation Park* (1942; fig. 17.1), is
one of these images, displaying the broad horizontal bands that became some-
thing of a signature in this period. Here the magnificent line of the river ties
together foreground and background, the glistening water serving like a visual
path leading the eye back and into the image. The lighter values at the top of the

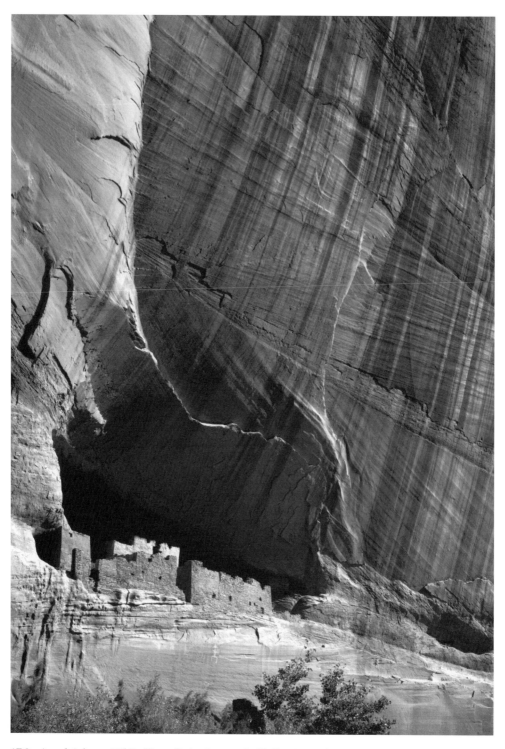

17.2. Ansel Adams. *White House Ruin, Canyon de Chelly National Monument, Arizona, 1942,*
 Copyright © 2000 by the Trustees of the Ansel Adams Publishing Rights Trust/CORBIS.
 All Rights Reserved.

frame attract the eye, too, and, coupled with the sweep of the river, they lead the vision upward toward the sky and suggest an emotional parallel of uplift and even heavenliness. The moment seems almost to hum, for although much of the scene is in shadow, the sun has broken through to fall upon the distant mountains and bathe them in glory-like effects. Though the mountains are huge, there is an immediacy between them and the viewer, for snowmelt flows down from the cliffs and to within a few yards of the observer.

White House Ruin, Canyon de Chelly National Monument, Arizona (1942; fig. 17.2) is a considerably different image. To photograph this ancient Anasazi cliff dwelling, Adams had to overcome the technical problems of working in canyon depths where the lighting varied from minute to minute. The image was also a direct art-historical reference, for in making it Adams consciously set up his tripod in almost exactly the same spot used by the nineteenth-century pioneer photographer Timothy O'Sullivan.[3] This photograph rewards study. On the cliff face below the buildings is a petroglyph which can easily escape the casual glance. Aside from deep black of the recess, much of this image lies in moderate tones of gray, and, unlike the Snake River image, it is a two-dimensional, almost flat scene. But that flatness is countered by the arresting markings on the stone, with the horizontal rock striations angling downward toward the right, while over the surface of the rock runs another set of lines caused by water run-off from above, forming nearly right angles where they meet the rock fissures. In addition to these strong formal qualities, the image also indicates a relationship between humans and nature. The vastness of the rock and the relative smallness of these buildings suggest that humanity may have a small place in the cosmos. Yet the scene also conveys a great closeness between people and nature, for these buildings are made of the soil itself and then nestled into this crevice so that they seem to be resting in the very navel of the earth.

The relationship between humans and nature at first seems considerably less intimate in what became Adams's most popular single image, *Moonrise, Hernandez New Mexico* (1941; fig. 17.3). Adams came upon this scene in the autumn of 1941 as he worked in New Mexico on the mural project. *Moonrise* was made at the end of a frustrating, unproductive day, when Adams had quit work and was driving back to Santa Fe. He happened to glance away from the highway and toward the small village of Hernandez on his left. From the west came the last few rays of the setting sun, illuminating the scene just as the moon rose above it in the east. Adams pulled to the road side, and rushed to photograph the fading scene; unable to locate his exposure meter in the panic, Adams calculated the exposure data from memory (who else would instantly recall the candles-per-square-foot luminescence of a full moon?), and managed a single negative before the sun sank below the clouds. In all the hurry Adams had to forego his usual pre-exposure routine, and the negative consequently proved difficult to print; over the next three decades Adams massaged it, achieving increasingly dramatic variations of the image.[4]

Although much about the making of *Moonrise* was serendipitous, the subject was hardly a new one, for as he said, "I have always been moonstruck."[5] As early as 1925 he had photographed a lunar eclipse, in 1932 he placed that tiny moon-sliver in *Dawn, Mount Whitney* (Figure 16.1), and during the 1930s and 1940s he made the moon even more prominent. Adams's lunar infatuation was inspired in part by

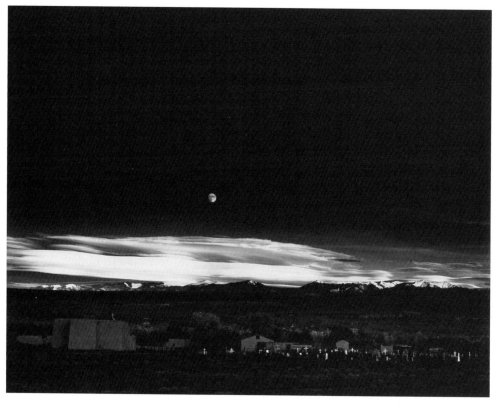

17.3. Ansel Adams. *Moonrise, Hernandez, New Mexico, 1941*, Copyright © 2000
by the Trustees of the Ansel Adams Publishing Rights Trust. All Rights Reserved.
Courtesy George Eastman House.

the romantic literature that he had consumed since an early age. The book that had
prompted his first visit to Yosemite described the moonlit valley as "an indefinite
vastness, a ghostly and weird spirituality," and in Adams's well-thumbed copy of
Towards Democracy, poet Edward Carpenter described the moon as a repository of
"the mystery of creation." Adams himself had experimented with poetry during
the 1920s, with lines presaging the scene he would later capture beside that New
Mexican road: "O moon, you stare as a white cave from the cold stone of the sky /
And the long mesas flow far under your silence..."[6]

Like his poetry, Adams's *Moonrise* also reaches melodramatically for mystery
and vastness. Figure 17.3 proceeds through a series of horizontal bands, first a
swath of desert brush in the foreground, next a narrow ribbon of buildings, then
another stretch of sage that rises to the distant mountains, followed by streaks of
clouds, and finally the broad sky, occupying over half the frame and dramatically
punctuated with the moon's full disc. Early prints have a lighter and more clouded
sky, but through the years Adams began to realize his vision as he isolated his moon
in the velvety blackness. There are some touches of existential loneliness to the
image, for Hernandez seems an insignificant outpost beneath the empty canopy of
the sky. But the greater effect has less to do with isolation and partakes more of
Adams's favored theme of interconnectedness. Though some of the structures

appear to be recently built, and modern utility poles dot the village, the preponderance of adobe building gives Hernandez a sense of ancient earthiness and a quality of enduring rootedness. The church, bearing connotations of faith's mysteries, is the single largest single thing in the image, and the graves are marked by crosses, printed as brightly as the moon, symbolizing the hope of resurrection and a cosmic scale of time. Indeed, ordinary earth-bound time was not much on Adams's mind as he made this image, for he failed to note the time or date, and it was only decades later when astronomers calculated the celestial angles and determined the actual moment of exposure (4:49 pm on November 1, 1941).[7]

By the autumn of 1941, Adams had thus begun to find a certain stride. As he photographed Hernandez, the Snake River and Canyon de Chelly, he practiced an increasingly expansive photography that took him beyond Yosemite and into a broader set of images than those of earlier times. *Moonrise* and *White House Ruin* also had their traces of humanity; as such they indicated a nascent purposefulness to Adams's work as he began to regard the landscape as not only glorious in itself but also for the spiritual and sustaining qualities it might provide for humans.

The Japanese attacked Pearl Harbor and the United States entered World War II just a few weeks after Adams made *Moonrise*. Although eager for some way to put his skills to work for the military, he was, like Weston, beyond the age for normal military service. His direct contributions were limited and even bizarre: teaching photography to hospitalized GIs, developing a curious scheme for the photographic identification of corpses, and even making propaganda photographs of San Francisco's Italian-Americans exercising their civil liberties.[8]

But Adams's more significant efforts lay elsewhere. At one point in 1943 he declared his greatest wartime contribution was "interpreting the natural scene as a part of what we are fighting for."[9] With this work, Adams joined a larger movement that had begun to emerge in American culture during the late 1930s. Following themes already explored by the likes of Thomas Hart Benton, various artists and writers began portraying Americans as connected to their land not just by location but also by fate, suggesting that the land's natural qualities expressed the people's political strengths. By the end of the 1930s documentary photographers had left behind their Dustbowl imagery to make images of a landscape that was productive, hospitable, and, they argued, politically unifying. Painter Joe Jones likewise turned from canvases of urban conflicts and began to execute paintings of cooperative labor in vast fecund fields, while John Steinbeck's 1939 *Grapes of Wrath* made epic connections between survival of the land and survival of the people. A year later Woody Guthrie wrote "This Land Is Your Land," using an extended geographic inventory (Redwood forests, Gulf Stream waters) to stress the broadest kinds of ownership: "this land was made for you and me." Irving Berlin's "God Bless America" called down divine favor upon a similar listing ("from the mountains, to the prairies") and enjoyed even more popularity; though written in 1918, the song became known in 1938 when Kate Smith belted it out over the airwaves, and by 1941 it could be heard across the land.[10] This conjunction of landscape and national symbolism reached a zenith of sorts that same year with the completion of Mount Rushmore National Memorial. Since the nineteenth century, Americans had linked

national destiny to continental breadth and democratic institutions to the unsettled frontier, but as World War II approached, they managed a particularly intense and emotional conflation of landscape and patriotism.

Adams's own sense of how photography could make connections between America and Americans emerged gradually in 1941. Initially there seemed to be little of this nationalism in his motivation for the National Park mural project; at first Adams was probably more excited by the project's promise of artistic freedom and economic reward. But things began to change in the summer of 1941. Adams proposed that MOMA sponsor an invitational exhibition called *Images of Freedom*, and the Museum's exhibition press release asked photographers to assess "the vast, unconscious power of millions of us living on the American earth…Let us look at the earth, the sky, the waters. Let us look at the people…What are our resources and our potential strength?"[11] After Adams began work for the Interior Department in the fall, he continued to speak along these lines, suggesting to his employers that his own photographs might promote national unity and strengthen Americans' resolve by demonstrating "the scope, wealth and power of the resources of our country…"[12] These ideas were both curious (ugly coal pits were more likely war resources than Adams's beautiful canyons) and self-serving (he clearly wanted his Interior Department patronage to continue during the war), but Adams was also genuinely anxious about the looming war, and with time he began to offer increasingly heart-felt linkages between his photography and Americans' war-time needs. Writing just seven days before Pearl Harbor, Adams expressed the hope that his work might lighten some of the gloom of imminent conflict, describing his subject as exploring "the spiritual values of the Natural Scene and its effect upon people," and saying that "the contemplation of a rock, or a tree, or a cloud in these times will have healing and strengthening effects."[13]

There were many wartime uses for photography, and Adams occasionally lent his skills to reconnaissance and propaganda efforts. But for art photography he saw a more subtle purpose, the provision of comfort and sustenance at deep emotional levels. In a time of loud bombast, Adams wanted nuanced quietness, and he accordingly resented Edward Steichen's 1942 *Road to Victory* photographic exhibition, which not only came to MOMA without Adams's consultation, but also regaled audiences with the swaggering jingoism of Steichen's intense photographic enlargements and Carl Sandburg's hyperbolic text. In his own photography Adams aimed to convey America's natural grandeur, scenes that *might* inspire a few viewers to take arms and repel invaders, but which were intended more to be muted and sustaining.

Adams also wanted to draw out the interrelationships between humans and the landscape. That had of course been a theme in recent works like *White House Ruin* and *Moonrise, Hernandez* (figs. 17.2 and 17.3), and in January 1943 Adams expressed his intention to make more such photographs: "my next phase will be *people in relation to Nature.*"[14]

But it was a tough assignment to photograph humans in Adams's favorite natural places. The war brought some people to his Sierra, mostly as transient trainees or convalescents. But it also brought one large group more permanently; as many as 10,000 of the 110,000 "relocated" Japanese-Americans were interned at the

Manzanar camp, located in California's Owens Valley and situated just below the eastern Sierra, Adams's range of light. And so Adams, "moved by the human story unfolding in the encirclement of desert and mountains, and by the wish to identify my photography in some creative way with the tragic momentum of the times," began photographing Manzanar in the fall of 1943. As Adams worked he created an odd amalgam of political critique, nature sustenance and American pride, and when the work was finally completed, it had become his most extensive war-time project, first an exhibition and then a book, *Born Free and Equal: Photographs of the Loyal Japanese-Americans at Manzanar Relocation Center, Inyo County, California* (1944).[15]

Adams's Manzanar story was in part a tale of frightful injustice. Selecting a bold main title and taking his opening text from the Fourteenth Amendment, Adams pointed to the flagrant unconstitutionality of rounding up American citizens without due process and then imprisoning them merely because of their racial ancestry. *Born Free and Equal* stressed the loyalty of the Manzanar internees, and emphasized the brutality of a round-up that swept in the very young, the very old, and the infirm. Adams intended for his book to show Americans that in their own ugly "predatory instincts and actions" they had come to resemble the very "enemy the democratic peoples are fighting."[16]

If Adams's text was inclined towards finger-wagging, his photographs worked in another way. The images were designed not to document abuse, but to illustrate the absurdity of prejudice, prejudice against people who were so unexceptionally *American*, ordinary people like Adams's readers. In his portraits, the inmates have furnished their houses with common clocks and radios, their children play with dolls and trains just like kids outside the camp, and they use forks and spoons—not chopsticks—to eat ordinary-looking meat and potatoes. Their beliefs are familiar, too, for these people worship in Christian churches, and their recreation is thoroughly American, as well—Adams photographed the inmates playing a well-attended baseball game. In still another set of images, Adams demonstrated that the people of Manzanar were patriots as well as Americans, for he photographed uniformed individuals serving in nursing units, the Women's Army Corps, and particularly the Army's 442nd Combat Team—that unit of Japanese-American volunteers which fought with notable gallantry in the Italian theater.[17] In these ways *Born Free and Equal* was a resounding indictment of the relocation effort, portraying the Manzanar inmates as threatless and patriotic people deprived of their constitutional rights.[18]

But Adams thought Manzanar represented triumph as well as tragedy. With *Born Free and Equal* he continued to develop his theme that landscape can be spiritually uplifting and emotionally sustaining. By most standards, Manzanar would hardly seem the locus for such a motif. It was after all a dry, windy, and isolated concentration camp where a demanding climate only compounded the inmates' misery. But Adams's tastes were hardly run-of-the-mill, and the camp had been plopped down in the Owens Valley that he loved and in a region where he had photographed for years (Mount Whitney was only a few miles from Manzanar). Seen through Adams's eyes, "a mood of sunlight and the grandeur of space dwells in the Owens Valley," ringed as it was by the mountains he relished. Adams allowed that the Japanese-Americans had been sentenced to "years of strain and sorrow," but felt that they had had the fortune to have been deposited in a "tremendous landscape"

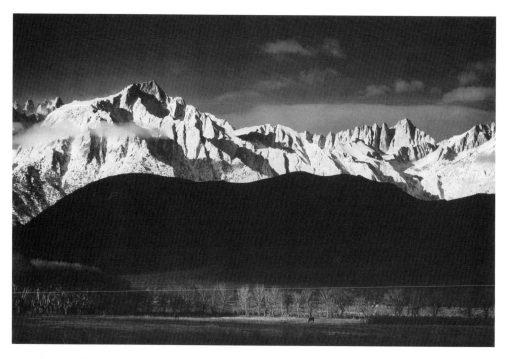

17.4. Ansel Adams. *Winter Sunrise, Sierra Nevada, from Lone Pine, California, 1944,*
Copyright © 2000 by the Trustees of the Ansel Adams Publishing Rights Trust.
All Rights Reserved. Courtesy George Eastman House.

where, Adams believed, "the acrid splendor of the desert, ringed with towering mountains...strengthened the spirit of the people of Manzanar."[19] Thus Adams's greater subject, more than the inmates' trampled rights or their love of baseball, was their American landscape, and to his way of thinking the project was doubly timely, for it dealt not only with an awful episode in the terrible war, but also with the way that the natural scene offered a balm sufficient even for the worst of modern times.

Predictably, Adams thought the mountains were among nature's best comforts. His very first image in *Born Free and Equal* shows an inmate staring quietly toward distant mountains that seem to reinforce his quite, thoughtful, and seemingly determined mood. Another photograph depicts a more graphic human relationship with the landscape, for it shows neatly plowed fields leading towards mountains rising majestically in the distance, an exercise in linear perspective which minimizes the fact that the inmates in the foreground are not bucolic contemplators but farmhands involved in back-breaking stoop labor. With still another image—*Winter Sunrise, Sierra Nevada, from Lone Pine, California* (1944; fig. 17.4)— Adams brought the surrounding mountains even closer. As the book's final landscape, *Winter Sunrise* served as Adams's last and most beautiful portrayal of the surrounding setting, and he chose this moment of a sunny dawn to symbolize the hopeful "destiny" awaiting "the people of Manzanar."[20]

Adams had a firm notion of what he desired from this scene, for he had previously studied and even photographed it. He knew that he wanted a winter sunrise, when snow cover and the sun's low meridian would produce dramatic

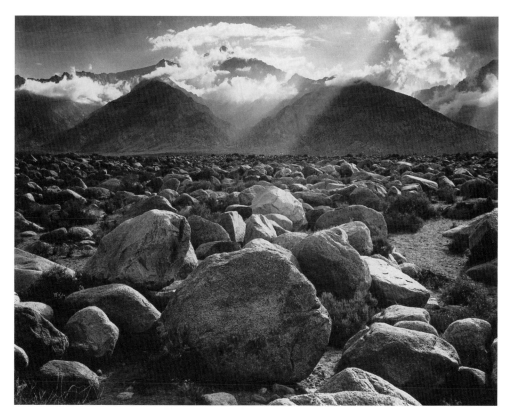

17.5. Ansel Adams. *Mount Williamson, Sierra Nevada, from Manzanar, California, 1945,*
Copyright © 2000 by the Trustees of the Ansel Adams Publishing Rights Trust.
All Rights Reserved. Courtesy George Eastman House.

effects. But the landscape was uncooperative, and on four separate mornings Adams had left Manzanar and driven out into the morning chill only to find that heavy clouds obscured the peaks. Finally, though, the landscape gave Adams what he wanted, "a bright, glistening sunrise with light clouds streaming from the southeast and casting swift-moving shadows on the meadow and the dark rolling hills."[21] Yet even with these larger elements in place, there were still frustrating details. One was the horse grazing in the light along the lower portion of the image, a small element that might potentially reinforce the quietness and beauty of the scene; but the creature insisted on presenting only its rump to the camera. As the lighting conditions began to shift, Adams grew anxious that he might have wasted still another frigid morning, but then at the last possible moment the horse presented a more stately profile and Adams was able to make his exposure.

There was another detail to resolve. Students from Lone Pine High School had climbed the rocky slope in the upper left portion of this image and whitewashed a huge "L P" as testimony to their school pride. Adams thought this was "a hideous and insulting scar on one of the great vistas of our land," and to obliterate it he resorted to post-exposure work, and "ruthlessly removed what I could of the L P from the negative."[22] (The eradication process took time, and there are a few early prints, like this one from George Eastman House, in which the letters remain visible.) Here was

an example of one kind of human interaction with the landscape, and maybe a relevant one at that, for there is an arguable connection between the small-town chauvinism that whitewashed those hills and the more widespread sentiments that had victimized the Japanese-Americans. Adams's interest, though, was not just in any relationship, but in harmonious relationships, and he was therefore willing to use the cosmetics of his craft in an effort to hide what seemed to him a blemish.

Even with this, *Sunrise* did not fully evoke the spiritual qualities that Adams associated with Owens Valley. Though intense, the scene's effect runs more toward peacefulness than grandeur and splendor. To convey those qualities, Adams seems to have had another image in mind, one that he finally realized in 1945: *Mount Williamson, Sierra Nevada, from Manzanar, California* (fig. 17.5). Rising over fourteen thousand feet above Manzanar to its east, Williamson is a giant dominating the entire valley, at sunset casting a shadow extending the full ten miles to Manzanar and engulfing the camp. For Adams, Mount Williamson was "the magic mountain," a towering majesty standing "magnificent and shimmering under the clear sun." Even with Adams's well-seasoned mountain connoisseurship, he still thought this was a particularly grand peak: "no summit of the Sierra looms so impressively above its immediate base as Williamson."[23] Adams described Williamson lavishly in *Born Free and Equal,* and clearly wished to include a photograph conveying some of the magic that he believed it imparted to the Japanese-Americans imprisoned at its base.

But again nature proved to be as uncooperative as it was magnificent. Despite repeated attempts, Adams only managed to obtain his visualization of *Mount Williamson* in August 1945—well after the book's publication and just as the war was winding to its conclusion. Finally, a summer thunderstorm brewed up with spectacular clouds and sheets of rain, and Adams drove to his well-scouted location, a stunning bolder field stretching between Manzanar and the Sierra. He climbed atop his car for a better vista, made a good number of adjustments and then released his shutter.[24]

Adams's patience and efforts infused the scene with spiritual qualities. In this rendition, Williamson seems rather like a Sinai of the American West, with a voice rumbling in the lower registers and shafts of light streaming down in a revelatory performance. The image testifies to nature's immense forces, some presently playing amidst the storms on Williamson's shoulders, and others earlier heaving those boulders about its base. Adams's car-top vantage point lends *Mount Williamson* some of the surrealistic quality he also brought to *Moonrise,* giving nature a preternatural feel as the distant mountain and the immediate rocks all sit insistently within the frame, and even imparting a touch of vertigo with a perspective that seems to rush along the boulders toward Williamson.

Mount Williamson, Winter Sunrise and *Moonrise* were of course renditions of the natural world that arose as much from Adams's imagination and skill as from the scenes before his cameras. By this time in his career Adams was accomplished at representing nature so that it might correspond to his own notions, juggling viewpoints or camera angles so as to avoid the human detritus to be found in even the remotest portions of the Sierra, or, as in the case of *Winter Sunrise,* using his considerable darkroom legerdemain in the effort to banish the offensive evidence of youthful school spirit.

Mount Williamson was a product of the same imagination. In *Born Free and Equal*, Adams had described the view from Manzanar as the nation's promise, saying that "the huge vistas and the stern realities of sun and wind and space symbolize the immensity and opportunity of America."[25] But of course there was neither vastness nor latitude for the inmates' vistas. Theirs was not the opportunity to see Williamson from atop a free-roaming Pontiac; rather than one of immensity, *their* view of Williamson was through the barbed-wire strands encircling *their* portion of America, a concentration camp. And even if the Japanese-Americans had shared in Adams's freedom, it is not at all certain that they would have viewed nature through the same cultural prism through which Adams admired the mountains as "a strengthening inspiration to the people."[26] Clearly the inmates had respect for nature, and they may have even drawn strength and inspiration from it. But they did not share Adams's expansiveness, for when they turned to the mountains surrounding Manzanar, it was in order to collect the plants and stones which they then brought back to Manzanar and used to construct a traditional Japanese garden right in the heart of the camp. Adams's eye, trained by Western romanticism, followed the boulders outward toward a towering mountain, but the inmates' more Eastern sensitivities led them to retrieve similar rocks which they then arranged around a low pool of water. Both products were constructed visions, for just as the inmates used trowels and shovels to fashion their traditional scene, Adams used his techniques and his patience to obtain his majestic photographs. But what was for Adams a landscape evoking American potential was for the Japanese-Americans but another location of American injustice.

The Manzanar experience left Adams primed for what he believed would be "the highest function of post-war photography...to relate the world of nature to the world of man."[27] As the war wound to its conclusion, he sketched some of his feelings about nature and his ideas about photography, and published them along with a portfolio of images in the December 1945 number of the *Sierra Club Bulletin*. The piece was the seedbed for Adams's work over the next two decades, a project of nature photography that he described as "the revelation of the deeper impulse of the world."[28] He offered a set of sixteen photographs, recycling older images and incorporating newer ones, continuing with the kind of ordered arrangement he had used in *Born Free and Equal*, so that the images would "suggest, in their sequential relationship, the germ of a new concept of interpretation of the natural scene."[29] For example, two such photographs, *White House Ruin* (fig. 17.2), and the photo of an ancient saguaro cactus, establish a continuity between "the antiquities of man" and "the antiquities of nature." Photographs of a Yellowstone geyser, Yosemite waterfalls, and Grand Canyon clouds evoke the power and variety of water, while other images indicate the march of seasons.

Adams also offered his words, a poetic prose in the manner of Whitman and Carpenter. Here Adams tried to indicate that nature could satisfy those yearnings that humans otherwise addressed through religion, a kind of divine disclosure open to anyone, because nature "Reveals to all people / The patterns of eternity." Through nature, too, it was possible to achieve religion's promise of unity, and in accompaniment to *The Tetons and Snake River* (fig. 17.1), where the stream seems a

serene avenue into the very heart of the cloud-crowned mountains, Adams said that the individual who knows and attends nature's rituals of the passing seasons "becomes one with the world."[30] Here then was communion, not with some supernatural deity but with the material world of nature.

Adams was not alone in this emphasis on the emotional value of nature. In the years immediately following World War II, there was a modest greening in American culture as prominent figures began to speak of nature as a psychological necessity. One of those figures was Joseph Wood Krutch, who after the war began to write about the nature-human community with an optimism which stands in marked contrast to the glumness of his earlier work, *The Modern Temper* (1929). Probably the most influential work published during this natural awakening was Aldo Leopold's *A Sand County Almanac* (1949), a book that eventually found its way into many more backpacks than Edward Carpenter's *Toward Democracy*. Leopold had begun his career as a forester who occasionally worked for the sports hunting industry, but by the time he wrote *Sand County Almanac* he had come to a non-exploitive wonder over nature's display, and to a prose that bears some resemblance to Adams's photography with its combination of obvious reverence and apparent directness.[31]

Adams's postwar photography was supported by a Guggenheim grant that allowed him to continue the National Parks project in 1946 and 1947. The project extended his horizons beyond the West to include more nature and a more various nature, much of which he photographed in delight. This excitement continued over the next few years, recalling the keen pleasure with which Adams made *Monolith* two decades before. But some of his earlier Sierra giddiness was replaced by a kind of appreciative solemnity as Adams ranged across the nation. A sense of flowing destiny began to supersede what had been an earlier aura of grand stasis; and where the younger man had looked up at the eternal sky and photographed Half Dome from close and below, the older Adams was more the man of perspective, viewing his mountains from the distance of *Mount Williamson* and expressing a growing fascination with time's passage.

One of his more intense nature experiences occurred in 1948 at the Grand Canyon. Working in his usual early-morning hours, Adams experienced "a great surge of visual song" as a comet streaked across the pre-dawn sky. Standing upon the canyon's rim—"the comet in the sky, the fossils at my feet; gigantic span of distance, and gigantic span of time"—Adams had a portentous feeling that "someday the earth may meet with the Exceptional."[32]

As he put these experiences to film, Adams often worked with familiar subjects. The moon remained a favorite, which he photographed in Yosemite, Joshua Tree National Monument, and Alaska. There were new themes, too, such as the free-standing trees that he depicted singly against rock backgrounds in places like Sequoia and the Great Smoky Mountains National Park, or in Sunset Crater National Monument. But Adams's more successful spiritual renditions were of mountains. He continued to photograph the mountains around Yosemite, visited the Crater Lake area, captured Mountain Rainier at sunrise, and returned to Lone Pine for still another sunrise. Chief among these early-morning mountain images was *Mount McKinley* and *Wonder Lake, Denali National Park, Alaska* (1948; fig. 17.6).

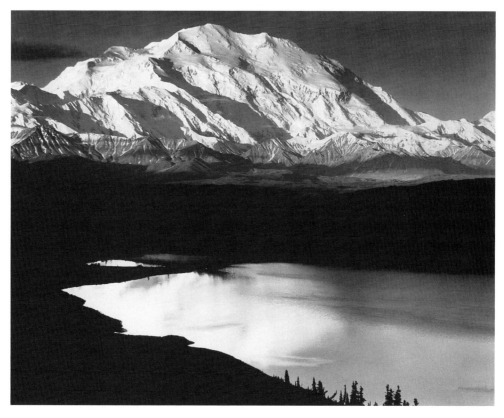

17.6. Ansel Adams. *Mount McKinley and Wonder Lake, Denali National Park, Alaska, 1948*, Copyright © 2000 by the Trustees of the Ansel Adams Publishing Rights Trust. All Rights Reserved. Courtesy George Eastman House.

Adams was "stunned by the vision" of this "vast, magnificent mountain," huge even by his accustomed sense of scale: he and his camera were thirty miles from the mountain's base when he exposed this photograph. The image was made at dawn, sometime around 1:30 a.m., and though the arctic summer days were long, this brilliant scene, like many moments of revelation, was ephemeral, for this proved to be one of only two cloudless days during the week that Adams spent fighting the mosquitoes and stalking the mountain from his Wonder Lake outpost.[33] As with his other mountain images of the period, *Mount McKinley* has a moderate foreground above which a spectacular mountain rises in the distance. His treatment of McKinley was distinct, however, for he rendered the mountain to indicate that it was larger than Williamson by allowing it to occupy more of his frame. Almost completely snow-covered, McKinley stands white and pearlescent above the dark and forested foothills, and its grandness is echoed by Wonder Lake—though not by a conventional reflection. Instead, thanks to Adams's creative framing and treatment, the image actually has two large glowing bodies, each set in its own dark background and of similar shape.

It is difficult to approach Mount McKinley without raised expectations, and Adams had doubtlessly heard his share of superlatives by the time he got there. There were other Parks, though, that took him by surprise, and Texas's Big Bend

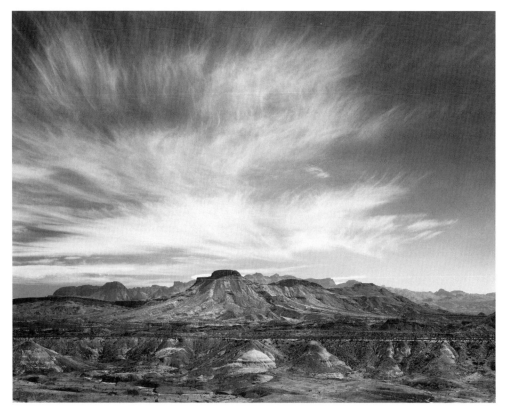

17.7. Ansel Adams. *Burro Mesa and the Chisos Mountains, Big Bend National Park, Texas, 1947,*
Copyright © 2000 by the Trustees of the Ansel Adams Publishing Rights Trust/CORBIS.
All Rights Reserved.

was one of them. The area offers nothing so huge as McKinley, and it was there in 1947 that Adams photographed the much more humble, and more humbly named, Burro Mesa. But as Adams portrayed the scene in his *Burro Mesa and the Chisos Mountains, Big Bend National Park, Texas* (1947; fig. 17.7), he achieved one of his most effective visualizations of that lingering presence that Adams had experienced at the Grand Canyon. With their delicate appearance, cirrus clouds often look like fine brush strokes against a blue sky, and here above Burro Mesa there are cirrus clouds that seem as though they might be made by a supernatural hand, spirit streamers rising from a spirit-filled landscape. Big Bend was a seldom-visited Park, and Adams was pleased that it had suffered little of the commercialism plaguing Yosemite or the Grand Canyon. But it was ethereal qualities which made Big Bend "one of the grandest places I have ever seen," lending it "a magical mood" that he tried to convey in photographs such as this.[34]

Effective in their own right, Adams hoped to compound the aura of images like *Burro Mesa* and *Mount McKinley* by presenting them with others of their kind. In a brief three-year period, he published five separate collections that showcased his landscape photography and gave special attention to work in the National Parks (there was a sixth and still longer publication in the planning).[35] Adams considerably expanded the interpretative text beyond his 1945 experiment, so that with

the publication of *My Camera in the National Parks* (1950), he surrounded the images with sizable chunks of borrowed poetry and four of his own essays. With sections bearing titles such as "The Meaning of the National Parks," Adams labored to insure that his audiences understood the critical importance and sustaining qualities of scenes like *Mount McKinley and Wonder Lake*.

One of those messages concerned the precariousness and fragility of the National Parks. Later in life Adams said that he never created any *single* image *specifically* for environmental causes,[36] but it is clear that he was willing to employ his art for the promotion of general environmental awareness. Although *My Camera in the National Parks* (1950) included images such as *The Tetons and the Snake River* to evoke spirituality, Adams's text was more preachy than evocative, using ominous tones to remind audiences of their responsibilities and to heighten their anxieties. Rather than as sinners dangling over a fiery pit, Adams approached his readers as though they had a god-like responsibility to avert catastrophe, telling them that they held "the future in a delicate and precarious grasp, as one might draw a shimmering ephemerid from the clutches of a web."[37]

For all of Adams's concerns about the delicacy of the parks, he was more interested in what he regarded as the spirituality of the nature within their borders. Using his text to underscore the intent of images like *Burro Mesa* or *Mount Williamson*, Adams told his readers that these mountains, along with the other beauties of nature were "the symbols of spiritual life—a vast impersonal pantheism." Adams regarded this not so much as the one true religion, but rather as something more like a proto-religion, with nature as a single source "transcending the confused myths and prescriptions that are presumed to clarify ethical and moral conduct," and providing "the ultimate echo of God."[38] A force prior to religion, the nature spirit was in Adams's thinking also a precursor to true conservation, for once Americans understood and experienced the holiness of places such as the National Parks—expressed in images like *The Tetons and Snake River*—they would not allow the desecration of development nor the sacrilege of pollution.

Adams's prose was often serviceable. But the more effective poetic sections in his books occurred when he borrowed from others, particularly Walt Whitman. This was a continuation of an early practice—the Manzanar book contained a few Whitman lines—but Adams was more inclined to appropriate Whitman during the postwar years. He often selected well, choosing those of Whitman's words that worked as eloquent complements to the pantheism Adams tried to convey in his images. Upon opening the National Parks portfolio, one first encounters Whitman's proclamation that "the whole earth and all the stars in the sky are for religion's sake," that the "substances, beasts, the trees, the running rivers, the rocks and sands" together constitute "a world primal again, vistas of glory incessant and branching." Thereafter Adams proceeded through the collection with his similarly reverential renditions of flowing waters, massive rocks, and desert sands.[39]

During the 1950s Adams continued to emphasize relationships between humans and a pantheistic nature. Images still poured from his camera and darkroom, yet the bulk of Adams's spectacular photographs like *Winter Sunrise* were

works of the 1940s, and never again did he produce such a cluster of monumental landscapes. Instead, Adams's greater achievement of the 1950s was *This Is the American Earth*, an exhibition and then a book presenting many of those images along with a text by collaborator Nancy Newhall.

Adams's reverential pantheism was at the heart of *This Is the American Earth*, and the message had acquired increased urgency by the time the book appeared at the end of 1959. The text was an improvement over Adams's earlier publications, achieving more sustained and more rhythmic poetic overtones. First exhibited and then published under the auspices of the Sierra Club, *This Is the American Earth* not only provided Adams with his largest audience to that point in his career, it also earned him a national recognition and popularity never achieved by the likes of Stieglitz, Strand, or Weston. Approaching nature in a combination of wistful veneration and aesthetic longing, *This Is the American Earth* resonated with an emergent cultural mood that would characterize American environmentalism during the 1960s and afterwards.

A fair portion of the book's success was due to Nancy Newhall. Beginning during her wartime work at MOMA, Newhall had become both amanuensis and collaborator to American creative photography, interviewing Stieglitz, editing Weston's Daybooks, and co-authoring Strand's *Time in New England*. But Newhall was closer to Adams than to the other photographers. Linked institutionally through their positions at MOMA, she and Adams had a nonromantic friendship something like that of drinking buddies; once she and husband Beaumont severed their connection with the Museum, Newhall worked increasingly as Adams's collaborator on books and magazine pieces, and she also began to write his biography. Better educated than Adams and more inclined than he to visit the library, Newhall brought to their projects a wider set of cultural and historical references, as well as a penchant for short, hortatory phrasing that proved complementary to his photographs.

Like the Strand-Newhall production of *Time in New England*, these Adams-Newhall collaborations took place against the backdrop of the Cold War. Adams was dismayed over the simmering hostility between the United States and the Soviet Union, and horrified at the destructive possibilities of that nuclear weaponry.[40] But when the Photo League was blacklisted, Adams was much less the stalwart than Strand. He first rallied to the League's defense, but in short order he (and Newhall, too) resigned from the club in order to "keep our political noses clean."[41]

Adams likewise distanced himself from developments in the American art community. The late 1940s and early 1950s saw the rise of Abstract Expressionism, a movement that baffled and angered Adams with its insistence that gesture and accident and pattern were more significant than were representation and design.[42] If much of American painting seemed too esoteric and abstract, Adams complained of an opposite development in American photography, where MOMA's photography department, now under the direction of Edward Steichen, seemed to be headed toward a maudlin and popular presentation that discounted artistic interpretations. Steichen's wartime exhibitions had been too propagandistic for Adams's taste, and, unlike Strand, he considered

Steichen's 1955 *Family of Man* show not only an affront to photographic standards (too much grain, too much unauthorized appropriation), but also a sentimentalized presentation of human faces with a message no deeper than "people are good." This anger was the product of a feud with Steichen. Recently Adams had been dismayed when Steichen squeezed Beaumont Newhall out of MOMA; the Newhalls left New York for Rochester, New York, where Beaumont book a position at George Eastman House, and in a combination of loyalty and protest Adams resigned from the departmental board.

During this time Adams and his conservation associates concluded that some of their own most cherished spaces had become more threatened than ever. In response to plans that would allow new roads into remote National Park lands, the Sierra Club shed its older recreational focus for a more preservationist orientation, dropping from its bylaws an original pledge to render the mountains accessible, and for the first time hiring an executive director—the energetic David Brower—to oversee the club's preservationist campaigns. These were moves that Adams approved, and he thought the time had come to wage a fight against "the sonsofbitches and bastards who are giving away the public domain."[43] Club officials eventually agreed with Adams that public education should receive increased attention, and his opportunity arose in 1954 when the club made plans for an exhibition in the LeConte lodge at Yosemite (where Adams had been summer caretaker some thirty years before). He was placed in charge of the exhibition, enrolled Newhall to prepare the text, and together with her settled on the exhibition's title, *This Is the American Earth*.

Structurally, the exhibit was modeled after *Time in New England*, where Strand and Newhall had forged an effective meld of photographs and words. Like that earlier collaboration, there was also an intended prophylactic dimension to *This Is the American Earth*; just as Strand had teamed with Newhall to strike a note for civil liberties during a time of political witch hunts, Adams now enlisted her in a similar campaign for the endangered environment. From its conception the project was expansive, with over one hundred photographs, and it was intended to reach sizable audiences; mounted on fourteen separate panels, *This Is the American Earth* traveled first to Stanford University and then Boston, after which the Smithsonian Institution circulated it nationwide until 1959. Four duplicate versions of the exhibition were circulated overseas by the United States Information Agency, indicating that official America not only thought the exhibition was safe enough, but also that its edginess might advertise an American tolerance for free speech.[44]

The exhibition was but prologue. Since the time of his Guggenheim travels, Adams had planned "a book of many pictures and considerable text,"[45] and he came to think of the exhibition as an early draft of the book. Though Sierra Club officials had been slow to grasp the project's potential, their enthusiasm grew and eventually *This Is the American Earth* appeared as a large, handsome book published under club imprint. And it was a terrific success. The first press run sold out quickly, and awards were bestowed by the publishing industry and the American Library Association. Before *This Is the American Earth* went out of print in the 1970s, some 200,000 copies had been sold, and for a time royalties from the book were an important source of

club revenue. More significantly, the book's message became something of a defining vision within the organization, and was crucial in refashioning the Sierra Club from a California outing society into the nation's environmental conscience.[46]

Both Adams and Newhall were listed as the book's authors. Here as in their other projects, the collaboration was extensive, and the most intense scholarly treatment has yet to distinguish all of their separate contributions.[47] Some portions are clearly attributable to Newhall, and there are Renaissance history lessons of a sort that one cannot find anywhere in Adams's other writings; some sections referring to New England historical figures like Roger Williams and Jonathan Edwards look suspiciously as though Newhall had recycled material excised from her earlier collaboration with Strand. Still, though, Adams's influence was everywhere, even down to the choice of words and the construction of phrases, such as "the tongues of angels," which he had appropriated from St. Paul and used at least ten years earlier.[48] On a more fundamental level, Adams was responsible for the book's basic conception, for the environmental principles that he had absorbed over a lifetime were new to Newhall, and she was frankly surprised by what she called their "vastness, complexity and explosiveness!"[49]

From its very beginning, *This Is the American Earth* strives to draw a connection between humans and nature. Even before the usual front matter of copyright and so forth, readers are confronted with a large, double-page reproduction of Adams's *Winter Sunrise* (fig. 17.4). With its large format and its impressive horizontal flow, the image almost seems to embrace one with a scene of mountain, sky, and field. Below the image are the book's very first lines of text, stressing with repetition (and some awkwardness) that this is not just beauty, but the reader's *American* beauty: "This, as citizens, we all inherit. This is ours, to love and live upon, and use wisely down all the generations of the future." According to the authors it was an ancient kinship, one stretching back before there was an America, through the eons measured by fossils underfoot or comets overhead, and to the accompaniment of an organic, almost Jungian, memory, for "Our blood is sea water: it remembers tides, the moon's pull."[50] Nature thus becomes something of a huge residuum of human understanding, not just a terrific library of factual information but also the very foundation upon which ideas rise; even if civilization was destroyed ("Were all learning lost, all music stilled"), so long as nature remained then man "could again hear singing in himself / and rebuild anew the habitations of his thought." Nature's vastness and illuminating power are manifested in the image accompanying these words, a double-page spread of the sun-drenched immensity of Adams's *Mount McKinely and Wonder Lake* (fig. 17.6).[51]

The book celebrates a closeness to nature, sometimes loudly, at other times more sedately. Sharing the pages with *Clearing Winter Storm* was the assurance that those who manage the trek "shall see storms arise, and, drenched and deafened, / shall exult in them. You shall top a rise and behold creation."[52] But *This Is the American Earth* was cautionary as well as celebratory. Along side the story of nature's greatness and necessity was also the story of humanity's nearsighted destructiveness. The growth of Western civilization was traced from the first tools, through the wheel and beyond, achievements of a sort but all with their dubious aspects, for as the text says, "we remember Faust, and dread his bargain as our own."[53]

This Is the American Earth became an immensely influential book. No less a fig-ure that Justice Douglas hailed it as one of the finest conservation statements ever made. With their combination of image and poetry, Adams and Newhall had man-aged a broad and generalized message in a literature more inclined toward the specified hue and cry of Rachel Carson's contemporary book, *The Silent Spring* (1962).[54] *This Is the American Earth* played an important role in helping voice and even define the sentiments of an American environmentalism, and its enduring evocative power brought the book back into print in 1992. Critic Robert Hughes once said that Adams's images are "the cult images of America's vestigial pantheism," and the pho-tographs do have about them, particularly in the context of *This Is the American Earth*, a quality of nondoctrinal nature spirituality, offering Americans some of what more traditional religious seek to provide.[55] Beauty and mystery abound in Adams's pho-tographs, and the immediacy of his images offers a sense of connectedness if not communion. There is, too, a hint of eternity in these evocations of grand processes and vast amounts of time, offered up in ways intended to give the viewer something akin to religion's special understandings—perhaps even a feel of revelation. Additionally, there are strong elements of crusade and evangelicalism, with the con-servation cause offering all the purpose and proclamation one might want.

This Is the American Earth also highlights some of the conundrums of Adams's ideas about nature and humans. He praised nature as the bedrock from which civiliza-tion arose, but at the same time Adams regarded the civilization around him as calamitous. Adams also evinced a curiously contradictory notion of humanity's status with regard to nature. On the one hand, people are described as rather insignificant new arrivals, and on the other hand as creatures with not only responsibilities toward nature but also the power necessary to discharge those responsibilities: "Man Creator, Man Deliverer, Messiah...create *now* a new heaven that shall lie lightly on this earth."[56]

Much the same tension was evident in the art of Adams's photography, too. In his more humble moments, Adams portrayed himself as a selfless vehicle for nature's glory, and when *This Is the American Earth* was in press, he described him-self in terms reminiscent of Emerson's transparent eyeball. "I have nothing going on in IN my cranium and heart that is more important than the essence of what is going on in the outer world," he wrote in a letter to the Newhalls, "I am but an instrument, a part of, this outer continuum."[57] The book ends on something of the same note. Stretching across the final two pages is his photograph, *Aspens, Northern New Mexico* (1958; fig. 17.8), a rarity among the more powerful images in the book, for it was recent and had been created only the preceding autumn. Accompanying it is the text's last line, "Tenderly now let all men turn to the earth," a benediction sending us passively to that outer world.[58]

Adams may have worked tenderly as he made *Aspens* in the mountains north of Santa Fe, but he also worked with a good deal going on in his head and heart, for the image was painstakingly executed.[59] Adams could describe himself as lowly instrument, supine before a beauty that conveyed itself through him. But he was more the proud and active creator, and in the practice of his art, Adams's oft-used piano analogy was actually much closer to the truth, for natural scenes such as this aspen grove were actually the instruments upon which Adams played his visual melodies.

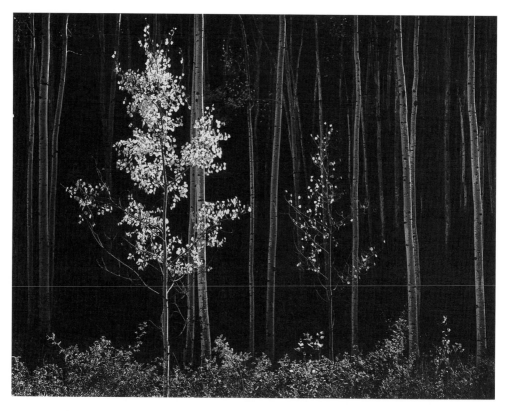

17.8. Ansel Adams. *Aspens, Northern New Mexico, 1958* (horizontal), Copyright © 2000 by the Trustees of the Ansel Adams Publishing Rights Trust. All Rights Reserved. Courtesy George Eastman House.

1. Mary Street Alinder, *Ansel Adams: A Biography* (New York: Henry Holt, 1996). 187-88, 205, 216-19, 275.

2. Alinder, *Ansel Adams*, 200-201. AA to NN, June 11, 1942, AAA/CCP.

3. AA to BN and NN, October 26, 1941, in Mary Street Alinder and Andrea Gray Stillman, eds., *Ansel Adams: Letters and Images 1916-1984* (Boston: Little, Brown and Company, 1988), 132.

4. Ansel Adams, *Examples: The Making of 40 Photographs* (Boston: Little, Brownand Company, 1983), 41-43. Alinder, *Ansel Adams*, 188-200. Ansel Adams, *An Autobiography* with Mary Street Alinder (Boston: Little, Brown and Company, 1985), 274-75.

5. Adams, *Examples*, 133.

6. James M. Hutchings, *In the Heart of the Sierra* (Yosemite and Oakland: Pacific Press, 1868, 1888), 337. Edward Carpenter, *Towards Democracy* (London: George Allen and Co. Ltd at Ruskin House, 1911), 151. AA quoted in Nancy Newhall, *Ansel Adams: Volume I, The Eloquent Light* (San Francisco: The Sierra Club), 42.

7. This dating represents the efforts of astronomers working over a decade. Alinder, *Ansel Adams*, 199-200. Ironically, Carpenter had in his poem dismissed astonomers while speaking to the moon: "the scientific people for all their telescopes know as little about you as any one." (*Towards Democracy*, 151)

8. Alinder, *Ansel Adams*, 172-73. AA to EW. 1943 ("Tuesday—by Gawd!"), *Letters*, 140.

9. AA to David McAlpin, June 21, 1943, AAA/CCP.

10. See William Stott, *Documentary Expression and Thirties America* (New York: Oxford University Press, 1973), 255.

11. Nancy Newhall, "Image of Freedom," Museum of Modern Art press release, October 16, 1941, quoted in Jonathan Spaulding, *Ansel Adams and the American Landscape: A Biography* (Berkeley, University of California Press, 1995), 180.

12. AA to Newton Drury, October 20 1941, in Nancy Newhall, "The Enduring Moment," ms in Newhall Collection, CCP, 187-88.

13. Ibid., November 30, 1941, and December 23, 1941, AAA/CCP.

14. AA to David McAlpin, January 10, 1943, *Letters*, 143.

15. Ansel Adams, *Born Free and Equal: Photographs of the Loyal Japanese-Americans at Manzanar Relocation Center, Inyo County, California* (New York: U. S. Camera, 1944), 7-9. There were two others who also photographed the camp—Dorothea Lange, working for the Office of War Information, and inmate Toyo Miyatake, who photographed surreptitiously on his own accord. Of the three photographers, Adams's images have the greatest pastoral element and the least feel of imprisonment. Adams, *Autobiography*, 260; *Born Free and Equal*, 4, 9; Graham Howe, Patrick Nagatani, and Scott Rankin, eds., *Two Views of Manzanar: An Exhibition of Photographs by Ansel Adams/Toyo Miyatake* (Los Angeles: Frederick S. Wight Art Gallery, UCLA, 1978), 10-11. Jan Zita Grover, "The Winner Names the Age: Historicism and Ansel Adams's Manzanar Photographs," *Afterimage* 16 (April 1989), 14-18. Judith Fryer Davidov, "'The Color of My Skin, the Shape of My Eyes': Photographs of the Japanese-American Internment by Dorothea Lange, Ansel Adams, and Toyo Miyatake," *Yale Journal of Criticism* 9 (1966), 22.

16. Adams, *Born Free and Equal*, 110.

17. To indicate that there was a long tradition of such combat service for the United States, Adams portrayed Harry Sumida, a Navy veteran of the Spanish American war who had been wounded while serving as a gunner on the battleship *Indiana*.

18. Office of War Information officials solicited the exhibit for a Pacific tour in order to demonstrate the "kindness" of the United States toward Japanese peoples. Sadly, in an era that also gave rise to Batan and Auschwitz, Manzanar *was* a relatively decent place. Spaulding, *Ansel Adams and the American Landscape*, 209.

19. Adams, *Born Free and Equal*, 12, 9.

20. Ibid., 106-7.

21. Adams, *Examples*, 164.

22. Ibid., 164-5.

23. Adams, *Born Free and Equal*, 13.

24. Adams, *Examples*, 68-69.

25. Adams, *Born Free and Equal*, 9.

26. Adams, *Examples*, 65.

27. Ansel Adams, "A Personal Credo, 1943," *American Annual of Photography* 58 (1944), 7.

28. Ansel Adams, "Problems of Interpretation of the Natural Scene," *Sierra Club Bulletin* 30 (December 1945), 47-50.

29. Ibid., 50.

30. "Sixteen Photographs by Ansel Adams," *Sierra Club Bulletin* 30 (December 1945), 31-46.

31. For more on these developments, see Stephen Fox, *John Muir and His Legacy: The American Conservation Movement* (Boston: Little, Brown and Company, 1981), 233-249.

32. AA to NN, November 18, 1948, *Letters*, 199.

33. Adams, *Autobiography*, 284-85. Adams, *Examples*, 74.

34. AA to Francis Farquhar, February 16, 1947, *Letters*, 181-2.

35. Ansel Adams, *Yosemite and the High Sierra* (Boston: Houghton Mifflin, 1948). Ansel Adams, *Portfolio One* (San Francisco, 1948). Ansel Adams, *My Camera in Yosemite Valley* (Boston: Houghton Mifflin, 1949). Ansel Adams, *My Camera in the National Parks* (Boston: Houghton Mifflin, 1950). Ansel Adams, *Portfolio II—National Parks* (San Francisco, 1950).

36. Adams, *Examples*, 106.

37. Ansel Adams, *My Camera in the National Parks*, np.

38. Ibid. np

39. Adams, *Portfolio Two*, np.

40. AA to David McAlpin, August 1945, AAA/CCP. AA to NN, April 30, 1954, Newhall Collection, CCP.

41. AA to NN, June 23, 1949, Newhall Papers, CCP.

42. AA to NN, September 15, 1948, Newhall Papers, CCP. AA to NN, February 27, 1950, *Letters*, 214-216. AA to Philippe Halsman, December 8, 1947, *Letters*, 186-7.

43. AA to EW, May 15, 1955, AAA/CCP.

44. There were refinements, though, and Newhall later sold USIA on an exhibition more in keeping with its customary products, a combination of Adams and Whitman which pointed to the American soil as democracy's special seed ground. David Featherstone, "This Is the American Earth: A Collaboration by Ansel Adams and Nancy Newhall," in Michael Read, ed., *Ansel Adams New Light: Essays on his Legacy and Legend* (San Francisco: Friends of Photography, 1993, *Untitled* 55), 63-73. *Autobiography*, 215.

45. Adams, *My Camera in the National Parks*, np.

46. Featherstone, "This Is the American Earth," 63, 70.

47. Ibid., 63-73.

48. NN to AA, October 24, 1958, *Letters*, 252-54. Ansel Adams and Nancy Newhall, *This Is the American Earth* (Sierra Club: San Francisco, 1960), 84. AA to NN, November 18, 1948, *Letters*, 199.

49. NN to AA, June 10, 1954, in Featherstone, "This Is the American Earth," 65.

50. Adams and Newhall, *This Is the American Earth*, ii-iii, 1.

51. Ibid., 86-7

52. Ibid., 78, 84.

53. Ibid., 8

54. Spaulding, *Ansel Adams and the American Landscape*, 313.

55. Robert Hughes, "The Master of Yosemite," *Time* 114 (3 September 1979), 37.

56. Adams and Newhall, *This Is the American Earth*, 46

57. AA to NN, BN and Minor White, June 16, 1959, *Letters*, 258.

58. Adams and Newhall, *This Is the American Earth*, 88-89.

59. Adams, *Examples*, 60-64.

18. Posthumous Existence

During the twenty years leading up to his death in 1984, Adams's friends and a growing public knew him as a remarkably vital man who founded organizations, promoted environmental causes and issued a torrent of prints. Yet in some ways, Thomas More's odd phrase from *Utopia*—"a posthumous existence"[1]— aptly describes the last two decades of Adams's life, a time when much of his creativity had reached its end. During his last twenty years, his production of new negatives declined significantly as he devoted himself to printing and re-printing from a limited number of earlier ones. His old inspiration began to fail him, too, for the growing degradation of nature seemed to curtail the joy that had been so crucial to his art. Though Adams himself had not passed away, his greatest art had passed, and he increasingly devoted himself to sorting out his life, making arrangements so that his legacy and reputation would be to his liking once he actually died.

Thanks to those arrangements, Adams achieved a posthumous existence of a kind Thomas More never envisioned—an eerie, lingering presence that continues years after his death. The private and public relationships built during those last decades earned for Adams a durable affection, and in some quarters he is still referred to not only by his first name but also in the present tense. At times it seems as though the organizations that Adams founded late in his life are involved in the perpetual care of his memory, and in the archives one can visit not only his prints and documents, but also the soiled Stetson that crowned his head or the well-worn rings that encircled his fingers. Adams also made provisions for the continued promulgation of his words and images, resulting in a tide of books, prints, and posters emerging under the dead man's name, and in the ontological curiosity of publication dates that are a decade and more beyond the date of the author's death. Thus, although Ansel Adams's art production slackened well before mortality caught up with him, he managed through the warmth of his reputation and the hardiness of his corporations to fashion a peculiar immortality for himself.

Precise dating is always tricky with regard to Ansel Adams, but the beginning of his end seems to have come around 1963. It was at this time that Adams became, as he said, "conscious of not too many years remaining," and developed a compelling urge to make a reckoning: "I MUST sum up my work."[2] There were a number of such summations, one of the largest of which opened in San Francisco during the fall of 1963, a retrospective exhibition entitled "Ansel Adams: Photographs 1923-1963. The Eloquent Light." Curated by Nancy Newhall, the show was a huge affair stretching through nine separate galleries, and appeared to omit little of Adams from offerings that included not only 450 photographs, but also books, portfolios, decorative screens, and a wealth of per-

337

sonal bric-a-brac. That same year Newhall published the first volume of her Adams biography, a book stronger on anthology than analysis, with much of the text being reprinted and recapitulated letters, manuscripts and publications that Adams himself had written. The previous year, 1962, had brought the completion of what he intended as his final home, a magnificent house directly on the Carmel coast, a mile or so south of Weston's Wildcat Hill. Built to Adam's specifications, the home represented a retreat from his out-of-doors roaming amidst the mountains, and a withdrawal from the repeated new beginnings so often symbolized in his images of mountain sunrises. This last home was finely outfitted for the indoor work of darkroom and office, and kept nature beyond the westward-looking windows from which the aging man watched (but did not photograph) the daily finalities of Pacific sunsets.

Though these were years of summary, they were not a time of idleness. Adams was terrifically busy after 1963, and for a decade or so he occasionally created new images. In a few powerful photographs Adams revisited familiar visual themes like winter storms in Yosemite or the moon rising above Half Dome; there were some new subjects, too, and with his advancing years Adams demonstrated a fondness for the cathedral-like spaces evoked by California's ancient redwoods. But such fresh pieces were increasingly rare. Writing to Newhall in 1973, Adams admitted that "I have done little—very little—new work," and allowed that his principal preoccupation had become the printing and reprinting of older negatives.[3] Many of those repeated images had become quite popular, and to meet the demand Adams began issuing a greater volume of prints than ever before. With this immense popularity, Adams won for photography a degree of acceptance in museums and galleries with his combined appeal to popular culture and the market place. As A. D. Coleman noted just when their popularity was accelerating, Adams's photographs hover somewhere close to the works of Andrew Wyeth and Rockwell Kent; accessible, visually rewarding, and easily recognizable; they do not challenge or alienate audiences, but instead invite viewers into art spaces and gently ask them to linger.[4] Those photographs sold well, too. During the 1970s Adams's images were at the advancing crest of a bull market in American photography, and although Adams raised his own prices only moderately, in the secondary market there were truly astronomical sums paid for his prints—particularly after he announced that he would no longer accept orders after December 31, 1975.

Commercial concerns were in part responsible for the paucity of Adam's creative work. He admitted to Newhall that his lack of freshness was largely because "I 'pot-boil,'" and the reprinting of tried and true images like *Moonrise* was one sure way to earn money.[5] But commercial customers offered greater rewards than their art counterparts, and in what seems more a pursuit of the bottom line than anything like a principled (or coherent) endorsement program, both Adams and his photographs were available to generous corporate bidders throughout the 1960s and 1970s. In 1969 he sold one of his Yosemite winter scenes to the Hills Brothers coffee company, with the image subsequently appearing throughout the nation on thousands of three-pound coffee cans. In 1972 Adams actually starred in a Datsun television commercial, conveying the company's promise to plant a tree in the National Forests for each test drive taken in a Datsun.

The largest and most lucrative of Adams's projects was *Fiat Lux* (1967), a picture book published by the University of California to commemorate the school's one-hundredth anniversary. University President Clark Kerr approached Adams and Newhall in the spring of 1963, and a year later they had a contract to cover nine major campuses, scores of secondary facilities, and a host of faculty and staff. Adams worked steadily on the project for four years, producing sixty-seven hundred negatives; much of the work has the flat, uninspired look of an effort aimed more at coverage than interpretation, and there are derivative images such as *Moonrise, U.C.L.A* (1967) which hearken back to earlier works like the Hernandez *Moonrise*. *Fiat Lux* also left bad feelings on all sides. The project was nearly killed when Ronald Reagan became governor and launched his infamous assault on the University. Later, university officials became disenchanted with Adams and Newhall, saying that their submission was both untimely and poorly crafted.[6]

Fiat Lux also brought Adams face-to-face with the 1960s. Student politics and the counter culture emerged on California campuses as Adams began the project, and he was clearly bewildered by some of the more anarchic and confrontational aspects of the student movements. He was perplexed by one young man's enthusiasm for destructive protest, and bristled when a group of student photographers accused him of being irrelevant when he emphasized natural beauty over social issues.[7] His fellow California photographer Imogen Cunningham was much more at ease with campus sentiments (and fashions—she wore a peace symbol and drove a Volkswagen bus); Cunningham good-naturedly chided Adams for his seemingly retrograde ways and establishment connections, and at one point sent him a marijuana plant potted in one of his Hills Brothers coffee cans. Adams did, though, have a degree of empathy with students, for he thought that the aquarians of the 1960s were preferable activists to the comrades he had encountered in the 1930s, and he rather liked their spirit if one could just get beyond the "appearances of squalor and unconventional conduct."[8]

There was some wistfulness to Adams's comments about the students, for it seemed to him that his own causes had lost much of their spirit. By 1965 he admitted that the joy and wonder which he had once found in environmental work had waned. Writing to Willard Van Dyke, Adams said that "'conservation' used to be thought of as protection of natural beauty" at a time when "the urgency was minor, and the euphoria involved was considerable." Now, though, with pesticides, pollution, and land misuse, there was less glory, more ugliness, and greater desperation, and as Adams told a group of architects gathered at Yosemite that same year, the prevalent "creeping death" of the times was beginning to erode "the euphoria of beauty."[9] Thus by the mid-1960s the urgency of defending nature had displaced much of the pleasure that he once took in photographing it, and sometime during those years the fighting itself also became unsatisfying. The environmental ranks that had once seemed so united were increasingly plagued with internecine battles, as pro-development forces within the Park Service worked at odds with the agency's very purpose, and even the Sierra Club was torn by intensely debated issues like the proposed Diablo Canyon nuclear power plant. Adams and Brower found themselves the leaders

of divergent factions, and although Adams emerged victorious from the brawl, he was so disillusioned that in 1971 he resigned from the club's board, a position he had held for thirty-seven years.[10]

As environmentalism became increasingly politicized, Adams increasingly politicked on his own. As early as 1958 he had stepped outside the Sierra Club, directly contacting members of the Eisenhower cabinet to protest a proposed road through Yosemite.[11] Up through the 1980s he practiced a personal politics, exploiting his growing prominence to wrangle meetings during which he lobbied four sitting presidents: Johnson, Ford, Carter, and Reagan. Apparently Adams felt that reasonable people needed to talk with one another, and Adams came away most satisfied with Carter, who gave him an attentive audience. He was much less impressed when he interviewed his nemesis Reagan, who seemed almost blank ("my impression at the close of the meeting was that the vacuum had hit the fan"), and to have only a tenuous hold on reality (Reagan claimed to be an environmentalist himself, and said that Interior Secretary James Watt worked in nature's best interests).[12]

If Adams gradually left organizational politics for a more personal lobbying, he made certain that upon his death there would be institutions to convey his personal story. For much of his career he had tried to established organizations to insure that American photography developed as he thought it should, and now late in his life, he wanted to make certain that his own life would be understood as he thought it should be. In 1962, soon after Edward Steichen retired as director of MOMA's Photography Department, Adams began to build a relationship with John Szarkowski, Steichen's successor, and in 1979 Adams finally garnered what had been impossible during the Steichen years, his first full-fledged solo exhibition at MOMA.[13] But his most intense efforts were devoted to founding organizations in the West where his involvement could be more direct. Early in 1967, Adams, the Newhalls, Brett Weston, and others from Northern California formed what they called the Friends of Photography. Dedicated to the furtherance of creative and representational photography of the sort that Adams, Weston, and others practiced, the Friends eventually became an energetic promoter of exhibitions and workshops, and a significant publisher of photographic books. Adams's art was frequently among the Friends's offerings, and the agency itself remained structurally and emotionally tied to Adams; during its first decade the Friends survived in Carmel on his subsidies, and then in better times the organization moved to San Francisco where its headquarters was named The Ansel Adams Center.

There was a need for something in addition to such exhibition and publishing efforts. Adams had become influential by producing a huge number of prints and letters, and at the close of his life these amounted to a sizable but unorganized archive. If these collections were to be of benefit to anyone, much less do their job of securing Adams's historical reputation, they clearly needed to be housed in some academic institution where they would be preserved and arranged, and made accessible to scholars and others willing to tell the Adams story. He offered the materials to the University of California and broadly hinted that they might be included in a photography center at the new campus at Santa

Cruz, just up the coast from Carmel and well within the shadow of his influence.[14] But the University rejected Adams's offer—perhaps out of lingering animosity over *Fiat Lux*—and in 1974 Adams gave his archive to the University of Arizona, where it became the foundation of the Center for Creative Photography. There, in the unlikely desert town of Tucson, Adams's materials have been superbly managed, so that they not only radiate his ideas and vision, but also have allowed the Center to attract a significant number of other important archives (including Weston's and Strand's), and achieve much of Adams's long-standing vision of a truly national photographic hub.

Of all Adams's autumnal organizations, the one most specifically tasked with tying up the loose ends of his life was the Ansel Adams Publishing Rights Trust, established in 1975 in the hope that "even after my death...projects that I may not have finished will be completed in the spirit and with the attention to quality I have tried always to require."[15] Designed to funnel proceeds back to Virginia, Michael, and Anne, upon Adams's death the Trust saw to the posthumous completion of Adams's unfinished projects like the autobiography and a correspondence collection, and then went on to undertake remarkably creative and extensive publication efforts surpassing even Adams's fertile imagination, including products such as the *Ansel Adams Screensaver*.

There was, then, some autonomy in the organizations that Adams created to tend his flame. This structural independence was in part simple pragmatism on his part, a recognition that, as he put it, "the artist who has left the world is helpless to control the vagaries of curators and historians."[16] But in fact Adams was not quite as laissez-faire as he appeared to be, and he hoped to exercise at least some influence over the interpretative vagaries of those who came after him. In this business of "organizing my life,"[17] Adams was unwilling to leave one thing to chance, for he very much wanted to be beloved and to be remembered lovingly. And he managed to get pretty much what he wanted. Compared to Weston with his Parkinson's, Strand with his expatriation, and Stieglitz with his churlishness, Adams's last years were companionable, enriched by a large group of younger men and women who were tied to him not only by the bonds of affection but also as his employees in one way or another. They also went on to staff organizations like the Friends and the Trust. Having consigned his reputation to such loving hands, Adams may well have felt little need to exercise direct oversight.

His last great effort at organizing his life was his *Autobiography*, co-authored by his chief-of-staff and nurse, Mary Street Alinder. By design, the book avoids conventional chronological structure, and instead portrays his life as a story of warm human relationships, with chapters devoted to the likes of the Newhalls or Bender. Here the strains and animosities of a lifetime are mostly unmentioned: Virginia was an adored wife, the children were keenly appreciated, and David Brower was a saint. For a man who achieved fame through the camera, Adams said frustratingly little about the art of his photography, and quite an exasperatingly lot about fondly remembered anecdotes. To be sure, Adams allowed himself a few enemies like Reagan and Steichen, but as he reconstructed his story during those final years—sometimes working from his

sickbed—it became largely the tale of a man who had loved and respected those around him, and who had done little that might earn him anything but a lasting warmth and affection in return.

By most indications people have responded as Adams wished. Many of those who knew him continue to speak of him with affection, and he has become a beloved figure throughout the nation. In the years just before his death, Adams was showered with peculiarly American tokens of admiration. From President Carter came the Medal of Freedom (also bestowed on Beverly Sills and Hyman Rickover during the eclectic year of 1980). Adams's portrait was placed on the cover of *Time* magazine, and the issue's lead story proclaimed him "the Grand Old Man of a still young art."[18] Cartoonist Garry Trudeau gave Adams a more cherished accolade, a personalized cartoon ("for Ansel—with admiration and friendship"), in which "Doonsbury" characters stare admiringly at a flannel-decked, Yosemite-situated Adams. After Adams's death, the honors took on a different tenor, for the nation that had grown to love his interpretations of its landscape began to name that very landscape after him. In 1984 federal legislation was introduced which eventually resulted in the designation of over 200,000 acres of the Sierra as the Ansel Adams Wilderness Area, and in 1985, a year and a day after his death, a crag overlooking Adams's favorite Sierra spot officially became Mount Ansel Adams.[19]

Not long afterwards, his ashes were placed atop Mount Ansel Adams. In the misty mixture of love and landscape surrounding Adams's death, events had managed to replicate an experience he described more than fifty years before: "space becomes intimate...and you mingle your being with the eternal quietude of stone."[20] The mountain top was a fitting end for this photographer for whom photography was as much an experiential as a representational art form. Uniquely possessed with a passion for granite, Adams had in his life's work attempted to bridge the distance between self and subject, and in death he achieved a kind of final intimacy.

1. More created an imaginary nation driven by the principles of efficiency and community good. He startlingly combined these two values when he envisioned a kind of euthanasia squad, composed of well-meaning community elders and religious authorities. Their job was not to hasten anyone's death (though they were willing to make arrangements, if asked). Instead, the committee's purpose was to visit the hopelessly ill, gently leading them to recognize the futility of their painful lives. In a set speech developed for the situation, invalids heard not only about the reasonableness of euthanasia (they were told that they had become unproductive drains upon the community), but also that death was not really so different from what they already knew: these terribly infirm individuals were assured that they were already leading "a sort of posthumous existence." Thomas More, *Utopia* (1516; New York: Penguin Books, 1965), 102.

2. AA to NN, October 27, 1964, Beaumont and Nancy Newhall Collection, CCP. AA to NN and BN, March 6, 1962, Beaumont and Nancy Newhall Collection, CCP.

3. AA to BN and NN, September 13, 1973, from Mary Street Alinder and Andrea Gray Stillman, eds. *Ansel Adams: Letters and Images 1916-1984* (Boston: Little, Brown and Company, 1988), 321; hereafter *Letters*.

4. A.D. Coleman, *Light Readings: A Photography Critic's Writings 1968 - 1978* (New York: Oxford University Press, 1979), 123-24. The essay is "Ansel Adams: Let Me Make One Thing Perfectly Clear," *Village Voice*, September 21, 1972.

5. AA to BN and NN, September 13, 1973, *Letters*, 321.

6. Ansel Adams and Nancy Newhall, *Fiat Lux: The University of California* (New York: McGraw-Hill 1967). Louise Strover, "Ansel Adams, Nancy Newhall and *Fiat Lux*," *History of Photography* 18 (Autumn 1994), 272-78.

7. Strover, "Ansel Adams, Nancy Newhall and *Fiat Lux*," 276. AA to Willard Van Dyke, September 16, 1965, Willard Van Dyke Archive, CCP. Ansel Adams, *Ansel Adams: An Autobiography* with Mary Street Alinder (Boston: Little, Brown and Company, 1985), 234-35.

8. Ansel Adams, "Give Nature Time," Occidental College Commencement Address," June 11, 1967, AAA/CCP, 3.

9. AA to Willard Van Dyke, September 16, 1965, Willard Van Dyke Archive, CCP. Ansel Adams, "The Conservation of Man," *American Institute of Architects Journal* 45 (June 1966), 68, 70.

10. Jonathan Spaulding, *Ansel Adams and the American Landscape: A Biography* (Berkeley: University of California Press, 1995), 340-49.

11. AA to Fred Seaton, Sinclair Weeks and Conrade Wirth, July 7, 1958, *Letters*, 251.

12. Ansel Adams to Otis Chandler, July 5, 1983, *Letters*, 381. Adams, *Autobiography*, 348-52.

13. *Born Free and Equal* in 1944 had been a minor, focused show.

14. Ansel Adams, "Address by Ansel Adams: U.C. Santa Cruz Charter Day Dinner," March 30, 1965, AAA/CCP, 12.

15. Adams, *Autobiography*, 361.

16. Ibid., 254.

17. Ibid., 361

18. Robert Hughes, "Master of the Yosemite," *Time* 114 (September 3, 1979), 36.

19. Cartoon in *Letters*, 372. Spaulding, *Ansel Adams and the American Landscape*, 366-68; Mary Street Alinder, *Ansel Adams: A Biography* (New York: Henry Holt, 1996), 390-391.

20. Ansel Adams, "Retrospect: Nineteen-Thirty-One," *Sierra Club Bulletin* 17 (February, 1932), 8.

19. Conclusion: Perpetual Elation

Lines from Friedrich Nietzsche are prominent in Edward Weston's eclectic collection of quotations. It is a decidedly cheery and inspirational Nietzsche who emerges from Weston's collection, with little of the philosopher's sardonic wit or ironic teasing. One excerpt in particular tells artists that if they are truly to see and know the world, they must have "a kind of youthfulness, of vernality, a sort of perpetual elation."[1] Nietzsche intended this as an admonition for continuing creativity. But for Weston, Strand, Adams, and Stieglitz, the lines seem more descriptive rather than prescriptive. There was irrepressible optimism in the ways that they lived their lives and made their images. Certainly they had their low moments—Weston especially in those last years—and their elation was more persistent than perpetual. But still they all had about them an assuredness or confidence which was remarkably resurgent over the years.

The upbeat notes commenced almost from the beginning of these photographic careers. Stieglitz joyously photographed as he roamed the European countryside, Strand was mesmerized by summer shadows on the porch, Weston ecstatically portrayed odd angles in the attic, and Adams thrillingly captured Yosemite's crags and waterfalls. The basal optimism prevailed despite the inevitable crises and disappointments, often until almost the very end. Adams sketched the verbal love portraits of his *Autobiography* and planned additional projects just as his failing heart made him bedridden. Strand, nearly blind but never despairing, continued photographing with the help of a wife who aimed and focused his camera. Stieglitz, though an isolated curmudgeon, still opened his gallery daily in the confidence that there were subjects and people he could dominate, and that America needed his offerings. In Weston's case, Parkinson's Disease robbed him of both his beloved photography and his particularly sensual vernality: "Alas Lackanookee!" was his closing in a late letter to Adams. And yet just months before he died, Weston still had the mettle to flirt with Miriam Lerner, whose "responsive and stimulating" body had once inspired his voluptuous nudes, and whom he now coyly called "wonderful, beautiful, simpatica."[2]

The assurance of these careers was complemented by a sense of accomplishment, and these four photographers often felt that things were going their way. In the end, those feelings seem mostly justified. Thanks in large part to Stieglitz and the others, photography has been accepted as a fine art. Moreover, their reputations became large, their works well known, and much of subsequent art photography reflected their influence. Each man attracted a number of students and admirers, and Strand, Weston and Adams were granted that peculiar accolade of the American art world, the late-in-life blockbuster exhibition at a prestigious East Coast museum. They even had some influence beyond the visual arts, and Adams and Strand were both invited to the White House. Their work spurred the ascendancy of straight photography in America, and though this was a larger

development and not entirely their doing, their accomplishments helped to make soft-focus pictorialism little more than an atavistic or experimental motif by the later part of the twentieth century.

Often they had hoped for hegemony in American art photography, but this eluded them. There have been a number of photographic currents that owe little to Weston and the others. The street photography of their contemporary Walker Evans and later individuals like Robert Frank was accomplished without the aestheticizing impulses of Stieglitz and the others. Nor is much of their influence to be found in the kind of surrealism practiced by Jerry Ulesmann with his improbable double exposures. But in other quarters their influence was certainly felt. There are echoes of Strand's humanism in W. Eugene Smith's photographs of Spanish and Japanese villages. Adam's images have their counterpart in the similarly popular nature photography of Eliot Porter, and some of Weston's modernist concerns can be seen in the images of Aaron Siskind. Stieglitz's and Adams's insistence that nature provides access to unknown spiritual frontiers surfaces in the images of Paul Caponigro and Minor White. In short, Adams and the others could rest assured that they had strongly influenced if not entirely directed the subsequent course of American art photography.

The abiding optimism of Strand and the others was also reflected in their epistemological orientations. They rather blithely refused to accept the common inclination to regard representations as the product either of the subject or of the mind which describes or beholds that subject. There has also been an accompanying tendency to say that we act more or less in one of two ways, either as the (more passive) knower or as (the more active) artificer when we go about acquiring knowledge and making our representations. But while Adams, Weston, Strand, and Stieglitz recognized these dichotomies, they were unwilling to accept them fully, and preferred instead a genial ambiguity, favoring first one and then the other epistemological posture.

Sometimes they favored the power of the mind. Like many of their contemporaries, they recognized that little of our knowledge or representation occurs without the mind's impress, that the mind not only holds knowledge but also arranges and shapes it. Thus representations such as photographs have an additive dimension, for they are renditions which enhance nature with the mind's illuminations. The photographers' images were not just of the world, but also replete with the designs that they rendered from that world. As Strand worked, for instance, he was inclined to convey interrelational patterns, sometimes in nature where plants and animals were connected, as in the image of a rain-drenched cobweb (fig. 7.2), and sometimes in less visible social connections, such as those between the fishermen in his film, *The Wave*. Likewise Weston wanted to portray the contractile forces that he had come to understand in the magnificently convoluted *Pepper [No.32]* (fig. 12.5). In order to exercise and impart such perceptions, these photographers were willing to manipulate their images' contents, sometimes excising from negatives as Stieglitz did with a distracting pile of timbers in *Winter—Fifth Avenue* (fig. 2.4), and sometimes using extra devices as Adams did with that special filter that so dramatically enhanced a Yosemite monolith (fig. 15.2). The purpose in all this was to convey what the mind had garnered, and occasionally the photographers' attempts

seemed to go beyond manipulation and into abusiveness, as when Stieglitz's understanding of Woman led him to cage or perch his models rather like captive animals. Thus at times the exercise of the photographers' mental visions impinged upon their subjects' autonomy.

But theirs was not just a story of the mind. It was also a story of the subjects that the mind illuminates, and these photographers often worked with a deep regard for the independence, and even the recalcitrance, of the outer world. They repeatedly said that one should tread lightly upon those subjects. Weston admired the Mexican craftsmen who showed him that one could gently gild the lily of nature, demonstrating with simple gourds and a few paint strokes the similarities of vegetable and animal forms (fig. 11.5). There was a corresponding tenderness to Stieglitz's rain-splattered apples (fig. 4.2), serenely and carefully presented with the sense that a mere breath might spoil the scene. Yet sometimes this respect for the apparent fragility of the photographers' subjects could be carried to extremes, most notably when Weston and the others complained about, or even rejected, language. Surely our words, and particularly our metaphors, may confuse our representations and lead us into trouble (famously: Vietnam is a domino). But we cannot flee from language as Weston sometimes wished; it is all we have, the necessary conduit through which our thoughts flow. Indeed, Weston's photography probably benefited from all his journaling, and his art suffered when he abandoned his Daybook.

Weston once noted that Emerson had admonished us to "make friends with matter."[3] It was an admonition Weston and the others seldom needed. So often, as with Strand's Akeley (fig. 7.1), the regard for matter is palpable; like good friends, the photographers were frequently quite close to their particular subjects. Yet it was not just the particulars they sought. They often said that an understanding or knowledge of the parts could lead us beyond the separate subjects and towards more universal wholes, and in their photography there was a repeated thrust toward the transcendental. *Weston's Pepper No. 35* (fig. 12.3) began with a magnificent individual vegetable, but he hoped the image would lead us toward the larger subject, what he called the "pepper plus." Similarly, Adams's image of a beclouded Texas mesa (fig. 17.7) was intended to lead us toward a mountain spirit. This transcendental dimension was pervasive in the work of these photographers, even in the atheistic photography of Strand, whose young Italian man (fig. 9.4) stands before us not only in his simple physicality but also as the emblem of a grander human spirit.

For Stieglitz and the others, the world was knowable, and more than once they indicated a belief that it was knowable in its ultimates. In this way these photographers lacked the wistfulness that was so common in twentieth-century epistemological discussions, for they did not share the common sensibility that we are disconnected from ultimates, that the world is in the largest sense unknowable. Quite the contrary. For all their respect for Nietzsche and other contemporary thinkers, they evinced little of the Nietzschean sense of the absurd. Certainly they shared the existentialists' position that meaning comes with our efforts, with our illuminations. But unlike the existentialists, they contentedly believed in independent essences (even, in Weston's case, quintessences). Confidence, more than angst, was their métier.

The upbeat mood may perhaps account for the appeal of their work. There is a joy in Weston's nudes, a glory to Adams's mountains, and not much tragedy in either. But their persistent optimism does not always seem warranted, for their art and their orientation could fail them late in life. Stieglitz moved to cloud photography almost unavoidably, when he proved unable to dominate and depict the more earthly nudes with which he had been working. Weston's despair was the most gripping of the lot, a sense that disease had cut him off from his work long before he was finished. In contrast, Adams and Strand remained enormously productive, but their photography of mountains or peasants continued so repetitiously that it became clichéd. Moreover, the four photographers at times seemed to find importance and universality in most any subject, and as Walter Benjamin once noted, such transcendental photography is problematic for it nearly "raises every tin can into the realm of the all."[4]

In the end, though, I come away from these men with a good deal of admiration. They worked reflectively, thoughtfully composing images while trying to situate their art within broader intellectual contexts. In these efforts, they underscored one of the important realizations of their time, the recognition that the mind plays a huge role in representation—and they did this while working in a medium that sometimes seems transparent, an art most purely imbued with the subject more than the mind. Finally, they had long and productive careers, working seriously and sometimes with great sacrifice. With their art and their lives often intimately connected, they created many very good photographs—and more than their share of truly magnificent ones.

1. Edward Weston collection of quotations. EWA/CCP.
2. EW to AA, April 1948, Mary Street Alinder and Andrea Gray Stillman, *Ansel Adams: Letters and Images 1916-1984* (Boston: Little, Brown and Company, 1988), 192. DBI, September 29, 1925, 129. EW to Miriam Lerner, March 10, 1955, EWA/CCP.
3. Weston quotation collection, EWA/CCP.
4. Walter Benjamin, "A Short History of Photography," 1931, in Alan Trachentenberg, ed., *Classic Essays on Photography* (New Haven, CT: Lette's Island Books), 213-15.

Index

*Illustrations appear on pages indicated in **bold**.*

Index

Anderson County Library
300 North McDuffie Street
Anderson, South Carolina 29622
(864) 260-4500

Belton, Honea Path, Iva,
Lander Regional, Pendleton,
Piedmont, Powdersville,
Westside, Bookmobile